1993

Yale Publications in the History of Art

Walter B. Cahn, Editor

Yale University Press

New Haven & London

ROMAN
SCULPTURE

Diana E. E. Kleiner

Published with the assistance of the Getty Grant Program.

Designed by Ken Botnick.
Set in Linotron 202 Bembo type by Tseng Information Systems.
Printed in the United States of America by Arcata Graphics/ Halliday.

The paper in this book meets the guidelines for permanence and durability of the Committee on Production Guidelines for Book Longevity of the Council on Library Resources.

10 9 8 7 6 5 4 3 2 1

Library of Congress Cataloging-in-Publication Data

Kleiner, Diana E. E.
 Roman sculpture / Diana E. E. Kleiner.
 p. cm. — (Yale publications in the history of art)
 Includes bibliographical references and index.
 ISBN 0-300-04631-6
 1. Sculpture, Roman. I. Title. II. Series.
NB115.K57 1992
733'.5—dc20 91-46265
 CIP

Frontispiece: Arch of Marcus Aurelius, Triumph, 176–80. Rome, Museo del Palazzo dei Conservatori. (See fig. 261.)

For Alexander Mark Kleiner

CONTENTS

ix Preface and Acknowledgments

xi Abbreviations

1 Introduction

CHAPTER I

23 The Art of the Republic

CHAPTER II

59 The Age of Augustus and the Birth of Imperial Art

CHAPTER III

123 Art under the Julio-Claudians

CHAPTER IV

167 The Civil War of 68–69, the Flavian Dynasty, and Nerva

CHAPTER V

207 Art under Trajan and Hadrian

CHAPTER VI

267 Antonine Art: The Beginning of Late Antiquity

CHAPTER VII

317 The Severan Dynasty

CHAPTER VIII

357 The Third Century: A Century of Civil War

CHAPTER IX

399 The Tetrarchy

CHAPTER X

431 The Constantinian Period

465 Glossary of Greek and Latin Terms

469 Index

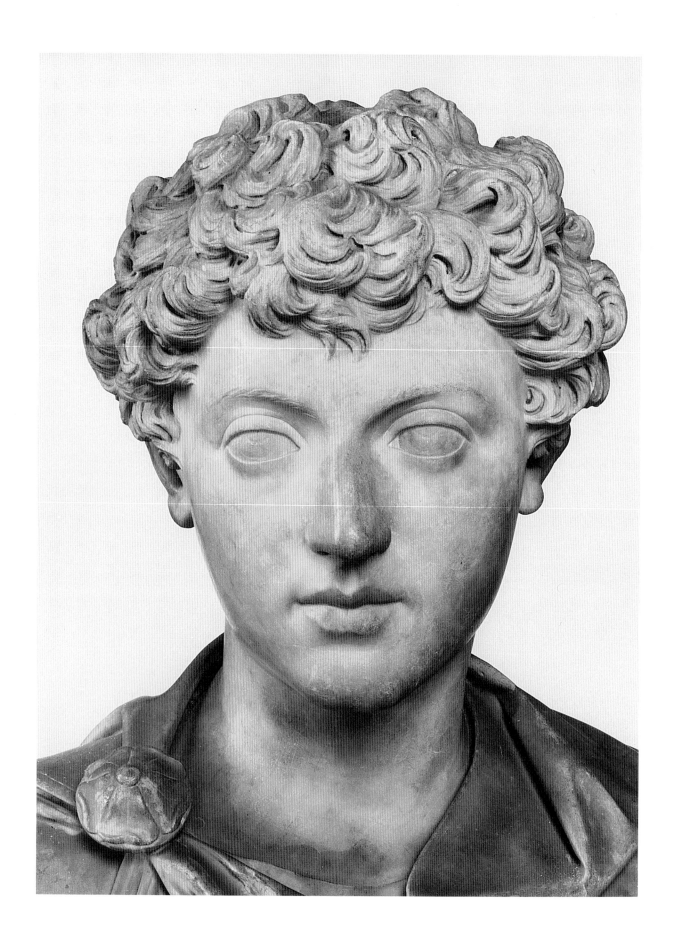

Portrait of Marcus Aurelius, ca.140. Rome, Museo Capitolino.
Photo courtesy of Gisela Fittschen-Badura

PREFACE & ACKNOWLEDGMENTS

This book owes its inception to Judy Metro of Yale University Press, who in 1982 suggested that I write a comprehensive study of Roman sculpture to complement the one on Greek sculpture by Andrew Stewart of Berkeley. The idea intrigued me because a book that concentrates on Roman sculpture is, in itself, new. There is no survey book devoted to Roman sculpture alone, with the possible exception of the out-of-date and long out-of-print survey by Eugenie (Mrs. Arthur) Strong, *Roman Sculpture from Augustus to Constantine* (London, 1907) (and an Italian translation published in 1923–26). The survey books that have been written in more recent years – for example, those by Bernard Andreae, Richard Brilliant, George M. A. Hanfmann, Helga von Heintze, Martin Henig, Andrew Ramage, Nancy Ramage, and Mortimer Wheeler – deal with sculpture, painting, and architecture, which necessitates a less detailed treatment of the sculptural material. The only recent study that concentrates on sculpture is Donald Strong's *Roman Art* (Harmondsworth, 1976), but although Strong focuses on sculpture he also devotes attention to painting, mosaic, and the minor arts.

In any case, the scope and organization of this book are different from those of earlier surveys. Above all, I have strived for a balanced perspective on Roman sculpture, concentrating not only on art commissioned by the court in Rome and the aristocracy in the provinces, but on the art of freedmen and slaves. Of equal importance is the interrelation between the art of those of different social status. I have also included portraits and reliefs representing women and children who are largely ignored in studies of Roman art. Even portraits of the empresses, which are sometimes more original and interesting than those of their husbands, are rarely included in surveys of Roman art. Attention is given, therefore, not only to major monuments but to less well-published works of lower quality that are, however, of high historical and cultural interest. This material is important not only for our understanding of Roman art but also of Roman society and Roman patronage.

I wrote this book during the 1987–88 academic year. My greatest debt is to the president of Yale University, Benno C. Schmidt, Jr., who granted me a special leave of

absence from teaching and administrative duties to write *Roman Sculpture,* which would not have come into being at this time without President Schmidt's wise advice and generous support. I am also grateful to the former provost, William D. Nordhaus, and to the former dean of the Graduate School, Jerome J. Pollitt, for their counsel and encouragement.

I am grateful to the J. Paul Getty Trust for its generous grant in support of the publication of this book, and I would like also to acknowledge another grant from the John F. Enders Fellowship of Yale University. The latter enabled me to benefit from the expert research assistance of Eric Varner in securing bibliographic references. Additional bibliographic work, as well as help in organizing the illustrations, was provided by a Yale College undergraduate, Annelisa Stephan, during the 1988–90 academic years. I owe a debt of gratitude to her and to many other Yale students. I want to thank the graduate students in Classics and in the History of Art who have listened to my ideas and presented many of their own. Countless Yale undergraduates have also passed through my courses on Roman art and architecture, and I am grateful to them for their enthusiasm for the study of Roman art and especially for their many challenging questions and astute comments.

I also want to thank my husband, Fred S. Kleiner, and friends and colleagues Sarah Cormack, Natalie Kampen, John Pollini, Eric Varner, Cornelius Vermeule, Gordon Williams, and Susan Wood, who generously read all or part of the manuscript and offered many useful suggestions. I owe a special debt of gratitude to Gordon Williams, not only for his sensitive reading of the text, but for his generous support and encouragement.

Special thanks are also owed to Lorraine Alexson for her expert editing of the text and for her help in preparing the glossary, to Ken Botnick for his masterful design of the book and for laying out the plates, and to Marni Kessler for invaluable assistance in making the index. Judy Metro's significant contribution to this book has already been acknowledged, but I want to thank her also for her support and encouragement along the way.

It was a great challenge to collect the 421 photographs that illustrate this book, and I am grateful to Yale University for a triennial leave in spring 1991 that allowed me to do just that. I thank first and foremost Helmut Jung of the Deutsches Archäologisches Institut in Rome, Elena Quevedo of Art Resource in New York, Gisela Fittschen-Badura, and Klaus Fittschen for their generous help in acquiring most of the photographs. A great debt is also owed to William Valerio, who selflessly took time from his own research to keep track of my many photograph orders in Rome. I also acknowledge the invaluable help of Edmund Buchner, Richard Gergel, Antonio Giuliano, Eugenio La Rocca, Anna Marguerite McCann, and R. R. R. Smith, who kindly provided me with photographs from their personal collections. Judith Barringer, Eve D'Ambra, and Lee Ann Riccardi are to be thanked for locating miscellaneous photographs in Athens and Rome. Additional photographs were provided by the following museums and institutions: Musées d'Arles (Arles), American School of Classical Studies, Corinth Excavations (Athens), Deutsches Archäologisches Institut (Athens), École française d'Archéologie (Athens), National Museum (Athens), Staatliche Museen, Antikensammlung (Berlin), Museum of Fine Arts (Boston), Civici Musei d'Arte e Storia di Brescia (Brescia), Harvard University Art Museums(Cambridge, Mass.), Forschungsarchiv für römische Plastik Köln (Cologne), Ny Carlsberg Glyptotek (Copenhagen), The British Museum (London), Victoria and Albert Museum (London), Museo Civico (Lucera), Römisch-Germanisches Zentralmuseum (Mainz), Hirmer Verlag München (Munich), Staatliche Antikensammlung und Glyptothek (Munich), Yale University Art Gallery (New Haven), American Numismatic Society (New York), Metropolitan Museum of Art (New York), Bibliothèque Nationale (Paris), Musée du Louvre (Paris), The University Museum of Archaeology and Anthropology, University of Pennsylvania (Philadelphia), Fototeca Unione at the American Academy (Rome), Istituto centrale per il catalogo e la documentazione (Rome), Musei Capitolini (Rome), Soprintendenza Archeologica di Roma (Rome), Stadtbibliothek (Trier), Archivio Fotografico Musei Vaticani (Vatican City), Kunsthistorisches Museum (Vienna), Dumbarton Oaks Collection (Washington, D.C.), and Worcester Art Museum (Worcester).

I owe a special kind of debt to my father, Morton H. Edelman, my brother, Robert G. Edelman, and my sister, Nancy E. Wells for the loving support they gave me during the year I wrote this study. The memory of my mother, Hilda W. Edelman, is always sustaining and it gives me great pleasure to know how much she would have liked this book.

Roman Sculpture is dedicated with great love and devotion to my six-year-old son, Alexander Mark Kleiner, named for two men who figure prominently in this book. The first – Alexander the Great – Hellenistic general and ruler whose inspired portraits were widely imitated by the emperors of Rome; the second – Marcus Aurelius – successful general, merciful emperor of Rome, and sensitive philosopher – who presided over the Roman empire at a critical time of transition. On 28 May 1985 my Alexander Mark came into the world, and his handsome face, sparkling eyes and smile, and exuberant personality inspired this book.

ABBREVIATIONS

AA	Archäologischer Anzeiger	*DialArch*	Dialoghi di archeologia
AbhBerl	Abhandlungen der Deutschen Akademie der Wissenschaften zu Berlin	*DOP*	Dumbarton Oaks Papers
AbhLeip	Abhandlungen der Sächsischen Akademie der Wissenschaften zu Leipzig, Philologisch-historische Klasse	*EAA*	Enciclopedia dell'arte antica, classica e orientale
ActaAArtHist	Acta ad archaeologiam et artium historiam pertinentia	*Eikones:* *AntK-BH*	Studien zum griechischen und römischen Bildnis. Hans Jucker zum sechzigsten Geburtstag gewidmet. Antike Kunst. Beiheft 12 (1980)
ActaArch	Acta archaeologica [Kobenhavn]	*GettyMusJ*	J. Paul Getty Museum Journal
AfrIt	Africa italiana	*JAC*	Jahrbuch für Antike und Christentum
AJA	American Journal of Archaeology: The Journal of the Archaeological Institute of America	*JBerlMus*	Jahrbuch der Berliner Museen
		JdI	Jahrbuch des Deutschen Archäologischen Instituts
AM	Mitteilungen des Deutschen Archäologischen Instituts, Athenische Abteilung	*JRA*	Journal of Roman Archaeology
		JRGZM	Jahrbuch des Römisch-Germanischen Zentralmuseums, Mainz
AnalRom	Analecta romana Instituti Danici	*JRS*	Journal of Roman Studies
ANRW	H. Temporini ed., *Aufstieg und Niedergang der römischen Welt* (Berlin 1972–)	*JWalt*	Journal of the Walters Art Gallery
		JWarb	Journal of the Warburg and Courtauld Institutes
AntAfr	Antiquités africaines		
AntCl	L'Antiquité classique	*KölnJb*	Kölner Jahrbuch für Vor- und Frühgeschichte
AntK	Antike Kunst		
AntP	Antike Plastik	*MAAR*	Memoirs of the American Academy in Rome
ArchCl	Archeologia classica		
ArchNews	Archaeological News	*MainzZ*	Mainzer Zeitschrift
ArtB	Art Bulletin	*MarbWPr*	Marburger Winckelmann-Programm
ArtJ	Art Journal	*MdI*	Mitteilungen des Deutschen Archäologischen Instituts
ASAtene	Annuario della Scuola archeologica di Atene e delle Missioni italiane in Oriente	*MedKob*	Meddelelser fra Ny Carlsberg Glyptotek [Kopenhavn]
BABesch	Bulletin antieke beschaving: Annual Papers on Classical Archaeology	*MEFRA*	Mélanges de l'École française de Rome: Antiquité
BCH	Bulletin de correspondance hellénique	*MélRome*	Mélanges d'archéologie et d'histoire de l'École française de Rome
BdA	Bollettino d'arte		
BEFAR	Bibliothèque des Écoles françaises d'Athènes et de Rome	*MemLinc*	Memorie: Atti della Accademia nazionale dei Lincei, Classe di scienze morali, storiche e filologiche
BMusArt	British Museum of Art		
BonnJbb	Bonner Jahrbücher des Rheinischen Landesmuseums in Bonn und des Vereins von Altertumsfreunden im Rheinlande	*MemPontAcc*	Memorie: Atti della Pontificia Accademia romana di archeologia
		MM	Madrider Mitteilungen
BSR	Papers of the British School at Rome	*MonAnt*	Monumenti antichi
BullCom	Bullettino della Commissione archeologica comunale di Roma	*MonPiot*	Monuments et mémoires: Fondation E. Piot
BWPr	Winckelmannsprogramm der Archäologischen Gesellschaft zu Berlin	*MüJb*	Münchener Jahrbuch der bildenden Kunst
BZ	Byzantinische Zeitschrift	*NakG*	Nachrichten von der Akademie der Wissenschaften in Göttingen
CAH	Cambridge Ancient History		
CEFR	Collection de l'École française de Rome	*NC*	Numismatic Chronicle
CIL	Corpus Inscriptionum Latinorum	*NSc*	Notizie degli Scavi di antichità
CollLatomus	Collection Latomus	*NuovB*	Nuovo bullettino di archeologia cristiana
DAIR	Deutsches Archäologishes Institut Rom		

ÖJh	Jahreshefte des Österreichischen archäologischen Instituts in Wien	*SchwMbll*	Schweizer Münzblätter
OpArch	Opuscula archaeologica	*StClas*	Studii Clasice
OpRom	Opuscula romana	*StEtr*	Studi etruschi
PAAR	American Academy in Rome: Papers and Monographs	*StMisc*	Studi miscellanei: Seminario di archeologia e storia dell'arte greca e romana dell'Università di Roma
ProcBritAc	Proceedings of the British Academy		
RA	Revue archéologique	*TAPA*	Transactions of the American Philological Association
RdA	Rivista di archeologia		
RendNap	Rendiconti dell'Accademia di archeologia, lettere e belle arti, Napoli	*TAPS*	Transactions of the American Philosophical Society
RendPontAcc	Atti della Pontificia Accademia romana di archeologia: Rendiconti	*TrWPr*	Trierer Winckelmannsprogramme
		TrZ	Trierer Zeitschrift für Geschichte und Kunst des Trierer Landes und seiner Nachbargebiete
RivIstArch	Rivista dell'Istituto nazionale d'archeologia e storia dell'arte		
RM	Mitteilungen des Deutschen Archäologischen Instituts, Römische Abteilung	*YCS*	Yale Classical Studies
		ZPE	Zeitschrift für Papyrologie und Epigraphik
RN	Revue numismatique		
SBMünch	Sitzungsberichte, Bayerische Akademie der Wissenschaften [München], Philosophisch-historische Klasse		

An extensive list of standard abbreviations for ancient texts is to be found in *The Oxford Classical Dictionary*, 2d ed. (Oxford, 1970).

INTRODUCTION

This book is intended as a study of Roman monumental sculpture in its cultural, political, and social contexts, and my goal is to present a balanced assessment of art commissioned not only by the imperial elite but also by Roman private patrons, including freedmen and slaves. Because of the extraordinary geographical extent of the Roman empire and the number of diverse populations encompassed within its borders, the art and architecture of the Romans were always eclectic and are characterized by varying styles attributable to differing regional tastes and the diverse preferences of a wide range of Roman patrons. I treat all the major public and private monuments but also many less well-known monuments, either because they are important in their own right or because they shed light on the interrelation between aristocratic art and the art of freedmen. The emphasis is on sculpture in the capital city of Rome, but significant monuments erected in the provinces are also discussed. Roman works of art are not examined in isolation, as is often the case, but are treated in the context of the historical and social background of the period and, where appropriate, as elements of an architectural complex. Sculpture was part of everyday Roman life – and of death – and was commonly placed in fora, basilicas, temples, and baths in the public sphere, and in houses, villas, gardens, and tombs in the private realm.

Since Roman monuments were generally designed to serve the needs of their patrons rather than to express the artistic temperament of their makers, I have paid considerable attention to the monuments' commissioners or honorands who came from different levels of society, ethnic backgrounds, and geographical locations. Because Roman artists were unimportant socially (they came from the slave and freedman class), few artists' names have come down to us, and they are almost invariably Greek names. The significance of those artists whose names we have, such as Pasiteles, who helped promote a taste for Greek art in Rome, should not be overemphasized, but their oeuvres will be examined and their contributions to the history of Roman art assessed whenever possible.

This introduction is thematic in nature and defines Rome and its empire. It identifies imperial and private

patrons from Rome and the provinces; discusses the position of the artist in Roman society and the materials he used; places Roman sculpture in its architectural context; gives the typology of the monuments; characterizes Roman eclecticism; and discusses the historiography of Roman art. The main section of the book is organized chronologically, beginning in 753 B.C., at the time of the foundation of Rome, and ending with the conversion of Constantine the Great to Christianity and the transfer of the capital from Rome to Constantinople. Within each period, the material is treated typologically, for example, portraiture, state relief sculpture, the art of freedmen, and provincial art; each chapter culminates in a discussion of the general characteristics of the period and the origins and legacy of its monuments. Throughout, considerable attention is paid to the nature of scholarly discussion and debate in the field of Roman art. Although the general outline of the development of Roman art is by now well known, new discoveries and innovative methodologies continue to alter our perception of individual works and groups of monuments. One of my major goals in this book is to demonstrate how active and even unsettled scholarship on Roman art is today and to suggest fruitful areas for future research.

Definition of Rome and Its Empire
Geographical and Chronological Limits

Rome is now a metropolis and was once an empire; this book examines the sculptural remains of both the city and the civilization. According to tradition, the city of Rome was founded on 21 April 753 B.C. At its apogee, under Trajan, the Roman empire stretched from the British Isles to North Africa and the Middle East. The city of Rome lies on the banks of the largest river in central Italy – the Tiber – a strategic position that encouraged mercantile activity and allowed the city to thrive economically. Rome was also blessed with natural hills that were readily defensible, and the earliest habitation clustered on these. The remains of an Iron Age village on the Palatine hill and a nearby wall give merit to the tradition that asserts that Romulus founded the city on that hill in the eighth century B.C.

Romulus's Iron Age village comprised primitive thatched huts of mud brick and wattle and daub, and in the cemetery below were cinerary urns in the form of houses and helmets. The city subsequently came under Etruscan control, and by the late republic the artistic embellishment of the new municipality included cult statues, honorific statuary, and historical reliefs. Many of these bear the stamp of their Etruscan past. The history of Roman sculpture is thus, from its beginnings, the history

of the sculptural output of the city of Rome. Roman colonization began in the republic with the founding, in the fourth century B.C., of colonies in Italy such as Ostia, the port of Rome. The following centuries witnessed Roman colonization in Asia Minor, Greece, Gaul, Africa, Egypt, and elsewhere. The military conquests of the republic and early empire enabled the Romans to expand throughout Italy and the Mediterranean.

At the same time, Rome became exposed to other artistic cultures, notably that of Greece, and shook off its dependence on Etruscan art. During the last two centuries before Christ, a distinctive Roman manner of sculpting emerged. In each of the new colonies, Rome built cities – miniature Romes – that were provided with the amenities of everyday life as well as with the trappings of a typical Roman city, including a forum, basilica, senate house, temples, baths, and private residences, all of which were embellished with sculpture. The inhabitants of these new cities included the indigenous population and Roman settlers who were predominantly army veterans allotted land in reward for loyal service. The Roman soldiers emigrated with their families and also brought with them their religious beliefs, social customs, and artistic predilections. Once in their new homes, they encountered natives who clung tenaciously to their traditions and artistic preferences. What resulted was the confluence of foreign and local elements in a new style that is usually referred to as provincial, indicating that it was produced in the provinces under Roman political jurisdiction during the Roman period.

Although works manufactured in all of the Roman provinces have certain features in common, each is a product of its own distinctive region. The word provincial also connotes a lack of quality and sophistication, but it is not used here in a pejorative way. Although some works of Roman provincial sculpture are inferior, others, especially those made in the eastern provinces where the Hellenistic Greek tradition had made strong inroads, are masterpieces of their time. This book concentrates on the sculpture made in the city of Rome and central Italy, but major provincial monuments are examined for their own merits and because of the light they shed on the interrelation between the art of the capital and that of the Roman provinces. Little attempt is made, however, to deal with provincial portraiture, which comprises provincial versions of portrait types from the city of Rome. An exhaustive study of Roman art in the provinces is so complex that it needs to be the subject of a separate volume.

The Patrons

Roman society was rigidly structured, with the extent of a man's landholdings determining his social position. In the republic, the patrician class (*patricius*) comprised the most privileged families of Rome, including, for example, the Aemilii, Claudii, Cornelii, Furii, Julii, Servilii, Sulpicii, and Valerii. Male members of these *gentes* were magistrates, held important religious posts, and served in the Roman cavalry. The patricians were distinct from the *plebs,* who consisted of the remainder of the Roman citizenry. At first, the plebs were denied the privileges afforded the patricians, including holding major magistracies and religious offices. They were also not allowed to serve in the senate or to marry patricians but were not prohibited from serving in the army. The stark distinctions between these two branches of Roman society dwindled in the late republic, and under the empire the aristocracy or *nobiles* consisted of the senatorial class at the apex and the equestrians (*equites*) just below. Together they constituted the *ordo*. Under Augustus, membership in the senate was practically hereditary (new men could be introduced by the emperor), and the senatorial class became the reserve of the privileged few. The equestrian order was just below the senatorial order in the social scheme, although its members could be promoted to the senate. Nonetheless, the interests of the equites tended to be less political, and they were, for the most part, content to marry members of the senatorial class and to enjoy their wealth and status. Those who did not belong either to the senatorial or equestrian orders were loosely referred to as plebeians. Strictly speaking, it was the municipal senators, or decurions, and freedmen who constituted the next social class, with slaves and the free poor at the very bottom of the scale. Slaves and freedmen were the most upwardly mobile because, although they were brought to Rome in bondage, many were highly skilled professionals, such as doctors, lawyers, and teachers. A considerable number even found employment in the imperial court or among the aristocracy. Some rose to great heights. Claudius's freedmen, Narcissus and Pallas, for example, wielded considerable influence over imperial policy in the mid-first century.

The only professions considered suitable for members of the upper classes were the management of their estates and service to the state, whether military, civic, or both, leaving the financially rewarding positions in commerce and elsewhere open to equestrians and freedmen. It is not surprising that the first works of art commissioned by aristocratic patrons were tied to their political or military lives or to their residences. Honorific portraits of great generals or statesmen were made to embellish public spaces, triumphal paintings recorded military successes, statues of captive provinces were displayed in a theater in Rome, Greek masterpieces and their replicas or variations were exhibited both in public buildings and private domiciles. With Rome's first emperor Augustus, art and ideology became inextricably bound as the emperor's military ventures and political, dynastic, and social policies were given visual form in the sculptural programs of his forum, his state relief sculpture, and in his portraiture. He established a trend that was to continue to flourish under his successors and that lasted into the Constantinian period.

Freedmen were, on the whole, less well to do than the aristocrats and were also hampered by legal proscriptions such as the one that restricted the placement of ancestral portraits in household cupboards (*armaria*) to the *nobilitas*. Nonetheless, some – like the baker Marcus Vergilius Eurysaces – were able to amass considerable fortunes, which they spent in part on monumental tombs elaborately decorated with professional scenes and funerary portraits. In fact, most of the surviving Roman monuments commissioned by freedmen are sepulchral.

These freedmen were manumitted slaves who had originally been brought to Rome as captives beginning in the second century B.C. Once in Italy, the slaves were divided into two main groups: the *familia urbana* and the *familia rustica,* consisting of domestic and agricultural slaves, respectively. The majority of domestic slaves, who came from the Greek East, were relatively well educated and possessed valued skills. They were eventually manumitted by their patron in return for work and loyalty or for financial benefit to the patron.

Once freed, the slaves were still obligated to their patron and owed him *obsequium et officium* (proper respect and duty), but they were allowed to take up professions and thereby earn enough money to live comfortably and to pay for their funerary monuments. In the early republic, the patron provided a burial place for his domestic slaves and freedmen (*libertini*), who were often interred in the same tomb as the master and his family, but by the late republic, libertini had become richer and more independent, and many built their own tombs according to their own taste. At the same time, masters still erected tombs for the poorer enfranchised slaves, usually in the form of columbaria, such as those of the Vigna Codini, where the ashes of hundreds of slaves and freedmen were housed together.

Social hierarchy was also apparent in those Roman provinces overseen by senior administrators, who were sometimes even imperial heirs. Each province had its own high priest, and those living in the provinces could gain Roman citizenship, which provided their descendants with the possibility of becoming members of the

equestrian order or of the senate. With time, the army was also open to those from the provinces who reached great heights. Many third-century soldiers, for example, rose from military positions in the provinces where they were born to become emperors of Rome. The patrons of monuments erected in the provinces were thus even more varied than those who commissioned works in Rome. They would have included the emperor or a member of his family who, on occasion, was the dedicator or recipient of a monument honoring a diplomatic or military success in a specific province. The Arch of Augustus at Susa (see figs. 96–97), for example, commemorates the signing of a treaty between the emperor and a local king, Marcus Cottius; and the monument of Trajan at Adamklissi (see figs. 196–198) is a local testament to the emperor's Dacian campaigns, made roughly contemporaneously with the Forum and Column of Trajan in Rome (see figs. 177–180). Also honored with monuments in the provinces were foreign aristocrats like Gaius Julius Antiochos Philopappos, a descendant of a deposed king of Commagene, who became a Roman consul. His sister, Balbilla, erected his tomb on the Mouseion Hill in Athens, where he died, and had it ornamented with a scene depicting him on the day of his adlection into the senate (see figs. 199–200). Veterans of Caesar's army in Gaul were honored in a mausoleum at St.-Rémy that is crowned by their statues and is carved with battle and mythological scenes (see fig. 99). The names and honorary titles of minor magistrates of freedman extraction are preserved for posterity on tombs in Pompeii with the representation in relief of the chairs occupied by someone of their position.

In the Roman milieu, it was the patron who had the most significant impact on the appearance of a work of art. The work could reflect an emperor's political or social policies, record historical events in minute detail, preserve for posterity the features and professional status of a lowly baker, and record its commissioner's hope for life in the eternal hereafter. Such a close association of patron and product necessitates, whenever possible, a careful examination of the patron's biography and artistic predilections.

The Artists

Commentaries on Greek art written by Latin authors (for example, the chapters in Pliny the Elder's *Natural History*) record the names and describe the major achievements of such Greek sculptors as Lysippos, Pheidias, Polykleitos, and Praxiteles. The fame of these illustrious sculptors and the brilliance of their creations were not lost on the Romans. Although early on criticized

by Plutarch for their interest in barbaric spoils (*Life of Marcellus* 21), the Romans quickly developed a love for Greek culture and a taste for Greek art. They were introduced to Greek art after the late third century B.C. by the abundant display of plundered Greek masterworks in Roman triumphal processions. After the supply of originals dwindled, whole schools of copyists began turning out near replicas and new variations to fulfill the demands of a seemingly insatiable Roman audience. Despite the Roman admiration for such statues as the Doryphoros of Polykleitos or the Venus of Praxiteles, there was a surprising lack of interest in artists of contemporary times, including many of the copyists themselves. Most of those who executed these replicas are nameless, save for Pasiteles, a sculptor from South Italy known for his eclectic pastiches of earlier Greek works, and his disciples, Stephanos and Menelaos. In fact, the names of Roman artists, be they native Italians or, as was more usual, men from Greece or Asia Minor, are rarely recorded. This is probably because Roman artists were of low social status since they came from the slave population or from the freedman class and were considered mere artisans. Such was the fate of both the greatest artists of the day who worked in the emperor's court and of the lowly stonecarvers employed in workshops producing sepulchral reliefs for the tombs of freedmen. Nonetheless, it is not surprising that the few names that are known today belong, for the most part, to artists or architects working for imperial patrons. Arkesilaos fashioned the cult statue of Venus Genetrix for the Forum of Julius Caesar in Rome. Surrounding Augustus were his gem-cutter, Dioscurides, his painter, Studius, the architect and theoretician, Vitruvius, and Diogenes, an Athenian sculptor who carved the caryatids of the porch of Agrippa's Pantheon. The painter Fabullus was credited with the paintings in Nero's Domus Aurea built by Severus and Celer, its architect and engineer, respectively, while the colossus of Nero was fashioned by the Greek Zenodoros. Domitian's chief architect was Rabirius, and Trajan's military engineer, who accompanied the emperor on his Dacian campaigns, was Apollodorus of Damascus. It was the same Syrian architect, who was responsible for building Trajan's forum in Rome, who should probably also be credited with the innovative idea of encircling the Column of Trajan with a helical frieze (see figs. 179–184).

Just as the son of a Roman senator was destined to be a senator himself, the son of an artist was likely to follow in his father's footsteps. Artistic dynasties were the rule in republican and Augustan times, and these were organized along the lines of their classical and Hellenistic predecessors. In fact, the family workshops that produced statuary for Roman patrons in the late republic and in the age of Augustus were themselves Greek. Ac-

cording to Pliny, in the mid-second century, the Porticus Metelli in Rome was enhanced with statues by Philiscus of Rhodes, Timarchides, Dionysius, and Polycles, sons of Timarchides, Pasiteles, Heliodorus, and Polycharmus (Pliny, *Natural Hist.* XXXVI, 34, 35). From the same dynasty comes Dionysius, son of Timarchides, and his nephew, Timarchides II, son of Polycles II, both Athenians who carved their signatures on a marble portrait of a Roman official, Gaius Ofellius Ferus, made on Delos in about 100 B.C. This suggests that one Greek workshop, comprising members of different generations of the same family, were producing works for Roman patrons both in Rome and on the Greek island of Delos, where Roman citizens had settled in the late second century B.C. Whether they produced the works on the site or exported them to their respective destinations is not certain.

That Greek artists made portraits of Roman patrons on Delos is therefore attested, but the identities of most of the artists who fashioned portraits of both public and private personalities are unknown. These include artists of little talent as well as the great creative geniuses of the day who encapsulated a given emperor's ideology in his facial features. Augustus's nameless court portraitist, for example, rejected the Roman veristic tradition canonized in the republic in favor of an image of the emperor as eternally youthful, which he based on Polykleitan statues of youthful athletes. The court artist of Constantine the Great effected one of the most dramatic transformations in the history of Roman portraiture by metamorphosing Constantine from a bearded tetrarch with a blocklike head into a neo-Trajan with a smooth face and classical cap of hair. The only surviving signatures on imperial portraits are found on statues made in the Greek East where the practice of signing works of art was more firmly entrenched. A statue of Claudius as Jupiter made in Olympia (see fig. 107), for example, is carved with the names of the Athenian artists, Philathenaeus and Hegias. A statue of the same emperor in Athens bears on its base the signature of Eubulides of Piraeus.

Miscellaneous religious, mythological, and decorative works also bear the names of Greek artists, but only one extant Roman state relief has a signature, that of the *Extispicium* Relief in the Louvre, where the foot of the bull is carved with the name of one Marcus Ulpius Orestes, a Greek who must have received Roman citizenship under Trajan.

Because of the dearth of surviving evidence, little scholarly effort has been expended on the subject of artists in the Roman world. Nonetheless, as I discuss below, an increasing number of studies are devoted, at least in part, to isolating artistic personalities and to characterizing their contribution to the art of their time and to the history of Roman art in general.

Materials

The funerary urns in the form of houses and helmets that enclosed the remains of the inhabitants of Romulus's eighth-century B.C. village on the Palatine were made of impasto or bronze. The Etruscans favored bronze and terracotta for their sculpture, although local stone began to be popular for Etruscan sarcophagi in the late Hellenistic period. The earliest Roman sculpture followed the Etruscan example. The late fourth-century B.C. "Brutus" (see fig. 2) and the "Arringatore" of the early first century B.C. (see fig. 10) are fashioned out of bronze, and the Via S. Gregorio pediment of the second half of the second century B.C. (see fig. 36) is filled with terracotta statues. Concurrently, works were made in the city of Rome out of such local stones as tufa and travertine. The latter was especially popular during the first century B.C. From the early second century on, imported stones from Greece also began to be used for sculpture in Rome. The primary sources were the same marble quarries that had been used by Greek sculptors for centuries, primarily those of Mount Pentelicon near Athens and the island of Paros.

It was, however, the opening in Caesarian times of the marble quarries at Luna, the modern Carrara, on the northwest coast of Italy that revolutionized the manufacture of Roman sculpture. From then on the majority of Roman portraits and reliefs from Rome and central Italy were fashioned out of the handsome fine-grained white marble with a blue-gray tinge found there. Luna was in Etruscan hands until 177 B.C. when the Romans established two thousand colonists there. Nonetheless, there is no evidence that the Etruscans made use of the stone for any of their buildings or sculpture. It seems certain that the rich source of marble at Luna was first tapped under Caesar and that the use of Italian marble in Rome does not antedate the time of about 50 B.C. The location of Luna near the sea greatly facilitated the distribution of the marble. The stone was brought by ships to Ostia and thence transported up the Tiber to Rome where special wharves were constructed to receive it. It was, however, after Caesar's death – specifically in the 30s B.C. – that Luna marble became available in Rome in great quantities. The first major building in which Italian marble was used extensively was Augustus's Temple of Apollo Palatinus, begun in 36 B.C. and dedicated in 28 B.C.. It was the full-scale exploitation of the Luna quarries in the age of Augustus that made possible the emperor's boast that he had found Rome to be a city of brick and transformed it into a city of marble (Suet., *Aug.*, 28). Luna marble, especially the finer varieties suitable for statuary and relief sculpture, was thus probably readily available in Rome for more modest monuments shortly after 30 B.C.

Luna marble, along with imported marble from Greece, continued to be popular for monuments in the city of Rome under the Julio-Claudian and Flavian emperors. Trajan's forum was constructed of Luna marble, although it was under the Flavians, Trajan, and Hadrian that there was an increasing taste for imported stones of varied colors. The interior columns of Trajan's Basilica Ulpia were fashioned of gray granite, as were some of those of Hadrian's Pantheon. The gray granite was quarried at Mons Porphyrites in Egypt. Some of the statues of Dacian prisoners that decorated the second-story colonnades of Trajan's forum in Rome were fashioned from *pavonazzetto* marble from a Phrygian quarry.

The taste for variegated marbles in Rome continued into the third and fourth centuries. Luna marble heads were, for example, inserted into busts of imported colored marble. Under the tetrarchy, porphyry, from the quarry of Mons Claudianus in Egypt, was favored for the portraiture of the four co-equal emperors, whose geometric visages were more effectively rendered in the hard red stone.

Although the majority of the surviving works of monumental sculpture made in the city of Rome are of Italian and imported marble from Greece and Asia Minor, provincial works were carved from local stone. Furthermore, there are today only a small number of extant works, primarily portraits, made of gold, silver, or bronze. There were considerably more of these in antiquity. In fact, marble works survive in disproportionate numbers because marble was less valuable than metal, and the gold, silver, and bronze statues were melted down so that their material could be reused. It is thus important to keep in mind that what we have today is not an accurate reflection of what there was in antiquity.

Roman Sculpture and Its Architectural Context

Although the spiral frieze of the Column of Trajan (see fig. 179) and the great panels of the Arch of Titus (see figs. 155–156), as well as other imperial and private reliefs, are still in their original locations, other state reliefs and the majority of Roman portraits, sarcophagi, altars, funerary reliefs, and Roman copies of Greek masterworks are now on display in museums in Rome and around the world. The setting aside of special buildings for the display of art, ancient equivalents of modern museums, is known from Roman times. Examples include the Porticus Metelli, which in the Republican and Augustan periods served to showcase both Roman replicas of Greek masterpieces and new Roman variations of famous Greek prototypes; and the Templum Pacis, a temple surrounded by an open rectangular space with porticoes, which displayed such diverse works as Myron's cow and a statue of the River Nile, sculpture looted from Greece by Nero, and spoils plundered by Titus from the temple in Jerusalem. Although ostensibly museums, the Porticus Metelli and the Templum Pacis were both triumphal monuments commemorating respectively a Republican and a Flavian military victory.

Roman sculpture cannot be examined in isolation. It was an integral part of everyday life and was exhibited in public places like fora, basilicas, temples, theaters, and baths. State reliefs recorded the great deeds of renowned emperors and generals, and it can be argued that Roman columns and commemorative arches were little more than supports for sculpture. Portraits preserved the facial features of Roman public figures for posterity, and veritable portrait galleries were created in such major public structures as the Forum of Augustus, where the historical heroes of the republic were juxtaposed with Augustus's human and legendary ancestors. Dynastic groups were displayed interspersed with images of divinities and mythological beings (some copies of famous Greek masterpieces) in theater stage buildings; and baths were ornamented with portraits of the imperial family and local patrons, as well as sea creatures and gods like Neptune, powerful heroes like Hercules, and statues of well-built athletes. Some of these statues came from earlier locales, others were commissioned to enhance a specific program, such as Caracalla's Herculean imagery for his baths in Rome. In the private sphere, the nobility showcased their distinguished ancestry in the armaria of their houses, and the gardens and porticoes of country and maritime villas were filled with portraits of Greek writers and Hellenistic kings, and a wide variety of mythological conceits. In the Villa of the Papyri in Herculaneum, for example, portraits of such Hellenistic rulers as Seleukos Nikator of Syria and Philetairos of Pergamon were displayed not far from a bronze replica of the head of Polykleitos's Doryphoros and a copy of a classical Amazon.

Sculpture was also essential in commemorating death among the Romans. Wax masks resembling the ancestors of the deceased were paraded in aristocratic funerary processions, and the remains of the deceased were placed at a later date in coffins enhanced with decorative or narrative scenes. The last resting places of freedmen, like that of the baker Eurysaces in Rome (see fig. 90), were marked by tombs with scenes immortalizing their professions or with portrait reliefs of themselves and their families.

Roman art was not art for art's sake. Even Roman replicas of famous Greek originals were valued more as reflections of a patron's refined Hellenic taste than as works in their own right. Public portraits celebrated the

virtues and accomplishments of those they represented or were arranged in groups that associated the honorand with an illustrious predecessor or an eventual heir. Private portraits were, at least at first, an integral part of ancestral veneration. Cult statues were placed in the cellae of temples where they were the object of religious veneration. Historical reliefs recorded the deeds and virtues of the emperors, and professional scenes of freedmen preserved for posterity less momentous personal accomplishments.

Even though the city of Rome was plundered and rebuilt over millennia, the evidence of displays of sculpture is still considerable. The works of art stolen from cities vanquished by Rome in the republic were the first pieces publicly displayed in structures like the Porticus Metelli. These original works were soon accompanied by variations based on earlier prototypes by such artists as Pasiteles and also by works of Roman invention. Pompey's theater included not only a cult statue of Venus Victrix, his divine protectress, but also figures of subjugated provinces. The Roman Forum held a profusion of honorific portrait statues on tall columns that jostled for attention with equestrian statues on massive pedestals. The sculptural program of the Forum of Augustus was elaborate and carefully planned with a cult statue of Mars, Venus, and the Divine Julius Caesar in the cella of the Temple of Mars Ultor, and a pediment with additional figures of Mars, Venus, and other divinities and personifications. The second-story colonnades had caryatids based on fifth-century B.C. models (see fig. 83); the first-story columns were interspersed with statues of famous men of the republic, members of Augustus's family, and Romulus and Aeneas – the fathers of the Roman people and of the Julian family. The Forum of Trajan was also richly enhanced with relief and portrait sculpture celebrating Trajan's military defeat of the Dacians, described in detail in the historiated column and also referred to in the figures of captive Dacians and in a frieze of triumphant Victories slaying bulls (see figs. 178–179). Trajan's victory over death was also alluded to since the emperor's funerary urn was placed in the base of his column. The Flavian victory over Jerusalem was featured in the objects selected for display in the Templum Pacis, and the Baths of Caracalla included in its vast array of sculpture, images of huge proportions, including those of Hercules, the Greek hero who attained immortality (see fig. 305). The Baths of Constantine included a dynastic group of the emperor and three of his sons (see figs. 396–397). The aristocratic Tomb of Gaius Cestius has two preserved bases that once supported portraits in the round of two of his illustrious ancestors. Tombs of freedmen, which still stand along the major sepulchral streets outside the walls of the city, have portrait reliefs in their facades.

Typology of the Monuments

The two major categories of Roman sculpture are portraiture and relief sculpture, although there is an overlap between the two since some portraits were executed in relief and some reliefs include distinctive portraits. Certain portraits were made specifically for public display and as instruments of imperial propaganda in Rome and the provinces; others were private commemorations executed for the patron's residence or tomb. Relief sculpture is also found both in the public and private context. Narrative and ceremonial scenes featuring the emperor were affixed to altars, arches, columns, temple podia, and so on, and professional vignettes or portrait reliefs decorated the tombs of freedmen. Sarcophagi made for members of the imperial circle, the aristocracy, and freedmen alike, were also ornamented with decorative, mythological, or narrative reliefs. Some works of Roman sculpture, however, do not fall into these two broad categories, as, for example, copies and variations of earlier masterpieces and decorative sculpture.

Roman portraiture, which had its origins in Roman sepulchral and ancestral practice and in the Hellenistic and Etruscan past, emerged as a form of public commemoration in the republic when scores of statues on columns or pedestals were displayed in such prominent public spaces as the Roman Forum. Portrait galleries, like that in the Forum of Augustus, in which historical Romans and legendary heroes stood side by side, were public versions of the private shrines with ancestral portraits that were kept in the wings or *alae* of the private domiciles of the nobility. Funerary portraits in relief honoring freedmen also proliferated in republican and Augustan times and these were extremely popular because they provided freedmen with an opportunity to commission individual and family group portraits. Although the children of freedmen were full citizens with all rights, Roman law prohibited freed slaves from displaying family genealogies in their homes.

Although the majority of Roman portraits are life-size, some are carved in miniature, others at colossal scale. Colossal portraits always depict emperors or a member of the imperial family and tended to be favored at certain times and in certain locales. Although preliminary versions of a court portrait may have been made in wax or terracotta from a live model, these *bozzetti* or preliminary models were translated into marble and replicated. The original prototype presumably was manufactured in Rome. Marble copies were displayed in strategic places in the capital and were sent (probably through the local art trade rather than a centralized governmental agency, in both finished and unfinished

states) to major artistic centers in the provinces, such as Athens, Aphrodisias, and Alexandria. There they in turn served as models for additional imperial likenesses made by local artisans. These provincial copies were distributed to workshops in smaller cities for further duplication. By this means the imperial portrait departed further and further from its original prototype, although it usually continued to be a recognizable likeness of its subject. Although the so-called pointing process, a mechanical means of replication by which a small number of points are measured from original to copy, appears to have been employed in Rome and elsewhere, considerable variation among the heads exists. Discrepancies include artistic merit, dimensions, and even small details in the facial features and coiffures. For this reason, what have been termed replica series are often difficult to establish. Nonetheless, the determination of such replica series has been a major goal of scholarship on Roman portraiture in the last two decades. Scholars distinguish between those replicas produced by the pointing process that closely resemble one another and are based on the same original prototype, and variants that are less like the prototype and conform to it only in a general way. Distinguishing a replica from a variant is further complicated since the original prototype was sometimes altered to create still another version and, less frequently, two or more portrait types were combined to form a new type.

Since the late nineteenth century, scholars have relied on numismatic portraits to establish the chronology and typology of the portraits of a given imperial personage. There are sound reasons for this. The first lifetime portraits on coins were struck by Julius Caesar, and all the Roman emperors from Augustus to Constantine followed his lead. These coin images were accompanied by legends giving the name of the subject and sometimes referring to the event that led to the commissioning of the coin type. The great number of surviving Roman coins provides an almost complete series of numismatic portraits. It is through the similarity of the facial features and hairstyle of portraits in the round to those on coins that scholars have identified portraits and portrait types of almost all the Roman emperors. Nonetheless, numismatic portraits are diminutive in scale and are almost always rendered in profile, which means a less detailed likeness not always comparable to its larger counterpart. For this reason, heavy reliance on numismatic criteria in researching Roman portraiture has given way to a greater dependence on facial features, hairstyles, and stylistic criteria. Furthermore, portrait methodology has become increasingly sophisticated, with greater attention being paid to new creations of the prototype, the confluence of types, the afterlife of a given type, provincial replicas and

variations, and perhaps most significantly, the reworking of the features of one emperor into those of another.

One issue that has not received the attention it deserves is the occasion for the creation of a new portrait type. Although Augustus, who was emperor for nearly forty years, had only two portrait types created during his principate, other members of the imperial court had many more. Scholars have traditionally sought to link the formulation of portrait types with major political or personal events in the life of the individual commemorated. Although this seems logical, there is little to substantiate it. It is not impossible that changes in fashion or personal whim may also have inspired new portrait types.

As noted, precious metals like gold and silver were also used for imperial portraiture. Because the value of the material used was greater than that of the portrait, few metal portraits survive. Notable exceptions are those of Marcus Aurelius in Avenches and Lucius Verus in Turin (see fig. 240) that are made of gold and silver, respectively. Portraits of emperors were sometimes set up alone or with images of gods and depicted their subjects in a wide variety of roles. From the Julio-Claudian period on, dynastic groups were also favored. Some depicted the emperor and his natural or chosen heirs; others incorporated female members of the dynasty as well as the present emperor's illustrious predecessors.

The development of Roman portraiture is marked by its shifting allegiance to the creation of a likeness or fictional account of its subject. Republican portraiture is characterized by meticulous attention to the idiosyncratic details of the sitter's physiognomy – a parallel development to the early Roman devotion to ancestral portraits and death masks and to a special penchant for depicting the faces of old (or at least mature) men and women. A similar interest is documented from about A.D. 64 to the end of the Flavian dynasty in 96. The latest portraits of the emperor Nero depict him with increasing realism and plasticity, and Galba and Vespasian are rendered as down-to-earth soldiers in life-like portraits that owe much to their republican prototypes. In fact, this realistic or veristic style, which emphasizes a detailed description of the face, complete with wrinkles and blemishes, was popular (with the exception of the portraits of Trajan) concurrently with a taste for military portraiture. This is also apparent in the third century. The portraits of Caracalla represent an abrupt change from those of his father, Septimius Severus, founder of the Severan dynasty. Instead of being depicted with the curly locks and plastic beard of his father, Caracalla is portrayed with a closely cropped military hairstyle and beard and with a severe geometric face with intense expression. It was the mature portraiture of Caracalla that served as the main model

for the portraits of the so-called soldier-emperors of the third century.

The primary purpose of the fictional portrait, however, is to subsume the subject's individuality in a symbolic image that emphasizes retrospective associations. Although the early portraits of Augustus must bear some resemblance to the handsome youth who became Rome's first emperor, his distinctive physiognomy, including a broad cranium, narrow chin, and aquiline nose, are of less consequence to the artist than was his resemblance to the statues of Greek athletes of the fifth century B.C. The overall configuration of the face and the cap of hair, with its neatly arranged comma-shaped locks, derive from classical visages such as that of Polykleitos's Doryphoros. When Trajan became emperor, he commissioned a portrait that maintained the maturity and military imagery of his immediate predecessors but rejected its veristic style in favor of a smoother image with a cap of hair in the Augustan mode. The most dramatic example of portraiture that was deliberately fictional and retrospective was that of Constantine the Great. His earliest portraits on coins appear to be relatively accurate likenesses of the youth whose physical resemblance to his father is further underscored by depicting him in an identifiable tetrarchic style with geometric head, military hairstyle, and beard. In his later images, he appears with a smooth face, an Augustan-Trajanic cap of hair and an idealized expression that accentuates his youthfulness. The court artist has deftly transformed Constantine from a member of the tetrarchy to the sole emperor of Rome who is more similar to his ideological "fathers," Augustus and Trajan, than to his natural father, Constantius Chlorus.

Roman relief sculpture also emerged as a viable vehicle for the transmission of Roman political messages in the republic. Like Roman portraiture, it was based in part on Greek and Etruscan prototypes. Some of its earliest examples, like the battle frieze from the Aemilius Paullus Monument in Delphi (see fig. 5), are so close stylistically to their models as to be nearly indistinguishable. Nonetheless, from the outset there was an interest in the depiction of Roman religious rites and civic events, and a new, thoroughly Roman style was created for this purpose. Although most of these scenes were straightforward narrations of battles, triumphal processions, sacrifices, and so forth, with rigorous attention to historical accuracy, there are examples of fictional accounts. These appear to have been more popular during the High Empire and Late Antiquity than earlier. An example is the fictional apotheosis of Antoninus Pius and Faustina the Elder from a relief on the pedestal of the Column of Antoninus Pius, where husband and wife, whose deaths occurred twenty years apart, are depicted as if their consecration had taken

place simultaneously (see fig. 253). Another example is the fictional meeting of the tetrarch Galerius and the Persian king Narses on the battlefield, a scene that figures prominently in the surviving pier decoration of the Arch of Galerius at Salonica (see fig. 388). Although Galerius and Narses were the generals of opposing forces, they never met face to face in battle.

Roman reliefs were contained within horizontal and vertical panels, expanded in friezes, including spiral ones wrapped around columns and enclosed in roundels. They are featured in isolation or grouped with others with related subject matter. They represent Greek mythology, Roman legend, Roman religious rites, battles, ceremonial scenes such as the emperor's address to his troops (*adlocutio*), the emperor's granting of clemency to barbarian foes (*clementia*), the emperor's exit and entry into Rome (*profectio* and *adventus*), apotheosis, and, more rarely, scenes from private life such as hunting, professional scenes, and domestic vignettes.

There are three other major categories of Roman sculpture. The first is Roman idealizing sculpture, which represents divinities, mythological figures, heroes, and athletes with generic features. Many of the statues of these subjects were Roman replicas of lost Greek masterpieces; others were Roman pastiches of two or more Greek prototypes. Still others were new Roman creations designed for specific contexts, for example, the cult statue of Mars for the Temple of Mars Ultor in the Forum of Augustus (see fig. 150). Roman decorative sculpture was also produced in abundance and included such items as candelabra and table supports used in civic, religious, and domestic contexts. Examples of the third category, minor arts, are not strictly speaking sculpture, but coin obverses and reverses, medallions, cameos, and such metal objects as bowls were sometimes ornamented with the portraits of emperors and significant scenes of state. They must therefore be evaluated with monumental sculpture. Coins were used as public vehicles of imperial propaganda by the emperors, whereas medallions and cameos served as private presentation pieces. Metal plates and bowls were used as domestic display pieces or tableware.

Roman Eclecticism

What I shall call here Roman eclecticism must be defined from the outset. Roman art is not characterized by a single style but by a multiformity due to differing regional tastes and to the diverse preferences of a wide variety of Roman patrons. The style of imperial relief sculpture ranges from the conscious neo-Greek classicism

of the friezes of the Ara Pacis Augustae (see fig. 75) to what has been called a Late Antique style that is schematic, frontal, and hieratic and is best exemplified by the fourth-century frieze from the Arch of Constantine (see fig. 412). On many monuments, two or more styles may be seen side by side. No single period has a unified "Roman style." In fact, the style of contemporary official and private monuments often differed markedly, as did that of coeval monuments in the capital and the provinces.

The idea of a Roman monument as a fusion of diverse components and styles can be traced to the republic but continued throughout the history of Roman art. Parts of a statue, for example, were considered interchangeable. While the Greeks thought of the head and body of a person as an indivisible whole, the Romans viewed the human being as a conglomeration of parts, parts that could and did have an independent existence. The most important part of a person was the head because it was in the face that the person's individuality resided. The head could therefore be separated from the body, and it was in Roman art that the bust portrait became a viable and popular form. In fact, in the Roman context, the body sometimes became a mere prop for the head. Standard body types – like the cuirassed general, togate magistrate, matron as Venus – were undoubtedly fashioned in workshops with the heads carved separately by special portrait artists.

Roman artists had a similar approach to the production of sarcophagi. The workshop completed the mythological or battle scene on the main body of the sarcophagus, sometimes leaving the heads of the scene's protagonists unfinished. Later, the heads of the deceased and his family could be added by a special portrait artist according to the patron's specifications. The portraits, therefore, often exhibit an entirely different style than the unidentifiable figures in the rest of the scene. An example is the Ludovisi battle sarcophagus in the Museo Nazionale delle Terme (see fig. 359) where the long streaming curly hair of the barbarians, articulated with deep shadows by the drill, is in strong contrast to the short coiffure of the main protagonist whose more classicizing portrait was certainly added by a different portrait artist.

Other parts of the body, especially the arms, could also operate independently from the rest of the body. The right arms of such well-known statues as the "Arringatore" (see fig. 10) and the Primaporta Augustus (see fig. 42) project into the viewer's space with a powerful gesture of address, suggesting that the arm has a life of its own. Such a treatment of the individual parts of the body as separate entities in Roman art has been aptly called the *appendage aesthetic* and had its origins in Etruscan art.

This interchangeability of parts was sometimes sub-ject to the whims of fashion. In the imperial period, many female portraits were fitted with coiffures made of a separate piece of marble, so that the coiffure could be updated if fashion changed.

Male portraits were also frequently adjusted. When an emperor suffered an official condemnation by the senate (*damnatio memoriae,*) for example, his portraits were destroyed, mutilated, or recast with the features of a successor. The bodies of such portraits were, however, often retained intact and supplied with the heads of the new emperor, the body again serving as a prop for the head.

State reliefs were also sometimes recut for use in a new context. A well-known example is the *profectio* scene from the Cancelleria Reliefs (see fig. 159). The relief was first intended as part of a monument to Domitian but, after his death and damnatio memoriae, reworked for Nerva. The portrait head of the emperor in tunic and mantle and surrounded by divinities and personifications now bears Nerva's facial features and Domitian's wavy hairstyle recut over the forehead in a more severe manner consistent with Nerva's taste.

The Roman penchant for interchangeable parts was accompanied by an equal devotion to stylistic diversity, indeed to a deliberate eclecticism. Roman eclecticism and the coexistence of different styles, even within the same monument, was already apparent in the republic. On the base of the "Altar of Domitius Ahenobarbus," for example, a Hellenistic style is fittingly chosen by the artist for the Greek myth of the marriage of Poseidon and Amphitrite, whereas a more straightforward narrative style in the contemporary Roman mode is used for the Roman scene of census and sacrifice (see figs. 30–31). Such a combination is also apparent among freedmen, at least by the age of Augustus. The tomb of the baker Marcus Vergilius Eurysaces, for example, has on its facade a majestic portrait relief of Eurysaces and his wife Atistia (see fig. 92), in which the devoted pair is portrayed in the latest dress and wearing the most up-to-date court coiffures. The poses and sensitive rendering of the figures' drapery is comparable to the contemporary Ara Pacis Augustae. Nonetheless, this approximation of court portraiture of the time is in direct opposition to the style of the baking frieze that encircles the monument (see figs. 93–95). It is not only made of an inferior and less costly stone (travertine versus Luna marble) but also shows the artist's complete disregard for the artificialities of court portraiture. The figures in the baking scene are ill proportioned, and the artist pays little attention to perspective. His main concern is to get his story across, whatever the artistic consequences.

In Flavian times, a classicizing style is employed for the adventus and profectio of Domitian's Cancelleria Reliefs (see figs. 158–159), but the even better-known

Domitianic Arch of Titus is executed in what has been called an illusionistic style (see figs. 155–156).

Nowhere in a single imperial monument is stylistic diversity more apparent than in the base of the second-century Column of Antoninus Pius. The apotheosis of Antoninus and Faustina is dutifully rendered in a cold but beautiful classicizing style with large elegant figures against a blank background (see fig. 253), but the double *decursio* (ritual circling of the funerary pyre) has miniature equestrians on what look like toy horses prancing around in a circle viewed at the same time from head on and from above (see fig. 254).

It is apparent from the foregoing discussion that the coexistence of two or more styles in a given historical period or even within the same monument is present from the outset in Roman art.

The Historiography of Roman Art

Pliny the Elder, writing during the principate of Vespasian, produced what might be characterized as the first surviving commentary on Roman art. Although the range of his *Natural History* is encyclopedic, it includes significant chapters on art and is thus unique among known literary texts preserved from antiquity. It provides information about patrons, artists, and specific monuments. Pliny describes, for example, the ancestral portraits in the armaria of aristocratic houses; portraits on shields; the sculpture in the Theater of Pompey in Rome; the cult statue of Venus Genetrix made by Arkesilaos for the temple of the goddess in the Forum of Julius Caesar; the caryatids made by Diogenes the Athenian for Agrippa's Pantheon; the portrait seal of Augustus designed by Dioscurides; the 120-foot statue of Nero by Zenodoros; the art collection of Asinius Pollio; Marcus Scaurus's gem collection; and even records the existence of such an unusual artist as Iaia of Kyzikos, a virginal female painter who was active in Rome in the late republic and known for her portraits of women.

Chroniclers of the Middle Ages have also left accounts of Roman monuments. These sometimes provide significant details; for example, it is reported in the *Mirabilia Urbis Romae* of the twelfth century that the bronze equestrian statue of Marcus Aurelius (see fig. 236) had a barbarian below the horse's hoof. The Renaissance rediscovery of antiquity led artists and architects, who revered works of ancient sculpture, architecture, and painting as treasured relics of the past, to record significant remains in word and image. Engravings and drawings by artists of the sixteenth to the eighteenth century record monuments that are now lost, as for example, the so-called Arco di Portogallo, a fifth-century arch that in-

corporated two Hadrianic reliefs in its fabric (see figs. 221–222). Only the reliefs are preserved today because the arch was dismantled in 1662 on orders from Pope Alexander VII because it obstructed horse races that traversed the street it spanned. The Renaissance and modern periods thus simultaneously witnessed the wanton destruction of works of Roman art and their partial preservation through visual documentation. The rediscovery of the lost cities of Vesuvius, especially Pompeii and Herculaneum, was also accompanied by concurrent treasure hunting and the scientific recording of data. Works of sculpture were looted by some while painstaking plans of villas and other monuments were being drawn by others.

Although Renaissance artists and antiquarians saw Greek and Roman art as part of a classical continuum, Johannes J. Winckelmann, writing in the late eighteenth century, presented a more fragmented picture of an ancient art that culminated in fifth- and fourth-century Greek masterworks and declined in Hellenistic and Roman times.

It was not until the late nineteenth century that the distinctive contribution of Roman art to western culture began to be fully appreciated. The change of its status is due to the writings of Franz Wickhoff, who recognized that the continuous narrative reliefs of such monuments as the columns of Trajan and Marcus Aurelius (see figs. 179, 263) served as the models for an illuminated manuscript called the Vienna Genesis. He could find nothing in Greek art from which to trace their ancestry and concluded that such visual commentaries were a clever Roman invention. He also recognized in some works of sculpture commissioned by the Flavian dynasts – for example, the spoils panel from the Arch of Titus (see fig. 155) – a distinctive illusionism whereby pictorial devices were used to suggest that the scene had a spatial environment in which some of the figures disappeared into the background through an impressionistic haze. The late nineteenth-century fascination with contemporary impressionistic paintings undoubtedly sharpened Wickhoff's sensitivity to such stylistic nuances and attests to the fact that like all historians his scholarship reflects the tenor of his own times.

Another ground-breaking study was produced about the same time by Alois Riegl. Unlike Wickhoff's, it did not focus on the great state monuments, but instead on late Roman metal ornaments produced in the northern provinces. These were characterized by an abstract and linear style that had more in common with works of medieval than classical art. Since major works of Late Antique sculpture in the city of Rome shared these properties, Riegl realized that a relatively consistent style was used for works of both major and minor art in Rome and the provinces in late Roman times. Since his observations

served as the basis for modern art historical studies, it is difficult today to recognize their revolutionary effect on the scholarship of their own time.

The first comprehensive examinations of Roman art were published in the nineteenth and early twentieth centuries and include general studies on Roman sculpture and encyclopedic catalogues of large bodies of material housed in major museum collections. Broad studies on such topics as Roman portrait iconography, Roman sarcophagi, and Roman altars were also published at this time. In addition, specialized investigations of the Late Antique style, the Greek element in Roman art, the Etruscan and Mid-Italic traditions in Italy, on Roman artists, Republican art, and art in the age of Augustus appeared, as did penetrating studies on such subjects as republican portraiture and Roman state relief sculpture. Monographic studies of major monuments were also prepared, and the *Römische Herrscherbild* series on imperial portraiture was initiated.

The 1950s and 1960s witnessed studies on the structural analysis of Italic portraits and reliefs, Roman taste, pluralism in Roman art, Roman religious rites, Roman artists, sarcophagus workshops, Roman art in the provinces, and countless studies on Roman portraiture and state relief sculpture, but the most epoch-making work of this period must be attributed to Ranuccio Bianchi Bandinelli, whose highly influential books on social class and style revolutionized the study of Roman art. Bianchi Bandinelli demonstrated that imperial and aristocratic patrons favored a highly artificial style dependent on classical and Hellenistic Greek art, while minor magistrates and freedmen were partial to a style that betrayed its indigenous Italic origins. He considered the Greek style a superficial veneer chosen by philhellenic trendsetters like Augustus and Hadrian whose Hellenic taste eventually lost out to its native and provincial counterparts.

The most recent scholarship on Roman art, that of the 1970s and 1980s, has focused on a wide variety of monuments and issues. The very diversity of the subject matter owes much to the work of scholars like Bianchi Bandinelli who made the art of freedmen and provincial Roman art worthy subjects of study. The most significant areas of current research in Roman art are studies of major monuments, lost monuments, imperial and private portraiture, funerary art, the art of freedmen, Roman copies of Greek originals, and studies of Roman artists. Because these have yet to be evaluated as a group, a detailed examination of the current trends in scholarly inquiry is included here.

Major Monuments and State Relief Sculpture

There are still major monuments that need their first monographic treatment and others that should be rethought. Access to some of them has been increased by the erection of scaffolding in Rome in the 1980s for purposes of conservation, and scholars have been able to examine the fabric and sculptural details of such monuments as the arches of Titus, Septimius Severus, and Constantine, and the columns of Trajan and Marcus Aurelius. A new book on the Arch of Titus is the first monographic study of the arch since a lengthy 1934 article. Its major conclusions – for example, that the arch was not the product of the same workshop as Trajan's at Benevento and that the date of the arch must fall within the principate of Domitian – were made possible by the author's firsthand examination of the arch. A close study of the stonework of the Great Trajanic Frieze (see figs. 185–186) also necessitated close examination of the reliefs, four sections of which are embedded in the central bay and short sides of the attic of the Arch of Constantine.

Interest in such masterpieces of Roman art and ideology as the Ara Pacis Augustae remains unabated. A series of articles on the identification of the main protagonists, the acanthus frieze, the Greek and Etruscan models, and Augustus's dynastic and social policy, have recently appeared. Perhaps most significant is the small excavation undertaken near the Ara Pacis and the Mausoleum of Augustus that provided evidence that both were part of an architectural complex that included the base for the emperor's funerary pyre (his *ustrinum*) and a sundial in the form of an obelisk with an orb and a metal spike at its apex that designated years, months, and even hours and that was so carefully orchestrated that its shadow fell on the Ara Pacis on Augustus's birthday.

The Column of Trajan and the Arch of Trajan at Benevento have also received considerable attention and even some studies of state relief sculpture as a whole have been attempted. More encyclopedic is a new chronological compendium of Roman state reliefs that is being published in a series of articles in the *Bonner Jahrbücher*. These deal with the Ara Pacis Augustae and with state reliefs from the Augustan to Constantinian period from the city of Rome that are now separated from their original architectural contexts. The main contribution of these studies lies in bringing together well-known pieces (such as the sections of the Great Trajanic Frieze or the Hadrianic hunting tondi) with little-known fragments.

Lost Monuments

Scholars have also become increasingly concerned with lost monuments that, when reconstructed, can augment and even alter our knowledge of the development of Roman art. These lost monuments are known today only from surviving fragments, literary and historical descriptions, numismatic representations, or from depictions in other media. A famous cult statue, portraying Mars, Venus, and the divine Julius Caesar, for example, no longer survives but is known from a copy in relief that is now in the Archaeological Museum in Algiers (see fig. 84). Eleven panel reliefs, eight now embedded in the fabric of the Arch of Constantine and three in the walls of the Museo del Palazzo dei Conservatori, representing scenes from the life of Marcus Aurelius, survive – but the arch or arches from which they came do not (see figs. 256–262).

Different hypothetical reconstructions have been suggested. A wide variety of fragments has been associated with the lost Arch of Claudius that celebrated the emperor's British victory and was put up between 51 and 52 across the Via Lata in Rome (see fig. 376). Parts of the inscription and the sculptural decoration have come to light in a series of excavations from the Renaissance on, and the original appearance of the arch has been extrapolated from them. In some cases, no inscription or fragments survive. The so-called Arc du Rhône has been reconstructed, for example, on the basis of later drawings of the Augustan arch and contemporary surviving structures in southern France. Sometimes there are neither extant sculptural remains of the monument nor later drawings. Such is the case with the lost Arch of Nero in Rome that is known only in numismatic renditions. Tacitus also records that the arch was erected on the Capitoline hill in 62 in honor of Nero's Parthian victories. The arch has recently been reconstructed on the basis of its depiction on Neronian bronze coins through a die study linking the entire sequence of coins from both the Rome and Lyons mints (see fig. 131). The earliest dies of the series indicate that the arch had innovative features that were not thought to appear in Roman commemorative arch design until the second and third centuries.

Imperial Portraiture

The most ambitious project in the field of Roman portraiture today is the *Römische Herrscherbild* series of the German Archaeological Institute. The series was begun in 1939 and many volumes have been published thus far. While some of these focus on the portraits of a single emperor or an entire imperial dynasty – including female members and children – at least one is a more general study that relies heavily on literary sources and deals with such issues as the cost of statuary, the reasons for the erection of imperial statues and their placement, statues in precious metals, colossal statues, the imperial cult, and so on. Other recent books have focused on portraits of specific periods, as a single century. These include discussions of female portraits and portraits of private individuals of the period, although their focus is on the likenesses of imperial males. Monographs on specific personalities, for example, those of Augustus and his grandsons Gaius and Lucius Caesar, also concentrate on the emperors and their male progeny; there has been less interest in the portraits of women. There are a small number of monographs on the portraits of empresses, for example, on Livia, Sabina, Antonia the Younger, and Faustina the Younger. Most of the imperial women, however, are treated as appendages to their husbands and are discussed only briefly in the addenda to books on the emperors, as in those from the *Römische Herrscherbild* series on Hadrian, the Antonines, and Constantine and his sons. The Severan empresses and private ladies of the period are discussed in a monograph, and there are surveys of female hairstyles in the Julio-Claudian and Antonine periods. But there is still a pressing need for the monographic treatment of major imperial ladies and studies of female portraiture of given periods.

Some of the best and most up-to-date discussions of individual portrait heads are to be found in the exemplary museum catalogues of the Musei Capitolini that concentrate on both male and female subjects. The catalogue entries are comprehensive and focus on the question of imperial replica series, listing whenever possible the exact copies and provincial variations of a given portrait. Despite the emphasis on replicas and variations, the authors also discuss style, technique, and chronology, and attempt to come to terms with the many controversies surrounding the portraits. The new catalogues of the portraiture and other sculpture in the Museo Nazionale delle Terme are also concerned with the latest debates.

The establishment of more precise replica series for imperial portraiture and the careful evaluation of reworked heads is, in fact, at the forefront of Roman studies today. The Roman preference for recasting the features of one Roman emperor with those of one of his successors is already well known. The Roman practice of damnatio memoriae called for the destruction or mutilation of the lifetime portraits of such despotic emperors as Nero and Domitian, who were also not commemorated in posthumous images, but recent scholarship has demonstrated that the reworking of imperial male portraits may have been more widespread that hitherto believed. When a

portrait is recast with another's features, some of those of the original subject are retained. Features that were earlier thought to have been adopted by one emperor in order to associate himself with a predecessor might now be evaluated as characteristics retained from the original portrait. The new studies on this subject will not only inspire future endeavors but are also likely to revolutionize our knowledge of the use of retrospective associations in Roman imperial portraiture.

Private Portraiture

Studies of private portraiture are much rarer. They have often made clear why private portraits have been of less interest to scholars: first, rich biographies of famous people cannot be attached to them; second, private portraits generally follow the conventions and style of contemporary portraits of leading public figures. Nonetheless, private portraits are occasionally quite different from contemporary public portraits, not only in form, but in intent as well. Indeed, the special fascination of the study of Roman private portraiture lies in the identification and analysis of the simultaneous dependence of private portraits upon public ones and their independence from their more famous models. Studies of private portraiture to date have either concentrated on a certain period (for example, those of Trajanic or Hadrianic times), on a certain kind of portrait (for example, of children), or on a certain class of monuments (as funerary reliefs and altars). Those that focus on sepulchral reliefs and altars deal with portrait commissions of freedmen and depict women and children as well as men. The rare appearance of women and children in scenes of state relief sculpture has only begun to occupy the attention of scholars.

In sum, one of the most important issues in the study of Roman portraiture remains the identification of replica series of imperial personages. The chronology of a given emperor's portraiture continues to be established by the order of his numismatic output and by the configurations of his features and hairstyle, as well as by stylistic criteria. There has been less interest in private portraiture and in portraits of women and children of all social classes, but an increasing number of scholars are turning to these as a fruitful area for research.

Funerary Art and the Art of Freedmen

The last several years have seen the publication of a number of important studies on the funerary art and architecture of Rome and its environs. Until recently,

funerary reliefs, urns, and altars were largely ignored in favor of the examination of Roman sarcophagi. The latter, traditionally thought to have been an art form of the aristocracy, have been scientifically investigated since the nineteenth century.

Foremost among the recent additions to scholarship is an extremely useful handbook on Roman sarcophagi that is a compendium of all known types and summarizes iconographic and stylistic theories to date. The literature of the 1950s and 1960s that concentrated on specific types (such as the season or battle sarcophagus) or on individual sarcophagus workshops (such as those in Greece and Asia Minor) continue to be produced, as do studies of sarcophagi in museum collections.

It was, however, Bianchi Bandinelli's work in the 1960s and early 1970s on the relation of art and social class that served as the catalyst for an increased interest in the art and architecture commissioned by the freed class in Rome and by local magistrates in the provinces – much of which is funerary – and the interrelation between this art and that made for the emperor and the ruling class. A seminar at the University of Rome, under the direction of Bianchi Bandinelli, culminated in the publication of a collection of key articles on tombs and their sculptural decoration that were commissioned by magistrates in towns such as Pompeii and Chieti.

In the course of the 1970s, a series of seminal books and articles on the funerary reliefs of freedmen in Rome was published. Although each associated a particular class of funerary monuments with a special group of patrons – that is, Roman freedmen – two included corpuses of all known examples from Rome. Other studies covered the collection of the *kline* monuments with reclining portraits from Rome that also exclusively honored freedmen and dealt with private deifications on such funerary monuments as altars, urns, and sarcophagi, of which the patrons were predominantly enfranchised slaves. In a study of Roman professional scenes, it was demonstrated that such scenes appear primarily on tombs, funerary altars, and sepulchral stelae, which were also commissioned by freedmen. New books on Roman altars and urns, both memorializing freedmen, have also appeared. Other new studies indicate that funerary monuments beyond the boundaries of Rome and its immediate environs are now also receiving increased attention, including those on funerary reliefs with portraits from central and South Italy and funerary stelae and urns from Umbria.

All of these studies have made it clear that there was an unbroken chronological sequence, with some overlap, from the funerary reliefs of the late republican and Augustan periods to the altars, urns, and sarcophagi of the period of the High Empire. Furthermore, although Roman sarcophagi were clearly commissioned

by well-to-do individuals, many with a taste for Greek subject matter, sarcophagi were not exclusively an aristocratic phenomenon. Decorated sarcophagi depicting professional scenes such as shoemaking and architecture were produced in Rome, and sarcophagi in Rome and North Italy with inscriptions identifying the deceased as slaves and freedmen are also attested. Even some of the Roman sarcophagi with mythological scenes may have been commissioned or purchased by freedmen. Such a hypothesis is difficult to prove because few Roman sarcophagi have been found in situ and few have surviving epitaphs. Nonetheless, it was Roman freedmen who by the second century already had a long tradition of commissioning funerary monuments enhanced with both decorative motifs and professional scenes and portraits, some of which had mythological overtones. Several studies have focused not only on the sepulchral monuments of freedmen but on the interrelation between those and imperial and aristocratic funerary commissions. The studies of the 1970s and 1980s on funerary altars, urns, and reliefs have broken important new ground and have brought the examination of Roman funerary art to the forefront of the literature on Roman art.

Roman Copies of Greek Originals

In the past, Roman copies of Greek art were thought to be significant only because they reflected famous Greek masterpieces. Scholars used the surviving texts of such ancient writers as Pliny the Elder and Pausanias, who described famous Greek masterworks, in conjunction with extant Roman marble copies to reconstruct the oeuvre of a Greek master. In recent years, however, Roman copies have been evaluated as works of Roman art and as illustrations of the Roman taste of a given period. Scholarship is now focusing on why some renowned works, such as the Doryphoros of Polykleitos, were replicated again and again, while others were confined to specific periods. The settings for these copies, whether a public space, bath complex, or private villa, are also beginning to be evaluated. Scholars are assigning Roman dates to these works and attempting to determine what the date and context together reveal about the taste of individual Roman patrons or a whole class of patrons.

Closely allied with the study of Roman copies as works of Roman art is the question of whether the Romans desired exact replicas and were capable of producing them through mechanical copying. Studies of Greek statuary and portraiture of the 1940s and 1950s, in which the process of exact pointing among the Romans is described, helped to popularize the notion of its wide

practice. This has been questioned in recent years by scholars who have maintained that the purpose of Roman copies was not to make an exact replica in scale and detail but rather a similar version of the prototype. This slight adjustment in semantics leads to the important realization that Roman copies were not only reflections of their Greek models but also of their new makers, their own time, and their contemporary context. This clarification, which is gaining acceptance, underscores the Romanness of Roman copies and indicates that this is a productive area for research.

Related to the study of Roman copies or variations of Greek masterworks is the increased interest in Roman idealizing sculpture, whether replicated or created anew. Recent books on the cult images of imperial Rome are examples of this trend. Also related are studies on materials, the ancient marble trade and art market, quarrying in antiquity, and so forth. The ground-breaking studies of John Bryan Ward-Perkins on the marble trade and quarrying and by other scholars on sarcophagus workshops and the materials from which their products were made, have served as the basis for the most recent explorations into these subjects.

Roman Artists

A little explored issue in Roman art is that of the identity of artistic personalities and workshops. We have scant information about Roman artists, and few names of Roman artists or architects have come down to us. This is in great contrast to the vast amount of surviving documents of Roman political and social history and to our knowledge of Greek artists. In fact, we know a great deal about Greek sculptors, painters, and architects. Artists who worked for Roman patrons on both official and private monuments, however, generally remain nameless. Attempts have been made to isolate artistic hands in mural paintings in Pompeii, but this is more difficult to do in sculpture where scholars must deal with the problem of replication. Some marble portraits of emperors, for example, were duplicated in multiple copies for distribution around the empire. We can discuss the anonymous master of an individual work of art, but it is difficult to assign several works of art to an individual or a workshop.

In Roman architecture, we are on somewhat firmer ground. We do know the names of a few famous architects, among them Severus, Celer, and Apollodorus of Damascus. Severus and Celer were responsible for Nero's Domus Aurea and Apollodorus of Damascus for the Forum of Trajan, but probably their names have been recorded for posterity primarily because of the great

engineering feats for which they were responsible. The Domus Aurea, for example, had a banqueting hall with a revolving ceiling representing the motions of the heavenly bodies. In order to make room for the Forum of Trajan, Apollodorus had to have the Quirinal hill cut back 125 feet, a number commemorated by the height of the Column of Trajan built as the centerpiece of his forum. But the names of the artists responsible for such masterpieces as the Ara Pacis Augustae, the Arch of Titus, the columns of Antoninus Pius and Marcus Aurelius, and thousands of Roman portraits – to name a few examples – are all lost.

As mentioned earlier, the question of artists and hands is essentially an unexplored area in Roman studies but has been done with considerable success in studies on late Roman portraiture. A group of portraits of Caracalla and other members of the Severan dynasty, for example, have been associated with a court sculptor identified today as the "Caracalla Master," and the portraits of Gordian III, have been attributed to the "Gordian Master."

The relief portraits of freedmen of republican and Augustan times have not been attributed to specific hands, but some effort has been made to differentiate among workshops responsible for such commissions. Nonetheless, the most significant evidence for sculptural workshops in Roman times comes from Aphrodisias, with its great cache of decorative sculpture, portraiture, and major imperial relief commissions, such as the Sebasteion. The extant sculpture associated with the School of Aphrodisias was first discussed in depth in the 1940s. A large body of material, consisting of signed pieces, signatures alone, and statuary close enough in style to be grouped with the former, can be attributed to what must have been one of the leading centers for the production of sculpture in the East. Its primary exponents were members of several family dynasties who were responsible not only for works of art in their native country but for others abroad, especially in Italy. Some of these were produced in Asia Minor and exported, others seem to have been made by Aphrodisian artists who traveled the empire in search of lucrative commissions. One group appears to have enjoyed the patronage of the emperor Hadrian, executing works for his villa at Tivoli, and a portrait relief immortalizing his favorite, Antinous. The School of Aphrodisias continues to be of interest to scholars.

Traveling workshops were already firmly entrenched elsewhere in the Roman world. It has been demonstrated, for example, that an itinerant workshop in Augustan Gaul, the "Mausoleum Workshop," was responsible for the erection of distinctive tower tombs decorated with reliefs and sepulchral statuary in southeastern France, the best-known example of which is the Mausoleum of the Julii (see fig. 99). Although the workshop was made up of local artists, the inspiration for the form of the tombs and their sculptural decoration came from Italy.

Roman Art in Context

As discussed earlier, Roman sculpture was rarely set up in isolation but was instead displayed in public and private edifices. The statuary programs of groups of Roman buildings, such as baths and theaters, as well as those of individual structures and patrons, have attracted increased interest among scholars. Foremost among the new studies are those that focus on the display of sculpture in baths, theaters, and villas; the collection of this material has allowed scholars to reach some significant conclusions.

The collection of sculpture from baths throughout the Roman world, for example, indicates that sculpture was not displayed in all public baths and that three-quarters of the sculptural finds are concentrated in Asia Minor, Italy, and North Africa. Most of the sculptures, which were a mixture of old pieces and others made specifically for a new commission, depicted mythological figures associated with water, deities associated with health, and athletes and heroes. Portraits of the patrons who sponsored the baths and the imperial family are also included in the scheme, and most of the pieces were set up in the *frigidarium* of the baths. Such studies are important steps toward a comprehensive picture of Roman statuary programs in public settings. The sculptures were originally complemented by stuccoes, reliefs, paintings, and mosaics, and there was sometimes an organizing theme.

Provincial Art

Studies of Roman sculpture in individual provinces emerged in the 1950s and 1960s. Some of these focus on art in a specific province, while others suggest that there were compositional and thematic correspondences among provincial sculpture and that of the Late Antiquity style in Rome and the provincial capitals favored by the tetrarchs and Constantine. Although there have been recent attempts to integrate the art of the city of Rome with that of the provinces, there continues to be a pressing need for additional studies of sculpture in the Roman provinces.

Pluralism and Patronage

Roman art presents a special problem for the historian of art not confronted in studying any other ancient

artistic culture – the futility in many instances of trying to date a work of art by style, something one takes for granted for most other periods, as, for example, for Greek art. In Greek art, even the introductory student learns that monuments can be dated and put into context by style with complete confidence. This is the kind of approach that seems natural to most of us, but in Roman art it doesn't work. Roman art is different. Scholars now recognize that difference as a basic feature of Roman art. It was Otto Brendel who was a pioneer of this viewpoint in the early 1950s. When Brendel wrote of pluralism in Roman art, he was referring to individual chronological periods. There is indeed a much greater variety in the Roman art of any given period than in any other ancient art, but it is also possible to find conflicting styles in the same Roman monument.

What accounts for the pluralism of styles in Roman art? The most important questions to ask when analyzing any Roman monument is, who paid for the monument and what was the patron's purpose in commissioning it? Different patrons, often from different social classes, had monuments made, and the same patron sometimes had different purposes behind his commissions. The questions of pluralism and patronage should be taken into consideration when dealing with any individual Roman monument.

Brendel has called Roman art the first "modern" art because of its pluralism – the range of stylistic choices open to the artist. Roman art is the first modern art in still another way – in the range of patrons, from emperors to freedmen, who demanded art – a range paralleled today but without precedent in the ancient world. It was the correlation between the social class of the Roman patron and the subject matter and style of the commission that was emphasized by Bianchi Bandinelli, whose series of books have profoundly influenced scholars of Roman art in Europe and the United States for the past thirty years. What has gained significance only within the last decade, however, is the interrelation between art commissioned by the aristocracy and by freedmen. Neither should be treated in isolation. It has long been thought that court and upper-class modes filtered down to freedmen and that Late Antique monuments commissioned by imperial personages took on some of the most prominent characteristics of the art of freedmen of the late republic and early empire. Nonetheless, the alliance between the two may be even closer than previously believed. Even Roman state reliefs thought to epitomize the classicizing style in court sculpture, like the apotheosis scene of the pedestal of the Column of Antoninus Pius (see fig. 253), are being shown to incorporate compositional devices and themes used earlier in the art of Roman freedmen. Further research in this area should yield the kind of results that will significantly alter our understanding of Roman art.

Bibliography

The Historiography of Roman Art: J.J. Winckelmann, *Geschichte der Kunst des Altertums* (Dresden, 1764). F. Wickhoff, *Der Wiener Genesis* (Vienna, 1895). A. Riegl, *Die spätrömische Kunstindustrie nach den Funden in Oesterreich-Ungarn*, I (Vienna, 1901).

The first museum catalogues: W. Amelung, *Die Sculpturen des Vaticanischen Museums*, I (Berlin, 1903); II (Berlin, 1908). G. Lippold, *Die Skulpturen des Vatikanischen Museums*, III, 1 (Berlin, 1936); III, 2 (Berlin, 1956). O. Benndorf and R. Schöne, *Die antiken Bildwerke des Lateranischen Museums* (Leipzig, 1867); H. Stuart Jones, *A Catalogue of the Ancient Sculpture Preserved in the Municipal Collections of Rome: The Sculptures of the Museo Capitolino* (Oxford, 1912). H. Stuart Jones, *A Catalogue of the Ancient Sculptures Preserved in the Municipal Collections of Rome: The Sculptures of the Palazzo dei Conservatori* (Oxford, 1926).

Early General Studies and Early Studies on Specific Topics: J.J. Bernoulli, *Römische Ikonographie I–III* (Stuttgart, 1882–94). Carl Robert, *Die antiken Sarkophagreliefs* (Berlin, 1890 ff.). W. Altmann, *Die römischen Grabaltäre der Kaiserzeit* (Berlin, 1905). E. Strong, *Roman Sculpture* (London, 1907). G. Rodenwaldt, "Römische Reliefs: Vorstufen zur Spätantike," *JdI* 55 (1940), 12–43. J.M.C. Toynbee, *The Hadrianic School: A Chapter in the History of Greek Art* (Cambridge, 1934). P. Ducati, *L'Arte in Roma dalle origini al sec. VIII* (Bologna, 1938). M.F. Squarciapino, *La scuola di Afrodisia* (Rome, 1943). F.W. Goethert, *Zur Kunst der römischen Republik* (Berlin, 1931). J. Charbonneaux, *L'art au siècle d'Auguste* (Paris, 1948). B. Schweitzer, *Die Bildniskunst der römischen Republik* (Leipzig, 1948). O. Vessberg, *Studien zur Kunstgeschichte der römischen Republik* (Lund, 1941). P.G. Hamberg, *Studies in Roman Imperial Art with Special Reference to the State Reliefs of the Second Century* (Copenhagen, 1945). G. Kaschnitz von Weinberg, *Römische Bildnisse* (Berlin, 1965). H. Jucker, *Vom Verhältnis der Römer zur bildenden Kunst der Griechen* (Frankfurt a.M., 1950). G. Becatti, *Arte e gusto negli scrittori latini* (Florence, 1951). O.J. Brendel, "Prolegomena to a Book on Roman Art," *MAAR* 21 (1953), 9–73. I.S. Ryberg, *Rites of the State Religion in Roman Art* (Rome, 1955). J.M.C. Toynbee, *Some Notes on Artists in the Roman World*, CollLatomus 6 (Brussels, 1951). A. Giuliano, *Il commercio dei sarcofagi attici* (Rome, 1961). C.C. Vermeule, *Roman Imperial Art in Greece and Asia Minor* (Cambridge, Mass., 1968). H. Schoppa, *Die Kunst der Römerzeit in Gallien, Germanien und Britannien* (Munich, 1957). R. Bianchi Bandinelli, *Archeologia e cultura* (Milan, 1961). *Rome: The Center of Power* (New York, 1970). *Rome: The Late Empire* (New York, 1971).

Major monuments: M. Pfanner, *Der Titusbogen* (Mainz, 1983). A.M. Leander Touati, *The Great Trajanic Frieze* (Stockholm, 1987). A. Borbein, "Die Ara Pacis Augustae," *JdI* 90 (1975), 252ff. D.E.E. Kleiner, "The Great Friezes of the Ara Pacis Augustae: Greek Sources, Roman Derivatives, and Augustan Social Policy," *MEFRA* 90 (1978), 753–85. E. La Rocca, *Ara Pacis Augustae* (Rome, 1983). E. Buchner, *Die Sonnenuhr des Augustus* (Mainz, 1982). W. Gauer, *Untersuchungen zur Trajanssäule 1: Darstellungsprogramm und künstlerischer Entwurf* (Berlin, 1977). S. Settis, ed., *La colonna traiana* (Turin, 1988). S. Stucchi, "TANTIS VIRIBVS: L'area della colonna nella concezione generale del Foro di Traiano," *ArchCl* 41 (1989), 237–92. K. Fittschen, "Das Bildprogramm des Trajansbogens zu Benevent," *AA* 87 (1972), 742–88. W. Gauer, "Zum Bildprogramm des Trajansbogens von Benevent," *JdI* 89 (1974), 308–35. F.J. Hassel, *Der Trajansbogen in Benevent* (Mainz, 1966). M. Rotili, *L'arco di Traiano a Benevento* (Rome, 1972). A. Bonanno, *Portraits and Other Heads on Roman Historical Reliefs up to the Age of Septimius Severus*, British Academy at Rome, Suplementary Series 6 (1976). M. Torelli, *Typology and Structure of Roman Historical Reliefs* (Ann Arbor, 1982). G. Koeppel, "Die historischen Reliefs der römischen Kaiserzeit I–V," *BonnJbb* 183 (1983), 61–144; 184 (1984), 1–65: 185 (1985), 143–213; 186 (1986), 1–90; 187 (1987), 101–57.

Lost monuments: P. Zanker, *Forum Augustum* (Tübingen, 1969) (Algiers Relief of Mars, Venus, and Divus Julius). I.S. Ryberg, *The Panel Reliefs of Marcus Aurelius* (New York, 1967). E. Angelicoussis, "The Panel Reliefs of Marcus Aurelius," *RM* 91 (1984), 141–205. H.P. Laubscher, *Arcus Novus und Arcus Claudii: Zwei Triumphbögen an der Via Lata in Rom* (Göttingen, 1976) (British Arch of Claudius). A. von Gladiss, "Der 'Arc du Rhône' von Arles, *RM* 79 (1972), 17–87. F.S. Kleiner, *The Arch of Nero in Rome* (Rome, 1985).

Colossal imperial portraits, dynastic groups, and imperial role playing: H.G. Niemeyer, *Studien zur statuarischen Darstellung der römischen Kaiser* (Berlin, 1968). T. Pekáry, *Das römische Kaiserbildnis in Staat, Kult und Gesellschaft* (Berlin, 1985), 81–83, 90–96, 104–6.

The pointing process and the distribution and replication of imperial portraits: E. Swift, "Imagines in Imperial Portraiture," *AJA* 27 (1923), 286–301. M. Stuart, "How Were Imperial Portraits Distributed throughout the Roman Empire?" *AJA* 43 (1939), 601–17. G.M.A. Richter, *Ancient Italy* (Ann Arbor, 1955), 105–11 (pointing process). F. Albertson, *The Sculptured Portraits of Lucius Verus and Marcus Aurelius (A.D. 161–180): Creation and Dissemination of Portrait Types* (Diss., Bryn Mawr College, 1980), 6–29. B. Ridgway, *Roman Copies of Greek Sculpture, The Problem of the Originals* (Ann Arbor, 1984) (pointing process). J. Pollini, *The Portraiture of Gaius and Lucius Caesar* (New York, 1987), 8–17.

Replicas, replica series, and variations of imperial portraits: W. Trillmich, "Zur Formgeschichte von Bildnis-Typen," *JdI* 86 (1971), 170–213. K. Polaschek, *Studien zur Ikonographie der Antonia Minor* (Rome, 1973), 11–14. P. Zanker, *Studien zu den Augustus-Porträts* (Göttingen, 1973), 10–13. K. Fittschen, *Katalog der antiken Skulpturen in Schloss Erbach* (Berlin, 1977), 4–8. K. Fittschen, "Hinterköpfe: Über den wissenschaftlichen Erkenntniswert von Bildnisrückseiten," *Praestant Interna: Festschrift für Ulrich Hausmann* (Tübingen, 1982), 123–24. P. Zanker and K. Fittschen, "Herrscherbild und Zeitgesicht: Probleme mit der Forschung in der klassischen Archäologie," *Forschung in der Bundesrepublik Deutschland: Beispiele, Kritik, Vorschläge*, ed. C. Schneider (Weinheim, 1983), 23–30. P. Zanker, *Provinzielle Kaiserporträts* (Munich, 1983), 7–10, 27, 40.

The *Herrscherbild* series on imperial portraiture:
M. Wegner, *Die Herrscherbildnisse in antoninischer Zeit* (Berlin, 1939). W. H. Gross, *Bildnisse Traians* (Berlin, 1940). R. Delbrueck, *Die Münzbildnisse von Maximinus bis Carinus* (Berlin, 1940). M. Wegner, *Hadrian, Plotina, Marciana, Matidia, Sabina* (Berlin, 1956). G. Daltrop, U. Hausmann, and M. Wegner, *Die Flavier* (Berlin, 1966). H. B. Wiggers and M. Wegner, *Caracalla, Geta, Plautilla, Macrinus bis Balbinus* (Berlin, 1971). M. Wegner, J. Bracker, and W. Real, *Gordian III bis Carinus* (Berlin, 1979). A. K. Massner, *Bildnisangleichung: Untersuchungen zur Entstehung und Wirkungsgeschichte des Augustusporträts* (Berlin, 1980). H. P. L'Orange, *Das spätantike Herrscherbild von Diokletian bis zu den Konstantin-Söhnen 284–361 n. Chr.* (Berlin, 1984). T. Pekáry, *Das römische Kaiserbildnis in Staat, Kult und Gesellschaft* (Berlin, 1985). D. Boschung, *Die Bildnisse des Caligula* (Berlin, 1989).

Portraits of empresses and female coiffures: M. Wegner, "Datierung römischer Haartrachten," *AA* 53 (1938), 279–329. W. H. Gross, *Iulia Augusta* (Göttingen, 1962). J. Meischner, *Das Frauenporträt der Severzeit* (Berlin, 1964). A. Carandini, *Vibia Sabina* (Florence, 1969). K. Polaschek, "Studien zu einem Frauenkopf im Landesmuseum Trier und zur weiblichen Haartracht der iulisch-claudischen Zeit," *TrZ* 35 (1972), 141–210. K. Polaschek, *Studien zur Ikonographie der Antonia Minor* (Rome, 1973). K. Fittschen, *Die Bildnistypen der Faustina Minor und die Fecunditas Augustae* (Göttingen, 1982). P. Zanker and K. Fittschen, *Katalog der römischen Porträts in den Capitolinischen Museen und den anderen kommunalen Sammlungen der Stadt Rom*, 3 (Mainz, 1984).

Recent Rome museum catalogues: A. Giuliano, ed., *Museo Nazionale Romano: Le sculture*, 1, 1– (Rome, 1979). P. Zanker and K. Fittschen, *Katalog der römischen Porträts in den Capitolinischen Museen und den anderen kommunalen Sammlungen der Stadt Rom*, 1, 3 (Mainz, 1985, 1984).

Reworked portrait heads: H. Blanck, *Wiederverwendung alter Statuen als Ehrendenkmäler bei Griechen und Römern* (Rome, 1969). H. Jucker, "Iulisch-claudische Kaiser- und Prinzenporträts als 'Palimpseste,'" *JdI* 96 (1981), 236–31. M. Bergmann and P. Zanker, "'Damnatio Memoriae': Umgearbeitete Nero- und Domitiansporträts: Zur Ikonographie der flavischen Kaiser und des Nerva," *JdI* 96 (1981), 317–412. J. Pollini, "*Damnatio Memoriae* in Stone: Two Portraits of Nero Recut to Vespasian in American Museums," *AJA* 88 (1984), 547–55. T. Pekáry, *Das römische Kaiserbildnis in Staat, Kult und Gesellschaft* (Berlin, 1985), 29–41.

Private portraiture and portraits of children, including the grandsons of Augustus: G. Daltrop, *Die stadtrömischen männlichen Privatbildnisse trajanischer und hadrianischer Zeit* (Münster, 1958). W. Gercke, *Untersuchungen zum römischen Kinderporträt von den Anfängen bis in hadrianische Zeit* (Hamburg, 1969). P. Zanker, *Studien zu den Augustus-Porträts, I: Der Actium-Typus* (Göttingen, 1973). J. Pollini, *The Portraiture of Gaius and Lucius Caesar* (New York, 1987).

Women and children in scenes of state: D. E. E. Kleiner, "The Great Friezes of the Ara Pacis Augustae. Greek Sources, Roman Derivatives, and Augustan Social Policy," *MEFRA* 90 (1978), 753–85. N. Kampen, "The Muted Other," *ArtJ* (1988), 15–19 (the Basilica Aemilia Frieze).

N. Kampen, "Between Public and Private: Women as Historical Subjects in Roman Art," in S. B. Pomeroy, ed., *Women's History and Ancient History* (Chapel Hill, 1991), 218–48.

Roman sarcophagi: C. Robert, *Die antike Sarkophagreliefs* (Berlin, 1890, 1897). H. Gabelmann, *Die Werkstattgruppen der oberitalischen Sarkophage* (Bonn, 1973). H. Sichtermann and G. Koch, *Griechische Mythen auf römischen Sarkophagen* (Tübingen, 1975). A. Giuliano and B. Palma, *La maniera ateniese di età romana: I maestri dei sarcofagi attici, StMisc* 24 (1975–76). A. M. McCann, *Roman Sarcophagi in the Metropolitan Museum of Art* (New York, 1978). I. I. Saverkina, *Römische Sarkophage, I: Römische Sarkophage in der Ermitage* (Berlin, 1979). G. Koch and H. Sichtermann, *Römische Sarkophage* (Munich, 1982). D. E. E. Kleiner, "Roman Funerary Art: Observations on the Significance of Recent Studies," *JRA* 1 (1988) (Sarcophagi of Roman freedmen).

Art and social class in Rome and the provinces: R. Bianchi Bandinelli, *Archeologia e cultura* (Milan, 1961). R. Bianchi Bandinelli, ed., *Sculture municipali dell'area sabellica tra l'età di Cesare e quella di Nerone (StMisc* 10 (Rome, 1966). R. Bianchi Bandinelli, *Rome: The Center of Power* (New York, 1970); *Rome: The Late Empire* (New York, 1971).

Funerary reliefs of freedmen: E. K. Gazda, "Etruscan Influence in the Funerary Reliefs of Late Republican Rome: A Study of Vernacular Portraiture," *ANRW* 1, 4 (Berlin, 1973), 855–870. P. Zanker, "Grabreliefs römischer Freigelassener," *JdI* 90 (1975), 267–315. H. G. Frenz, *Untersuchungen zu den frühen römischen Grabreliefs* (Frankfurt a. M., 1977). D. E. E. Kleiner, *Roman Group Portraiture: The Funerary Reliefs of the Late Republic and Early Empire* (New York, 1977). H. G. Frenz, *Römische Grabreliefs in Mittel-und Süditalien* (Rome, 1985). S. Diebner, *Reperti funerari in Umbria a sinistra del Tevere (I sec. a.C.–I sec. d. C.* (Rome, 1986).

***Kline* monuments and private dedications:** H. Wrede, "Stadtrömische Monumente, Urnen und Sarkophage des Klinentypus in den beiden ersten Jahrhunderten n. Chr.," *AA* (1977) 395–431. H. Wrede, "Klinenprobleme," *AA* (1981), 86–131. H. Wrede, *Consecratio in Formam Deorum: Vergöttlichte Privatpersonen in der römischen Kaiserzeit* (Mainz, 1981).

Professional scenes: N. Kampen, *Image and Status: Roman Working Women in Ostia* (Berlin, 1981). G. Zimmer, *Römische Berufdarstellungen* (Berlin, 1982).

Roman altars and urns: W. Altmann, *Die römischen Grabaltäre der Kaiserzeit* (Berlin, 1905). D. E. E. Kleiner, *Roman Imperial Funerary Altars with Portraits* (Rome, 1987). D. Boschung, *Antike Grabaltäre aus den Nekropolen Rome* (Bern, 1987). F. Sinn-Henninger, *Stadtrömische Marmorurnen* (Mainz, 1987).

Roman copies of Greek originals: P. Zanker, *Klassizistische Statuen: Studien zur Veranderung des Kunstgeschmacks in der römischen Kaiserzeit* (Mainz, 1974). P. Zanker, "Zur Funktion und Bedeutung griechischer Skulptur in der Römerzeit," in *Le Classicisme à Rome aux Iers siècles avant et après J.-C., (Entretiens Hardt,* 25, 1978), 283–306. B. Ridgway, *Roman Copies of Greek Sculpture, The Problem of the Originals* (Ann Arbor, 1984).

Cult images of imperial Rome: W. Schürmann, *Unter-*

suchungen zu Typologie und Bedeutung der städtrömischen *Minerva-Kultbilder* (Rome, 1985). C.C. Vermeule, *The Cult Images of Imperial Rome* (Rome, 1987).

Travertine: R. Delbrueck, *Hellenistische Bauten in Latium* (Strassburg, 1907–1912), II, 43–44, 56ff. T. Frank, *Roman Buildings of the Republic: An Attempt to Date Them from Their Materials, PAAR* 3 (1924), 32–33. M. E. Blake, *Ancient Roman Construction in Italy from the Prehistoric Period to Augustus* (Washington, 1947). G. Lugli, *La tecnica edilizia romana* (Rome, 1957).

Luna marble: H. Blümner, *Technologie und Terminologie der Gewerbe und Künste bei Griechen und Römern,* III (Leipzig, 1884), 39–41. C. Dubois, *Étude sur l'administration et l'exploitation des carrières marbres, porphyre, granit, etc. dans le monde romain* (Paris, 1908), 3–17. L. Banti, "Antiche lavorazioni nelle cave lunensi," *StEtr* 5 (1931), 475–97. A. Moretti and J. B. Ward-Perkins, "Marmo," *EAA* 4 (1961), 861–62, 869. R. Gnoli, *Marmora romana* (Rome, 1971).

Imported marble: R. Delbrueck, *Antike Porphyrwerke* (Berlin, 1932). M. Blake, *Roman Construction in Italy from Tiberius through the Flavians* (Washington, 1959). *Roman Construction in Italy from Nerva through the Antonines* (Philadelphia, 1973). M. Waelkens, "From a Phrygian Quarry: The Provenance of the Statues of the Dacian Prisoners in Trajan's Forum at Rome," *AJA* 89 (1985), 641–53. M.L. Anderson and L. Nista, eds., *Radiance in Stone. Sculptures in Colored Marble from the Museo Nazionale Romano* (Rome, 1989). R.M. Schneider, "Kolossale Dakerstatuen aus grünem Porphyr," *RM* 97 (1990), 235ff.

Portraits in precious metals: K. Scott, "The Significance of Statues in Precious Metals in Emperor Worship," *TAPA* 62 (1931), 101–23. T. Pekáry, "Goldene Statuen der Kaiserzeit," *RM* 75 (1968), 144–48. *Das römische Kaiserbildnis in Staat, Kult und Gesellschaft* (Berlin, 1985), 66–80 (gold and silver).

Quarrying and the art trade: J. B. Ward-Perkins, "Quarrying in Antiquity," *ProcBritAc* 57 (1971), 137–58. J. B. Ward-Perkins, "The Marble Trade and its Organization: Evidence from Nicomedia," in J.H. D'Arms and E.C. Kopff, eds., *The Seaborne Commerce of Ancient Rome: Studies in Archaeology and History, MAAR* 36 (1980), 325–38. J. B. Ward-Perkins, "Nicomedia and the Marble Trade," *BSR* 58, n.s. 35 (1980), 23–68. M. Waelkens, "Carrières de marbre en Phrygie," *BMusArt* (1982), 33–54. M. Waelkens, *Die kleinasiatische Türsteine* (Mainz, 1984). M. Waelkens, "From a Phrygian Quarry: The Provenance of the Statues of the Dacian Prisoners in Trajan's Forum at Rome," *AJA* 89 (1985), 641–53.

Sarcophagus workshops and materials: G. Ferrari, *Il commercio dei sarcofagi asiatici* (Rome, 1966). H. Wiegartz, *Kleinasiatische Säulensarkophage* (Berlin, 1965); "Marmorhandel, Sarkophagerstellung und die Lokalisierung der kleinasiatischen Säulensarkophage," *Mélanges Mansel* I (Ankara, 1974), 345–83; "Kaiserzeitliche Reliefsarkophage in der Nikolauskirche," in J. Borchhardt, ed., *Myra: Eine lykische Metropole* (Berlin, 1975), 161–251. M. Waelkens, *Dokimeion. Der Werkstatt des repräsentativen kleinasiatischen Sarkophage* (Berlin, 1982). J. Clayton Fant, "Four Unfinished Sarcophagus Lids at Docimium and the Roman Imperial Quarry System in Phrygia," *AJA* 89 (1985), 655–62.

Roman artists: J. M. C. Toynbee, *Some Notes on Artists in the Roman World* (Brussels, 1951). A. Burford, *Craftsmen in Greek and Roman Society* (London, 1972). S. Nodelman, *Severan Imperial Portraiture* (Diss., Yale University, New Haven, 1965) (the "Caracalla Master"). S. Wood, *Roman Portrait Sculpture, 217–260 A.D.* (Leiden, 1986) (the "Gordian Master"). H. G. Frenz, *Untersuchungen zu den frühen römischen Grabreliefs* (Frankfurt a.M., 1977) (workshops for the portraits of Roman freedmen). M. Floriani Squarciapino, *La scuola di Afrodisia* (Rome, 1943). K. Erim, *Aphrodisias: City of Venus Aphrodite* (New York, 1986). F. S. Kleiner, "Artists in the Roman World: An Itinerant Workshop in Augustan Gaul," *MEFRA,* 89 (1977), 661–696 (traveling workshops).

Roman art in context: H. Manderscheid, *Die Skulpturenausstattung der kaiserzeitlichen Thermenanlagen* (Berlin, 1981). M. Fuchs, *Untersuchungen zur Ausstattung römischer Theater* (Mainz, 1987). R. Neudecker, *Die Skulpturenausstattung römischer Villen in Italien* (Mainz, 1988).

Provincial art: C. C. Vermeule, *Roman Imperial Art in Greece and Asia Minor* (Cambridge, Mass., 1968). R. Bianchi Bandinelli, *Rome: The Late Empire* (New York, 1971). G. Mansuelli, *Roma e il mondo romano,* I–II (Turin, 1981).

Pluralism and patronage: O. Brendel, "Prolegomena to a Book on Roman Art," *MAAR* 21 (1953), 9–73. O. Brendel, *Prolegomena to the Study of Roman Art* (New Haven, 1979).

The interrelation between the art of the aristocracy and freedmen: D. E. E. Kleiner and F. S. Kleiner, "The Apotheosis of Antoninus and Faustina," *RendPontAcc* 51–52 (1978–80), 389–400.

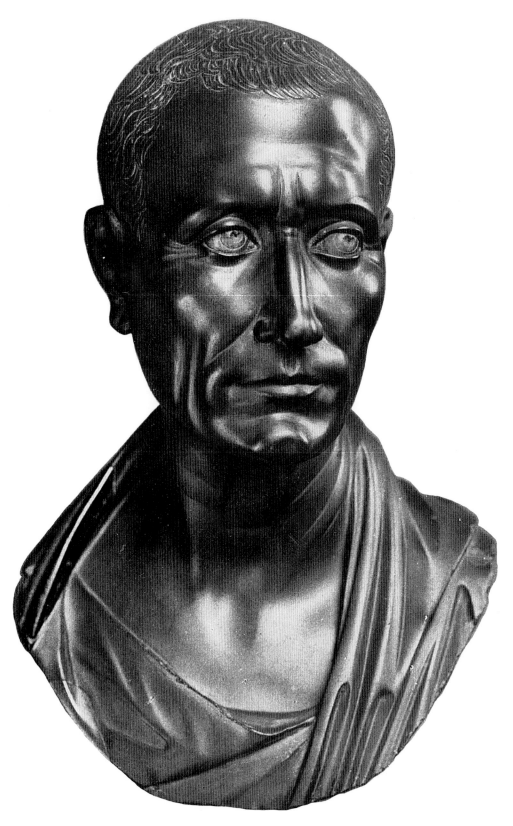

Green diabase portrait of Julius Caesar, from Egypt, based on a
portrait of ca. 44 B.C. (See fig. 27.)

THE ART OF THE REPUBLIC

CHAPTER I

Forerunners: Etruscan, Greek, and Mid-Italic

According to legend, Rome was founded by its first king, Romulus, on 21 April 753 B.C. Romulus was a descendant of Aeneas, who fled burning Troy for the shores of Italy. It was Aeneas's son, Ascanius, who was responsible for the founding of the town of Alba Longa in Italy that was ruled by his descendants for the following four centuries. The last king, Numitor, was overthrown by his brother, Amulius, and Numitor's daughter, Rhea Silvia, was coerced into becoming a Vestal Virgin to ensure that she produce no male heirs. Nonetheless, she bore Romulus and Remus to Mars, the god of war. The babies were set adrift by Amulius upon the Tiber. They did not drown but were carried by the river to a place near the Palatine hill where they were found next to a fig tree by a she-wolf who suckled them. They were adopted by a local shepherd and his wife and as young men returned to Alba Longa to regain their heritage by slaying Amulius and replacing Numitor on the city's throne. Afterward, they set out to establish their own city on the site at which they were saved. Disputes over the form that city should take led to the murder of Remus by Romulus and Romulus's sole kingship of Rome that lasted from 753 to 717 B.C.

Romulus's first Iron Age settlement on the Palatine hill comprised a number of primitive huts with foundations carved out of the tufa rock of the hill and superstructures made out of wooden poles, thatch, and wattle and daub. The residential area overlooked a swamp that served as the Iron Age cemetery and was later to become the Roman Forum.

A renowned bronze statue made about 250 years after the founding of Rome serves as a totem of Rome of about 500–480 B.C. (fig. 1). It depicts the very symbol of the city itself – the she-wolf – who nourished the twins on the shores of the Tiber near the Palatine. Nonetheless, whether or not the she-wolf refers to the myth of Romulus and the founding of Rome is debated by scholars; the myth may be a later invention. In any case, the twins were added to the statue in the fifteen century, probably by Antonio Pollaiuolo, and appear to have had no ancient counterparts. The she-wolf is a tour de force by

1 She-Wolf, ca.500–480 B.C. Rome, Museo del Palazzo dei Conservatori. Photo: DAIR 70.652

Where photograph negative numbers exist, they follow the name of the repository.

an unknown artist, probably a Greek working in the tradition of Etruscan bronze casting, who has, for a Roman patron (possibly the state itself since the statue was certainly a public monument), translated his first-hand knowledge of the animal and its reactions into a masterpiece of metalwork. The artist knows how the she-wolf would respond to some sort of threat. Her ears prick up, her nostrils flare, her eyes widen, her teeth are bared, her body grows taut with tension. Her muscles and tendons are visible beneath her hide and her head turns abruptly toward the source of danger. The artist's keen observation of nature is deftly combined with a sure sense of ornamentation most apparent in the continuous decorative pattern of the she-wolf's fur bordering her face, around her neck, around her upper body, and down her back. Here realism gives way to stylization because, as has been pointed out, wolves are covered with fur and do not have manes. In fact, the mane imparts a leonine look that adds to the ferociousness of the animal and her protectionism as a totem of Rome.

In the new city purportedly founded by Romulus, women were at a premium. In order to rectify the situation, Romulus planned a festival of games, to which he invited neighboring peoples, including the Sabines. The ensuing abduction of the Sabine women by Roman men led to a war that the women themselves eventually mediated and then to peaceful cohabitation in the city of Romans and Sabines and the sharing of the throne by Romulus and the Sabine king Titus Tatius.

After a raging storm in the Campus Martius, Romulus was said to have been transported to heaven in a cloud. He became a god and the throne of Rome was occupied by a succession of Sabine kings, including Numa Pompilius, Tullus Hostilius, and Ancus Marcius. Ancus Martius died in 616 B.C. and was succeeded by the first of the Etruscan kings, Tarquinius Priscus, who ushered in a period in which Etruscan art and architecture exerted a major impact on Rome and led to what might be termed the Etruscan component in early Roman art. Tarquinius Priscus was followed by other Etruscan kings, Servius Tullius, and Lucius Tarquinius (Tarquinius Superbus). The downfall of the latter in 510–509 B.C. led to the founding of the republic.

The bronze she-wolf dates to the late sixth or early fifth century B.C. and was thus manufactured in the early republic. What kind of art was commissioned in Rome prior to this time? Small terracotta statuettes of men and women have been discovered in early Iron Age graves, sometimes inside bronze urns in the form of houses. Monumental sculpture in terracotta is, however, not attested until the reign of Tarquinius Superbus when it was used by the Etruscan sculptor Vulca of Veii to make an over-life-size cult statue of Jupiter and a quadriga group

for the Temple of Jupiter on the Capitoline hill, undoubtedly the most prestigious commission of the day. These do not survive but in appearance must be close to those of the Portonaccio Temple of about 515–490, possibly made by artists from the school of Vulca of Veii, the best-known of which is the so-called Apollo of Veii. It appears that Tarquinius Superbus had a master plan for the glorification of Rome that included not only the Temple of Capitoline Jupiter but commemorative statues of Rome's former kings in both the Roman Forum and on the Capitoline.

Superbus's ambitious building program appears to have been continued in the early years of the republic that saw the construction of a number of major temples. A cult statue of Ceres made in 484 B.C. was probably the first such statue in bronze in Rome. Commemorative portrait statues also cast in bronze and set up in public places became commonplace in the early republic. A late fourth-century example may be the so-called Brutus (fig. 2), the date of which is very controversial, with suggestions ranging from the fourth to the first centuries B.C. This very controversy accentuates the problem of studying early Roman bronze sculpture because it is difficult to differentiate an Etruscan and a Roman work of art. More often than not the patron was probably a Roman and the artist an Etruscan or a Greek working in an Etruscan bronze-casting technique, as was the case with the she-wolf. Brutus has a cubic face, high cheekbones, deep-set eyes shadowed by bushy brows, a high forehead, a hooked nose, thin lips, and a short clipped beard and moustache. His hair is combed in thin strands from the crown of his head over his forehead and most of the locks are swept to one side. These features are comparable to those of other Etruscan bronze portraits of the mid-fourth to the mid-third centuries B.C., although the over-life-size scale of the head is inconsistent with Etruscan practice where over-life-size dimensions were reserved for images of divinities. It has been suggested that the head must therefore have belonged to a statue displayed in a public place, probably of an equestrian because of the slight downward tilt of the head. The erection of such an equestrian statue in Italy at this time has been ascribed to the influence of the Greeks, and important correspondences have been drawn between Etruscan and Greek portraits of the late fifth to third centuries. The Brutus is an excellent example of the confluence of Greek, Etruscan, and Roman features in the art of the early republic. It is an illustration of an incipient eclecticism that was to become one of the most outstanding features of Roman art.

The Brutus has also been called a Mid-Italic work. Mid-Italic art in bronze and stone was produced by indigenous Italians from the third century B.C. Although

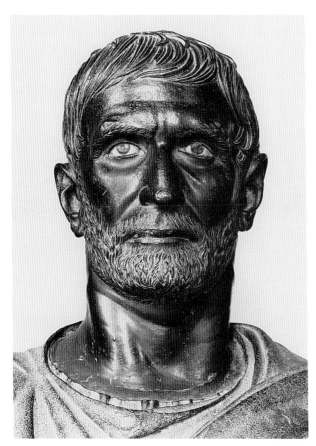

2 "Brutus," late fourth century B.C. Rome, Museo del Palazzo dei Conservatori. Photo: DAIR 67.6

exposed to both Hellenistic Greek and Etruscan art, Mid-Italic art borrows subject matter and compositional devices from its more illustrious predecessors but develops its own pictorial language characterized by basic simple forms and scant interest in elegant proportions and correct perspective. An example is the fourth–third century B.C. relief of a shepherd with his sheep from Lucera (fig. 3), which is controversial in date but epitomizes the Mid-Italic style. The shepherd, his body a rough triangle supporting a large blocklike head with etched-in hair, crude facial features, and supported by stumpy legs, holds his shepherd's crook with his oversized right hand. The left arm and hand are not delineated. The figure is silhouetted against a blank background and the rear half of the horse, which is all that survives, is not foreshortened. The artists responsible for such works as the Lucera relief were undoubtedly local artists, and they must be distinguished from their more sophisticated and well-trained counterparts who entered Italy during the centuries of conquest.

Such honorific statues as the Brutus were sometimes displayed alongside statues of divinities plundered by Roman generals in wars with neighboring peoples in the fifth and early fourth centuries B.C. It was these captured works of art that served as a means of introducing

the artistic accomplishments of other cultures to Rome. Many of these works – as well as religious buildings – were, however, destroyed in the Gallic sack of Rome in 390 B.C. The city was set afire; when the smoke cleared, one of the few monuments left standing was the Temple of Jupiter Capitolinus.

The Romans learned an important lesson from the Gallic invasion: Rome needed a defensive wall system. In the years following the sack, a great stone circuit was built around the republican city. Sections of the Servian Walls still stand in Rome today. Defensive walls were also constructed for Rome's newly founded Italian colonies, for the fourth and third centuries witnessed a great period of expansion in Italy through military conquest. The first Roman colony was at Ostia at the mouth of the Tiber. The rectangular grid of the camp or *castrum* had already been laid out in the mid-fourth century. Wars against the Samnites in Campania in the fourth and third centuries and victory over Tarentum in 270 B.C. gave Rome control of South Italy. The Romans successfully subjugated the Etruscans in the third century and forced their Gallic enemy back to the Po Valley.

The success of Roman expansion in Italy led to forays into the Mediterranean. Rome became embroiled in the First Punic War with Carthage, and Carthaginian surrender led to the establishment in 227 B.C. of Roman provinces in Corsica, Sardinia, and Sicily. The Second Punic War brought Spain into the Roman fold in 206 B.C. The three wars with Macedonia, culminating with the Battle at Pydna in 168 B.C., gave Rome full control over Greece. The Third Punic War led to the Roman occupation of Carthage and to the founding of the province of Africa.

3 Relief of a shepherd from Lucera, fourth–third centuries B.C. (?) Lucera, Museo Civico. Photo: G. Fiorelli

It was the Roman contact with the Greeks of South Italy and Sicily and with Greece itself that was to exert a lasting influence on Roman art. Sicily became a Roman province in 227 B.C. Syracuse was taken in 211 B.C., and plunder from that city was displayed in Marcellus's triumph in Rome of the same year. The consul Lucius Mummius took Corinth in 146 B.C. The Sanctuary of Apollo at Delphi was plundered by Sulla in 86 B.C., and in the same year Sulla conquered Athens and demolished the city walls. When the Roman generals arrived in South Italy, Sicily, and Greece, they encountered not only countrysides of great beauty, but a wealth of artistic treasures. They expropriated many of these treasures and brought them back to Rome to display in triumphal processions. The plundered spoils included arms and armor, statues in bronze and marble, paintings, and gold and silver tableware. The triumphs in which these objects were displayed thus served as the vehicle for the introduction of Greek art to the Romans in the capital. The subsequent installation of the war booty in temples, theaters, porticoes, and other public structures constituted a permanent exhibition of Greek masterpieces for the Romans to study and emulate.

At the same time, in the course of the second and first centuries B.C., Roman generals and Roman colonists began to commission portraits and build Roman monuments in Greece. At first, these works of art were based in large part on Greek prototypes, but the Roman commissions in Greece still bore a distinctive Roman stamp. This is apparent in both portraiture and in relief sculpture.

An example of the former is a numismatic portrait of Titus Quinctius Flamininus, a Roman consul with philhellenic leanings, who defeated Philip V of Macedon in 197 B.C. (fig. 4). The portrait is on the obverse of a gold stater designed and struck in Greece. It portrays Flamininus during his lifetime, just after his military victory. This is in itself of significance. In second-century Rome such lifetime portraits of victorious generals were not produced. Instead mint masters struck coins with a wide variety of subjects, including images of gods, but representations of living generals were excluded in favor of those of deceased relatives. This tradition was, however, rejected in Rome in 44 B.C. when Julius Caesar struck coins with his own portrait. Such a custom did not, however, exist in the Greek East where coins with lifetime portraits of renowned leaders were minted from the time of Alexander the Great. Flamininus's portrait follows in this Hellenistic tradition. In fact, the reverse image of a standing Victory with a wreath crowning Flamininus's name is the same motif as that on the reverse of coins of Alexander himself.

It is instructive to compare the numismatic portrait of Flamininus with one of a second-century Greek king,

4 Gold stater with portrait of Titus Quinctius Flamininus, 197 B.C. London, British Museum. Photo: Hirmer Verlag München, 2000.078

Perseus of Macedon, because it is with Hellenistic portraits that the portrait of Flamininus finds its closest correspondence. Although the portrait of Flamininus is the earliest surviving portrait of a famous Roman whose identity is secure, it is fashioned in a style that is thoroughly Hellenistic. Flamininus is portrayed with his own distinctive facial features but, like Perseus, he wears a beard and is depicted with flowing locks combed from the crown of his head down over his forehead and allowed to grow long on his neck. Republican Romans did not wear beards, at least after Scipio supposedly set the fashion for the clean-shaven look in the late third and early second centuries B.C. – the first barber is attested in Rome in 300 B.C. – and were represented with very little hair or as bald.

Another example of the Hellenistic component in early Roman sculpture in Greece is the Monument of Aemilius Paullus commissioned to commemorate the Roman general's victory over Perseus at the Battle of Pydna in 168 B.C. It was erected not on the battlefield and not in Rome but at Delphi in Greece, the location of the famous Sanctuary of Apollo and of numerous shrines and victory monuments. In fact, the Monument of Aemilius Paullus at Delphi was the very same monument begun earlier on the site by Perseus. After Aemilius Paullus's victory over Perseus at Pydna, the Roman expropriated the monument from the Greek king and transformed it into one honoring himself. The Monument of Aemilius Paullus thus commemorates Paullus's double victory over Perseus, first at Pydna and then at Delphi. The

monument consisted of a rectangular pillar on a stepped base, crowned with a statue of Perseus on horseback that was replaced with a bronze equestrian of Aemilius Paullus. Paullus also added a frieze that encircles the pillar near the apex.

The frieze (fig. 5) depicts the battle between Romans and Macedonians, identified by their armor and shields. The scene is carved by Greek artists in a Hellenistic style with standing figures and horsemen, many of whom are engaged in hand-to-hand combat, against a blank background. A naked figure lying on the ground is of special interest. It is a male deliberately depicted in Greek heroic nudity rather than in the customary battle dress. The artist pays special attention to varying the postures of the soldiers and horses, which are portrayed as rearing and collapsing as well as foreshortened from the rear, illusionistically disappearing into the background haze. What separates this lively battle scene from its Hellenistic prototypes is the frieze's subject matter. Although the opposing sides are identified by their different battle gear, of greater significance is the attention the unknown designer of the frieze has paid to the story of the Battle of Pydna. This is not a mythological battle that makes veiled reference to a contemporary one but a battle that can be no other than Pydna. This is made apparent by the inclusion of the foreshortened horse without a rider, which is not only a tour de force rendition in the Greek manner but one of the only Roman details in the scene, one that enables the conflict to be identified with certainty with Pydna. The story of the Battle of Pydna goes as follows: It was foretold by an oracle that whichever side started the battle, would lose it. The generals on either side thus held their troops carefully in check. At one point, one of the Roman horses – the riderless horse – got loose from his master and began galloping toward the opposition. Perseus thought the other side had begun the battle and attacked in turn, thereby initiating the onslaught himself. Thus what had been foretold came to pass. The Macedonians began and lost the battle to Aemilius Paullus. This specificity of detail transforms what at first glance appears to be a thoroughly generalized Hellenistic battle scene into a work of Roman art with a definite preference for carefully recording a specific event.

Introduction of Greek Art to Italy
Greek Masterpieces and Roman Copies

The gold stater of Flamininus and the Monument of Aemilius Paullus were both produced on Greek soil, but it has already been mentioned that it was the triumphs of such generals as Aemilius Paullus that displayed captured Greek weaponry and, more importantly, masterpieces of Greek art that served as vehicles for the introduction of Greek art to Italy. Such triumphs involved elaborate processions from the Porta Triumphalis along the Via Sacra to the Capitoline hill where the triumphator, dressed in a toga with a broad purple stripe (*toga praetexta*) and carrying the attributes of Jupiter, offered a sacrifice to the chief state god at an altar in front of his most revered temple, that of Jupiter Optimus Maximus Capitolinus. These triumphs are graphically recorded in historical accounts of the lives of well-known Roman generals, and an idea of their appearance can be gleaned from Renaissance paintings based on the same literary accounts. The triumph celebrated by Flamininus in honor of his victory over Philip, for example, is described by Livy. "The triumph lasted for three days. On the first day armor and weapons were exhibited, and also statues in bronze and marble, more of which were expropriated from Philip than were captured from cities of Greece. On the second day gold and silver, worked, unworked, and coined, were paraded. Of unwrought silver there were 43,270 pounds; of wrought silver there were many vases made of bronze and, in addition to all this, ten shields of silver" (Livy 34.52.4–5, trans. J.J. Pollitt, *Rome: Sources and Documents*, p. 43).

Another triumph, that of Marcus Claudius Marcellus in 211 B.C., which displayed plunder from Syracuse, is described at length by Plutarch in his *Life of Marcellus*. The picture that it gives us of a republican triumph and of the reaction of conservative aristocrats of the day to works of Greek art are significant enough to quote a lengthy portion of it here.

> When the Romans recalled Marcellus to the war with which they were faced at home, he returned bringing with him many of the most beautiful public monuments in Syracuse, realizing that they would both make a visual impression of his triumph and also be an ornament for the city. Prior to this Rome neither had nor even knew of these exquisite and refined things, nor was there in the city any love of what was charming and elegant; rather it was full of barbaric weapons and bloody spoils; and though it was garlanded with memorials and trophies of triumphs, there was no sight which was either joyful or even unfearful to gentle and refined spectators. But just as Epaminondas called the Boeotian plain the "dancing floor of Ares" and Xenophon called Ephesos "the workshop of war," so too, in my opinion, one might apply Pindar's phrase "the war-deep precinct of Ares" to the Rome of that day. For this reason Marcellus was even more respected by the populace – he had decorated the city with sights which both provided pleasure and possessed Hellenic charm and persuasiveness – while Fabius Maximus was more respected by the older Romans. For Fabius neither disturbed nor carried any such things from Tarentum when he took it, but rather, although

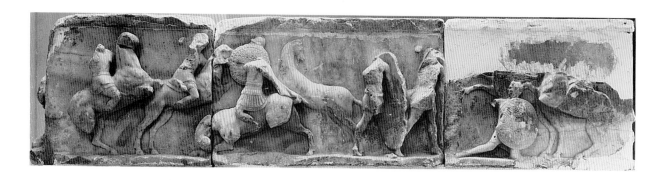

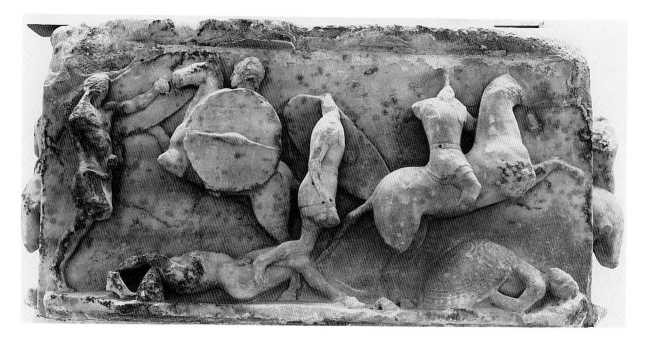

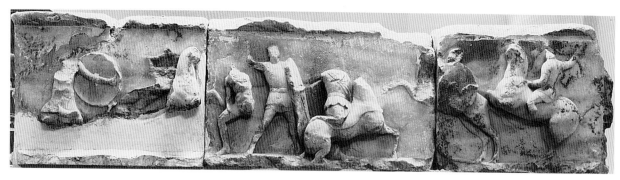

5 Monument of Aemilius Paullus, battle relief with riderless
horse, 168 B.C. Delphi, Delphi Museum. Photo: École française
d'archéologie, Athènes, 18205–18207

he carried off the money and other valuables of the city, he allowed the statues to remain, adding this widely remembered remark: "Let us leave," he said, "these aggravated gods to the Tarentines." The elders blamed Marcellus first of all because he made the city an object of envy, not only by men but also by the gods whom he had led into the city like slaves in his triumphal procession, and second because he filled the Roman people (who had hitherto been accustomed to fighting or farming and had no experience with a life of softness and ease, but were rather, as Euripides says of Herakles, "vulgar, uncultured but good in things which are important") with a taste for leisure and idle talk, affecting urbane opinions about the arts and about artists, even to the point of wasting the better part of a day on such things. But Marcellus, far from feeling this way, proclaimed proudly even before the Greeks that he had taught the Romans, who had previously understood nothing, to respect and marvel at the beautiful and wondrous works of Greece. (Plut., *Vit. Marc.* 21, trans. Pollitt, *Rome: Sources and Documents*, pp. 32–33)

The works of art that possessed "Hellenic charm" were undoubtedly Greek bronze and marble cult statues, images of Greek athletes, and so forth. Specific examples can be documented in the extant historical accounts. The same Fabius, for example, who is credited with reluctance to remove cult statues from the temples of Tarentum is reported by several authors to have taken from that same city a colossal statue of Hercules attributed to the fourth-century Greek sculptor Lysippos. Once in Rome, the statue was set up on the Capitoline hill by Fabius himself. Marcus Fulvius Nobilior is said to have transported to Rome a terracotta group of the Muses by the Greek artist Zeuxis. A statue of Athena by Pheidias was brought to Rome by Aemilius Paullus and subsequently set up in the Temple of Fortune. A very influential statuary group by Lysippos representing Alexander the Great and his cavalrymen and commemorating the Battle of Granikos was brought to Rome from Macedonia by Quintus Metellus and set up in the Porticus Metelli (later the Porticus Octaviae).

Roman Copies as Roman Works of Art:
The School of Pasiteles

Even though the Roman exposure to such statuary was criticized by the old guard, the display of Greek masterpieces in Roman public squares and religious buildings led to an increasing demand for works of Greek art by those who could afford them. This demand was part of a rapidly increasing appreciation of Hellenic culture, including literature, music, painting, architecture,

medicine, and philosophy in the Roman upper classes. The desire for such works could not be matched by the supply and opportunistic workshops in Italy began manufacturing replicas of the most popular subjects in great quantities. Some of these decorated public places, others were set up in the atria or gardens of private residences. It is to these zealous copyists that we owe much of our present knowledge of lost Greek masterworks. These replicas, however, should not be viewed, as they are by some, merely as inferior Roman imitations of lost Greek works of higher quality. They are significant documents of changing Roman taste and of Italian workshop technique.

While some workshops turned out near carbon copies of the same prototype, other more adventurous artists grouped popular statuary types in novel combinations, fused stylistic characteristics of several periods in a single image, or created variations on a popular theme. The undisputed master of eclectic copying was a South Italian Greek artist whose name is documented – Pasiteles – who not only described famous works of art in a multi-volume tome but also founded a workshop in Rome that continued to function into the age of Augustus.

Pasiteles seems to have lived between about 106 and 48 B.C., that is, his period of artistic activity seems to be roughly comparable to the period of Pompey the Great. His name is attested in the writings of both Cicero and Pliny, where he is described as a silversmith and sculptor who "never made anything unless he made a model beforehand" (Pliny, *HN* 35.156, trans. Pollitt, *The Art of Ancient Greece, 1400–31 B.C., Sources and Documents,* 2d ed. [Cambridge, 1990], p. 207). It is thought that the "model beforehand" refers to the plaster cast that served as an exact duplicate of the chosen prototype. Unfortunately, there are no extant works of Pasiteles, although statues signed by artists who were members of his school have survived.

The best known of Pasiteles's pupils is Stephanos, who was active in the second half of the first century B.C. Stephanos's signature is preserved on the trunk of the tree that serves as the support for a marble statue, known today as the Stephanos athlete (fig. 6). It is one of many copies of the same prototype and dates to about 50 B.C. That the artist chose to depict an athlete is in itself significant since statues of youthful male athletes were extremely popular in the classical age. The artist has also intentionally imbued the statue with a Greek air. The young man stands with his weight on his left leg and his right leg relaxed. His left shoulder is slightly higher than his right, giving the statue a subtle tilt. His left arm is bent; his right arm rests at his side. This is a pose popular in "Severe style" statues of the early classical period, although the statue is not a copy of any known type. The

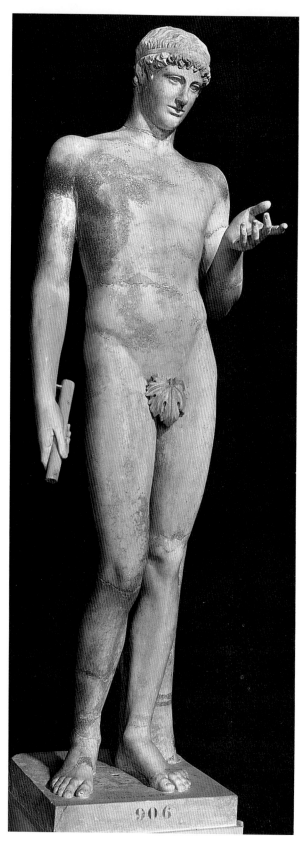

6 Athlete, by Stephanos, ca.50 B.C. Rome, Villa Albani. Photo: Alinari/Art Resource, New York, 27564

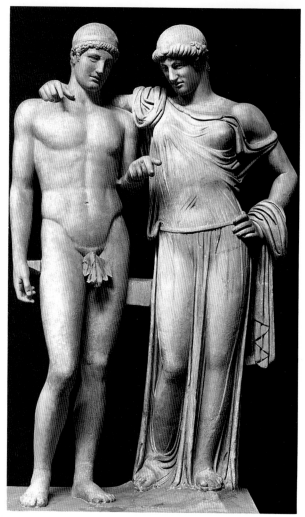

7 Orestes and Electra, from Pozzuoli, ca.50–25 B.C. Naples, Museo Nazionale. Photo: Alinari/Art Resource, New York, 11121

head and tightly curled hairstyle are also close to heads datable to the early fifth century. The Stephanos athlete survives in a number of copies, which suggests that the statue served as a kind of canon for the Pasitelean workshop, an ideal male figure that could be represented on its own or in combination with other figures.

Such an eclectic pastiche is the "Orestes and Electra" group from Pozzuoli (fig. 7), which is attributed to the Pasitelean School but not to a specific artist and probably dates to about 50–25 B.C. In it, the Stephanos athlete is embraced by a female figure; her pose and drapery is closely based on the so-called Venus Genetrix type of the mid-fifth century B.C. Her hair is tightly rolled around a fillet, and her facial features and the musculature of her body have a decidedly masculine appearance; these characteristics suggest that the artist was using male Severe-style statues as his prototypes. The group of "Orestes and Electra" is thus an excellent illustration of the interest of artists of the Pasitelean School in combining not

only two disparate statuary types but also different Greek styles in a single figure. The resultant alliance is not carefully disguised, and it is likely that such a statuary group was made for a highly sophisticated audience that would take considerable pleasure in being able to recognize the group's diverse sources. There is no reason to believe that the group of "Orestes and Electra" depicts this particular mythological pair, although such labels were given to these groups in the literature of the eighteenth and nineteenth centuries. The lack of portrait features also makes their identification as a late republican couple unlikely. It is perhaps better to interpret this group as a deliberate pastiche of two statuary types highly favored by a Roman intelligentsia in the late republic. Some scholars favor precise mythological identifications for these figures, while others believe that the groups have general mythological overtones but do not depict specific mythological pairs.

Another Pasitelean pastiche of note is the "S. Ildefonso" group (fig. 8), formerly in the Sallustian Gardens in Rome, which consists of two youthful male figures. The one on the right is in the pose of Polykleitos's Westmacott athlete of the mid-fifth century B.C. and supports a version of a different Polykleitan head of contemporary date – that of the Doryphoros. The figure is combined with that of another youth who leans toward him and puts his left arm around his companion's shoulder. This second figure is a copy of the mid-fourth century B.C. Apollo Sauroktonos by Praxiteles, although the head of Antinous does not belong to the original group and was added later by Hadrian.

The youth on the right ignites a garlanded altar with a torch that has suggested to some scholars that the group has funerary symbolism, but the female caryatid figure on a pedestal behind the same figure cannot be similarly interpreted. The latter became popular in the age of Augustus when copies of the fifth-century Greek originals were produced in reduced scale for Augustus's forum (see fig. 83). The inclusion of the caryatid along with the highly polished classicizing style and the taste for Polykleitan prototypes suggests that this group was created in the early Augustan period, that is, about 25 B.C. Some scholars believe that the group represents the mythological twins Castor and Pollux, but a less precise identification seems more suitable. The decision by the emperor Hadrian, who was philhellenic in his artistic predilections, to update the work by adding a portrait of his favorite, Antinous, attests to the continued Roman penchant not only for classicizing statuary but for reusing "antique" works in new contexts.

Another member of the Pasitelean School was Menelaos, who left his signature on the well-known Ludovisi group that depicts an embracing woman and youth (fig.

9). The voluminously draped woman's posture and head are based on different late fourth-century prototypes, while the boy's body type and head find their closest parallels in Hellenistic sculpture. The group dates to the last quarter of the first century B.C., that is, it is an Augustan work, and it might be said that the artistic experiments of the Pasitelean artists enabled artists in Augustus's employ to create works of art in which earlier styles were more subtly combined. A case in point, as we shall see, is the statue of Augustus from Primaporta (see fig. 42) in which a court artist succeeded in uniting in masterful fashion a Polykleitan stance and head, a post-Lysippan gesture, and a complex Augustan and Tiberian propaganda.

It has been suggested that the Ludovisi statue is a sepulchral group of mother and son even though specific portrait features are not delineated. This is not impossible since a classicizing style in portraiture (although with an air of individuality) was ushered in under Augustus, and this group appears to be Augustan in date. Republican portraiture, however, prided itself on its extreme realism or verism. Furthermore, Greek funerary statues are not portraits, so the exclusion of portrait features in such a group would be consistent with the full appreciation of Greek art by both the artists in the School of Pasiteles and by contemporary Roman customers.

Republican Portraiture

Origins and Patrician Portraiture

Republican realism or verism in portraiture seems to reflect the Roman belief that the individuality of a person lay in his or her facial features. It was this conviction that led to the commissioning not only of bust-length portraits but also of individualistic portrait heads on stock body types that often diverged in age and execution from the heads they supported. As mentioned earlier, this belief is in strong contrast to the earlier Greek view that the essence of a person was found in both the head and body, which formed an indivisible whole. For the Romans, the emphasis shifted to the face, the body serving as a kind of prop for the head, although one that identified the subject's profession or role, such as general or magistrate. In both commemorative lifetime and funerary portraits, it was the individual's facial features that were emphasized.

If a Roman citizen's individuality lay in his or her facial characteristics, then a realistic rendition of those features was essential in order that one Roman could be clearly differentiated from another. This realism in Roman portraiture, which had no true counterpart in the art of other cultures, nonetheless drew on earlier sources, including Etruscan, Hellenistic, and – less probably – Egyptian portraiture.

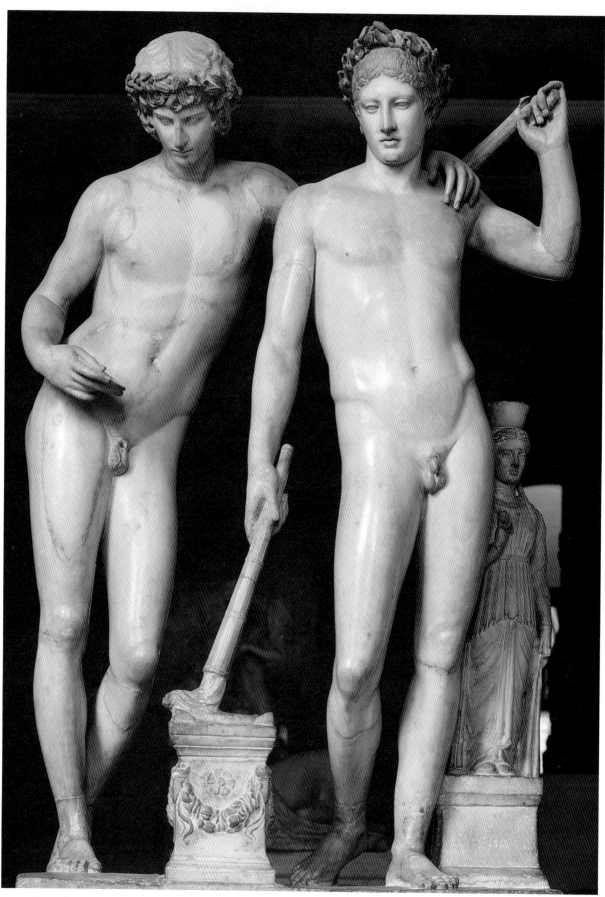

8 S. Ildefonso Group, from Rome, Sallustian Gardens,
ca. 25 B.C. Madrid, Prado. Photo: Hirmer Verlag München,
644. 1053

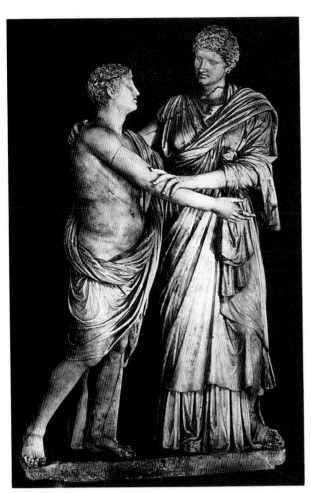

9 Ludovisi Group, by Menelaos, last quarter of the first century B.C. Rome, Museo Nazionale delle Terme. Photo: DAIR 34.190

Surviving literary sources are unanimous in proclaiming that the first century B.C. witnessed the blossoming of portraiture in Italy. During this century, stone – as opposed to bronze, silver, gold, and other costly materials – was increasingly used for portraits. The production of portraits in stone made possible the economical replication of sculptured likenesses of important personages and also permitted the commissioning of durable portraits of Romans of lesser means, notably freedmen.

It is also during the first century B.C. that Rome became an important artistic center. Many works of art were transported to Rome, and many artists were brought to Rome as slaves; others came in search of commissions. Understandably, the art of the late republican period is characterized by the coexistence of diverse stylistic trends and by eclecticism. The "Italo-Hellenistic" or Mid-Italic style that dominated Roman sculpture of the third and second centuries B.C. and produced such works as the bronze "Brutus" (see fig. 2) as well as the stone portrait of a young Scipio from the Tomb of the Scipio family, was gradually modified as Roman artists

became increasingly exposed to the sculpture of the Hellenistic East. A complicated process of assimilation took place that was made even more complicated by the fact that the works of Greek art that flooded the capital were themselves of different styles, ranging from consciously classicizing pieces to exuberant baroque creations. Likewise, the artists who came to work in Rome represented the varied artistic backgrounds of central and southern Italy, Greece and the Greek islands, and Asia Minor.

It is thus impossible to outline a clear evolution of the republican portrait style from decade to decade. Instead, we must be prepared to accept that at any given time works of quite different character were being produced. It is nevertheless possible to describe two fundamentally different stylistic trends in the late republican period. The first is an outgrowth of the Mid-Italic style and is essentially veristic. It draws on the art of the pre-Roman Italic tribes and the art of the Etruscans. The portraits are usually somber, static, frontal, without an overt display of emotion, and with considerable attention paid to the details of the subject's appearance – skin texture, lines, blemishes, and so forth – resulting in a maplike representation of the face. In the second trend, which owes its character to Hellenistic Greek art, greater emphasis is placed on dramatic movement and inner expression; the subject appears charged with energy, the eyes are often upturned and the neck twisted, and the surfaces are modeled in large, plastic forms.

The Etruscan impact on early republican portraiture can be documented with some certainty. Etruscan models were readily available on Italian soil, and the Romans were profoundly influenced not only by Etruscan political, religious, and funerary customs but also by Etruscan city planning, temple architecture, painting, and sculpture. In fact, our discussion of the bronze portrait of "Brutus" has made it apparent that there is no clear distinction between Etruscan and Roman portraiture in bronze in the early republic. From the fourth century B.C. on, expert Etruscan bronzecasters were already fashioning portraits for Roman patrons. Many of these portraits, as well as those in terracotta and marble from the third through the first centuries B.C., possess features that might be described as realistic. It is possible, however, that this realism can be ascribed not to an indigenous Italian concern but to the contact of Etruscan artists with the portraiture of Hellenistic Greece.

A case in point is the well-known statue of an orator from Lake Trasimene in Etruscan territory nicknamed the Arringatore, that is, the haranguer. The full-length bronze statue (fig. 10) dates to about 90–70 B.C. The artist who made the statue was probably an Etruscan bronzecaster, but the image is thoroughly Roman. The man's name, Aulus Metellus, is inscribed in Etruscan letters on

the hem of his garment, which is a Roman toga. He also wears the high boots of a Roman magistrate. What is especially striking about the image is the strong forward gesture of the man's right arm – a gesture of address – that earned the statue its nickname. The gesture energizes the space around the statue and owes much in that regard to post-Lysippan Greek experiments in figural torsion. The arm of the Arringatore seems to take on a life of its own and is an example of what one scholar has called "the appendage aesthetic," in which one part of the body is singled out for special attention by the artist. The Roman interest in emphasizing certain parts of the body – the arm, the hand, the head – over others is inherited from the Etruscans who did the same.

The head of the Arringatore – with its cubic structure, furrowed forehead, lined neck, aquiline nose, and large eyes with crow's-feet at the corners, is in the Roman veristic tradition. The plastic modeling of the shifting planes of the face and the upturned head show the statue's indebtedness to the Hellenistic East. The hair is short and adheres to the shape of Metellus's skull, although the hair over the forehead is a little fuller. Nonetheless, it recedes at the temples and is almost geometric in shape.

Realism in Greek portraiture may have already begun in the early fifth century B.C. with such Severe style "portraits" as the so-called herm head of Themistokles in Ostia, the date of which is much disputed. But Roman portraitists looking for realistic models were undoubtedly more familiar with Hellenistic ruler portraits depicting Alexander the Great and his successors in Macedonia, Syria, Egypt, and elsewhere. The portraits of these kings are unquestionably identifiable likenesses of their subjects, but they are also characterized by blatant artificialities, such as long flowing locks emanating in concentric circles from the crown of the head, a powerful twist of the neck, a wide-opened upward glance of the eyes, parted lips, and above all by the assimilation of the subjects to a host of Greek divinities and heroes. Alexander the Great was depicted, for example, with the attributes of Zeus and was partially assimilated to Herakles; and Mithridates VI of Pontus was portrayed like Herakles.

The portraits of Mithridates were created in the early first century B.C. At the same time, Greek artists were fashioning portraits of nonroyal patrons on Greek soil that presented a more straightforward picture of their subjects. The finest and largest body of these survives from the island of Delos, which became the home in the late republic of a growing community of Roman traders and merchants, lured to Delos because of its strategic location for trade by sea. These Roman colonists built houses with colonnaded courtyards in the Greek style and commissioned portraits of themselves also – at least in part – in the Hellenistic Greek mode.

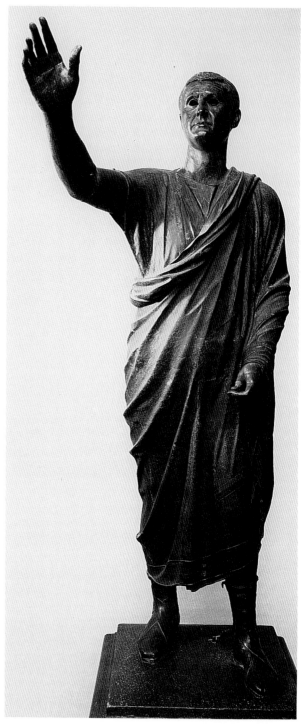

10 "The Arringatore," from Lake Trasimene, ca.90–70 B.C. Florence, Museo Archeologico. Photo: DAIR 62.40

An example is the full-length portrait of the "Pseudo-Athlete" that dates to the early first century B.C. (fig. 11). It is one of two statues discovered in the House of the Diadoumenos on Delos, the other statue being a Roman copy of the mid-fifth century B.C. Diadoumenos, or youth tying a fillet around his head, by Polykleitos, the statue from which the house takes its name. The juxtaposition of the two images in the house of a Roman

patron on the Greek island of Delos is intentional and instructive. The patron had a taste for Greek sculpture and indulged it by purchasing a copy of a famous Greek masterpiece for display in his home, a peristyle house of Greek plan. He chose to honor himself by commissioning a companion piece that portrayed him as a Greek athlete. He is depicted completely nude save for a chlamys draped over his left shoulder and wound around his right arm. The same arm rests on his right hip, and he stands in the classical *contrapposto* pose with the accompanying tilt of the shoulders and hips. His weight rests on his right leg, and his left leg is bent and drawn back with his left foot elevated from the ground. His head is turned sharply to his left, and he gazes upward. It is, therefore, apparent that although the body type is based on that of the mid-fifth century in Greece, the abrupt twist of the head and the upward glance betray the influence of Hellenistic

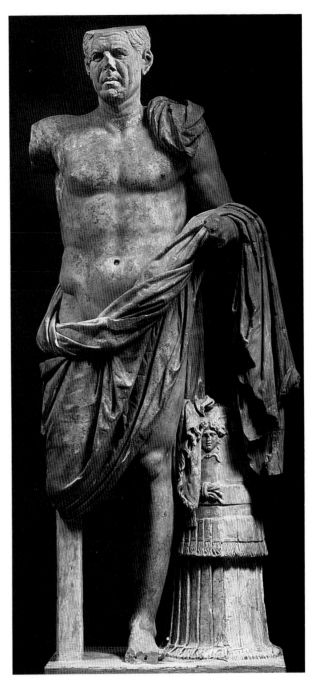

12 General, from the Temple of Hercules at Tivoli, ca.75–50 B.C. Rome, Museo Nazionale delle Terme. Photo: DAIR 32.412

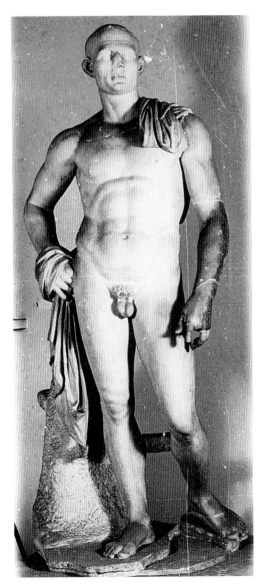

11 "Pseudo-Athlete," from Delos, early first century B.C. Athens, National Archaeological Museum. Photo: National Archaeological Museum, Athens, T.1828

ruler portraiture. Nonetheless, what sets this statue apart from its classical and Hellenistic predecessors is the inconsistency of body and head and the stark realism of the face. Although the unknown Roman is clearly depicted as an athlete, he is called a pseudo-athlete because his youthful and muscular body is not accompanied by the head of a youth, but instead by the realistic rendition of the head of a man past his prime; he is middle-aged with a balding hairline, lined forehead, sagging jowls, large ears, misshapen head, and a prominent Adam's apple.

The same Romanized Hellenistic type can be seen in Rome slightly later. It is epitomized by the so-called Tivoli general, a portrait of a Roman military man discovered in the substructures of the Temple of Hercules at Tivoli (fig. 12). The statue, dating to 75–50 B.C., is made of Greek marble. The general's breastplate has been removed and placed next to his left leg, where it serves as a support for the statue. His chest is bare in the heroicized Greek mode although his mantle is draped not only over his left shoulder but around his genitals and over his left arm. Gone is the bold total nudity of the Pseudo-Athlete fashioned on Greek soil; in the Roman orbit modesty generally prevails. A subtle contrapposto puts the man's weight on his left leg, and there is a slight tilt to the shoulders. The musculature of the chest is accentuated, and the body type is of a youthful and vigorous subject. The treatment of the body is thus in opposition to that of the face that portrays an older man with lined forehead, bags under his eyes, prominent crow's-feet, creased cheeks and neck, and sagging jowls. The foregoing features are consistent with those favored in the republican veristic style, although the turn of the head and the plastic fluid modeling of the man's face point to the profound impact of Hellenistic portraiture.

Of special significance is that this new Roman interest in realism developed in tandem with Roman ancestral and funerary practice as recorded in the writings of Polybios and Pliny. Polybios, a Greek historian brought to Rome as a prisoner after the Battle of Pydna in 168 B.C., became the friend and tutor of Scipio Aemilianus. His history of Rome from the mid-third to the mid-second century records the funerary customs of the Roman nobility that include a funerary cortege where wax masks of deceased ancestors kept in family shrines are publicly displayed.

[When a prominent Roman died he was taken, in the course of the funeral procession, to the *Rostra* in the Forum where a son or relative then gave a public eulogy recounting the virtues of the deceased.] After this, having buried him and performed the customary rites, they place a portrait of the deceased in the most prominent part of the house, enclosing it in a small wooden aedicular shrine. The portrait is a mask which is wrought with the utmost attention being paid to preserving a likeness in regard to both its shape and its contour. Displaying these portraits at public sacrifices, they honor them in a spirit of emulation, and when a prominent member of the family dies, they carry them in the funeral procession, putting them on those who seem most like [the deceased] in size and build. . . . [The men so dressed also wore the togas and carried the insignias of the magistracies which had been held by the person whom they were impersonating.] One could not easily find a sight finer than this for a young man who was in love with fame

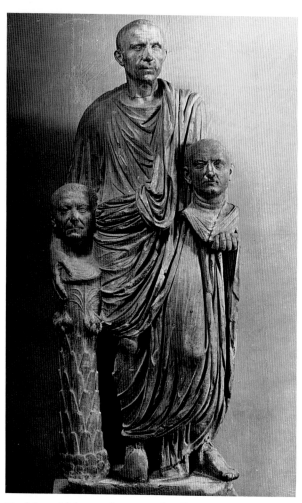

13 Man with busts of ancestors, late first century B.C. Rome, Museo del Palazzo dei Conservatori. Photo: DAIR 37.378

and goodness. For is there anyone who would not be edified by seeing these portraits of men who were renowned for their excellence and by having them all present as if they were living and breathing? Is there any sight which would be more ennobling than this? (Polyb. 6.53, trans. Pollitt, *Rome: Sources and Documents,* p. 53)

In his *Natural History,* Pliny describes the wax ancestral masks carried in funerary processions as well as their display in the alae of Roman houses. He also indicates that these were kept in household shrines and were linked by the genealogical lines of a family tree. Furthermore, he indicates that the rooms of the house set aside for the family archives contained scrolls and other records of the illustrious deeds of family members (Pliny, *HN* 35.6–7, trans. Pollitt, *Rome: Sources and Documents,* p. 54).

A marble portrait of a togate man (*togatus*) with two busts of male ancestors (fig. 13) may illustrate the Roman funerary ritual recorded in the writings of Polybios and Pliny. The draping and carving of the man's toga suggests an Augustan date for the statue; the head of the togatus

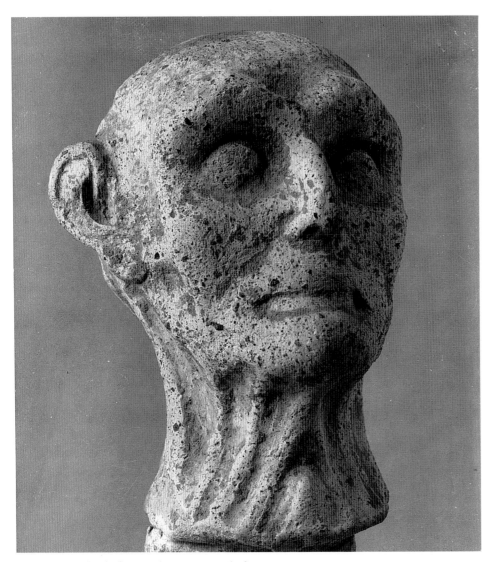

14 Terracotta head of a man, from Rome, early first century
B.C. Paris, Musée du Louvre. Photo: Cliché des Musées
Nationaux

is ancient but does not belong to the original piece. The two busts are worked in the round and are thus probably not meant to be interpreted as wax masks. Since it is hard to imagine that the man could support the weight of two bronze or marble busts, the artist may have intended the portraits to be understood as terracotta busts or as wax images (*imagines*) that are not actual masks. In any case, the heads appear to be Augustan interpretations of veristic republican heads with the two men, possibly a generation apart, portrayed in a frankly realistic style with forehead lines, crow's-feet, cheek and neck creases, balding heads, and so on.

It is not surprising that none of the wax masks has survived, but an under-life-size terracotta head from Rome of the early first century B.C. possesses some of their most outstanding features (fig. 14). The unopened eyes are

ghoulishly sunken deep in their sockets, the cheekbones are high and accentuated, but the cheeks themselves have fallen in, the mouth appears like a toothless slit, the neck is sunken and deeply lined; in fact, it is this head, more than any other surviving examples, that seems to exhibit actual characteristics of the human face after death.

That is not to say that all terracotta busts of contemporary date were based on death mask portraits. The terracotta portrait of a man of about 50 B.C. from near Cumae (fig. 15) is noteworthy for its attention to realistic detail seen in the bags under the eyes, crow's-feet, furrowed forehead, flabby neck, thinning hair, and even a deep scar beneath the right eye. The face is, however, not a dry record of the man's features but rather a lifelike rendition of an individual who possesses some of the artificialities of Hellenistic portraiture, such as the sharp

turn of the neck and the partially upturned eyes. The eyes also have an intensity of gaze and a thoughtfulness that is lacking in the sightless orbs of the Rome bust. Although some scholars have suggested that the immediacy of the head from Cumae is because it was made from a life mask, it is too animated a portrait to have been based on such a cast. It was more likely a terracotta bozzetto for a more finished work of bronze or marble.

One of the masterpieces of republican portraiture in marble is the head of an unknown man, probably a patrician, from near Otricoli (fig. 16). Although the authenticity of the head is sometimes questioned, it appears to be ancient and dates to about 50 B.C. Although the artist has lavished as much attention on facial detail as did the creator of the terracotta from Cumae, the Otricoli portrait is devoid of the Hellenistic torsion and lively animation of the head from Cumae. The Otricoli head is frontally positioned, and the man's expression is somber. Every wrinkle and every fold of flesh of the unknown man is carefully delineated by an artist who created an almost topographic map of the face. The forehead is deeply furrowed, and there are creases over the nose. Heavy folds of flesh overlap the upper eyelids, and there are sagging bags under the eyes. The man's cheeks are deeply marred by receding folds and deep creases etch his cheeks. His neck is lined with a series of concentric wrinkles. The man is balding although the hair on the back of his head is carved in thin strands toward his ears and down his neck. Nonetheless, the Otricoli head is a powerful portrait of a republican noble with a large hooked nose, strong jutting chin, and high cheekbones and is too lifelike to be based on ancestral death masks. Rather, it illustrates the Roman republican interest in recording reality by delineating exactly a person's individual facial features, which was a parallel development to the interest in making death or life masks. In the Otricoli portrait, however, the artist's preoccupation with detail seems to have become an end in itself. Although the artist's basic goal was undoubtedly to create a veristic image of a specific person, the furrows and wrinkles, which stand for the experience and wisdom of the sitter, become the subject of the work of art. Only mature men and women were considered to be worthy subjects of portraiture in the late republic; there are no surviving republican portraits of youths or children.

Female Portraiture in the Republic

Female portraits of the late republic are more idealized than those of their male counterparts, although both share stylistic and technical features. In fact, the republican artist lavished more attention on womens' hairstyles than on their facial features, and these coiffures initially

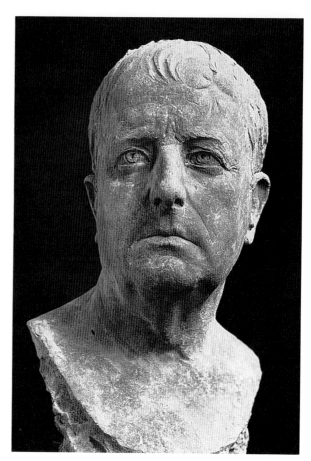

15 Portrait of a man, from near Cumae, ca. 50 B.C. Boston, Museum of Fine Arts, gift by contribution. Photo: Courtesy, Museum of Fine Arts

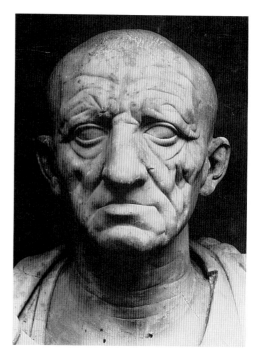

16 Portrait of a man, from near Otricoli, ca. 50 B.C. Rome, Museo Torlonia. Photo: DAIR 1933.58

display their indebtedness to Mid-Italic, Etruscan, and Hellenistic Greek prototypes. Female private portraits of 75–50 B.C., for example, exhibit a wide variety of coiffures. The simplest is of Hellenistic Greek origin and has the hair parted in the center, brushed back in waves, and fastened at the back of the head. More elaborate variants, also with Hellenistic Greek sources, include coiffures with one or two corkscrew curls in front of the ears or with hair layered over the forehead. In another late republican hairstyle, the hair is tied in a knot on the top of the head.

It is only in the last decades of the first century B.C. that a totally new hairstyle without Greek or Etruscan predecessors captured the imagination of Roman women of all classes. The so-called *nodus* coiffure began to be worn by women of the upper classes in about 40 B.C. In this hairstyle the hair at the top of the head is parted on both sides and combed into a roll or nodus over the forehead. The hair at the sides of the head is combed over and behind the ears and fastened in the back. The coiffure appears on coins minted in Rome by Lucius Mussidius Longus in 42 B.C. and by Gaius Numonius Vaala in 41 B.C. In each case, a woman with individualistic features is represented, perhaps Fulvia, the third wife of Mark Antony (d. 40 B.C.), in the guise of Victory. The first Roman woman to appear in her own right on a coin is Octavia, the fourth wife of Mark Antony, who was born in 66 B.C. and died in 11 B.C. She is depicted with a nodus coiffure on an aureus of 39 B.C. One of the most characteristic features of Octavia's coiffure is the thick strand of hair that originates in the nodus and continues behind it over the top of the head. A variant of this nodus coiffure may be seen on an aureus of 38 B.C., struck at an eastern mint by Mark Antony and bearing Octavia's portrait. In this case, the nodus is emphasized, and the strand of hair over the head is thinner. The variant appears on other issues of 36–35 B.C.

A portrait of Octavia from Velletri (fig. 17) and datable to the early 30s B.C. by comparison with the numismatic portraits, combines features of the aurei coiffures. The large central strand of hair is connected to the nodus as in the first variant, but the bun in back is high and more comparable to the later version. The Velletri head has the wavy hair over the ears and the curls falling on the neck behind the ears that characterize both variants. By about 25 B.C., the strand of hair over the top of the head seems to have gone out of fashion.

The nodus coiffure is worn not only by Octavia but also by other women of the Augustan court in portraits produced in the 30s B.C. These portraits are also examples of a new classicizing trend in Augustan portraiture in which the individual's facial features are smoothed over and idealized. What is, however, striking is that private

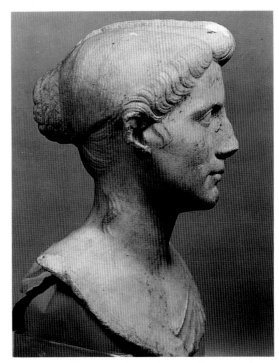

17 Portrait of Octavia, from Velletri, early 30s B.C. Rome, Museo Nazionale delle Terme. Photo: DAIR 40.1182

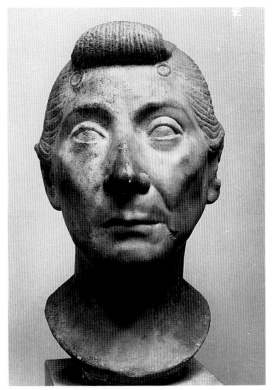

18 Portrait of an old woman, from Palombara Sabina, 30s B.C. Rome, Museo Nazionale delle Terme. Photo: DAIR 62.1835

portraits of elderly men and women manufactured in the
30s continued to be fashioned in what can only be de-
scribed as a veristic style, although – at least for women –
the more idealizing style of the earlier period did not die
out entirely.

An example is a marble portrait of an old woman
(fig. 18), from Palombara Sabina, which is worked for in-
sertion into a full-length statue. The woman is depicted
with a thin oval face with pronounced cheekbones and
sunken cheeks. She has thinly arched brows and almond-
shaped eyes with prominent upper lids. She has pouches
under her eyes and creases at either side of her tightly
closed but somewhat rounded lips. Her hair is rolled in
a nodus over her forehead with one tendril escaping on
either temple. The nodus is connected by a narrow strand
of hair to a bun into which is gathered the remainder of
the loose hair and is wound with a narrow braid.

Portraits of Freed Slaves

Enfranchised slaves (*libertini*) also began to commis-
sion portraits in the late republic that were based closely
on aristocratic models and at the same time were char-
acteristic of their own class. The best examples of such
portraits can be seen in the late republican and Augus-
tan funerary reliefs of libertini that comprise full- or
bust-length portrayals of the deceased and one or more
figures accompanied by identifying attributes. Although
these libertini do not have the rich historical biogra-
phies of famous Romans, their epitaphs identify them
and establish their relations (for example, *pater* = father,
uxor = wife, *filius* = son); their status as freedmen or
freeborn; their profession (for example, *medicus* = doc-
tor); the circumstances that led to the erection of the
monument (*ex testamento* = from the will of) and some-
times which of the persons portrayed are dead (Θ) or still
alive (*vivit*).

In antiquity, these reliefs were not freestanding
monuments but decorated the facades (or in some cases
the interiors) of tombs that lined the roads leading out
of Rome. One example is a relief of about 75–50 B.C.,
with four bust-length portraits of members on9th Fon-
teius family (fig. 19). It is set into the facade of a par-
tially preserved tomb (fig. 20), found on the Via Labicana
and now reerected in the cloister of the Museo Nazio-
nale delle Terme. The tomb is of tufa, but a more ex-
pensive stone, travertine, is used for the funerary relief
and the inscription plaque. The epitaphs that accompany
such Roman funerary portrait reliefs state explicitly that
almost every person depicted is a former slave. Excep-
tions are few in number, and those freeborn persons who
are portrayed are always either the offspring of freedmen
or the patrons who granted freedom to the freedmen

who commissioned the relief. Thus, those who commis-
sioned the funerary portraits all come from the same stra-
tum of Roman society, yet they show their indebtedness
to the contemporary portraiture of famous aristocratic
personages.

An example of this is the funerary relief of a man
and his wife from the Via Statilia in Rome (fig. 21).
The relief, which dates to 75–50 B.C. is an example of
the more ambitious of the two surviving types of freed-
men funerary reliefs – that with full, rather than the less
expensive, bust-length portraits. The full-length figures
of the pair are arranged frontally side-by-side without
touching. The man is clothed in a tunic and short, narrow
toga with a prominent central fold characteristic of early
Roman togate statuary; the woman wears a tunic and
palla. He is posed in the statuary type referred to as toga-
tus, with an arm sling where the right arm is bent and
confined in a sling draped over the right and left shoul-
ders; she has one arm across her waist, the other bent
with her right hand beneath her chin in the so-called *pudi-
citia* posture that emphasizes the virtues of modesty and
fidelity. The man's portrait is in the veristic style of the re-
public. He is depicted with a broad face, closely cropped
hair that follows the shape of his skull and recedes at the
temples, broad nose, large ears, furrowed forehead, bags
under the deeply shadowed eyes, and lined cheeks and
neck. The female portrait is a more generalized repre-
sentation of the face with a conscious idealization of the
features. She shares her husband's broad face, brows that
cast shadows over the eyes below and broad nose, but her
skin is smooth, unlined, and free of blemishes. Neither
portrait displays features of the spirited portraiture of the
Hellenistic style. In fact, nearly every relief portrait of
a freedman or freedwoman of republican date is rigidly
frontal, and there is little contact whatsoever among the
individuals portrayed.

While the majority of Roman freedmen and freed-
women are depicted in toga and palla – their respective
badges of Roman citizenship – a few are portrayed in
heroic nudity. The latter are based on a statuary type
documented as early as the third quarter of the fifth cen-
tury B.C. in Greece and favored by military men in the late
republic and Augustan times, as, for example, the gen-
eral from Tivoli (see fig. 12). Although slaves could not
serve in the Roman army, a privilege reserved for mem-
bers of the aristocracy, the freeborn children of freedmen
were allowed to enlist. Those who did were proud of
their elevated status and displayed it with dignity on their
sepulchral markers. Such is the case with the soldier of
freedman descent who is depicted in a funerary relief on
the Via Appia that dates to the late first century B.C. (fig.
22). The man is nude, save for a chlamys. He holds a
sheathed sword in his left hand and a breastplate rests

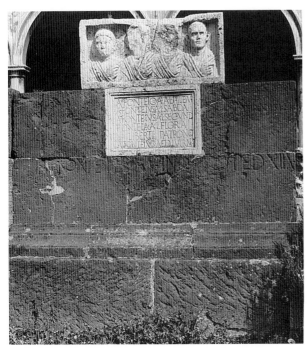

19 Funerary relief of the Fonteius family, from the Via Labicana, 75–50 B.C. Rome, Museo Nazionale delle Terme. Photo: DAIR 73.747

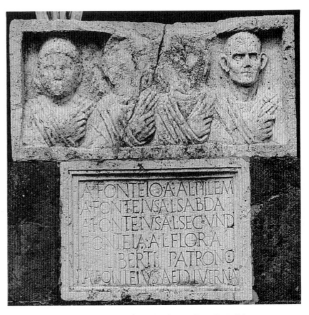

20 Tomb of the Fonteius family, from the Via Labicana, 75–50 B.C. Rome, Museo Nazionale delle Terme. Photo: D. E. E. Kleiner and F. S. Kleiner, 75.15.34A

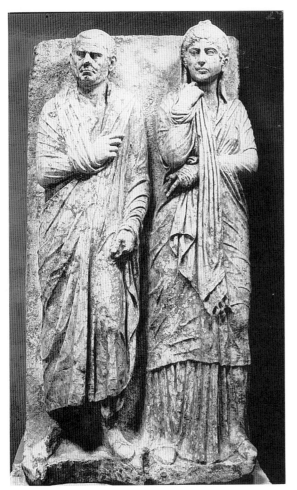

21 Funerary relief of a man and his wife, from the Via Statilia, 75–50 B.C. Rome, Museo del Palazzo dei Conservatori. Photo: DAIR 29.172

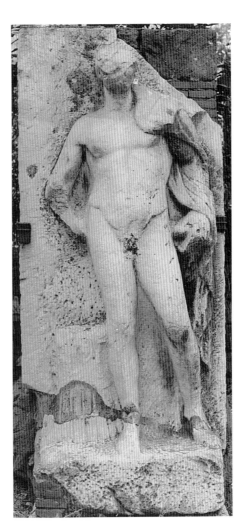

22 Funerary relief of a soldier, from the Via Appia, late first century B.C. Rome. Photo: D. E. E. Kleiner and F. S. Kleiner, 72.I.5

beside his right leg. Although depictions of sons of freedmen in heroic nudity are relatively rare, those that have survived document the fact that Greek heroic imagery was not the monopoly of the elite.

Numismatic Portraits and the Beginnings of Dynastic Portraiture

Both a veristic style and a Hellenistic style may be found in the numismatic portraits of the pre-Augustan period. These portraits constitute our only series of clearly dated monuments during the late republic, but it must be borne in mind that the portraits of moneyers' ancestors that appear on the coins may be based on earlier sculptured likenesses. Numismatic portraits of the veristic style include those of Gaius Coelius Caldus, about 62 B.C.; Aulus Postumius Albinus, type I, 49–48 B.C.; Gaius Antius Restio, about 46 B.C.; and Julius Caesar, group A, 44 B.C. Hellenistic-style numismatic portraits include those of Lucius Cornelius Sulla and Quintus Pompeius Rufus, about 54 B.C.; and Pompey the Great, type I, about 46–45 B.C. The coin reverses depict scenes from the honorand's personal family history or from mythology or the early history of Rome, as, for example, the scene from the Rape of the Sabine Women on the reverse of a coin of Titus Tatius struck by Lucius Titurius Sabinus in Rome in 88 B.C.

The Portraiture of Pompey the Great

Gnaeus Pompeius, called Magnus after 81 B.C., or Pompey the Great, was born in 106 B.C. He had a distinguished military career in Sicily, Africa, and especially in the East where he defeated Mithridates of Pontus. A variety of triumphs were voted in honor of his victories, and he became a senator. He was instrumental in the foundation of new Roman colonies and paid special attention to the organization of the eastern provinces.

He was married first to Aemilia, then to Mucia, to Caesar's daughter, Julia, and finally to Cornelia – the last two because the marriages cemented political alliances, first with Caesar and then with Scipio. By refusing a second alliance with Caesar at the death of Julia, Pompey set the stage for a military confrontation between the two that culminated in 48 B.C. in the Battle of Pharsalus on the plains of Thessaly in Greece. Pompey was defeated and subsequently fled to Egypt where, upon his arrival, he was stabbed to death. Nonetheless, Pompey was admired for his military expertise, his mastery of Roman politics, and for his skill in interpersonal relations, epitomized by his marriages to Julia and Cornelia, who, although betrothed to him for political ends, were deeply devoted to him.

Military and senatorial responsibilities took most of Pompey's time, but he did commission a great Roman theater, dedicated in 55 B.C., that bore his name. The Theater of Pompey was located in the Campus Martius and had at its apex a shrine to Venus Victrix, the goddess who helped guarantee Pompey's military successes. The theater was also ornamented with statues of the Roman provinces, some of which Pompey had been instrumental in bringing under Roman domination. The name of Coponius, the artist responsible for these statues, is recorded.

Numismatic portraits of Pompey inscribed with his name were struck posthumously by his sons. From their similarity to these numismatic images, two surviving marble portraits, now in Copenhagen and Venice, have been identified as Pompey; a third in New Haven has recently been shown to be a modern forgery, although some scholars continue to defend its authenticity.

The Copenhagen head of Pompey the Great (fig. 23) was discovered in the Licinian Tomb on the Via Salaria in 1885, along with a series of other portraits, sarcophagi, and decorated funerary altars. The tomb, of Claudian date, served as the last resting place of Pompey's descendants in Rome who were justifiably proud of their celebrated ancestor and displayed his visage, among those of other family members, in an underground portrait gallery. Although the portrait appears to have been based on a lifetime public image of Pompey – possibly created for his theater around 50 B.C. when he was fifty years old – the surviving head is a marble copy of Claudian date. The face is treated in a veristic style; Pompey is depicted with a round fleshy face, double chin, furrowed forehead, small deeply set eyes with fleshy protuberances above, a bulbous nose, and thin lips. He is, however, not represented with the characteristic republican receding hairline or balding pate. Instead, Pompey wears a full head of tousled locks, brushed in such a way that they stood up over his forehead (*anastole*), and long sideburns. In other words, Pompey is portrayed with a hairstyle that approximates that of Alexander the Great, the great king and general of the Greek East. Pompey's vision of himself as another Alexander is attested in Plutarch's *Life of Pompey*. Plutarch reports that Pompey wore his hair in an upswept style and also affected the melting gaze of Alexander, the latter unquestionably not incorporated into this portrait. In its verism, the portrait of Pompey is true to its time, but it is the first surviving Roman portrait in the round that deliberately associates its subject with an earlier historical personage. It is a striking example of the deliberate use of Roman portraiture for political propaganda, a trend that begins here but was to be perfected under Rome's first emperor, Augustus.

The heavily restored portrait in Venice (fig. 24) is,

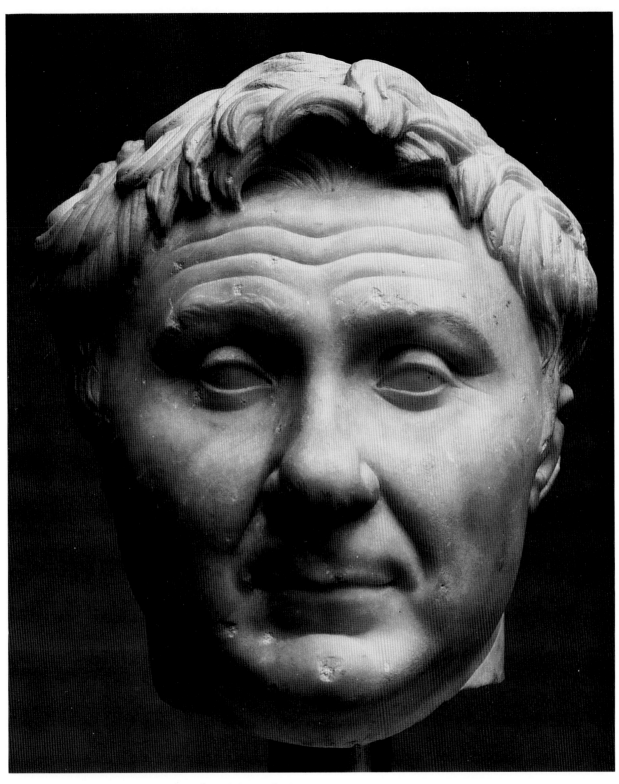

23 Portrait of Pompey the Great, from the Licinian tomb
on the Via Salaria, Claudian copy of a portrait of 50 B.C.
Copenhagen, Ny Carlsberg Glyptotek. Photo: Courtesy of the
Ny Carlsberg Glyptotek, Copenhagen

however, of a different type. The round face is somewhat thinner. The facial features – small eyes, bulbous chin, thin lips – are clearly recognizable as Pompey's, but their individuality is somewhat smoothed over and idealized. Although the cap of hair is full and somewhat tousled and Pompey has long sideburns, the coiffure does not have a pronounced anastole. This is probably owing to the extensive restoration of the head; the original coiffure was probably a closer approximation to that of Alexander. The assimilation of Pompey to Alexander was further underscored in this portrait by the abrupt turn of the head (missing in the Copenhagen portrait) – a Hellenistic device – and the slight idealization of the features. In this portrait, it is even possible to see a reminiscence of Alexander's melting gaze. The Venice Pompey is probably a Claudian copy of a lifetime portrait made between 70 and 60 B.C of a more youthful Pompey.

The Portraiture of Julius Caesar

Pompey's rival, Gaius Julius Caesar, son of Gaius Caesar and Aurelia, was born in 100 B.C. His early political career reached a high point in 63 B.C. when he was elected *pontifex maximus,* and in 59 he made an important alliance with Pompey and Crassus, forming what is referred to in modern times as the First Triumvirate. It was further strengthened by the marriage of Pompey to Caesar's daughter Julia but began to unravel after Julia's

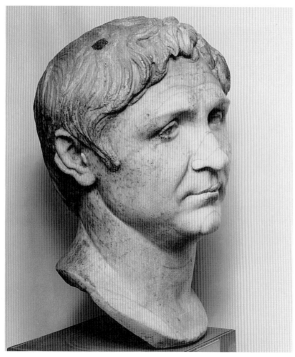

24 Portrait of Pompey the Great, Claudian copy of a portrait of 70–60 B.C. Venice, Museo Archeologico. Photo: DAIR 82.686

death in 54 and Crassus's death in battle in Parthia in 53. During the years 58–49 B.C., Caesar was involved in the conquest of Gaul, but in 48 he clashed with Pompey at the Battle of Pharsalus on the plains of Greece. The result of this military contest was complete victory for Caesar and the flight of Pompey to Egypt where he was murdered. Caesar, who had married Cornelia, daughter of Cinna, in 84 B.C., later Ploteia, and finally his third wife, Calpurnia, in 59, now became embroiled in a war with Ptolemy XIII that culminated in the placement of Caesar's mistress, Cleopatra, on the throne of Egypt. During 48 and 47, Caesar embarked on military campaigns in Asia Minor and Africa against the remnants of Pompey's supporters. He subsequently celebrated four triumphs – Gallic, Alexandrian, Pontic, and African – and in 45 was again the victor in a war, this time the final battle against Pompey's sons at Munda in Spain. Before the Battle of Pharsalus, Caesar was appointed dictator, a position that was renewed in October of 48 for ten yeears and again in 44 for life.

Caesar was not only a gifted military commander but a writer who recorded his wartime experiences in *De Bello Gallico* and *De Bello Civili*; a founder of numerous colonies in which he settled many of his loyal army veterans; and the builder of great public works both in Rome and in the provinces. In his *Life of Caesar,* Suetonius (*Caes.* 44) reports that the dictator commissioned a temple of Mars and a theater in Rome, and planned several major engineering enterprises in the provinces. The latter included the draining of the Pomptine Marshes and of Lake Fucinus, a highway running from the Adriatic across the Apennines to the Tiber, and a canal cutting through the Isthmus of Corinth. Some of these projects were canceled after his death. Caesar's greatest surviving public work is undoubtedly his forum and the Temple of Venus Genetrix that it encloses. The complex comprised a religious and civic center that provided the Roman populus with both an attractive and spacious place in which to conduct daily affairs and also served to glorify Venus, divine patroness of the Julian *gens,* and, indirectly, Caesar himself.

Despite his many accomplishments as a general, statesman, colonizer, and social reformer, Julius Caesar was resented for his supreme consolidation of power and was assassinated by some senators, including Marcus Brutus and Gaius Cassius on the Ides of March 44 B.C. In his will, Caesar adopted Gaius Octavius as his son and successor and, after his death, was divinized by the senate.

Shortly before his assassination, Caesar had coins struck with his own lifetime portrait, forever altering the development of Roman numismatic portraiture. The lifetime image of a ruling Roman was now considered

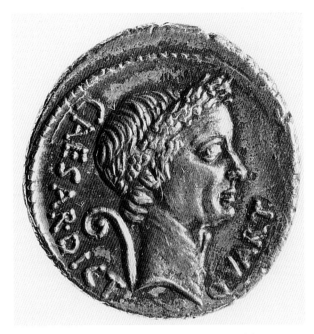

25 Denarius with portrait of Julius Caesar, struck by M. Mettius, 44 B.C. London, British Museum. Photo: Courtesy of the Trustees of the British Museum

to be an appropriate subject for coinage and, in view of the wide distribution of coins throughout the empire, one that could be manipulated for political ends. The first example appears to be the denarius, struck in the Rome mint by Marcus Mettius and consequently referred to as the Mettius denarius (fig. 25). It was minted in 44 B.C. and commemorates the presentation of the diadem to Caesar during the annual celebration in honor of Lupercus, the god of fertility (*Lupercalia*) on the Capitoline hill. It is inscribed with Caesar's name and the title of *dictator* and depicts Caesar in a veristic portrait with furrowed forehead, prominent nose and chin, large eyes, relatively straight brows, narrow lips, creased cheeks, a very long, deeply lined neck, and a prominent Adam's apple. His hair is combed from the crown of his head in front of his ears and on the nape of his neck. He wears a laurel wreath that covers the peak of his forehead. It is apparent that his hair is receding behind it, and one of the purposes of the wreath is thus clear. In his physical description of Caesar, Suetonius reports that Caesar was "tall, fair and well-built, with a rather broad face and keen, dark-brown eyes." Furthermore, "his baldness was a disfigurement which his enemies harped on, much to his exasperation; but he used to comb the thin strands of hair forward from his poll, and of all the honors voted him by the Senate and the People, none pleased him so much as the privilege of wearing a laurel wreath on all occasions – he constantly took advantage of it" (Suet., *Caes.* 45). The portrait of Caesar is thus true enough to life, not only in reflecting the dictator's distinctive facial

features but also in recording both his baldness and his attempt to disguise it.

Based on their similarity to the epoch-making numismatic likeness of 44, numerous portraits of Caesar have been identified with certainty. Most of these portraits appear to be later replicas of a variety of Caesarian types, created either during the dictator's lifetime or as posthumous interpretations. Only one seems to be a Caesarian original; another may have been erected in the months following the assassination.

The lifetime portrait comes from Tusculum (fig. 26) and is known also in several later replicas and variations. It has been associated with the Mettius denarius and appears to be a contemporary portrait of Caesar. The dictator is represented with high forehead with receding hairline, broad face, straight brows, a prominent nose and chin, creases near the mouth and on the long neck, and a protruding Adam's apple.

A head in Berlin (fig. 27) is a striking portrait of Caesar made in the Hellenistic East. It is fashioned out of dark green diabase slate that comes from Egypt, and scholars have consequently suggested that it may be the portrait commissioned by Cleopatra for the Caesarium in Alexandria put up shortly after Caesar's death and deification. The head belongs to a draped bust, and Caesar's head is turned sharply to his left. The dictator's facial

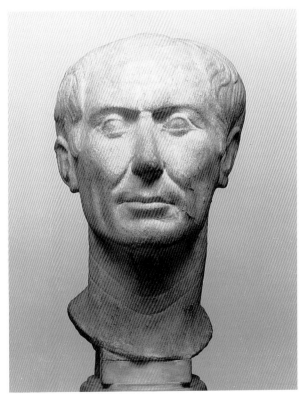

26 Portrait of Julius Caesar, from Tusculum, ca. 44 B.C. Turin, Castello di Aglie. Photo: DAIR 74.1565

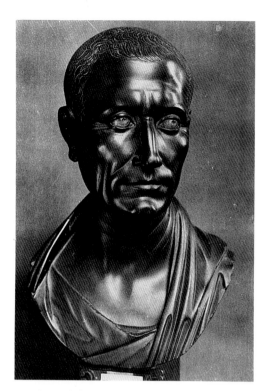

27 Green diabase portrait of Julius Caesar, from Egypt, based on a portrait of ca.44 B.C. Berlin, Staatliche Museen, Antikensammlung. Photo: Bildarchiv Foto Marburg/Art Resource, New York, 1.006.729

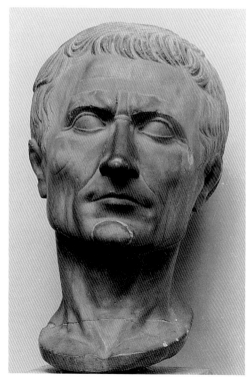

28 Portrait of Julius Caesar, Augustan. Pisa, Campo Santo. Photo: DAIR 72.263

features are those of the Mettius denarius and the Tusculum head, and the furrowed forehead and creased cheeks and neck are emphasized by the artist. The pupils and irises of the eyes, added in another stone, are incised.

One posthumous type is known in a number of replicas, the best-known examples being the heads of Caesar in Pisa (fig. 28) and in the Museo Chiaramonti in the Vatican. The type is consequently referred to as the Pisa-Chiaramonti type, and an examination of its two best extant examples indicates that the type must have been created in the time of Augustus. Although depicted with the same square-shaped face, furrowed forehead, distinctive nose and chin, creased cheeks and lined neck, Caesar wears an Augustan coiffure that consists of a fuller cap of hair arranged in a pattern of repeating comma-shaped locks across the forehead. Both portraits are splendid examples of posthumous renditions of recognizable subjects that have been updated by the addition of more modern hairstyles, bust types, and so forth, characteristic of their own age and not of the subject's lifetime. In this case, the artist's vision of the Augustan ideal has also caused him to rejuvenate his subject by softening facial wrinkles and giving him a youthful vitality.

The Portraiture of Mark Antony

Mark Antony, son of Marcus Creticus, was born in about 83 B.C. He embarked on a military career, serving first in Palestine and Egypt and then under Caesar in Gaul and Greece where he took part in the Battle of Pharsalus. Both he and Caesar's grandnephew, Octavian, vied for power and both opted, for strategic reasons, to enter into an alliance with Lepidus in 43 B.C., known today as the Second Triumvirate. Antony and Octavian joined forces to avenge Caesar's assassination and were successful in 42 B.C. against Brutus and Cassius at the Battle of Philippi. Afterward, it fell to Antony to reorganize the eastern part of the empire, where he met and became involved with Cleopatra. He returned to Italy in 40 and strengthened his ties to Octavian by marrying his sister, Octavia. There had been previous marriages to Fadia, Antonia, and Fulvia. Nonetheless, the lures of Cleopatra and her wealthy Egyptian kingdom continued to beckon, and Antony returned to his mistress's side in 37. The pair were openly worshipped in the East as Osiris and Isis. Antony continued to annex eastern lands, like Armenia, and in 34 celebrated a triumph in Alexandria for his efforts, at which time Cleopatra and her children – including Caesarion, the alleged son of Cleopatra and Caesar – were declared rulers of a greater Egypt. Subsequently, Antony requested a divorce from Octavia, which angered Octavian. Octavian published what he claimed was Antony's will, making clear Antony's inten-

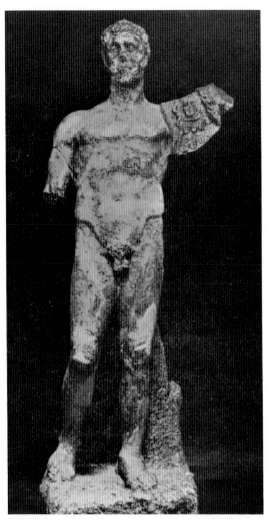

29 Statue of Mark Antony, ca.40–31 B.C. Cairo, Museum.
Photo: *Notiziario Archeologico* 3 (1922), fig. 9

tion to leave his estate to his children with Cleopatra, in violation of Roman law, and to be buried in Alexandria. Such revelations tarnished Antony's reputation in Rome and enabled Octavian both to cancel Antony's remaining powers and to wage war against Cleopatra. Octavian soundly defeated Antony in a naval battle off Actium in western Greece in 31 B.C. Antony and Cleopatra subsequently committed suicide.

Antony's skill as a military commander, as well as his powerful physique, are accentuated in portraits made of him during his lifetime. The most outstanding example is a nude full-length limestone statue of the *triumvir* now in Cairo (fig. 29) that dates to about 40–31 B.C.. The identification of this portrait as Antony is now almost universally accepted, and there is indeed a striking correspondence between the face of this statue and Antony's portrait on coins. The numismatic likenesses depict Antony with a squarish visage, thick neck, a boxer's misshapen but large nose, wide-open round eyes, prominent chin, and a full cap of hair arranged in comma-

shaped locks across his forehead and in front of his ears and growing relatively long on the back of his neck. The statue, undoubtedly manufactured in the eastern part of the empire, depicts Antony in a figural type favored earlier by Alexander the Great, as, for example, in a bronze statuette of the Hellenistic ruler now in Paris thought to be a small-scale version of the Alexander with a lance by Lysippos. Antony's weight rests on his left leg; his right leg is relaxed with his right heel raised. There is a subtle tilt to both waist and shoulders, and his left arm is extended upward and covered with an aegis decorated with a gorgoneion and a serpent. His left hand probably originally rested on a scepter.

From the foregoing discussion, it is clear that Roman republican portraiture commissioned in the West and East, by triumvir or freedman, of a subject living or deceased, was – above all – veristic. The major goal of commemorative public statuary or private funerary portraiture was to preserve for posterity the individuality of the subject's facial features. The detailed, almost cartographic rendition of the human face, however, sometimes became an end in itself, and the endless array of wrinkled faces was sometimes less individualistic than indistinguishable. It is, however, also apparent that the Hellenistic tradition was still highly influential and that heroic Hellenistic body types and Greek affectations such as the anastole of Alexander the Great and the Hellenistic ruler's upturned gaze, along with the Hellenistic torsion of the body and Greek heroic nudity, were employed to associate these matter-of-fact republicans with the glorious Hellenistic past or to identify them with a specific historical personage such as Alexander. Pompey, as we have seen, wears the anastole of Alexander, and Mark Antony and Caesar are represented with Alexander's attributes of aegis and scepter.

Triumphal Painting and the Beginnings of Roman Relief Sculpture

We have already examined the Aemilius Paullus Monument, the victory monument of a Hellenistic king in Greece expropriated by a Roman general and encircled with a relief frieze depicting a Roman battle in a Hellenistic style (see fig. 5). It is apparent that the earliest surviving Roman reliefs were based in large part on Hellenistic models also in relief. But the Roman taste for contemporary subject matter surfaced in what are known as triumphal paintings at least as early as the first half of the third century B.C. when such documentary painted panels are first attested in surviving literary accounts. These triumphal paintings were prepared by special art-

ists who accompanied the Roman troops on their military campaigns and recorded not only the battles but more often the subjugated cities. The paintings were carried aloft in the returning general's triumph. Further explication was often provided by supplementary oral or written accounts of the events described in the paintings. Although the paintings themselves do not survive, some reflections of them do, and these demonstrate that the scenes both included landscape elements and appear often to have been rendered in bird's-eye or aerial perspective. It is also likely that the artists who fashioned them were little concerned with consistency of scale and that the most important figures were regularly represented as the largest in size. These paintings of battle sites must have had a maplike appearance and were another example of the republican insistence on precisely recording detailed information for a wide audience.

Triumphal paintings seem to have been a Roman invention. Their reliance on a bird's-eye perspective, hierarchy of scale, and symbolic rather than realistic depictions of people and objects are not documented in Hellenistic Greek art, except in the realm of Hellenistic science, where topographic chorographies were used as illustrations for books on such subjects as geography. Such chorographies described visually the characteristic appearance of different sites and are associated with a painter named Demetrius who appears to have come to Rome from Alexandria in the early second century B.C. The topographies may well have originated in Alexandria in the Hellenistic period. Their devices were adopted for Roman triumphal painting, the purpose of which was, like the chorographies, essentially informational. Nonetheless, at the same time such topographic description began to appear in both decorative and narrative contexts.

An example of the former is the so-called Nile Mosaic from Palestrina, now exhibited in the museum built over the remains of the upper sanctuary that dates to approximately 80 B.C. The mosaic was designed during the age of Sulla and perhaps commissioned by the dictator himself to decorate the pavement of an apsidal hall next to the Temple of Fortuna Primigenia at Palestrina. The mosaic is made of very small colored tesserae, is heavily restored, and exemplifies topographical map making in Rome under the influence of traveling Alexandrian artists like Demetrius. The Alexandrian origin of such a work is underscored by the Egyptian subject matter of the mosaic. The subject is the Nile River in flood, the blue striations of the river serving as the backdrop for exotic Egyptian locales and a wide variety of Nilotic animals. Hippopotamuses and crocodiles emerge from the water and lounge along the riverbank. Sacred ceremonies to Egyptian divinities like Serapis and Isis take place in

sacred settings with architecture depicted in combined head-on and bird's-eye views. These man-made structures and the natural landscape dominate the diminutive human figures.

The earliest example of a narrative painting from Rome that makes use of the technical devices of Roman triumphal painting is a fresco fragment from a tomb on the Esquiline hill now in the Museo del Palazzo dei Conservatori. The fragment, which represents a historical scene and is preserved in four tiers, must have been part of a large figural cycle that encircled the interior of the tomb. The protagonists interact against a blank white background, but the scenes are not devoid of topographical references; there is a crenellated fortification with two civilians peering out in the second band. The most important figures are depicted in larger scale than the others; in fact, they occupy the full height of the band, and their names, Marcus Fannius and Quintus Fabius, are also designated. The legs of one are still visible in the uppermost band, and both are portrayed next to the battlement in the second tier. The one on the left probably wears a cuirass, a mantle over his shoulder, an elaborate helmet, greaves, and carries a large shield. He offers his right hand to his adversary who is clothed in a short toga and carries a spear. The same two principal figures are repeated and named in the third register where the left figure once again offers his hand to his companion. The figure on the right wears the same costume as above and again carries a lance. The figure on the left is differently garbed. The cuirass and helmet are gone, although he is still clad in a short waist-wrapped tunic, mantle, and greaves. To the left of the central pair is a combatant and to the right a group of figures of different sizes with two in profile and one frontal, all in reduced scale. A battle rages on different levels of terrain in the lowest band. The soldiers wear both Roman and Samnite costumes, and scholars have therefore identified the scene as a historical episode from the Second Samnite war in the 320s B.C. in which Rome's cavalry was commanded by one Quintus Fabius Maximus Rullianus. The forms of the letters and the style of the figures, however, suggest a date in the first half of the third century B.C. for the frescoes; the family tomb may well have been commissioned by the commander's son in honor of his illustrious father.

We have thus seen that the Monument of Aemilius Paullus (see fig. 5) is an example of the hybrid character of late republican relief sculpture and, although manufactured on Greek soil, has city of Rome counterparts that demonstrate their indebtedness to both Hellenistic Greek art and Roman triumphal painting.

The "Altar of Domitius Ahenobarbus" (Paris-Munich Reliefs)

The finest surviving work of monumental sculpture of the late republic is also the one that best illustrates the eclectic character of the period. The monument in question is the so-called Altar of Domitius Ahenobarbus that, in reality, appears to have been neither an altar nor a monument put up in honor of Domitius Ahenobarbus or any member of the Ahenobarbus family. The date of its manufacture is also highly controversial, and suggestions range from the second century B.C. to around 30 B.C. Until recently, scholarly consensus has favored a date of about 115 B.C. and an identification of the monument as a statuary base supporting a sculptured group of sea creatures by Scopas the Younger. Such a statuary base may have come from a temple that was located in Piazza S. Salvatore in Rome; it was moved in 1639 to Palazzo S. Croce. Nonetheless, there have also been attempts to associate the statuary base with the statesman and orator Mark Antony, the grandfather of his more famous namesake (see fig. 29). A recent and attractive theory suggests that the figural scenes on the base furnish a biographic narration of Antony's naval victories in the Greek East and of his position in Rome as censor in the early 90s B.C., providing an early first century B.C. date for the base. Instead of the Scopaic group, it would have been crowned with a family statuary group or have included personifications, vanquished enemies, or military trophies. Furthermore, it has been posited that the original monument was sited outdoors, so that all four sides were visible, and it was near temples of Neptune and Mars – the divinities honored along with Antony – in the relief scenes. Unfortunately, the monument's surviving reliefs are no longer in place. They were separated long ago and are now on display in Munich and Paris. For this reason and because the reliefs are no longer thought to commemorate the Ahenobarbus family, scholars are beginning to refer to them as the Paris-Munich Reliefs rather than as the "Altar of Domitius Ahenobarbus." The suggestion in the late nineteenth century that the two sets of reliefs decorated the same republican monument has, however, been universally accepted. The reliefs in Munich and Paris were done in disparate styles and portray different subjects, although the scenes are linked by Tuscan pilasters that straddle the four corners and divide the four relief scenes from one another.

The three reliefs in Munich (fig. 30), carved of East Greek marble (white with blue streaks), depict a sea *thiasos,* a marine procession of sea creatures and sea deities, celebrating the wedding of Neptune and Amphitrite. The main protagonists – Neptune in profile but with his muscular chest almost frontal and holding the reins, and Amphitrite, a nereid and Neptune's demure bride with veil and in the modest pudicitia pose – are portrayed in the middle of the relief on one of the two long sides of the base. They sit in a cart, the front wheel of which overlaps the frame, drawn by two tritons. The triton in the foreground blows on a conch shell to calm the waters and announce the arrival of Neptune and Amphitrite, and the one in the rear carries a cithara. The two tritons may be an allusion to Triton himself, the future son of Neptune and Amphitrite. Both tritons have tousled hair and muscular male chests, but their lower serpentine bodies have fish tails. Other creatures, which are half bull or horse and half fish and are led by reins held by small winged putti, carry languorous nereids who hold torches and boxes with gifts for the bride. This scene of the mythological marriage of a deity and a nereid is appropriately executed in a Hellenistic style characterized by a taste for swirling fish tails, foreshortened animals, and elegant well-proportioned figures in a wide variety of poses – including those that combine profile and rear views – and diaphanous drapery. The ultimate model for both the subject matter and the style can be found in such Hellenistic reliefs as those that encircle the podium of the Great Altar of Zeus at Pergamon of the mid-second century B.C.. Parallels can also be drawn with works of the minor arts in southern Italy. A scene of two nereids and a triton riding a sea creature is also similarly depicted on either short side of the "Altar of Domitius Ahenobarbus."

The Hellenistic style and marble of East Greek origin of the Munich reliefs have recently led scholars to suggest that the reliefs were not of Roman manufacture but of Hellenistic origin and were brought by the triumphator from the land of conquest. Although such expropriations of reliefs, and more often statuary, are paralleled elsewhere in the late republic, it seems unlikely here because of the striking correspondences of motif and composition in the two sets of reliefs that appear to have been carefully adjusted to complement one another.

The Paris relief (fig. 31) is carved of a different marble with no streaks and documents the Roman liking for combining disparate marbles in the same monument for the purpose of highlighting the most significant scene and setting it apart from subsidiary scenes. As already mentioned, it portrays a diverse subject from the Munich reliefs and is executed in a different style. The scene on what is the other long side of the base does not depict an episode from Greek mythology but a Roman historical event – the taking of the census accompanied by a lustration ceremony including a sacrifice to Mars. A large altar is represented in the center of the relief. On its left is the recipient of the sacrifice – the god Mars, larger than any other figure in the scene, wearing his customary

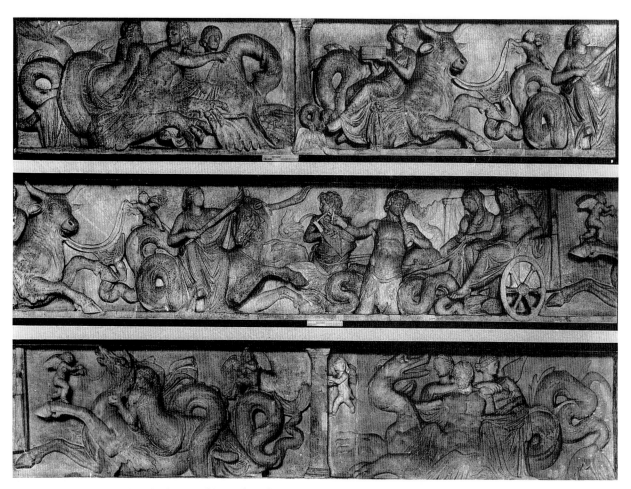

30 Altar of Domitius Ahenobarbus, Seethiasos, from Rome,
early first century B.C. Munich, Staatliche Antikensamm-
lungen und Glyptothek. Photo: Bildarchiv Foto Marburg/Art
Resource, New York, 1.003.620

31 Altar of Domitius Ahenobarbus, Census and Sacrifice,
from Rome, early first century B.C. Paris, Musée du Louvre.
Photo: Cliché des Musées Nationaux

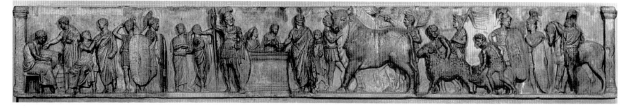

cuirass and helmet and carrying a spear in his upraised
right hand. A sword in a scabbard is held in his left hand,
and he leans on a large shield. He glances back beyond
the altar to the approaching procession. Two musicians
are depicted to the left of Mars, and two attendants stand
behind the altar. One pours a libation from a pitcher into
the patera held by the figure on the right of the altar – a
man in a tunic and toga with the upper edge of the toga
drawn up over his head (a restoration), like a veil (pos-
sibly Mark Antony himself) – who also looks toward
the oncoming procession and not at his libation dish, the
altar, or at Mars. Despite the fact that the altar is at the

center of the composition, it is the sacrificial procession
that serves as the artist's focus.

The importance of the procession, the Roman *suove-
taurilia,* the sacrifice of three animals (a bull, a pig, and a
sheep) here offered to Mars in gratitude for his protection
of the censors during their term of office, is underscored
by the oversized sacrificial animal victims. The bull occu-
pies the full height of the relief and indeed dwarfs his
attendants, the *victimarii.* They escort the animals and are
dressed in the appropriate costume of apronlike loincloth
or *limus* and are followed by two Roman soldiers with
oval shields and another soldier about to mount his horse,

the tail of which overlaps the framing Tuscan pilaster. The lustrum or purification of the Roman people occurred after the taking of the census – the purpose of which was to record the financial status of all Roman citizens, to place each individual in one of five tax brackets, to ascertain the population count, and to determine which members of the population were available for military service – is represented on the left of the relief. A seated togatus inscribes on a *tabula census* the information given him by a standing togatus holding his personal records. Another seated man witnesses his standing companion's oral declaration of the correctness of his statements. Two soldiers with oval shields serve as the transition between the scene of census and that of sacrifice. The spectator is meant to read the narrative of the scene from left to right: the taking of the census, the sacrifice to Mars that included the purification of the citizenry and soldiery of Rome, and the departure of the newly chosen army recruits.

The mood of both the census and the suovetaurilia is one of quiet dignity. The attendants and sacrificial animals proceed in a slow but steady pace toward the altar where they are patiently awaited by the sacrificant and by Mars, and the census is methodically recorded. What is most striking here is that the dramatic motion and Hellenistic flourishes of the mythological marriage cortege are gone, replaced by the somber and down-to-earth record of a specific event in Roman history enacted by upright figures of smaller scale. The seeming specificity of the census-sacrifice scene has led scholars to attempt to associate the scene with a historical personage, be he Domitius Ahenobarbus or Mark Antony, and with a specific census and sacrifice. What is of significance here, however, is not the precise identification of the main protagonist or the exact census or sacrifice but that the "Altar of Domitius Ahenobarbus" documents the coexistence of two diverse styles in a single monument in the late republic. It is another indication that Roman art was eclectic from its beginnings and that disparate styles appropriate to their subject matter were deliberately chosen by patrons and artists who had at their disposal an endless array of possibilities. A pronounced eclecticism in art is customarily the sign of a declining culture, but in Rome it surfaces at the very beginning of the birth of what might truly be termed Roman art.

The Città Castellana Base

While the "Altar of Domitius Ahenobarbus" includes a scene of Roman state ritual, a republican stone base or altar of about 40 B.C. celebrates Rome's legendary history. The base in question, which is from Falerii and is now in the atrium of the Cathedral of Città Castellana (figs. 32–33), is encircled with reliefs depicting Mars, Venus, and Vulcan. The deities are the recipients of a sacrifice offered in their honor by a bearded and helmeted figure in military dress and holding a lance and a patera from which he pours a libation on a garlanded altar. He is at the same time crowned with a laurel wreath by Victory carrying a palm branch. Scholars have convincingly identified the cuirassed figure, who also has bare feet, as Aeneas. Furthermore, it has been demonstrated that Aeneas is almost always clad in military attire while sacrificing, underscoring his martial accomplishments. The sole exception is the southwest relief panel on Augustus's Ara Pacis Augustae, where a peaceful Aeneas, father of the Julian family, wears a mantle that reveals a bare chest (see fig. 78). The victorious warrior sacrifices to Mars, the god of war, Venus, Aeneas's divine mother, and Vulcan, who was responsible for fashioning Aeneas's armor.

Stylistically, the figures on the Città Castellana Base are quite different from those in the census scene on the "Altar of Domitius Ahenobarbus." They are slender and elongated. Aeneas's head is in profile, and his body in a three-quarter view, while the bodies of the divinities are frontally positioned with their heads turned to the side. The figures stand on a groundline that constitutes the upper edge of the base's molding, and there is some space left above their heads, although the plumed helmet of Mars reaches to the uppermost border of the base. Even though the models for the three divinities were undoubtedly classically conceived statues by neo-Attic artists and the artist makes a valiant attempt to accentuate the men's musculature and Venus's curvaceous body, he was not adept at foreshortening the figures' limbs. Mars's right arm is smaller than his left, and both are awkwardly affixed to his torso. The artist, probably a local craftsman, created a base of doubtful artistic merit but one that serves as a significant document of the predilection of patrons in the last years of the republic for scenes celebrating the legendary history of Rome, an interest that was to continue to flourish under Rome's first emperor Augustus.

Reliefs from the Piazza della Consolazione

A series of stone reliefs, found in Rome in 1937 in the Piazza della Consolazione near the Capitoline hill, depict heraldic Victories, trophies, and shields, triumphal motifs that reappear time and again in the military art of the early to late Roman empire. The republican reliefs in question, which were discovered in 1938 during construction between the Via della Consolazione and the Via del Mare, may come from the frieze of a pillar monument resembling that of Aemilius Paullus; suggestions

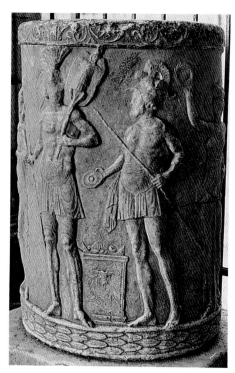

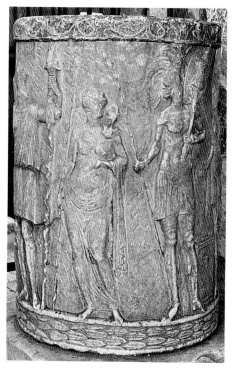

32 Città Castellana base, Aeneas, Mars, and Victory, from Falerii, ca.40 B.C. Città Castellana Cathedral, atrium. Photo: DAIR 78.768

33 Città Castellana base, Venus and Vulcan, from Falerii, ca. 40 B.C. Città Castellana Cathedral, atrium. Photo: DAIR 78.767

for the structure's date range from the second to the first centuries B.C. There are four surviving fragments, all fashioned of the same grayish stone.

Fragment B (fig. 34) depicts two rather static Victories in profile flanking a shield embossed with an eagle carrying a thunderbolt. The Victories clasp the ribbons of a swag that is draped across the top of the shield and are themselves framed by candelabra. A second relief (fragment A) (fig. 35) depicts a shield with the helmeted and profiled head of Roma flanked by trophies, and on the left also by a cuirass with fringed skirt. The breastplate has a central gorgoneion and Victories on the shoulder straps. Still another fragment (C) depicts a decorated greave, a muscled cuirass, and a round shield decorated with a Dioscurus on his horse and surmounted by a star. Fragment D represents a rectangular shield ornamented with a two-headed winged dragon. In the Roma panel, the objects are isolated from one another and spread across the blank background like a military still life. Displays in relief of military hardware are known from the Hellenistic period, as, for example, in the second-story balustrade of the Propylon of the Sanctuary of Athena at Pergamon of the early second century B.C., although there they are represented as a tangled pile rather than as discrete entities.

Dedicatory inscriptions bearing the names of kings and peoples of Asia who had entered into alliances with Rome were discovered nearby and may have belonged to this monument. An attractive but not conclusive theory is that the monument should be associated with the Roman general Sulla and the Mithridatic wars for which he was awarded a triumph.

The figures of the Victories and Roma are highly mannered, which suggests that the Piazza della Consolazione reliefs were carved by artists working in a neo-Attic style. The distinctive style was later abandoned, but such triumphal images as shields, breastplates, and trophies became an important component of imperial imagery under the empire. Sometimes, these were presented as a static still life; other times they were incorporated into a more complex composition.

Terracotta Pediment from the Via S. Gregorio

It was in the late republic that statues were used to fill the triangular space of temple pediments, a practice already favored by the Greeks and Etruscans. The earliest surviving Roman example is the pediment from the Via S. Gregorio on the Caelian hill in Rome, numerous fragments of which were discovered in 1878 and are now in the Museo del Palazzo dei Conservatori (fig. 36). The statues, almost fully in the round, are made of terracotta, a material favored by the Etruscans, but

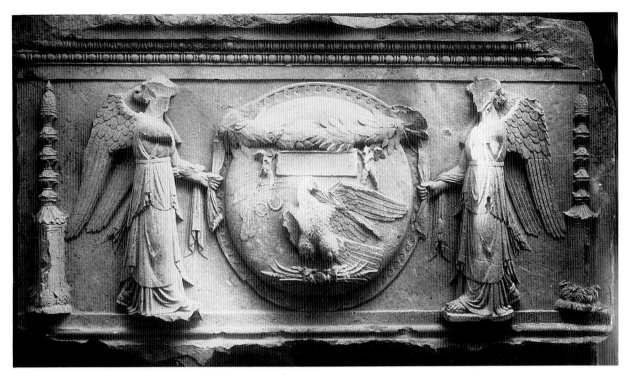

34 Relief from the Piazza della Consolazione, Victory and shield, second–first centuries B.C. Rome, Museo del Palazzo dei Conservatori. Photo: DAIR 41.2317

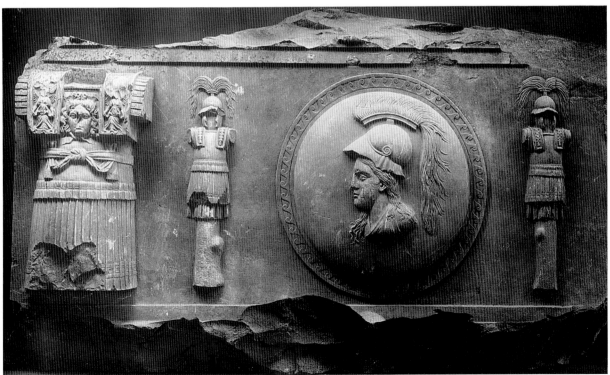

35 Relief from the Piazza della Consolazione, trophies and shield, second–first centuries B.C. Rome, Museo del Palazzo dei Conservatori. Photo: DAIR 41.2318

the main protagonists – Mars, Venus, and Victory – are drawn from Greek prototypes. Nevertheless, the subject matter of the pediment, the sacrifice of animal victims, may have been the suovetaurilia, a thoroughly Roman ritual. The divinities and personifications are larger in scale than the other participants, and the artist has skillfully placed them beneath the apex of the triangular field. A togate attendant and three victimarii are smaller in scale, and the animals originally filled the sloping sides of the pediment. Both the date and the original location of the pediment remain controversial. The neoclassical style has caused scholars to favor a date in the second half of the second century B.C., with some suggestions as late as 100 B.C. Although some scholars have posited that the pediment originally belonged to a temple on the Caelian hill, the most recent proposal attributes the sculptures to the Temple of Mars erected in the Circus Flaminius in 132 B.C.

The Beginning of Roman Art and the Legacy of Republican Eclecticism

It was during the late republic that a genuine Roman art came into being. At its very inception it was a highly sophisticated and eclectic art that drew heavily on carefully selected Etruscan, Greek, and Mid-Italic prototypes, which it combined with a thoroughly Roman vision of religion and public life to create a distinctive art that reflected the historical and social reality of the day. Most important was the Roman introduction to Greek art, first through Etruscan intermediaries and then directly through the vehicle of the Roman triumph. The earliest Roman attempt to record its military conquests in Greece was expressed in a Hellenistic vocabulary in the Aemilius Paullus Monument, but at the same time a new pictorial language was being developed to facilitate the transmission of information through triumphal paintings. It was thus in the realm of documentary reportage that a novel form of spatial perspective was first employed along with a symbolic rather than realistic depiction of the relative scale of people and objects. The use of different styles for different purposes in the republic was never arbitrary. Subject matter and style were intimately wedded. A Hellenistic style, for example, was considered appropriate for a Greek mythological scene – such as the marriage of Neptune and Amphitrite – whereas a new Roman documentary or journalistic style was chosen for the depiction of scenes of state ritual like the census and sacrifice, both on the "Altar of Domitius Ahenobarbus."

Considerable attention was lavished on precise detail in these new Roman scenes that recorded military campaigns and Roman rituals, paralleling the intense republican interest in exactly recording a person's facial idiosyncrasies. The republican veristic portrait, which must be seen as a parallel development to Roman ancestral practice, which necessitated wax or terracotta effigies of deceased ancestors to be kept in household armaria and paraded in subsequent funerary corteges, could not, however, have developed without Etruscan and Hellenistic models. It was the Roman genius for subsuming its artistic sources in an art that reflected its own religious beliefs and political vision of the world that led to the creation of a new kind of portraiture that has no parallel in any earlier civilization.

The same may be said of Roman copies of Greek masterpieces that all too often are admired and studied only for what they can tell us about the lost originals. The Roman replicas, however, are also exceptional indices of Roman taste, and the Pasitelean pastiches are novel works of art that also served as clever intellectual exercises for a highly educated Roman intelligentsia.

For the most part, it was this same aristocratic elite that both commissioned and was honored by art in the republic. Elderly patrician senators and mature generals had their features preserved for posterity in veristic likenesses set up in public places, and copies and variations of Greek masterworks were created for the same patrons' private dwellings. Both the commemorative statues and expropriated Greek statues put on public display were probably directed to the aristocracy, while the painted documentaries paraded in triumphal processions were undoubtedly meant to be intelligible to the populace at large. In the first century B.C. Roman freedmen began to commission portraits in the same veristic style as their aristocratic counterparts. As we shall see, it was the most outstanding features of Roman triumphal painting – including the novel perspective and hierarchy of scale – that were immediately adopted by freedmen in sculptured reliefs depicting professional and genre scenes and that were produced in great numbers in Rome and Italy in the Augustan age.

Women did not figure prominently in the art of the republic. Wives of men in the public eye, like Mark Antony, were honored with idealized coin portraits and probably as well by portraits in the round; freedwomen were portrayed next to their husbands in group funerary commemorations, but female figures – with the exception of goddesses and personifications such as Venus and Victory – are omitted from relief sculpture recording state ceremonies.

One of the most significant developments of the republic was the use of portraiture for political propaganda by major public figures. The portraits of Pompey and Mark Antony, while clearly in the veristic style of the

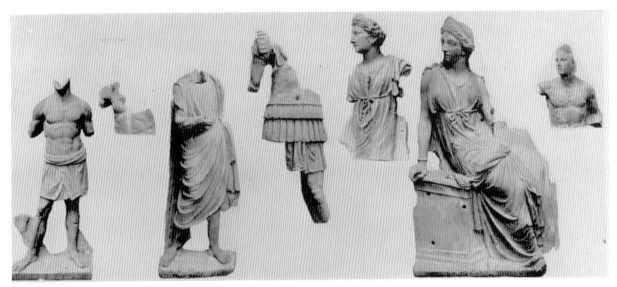

36 Terracotta pediment from the Via S. Gregorio, second half of second century B.C. Rome, Museo del Palazzo dei Conservatori. Photo: I. S. Ryberg, *Rites of the State Religion in Roman Art, MAAR* 22 (1955), fig. 14

republic, include subtle references to a remarkable Greek ruler of the past – Alexander the Great. The portraits of Julius Caesar also demonstrate their indebtedness to those of Alexander, but what was more important was that Caesar was the first Roman ruler to strike coins in the West with his lifetime portrait. These coins afforded Caesar the opportunity of personally overseeing the creation of his public image and of shaping its political impact. This privilege was to become an imperial right and is perhaps Caesar's most lasting artistic legacy to the emperors of Rome from Augustus to Constantine.

Bibliography

For texts documenting the period of the Kings and the Roman Republic, see especially J. J. Pollitt, *The Art of Rome c.753 B.C.–A.D. 333: Sources and Documents*, 2d ed. (Cambridge, 1983), 3–95, which I also relied on for the legendary and historical documentation of the period. The encapsulated biographies of such important historical personages as Pompey, Julius, Caesar, and Mark Antony, in *The Oxford Classical Dictionary*, 2d ed. (Oxford, 1970), are also invaluable.

Important general studies on Roman art of the republic include the following titles, some with special emphasis on the Etruscan, Greek, or Italic elements in early Roman art:

F. W. Goethert, *Zur Kunst der römischen Republik* (Berlin, 1931). P. Ducati, *L'arte in Roma dalle origini al sec. VIII* (Bologna, 1938). A. Andrén, *Architectural Terracottas from Etrusco-Italic Temples* (Lund, 1940). I. S. Ryberg, *An Archaeological Record of Rome from the Seventh to the Second Century B.C.* (London, 1940). O. Vessberg, *Studien zur Kunstgeschichte der römischen Republik* (Lund, 1941). H. Jucker, *Vom Verhältnis der Römer zur bildenden Kunst der Griechen* (Frankfurt a.M., 1950). G. Becatti, *Arte e gusto negli scrittori latini* (Florence, 1951). E. H. Richardson, "The Etruscan Origins of Early Roman Sculpture," *MAAR* 21 (1953), 77–124. R. Bianchi Bandinelli and A. Giuliano, *Etruschi e Italici prima del dominio di Roma* (Milan, 1973). B. M. Felletti Maj, *La tradizione italica nell'arte romana* (Rome, 1977). J. J. Pollitt, "The Impact of Greek Art on Rome," *TAPA* 108 (1978), 155–74. *La grande Roma dei Tarquinii* (Rome, 1990).

Bronze She-Wolf: O. W. von Vacano, "Vulca, Rom und die Wölfin," *ANRW* I, 4 (Berlin, 1973), 566–68. O. Brendel, *Etruscan Art* (Harmondsworth, 1978), 250–53.

Portonaccio Temple sculpture: M. Santangelo, "Veio, Santuario 'di Apollo': scavi fra il 1944 e il 1949," *BdA* 37 (1952), 147–69. E. Stefani, *NSc* (1953), 29–112. O. Brendel, *Etruscan Art* (Harmondsworth, 1978), esp. 238–44.

Honorific Statuary: O. Vessberg, *Studien zur Kunstgeschichte der römischen Republik* (Lund, 1941). G. Lahusen, *Untersuchungen zur Ehrenstatuen in Rome: Literarische und Epigraphische Zeugnisse* (Rome, 1983).

Portrait of "Brutus": R. Bianchi Bandinelli, *Dedalo* 8 (1927–28), 5–36. O. Brendel, *Etruscan Art* (Harmondsworth, 1978), esp. 398–400.

Lucera Shepherd Relief: R. Bianchi Bandinelli, *Rome: The Center of Power* (New York, 1970), 27. B. M. Felletti Maj, *La tradizione italica nell'arte romana* (Rome, 1977), 126, 234, fig. 35.

Coin of Titus Quinctius Flamininus: H. Kähler, *Der Fries vom Reiterdenkmal des Aemilius Paullus in Delphi* (Berlin, 1965), esp. 7–8, 36, pl. 24a–b. C. M. Kraay, *Greek Coins* (London, 1966), no. 579. J. P. C. Kent, *Roman Coins* (New York, 1978), 266, no. 23, pl. 9.

Coin of Perseus: C. M. Kraay, *Greek Coins* (London, 1966), no. 578.

Aemilius Paullus Monument: H. Kähler, *Der Fries vom Reiterdenkmal des Aemilius Paullus in Delphi* (Berlin, 1965).

The Roman Plunder of Spoils: M. Pape, *Griechische Kunstwerke aus Kriegsbeute und ihre öffentliche Aufstellung in Rom* (Diss., University of Hamburg, 1975).

Greek Masterpieces and Roman Copies: G. Lippold, *Kopien und Umbildungen griechischer Statuen* (Munich, 1923). H. Jucker, *Vom Verhältnis der Römer zur bildenden Kunst der Griechen* (Frankfurt a. M., 1950). G. Becatti, *Arte e gusto negli scrittori latini* (Florence, 1951). W. Trillmich, "Bermerkungen zur Erforschung der römische Idealplastik," *JdI* 88 (1973), 247–82. P. Zanker, *Klassizistische Statuen* (Mainz, 1974). F. Coarelli, "Architettura e arti figurative in Roma: 150–50 a. C.," in *Hellenismus in Mittelitalien- Colloquium 5–9 Juni, 1974* (Göttingen, 1976), 21–32. M. Bieber, *Ancient Copies: Contributions to the History of Greek and Roman Art* (New York, 1977). C. C. Vermeule, *Greek Sculpture and Roman Taste: The Purpose and Setting of Graeco-Roman Art in Italy and the Greek Imperial East* (Ann Arbor, 1977). J. J. Pollitt, "The Impact of Greek Art on Rome," *TAPA* 108 (1978), 155–74. P. Zanker, "Zur Funktion und Bedeutung griechischer Skulptur in der Römerzeit," *Le Classicisme à Rome aux Iers siècles avant et après J.-C.* (Entretiens Hardt, 25, Geneva, 1978), 283–306. B. S. Ridgway, *Roman Copies of Greek Sculpture* (Ann Arbor, 1984).

School of Pasiteles: M. Borda, *La Scuola di Pasiteles* (Bari, 1953). P. Zanker, *Klassizistische Statuen* (Mainz 1974). E. Simon, "Kriterien zur Deutung 'pasitelischer' Gruppen," *JdI* 102 (1987), 291–304.

Portrait of a Young Scipio: T. Dohrn, "Der Vatikanische 'Ennius' und der Poeta Laureatus," *RM* 69 (1962), 91.

The Arringatore: T. Dohrn, *Der Arringatore* (Berlin, 1968). R. Brilliant, *Gesture and Rank in Roman Art* (New Haven, 1963), 26–31 (for the "appendage aesthetic"). G. Colonna, "Il posto dell'Arringatore nell'arte etrusca di età ellenistica," *StEtr* 56 (1991), 99–122.

Ostia Themistocles: G. M. A. Richter, *Greek Portraits* (Brussels, 1955) I, 99ff., figs. 413–25. B. S. Ridgway, *The Severe Style in Greek Sculpture* (Princeton, 1970), fig. 137. M. Robertson, *A History of Greek Art* (Cambridge, 1975), I, 187–88.

Portraiture of Alexander the Great: M. Bieber, *Alexander the Great in Greek and Roman Art* (Chicago, 1964). T. Hölscher, *Ideal und Wirklichkeit in den Bildnissen Alexanders des Grossen* (Heidelberg, 1971). G. Kleiner, "Das Bildnis Alexanders des Grossen," *JdI* 65–66 (1950–51), 206–30. E. Schwarzenberg, "The Portraiture of Alexander," *Alexandre le Grand: Image et réalité* (Entretiens Hardt, 22, 1975), 223–67.

Portraiture of Mithridates VI of Pontus: G. Kleiner, "Bildnis und Gestalt des Mithradates," *JdI* 68 (1953), 73–95.

Republican Portraiture: F. W. Goethert, *Zur Kunst der römischen Republik* (Berlin, 1931). O. Vessberg, *Studien zur Kunstgeschichte der römischen Republik* (Lund , 1941). B. Schweitzer, *Die Bildniskunst der römischen Republik* (Leipzig, 1948). U. Hiesinger, "Portraiture in the Roman Republic," *ANRW* I, 4 (Berlin, 1973), 805–25. P. Zanker, "Zur Rezeption des hellenistischen Individualporträts in Rom und in den italischen Städten," *Hellenismus in Mittelitalien* (Göttingen, 1976), 2, 581–609. J. M. C. Toynbee, *Roman Historical Portraits* (London, 1978). R. R. R. Smith, "Greeks, Foreigners, and Roman Republican Portraits," *JRS* 71 (1981), 24–38.

Ancestral Portraiture: A. N. Zadoks-Josephus Jitta, *Ancestral Portraiture in Rome* (Amsterdam, 1932). E. Bethe, *Ahnenbild und Familiengeschichte bei Römern und Griechen* (Munich, 1935). A. Boëthius, "On the Ancestral Masks of the Romans," *ActaArch* 13 (1942), 226–35. F. Brommer, "Zu den römischen Ahnenbildern," *RM* 60–61 (1953–54), 163–71. H. Drerup, "Totenmaske und Ahnenbild bei den Römern," *RM* 87 (1980), 81–129. G. Lahusen, "Zur Funktion und Rezeption des römischen Ahnenbildes," *RM* 92 (1985), 261–89.

Female Portraiture in the Republic: R. Steininger, *Die weiblichen Haartrachten im ersten Jahrhundert des römischen Kaiserzeit* (Munich, 1909). H. P. L'Orange, "Zum frührömischen Frauenporträt," *RM* 44 (1929), 167–79. L. Furnée-van Zwet, "Fashion in Women's Hair-dress in the First Century of the Roman Empire," *BABesch* 31 (1956), 1–22. K. Polaschek, "Studien zu einem Frauenkopf im Landesmuseum Trier und zur weiblichen Haartracht der iulisch-claudischen Zeit," *TrZ* 35 (1972), 141–210. D. E. E. Kleiner, *Roman Group Portraiture: The Funerary Reliefs of the Late Republic and Early Empire* (New York, 1977).

The Portraiture of Octavia: P. E. Arias, "Nuovi contributi all'iconografia di Ottavia Minore," *RM* 54 (1939), 75–81. M. L. Marella, "Di un ritratto di 'Ottavia,'" *MemLinc*, ser. 7, vol. 3 (1942), 31–82. H. Bartels, *Studien zur Frauenporträt der augusteischen Zeit* (Munich, 1963), 14ff. K. P. Erhart, "A New Portrait Type of Octavia Minor(?)," *GettyMusJ* 8 (1980), 117–28.

The Portraiture of Freedmen: E. Gazda, "Etruscan Influence in the Funerary Reliefs of Late Republican Rome: A Study of Roman Vernacular Portraiture," *ANRW* I, 4 (Berlin, 1973), 855–70. D. E. E. Kleiner and F. S. Kleiner, "A Heroic Funerary Relief on the Via Appia," *AA* (1975), 250–65. P. Zanker, "Grabreliefs römischer Freigelassener," *JdI* 90 (1975), 267–315. H. G. Frenz, *Untersuchungen zu den frühen römischen Grabreliefs* (Mainz, 1977). D. E. E. Kleiner, *Roman Group Portraiture: The Funerary Reliefs of the Late Republic and Early Empire* (New York, 1977). D. E. E. Kleiner and F. S. Kleiner, "Early Roman Togate Statuary," *BullCom* 87 (1980–81), 125–33. H. R. Goette, *Studien zu römischen Togadarstellungen* (Mainz, 1990).

Republican Coins and Gems: E. Sydenham, *The Coinage of the Roman Republic* (London, 1952). H. Zehnacker, "Premiers portraits réalistes sur les monnaies de la république

romaine," *RN* 6ᶜ sér. 3 (1961), 33–49. M. L. Vollenweider, *Die Porträtgemmen der römischen Republik*, 1–2 (Mainz, 1972). H. Zehnacker, *Moneta: Recherches sur l'organisation et l'art des émissions monétaires de la République romaine (289–31 av. J.-C., BEFAR* 222 (1973). M. Bieber, "The Development of Portraiture on Roman Republican Coins," *ANRW* 1, 4 (Berlin, 1973), 871–98. M. Crawford, *Roman Republican Coinage*, 1–2 (Cambridge, 1976).

Pompey the Great: F. E. Brown, "Magni Nominis Umbrae," *Studies Presented to D. M. Robinson*, 1 (St. Louis, 1951), 761–64. D. Michel, *Alexander als Vorbild für Pompeius, Caesar und Marcus Antonius* (Brussels, 1967). E. La Rocca, "Pompeo Magno 'Novus Neptunus,'" *BullCom* 92 (1987–88), 265–92.

Julius Caesar: M. Borda, "Il ritratto tuscolano di Giulio Cesare," *RendPontAcc* 20 (1943–44), 347–82. E. Simon, "I, Das Cesarporträt im Castello di Aglie, II, Das Cesarporträt im Museo Torlonia," *AA* 67 (1952), 123–52. A. Alföldi, "Der Mettius Denar mit CAESAR DICT QUART," *SchwMbll* 13 (1964), 29–33. F. S. Johansen, "Antichi ritratti di Caio Giulio Cesare nella scultura," *AnalRom* 4 (1967), 7–68. T. Lorenz, "Das Jugendbildnis Caesars," *AM* 83 (1968), 242–49. F. S. Johansen, "The Portraits in Marble of Gaius Julius Caesar: A Review," *Ancient Portraits in the J. Paul Getty Museum*, 1 (Malibu, 1987), 17–40. P. E. Arias, "Problemi attuali della iconografia di Cesare alla luce del ritratto del Camposanto Monumentale di Pisa," in N. Bonacasa and G. Rizza, eds., *Ritratto ufficiale e ritratto privato* (Rome, 1988), 119–22.

Mark Antony: C. Watzinger, *Expedition E. v. Sieglin*, 1927, vol. II 1b, 11. O. Brendel, "The Iconography of Marc Antony," *Hommages à A. Grenier*, 1, *CollLatomus* 58 (Brussels, 1962), 359–67. D. Michel, *Alexander als Vorbild für Pompeius, Caesar und Marcus Antonius* (Brussels, 1967).

Triumphal Painting: G. Rodenwaldt, "Römische Reliefs: Vorstufen zur spätantike," *JdI* 55 (1940), 12–43. C. M. Dawson, *Romano-Campanian Mythological Landscape Painting, YCS* 9 (New Haven, 1944), 50ff. P. H. von Blanckenhagen and C. Alexander, *The Paintings from Boscotrecase* (Heidelberg, 1962), 54–58.

Nile Mosaic: E. Schmidt, *Studien zum barberinischen Mosaik in Palestrina* (Breslau, 1927). G. Gullini, *I mosaici di Palestrina* (Rome, 1956). H. Whitehouse, *The Dal Pozzo Copies of the Palestrina Mosaics* (Oxford, 1976).

Esquiline Tomb Painting: *Roma medio repubblicana* (Rome, 1973), 200–208 (F. Coarelli).

"The Altar of Domitius Ahenobarbus": A. Furtwängler, *Intermezzi* (Leipzig, 1896), 33ff., esp. 44–45. F. Castagnoli, "Il problema dell'Ara di Domizio Enobarbo," *Arti Figurative*, 1 (1945), 181–96. H. Kähler, *Seethiasos und Census: Die Reliefs aus dem Palazzo Santa Croce in Rom* (Berlin, 1966). F. Coarelli, "L''ara di Domizio Enobarbo' e la cultura artistica in Roma nel II secolo a.C., *DialArch* 2 (1968), 302–68. F. Coarelli, "Architettura e arti figurative in Roma: 150–50 a.C.," in P. Zanker, ed., *Hellenismus in Mittelitalien* (Göttingen, 1976), 38–51. T. Hölscher, "Beobachtungen zu römischen historischen Denkmälern. 1. Censordenkmal München-Paris 2. Das Schiffsrelief aus Praeneste im Vatikan," *AA* (1979), 337–48. M. Torelli, *Typology and Structure of Roman Historical Reliefs* (Ann Arbor, 1982), 5–25. A. Kuttner, "Some New Grounds for Narrative: Marcus Antonius' Base (the "Ara Domitii Ahenobarbi") and Republican Biographies," in P. Holliday, ed., *Narrative and Event in Ancient Art*, in press.

Reliefs from the Piazza della Consolazione: G. Picard, "Les fouilles de la Via del Mare et les débuts de l'art triomphal romain," *MélRome* 71 (1959), 263–79. T. Schäfer, "Die Siegesdenkmal von Kapitol," in H. G. Horn and C. B. Rügers, eds., *Die Numidier: Reiter und Könige nördlich der Sahara* (Cologne, 1979), 247ff. T. Hölscher, "Römische Siegesdenkmaler der späten Republik," in H. Cahn, ed., *Taenia: Festschrift für R. Hampe* (Mainz, 1980), 357ff. E. Kunzl, *Der römische Triumph Siegesfeiern im antiken Rom* (Munich, 1980). T. Hölscher, "Historische Reliefs," in *Kaiser Augustus und die verlorene Republik* (Mainz, 1988), 384–86.

Città Castellana Base: R. Herbig, "Römisches Basis in Città Castellana," *RM* 42 (1927), 129–47. I. S. Ryberg, *Rites of the State Religion in Roman Art, MAAR* 22 (1955), 27. G. K. Galinsky, *Aeneas, Sicily and Rome* (Princeton, 1969), 22–24. B. M. Felletti Maj, *La tradizione italica nell'arte romana* (Rome, 1977), 190–91, fig. 7. F. S. Kleiner, "The Sacrifice in Armor in Roman Art," *Latomus* 42 (1983), 298, fig. 7. T. Hölscher. "Historische Reliefs," in *Kaiser Augustus und die verlorene Republik* (Mainz, 1988), 382–83.

Terracotta Pediment from the Via S. Gregorio: I. S. Ryberg, *Rites of the State Religion in Roman Art, MAAR* 22 (1955), 22–23. F. Coarelli, "L'ara di Domizio Enobarbo' e la cultura artistica in Roma nel II secolo a.C.," *DialArch* 2 (1968), 345. F. Coarelli, "Polycles," *StMisc* 15 (1970), 85–86. B. M. Felletti Maj, *La tradizione italica nell'arte romana* (Rome, 1977), 139, 173, 179, fig. 41.

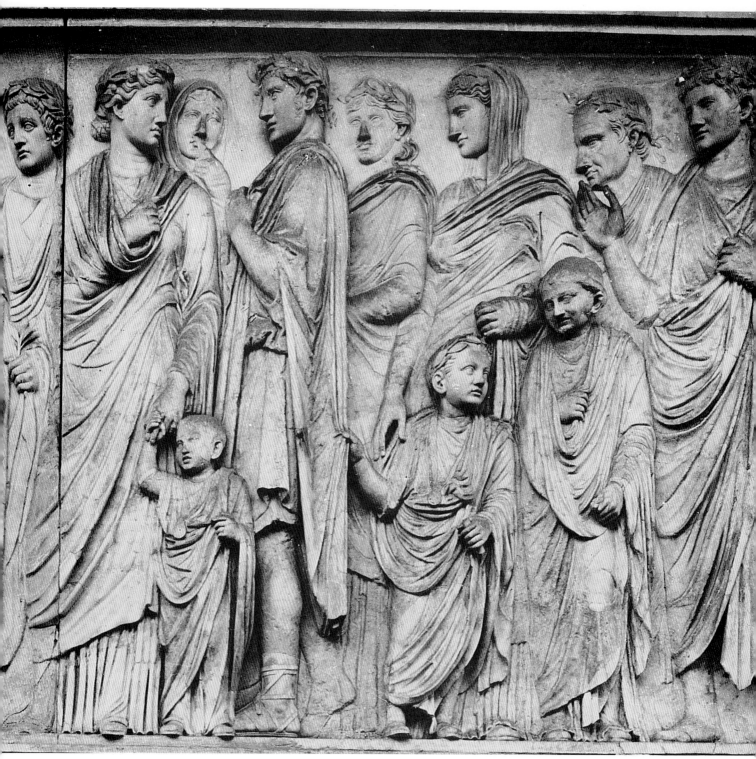

Detail. Rome, Ara Pacis Augustae, south frieze, Marcus
Agrippa and imperial family, 13–9 B.C. Photo: DAIR 72.2403

THE AGE OF AUGUSTUS &
THE BIRTH OF IMPERIAL ART

CHAPTER II

The man known to history as Augustus was born Gaius Octavius in Rome on 23 September 63 B.C. He was the son of Gaius Octavius and Atia, the niece of Julius Caesar. Octavian's proximity to Caesar gave him early training in public life. At the age of twelve, for example, he recited his grandmother's *laudatio* (funeral oration), and in 46 B.C., he accompanied his great uncle in his triumphal procession. In his last will and testament of 44 B.C., Julius Caesar, who had no sons of his own, adopted his nineteen-year-old grandnephew as his heir. In 43 B.C., Octavian became *propraetor* and consul for the first time and was recognized as Julius Caesar's adoptive son under the name Gaius Julius Caesar Octavianus. Soon after, Octavian joined with Mark Antony and Marcus Lepidus to form the second triumvirate, one of their goals being to avenge Caesar's assassination at the hands of Cassius and Brutus, which they did at the Battle of Philippi in 42 B.C. It was before this momentous battle that Octavian vowed to construct a temple to Mars the Avenger (Mars Ultor) if he won. On 1 January 42 B.C., Julius Caesar was proclaimed a god, and Octavian thus became *divi filius*. For political reasons, Octavian married Scribonia in 40 B.C. – they had one daughter, Julia – but divorced her soon after and married Livia, with whom he had more in common, in 38. From their union, she produced no heirs. It was during the early 30s that Octavian put himself under the protection of Apollo. He also took part in a number of campaigns, founded colonies, and supported Marcus Agrippa's attempt to adorn the city of Rome. Octavian made his opposition to Antony, his earlier co-member in the second triumvirate, and Cleopatra known, as well as his dedication to the formation of a united and peaceful Italy. In 31 B.C., he was victorious over Antony at a naval battle at Actium, off the western coast of Greece. A triumph was celebrated in 29 although not over Antony. Octavian attributed his military success in the case of Actium to Apollo, and in 28 B.C. he dedicated a temple to his patron god on the Palatine hill in Rome. On 16 January 27 B.C., he received the title *Augustus*. His virtues were commemorated in a golden shield set up in the senate house (curia) in the Roman Forum; a replica of that shield is preserved at Arles.

The power of Rome's first emperor was based on

his reputation as a military victor, bringer of peace, and staunch supporter of Roman (and not eastern) traditions. His genius, with regard not only to statecraft but to art, is that he presented to the ruling body and citizenry of Rome an ideology that combined history, law, social policy, religion, literature, and art and architecture. The greatest poets (as Virgil and Horace), historians (like Livy), gem cutters (such as Dioscurides), painters (Studius for one), sculptors (including Diogenes), and architects (as Vitruvius) of the day were responsible for translating this ideology into words and images. What they created therefore remains a testimony not only to their genius but also to that of their *princeps* or first citizen and patron, Augustus. The close association of imperial ideology with imperial portraiture and state relief thus had its inception under Augustus, and many successive emperors also chose to exercise control over both the subject matter and style of the works of art they and other members of the imperial circle sponsored.

Augustus spent the following years consolidating his power and expanding the borders of the Roman empire by the addition of numerous colonies. Portraits and large-scale monuments were erected in many of these new provinces in the emperor's honor.

Augustus suffered from ill health, and his concern for his own mortality translated into an obsession with the matter of the succession, especially in the second half of the 20s B.C. Augustus's goal was to shape Rome's future as well as its present. This meant that he had to choose his own successor. Since he had only one daughter, he married her to Marcellus, his sister's son, in 25 B.C., but the promising young man died in 23 B.C. Julia's second husband, Marcus Agrippa – who was compelled by Augustus to divorce his wife of about ten years to marry Julia – and eventually their two sons, Gaius and Lucius Caesar, became candidates in turn. The deaths of all three before that of Augustus himself thwarted the emperor's plans, and he was eventually forced to adopt Tiberius, the first son of Livia by her first husband.

The years between 18 and 12 B.C. were marked by Augustus's attention to religious and moral reforms. Changes in social policy were most apparent in the *Lex Iulia de adulteriis* (18 B.C.), which made adultery a crime, and the *Lex Iulia de maritandis ordinibus* (18 B.C.), which gave incentives for the procreation of children. The *Lex Papia Poppaea* of A.D. 9 affirmed the latter decree. Nonetheless, Augustus's moral laws were aimed primarily at women and not at all members of Roman society. Men were still free to have adulterous affairs, and their rights continued to be respected, whereas women who committed adultery were subject to the loss of property and even to exile – a fate that befell even Augustus's daughter, Julia, and his granddaughter, Julia the Younger.

At Lepidus's death in 12 B.C., Augustus became pontifex maximus in his place. The emperor was now in charge not only of the state but also took his place at the head of the Roman religion. In 2 B.C., he was saluted as *pater patriae* (father of his country).

Before his death on 9 August A.D. 14, at Nola, Augustus deposited his last will and testament and also an account of his accomplishments (known as the *Monumentum Ancyranum* or the *Res Gestae Divi Augusti*) with the Vestal Virgins. The account is of considerable interest and was carved on two bronze pillars in front of Augustus's mausoleum in Rome. The originals no longer survive, but the text is known from copies made for Roman cities in the provinces. The best preserved is the one engraved on the walls of the Temple of Roma and Augustus in Ankara. The text in Ankara is in Latin with a Greek translation. Three days later, on the seventeenth day of the month, the senate decreed that Augustus should be divinized.

Augustan Art

Augustan art did not begin in a vacuum. Augustan patrons and artists drew on Greek art and architecture and on monuments from Rome's own Italic, Etruscan, and republican past. Augustan art preserved these heritages and combined them with a new Augustan vision to create what Augustus hoped would be viewed as a new golden age. The resultant achievement was passed to posterity and exerted a lasting influence not only on later Roman art but on the art of more recent times. We will see that references going back to Rome's first emperor and to both the style and iconography of Augustan portraiture and state relief are common in Roman art.

The Rome of Augustus was a thriving metropolis of about a million inhabitants. It was built not of sundried bricks and terracotta as the Iron Age and Etruscan cities had been, but of Luna (Carrara) marble. The most famous monuments of the day – the Forum of Augustus, the Temple of Apollo Palatinus, and the Ara Pacis Augustae – were all largely fashioned from Luna marble. Under Augustus, the city of Rome had a great bathing establishment (the Baths of Agrippa), an entertainment center – including a great theater (the Theater of Marcellus), law courts, a senate house, and marble temples. The water system of the city was overhauled and three new aqueducts added. This new, Augustan Rome, this marble city, served as a model for cities founded by Augustus elsewhere in the Roman world. The major buildings of the capital city and those of the miniature Romes built in its image were enhanced with displays of cult and honorific statuary.

Of the greatest importance is the man who made

this new golden age of expansion, peace, and artistic achievement possible – Octavian Augustus. In order to understand the art of the age of Augustus, it is important to examine Augustus's dynastic and political ambitions, moral beliefs, political and social legislation, and the roles he played in life and in his portraiture as victorious general, grandnephew of Julius Caesar, emperor, chief priest of Rome, and ultimately a divinity.

The Portraiture of Augustus

As the first emperor of Rome Augustus exploited fully the art of political propaganda among the Romans, using art in the service of his political and social ideology. This is immediately apparent in the relief sculpture commissioned by him or in his honor and more subtly expressed in his numismatic and sculptured portraits. The emperor and his family were immortalized in individual portraits and in family groups, both in life-size and in miniature versions on coins and precious cameos. The coins were excellent vehicles for imperial propaganda since they were handled daily by citizens in Rome and the provinces. It was therefore to the Roman coinage that Octavian first turned to express his political aims.

A sestertius of 37 B.C. (figs. 37–38) illustrates the propagandistic capacity of the Roman coinage because it was used by Octavian to advertise his adoption as Caesar's son and thus attests to the validity of his claim to power. The obverse of the coin (fig. 37) follows the tradition of Julius Caesar by its inclusion of the portrait of a living man, in this case Octavian. The reverse (fig. 38) bears a portrait of Caesar that is accompanied by the legend "*Divus Julius,*" that is, the deified Julius Caesar, because the senate proclaimed Caesar a god in 42 B.C. The obverse portrait of Octavian depicts him with a beard of mourning and is labeled with the designation "*Divi filius,*" the son of a god. In this legend, Octavian declares himself the son of a god because the contemporary political climate in Rome, as opposed to the Hellenistic East, would not allow Octavian to be worshipped openly as a god. What is even more remarkable is that the bond between Octavian and Caesar was in part a fiction because Augustus was not really Caesar's son but was adopted posthumously in Caesar's will.

Portraits in the round representing Octavian as Caesar's heir were made at the same time as this numismatic portrait. A portrait of Octavian of 37 B.C. from the cryptoporticus in Arles (fig. 39), for example, may depict a melancholy Octavian with the beard of mourning. What is even more striking is that Octavian is represented as a youth. The portraits of Augustus are of considerable interest because they break completely in style and iconography with the portraits of the republic. During the republic, men of influence were men of age and experience, whose careworn features mirrored their lifelines. When Augustus began his rise to power, he was only nineteen years old; at thirty-two, he was master of the entire Roman world. Augustus emerged victorious from a bloody civil war and brought peace and prosperity to Rome. A new image was needed to express a new age. That image was of a young man full of vitality and

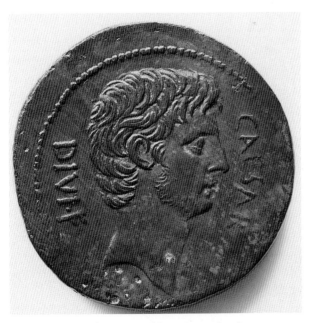

37 Sestertius with portrait of Octavian on the obverse, 37 B.C. London, British Museum. Photo: Hirmer Verlag München, 2000.065V

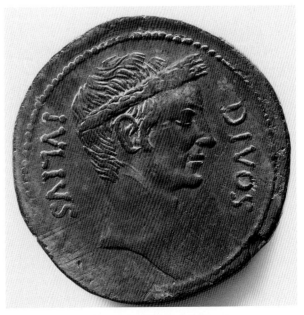

38 Sestertius with portrait of Divus Julius on the reverse, 37 B.C. London, British Museum. Photo: Hirmer Verlag München, 2000.065R

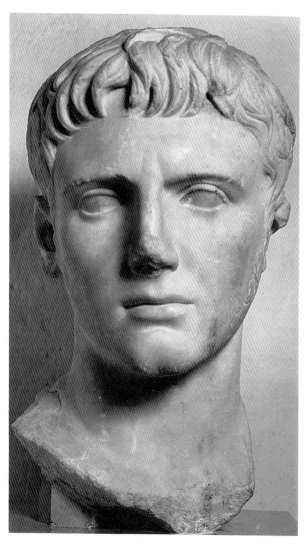

39 Portrait of Octavian, from the cryptoporticus in Arles, 37 B.C. Arles, Musées d'Arles. Photo: Photographies Michel Lacanaud, Musées d'Arles

enthusiasm for the business of running the empire. Artists called upon to create this new image could not look to models of the late republic because during that period no portraits were made of young men (or young women). This was not because there were no young people in the republic, but because young people were not important socially or politically and thus were not important artistically. With the young ruler Augustus the picture changed completely. Not only was Augustus important politically, so too were his young heirs, Gaius and Lucius. Augustus's social policies also called for the increased procreation of children by members of the Roman nobility. Artists who fashioned the earliest portraits of Rome's first emperor looked instead to artistic models made in a time when youthful beauty and athletic prowess were most admired – the fifth century B.C. A taste for art of classical (and even, as we shall see, Hellenistic) Greece was also a personal preference

of Augustus, who envisioned his age as golden, much like that of Pericles in Athens. Augustus visited Greece on a few occasions and was impressed by what he saw. We shall see that Augustus envisioned the youthful god Apollo as his personal protector and that the emperor commissioned many monuments that not only honored the god but linked him with Augustus's family lineage and with his imperial destiny. To the Greeks, Apollo was the god of goodness and beauty and the bringer of peace; the Apolline image of youthful radiance also served as an inspiration for the portraits of Augustus.

What is even more astounding is that Augustus is represented as youthful in *all* his portraits, even at his death in 14 at the age of seventy-six. According to Suetonius, Augustus in old age "had only partial vision. His teeth were small, few and decayed; his hair, yellowish and rather curly; his eyebrows met over his nose. . . . His body is said to have been marred by blemishes of various sorts – a constellation of seven birthmarks on his chest and stomach, exactly corresponding with the Great Bear; and a number of dry patches suggesting ringworm" (Suet., *Aug.*, 79). And yet in his portraits, Augustus was always portrayed as a beautiful youth. In life, Augustus grew old, but in his portraits he never aged. In antiquity such a fiction could succeed because relatively few people – and mostly those in Rome – actually saw the emperor close up and there were no photographs to reveal the fiction. It was for this reason that the image of the emperor could take any form that he and his court artists devised. The portraiture of Augustus is political portraiture that is comprised of calculated imperial images rather than likenesses of the individual. In the case of Augustus, the concept "portraiture" does not necessarily imply a realistic likeness.

When the divi filius coin was struck and the Arles portrait carved, Octavian was still only one of several claimants to imperial power. In 31 B.C., he eliminated his last rival, Mark Antony, at Actium. It was after this famous – though in reality fairly nondescript – naval battle that Augustus became sole ruler of the Roman world, in a year that also marks the beginning of the Roman empire. Augustus's victory at Actium meant the restoration of peace in a world that had seen far too much bloodshed, and Octavian used the victory and ensuing peace as the cornerstones of his political propaganda. Furthermore, the Battle of Actium provided artists and writers of the day with a subject that could be amply embellished with fictional flourishes that enhanced it to mythical proportions.

There were three major themes in Augustan propaganda after 31. The first was military victory as the foundation of his power, his new claim to his right to rule, replacing his earlier claim of being Caesar's heir. The sec-

ond was the peace achieved through military victory – the famous *pax romana* – that Augustus brought to the world; and the third, Augustus's claim to divine descent, not merely as the son of the new god Caesar but, as we shall see, as a direct descendant of Aeneas, son of Venus, a goddess whose divinity no one questioned. These three themes – victory, peace and prosperity, and divine descent – are all features of Augustan official portraiture and Augustan relief sculpture.

In 27 B.C., the senate bestowed on Octavian the title of Augustus, which indicated that he had a special personal majesty. The significant victory at Actium that had made Augustus the sole ruler of the Roman world established the need for the creation of an official portrait type for Rome's first emperor. The portrait of the mourning Octavian would no longer do. Fourteen replicas and variants of such a portrait type of Augustus have survived and have been grouped together and called the Actium type. It is the first of three basic portrait types of Augustus (excluding the mourning one, which is controversial and not accepted by all scholars) that follow one another in a roughly chronological sequence and are distinguished from one another by the arrangement of the emperor's hair. There is surprisingly little scholarly disagreement over these types in the literature on the subject. The dates of their creation, however, are sometimes disputed. In the Actium type, created just after Actium (although some date its inception to as early as 43 B.C.), the emperor's features show him to be a determined military man, and two deep vertical creases line his face from the inner corner of his eyebrows and top of his nose to the center of his forehead. Augustus is depicted with a full head of curls set in relative disorder. Some locks are brushed to Augustus's left and others to the right. They are parted from one another not in the middle of the forehead but at a point to the right of the vertical creases between the eyebrows. A few strands of hair on the emperor's right turn back toward the center. One of the best known examples of this type is the portrait of Augustus now in the Museo Capitolino (fig. 40) that dates to about 30 B.C.

The office of pontifex maximus gave Augustus even greater authority in religious matters. He already held memberships in all the major priesthoods. Never before had so much power been concentrated in the hands of one man. Nonetheless, the title that Augustus claimed he favored above all was the one that he felt described his special position as princeps. In 2 B.C., he was saluted as pater patriae. The portraiture of Augustus shows him in the roles he played in life: princeps, pater patriae, pontifex maximus, and so forth.

An example is the portrait of Augustus with veiled head (*capite velato*) from the Via Labicana in Rome (fig. 41). It may represent the emperor as pontifex maximus

and if so dates to after 12 B.C., the year in which Augustus became chief priest of Rome. The emperor wears a toga, its edge drawn up over his head, indicating that he is taking part in a solemn religious rite. His right arm is positioned to suggest that the emperor held a patera in his right hand and that he was in the act of offering a sacrifice. The head of the emperor – along with the neck, collarbone, and veil – is worked separately from the body and is made of Greek marble, while the body is fashioned from Italian marble. Comparisons of the style of the toga with that of other Augustan examples points to a late Augustan date for the statue. A special portrait artist was undoubtedly responsible for the head, which is a fine rendition of the still youthful emperor with a broad cranium and narrow chin, almond-shaped eyes shaded by sharp ridges that define the brows, an aquiline nose, and a rounded mouth. His face is smooth and idealized, and he wears the so-called Primaporta hairstyle and not that of the Actium type. The new hairstyle accompanies a new portrait type that is so named because the coiffure appears in the best-known portrait statue of the emperor found in his wife Livia's villa at Primaporta in 1863 (fig. 42). This hairstyle is characterized by its caplike appearance, the layers of hair arranged in comma-shaped locks over Augustus's forehead. The three locks above the nose and eyes consist of two parted at the center and a third on the emperor's right. The so-called Primaporta type seems to have been introduced to Rome in about 27 B.C., on the occasion of the reorganization of the Roman state and certainly no later than 20 B.C. It is today preserved in 170 replicas and variations and was therefore Augustus's primary portrait type. The Primaporta type is different from the Actium type in other ways as well. The emperor's neck is depicted as broader and shorter, the face is smoothed over and idealized, and the deep creases above the nose are gone. The ultimate model for the shape and idealization of the face and the configuration of the hair is the fifth-century B.C. athlete statue, such as the *Doryphoros* or Spear-bearer of Polykleitos, as apparent in a bronze Roman copy of the head of the *Doryphoros* from the Villa of the Papyri, now in the Naples Archaeological Museum.

The full-length statue portrays a cuirassed Augustus in the role of *imperator,* the head of Rome's military forces. The Primaporta statue, like other Augustan statues, was based on Greek athletic statues of the fifth century B.C., namely the *Doryphoros* of Polykleitos. This is apparent in the contrapposto of the pose with the right leg taut, the left leg relaxed, the left foot slightly raised, the varied heights of the shoulders and hips, and the position of the head. The major difference between the statue of Augustus and the *Doryphoros* is the gesture of the right arm – a Roman gesture of adlocutio or address that trans-

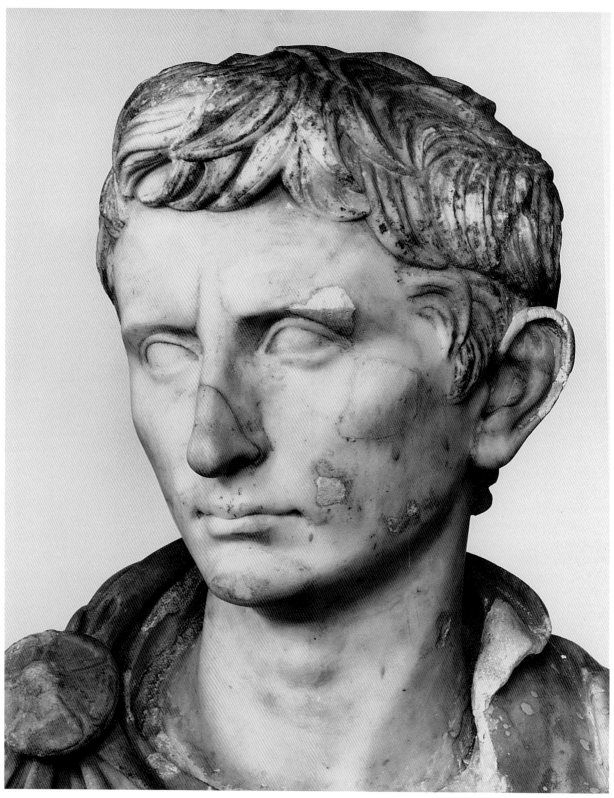

40 Portrait of Octavian, ca.30 B.C. Rome, Museo Capitolino.
Photo: Gisela Fittschen–Badura

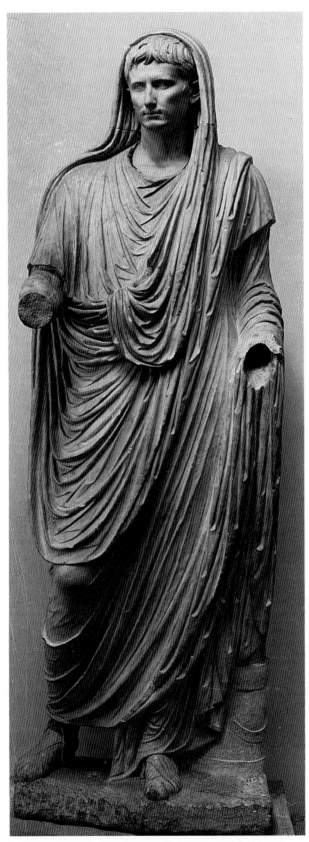

41 Portrait of Augustus as pontifex maximus, from the Via Labicana, after 12 B.C. Rome, Museo Nazionale delle Terme. Photo: DAIR 65.1111

forms the self-contained Greek image into a Roman one that activates the space around the statue and dominates the viewer. To date, most scholars have maintained that Augustus is represented in the Primaporta statue making an address, although a less likely reconstruction depicts the emperor with a lance in his right hand and a laurel branch in his left.

At the time this statue was first conceived, Augustus was in his early forties; nonetheless, he is still represented as youthful. The head of the statue is also in the classical Greek tradition. The shape of the head, cap of hair, and smoothed over and idealized features are comparable to those of the *Doryphoros,* although Augustus's personal physiognomy is allowed to show through. The portrait is a recognizable but artificial image. The emperor has a broad cranium, narrow chin, aquiline nose, rounded lips, and sharply ridged eyebrows, this last a hallmark of the Augustan style.

We have already seen that Augustus is presented here as a great general, a powerful orator, and as eternally youthful, with the body of a Greek athlete. Even the support for the marble statue at the left carries a message. Cupid or Eros, the son of Venus, rides on a dolphin. Cupid refers to Augustus's divine ancestry from Venus and may have dynastic implications as well. Some scholars describe Cupid's features as portraitlike and postulate that the chubby child may depict Augustus's grandson, Gaius Caesar, born in 20 B.C., although – as we shall see – this identification appears to conflict with the message of the statue's breastplate. The dolphin has political import since it refers to Augustus's naval victory at Actium.

The cuirass is completely covered with figures and has been used as a field for propagandistic messages, the iconography of which has yet to be fully deciphered. Even the rear of the statue, which is only summarily worked because the statue was displayed in a niche or against a wall, is ornamented with a trophy and part of a wing near the emperor's right arm. The trophy may complement the figure of a seated female captive on the front of the cuirass that may personify conquered Hispania (modern Spain). The other figures on the front of the breastplate are arranged in a series of zones, and the scene takes place in a cosmic setting. Caelus, or the Sky god, with his celestial mantle, is located at the apex. Just below him is the sun-god Sol in his four-horse chariot, as well as Aurora riding on the back of a female personification. The central register has the figures of Hispania on the left and another captive female barbarian, possibly Gallia, at the right. Beneath these are Apollo with his lyre riding on a winged griffin and Diana on the back of a stag, the same pair that crowned the Arch of Gaius Octavius on the Palatine. Tellus, or Mother Earth, cradling two babies and a cornucopia, reclines below.

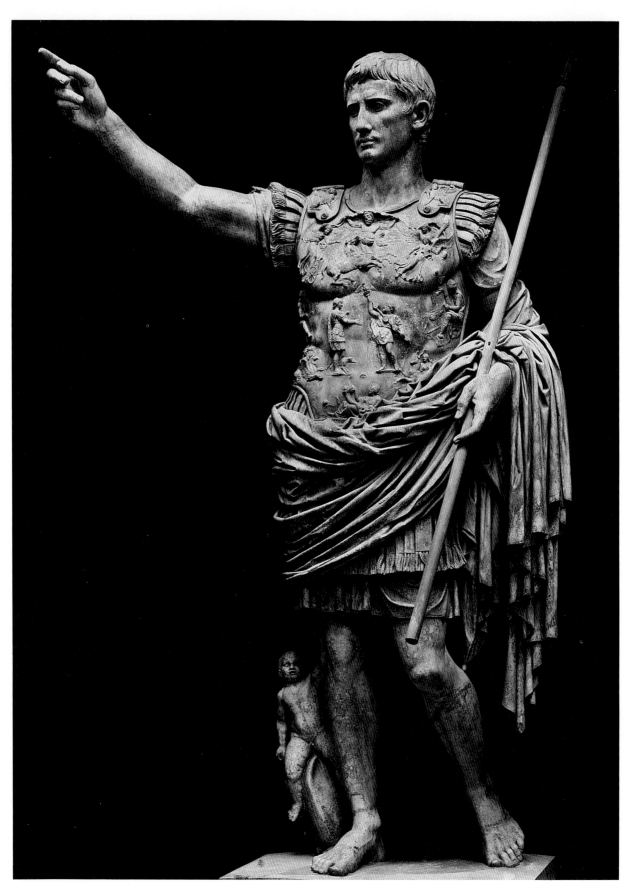

42 Portrait of Augustus as imperator, from the Villa of Livia
at Primaporta, Tiberian copy of 15 B.C. of an Augustan original
of 20 B.C. Rome, Vatican Museums, Braccio Nuovo. Photo:
Alinari/Art Resource, New York, 1318

The figures of the two captives and Apollo and Diana frame and focus on the breastplate's two most important figures. The one on the right is a Parthian barbarian, recognizable by his costume of tunic and baggy pants, who is sometimes identified as the Parthian king Phraates IV. He is holding a Roman standard that he is about to return to the man on the left who wears a helmet, a cuirass, and military boots, and who is accompanied by an animal that has been variously identified as a she-wolf or a dog. The identification of the military protagonist is equally controversial. Suggestions include Augustus-Aeneas, Tiberius, Mars, Romulus, and the *exercitus Romanus* – the personification of the Roman army. What is agreed upon, however, is the general subject matter of the scene – thought to portray the return to Rome in 20 B.C. of the military standards captured by the Parthians from the Roman general Crassus in 53 B.C. The statue thus commemorated Augustus's victory over Parthia, a diplomatic victory, won not on the battlefield but at the negotiating table. Nonetheless, Augustus made much of this victory because it was his first significant victory since Actium. At Actium, Augustus had defeated another Roman, Mark Antony, in a civil war. With the Parthian treaty, Augustus could claim a foreign victory as his basis for rule. Surviving historical sources indicate that Phraates IV restored the standards to Augustus, although Suetonius reports that it was Tiberius who served as the intermediary for the transfer (Suet., *Tib.*, 9.1).

This critical passage has fueled the controversy that continues to be debated. In the most recent discussions, it has been argued that the figure in the breastplate is Mars or the exercitus Romanus. Also at issue is the date of the marble statue from Livia's villa, which may replicate a bronze original set up in Rome or in the East. The statuary support in the form of a Cupid and dolphin strongly suggests that the Vatican statue is a copy. The emperor's bare feet, a curious detail since no general went into battle with bare feet but instead wore military boots, have been thought to indicate that Augustus was a divus at the time the statue was made or replicated. He is shown, however, in cuirass and barefooted in numismatic depictions dated shortly before and after 31 B.C. This controversy may never be resolved.

Nonetheless, it seems the most attractive theory remains that which identifies Tiberius as the hero of the breastplate. In this case, the marble statue must have been a copy of a bronze original statue of about 20 B.C. that may have had an undecorated breastplate and was possibly located in the Sanctuary of Athena at Pergamon where a base with feet positions that match those of this statue was found. The scene was added at the suggestion of Tiberius after Augustus's death, that is, in about A.D. 15, and was set up in Augustus's widow's house in Primaporta. Since Augustus was deified after his death, Tiberius was associating himself not only with his predecessor but with a god and was also portraying himself in a scene that commemorated a key event in Augustus's principate in which Tiberius served as Augustus's intermediary. Tiberius's legitimacy as Augustus's rightful successor is alluded to, as was Augustus's legitimacy as Caesar's successor in the divi filius coin. Such an interpretation would argue against the identification of the Cupid as Gaius Caesar. Gaius was no longer alive at Tiberius's accession and, in any case, Tiberius would not have wanted to acknowledge the emperor's elder grandson as Augustus's rightful heir. If the central scene on the breastplate depicts Tiberius receiving the Roman standards from a Parthian barbarian, or even from Phraates IV himself, it is another example of the Roman preference for the depiction of historical events amid environments peopled by gods and personifications.

Portraits of the emperor and his family were set up in Rome, and portrait models shipped to all the provinces to be copied or altered according to local concepts of the princeps or to conform to local workshop tradition. In the provinces, these copies or variations served as symbols of imperial authority and designated the city as a miniature Rome that enjoyed the fruits of Romanization. It was under Augustus that imperial portraits were first made in great numbers and disseminated to the provinces as icons of imperial imagery.

A case in point is the bronze head of Augustus from Meroë in the Sudan, the ancient capital of Ethiopia (fig. 43). It was discovered under the entrance staircase to a victory temple of the Ethiopians and was probably seized as booty by Ethiopian forces after the capture of Syene in 24 B.C. It is one of the few bronze heads of the emperor surviving from antiquity and is probably a fragment of a full-length bronze statue dating to 27–25 B.C. The intensity of the portrait is due in large part to the eyes, which are inlaid with marble; the irises are indicated in glass. The Primaporta hairstyle and the shape and features of the head suggest that it is a replica of a statue from the city of Rome.

Another portrait of Augustus possibly made for a provincial center is the bronze equestrian statue of the emperor, found in the north Aegean Sea in 1979 (fig. 44). The head and upper part of the body, including both arms, are preserved. The position of the body and the emperor's upper thighs indicate that he sat on a horse. He is clad in a tunic and military cloak (*paludamentum*), and the forward gesture of his right arm is one of adlocutio. It has been suggested that the portrait combines features of the Actium and Primaporta types with the hair arranged in the Actium pattern and the shape of the head and configuration of the facial features approximating those of

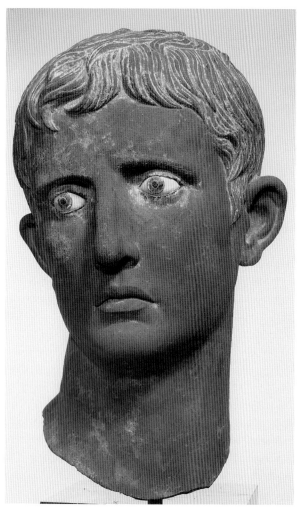

43 Bronze portrait of Augustus, from Meroë (Sudan), ca. 27–25 B.C. London, British Museum. Photo: Courtesy of the Trustees of the British Museum

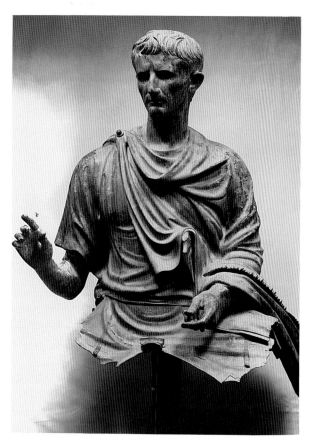

44 Bronze equestrian statue of Augustus, from the North Aegean Sea, last two decades first century B.C. Athens, National Museum. Photo: Deutsches Archäologisches Institut Athen, 80.977

the Primaporta type, although the deep vertical creases above the nose of the Actium type are also present. The statue has been associated with numismatic representations of an equestrian Augustus on *denarii* of 19–4 B.C. and probably also dates to the last two decades of the first century B.C. The equestrian statue may have been manufactured in a major center in the Greek East or produced in a workshop in Rome and either shipped to the East for display in a public space or set up in Rome or elsewhere in Italy and transported to the East at a later date.

The third portrait type of Augustus, the Forbes type (called by some scholars the Ara Pacis type because it is the one that appears in the emperor's portrait on that monument), represents the emperor with a hairstyle brushed to one side. A portrait from Rome (fig. 45) illustrates this type, which is preserved in thirty replicas and variants. The Forbes type is the most controversial of Augustus's portrait types. Dispute has centered on whether the type was created at about the same time as

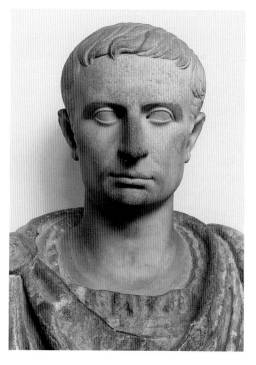

45 Portrait of Augustus after 20 B.C. Rome, Galleria Borghese. Photo: DAIR 80.2866

the Actium type or after the Primaporta type. Supporters of the latter claim to see the signs of age in the slight creases at the corners of the emperor's eyes and mouth visible in some of the copies of the Forbes type.

Augustus's portraits were updated in posthumous versions made immediately after his death as well as much later. An example is a portrait of the emperor from Ariccia (fig. 46), in which Augustus is depicted with the Primaporta coiffure. It is, however, a fuller version of the traditional hairstyle with an additional layer of hair, the whole cap more plastically rendered in the manner of the first and second centuries.

Although the names of the court artists responsible for creating Augustus's main portrait types are not known, the name of the man who carved Augustus's signet ring with the emperor's likeness has come down to us; it is Dioscurides (Suet., *Aug.*, 50). It is highly likely that Dioscurides had a hand in designing not only gems with the emperor's portraits but also those with quasi-historical scenes such as the famous Gemma Augustea.

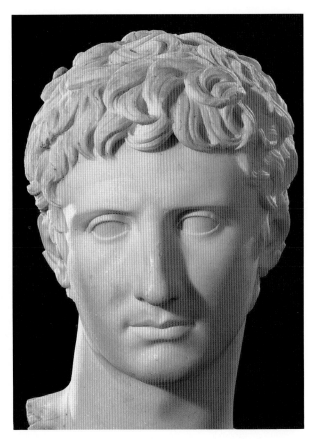

46 Portrait of Augustus, from Ariccia, first or second centuries. Boston, Museum of Fine Arts, H. L. Pierce Fund. Photo: Courtesy of the Museum of Fine Arts

The Gemma Augustea

The emperor is depicted, along with other members of his dynasty, in imperial cameos that were used as one-of-a-kind, private imperial presentation pieces. Cameos were first produced in Hellenistic times but continued to be popular under the Romans when they were decorated with portraits of individual members of the imperial family or with elaborate group scenes with historical and political references. Unquestionably, the best-known and arguably the finest surviving Roman cameo is the Gemma Augustea (fig. 47). The date of the large sardonyx gem is controversial. Some scholars date it to the principate of Augustus; others place it in the early Tiberian period; still others favor a Claudian date because it was under Claudius that there was a deliberate revival of Augustan imagery and a special affection for the kind of imperial group portrait that serves as the focus of the Gemma Augustea.

The scenes on the Gemma Augustea are arranged in two registers. In the upper tier, there are three human protagonists – all male – surrounded by a host of divinities and personifications. The three humans are distinguished from the others by their drilled pupils and by the fact that their specific features conform to those of identifiable members of the imperial circle – Augustus, Tiberius, and Germanicus. Augustus is seated on a *bisellium* (a seat of honor large enough to accommodate two distinguished persons) toward the center of the scene. He is nude from the waist up; the lower part of his body is wrapped with a mantle. His feet are shod with sandals

and rest on a shield. There is an eagle, the attribute of Jupiter and the symbol of imperial power, at his side, and he holds the augur's staff or *lituus* in his right hand and the scepter of Jupiter in his left. On the left, Tiberius, dressed in a toga and with a wreathed head, alights from a four-horse chariot and turns in the direction of the emperor. Augustus and his successor are further linked by the figure of Germanicus depicted as a youth in breastplate who also turns toward the emperor. Of the three historical personages only the identification of Germanicus is widely debated, with some scholars associating the young military man with Gaius Caesar. The presence of three historical personages indicates that the cameo alludes to a specific historical event, the precise identification of which has been debated. Suggestions include the triumph of Tiberius in 7 B.C., after his German victories; Tiberius's triumph in 12 after his victories in Illyricum; and the entrance of Tiberius into Rome in 9 after the Illyrian victories but in advance of campaigns in Germany. In the last case, it has also been pointed out that Germanicus was the one who had announced Tiberius's Illyrian conquest in Rome (Cassius Dio 56.16.4), which would explain his inclusion in the scene. The lower edge

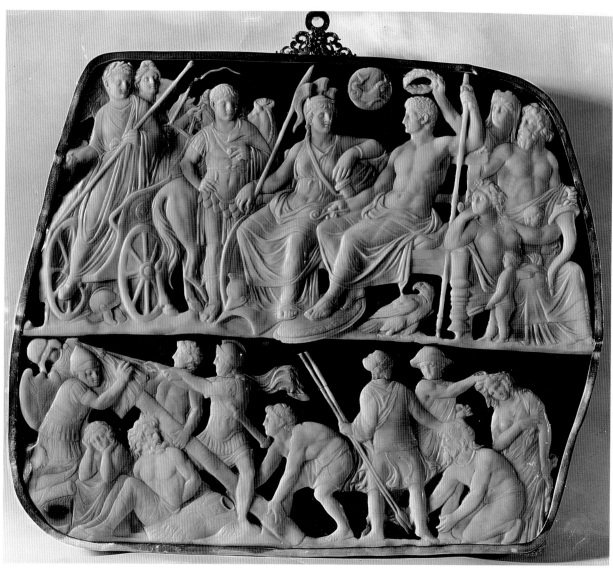

47 Gemma Augustea, ca.15. Vienna, Kunsthistorisches
Museum. Photo: Courtesy of the Kunsthistorisches Museum

of a toga is all that remains of a missing figure to the left
of Tiberius (the left side of the cameo was recut in post-
antique times, perhaps in order that the gem fit its new
gold setting). The figure has been variously identified as
the Genius Senatus, Tiberius's son, Drusus the Younger,
and Venus, among others. In support of Drusus, it has
been asserted that he was accorded honors at the time
of his father's Illyrian victory even though he did not
participate in the campaigns and even though Drusus,
in toga, and Germanicus, in battle dress, were Tiberius's
son and adopted son, respectively. Their inclusion would
thus make reference to the harmony or *concordia* of the
imperial family and serve as a visual statement of their
dynastic ambitions. Owing to the deaths of Gaius and
Lucius Caesar, Augustus formally adopted Tiberius in
4, and Tiberius was coerced into adopting the emperor's
nephew Germanicus at the same time. Such dynastic

allusions were common in the Augustan period and are
paralleled in the Ara Pacis and in other state monuments.

The other figures in the upper register are divinities
or personifications. Roma, whose foot rests on the same
shield as the emperor's, is seated next to Augustus. She
carries a spear in her right hand and wears a helmet; a
sword in a sheath is strapped across her chest. She wears
a long garment belted below her covered breasts, instead
of her traditional Amazonian costume. A capricorn, the
birth sign of Augustus, is enclosed in a roundel that
hovers between Roma and Augustus. Winged Victory ac-
companies Tiberius in his chariot and, in fact, holds the
reins of the four foreshortened horses. Tellus or Italia (or
perhaps the composite Italiae Tellus) with cornucopia and
two babies leans on the emperor's bisellium at the right.
The children serve not only as her attributes but under-
score her message of increased fecundity for the Roman

empire under the *Pax Augusta*. Furthermore, they may refer to Augustus's procreation laws, which encouraged a high birth rate especially among the aristocracy and which was a major theme of the sculptural program of the Ara Pacis. Reference to the city of Rome and Italy is complemented by a reference to the provinces and the world in the figure of Oikoumene, wearing the mural crown of the cities of the empire and symbolizing the civilized world. She holds the crown of oak leaves or *corona civica* above the emperor's head. Between Oikoumene and Italiae Tellus is a bearded male figure nude from the waist up, identified either as Neptune or Oceanus, the latter being the personification of the ocean that surrounded the earth.

The upper register of the Gemma Augustea thus celebrates Augustus's dominion over the civilized world, which included Rome, Italy, and the provinces. The Augustan peace, which ensured tranquility and abundance, was built on its military victories as well as on the personal charisma of Jupiter's representative on earth, a man whose legacy included his successor Tiberius and other members of his dynasty, like Germanicus.

Although the upper register may refer to Tiberius's return to Rome in A.D. 9 after a specific military encounter, the military imagery of the upper register can also be seen in the helmets and shields strewn below the feet of Augustus, Roma, Tiberius, and Germanicus, and in Germanicus's military garb. The military theme is continued in the lower tier with its scene of captive barbarians and the raising of a trophy by Roman soldiers. A shield attached to the trophy is decorated with the Scorpio, Tiberius's birth sign, suggesting that it was Tiberius's military victories that are being celebrated in this scene. Most scholars have identified the barbarians as Illyrians from the north. On the left, the trophy crowned by a helmet is raised by two helmeted soldiers with breastplates and by two males with bare chests, identified as freed slaves who joined the fighting forces in Illyricum. A male barbarian with long scraggly locks and beard has his hands tied behind his back. He confronts his captors with a defiant glance that is in strong contrast to the mournful expression of the female captive who rests her weary head in her hands. One scholar restores two additional male and female barbarians at the far left. On the right are barbarians being brought into submission. The male captive kneels in supplication, and the female is being pulled by the hair by a man who may be a Thracian warrior, identifiable by his distinctive hat. A crying child has been restored at the woman's right. The warrior with her back to the viewer is a woman in chiton, armor, and boots. Her hair is wrapped in a scarf and she holds two spears in her left hand. She is usually identified as a Thracian or Balkan auxiliary, but she has also been as-

sociated with the personification of Spain, who appears in like fashion in numismatic representations. Furthermore, Tiberius's German conflict necessitated the help of forces drawn from elsewhere in the empire, including Spain, and the right-hand scene must be seen as separate from the left. The trophy raising referred to Tiberius's successful Illyrian campaign, the submission scene to the German conflict that lay in the future. It is for this reason, among others, that one scholar dates the Gemma Augustea to 10, that is, it postdates the Illyrian campaign completed in 9 and predates the German campaign for which Tiberius was awarded a triumph in 12.

Augustus was never depicted with the attributes of Jupiter in state portraits fashioned during his lifetime. Augustus's attributes of the long scepter and eagle associate him with Jupiter, but the lituus he carries is not an attribute of Jupiter. Instead, the augur's staff signifies that the emperor is the god's viceregent, who interprets his will on earth and is an intermediary between the human and divine realm. The augur's staff may also make reference to Augustus's patron god, Apollo, who was the deliverer of the oracles that revealed the will of the gods. Although Augustus is not represented on the Gemma Augustea as Jupiter but rather as the god's representative on earth, the image is a far cry from the first-among-equals image that Augustus cultivated in his state portraiture. The Gemma Augustae was, like all Roman cameos, a private object, commissioned by the emperor or a member of his circle, as a presentation piece for a foreign dignitary or as a gift for another member of the Augustan inner circle. In the private realm, Augustus could adopt any guise he wanted. Nonetheless, it seems unlikely that he would have commissioned a work of art that celebrated Tiberius to such an extent. Although Tiberius is not represented at center stage, it is Tiberius's military victories, won in the name of his emperor and not Augustus's own, that are represented as the basis of the Augustan peace. Livia, Tiberius's mother, who is herself not included in the scene, might also have been the patroness of the cameo, but the most likely candidate is Tiberius himself. The Gemma Augustea seems to refer to Tiberius's Illyrian and German victories. His birth sign is appended to the trophy, and his adoption is alluded to in the upper register where he is aligned with Augustus and Augustus's nephew, Tiberius's adopted heir, Germanicus. Tiberius favored commissions in which he was the hero of the story, and there is evidence that in the first years of his principate he commissioned monuments that closely allied him not only with the divus Augustus but with his predecessor's military and diplomatic successes, especially those in which Tiberius himself played a key role. If the Gemma Augustea was a Tiberian commission of about 15, the portrayal of Augustus as Jupiter's

viceregent is more acceptable even in the realm of private commissions.

The Portraiture of Gaius and Lucius Caesar

Portraits of the emperor were sometimes erected in isolation and more often as part of imperial groups that emphasized not only imperial power but alluded to the formation of a new dynasty that would carry on the mission of Rome's first emperor. Augustus is displayed, for example, along with his two heirs, Gaius and Lucius Caesar, in a marble group portrait set up in the Julian Basilica at Corinth (figs. 48–50). The emperor's head, capped with the usual Primaporta coiffure, is covered with a mantle drawn up over his head in the manner of the Via Labicana statue (see fig. 41). In both, the emperor is in the act of offering a sacrifice, and in the Corinth statue he probably held a patera in his right hand. The portraits of Gaius and Lucius Caesar are, in contrast to that of Augustus, shown in heroic nudity with mantles draped over their left shoulders. The two youths died prematurely and the group can presumably be interpreted as Augustus making a sacrifice in honor of his heroicized deceased grandsons. To accentuate the close association of emperor and heir apparent, their coiffures are variants of the Actium and Primaporta hairstyles.

Gaius and Lucius Caesar were the sons of Augustus's only child, Julia, and Marcus Agrippa. Gaius, the elder of the two, was born in 20 B.C., Lucius in 17. Both were adopted by Augustus on the occasion of the second birth. The emperor lavishly bestowed titles on both boys, and after Agrippa died in 12 B.C., it became apparent that Augustus wanted one of his grandsons to succeed him. Gaius assumed the toga worn by men or *toga virilis* in 5 B.C., Lucius in 2 B.C. Gaius became consul in A.D. 1 and was admitted to the senate. Both he and Lucius were saluted as leaders of the equestrian order or *principes iuventutis*. Furthermore, the emperor took a great personal interest in his grandsons. According to Suetonius, Augustus was rarely separated from the boys. They sat beside him at dinner and accompanied his carriage on journeys. Augustus was also personally involved with the education of Gaius and Lucius; he taught them to read and to swim and even to imitate his handwriting (Suet., *Aug.*, 64.3). Augustus's high hopes for his grandsons were never realized since both died while still youths: Lucius in 2 at the age of 18; Gaius in 4 at 23.

Official numismatic and sculptured images of Augustus's grandsons and selected heirs, Gaius and Lucius Caesar, were produced from their infancy on, and it is not surprising that these were deliberately calculated to depict the princes as miniature versions of their illustrious

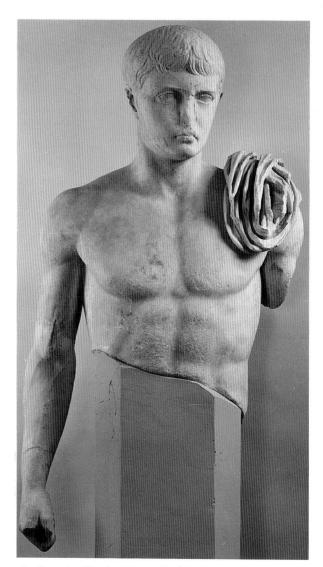

48 Portrait of Lucius Caesar, from dynastic group in Julian Basilica, Corinth, after 4. Corinth, Archaeological Museum. Photo: Courtesy of the American School of Classical Studies, Corinth Excavations

grandfather. Augustus's most outstanding facial characteristics may have been inherited by the boys through Julia, but it is also possible that in actuality they resembled Agrippa more closely. In any case, their actual or fictional resemblance to Augustus was accentuated in their portraits in order to underscore the inevitability of their succession. Both are depicted with smooth youthful faces with pointed chins and broad craniums. Both have rounded lips, aquiline noses, almond-shaped eyes, and straight brows like ridges and, most significantly, both are depicted with caps of hair that are variations of either Augustus's Actium or Primaporta coiffures.

The assimilation of Gaius and Lucius Caesar to Augustus was so successful that modern scholars have found it difficult to tell them apart, and scholarly writings on the portraits of Gaius and Lucius have focused on

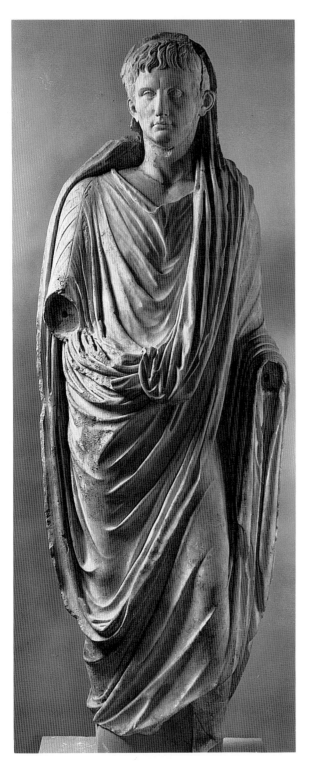

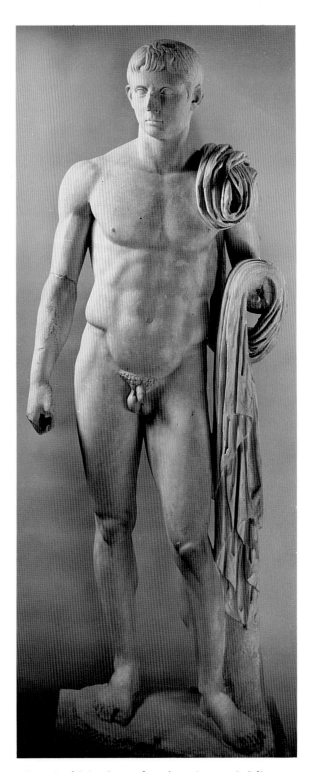

49 Portrait of Augustus, from dynastic group portrait in Julian Basilica, Corinth, after 4. Corinth, Archaeological Museum. Photo: Courtesy of the American School of Classical Studies, Corinth Excavations

50 Portrait of Gaius Caesar, from dynastic group in Julian Basilica, Corinth, after 4. Corinth, Archaeological Museum. Photo: Courtesy of the American School of Classical Studies, Corinth Excavations

differentiating them. Their classicizing style, characteristic of the Augustan and Julio-Claudian period, further complicates the issue. The most recent attempt to differentiate the boys includes a catalogue of thirty portraits of Gaius and ten of Lucius. The author believes that this discrepancy in number is due to the longer life and greater prominence in public life of Gaius rather than to the vagaries of preservation.

The portraits of Gaius and Lucius were popular during their lifetimes – after their death but before that of Augustus – and in the early years of Tiberius's principate. After that time, interest in them quickly diminished. Gaius's portraits have been divided into five types and Lucius's into three, these types associated with different events in the boys' lives.

The Corinth group of Augustus and his grandsons has been the focus of studies on the portraiture of Gaius and Lucius. The date of the group, discussed above (see figs. 48–50), is controversial, ranging from Augustan to Flavian times, and further debate has focused on distinguishing Gaius and Lucius. A date immediately after 4 seems most likely since the boys are displayed in total nudity and are thus heroicized. Careful study of numismatic evidence and other criteria have led to the identification of the fragmentary youth ("Corinth 136") as Lucius and the full-length figure ("Corinth 135") as Gaius. Gaius's Corinth portrait is thought to bear a closer physiognomic resemblance to Augustus's, which is what one would expect of the emperor's oldest heir.

As already mentioned, some scholars have postulated that the Cupid that serves as the support for the statue of Augustus from Primaporta (see fig. 42) has the facial features of the infant Gaius. The boy with the robe of a *camillus* in the north frieze of the Ara Pacis (see fig. 77) has also been associated with Gaius. Neither of these identifications seems to me convincing; if they were Gaius, they would have been fashioned in 20 B.C. and 13–9 B.C., respectively. The latter corresponds in date to the type 1 portrait of Gaius that depicted the boy between the ages of seven and thirteen and was probably created on the occasion of his introduction to public life and his first participation in military exercises. The type is best exemplified by a marble head from Pesaro (fig. 51), which represents him with a round boyish face, even features, and a three-pronged cap of hair resembling Augustus's Primaporta coiffure. Type 2 is Gaius's adolescent type (associated in the past by scholars with the young Octavian), which depicts a more mature boy of fourteen or fifteen with the features of Augustus and with the Primaporta coiffure. It has been related to the significant events of Gaius's life in 6–5 B.C.: the assumption of the toga virilis and his appointment as princeps iuventutis. Gaius's type 3 portrait appears to have been created at the time

of the young man's eastern mission in 2 B.C., his first major military undertaking. Type 4, to which "Corinth 135" (see fig. 50) belongs, seems to commemorate Gaius's appointment as consul in Rome in 1. Gaius's type 5 portraits are the most controversial. Thirteen portraits, some bearded and some not, originally attributed to Augustus (those with facial hair, for example, the well-known portraits in Arles [see fig. 39] and Verona, representing Augustus in mourning for Caesar), have now been associated with Gaius's campaigns in Arabia in 1 and in Armenia in 2–3. The inclusion of the beard is explained as a reference to the warlike Gaius's assimilation to Mars/Ares. Furthermore, the evidence of the famous divi filius coin of Augustus (see fig. 37) with the beard of mourning, contemporary to the Arles and Verona heads, is dismissed, and it is suggested that the coin depicts Octavian in the guise of the avenger of Caesar's death, Mars, and not as a grieving "son. This seems highly unlikely, and I still favor the identification of this type as that of the mourning Octavian.

That there are fewer extant portraits of Lucius make his portrait typology more difficult to establish. Nonetheless, the surviving candidates have been divided into three main types, representing Lucius as a boy of seven to thirteen (type 1), as an adolescent of fourteen to fifteen (type 2), and as an adult of eighteen (type 3). As in the case of Gaius, these appear to have been created to commemorate his introduction to public life (type 1), his designation as princeps iuventutis in 2 B.C. (type 2), and

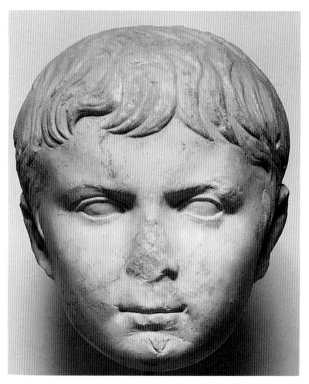

51 Portrait of Gaius Caesar, 13–9 B.C. Pesaro, Museo Oliveriano. Photo: DAIR 75.1108

his first major military undertaking, in his case to the West, in 1–2. It is to the third type that "Corinth 136" (see fig. 48) belongs.

The Portraiture of Marcus Agrippa

Marcus Vipsanius Agrippa, father to Gaius and Lucius Caesar, and himself the obvious successor to Augustus before his death in 12 B.C., was born in 64 or 63 B.C., probably to a well-to-do family. Agrippa was the life-long friend from school days and supporter of Augustus, and he used his great wealth – probably from the first of his three marriages, to Attica – to enhance Rome and thus personally augment Augustus's great building program. In Rome, for example, Agrippa built the Pantheon, the Baths of Agrippa, and two new aqueducts, the Aqua Julia and the Aqua Virgo. He was also the guiding force behind major Augustan building projects in the provinces, most outstandingly in Gaul and Greece, where he commissioned such diverse structures as the the Pont-du-Gard at Nîmes and the Odeon of Agrippa in Athens. In this way, Agrippa made a major contribution not only to the redesign of Rome but also to the building of smaller Romes elsewhere in the empire. He was a powerful and ambitious man who, like Augustus, was successful in war and peace, but he always subordinated his interests to those of his emperor.

Agrippa's lifetime portraits have been divided into two main types. The first, the Gabii type, was fashioned in 30–20 B.C., and the second, the Venice type, in 20–10 B.C. The Gabii type got its name from the best-known likeness of Agrippa, an exceptionally fine portrait discovered in the Forum of Gabii (fig. 52). It is one of four copies of the same original. Made of Pentelic marble, it depicts Agrippa as a man of action. It is done in the Hellenistic style, probably by a Greek artist, and is characterized by the turn of the head, the curvature of the brow, deep-set eyes, squarish forehead, and prominent musculature. Agrippa wears his hair in a full, somewhat tousled cap, resembling, but not the same as, that of Octavian in the Actium type.

Agrippa is also represented in a position of prime importance on the south frieze of the Ara Pacis Augustae (see fig. 75). There he is shown, in one of a number of diverse posthumous types, as a man of advanced years with the marks of age, including a wrinkled forehead, crow's-feet at the corners of his eyes, and flaccid cheeks.

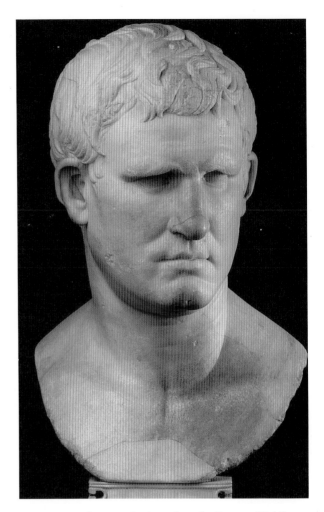

52 Portrait of Marcus Agrippa, from the Forum of Gabii, 30–20 B.C. Paris, Musée du Louvre. Photo: Cliché des Musées Nationaux

Female Portraiture in the Age of Augustus:
Livia, Octavia, and Julia

The portraits of Augustus's wife, sister, and daughter depict young women with smooth skin, lovely ageless countenances, and parted coiffures that are based on those of Greek goddesses. Although Julia was the daughter of Scribonia and not of Livia, and Livia and Augustus's sister, Octavia, were not related, the similarity of the three in their surviving portraits is striking and intentional. The assimilation of these court females to one another was due to Augustus's profound belief in the aristocratic family united not only by blood but by fictional visual association as well as his insistence on a classical idealizing style that tended to drain its subjects of their individuality.

The resemblance of the imperial ladies to one another in their portraiture complicates the establishment of

portrait typologies. They were even coiffed in similar fashion, with hairstyles based in part on Greek prototypes but also incorporating innovative Roman features, like the nodus, which proved to be popular not only among the aristocracy but also among freedwomen.

Livia Drusilla, the wife of the emperor Augustus, was born on 30 January 58 B.C. In 43 or 42 B.C., she married her first husband, Tiberius Claudius Nero, with whom she had two sons, Tiberius and Drusus, the former eventually succeeding Augustus. In 39 B.C., Nero divorced Livia so that she could marry Augustus. Together Augustus and Livia did not produce any children who survived, but they maintained a close lifelong relationship. In Augustus's will, Livia was adopted into the Julian family and given the name *Julia Augusta*. Discord developed between her and her son Tiberius during his principate, and at her death in 29 he refused to execute her will and allow her to be deified. It was left for the third emperor of Rome, Caligula, to process the will, and the fourth, Claudius, to see that Livia was finally deified.

Livia's portraits have been divided into four main types, named after the present locations of their finest examples: the Villa Albani-Bonn type, the Copenhagen type 616, the Copenhagen type 615, and the Marbury Hall type.

In the black basalt portrait now in the Villa Albani (fig. 53), which belongs to type 1, Livia is represented in the same ageless classicizing style as Augustus. Although the portrait was made in the late 30s B.C. and was most likely based on an original created in about 35 B.C., it probably depicts the twenty-year-old Livia at the time of her marriage to Augustus. She wears the distinctive coiffure of the period that she helped to popularize – the nodus coiffure – in which the hair over the forehead is twisted into a roll called a nodus. The remainder is brushed in waves over and partially covering the ears and gathered into a bun at the nape of the neck. The hairstyle was adopted not only by members of the court and the Augustan aristocracy but also, as we shall see, by freedwomen.

Type 2 was created in about 30 B.C. and appears to have been distributed widely in the East. A marble portrait in the Ny Carlsberg Glyptotek, which comes from Asia Minor, is one of two certain examples of this type. It depicts Livia with the same classicizing features and the same smooth skin, although the roll of hair over the forehead is considerably broader and there are long loose curls falling on each shoulder.

Type 3, the most widely distributed of the four and known in the largest number of surviving replicas and variations, is exemplified by another marble head now in the Ny Carlsberg Glyptotek (fig. 54). It was originally part of a dynastic group discovered in the Fayum in

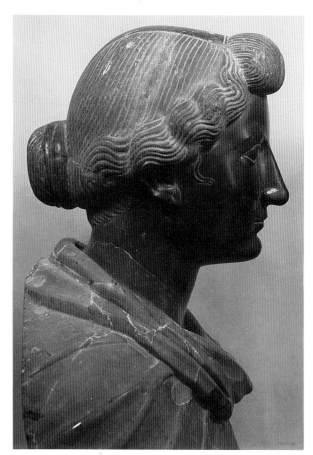

53 Basalt portrait of Livia, late 30s B.C. Rome, Villa Albani. Photo: DAIR 38.1216

Egypt. It included statues of Augustus, Livia, and Tiberius and was probably put up after the death of Augustus in 14. Nonetheless, Livia's portrait, which depicts her as a youthful bride and not as the matron of sixty that she was in 14, was probably based on a prototype created in the 20s B.C. In the portrait, Livia is depicted with a nodus over her forehead and with hair brushed in deep waves covering the top part of her ears and fastened in a bun wrapped with a braid at the nape of her neck. Loose tendrils of hair escape from the coiffure at her temples, along the sides of her face, and at the back of her neck. She is portrayed with an oval face, large, almond-shaped eyes, brows delineated by sharp ridges, a strong aquiline nose, and a small, rounded mouth. Her skin is unlined and the portrait preserves for posterity the features of a young woman, suggesting that Livia's portraits, like those of Augustus, were fictional images with a political aim. If Augustus was the eternal youth, Livia was his eternally youthful consort.

Nonetheless, some signs of age seem to have been incorporated in Livia's latest portrait type, the Marbury Hall type, as they may have been in Augustus's Forbes type. A marble portrait, formerly in Marbury

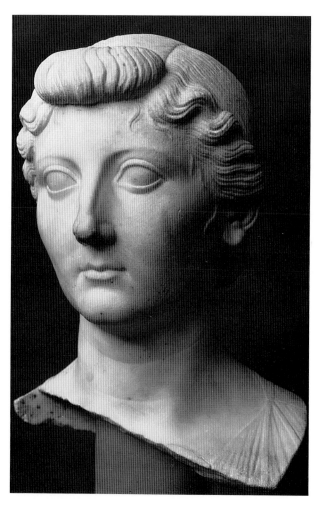

54 Portrait of Livia, from the Fayum, after 14. Copenhagen, Ny Carlsberg Glyptotek. Photo: Courtesy of the Ny Carlsberg Glyptotek, Copenhagen

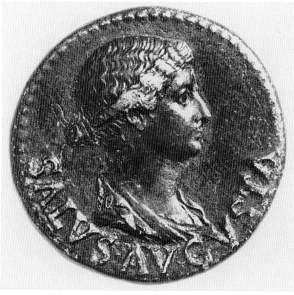

55 Sestertius with portrait of Livia as Salus Augusta, after 22. London, British Museum. Photo: Courtesy of the Trustees of the British Museum

Hall, depicts the empress with a nodus over her forehead, now linked with the bun at the back of her neck by a flat braid on the top of her head, and the hair at the side of her face is more waved in a more complicated pattern than in earlier types. Her face is still completely unlined, although the flesh on her cheeks, jaw, and neck have begun to sag and there are slight lines next to her nose and mouth. The original of the Marbury Hall type was probably first devised between 20 and 10 B.C.

Portraits of Livia, like portraits of Augustus, appeared on the Roman coinage. An example is a portrait on a sestertius dating to after 22 and portraying Livia as Julia Augusta (fig. 55). The numismatic portrait of Livia is accompanied by a legend – "Salus Augusta" – the health of the Augusta. The coin is one of a series commissioned by Tiberius in honor of Livia and her recovery in 22 from a serious illness, the same illness that inspired Tiberius to vow to build the "Ara Pietatis Augustae" (see figs. 118–120). The coin portrait shows Livia with the same facial features as in the sculptured portraits of the 30s B.C. and A.D. 14, but with a different coiffure, one that was popular with court females during the principate of Tiberius. This hairstyle is not the Augustan nodus coiffure, but a new hairstyle in which the hair is parted in the center and brushed in waves over the ears. It is then fastened in a bun, wrapped with a braid, and placed at the nape of the neck. One loose strand of hair escapes from the bun. One special characteristic of female versus male Roman portraiture is that the hairstyles of women changed to reflect variations in fashion, and portraits of deceased women were updated in posthumous versions even if there is no evidence that the woman wore a particular coiffure.

Coins such as the Salus Augusta coin were widely circulated throughout the empire. As we have seen, precious cameos had a more limited audience since they were intended as state or family presentation pieces. An example is the so-called Marlborough Turquoise Cameo of about 14–19 (fig. 56), which was manufactured after the death of Augustus and portrays Tiberius with his mother Livia. In this group portrait, Livia is shown in the guise of the goddess Venus with her drapery slipping off her shoulder. Such a portrayal of Livia as Venus is not surprising because Augustus's will stipulated that Livia be adopted into the Julian family, and Venus was the patron goddess of the Julian line. As in the Salus Augusta coin, Livia is depicted with an up-to-date Tiberian hairstyle. It is brushed in waves over her ears but tied in a knot, made up of a braid at a lower position at the nape of her neck. A corkscrew curl falls on her shoulder.

Another member of Augustus's court was the emperor's sister, Octavia. By 54 B.C., Octavia had married Gaius Marcellus, who died in 40. Immediately thereafter she married Mark Antony, who left her not long after

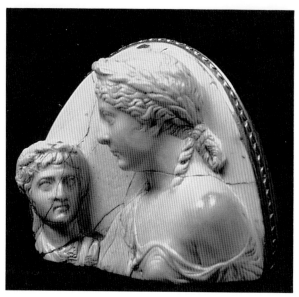

56 Marlborough turquoise cameo with portraits of Livia and Tiberius, ca.14–19. Boston, Museum of Fine Arts, H.L. Pierce Fund. Photo: Courtesy of the Museum of Fine Arts

57 Cameo with portrait of Octavia, 30 B.C. Paris, Bibliothèque Nationale. Photo: Phot. Bibl. Nat. Paris

to journey to the East. Although Antony divorced her in 32 B.C., her great nobility and virtue led her to raise Antony's children by Cleopatra and Fulvia as well as her own. Octavia died in 11 B.C.

Portraits of Octavia, like those of Livia, can be found on the Augustan coinage, in the round, and on precious cameos. A portrait of Octavia on a cameo of 30 B.C. (fig. 57), is roughly contemporary to the black basalt portrait of Livia in Rome (see fig. 53). Octavia has facial features similar to Livia, and the two resemble one another in their portraits, even though they were not related, because of the Augustan classicizing gloss that took cognizance of but smoothed over individual facial features. Octavia also wears the same coiffure as Livia. Octavia, however, may have worn it first and have been the trendsetter. Her hair is rolled in a nodus over her forehead with a thick strand of hair over her head (this thick strand appears only in Livia's Marbury Hall type), loose waves next to her face, a tight bun wrapped with braids at the nape of her neck, and an escaping tendril of hair.

Augustus's only child, his daughter, Julia, was born in 39 B.C. and married three times, first to Marcus Marcellus, then to Marcus Agrippa, with whom she had five children – Gaius and Lucius Caesar, Julia, Agrippina, and Agrippa Postumus – and last to Tiberius. Julia was famous, however, for her adulteries – not her marriages – and was banished from Rome by Augustus in 2 B.C. Julia is represented on coins with a variant of the nodus coiffure, but her portrait on the Ara Pacis Augustae is disputed. Alternate suggestions have included the female figure in the north frieze wearing a fringed shawl (see fig.

77) or the figure of "Livia" on the south frieze (see fig. 75). Only the latter's face is preserved. It is idealized and classicized, as are all of the portraits of women on the Augustan altar, and the woman is depicted with a wavy coiffure parted in the center and with long curls falling on her shoulders. Its attribution to Livia is more likely than that to Julia. In fact, the dearth of portraits of Augustus's only surviving child is noteworthy and may be due to more than the vagaries of preservation. As Augustus's daughter and the mother of his adoptive sons, Gaius and Lucius Caesar, Julia merited a position of importance on the Ara Pacis, her inclusion there may have served as one of her last public portrayals. Banishment from Rome by her father may have led to an unofficial damnatio memoriae, making her an unworthy subject for imperial portraiture.

The Portraits of Freedmen and Freedwomen under Augustus

The private portraiture of members of the Augustan aristocracy, the senate, and the equestrian rank seem to have followed the style and iconography of Augustan court portraiture. Nonetheless, portraits of the nobility were not the only ones commissioned in Augustan times. Enfranchised slaves or Roman freedmen also ordered portraits that continued the tradition of their republican counterparts (see figs. 19–22).

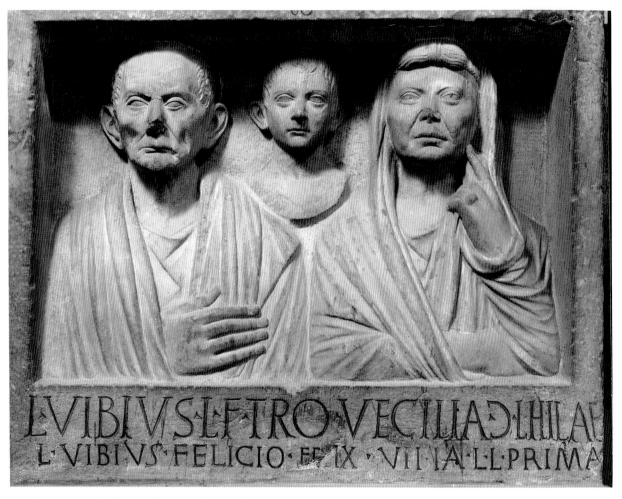

58 Funerary relief of Lucius Vibius and Vecilia Hila, 13 B.C.–
A.D. 5. Rome, Vatican Museums, Museo Chiaramonti. Photo:
Alinari/Art Resource, New York, 26984

An Augustan example is the funerary relief of Lucius Vibius and his family (fig. 58). The epitaph tells us that the father is Lucius Vibius, the freeborn son of Lucius Vibius, and a member of the Tromentina tribe. The man's portrait is in the veristic style of the republic. He is depicted as balding, as were Julius Caesar and other leading men of the late republic, and has the sunken cheeks characteristic of the so-called death mask type of the first century B.C. The woman, Vecilia Hila, wears a version of the nodus hairstyle favored in contemporary court circles by Livia and others (see figs. 53–54). The retrograde C following Hila's name in the inscription indicates that she was freed by a woman. Between the couple is their freeborn son, Lucius Vibius Felicius Felix. His bust portrait floats above their portraits, and his coiffure is in the new Augustan mode, comparable to the caplike coiffures with locks combed over the forehead and in front of the ears of Gaius and Lucius Caesar (see figs. 48, 50–51).

In fact, group portraits of Gaius and Lucius and other members of the imperial family in the round and in re-

lief (for example, on the Ara Pacis Augustae, see figs. 75, 77) inspired the production of family group portraits in relief of freedmen. An example is the fragmentary relief of a man, his wife, and their son that dates to the late first century B.C. (fig. 59). Husband and wife join their hands (*dextrarum iunctio*), signifying their marriage bond and their unity in perpetuity; their young son stands between them.

In a contemporary relief (fig. 60) three women and two men, all libertini, are positioned either frontally or in three-quarter views and gaze out from the horizontal frame. The three women resemble one another and may be sisters, but this cannot be ascertained from the epitaph, which merely states that all three women and the man on the left are *conliberti,* that is, all freedmen of the Furius family: Publius Furius, the freedman of Publius Furius, and the women, freedwomen of a woman (again there is the retrograde C), probably the wife of Publius Furius. The man and the woman on the far right of the relief and the couple in the center turn toward one another, and

59 Fragmentary funerary relief of a man, his wife, and their son, 13 B.C.–A.D. 5. Rome, Museo Nazionale delle Terme. Photo: D. E. E. Kleiner and F. S. Kleiner, 72.II.36

The funerary reliefs of libertini of the Augustan age are entirely free of mythological and allegorical overtones. The reliefs depict, almost without exception, men and women dressed in civilian garments. The subtleties and pretensions of aristocratic iconography are, for the most part, noticeably absent, that is, the approximation to deities, mythological figures, Greek athletes, and so on.

A comparison of the styles of aristocratic and freedman portraits of the Augustan period reveals that in portrait reliefs of freedmen there is a mixture of portrait styles that is missing in contemporary court portraiture. In fact, one of the chief characteristics of private funerary portraiture of the Augustan period is the coexistence of different styles, not only at the same date, but within the same relief. The portraits of the Vibius family, for example (see fig. 58), include a portrait of the father in the republican veristic style, a realistic portrait for the mother that does reveal, however, certain technical features of the Augustan style – for example, the manner of carving the eyelids and the mouth, and a fully classicizing head of a young boy that is most comparable to the official portraits of Gaius and Lucius Caesar. The woman, as noted earlier, also wears the up-to-date coiffure fashionable among court females and aristocratic ladies of the Augustan period.

An Augustan five-figure relief in the Ny Carlsberg Glyptotek presents an even more complex juxtaposition of portrait styles. The elderly couple at the right is represented in the republican veristic manner. The portraits at the left, while recording personal features, have been generalized to a certain extent in conformity with the new classicizing style. The heroic portrait at the center has direct parallels in the portraits of the emperor himself.

This heterogeneity of style in the funerary portraiture of freedmen is of unique importance for our understanding of Roman private portraiture in the age of Augustus because these funerary images are very likely the first and only portraits commissioned by the former slaves. We are, therefore, not dealing with copies of older portraits, which is so often the case with aristocratic family portraiture, but with new portraits conceived at the same time for the same monument.

In the private portraits of freedmen of the Augustan age, old men and women born during the republic are consistently represented with outmoded coiffures and with all the signs of advanced age that Augustus had suppressed in his own portraits and in those of his deified adoptive father. Only the younger freedmen emulate the Augustan portrait style.

it is likely that they are married pairs. The woman at far left was very likely unmarried, but this is conjecture based on the composition of the figures; nothing in the epitaph confirms it. The man at far right is also a freedman, but from a different family. He is Gaius Sulpicius, the freedman of Gaius Sulpicius. All three women wear the nodus coiffure, popularized by Livia, Octavia, and Julia in the 30s and 20s B.C. The freedwomen in the Furius relief thus imitate the latest Augustan fashion in coiffures. We cannot, of course, know how often women actually wore such elaborate hairstyles, but it is clear that they wanted to be remembered as adhering to the latest court fashion.

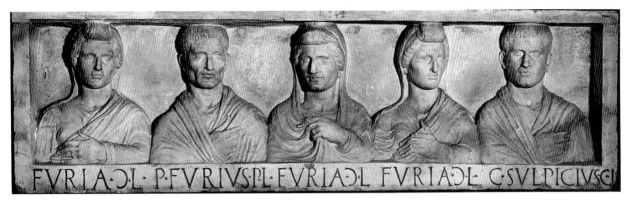

60 Funerary relief of freedmen of the Furius family, 13 B.C.–
A.D. 5. Rome, Vatican Museums, Museo Profano Gregoriano.
Photo: Archivio Fotografico Musei Vaticani XXXIV.34.37

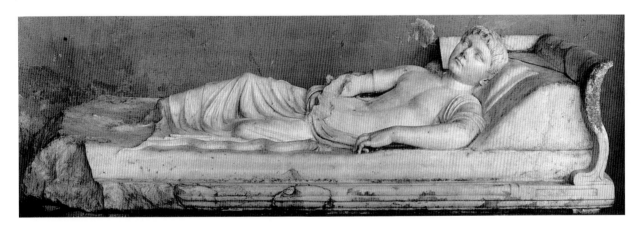

61 Kline portrait of a boy, late Augustan or early Julio-
Claudian. Rome, Museo Nazionale delle Terme. Photo: DAIR
80.2718

The Kline Portrait of a Boy

Freedmen and freedwomen were also commemo-
rated in sepulchral monuments in the form of funerary
beds or klines. The beds supported mattresses and pillows
on which the deceased reclined. The earliest surviving ex-
ample dates to the late Augustan or early Julio-Claudian
period (fig. 61). It depicts a boy and is thus also an ex-
ample of the Augustan penchant for the representation of
children in portrait and relief sculpture. The boy with his
round face, even features, and a cap of hair arranged in
comma-shaped locks over his forehead closely resembles
the Augustan princes Gaius and Lucius Caesar.

Augustan State Relief Sculpture

State reliefs commissioned by Augustus mirrored his
political and social ideology and also reflected his asso-
ciation with a variety of gods such as Mars Ultor and
Apollo. Before Philippi, Octavian vowed he would build
a temple to Mars Ultor for his aid in securing victory over
Caesar's assassins. The temple, which served as the focus
of the Forum of Augustus in Rome was, however, not
initiated until after Octavian's victory over Mark Antony
at Actium, and the temple and forum were not dedicated
until 2 B.C. Although I will discuss the complex later in
this chapter, the idea of its inception is important here.

Octavian's momentous victory at Actium cemented his position as sole ruler of the Roman world and gave him the authority and funds to commission such major works of art and architecture as his forum. He also began to embellish the nearby Roman Forum and the Palatine hill. Foremost among these commissions was a pair of honorary arches in Rome. A monument honoring the Actian victory was also erected near the site of the battle.

The Actium Monument at Nikopolis

Octavian's naval victory over Antony at Actium off the western coast of Greece was commemorated at Nikopolis in Greece with a monument erected on the site of the Roman command post. The structure, dedicated by Octavian in 29 B.C. to Neptune and Mars, had a dedicatory inscription and was ornamented with battle spoils – the prows and warship rams of Antony's fleet. The monument was not enhanced with relief sculpture, and there are no surviving remains of statuary.

The Arch of Gaius Octavius on the Palatine

Remains of a single-bay structure on the *Clivus Palatinus,* which may have served as an entrance gate to Augustus's Temple to Apollo on the Palatine hill, was probably begun after 31 and completed by 28, the year that saw the dedication of the Temple of Apollo itself. The arch honored Augustus's father, Gaius Octavius, and thus demonstrated that Augustus's victory at Actium gave him the security to proclaim publicly his *pietas* or devotion toward his real father as he had earlier for his divine adoptive "father," Julius Caesar. The arch also celebrates Augustus's association with Apollo, reported to be Augustus's divine father by Suetonius and Cassius Dio (Suet., *Aug.*, 94.4; Cassius Dio 45.2–3), according to Pliny's description of a statuary group on the arch depicting Apollo and Diana in a four-horse chariot (*HN* 36.36), the work of the Greek sculptor Lysias. The arch was thus simultaneously dedicated to Augustus's natural father and to his divine father; the ambiguity of Augustus's parentage was deliberately exploited in this prominent monument.

The Actian Arch of Augustus in the Roman Forum

Coin reverses of 29–27 B.C. record a second Augustan arch that has been associated with the foundations and part of the superstructure of a single-bay arch in the Roman Forum of about 29 B.C., although this association

has recently been questioned. It was located between the Temple of Divus Julius and the Temple of Concord and appears to have been severe in decoration but may have had Victories in the spandrels. The numismatic representations record the attic statuary, which, like the Palatine arch, consisted of a four-horse chariot group. In this case, the reins were not held by a god and goddess but by the living emperor himself. Although the arch celebrated, above all, Octavian's victory at Actium, the inner bays and the short sides of the arch were also ornamented with plaques carved with the names of republican magistrates. These *fasti consulares* underscored Augustus's claim to have restored the republic by avenging Caesar's assassination at Philippi.

The Temple of Apollo Palatinus

The Arch of Gaius Octavius and the Actian Arch of Augustus served as pedestals for statuary groups. Augustus's first major commission with a carefully orchestrated architectural and sculptural program was his Temple to Apollo on the Palatine hill in Rome. The temple was vowed in 36 B.C. after Octavian's war in Sicily against Sextus Pompeius, but it was not completed until after Actium. The temple was dedicated on 9 October, 28 B.C.

Velleius Paterculus (2.81.3) records Octavian's vow and the temple's construction: "After his victory Octavian returned to Rome, and announced that he meant to reserve for public use several houses which he had purchased through agents, to allow for more space round his own dwelling. He also promised to build a Temple of Apollo with a colonnade surrounding it, a work which he carried out with princely generosity." That Augustus's Temple to Apollo was linked to his own residence is hinted at in this literary description and is borne out by archaeological evidence that came to light when the area occupied by both house and temple was excavated beginning in the nineteenth century. By building temple and private residence side by side, Augustus was attempting to establish not only a physical but also a symbolic link between himself and the god who underscored their personal relationship. Apollo had not only assisted Augustus in two military campaigns, but he was rumored to be the emperor's divine father. During his lifetime, Augustus was said to have appeared at a private banquet in the guise of Apollo (Suet., *Aug.*, 70) and was even depicted with the attributes of the god in statues that were publicly displayed in Rome between 30 and 27 B.C. One of the most prominent was a statue of Augustus in the guise of Apollo in the library on the Palatine hill (Ps. Acro. ad Hor., *Epist.* 1.3.17), although this may have been set up after his death.

Augustus was not the first Roman patron to venerate Apollo. A temple to Apollo was set up near the Theater of Marcellus in Rome as early as the fifth century B.C. Although it was immediately after his victory over Sextus Pompeius in 36 B.C. that Octavian vowed that he would build a new temple in Rome to Apollo, it was his greatest military victory – the naval victory over Mark Antony at Actium – that established Apollo as Augustus's special deity. A temple to Apollo overlooked the sea where the momentous battle took place, and Augustus credited Apollo for his success in the naval venture. Augustus dedicated ten captured ships to Apollo and, at the same time, initiated a cycle of Actian games. In contemporary poetry, Virgil and Propertius characterize Apollo as intervening on behalf of Augustus against eastern enemies and their divinities.

The temple in Rome had a Greek marble cult statue of Apollo, probably by Scopas, accompanied by statues of his mother Leto by Cephisodotus, and his sister Diana by Timotheus. The statuary group no longer survives, although drapery fragments and a colossal head of Apollo have recently come to light. The group may, however, be envisioned as resembling that in relief of the three divinities frontally aligned on the so-called Sorrento Base (see fig. 68) and also paralleled in a series of Augustan neo-Attic terracotta reliefs.

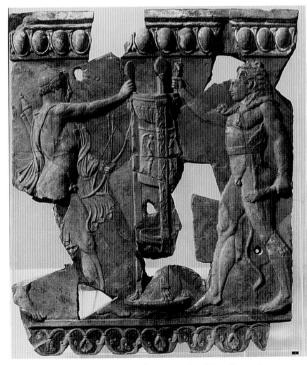

62 Terracotta plaque with the struggle of Apollo and Hercules for the Delphic tripod, from the Temple of Apollo Palatinus, ca. 28 B.C. Rome, Antiquario Palatino. Photo: Soprintendenza Archeologica di Roma

Excavations of 1968 in front of the temple revealed a series of terracotta plaques comparable to others manufactured in Rome in the first century B.C. and especially popular for temple decoration under Augustus. It has been demonstrated that these plaques from the Temple of Apollo Palatinus were not merely decorative but clothed the struggle between Octavian and Antony in mythological guise. Several of the plaques depict the contest between Apollo and Hercules for the Delphic tripod. In the corresponding myth, Hercules travels to Apollo's shrine at Delphi to seek absolution for a murder he has perpetrated. The oracle refuses to give a pronouncement, and the enraged Hercules attempts to steal Apollo's tripod in order to establish his own oracle. Apollo tries to stop him, but Jupiter has to intervene with a thunderbolt. Apollo gets to keep his tripod, while Hercules is sold into slavery. The terracotta plaque (fig. 62), which still retains traces of the multicolored paint that enhanced it, shows the two protagonists flanking the tripod and on an equal footing, but the fact that Apollo would ultimately be victorious was a foregone conclusion. Apollo and Octavian Augustus and Hercules and Mark Antony are deliberately associated in the plaques. Antony reveled in what he thought was his physical resemblance to Hercules, masqueraded in Rome as the god, and struck coins with his image; and, as noted, Augustus was rumored to be the son of Apollo. It has been posited that the representation of Apollo and Hercules at odds on the terracotta plaque is meant to allude to the historical conflict between Octavian and Antony at Actium. Apollo is depicted as the defender of the Delphic tripod, Octavian as the protector of Rome. The tripod is decorated with winged Victories, also an allusion to military success. The lotus blossoms decorating the lower border of the plaque are probably meant to refer to those of Egypt, home of the Egyptian queen Cleopatra, consort and ally of Mark Antony, and as a foreign foe, Octavian's primary enemy at Actium.

Another plaque depicts two maidens ornamenting a betile, or pillar monument, which is associated with Apollo by the presence of the god's attributes of cithara, bow, and quiver. It has been suggested that the betile may have had personal significance for Augustus because it also decorates a painted wall in the Room of the Masks in Augustus's Palatine residence. It is also thought that the choice of an archaizing style for these sculptures was also deliberate and conjures up the heroic past by celebrating the historical deeds of Octavian in the guise of Apollo's mythological exploits.

The temple's door jambs were decorated with representations of the Delphic tripod. Furthermore, Propertius (4.6.67) reports that the door frame was embellished with ivory panels depicting the sack of Delphi by the Gauls in 279 B.C. on one side and on the other,

the massacre of Niobe's children by Apollo and Diana. Augustus's defense of the Roman world and his avenging of Caesar's death may be alluded to in these scenes that ostensibly depict the deeds of Apollo. The temple was surrounded by a portico that, according to Propertius (2.31.3), had statues of Danaus and his fifty daughters in the intercolumniations. At their father's behest, all but one of the fifty brides murdered their husbands – who may also have been depicted as equestrians – on their wedding night. It has been hypothesized that the Danaids, descendants of Io, who was sent to Egypt and produced a family line that included the brothers Aegyptus and Danaus and who in turn fathered the fifty sons and fifty daughters depicted in the temple's portico, are surrogates for Cleopatra, and that the family feud stands for the civil war between Octavian and Antony.

In sum, it is apparent from scholarly interpretation of the sculptural program of the Temple of Apollo Palatinus that it was carefully orchestrated by Octavian, in concert with a master designer, to underscore his personal rapport with the god Apollo, and to make reference to his momentous victory over Antony and Cleopatra at Actium.

The Actian Apollo Relief

The so-called Actian Apollo Relief is reported to have been found in Avellino and is now in Budapest. Its original location may well have been Rome because the scene makes an unmistakable reference to Augustus's victory at Actium. The relief is in a very fragmentary condition, with the figures of only three humans and one god preserved. The god in question is Apollo himself, who is seated at the right on a rock, the weight of his back supported by a large tripod. His head is missing, and he is nude from the waist up with a mantle wrapped around his legs. He holds his lyre in his left hand and rests it across his left thigh. In front of him are the sterns of two ships. Apollo has his back to a procession of three males in tunics and cloaks. All are fragmentary, although their heads are preserved. The one in the middle is blowing a trumpet; the figure closest to Apollo carries a long object in his hands that has been variously identified as a torch, spear, trophy, or a bundle of sticks usually carried by lictors (*fasces*). Different identities for the man have been posited, and the figure's proximity to Apollo has led some scholars to see in him an imperial personage. The scene has been widely interpreted as one in which Augustus offers his gratitude to Apollo for his support at Actium. For that reason, the figure next to Apollo has been associated with Augustus himself or with Germanicus, who stopped in Actium on his way to Athens.

Neither seems convincing. The head does not conform to the portrait types of either Augustus or Germanicus, and it is unlikely that the object of veneration would be depicted with his back to the emperor or to any key member of the imperial house. If Augustus, or for that matter Germanicus, was represented in this relief, it must have been on the missing right side. The most likely date for this relief is after Actium but before the construction of the Ara Pacis, that is, sometime in the 20s B.C.

The Porticus Octaviae Reliefs

Another Augustan relief of Luna marble that makes references to Actium is one that was found in 1937 near the Porticus Octaviae in Rome and now in the Museo del Palazzo dei Conservatori. One fragment depicts the forepart of a warship with three beaks and a crest in the form of a wolf's head, but another section, instead from S. Lorenzo fuori le mura in Rome and now in the Museo Capitolino, includes sacrificial implements, as well as parts of ships. Similar subject matter and style have led the two to be associated, and they have been dated to about 20 B.C.

Temple of Apollo Sosianus

Also probably carved after Actium is a frieze, preserved in five fragments (figs. 63–64) that comes from the Temple of Apollo Sosianus (or Apollo in Campo), located in an area of Rome embellished under Augustus that included the Theater of Marcellus and the Porticus Octaviae. The fragments were discovered in excavations of the temple in 1937–38, are bordered with acanthus leaves and served as an interior frieze. Even though the figures are small in scale, they do not overlap and are distinctly carved to be viewed from a distance.

A passage in Pliny, which refers to the cult statue of Apollo brought to Rome from the East by Gaius Sosius (*HN*, 13.53), has led scholars to attribute the rebuilding of the Temple of Apollo and the commission of its frieze to the consul Sosius. Sosius had celebrated military successes in Syria for which he was awarded a triumph in 34 B.C. In 32 B.C., he left Rome to join Mark Antony as his general but was pardoned by Augustus after Actium. The rebuilding of the temple must thus postdate Actium. Other scholars do not think there is justification to connect the temple or the frieze with Sosius but believe it is likely that the temple's cult statue was one Sosius brought to Rome from Seleucia. In any case, the date of the rebuilt temple and its frieze has been determined by careful examination of its architectural ornament, which is similar

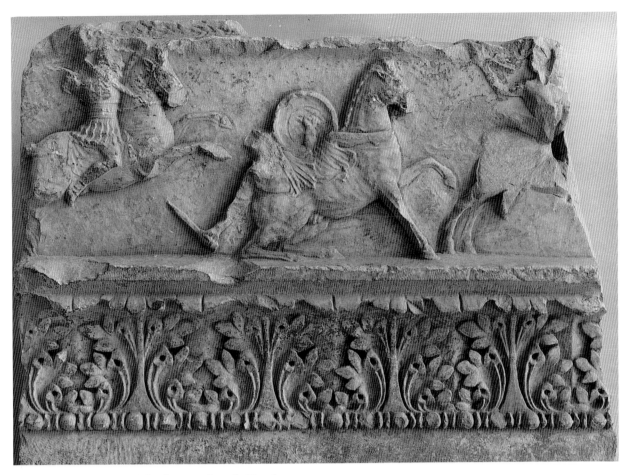

63 Fragment of frieze with battle scene, from the Temple
of Apollo Sosianus, ca. 20 B.C. Rome, Museo del Palazzo dei
Conservatori. Photo: DAIR 60. 1252

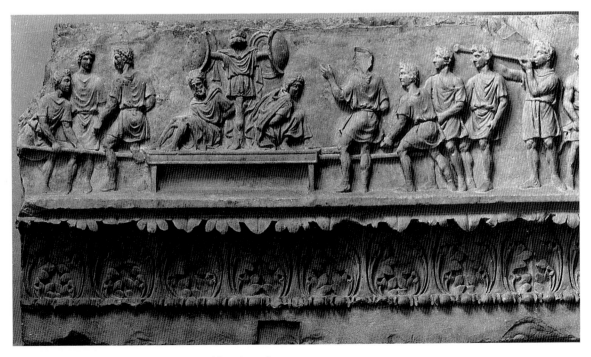

64 Fragment of frieze with procession and ferculum, from
the Temple of Apollo Sosianus, ca. 20 B.C. Rome, Museo del
Palazzo dei Conservatori. Photo: DAIR 71.45

in configuration and style to that of the Parthian Arch of Augustus of 19 B.C. For that reason, the frieze from the temple of Apollo Sosianus is traditionally dated to about 20 B.C.

The various fragments preserve parts of a battle and a triumphal and sacrificial procession. The battle scene (see fig. 63) comprises warring Romans in armor and Gauls in tunics on horseback. The equestrians are widely spaced, and the horses are shown rearing and collapsing as in the battle frieze from the earlier Monument of Aemilius Paullus in Delphi (see fig. 5). The Apollo Sosianus battle, like that at Delphi, is therefore based closely on Hellenistic Greek precedents. Also preserved are parts of two processions, or two parts of the same procession, moving from right to left and left to right toward a central point, as on the later Ara Pacis Augustae. In one, a small platform or *ferculum,* laden with sacrificial offerings, is carried on the shoulders of attendants; in the other (see fig. 64), attendants prepare to hoist on their shoulders a large ferculum that supports a trophy to which are chained two barbarian prisoners. The captives have most often been identified as Gauls, but there is no consensus on this issue. Literary descriptions of triumphal paintings indicate that such scenes were commonly crafted in the late republic, but the triumphal procession from the Temple of Apollo Sosianus is the first surviving representation in monumental architectural sculpture.

It and others like it were to serve as models for the triumphal friezes that encircled imperial commemorative arches in Rome, such as those of Titus and Septimius Severus (see figs. 154, 293–294). The large ferculum is followed by a trumpeter and by victimarii with three sacrificial bulls and accompanying *popae* (junior priests) with their mallets. At the end are two additional attendants, one with a vessel or *situla,* the other wearing a toga.

It has recently been demonstrated that the pediment of the Temple of Apollo Sosianus (fig. 65) was filled with classical Greek statuary. Athena stood beneath the apex of the gable flanked by the Greek heroes Theseus and Hercules, each embroiled in a battle with an Amazon. Next to these groups were others with mounted Amazons attacking kneeling Greeks, and there were fallen figures in the narrow eaves of the pediment. Even the Greeks used battles between Greeks and Amazons as allegorical references to historical conflicts, and it is possible that the patron of the Temple of Apollo Sosianus also meant these to allude to a specific Roman battle. Nonetheless, it is likely that these original statues were used here as a sign of both Sosius's civilized taste and of his success as a triumphant general (*triumphator*). The statues were undoubtedly brought by Sosius or some other Roman general to Rome as spoils of war and in that way complemented the Greek cult statue of Apollo in the cella of the temple. As has been pointed out, the aesthetic value of these Greek masterworks would have been appreciated all the more in antiquity where they could be viewed from the upper stories of the Theater of Marcellus.

Although the identities of the patron of the Temple of Apollo Sosianus and its frieze, and the historical battle and triumph that are commemorated in it, continue to be debated, the monument's significance is clear. Like the earlier "Altar of Domitius Ahenobarbus" (see figs. 30–31), it was an eclectic monument that combined Greek mythological statuary on the exterior with interior friezes executed in different styles – the Hellenistic-derived style of the battle scene and the more matter-of-fact narrative style of the triumphal and sacrificial procession. Nonetheless, what separates the interior frieze of the Temple of Apollo Sosianus from the reliefs from the "Altar of Domitius Ahenobarbus" is that the former is entirely devoid of mythological subject matter and seems to depict specific historical events in all its scenes.

The Mantua Relief

Another battle between Romans and Gauls from Rome is preserved on a relief from a fragmentary architrave now in Mantua (fig. 66). On the basis of the style of the architrave's ornament, the fragment has been dated to late Augustan times, and it has been suggested that it originally belonged to the internal decoration of the Temple of Castor and Pollux in Rome that was restored by Tiberius in 6. The strong modeling of the fighting figures, however, has led some scholars to posit a date in the Claudian period. If the Mantua Relief is Augustan, it is one of a small number of battle scenes surviving from that period. Despite the fact that Augustus celebrated significant military victories at Philippi and Actium, the monuments commissioned by the emperor and his generals do not concentrate on military themes, as was the case later with the emperor-general Trajan. War is alluded to only as the foundation for peace. The god Mars and stray pieces of arms and armor stand for military victory; if combat is actually represented, as in the Sosianus frieze and the Mantua Relief, it is done by means of allegory.

The Parthian Arch of Augustus in the Roman Forum

In 19 B.C., Augustus's Actian Arch may have been dismantled and its stones incorporated into a new arch on the same site, although the existence of two successive arches between the Temples of Caesar and Concord has recently been questioned. In any case, a new edifice com-

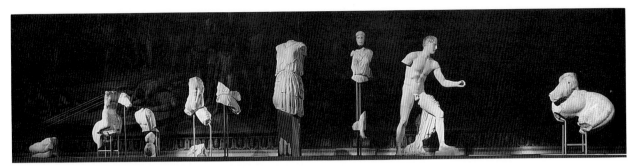

65 Reconstruction of pedimental sculptures from the Temple of Apollo Sosianus, ca. 20 B.C. Photo: Courtesy of Eugenio La Rocca, by Barbara Malter

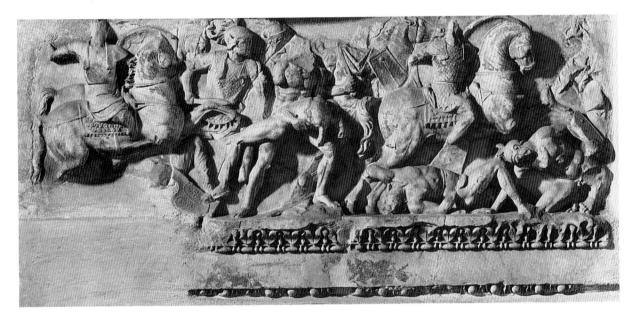

66 Relief with battle between Romans and Gauls, from Rome, late Augustan. Mantua, Palazzo Ducale. Photo: Alinari/Art Resource, New York, 18805

memorating Augustus's diplomatic victory over the Parthians – who in 20 B.C. returned the standards to Rome that had been lost to Parthia in 53 B.C. – was erected to the south of the Temple of Divus Julius in the Roman Forum. Augustus, who came to power in the civil war culminating with the battle at Actium, was anxious to solidify his legitimacy by commemorating instead his defeat of a foreign foe. (The Actian arch ostensibly celebrated the defeat of Cleopatra of Egypt, but all Romans would have been aware that Octavian's other foe was another Roman, Mark Antony.) The fragmentary remains of the arch have been used, along with the arch's reproduction

on the reverses of coins of Lucius Vinicius of 16 B.C. (fig. 67), to reconstruct the Parthian Arch. It consisted of a central, arcuated bay flanked by two trabeated bays, making it an arch with three openings. The arch was adorned by an inscription, by Victories in the spandrels, and by a crowning group of Augustus in a four-horse chariot – possibly the same one that had graced the earlier Actian Arch, although this one was flanked by statues of Parthians over the lateral passageways. Plaques with the fasti consulares and the *fasti triumphales* were located on the inner walls of the bays and on the two short sides of the arch. As noted, the Parthian Arch of Augustus is a

67 Denarius with obverse of Parthian Arch of Augustus, 16 B.C. New York. Photo: Courtesy of the American Numismatic Society, New York, 83.804

key monument in the history of Roman arch design because it is the first arch in Rome with a triple opening and the first with statues of Roman enemies on the attic. It was to serve as the main prototype for the later Parthian arches of both Nero and Septimius Severus (see figs. 131, 293–294).

The Sorrento Base

The "Sorrento Base," appears to have been made after Augustus assumed the title of pontifex maximus in 12 B.C. and makes reference both to the state religion, to the divine ancestors of the Julian family, and to Augustus's personal protector, Apollo.

The primary side of the fragmentary base depicts five Vestal Virgins in procession toward a seated statue of Vesta. Scholars have suggested that the event commemorated here is Augustus's dedication in 12 B.C. of the altar and shrine of Vesta on the Palatine. There is an Ionic portico and a round shrine in the background of the relief separated by a draped curtain from what seems to be the interior of Augustus's own house. The Ionic portico continues on to one of the short sides of the base. A door surmounted by the corona civica appears to identify the house as Augustus's. In front of the door is a seated male figure with a cornucopia, probably the *genius* of the emperor, who is flanked by Mars in battle dress with Cupid and Venus, now missing. (A recent alternative suggestion identifies the figure in military dress as Aeneas and

posits a missing figure of Romulus rather than Venus.) The other short side (fig. 68) depicts Diana, Apollo, and Leto, their figures derived from those of the cult statuary group of Augustus's Temple of Apollo Palatinus. The other long side is carved with a scene of Cybele with her lion and a dancing male figure traditional to her cult.

Apollo, as Augustus's divine father and protector, figured prominently in early Augustan relief sculpture. Mars, the god of war and father of Romulus and Remus and thus of the Roman people, and Venus, mother of Aeneas and the divine patroness of the Julian family, received homage in state monuments commissioned by Augustus in the last two decades of the first century B.C., to which time the Sorrento Base must date. This date is underscored by the fact that Vesta was closely associated with the position of pontifex maximus that Augustus assumed in 12 B.C. The pontifex maximus is sometimes referred to as *sacerdos Vestae,* and the emperor's *genius* was also tied to the religion of the state.

The Basilica Aemilia Frieze

The frieze from the Basilica Aemilia in the Roman Forum is another highly controversial monument. Dis-

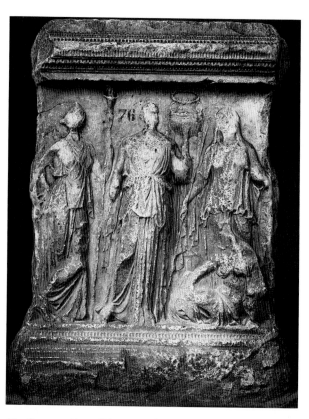

68 Sorrento Base, Diana, Apollo, and Leto, last two decades of the first century B.C. Sorrento, Museo Correale. Photo: DAIR 6518

covered in many small fragments, reconstructed, and now on display in the Forum Antiquarium (figs. 69–70), the frieze has been variously dated to both the republic and the imperial period, with most scholars favoring either 34 or 14 B.C. These dates correspond to restorations of the Basilica Aemilia itself, which was first built in 174 B.C. and repaired later. Although the republican date has received considerable favor, the Augustan date is also attractive and would allow an association of the frieze with Augustus himself. The restoration of 14 B.C., after a fire in the forum, was undertaken by a member of the Aemilius family but was funded by the emperor. A date of 14 B.C. for the frieze would make it roughly contemporary with the most renowned of Augustus's monuments – the Ara Pacis Augustae – and there is evidence that the two commissions had similar goals.

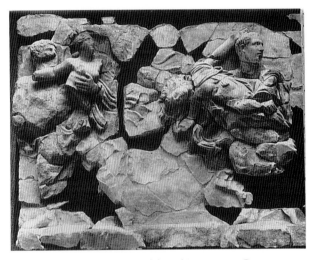

69 Basilica Aemilia, Rape of the Sabines, 14 B.C. Rome, Forum Antiquarium. Photo: DAIR 1939.722

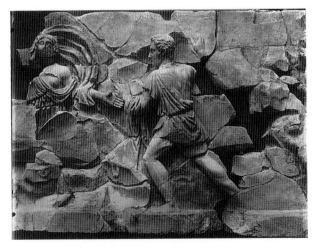

70 Basilica Aemilia, Punishment of Tarpeia, 14 B.C. Rome, Forum Antiquarium. Photo: DAIR 1939.721

The frieze, which appears to have circled the interior of the building, recounts events from Rome's legendary and mythical history, including such scenes as the Construction of the Walls of Lavinium, the Rape of the Sabines, the Punishment of Tarpeia, and various battles. As in the frieze from the Temple of Apollo Sosianus, there is little overlapping among the figures, and some of the figural groups betray the impact of Greek prototypes, especially in the Sabine scene. There are also major distinctions between the two.

Although the Hellenistic-style battle scene from the Apollo temple depicts rearing horses and falling riders, the triumphal and sacrifice scenes are relatively static. In contrast, almost all the surviving scenes from the Basilica Aemilia are full of lively action, and all are narratives; there are no ceremonial tableaux. Figures in active poses stack piles of blocks to make the walls of Lavinium, while a personification of that city bears witness to the event. The arms of some of the Sabine women (see fig. 69) are flung wide apart by the violent gestures of their captors. The womens' long hair seems electrically charged, and their draperies swirl around their heads and bodies. The male protagonists in the rape scene and in the Punishment of Tarpeia (see fig. 70) are depicted time and again in active lunging gestures. There are also many figures in quiet repose that successfully arrest the activity, the standing city personification of Lavinium, seated female personifications, and a married couple that stands side by side.

It has recently been suggested that the Rape of the Sabines and the Punishment of Tarpeia reflect the social policies of Augustus that encouraged marital fidelity and the increased procreation of children among the Roman aristocracy and the freed class.

The Sabine women were raped by the early Romans, who felt justified in taking this drastic action because they had no wives of their own and because reproduction was necessary for the continuance of Rome. In a later episode of the story, implied but not depicted in the surviving fragments of the frieze, the Sabine women intervene between their Sabine fathers and Roman husbands, and their mediation has been viewed as an example of what would have been considered correct behavior for Augustan wives and daughters. The Sabine men, anxious to avenge their women, go to the gates of Rome, where they gain access to the city by bribing the Roman maiden Tarpeia. Nonetheless, the Sabines have no mercy for Tarpeia and crush her beneath their shields. As has been hypothesized, Tarpeia's incorrect behavior endangered the fabric of Roman society. In this way, the frieze of the Basilica Aemilia both recounted Rome's history and represented a moral for contemporary women whose conduct Augustus sought to regulate.

The Ara Pacis Augustae

The greatest monument of Augustan state art is unquestionably the Ara Pacis Augustae or the Altar of Peace (see figs. 71–81), a permanent monument to Augustus's most notable achievement – the pacification of the Roman world. Peace and its consequences for Italy and the world, for the Roman aristocracy and high-ranking provincials, constitute the major theme of the reliefs that cover the exposed surfaces of the structure. The emperor's dynastic ambitions, social policies, and religious affinities are also celebrated in the altar, and there are subtle references to the military victories that made the Augustan peace possible. Fragments of the altar had already come to light in the sixteenth century, and the monument was first associated with the Ara Pacis Augustae known through literary and epigraphical evidence in the late nineteenth century. In the 1930s Mussolini commissioned the rebuilding of the Ara Pacis on the banks of the Tiber River next to Augustus's mausoleum.

The foundation stone of the altar was laid on 4 July 13 B.C., and a great ceremony was held on that day with a solemn sacrifice to the state gods and to the goddess Pax herself. The altar was completed and dedicated three and one-half years later on 30 January 9 B.C., the birthday of Augustus's wife, Livia. The choice of the latter was certainly not coincidental. Through diplomatic efforts in Gaul and Spain, Augustus brought peace to Rome and the empire, but Livia, the emperor's female counterpart, was the foundation of the imperial family and the concordia of that family is one of the other significant themes of the Ara Pacis. Although Livia and Augustus produced no children of their own, their progeny by earlier marriages fueled Augustus's hopes for the establishment of a dynasty. His daughter, Julia, produced Gaius and Lucius Caesar, who became the emperor's designated heirs, although the mantle eventually fell to Livia's son Tiberius.

In the *Res Gestae Divi Augusti,* Augustus describes his accomplishment and the consecration of the altar: "On my return from Spain and Gaul, after successfully restoring law and order to these provinces, the Senate decided under the consulship of Tiberius Nero and Publius Quintilius to consecrate the Ara Pacis Augustae on the Campus Martius in honor of my return, at which officials, priests, and Vestal Virgins should offer an annual sacrifice" (*Res Gestae Divi Augusti* 12).

The Ara Pacis Augustae was built on the Via Flaminia, the road taken by Augustus when he entered Rome from the north. The altar proper is inside a large marble precinct wall. The precinct has two doorways – on the eastern and western sides. The system of two doors appears to have been based on another monument – the Shrine of Janus Geminus in the Roman Forum preserved today on the reverse of coins of the emperor Nero. The shrine also had two doors on the eastern and western axis. According to tradition, when the two doors of the shrine were closed, peace reigned throughout the world. Augustus prided himself on closing the doors of the Shrine of Janus three times during his principate. Another formal model for the Altar of Peace was the Altar of Pity or the Altar of the Twelve Gods in the Agora in Athens. Built in the fifth century B.C., it too consisted of an altar surrounded by a marble precinct opened to the sky and pierced by doorways at east and west. These doorways were probably flanked by sculpted panels.

The altar proper of the Ara Pacis (figs. 71–72) was reached by a flight of steps and survives only in part. The upper section bears a frieze of animals being led to sacrifice – the annual sacrifice to Pax. The figures represented are all carefully distinguished by their ritual costumes, but none of the participants is an identifiable historical personage. All of the figures are anonymous because the scene is meant to stand not for a specific sacrifice to Pax but a recurrent celebration and a permanent symbol of dutiful respect. The procession is framed by majestic, horned-winged lions – a popular Augustan motif – and by a series of acanthus tendrils, another motif favored by Augustan artists. Elsewhere on the altar were relief depictions of personifications of provinces under Roman jurisdiction in Augustan times. These are in fragmentary condition but must have been relief versions of the kind of statuary display of provinces in the earlier Theater of Pompey.

Framing the altar and overshadowing it in size and importance is the great marble precinct wall. Seen from the inside (fig. 73), it is an imitation in marble of an actual temporary altar precinct with a wooden fence and garlands hanging from wooden posts. The garlands are laced with fruits – the fruits of all the seasons of the year – a reference to the blessings of peace that allow the soil to be cultivated. Above the garlands are paterae, the sacrificial plates from which libations were poured. The garlands themselves are hung from bulls' skulls, *bucrania,* a reference to the sacrificial victims. This ritual theme, incidentally, is an old one seen, for example, in the Hellenistic propylon of the Sanctuary of Athena in Pergamon.

On the outside, the precinct wall is divided into two zones. The swinging garlands and open air of the upper register of the inner precinct are gone, in favor of a frieze of figures that is unrealistically supported by the acanthus scrolls below (figs. 71, 79). The flowering acanthus even ornaments the corner pilasters, underscoring their role as decorative surfaces rather than architectural supports. Nonetheless, the flowing acanthus leaves are not purely

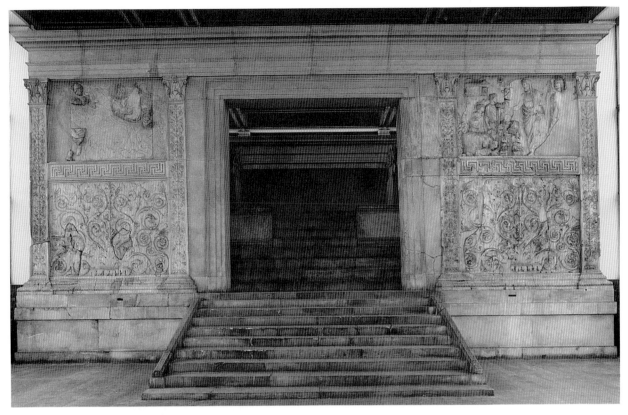

71 Rome, Ara Pacis Augustae, general view from west,
13–9 B.C. Photo: DAIR 72.647

72 Rome, Ara Pacis Augustae, altar with procession,
13–9 B.C. Photo: DAIR 66.105

73 Rome, Ara Pacis Augustae, interior with garlands and
bucrania, 13–9 B.C. Photo: DAIR 72.657

decorative. They carry the primary message of the altar – that peace leads to growth and rebirth. The imagery of renewed growth in Italy during this period of peace also suffuses contemporary literature, as, for example, in the fourth eclogue of the Augustan poet Virgil, where water lilies mix with acanthus and reddish grapes hang from thornbushes. Not only are plants flourishing on the Ara Pacis, but there are swans, snakes, lizards, and other creatures interspersed in the acanthus tendrils. Virgil mentions that swans were the sacred birds of Apollo, whom the Sibyl had prophesied as the future king of the Golden Age (10). Apollo was the patron god of Augustus, under whose rule the *aurea aetas,* or Golden Age, would come to be.

Above the scrolls, on the north and south long sides of the precinct wall are two parallel processions (or, as some scholars have argued, two parts of the same procession) moving toward the west end (figs. 74–77). The participants are not anonymous figures as on the small altar, but rather particular protagonists who take part in a specific procession – the ceremony accompanying the laying of the foundation stone on 4 July 13 B.C. This alone sets the Ara Pacis Augustae apart from its obvious model in classical Greece – the frieze of the Parthenon. On the Parthenon, there are also two parallel processions on the north and south sides moving toward one end of the monument. The subject is also a religious procession, but not a specific procession, and there are no portraits – it is one procession standing for all processions – as the sacrifice on the altar of the Ara Pacis. The precinct wall procession of the Ara Pacis is, however, an example of the Roman desire for specificity, similar to the earlier taste for veristic portraiture. Nonetheless, although a specific event is recorded here, the historical accuracy of the scene was undoubtedly altered to include key protagonists who may not have been present at the actual event and to underscore dynastic, social, and religious principles important to Augustus. The Augustan artist has rendered the Roman procession of 13 B.C. in a consciously classicizing style that emulates that of the Parthenon frieze – a linear style in which the depth of the relief is hardly more than two inches high and there is a quiet and dignified rhythm.

Although most of the life-size figures on the north and south friezes had portrait features, some of their identities elude us today. The faces on the north side were reworked during the Renaissance, and the individual features of the original heads on the south side have been subsumed beneath the classicizing gloss of Augustan portraiture. In fact, the collective identity of the youthful members of the Julian family was more important to patron and artist than was the realistic rendition of their distinctive facial traits. It is for this reason that much of the controversy that continues to surround the Ara Pacis focuses on the identification of the most prominent figures in the two great friezes.

The figures on the south frieze (see fig. 74) move from right to left. All scholars agree that Augustus, who can be identified by his physiognomy and the configuration of his coiffure (an example of the Forbes or Ara Pacis type), is present. The bottom of the figure is fragmentary, but the traditional interpretation suggests that the emperor was originally in the act of making a sacrifice. This explanation has recently been challenged, and it has been argued that Augustus was instead holding a lituus – associated with the chief state god Jupiter and also with Augustus's patron deity, the god of prophecy, Apollo – and was participating in an augural act associated with the ceremony of 13 B.C. Otherwise, Augustus is not singled out but represented as first among equals. The emperor is surrounded by lictors and official priests and followed by members of the imperial family. Close behind the emperor is Marcus Agrippa, Augustus's obvious successor, whose career ended prematurely with his death in 12 B.C. Also apparently included in the south frieze (see fig. 75) are the emperor's wife, Livia, and her two sons, Drusus and Tiberius, Drusus's wife, Antonia the Younger, also Augustus's niece, and their son, Germanicus, born in 15 B.C. Nearby is Antonia the Elder, another niece of Augustus, and her husband, Lucius Domitius Ahenobarbus, and their son and daughter. Most striking perhaps are the young children, like Germanicus, who tug on the togas or grasp the hands of surrounding adults. Their inclusion in this frieze underscores the new Augustan emphasis on youth – even children are present at the ceremony. In fact, the entire family appears to be there.

Never before in a state relief have men been depicted with their wives and children. As has been demonstrated elsewhere, children are included in the two great friezes of the Ara Pacis for a variety of specific reasons. The first has to do with Augustus's dynastic policies. In contrast to Agrippa, with his tired and lined face, Gaius and Lucius were mere boys at the time of the construction of the Ara Pacis. Gaius was seven at the time of the procession of 13 B.C., and Lucius was four. Children are included in the north and south friezes of the Ara Pacis also because of Augustus's social policy. Unimportant in republican times, Augustus held children in high esteem, and they played a significant part in his social legislation. They consequently figured prominently in the pictorial propaganda of the Altar of Peace. Owing to a declining birthrate among the nobility and the increased frequency in the manumission of slaves, Augustus was concerned that the slaves would soon outnumber indigenous Romans and that the *nobilitas* was in danger of extinction. To deal with these problems, he had a series of laws enacted. The *lex Julia de adulteriis coercendis* promoted marriage by bringing adultery under court jurisdiction rather than allowing it

to remain a private affair. To stimulate childbirth, the *lex Julia de maritandis ordinibus* was enacted at Augustus's instigation in 18 B.C. The law was emended in A.D. 9 by the *lex Papia Poppaea*. Together, these two laws removed stringent restrictions on marriage and stimulated the raising of children.

The figures in the north frieze (see figs. 76–77) proceed from left to right. On the western end are the senators and dignitaries, followed by families. As mentioned earlier, most of the heads on the north side are modern additions. Identification of the historical personages depicted there is therefore exceedingly difficult, although it is likely that prominent among them were Julia and Augustus's sister, Octavia. Also probably present are Julia and Agrippa's daughter and Augustus's granddaughter, Julia the Younger, wearing a toga.

Among the most controversial figures are those of the two boys in Trojan or Gallic costume on the south and north sides. The former is the elder of the two and is depicted pulling on Agrippa's garment. The latter is the toddler near Julia in the north frieze. Both wear tunics rather than the toga worn by Germanicus and the other imperial princes. They have long, curly locks and wear torques around their necks. Their proximity to Agrippa and Julia and the fact that they appear to wear Trojan attire have led some scholars to identify them as Gaius and Lucius wearing the costumes of participants in the Trojan games. That both boys took part in such equestrian exercises is attested. Furthermore, their nearness to Augustus is necessary to the overall dynastic and social message of the Ara Pacis and at present, I favor this interpretation. Nonetheless, other scholars have instead recognized the two boys as Gallic princes paraded in such processions as symbols of both Roman domination and clemency. This interpretation is also plausible because in the *Res Gestae* Augustus himself boasts that "in my triumphs there were led before my chariot nine kings or children of kings" (*Res Gestae Divi Augusti* 4). It is attested that Augustus's triumphs of 29 B.C. included such illustrious captives as Adiatorix, a Galatian prince with his wife and sons, and Alexander and Cleopatra, the children of Cleopatra of Egypt.

More should be said about the style of the friezes of the Ara Pacis and also about its artistic prototypes. Although the friezes of the Ara Pacis Augustae look back to the Panathenaic procession frieze of the Parthenon, it is not the only model. The Panathenaic procession frieze actually has few figures walking in quiet dignity. Instead, there are mostly galloping horsemen and attendants with temperamental bulls. And the models for the striking family groups on the Ara Pacis cannot be the Parthenon frieze where there are none, but family funerary reliefs of the fifth and fourth centuries B.C., as, for example, a fourth-century relief depicting Onesimos, Protonoë,

Eukoline, and Nikostrate in Athens. Stances, gestures, and glances unite the figures in much the same way as they join the group of what appears to be Antonia the Younger, Drusus the Elder, and their young son Germanicus, on the south frieze of the Ara Pacis. The distinction between relief levels adds an element of depth to both reliefs that is absent in the Panathenaic procession frieze. The similarity in the handling of figures in space in the fourth-century funerary relief and in the Ara Pacis is an additional reason for postulating that these reliefs, rather than the Parthenon frieze, served as models for the family groups on the Ara Pacis.

Unlike the Parthenon frieze, the Ara Pacis procession does not wind around all three sides of the monument but is restricted to the long walls. On the short sides are four panels with individual scenes, of which two are well preserved. These include scenes from the legendary history of Rome and thus complement those on the roughly contemporary Basilica Aemilia (see figs. 69–70). A scene of Aeneas making a sacrifice to the penates or household gods (fig. 78) is depicted on the panel on the southwest side. Aeneas, founder of the Julian family, is portrayed as a bearded older man, the pater Aeneas as re-created by Virgil for the Romans. Aeneas's presence here suggests Augustus's divine descent from Venus through Aeneas. Aeneas is depicted in roughly the same position as Augustus in the south frieze. Aeneas has a patera in his right hand and, with his left, he pours a libation on the altar. A hasta or spear, the sign of supreme authority, was probably also held in his left hand. Aeneas is accompanied by two attendants. One holds the dish of fruit, the other is represented with a sow. The sow is probably the white sow of Lavinium that Aeneas encountered on his arrival in Latium. There is a prophesy in Virgil's *Aeneid* that Aeneas would find the sow under an oak tree, just as the scene is depicted on the Ara Pacis. Virgil's poem is not fully reproduced in this panel. Instead the scene seems to be closer to a version of the story handed down by Dionysios of Halikarnassos. According to that version, Aeneas "slaughtered the sow for the ancestral gods," that is, the penates of his household, who had saved him from burning Troy and guided him to Latium. Augustus's return to Italy after a trip to Spain and Gaul is paralleled by Aeneas's arrival in Italy. In the scene on the Ara Pacis, Aeneas is followed by his adult son, Julus-Ascanius, from whom the Julian family received its name. The son is wearing a Trojan sleeved robe and holding a shepherd's crook because his grandfather, Anchises, the lover of Venus, was a shepherd. (Some scholars identify this figure, instead, as Aeneas's faithful friend, Achates, and one of the boy attendants as Julus-Ascanius. In any case, all agree that Aeneas's son is included in the scene.) The intended link between Augustus and Aeneas suggests that there may be a correspond-

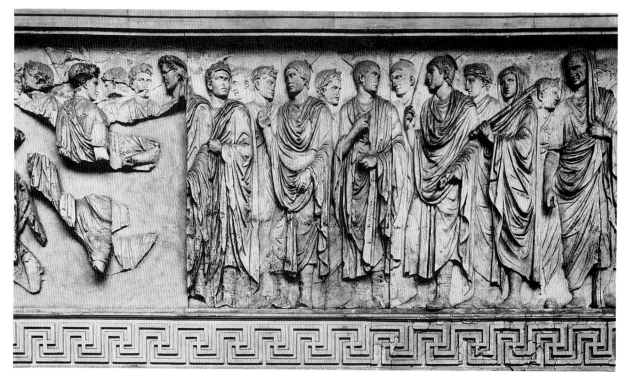

74 Rome, Ara Pacis Augustae, south frieze, Augustus and
lictors, 13–9 B.C. Photo: DAIR 72.2400

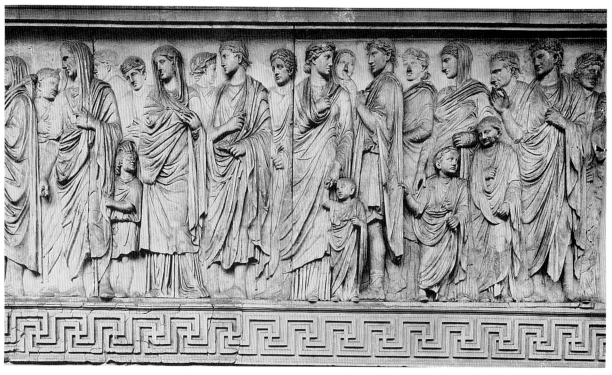

75 Rome, Ara Pacis Augustae, south frieze, Marcus Agrippa
and imperial family, 13–9 B.C. Photo: DAIR 72.2403

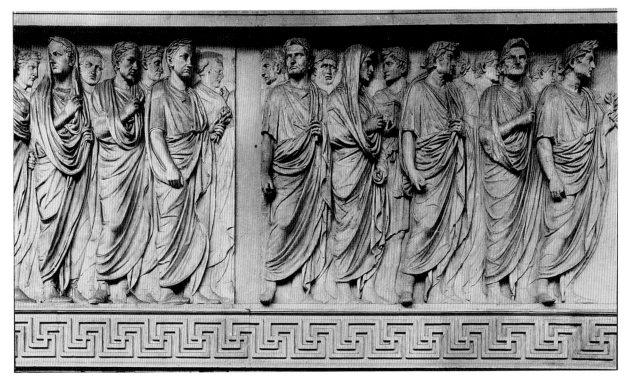

76 Rome, Ara Pacis Augustae, north frieze, senators,
13–9 B.C. Photo: DAIR 72.2401

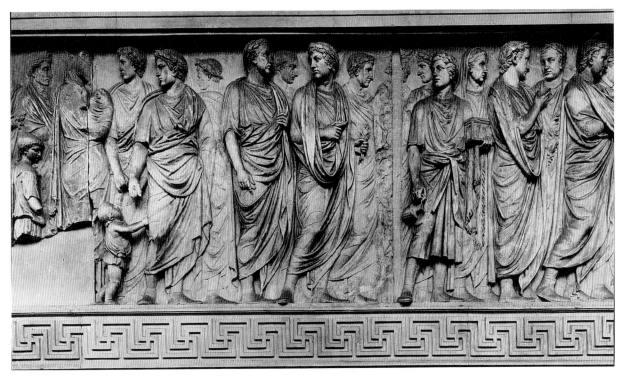

77 Rome, Ara Pacis Augustae, north frieze, senators and
imperial family, 13–9 B.C. Photo: DAIR 72.2402

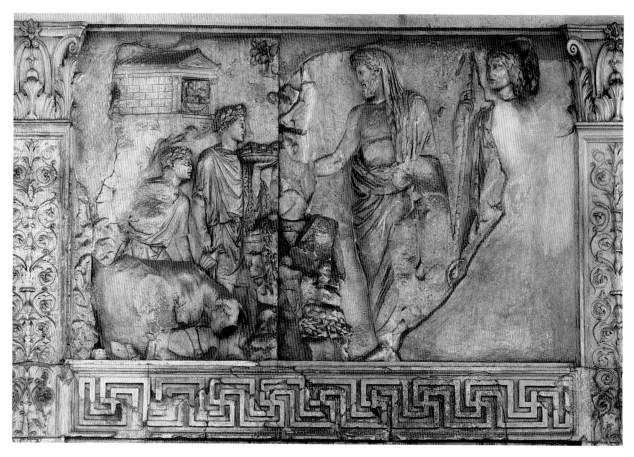

78 Rome, Ara Pacis Augustae, southwest panel with Aeneas, 13–9 B.C. Photo: DAIR 72.648

ing association among their "sons." Julus-Ascanius, in Trojan garb, appears at his father's side. Two boys in Trojan costume, one on the south and the other on the north frieze, also follow closely behind Augustus. Their proximity to the emperor and their assimilation to Julus-Ascanius raise the likelihood again that they are probably Augustus's grandsons and heirs. The style of the Aeneas panel also requires comment. The landscape setting and the placement of the domestic shrine in smaller scale in the background recall Hellenistic reliefs that must have served as models.

On the northwestern side of the Altar of Peace is a relief panel with a scene of Mars with the infant boys Romulus and Remus. It is badly damaged, but its principal features can be discerned. Mars, who is portrayed in armor and helmet, symbolizes the war by which Augustus brought peace to Rome. Mars is also the father of Romulus, who was the legendary founder of the state, who is depicted here along with Remus and the she-wolf. Mars was thus ultimately the father of the Roman people, Aeneas of the Julian family.

The southeast panel (figs. 79–80) represents the personification of Earth (Tellus) or Italy (Italia), or the com-

posite Italiae Tellus of the Gemma Augustea (some scholars identify her as Venus, Pax, or Ilia with Romulus and Remus) as a matronly woman with two bouncing babies on her lap. She is framed by female personifications of breezes with billowing mantles blowing over land and sea. There are also animals, flowers, and fruit – all symbols of fertility and growth. The same message is set forth: Peace brings prosperity and time for planting and harvesting and the security to raise children and plan for the future through the peace brought to Italy by Augustus. For this reason, the specific identification of the woman as Tellus, Italia, Italiae Tellus, Venus, Ilia, or Pax is not of great importance, since she is in a sense a synthetic symbol of all these personifications and divinities. Imperial patrons and court artists in the age of Augustus favored multiple associations in their portraiture as well as in their depiction of legendary and mythological figures, and this was matched by their predilection for disguising recognizable historical personages beneath a classicizing gloss.

Little but the clothed upper thigh of a seated figure with weapons, the goddess Roma, is preserved in the northeast panel. She was flanked by personifications of

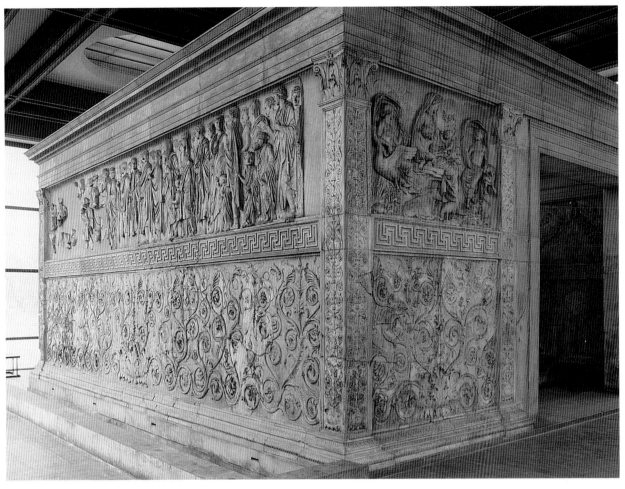

79 Rome, Ara Pacis Augustae, south and southeast sides,
13–9 B.C. Photo: DAIR 72.654

80 Rome, Ara Pacis Augustae, southeast panel with Italiae
Tellus, 13–9 B.C. Photo: Alinari/Art Resource, New York, 1187

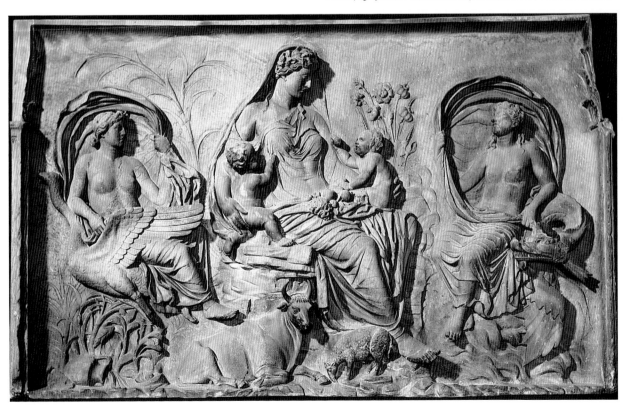

Honos on the left (the curly haired head of the youthful figure is preserved) and Virtus in Amazonian costume at the right. The pair had earlier been coupled on coins commemorating Pompey the Great's triumph of 70 B.C., and it has been suggested that they serve here to welcome the arrival to Rome of the victorious emperor, namely Augustus.

One figure is obviously missing in the friezes and panels of the Ara Pacis – Pax – the goddess to whom the altar is dedicated and to whom the annual sacrifice is offered. Although some scholars suggest that she was among figures preceding Augustus in the missing left-hand side of the south frieze, or that she was depicted in the southeast panel, these hypotheses seem unlikely. The rich imagery of the altar, with its wealth of allusions to peace, Mother Earth, Italy, children and families, animal and vegetal life, and tranquil sacrifices and ceremonial processions, provides a more complete image of the concept of peace than a representation of the goddess herself. The peace brought by Augustus to Rome and the empire through war with such foreign foes as Cleopatra and through diplomatic efforts in provinces like Gaul would provide members of the imperial circle and the aristocracy with the opportunity to consolidate family life and to raise children. The imperial children would ensure the continuity of the Julian dynasty and preserve the Augustan peace. In fact, it is above all pairs of male children that link the past, present, and future of Rome. The infants Romulus and Remus are suckled by the she-wolf. Romulus survives and founds the city of Rome. Through civil and foreign wars and diplomatic treaties, Augustus brings peace to Italy, personified by a matron with two healthy male twins on her lap. Augustus places Rome's future in the hands of his heirs, Gaius and Lucius Caesar. Augustus and Livia were the father and mother of Augustus's "sons" and of the Roman people. The ancestry of the Julian family was traced to the divine Venus through Aeneas, and the concordia of the imperial family was further underscored by the division of the sculptural program of the Ara Pacis into two distinct sections that might be described as gender specific. There are no female figures on the west, southwest, and northwest sides of the altar. War and the establishment of peace were the purview of the leading men of the day, Augustus and Agrippa. Mars was the father of the Roman people (the senatorial side), and Aeneas the father of the Julian family (the imperial family side). All four provided male progeny that founded Rome and ensured its continuity. The priests and senators of Rome, accompanying Augustus and Agrippa in procession, perpetuated the civic and religious institutions of the state. Although some men and several significant male children are depicted on the southeast and northeast sides of the Ara Pacis, women such as Livia, Julia, and Octavia, as wives and mothers, occupy pride of place in both contexts, and Italiae Tellus and Roma are the main protagonists on the east side of the outer precinct wall. In contrast to Aeneas and Mars, both are depicted in seated rather than standing positions. Italiae Tellus is not usually depicted in such a manner but was so arranged to serve as a pendant to Roma, who is often depicted as seated on a pile of arms and armor. The seated position, however, serves to underscore the nurturing function of the women who were not the political movers and shakers but rather contributed to the Augustan peace through their marital fidelity and fecundity. The themes stressed on this side of the Ara Pacis are correct female behavior that included the inclination and ability to bear children through youthful fecundity, the joys of motherhood, the unbreakable bonds of family life, hereditary succession, and the general abundance brought to Rome and the empire by the Augustan peace.

In fact, the position of the historical, legendary, and mythological figures on the Ara Pacis follows a strict hierarchy. The founders of Rome, also the fathers of the Roman people and the Julian family, are depicted closest to the altar, followed by the male leaders of the imperial house, the princeps and his son-in-law. Augustus and Agrippa are followed by their male heirs, and they in turn by their mothers, aunts, and sisters. The position of these individuals in the hierarchical scheme is a more significant indication of their identity than are their deliberately classicized facial features or their costumes. In the past, scholars have had difficulty in reconciling the separation of Agrippa and Julia, with one on the south and the other on the north side of the monument. The solution to this, I believe, is that it is Livia rather than Julia who is presented here as the "mother" of Gaius and Lucius. Julia was their natural mother, but it was Livia who became their new "mother" at the same time Augustus became their "father," that is, at their adoption by him in 17 B.C., a year that coincided with the birth of Lucius. Bereft of her own children, Julia became a kind of virgin goddess and mother of the Roman people (her counterpart, Roma, flanked by Virtues is depicted on the same side of the monument), while Livia became the fount of fecundity and is assimilated to Tellus/Italia/Venus/Pax in the southeast panel. The two babies on the personification's lap refer not only to childbearing in general and to Livia's new sons Gaius and Lucius in particular, but also to Livia's natural sons, Tiberius and Drusus, also depicted on the south frieze. Livia is doubly abundant. Livia's key position in the iconography of the Ara Pacis is signaled, as suggested earlier, by the fact that the monument was dedicated on her birthday.

In antiquity, the Ara Pacis Augustae was not an isolated building. It was part of an architectural complex in

81 Ara Pacis Augustae. Reconstruction of complex with Mausoleum of Augustus, ustrinum, and obelisk, 28–9 B.C. Photo: Courtesy of Edmund Buchner

the Campus Martius, which included not only Augustus's round mausoleum and his ustrinum (the base for his funerary pyre), but also a sundial in the form of an obelisk with an orb and metal point at the apex (fig. 81). The sundial designated years, months, and even hours and was carefully orchestrated so that its shadow fell on the Ara Pacis Augustae on Augustus's birthday. Also nearby was the Via Flaminia, the ancient road Augustus took on his return to Rome from Spain and Gaul after his pacification of the Roman world. Obelisks began to be popular during the Augustan period. This obelisk was actually the first of many to be brought from Egypt to Rome and is another example of the vogue for things Egyptian that swept Rome and Italy after the annexation of Egypt as a Roman province in 30 B.C. For this reason, the obelisk might be viewed as something more than a clock; it might well be interpreted as a victory monument over Egypt and Cleopatra, and Mark Antony, at the Battle of Actium. The obelisk, then, refers to Augustus's eastern victories, the Ara Pacis to Augustus's triumph over the western world and to the peace brought to the entire Roman world, and the ustrinum and mausoleum to Augustus's triumph over death, military victory, and victory over death linked by the concept of fame in the eyes of the Romans. The inscription at the base of the obelisk states that Augustus dedicated the monument to Sol, the sun, probably between 10 and 9 B.C. Augustus's patron god, Apollo, was, of course, the god of the sun, and he appears in the form of his bird, the swan, amid the acanthus tendrils on the Ara Pacis Augustae.

"he found Rome a city of brick and left it a city of marble" (Suet., *Aug.*, 28). This statement was, of course, a rhetorical exaggeration, but it is true that it was not until Augustus that marble came to be used as a standard building stone for public monuments. What made Augustus's boast possible was the very recent full-scale exploitation of the rich marble quarries at Luna, modern Carrara, on the western coast of Italy. Before Augustus, marble had to be imported all the way from Greece, which was extremely costly. A high-quality marble, however, had become available in Italy at a fraction of the price, and Augustus exploited the situation fully. Nonetheless, a great variety of decorative marble, possibly intended as symbolic spolia of the empire, is used in the Forum of Augustus.

Rome already had two fora in the time of Augustus – the Roman Forum and the Forum of Julius Caesar. Suetonius suggests Augustus's reason for building a third forum: "The reason for constructing his forum was the greatness of the population and the number of judicial cases; these made a third forum necessary, since the two already in existence were not sufficient" (Suet., *Aug.*, 29).

But much more important was that Augustus vowed to construct the forum earlier when he promised to build a temple to Mars Ultor, Mars the Avenger, in anticipation of the god's help in avenging Caesar's assassins, Cassius and Brutus, at the Battle of Philippi in 42 B.C. Work did not actually begin until after Actium (the specific date in unknown), and the Forum of Augustus was not completed until 2 B.C.

The Forum of Augustus and Its Sculptural Program

Another of Augustus's major commissions was a vast marble complex in downtown Rome that bears the emperor's name – the Forum of Augustus (fig. 82). The forum was constructed largely of Luna marble and best illustrates Augustus's boast, recorded by Suetonius, that

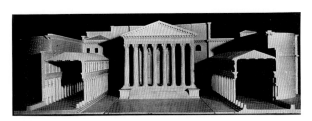

82 Rome, Forum of Augustus, model, dedicated 2 B.C. Photo: DAIR 69.810

Augustus built his forum right next to the Forum of Caesar, which Augustus also completed after Caesar's death. He also based the shape of his forum on Caesar's and the form of the Temple of Mars Ultor on Caesar's Temple of Venus Genetrix. Both the location and form of the Forum of Augustus thus make it apparent that the emperor intended his monument to serve as a political message in stone. The message is made more explicit by the elaborate sculptural program that embellishes both the temple and its precinct. The purpose of this sculptural decoration was not only to connect the emperor with his divine adoptive father but also to emphasize Augustus's divine lineage.

Augustus's forum was 125 meters long and 118 meters wide and was basically rectangular in shape. Two long porticoes line the central elongated area. The Temple of Mars Ultor was placed at the east end and was flanked on either side by an exedra. The forum was surrounded by a precinct wall that was 115 feet in height. This wall, which was made of peperino ashlar masonry and was originally faced with travertine, enclosed the forum and protected it from the surrounding tenements and from fire. The temple was placed with its back against the precinct wall, and it dominated the space of the forum in front of it. The temple is the Etruscan-Roman type with a closed back wall, high podium, staircase on one side, and a deep porch. It was octastyle, that is, it had eight columns across the front. The forum and temple were either constructed of or faced with marble. The temple podium, for example, was reached by a staircase of seventeen marble steps, and the colossal columns were also of marble. The capitals of the columns of the forum were of two different types – the more canonical ones were of the standard Corinthian order with volutes and central flowers growing out of a triple row of acanthus leaves. The other variety of capital was a free variation on the Corinthian type, with winged horses replacing the canonical volutes. The winged-horse capitals have close parallels in Greece. The capitals of the Lesser Propylaea at Eleusis, built in 50 B.C., are also zoomorphic, although bull protomes, rather than pegasi, emerge from the acanthus leaves. There is no question that the Augustan architect knew of the Greek capitals and modeled his own on them.

The porticoes flanking the Temple of Mars Ultor had two stories – the first was supported by Corinthian columns, the second decorated with attached caryatids or female supports that flank shields ornamented with heads of divinities (fig. 83). These caryatids are exact copies, in reduced scale, of the fifth-century B.C. caryatids of the south porch of the Erechtheion on the Athenian Acropolis. The direct contact of Augustan artists with Greek models could not be better illustrated. In fact, we know

that at the same time the Forum of Augustus was being constructed, Augustus was also funding a restoration of the four-hundred-year-old Erechtheion itself. Augustan architects or artisans performed the repairs and brought casts of the Erechtheion caryatids to Rome to use as models for the forum porticoes.

By using copies of the Erechtheion caryatids in his forum, Augustus was making a deliberate political statement in which he attempted to associate Augustan Rome with the Golden Age of fifth-century Greece, that is, Periclean Athens. The fact that Augustus coated his city with marble and boasted that he had changed Rome from a city of brick to one of marble is indicative of his love and admiration for things Greek. The Greeks, of course, used marble for their architecture. Augustus's predecessors in Italy, the Etruscans and republican Romans, did not. The round shields hung between the caryatids refer to victory in battle and perhaps even to the great Hellenistic king, Alexander the Great. It is known that Alexander hung shields in the Parthenon after his significant military victory at Granikos.

The Temple of Mars Ultor also had sculptural decoration in the pediment and the cella of the temple. The temple is is now largely in ruins, but we have a representation of it in miniature in a later relief from the Claudian "Ara Pietatis Augustae" (see fig. 120). Its pediment was filled with marble statuary. In the center is a heroically semidraped Mars Ultor, the Mars who helped Augustus avenge Caesar's death. To the left is Venus, the goddess who stood at the head of the Julian line. On her left shoulder stands a small Eros. Augustus, like Caesar before him, implies that he is descended from Venus. Next to her is a seated Romulus. On the right, stands Fortuna, the goddess of fate and luck who ensured Augustus's success in all his ventures. She is accompanied by Roma, who serves as a balancing figure for Romulus. Personifications of the Palatine hill and the Tiber River recline in the left and right corners, respectively.

Inside the temple was a statuary group of Mars, Venus, and Divus Julius. This group is not preserved, but a representation in relief – today referred to as the Algiers Relief because of its present location (fig. 84) – is purported to depict the threesome. Marble bases, also in relief, beneath the feet of Mars and Venus, suggest that they are statues. Mars, fully armed and bearded, with helmet, shield, cuirass, and spear, is in the center. Venus, at the left, leans on a column. She is Venus Genetrix, the goddess of Caesar's forum, whose presence advertises Augustus's divine descent. She is accompanied by her son Cupid, who bears a striking resemblance to the support of the Primaporta statue (see fig. 42). On the right is a young man with bare chest and Augustan cap of hair. Remains of metal on the forehead indicate that

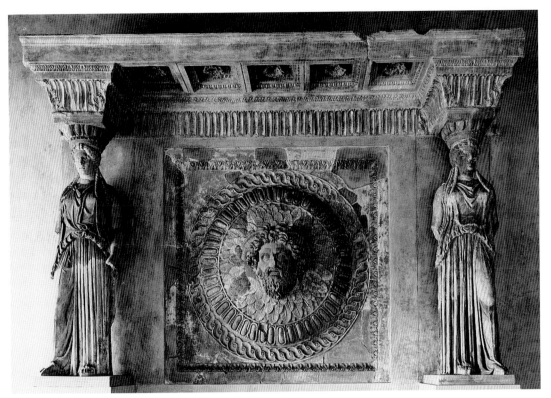

83 Rome, Forum of Augustus, caryatids, dedicated 2 B.C.
Photo: DAIR 61.1059

84 The Algiers relief with Mars, Venus, and Divus Julius, Augustan. Algiers, Archaeological Museum. Photo: Alinari/ Art Resource, New York, 47176

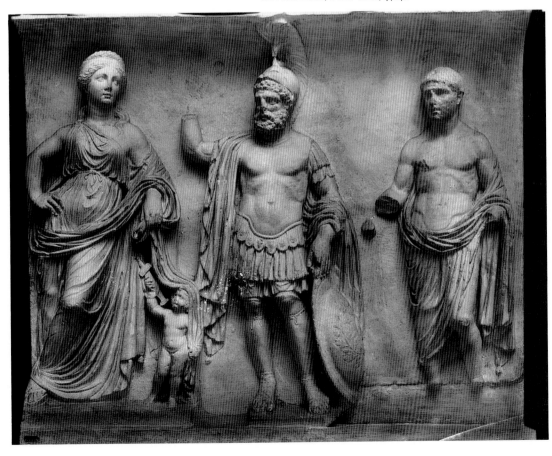

a star, perhaps to imply divinity, was originally affixed to the portrait. Augustus is known to have added a star to all the statues of Caesar to transform them into images of the divine dictator. For this reason, the most likely identification for this figure is Divus Julius, a god who had no place in the traditional Roman pantheon, but one who was of the greatest significance for Augustus. The portrait head of Caesar is itself of considerable interest. Caesar is not depicted with the lined forehead and neck and balding pate of his veristic lifetime portraits (see fig. 26). Instead, his divinization has magically transformed him into an eternal youth with a full head of hair. As we have seen, Roman portraits in the round are similarly rejuvenated in posthumous versions.

There are dozens of other statues in the Forum of Augustus. These include over-life-size statues of both mythical and historical Romans that line the two exedrae and both porticoes. Similar statues were displayed on the portico of the Temple of Apollo Palatinus. In the left exedra stood a portrait of Aeneas, founder of the Julian line; in the right, Romulus, founder of Rome. There were also figures of great men of the republic and Augustus's own ancestors, a kind of who's who of early Roman history. Remains of these marble statues, including heads, cuirasses, and togas, have been found in the excavations of the forum. Also discovered were the remains of trophies that had been placed in the upper niches of the exedrae.

The display of statuary in the colonnades and exedrae of Augustus's forum is a version in grand scale of the display of family genealogy in the alae of the private houses of the Roman aristocracy. Augustus emphasizes his descent from Aeneas, the son of Venus, and from Romulus, son of Mars.

These legendary founders of Rome were flanked by the statuary of historical Romans who had participated in the civil wars that culminated in Augustus becoming sole emperor of Rome. Although the Temple of Mars Ultor was vowed at Philippi, a battle that pitted Octavian against Italian foes, it was begun after Actium, a civil conflict that had a foreign flavor to it. The naval battle at Actium was actually pictured by Augustus's propagandists as a war against Cleopatra of Egypt rather than Antony of Rome. Furthermore, by 2 B.C., another foreign success, that of the return of the Parthian standards to Rome, was emphasized by Augustus to stress foreign victories rather than those over Italian citizens. The statuary display of the Forum of Augustus gave the emperor a visual opportunity to underscore the unity of all Roman generals under the Augustan peace, even those who had fought one another in earlier civil wars.

The Belvedere Altar

The Belvedere Altar is decorated on four sides with scenes that serve to summarize Augustus's political ideology, social laws, and religious beliefs. The front side of the altar (fig. 85) depicts a rocky setting with a pair of laurel trees flanking a flying Victory who sets an inscribed shield on a pillar. The shield's inscription refers to Augustus as pontifex maximus, which indicates that the monument cannot have been made before 12 B.C. The title pater patriae, which Augustus received in 2 B.C., is not given, suggesting that the monument has a terminus ante quem of 2 B.C. The rock must be the Palatine, the laurel trees the pair in front of Augustus's Palatine residence. The opposite side of the altar (fig. 86) depicts a chariot scene with the chariot drawn by four horses that rise from the horizontal groundline. The chariot holds a seminude male figure with mantle, now headless. As it rises, the chariot is acknowledged by a fragmentary male in toga at the left and a woman with two small boys at the right, all now headless. In the sky are Caelus at the right and the horses of the sun god at the left. The identity of the human protagonists continues to be debated. The scene is universally identified as one of apotheosis, but the figure in the chariot has variously been identified as Julius Caesar (the most likely candidate), Augustus (the depiction of his apotheosis prior to his death is unacceptable), or the deified Romulus. The male at the left is thought to be either Augustus, Tiberius, or the senator Julius Proculus; the woman at the right Livia, Julia, or Venus. There is near consensus that the two boys are Gaius and Lucius Caesar, although it has recently been posited that they are the two children of Romulus and his wife Hersilia.

Another side of the Belvedere Altar represents the seer Helenus and Aeneas's discovery of the sow of Lavinium that conflates two episodes in the saga of Aeneas as related by Virgil. The fourth side depicts Augustus's presentation of lares statuettes to the attendants of the street superintendents or *vicomagistri* and this altar, like others of contemporary date, was fashioned after Augustus's reorganization of the cult of the lares in 12–7 B.C. It was at the same time that worship of the lares at the crossroads was expanded to include the *genius* of Augustus.

That the Belvedere Altar was commissioned to honor Augustus as head of the Roman state religion and its reorganizer seems indisputable. His new title, pontifex maximus, is inscribed on a shield in front of the emperor's Palatine residence, and due respect is paid to Augustus's *genius* and to the cult of the lares. The prophecy

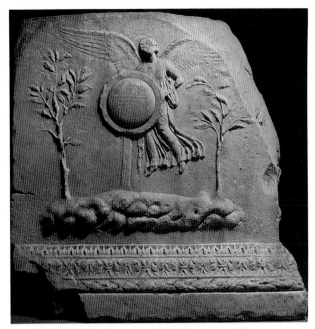

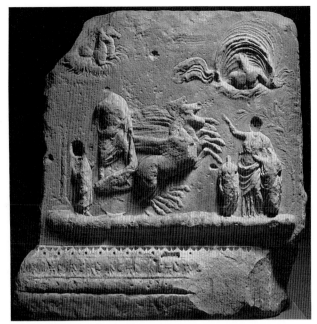

85 Belvedere altar, Victory and shield, 12–2 B.C. Rome, Vatican Museums. Photo: DAIR 75.1285

86 Belvedere altar, apotheosis of Julius Caesar, 12–2 B.C. Rome, Vatican Museums. Photo: DAIR 75.1289

of Rome's foundation and its fruition under Aeneas as the father of the Julian family are both alluded to. It is Augustus – civic (he wears the toga) and religious leader of the state – who has taken up Aeneas's mantle and guided Rome under the protection of his divine father and protector, Apollo (represented by the solar chariot). Augustus's hopes for the future of Rome lie in his two young heirs, Gaius and Lucius Caesar, depicted next to Livia (their new "mother"), possibly in the guise of Venus, at the right. In 2 B.C. both grandsons were still alive, and this closely knit family group, underscoring the emperor's social policies, is depicted to the right of the chariot with, in my opinion, Augustus at the left, both bearing witness to the apotheosis of Augustus's other "father," Julius Caesar. A concentration on Caesarian imagery at this date is not surprising because the Belvedere Altar is contemporary to the construction of the Forum of Augustus that honored Augustus's divine adoptive father – both in its inclusion of the Temple of Mars Ultor pledged before Philippi and in its display of a cult statue of Divus Julius.

Relief Sculpture of Freedmen

Freedmen also commissioned relief sculpture in the age of Augustus. Surviving examples are found in funerary contexts and were commissioned both by working-class patrons in Rome and by minor magistrates in towns elsewhere in Italy.

The Amiternum Reliefs

Two reliefs of local limestone from Amiternum, a town northeast of Rome, belong to the decorative program of a local tomb or tombs belonging to freedmen. The reliefs were discovered together in a cache of remains that included a pediment with a Medusa head and numerous late republican and Augustan epitaphs with references to members of the Peducaea and Apisia families. One depicts a gladiatorial combat (fig. 87), a popular Roman subject that appears frequently in funerary contexts in Rome, Pompeii, and elsewhere, and may, in this case, refer to the *bustuarii* or gladiators who fought at a funeral pile in honor of the dead. Here the two foes are engaged in hand-to-hand combat at the center of the relief panel. The opponents protect themselves with rectangular shields and raise their spears against each other. Each gladiator is accompanied by a single attendant who holds in readiness an additional supply of spears. The gladiators occupy the full height of the relief, while the less important attendants are diminutive in scale. The facial features of the protagonists are only barely indicated and the artist demonstrates that he is not a master of the depiction of the human form. The gladiators' feet, for example, are

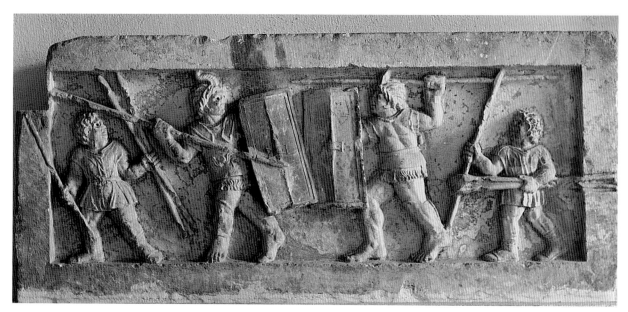

87 Amiternum relief with gladiatorial combat, Augustan.
L'Aquila, Archaeological Museum. Photo: Courtesy of
Antonio Giuliano

much too large for their bodies. Nonetheless, the art-
ist made a valiant attempt to vary the postures of the
four figures and to depict them in lively motion. The left
gladiator strides purposefully to the left but twists his
body back toward his opponent.

The other better-known relief (figs. 88–89) is as unique
as the gladiatorial scene is common. Extant historical and
literary texts describe Roman funerary rites, and Etrus-
can urns record the main features of an Etruscan funeral,
but the Amiternum Relief is the sole surviving visual
record of a Roman funerary procession. It represents the
musicians, the bearers of the funerary bier, the deceased
(or his effigy) on the funerary bed, the family mem-
bers and their slaves and freedmen, and the professional
mourners. The mood of the relief is somber, and the
figures are arranged in static groups. The postural va-
riety of the figures in the gladiatorial relief is missing
here. The monotonous repetition of figures in similar
postures might be seen as the mark of an inferior artist.
In contrast, the master designer of the roughly contem-
porary great friezes of the Ara Pacis Augustae (see figs.
74–77) enlivened his solemn procession by varying the
levels of relief, the postures and gestures of the figures,
and by including restless infants and toddlers in a formal
setting. But the goal of the Amiternum artist was differ-
ent from that of the designer of the Ara Pacis. The job
of the former was to represent in the small space of a
single panel an entire funerary procession, including the
deceased, eight pallbearers, seven musicians, the griev-
ing family and professional mourners, and the household
staff. Each figure had to be clearly differentiated, with

no overlapping, and the significance of the scene had to
be able to be taken in at once. The artist who carved the
Amiternum Relief was also not versed in the rendition of
perspective over which the Ara Pacis designer had com-
plete mastery. The Aeneas Panel on the Ara Pacis (see fig.
78), based on Hellenistic prototypes, is a case in point.
Aeneas sacrifices at his altar in the foreground, but the
household gods to which he makes offerings are diminu-
tive in scale and depicted in a small shrine at the upper
left and thus in the background of the relief. Instead, as
we shall see, the artist who carved the Amiternum Relief
depicted space in a highly innovative way (probably un-
wittingly) that presaged the future and was later adopted
by artists in the imperial employ.

The deceased (or his effigy) in a long tunic, is de-
picted on a funerary bed that is cushioned by a mattress
and a pillow and covered with a canopy ornamented with
images of the moon and stars, probably astrological signs
referring to the deceased's personal religious beliefs. The
figure is not completely prone. Rather, he props up his
head with his left hand and looks out as if to survey his
own funeral. This figure is undoubtedly based on reclin-
ing figures on Etruscan urns that are also depicted as if
still alive. The bed rests on a long bier supported by two
poles. The bier is held by eight male pallbearers, who may
be the deceased's slaves and freedmen. Those in the fore-
ground are taller than those in the background, and by
differentiating their height, the artist has indicated depth.
The pallbearers are led by the man who regulated the
funeral procession (the *designator*) and four flute players,
all in the foreground, with the first flute player depicted

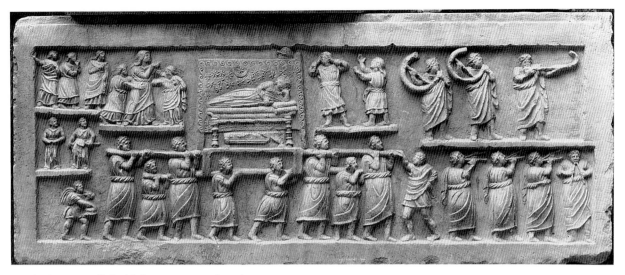

88 Amiternum relief with funerary procession, Augustan.
L'Aquila, Archaeological Museum. Photo: Alinari/Art
Resource, New York, 36101

en face. The rest of the procession includes, from right
to left: trumpeters, professional female mourners pull-
ing out their hair and beating their breasts, the grieving
widow and her two daughters, and the matron's female
slaves and freedwomen. These figures are not smaller in
scale than the male pallbearers in the background below,
and it is therefore not scale differentiation that is used
here to connote depth. Rather, these figures are depicted
in a second tier located above the heads of the pallbearers.
That they are standing on the ground and not floating in
the air is indicated by the fact that they are situated on
individual groundlines or turf segments as if they were
statuary groups on bases. Stacking figures of comparable
scale in registers and the use of turf segments in the Ami-
ternum funerary procession was of no interest to court
artists of Augustan times but became the norm in state
relief sculpture under the Antonine emperors. The use of
scale to denote hierarchy – apparent in the Amiternum
gladiator relief – is also missing in Augustan monuments
commissioned by the emperor, but in the early second
century Trajan used it to his personal advantage in reliefs
from the Arch of Trajan at Benevento (see figs. 190–191,
193) and elsewhere.

The Tomb of Marcus Vergilius Eurysaces

Marcus Vergilius Eurysaces was a businessman of
slave descent, specifically a baker, who had compiled a
considerable fortune selling bread to the army and with
those funds was able to erect a travertine-faced, concrete
tomb in Rome to house his wife's ashes. The tomb (fig.
90) has an inset portrait relief and a frieze that decorates

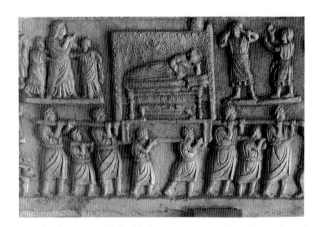

89 Amiternum relief with funerary procession, deceased, and
family, Augustan. L'Aquila, Archaeological Museum. Photo:
DAIR 61.4

three sides of the structure and describes in minute detail
the successive phases of the baking of bread.

The tomb has a trapezoidal plan. On the base stands
a series of vertical tubelike cylinders. On top of these is a
cornice with inscriptions on three sides of the monument
that name Eurysaces and give his profession as *pistor* and
redemptor, master baker and contractor.

Above the cornice are three rows of head-on cylin-
ders. These vertical and horizontal cylinders are thought
to imitate tubelike grain measures used in bread making.
Despite the inclusion of the grain measures, the tomb
itself is not in the form of a baker's oven, which some
scholars have suggested.

The fourth side of the tomb no longer survives. It
was demolished when the monument was incorporated

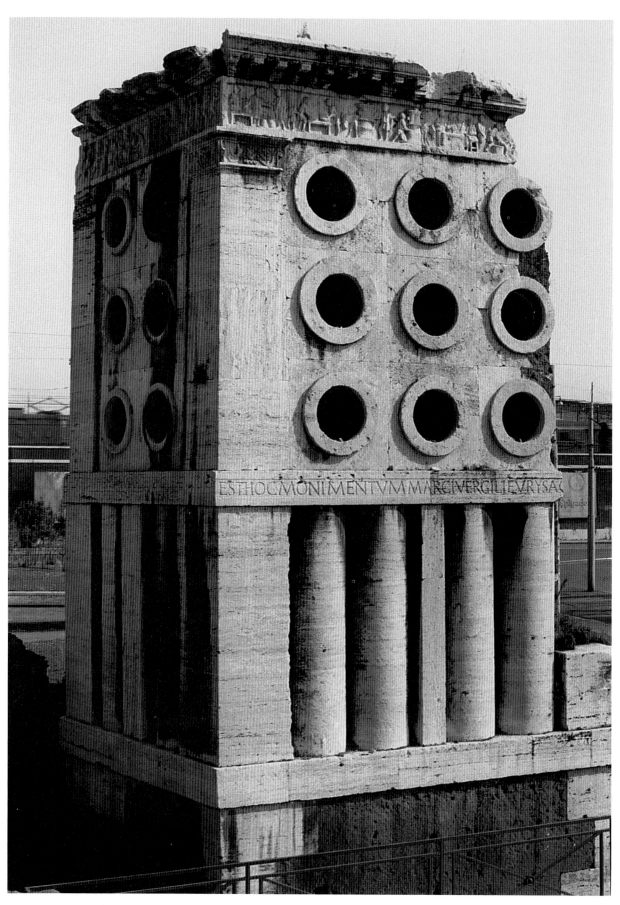

90 Rome, Tomb of Marcus Vergilius Eurysaces, general
view, late first century B.C. Photo: D. E. E. Kleiner and F. S.
Kleiner, 73.12.16A

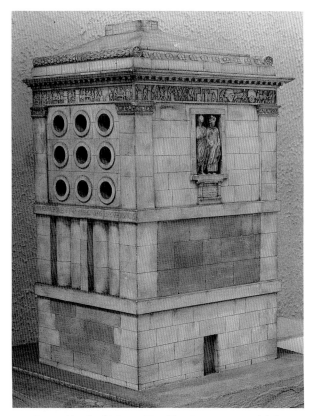

91 Rome, Tomb of Marcus Vergilius Eurysaces, model, late first century B.C. Photo: DAIR 72.2568

cinerary urn in the shape of a breadbasket, and the urn in turn placed in the burial chamber. Urns in the shape of baskets were popular for women. Some of these were wool baskets that memorialized a woman's domestic virtue, and Atistia's household skills may also be alluded to here. Nonetheless, the basket here is first and foremost intended as a breadbasket and is an additional allusion to the professional accomplishments of Atistia's husband. It was, after all, Eurysaces' success as a baker that enabled the tomb to be erected. The inscription below the portraits states that Atistia is buried *in hoc panario*, that is, in this breadbasket. The breadbasket probably refers to the urn rather than to the tomb itself.

In the portrait relief (fig. 92), Eurysaces and Atistia are depicted at full length. They are frontal and stand side by side without touching, although they turn slightly toward one another. Eurysaces is clothed in a tunic and toga, Atistia in tunic and palla. The folds of the garments are delicately rendered. An especially fine detail is the right hand of Atistia, which is caught beneath her garment and carefully modeled by the artist. A comparable passage can be found in the figure of Livia on the south frieze of the Ara Pacis (see fig. 75). Eurysaces has a veristic portrait and Atistia wears the latest coiffure – her hair piled high atop her head – which demonstrates that the portraits of the baker and his wife are based on contemporary imperial and aristocratic models.

In addition to the portrait relief there was a frieze across the other three sides of the monument. The frieze commemorates Eurysaces greatest claim to fame – not a great military victory, not a high public office – but the baking of bread. In fact, the frieze might be interpreted as a baker's version of Augustus's *Res Gestae* – a list of things accomplished. In this case, every detail of the baking of bread is clearly set out for the observer. The first scene (fig. 93) represents the grinding of the grain by mills, which are correctly depicted and comparable to those preserved at Pompeii. The grain was crushed between two stones, the upper one rotated by a mule that marches around the machine in circles, supervised by a tunic-clad attendant. That the young man is dressed in a tunic and not a toga is significant, indicating that he is at work.

Elsewhere on the frieze is a scene of the mixing of the batter in a great tub, the mixing facilitated by animal labor. Further to the left, workmen stand behind two large tables forming the individual loaves of bread by hand. The workmen are barechested. They are almost all in the same posture and not much attention is given to such artificialities as correct perspective. It is clearly the narrative that counts. Between the two tables is the supervisor in his business suit – the toga. The proximity of the workers to the oven (fig. 94), which is tended by another

into a tower of the city walls in the early Byzantine period. The tomb was uncovered again in the nineteenth century. The fourth side was, however, different in antiquity from the other three sides, as can be seen in a modern reconstruction of the structure (fig. 91). There was no inscription on the cornice, and no cylinders were placed either horizontally or vertically. There was no relief frieze on the fourth side.

Instead, the base was crowned by a plain second story, and the third story was decorated with a portrait relief of the baker and his wife, similar to those commissioned by contemporary freedmen. The side with the portrait relief was the facade of the monument because it faced two major roads, the Via Praenestina and the Via Labicana, that converged at this juncture from the countryside into Rome. For reasons of superstition as well as health, most Roman burials took place outside the city walls. Consequently, Roman tombs usually line the roads from the city. Eurysaces, a wealthy man, chose a prime piece of real estate for his tomb because its facade was visible to everyone entering Rome from either the Praenestina or the Labicana. Eurysaces' methodical selection of such a site for the tomb indicates that he was a man who did not want to be forgotten by posterity!

The burial chamber was located in the upper story of the tomb. The ashes of Atistia were deposited in a

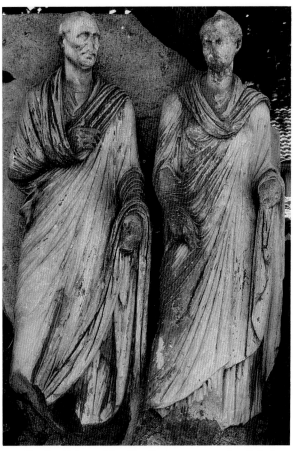

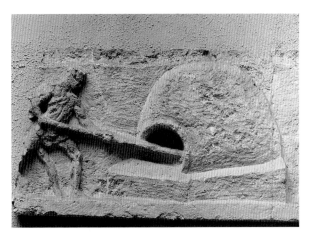

94 Rome, Tomb of Marcus Vergilius Eurysaces, baking frieze with oven, late first century B.C. Photo: DAIR 72.3823

92 Tomb of Marcus Vergilius Eurysaces, portrait relief of Eurysaces and Atistia, late first century B.C. Rome, Museo del Palazzo dei Conservatori. Photo: DAIR 32.1402

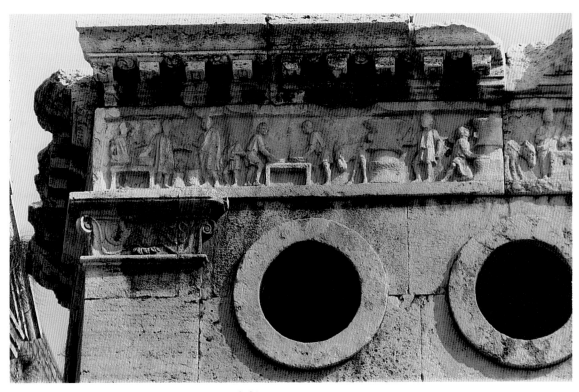

93 Rome, Tomb of Marcus Vergilius Eurysaces, baking frieze with mills and formation of loaves, late first century B.C. Photo: D.E.E. Kleiner and F.S. Kleiner, 73.12.12A

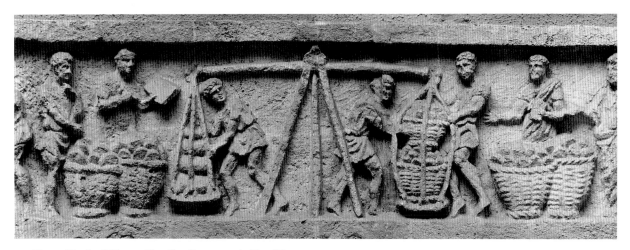

95 Rome, Tomb of Marcus Vergilius Eurysaces, baking frieze with weighing of loaves, late first century B.C. Photo: DAIR 72.3821

tunic-clad figure, is the reason they are barechested. The form of the dome-shaped oven is conclusive proof that the tomb itself does not replicate a Roman oven. Finally, there is a scene in which the baked loaves are piled high in baskets and weighed under the supervision of a magistrate, whose job it was to ensure that Eurysaces was not cheating the public (fig. 95). The inclusion of this scene was a form of personal propaganda by Eurysaces. It is his way of letting posterity know that he did not cheat, that his bread was always of good quality and proper weight.

In sum, the "Tomb of Marcus Vergilius Eurysaces" is clearly Atistia's final resting place. It is nevertheless Eurysaces and his profession that are celebrated in the monument. Atistia is not represented alone in the portrait relief but in a group portrait with her husband. And it is Eurysaces alone who is honored in the larger inscription and in the baking frieze that decorates three sides of the structure. Eurysaces has ostensibly erected a tomb in honor of his wife, but, in truth, it is his name, his profession, his achievements, and his facial features that he hopes will be preserved for posterity. Atistia appears as the attribute of her husband in the portrait relief, and even her remains were placed in a breadbasket urn, one last reference to her husband's accomplishments.

The style of the portrait and narrative reliefs are notable. The portrait relief, carved in Luna marble, is of very high quality; it is likely that a special portrait artist was commissioned to execute it. He did so in the Greek inspired mode, with Eurysaces and Atistia wearing the toga and palla and in the postures of the imperial figures on the south frieze of the Ara Pacis. The style of the baking frieze is quite different. In the frieze, the artists have used a straightforward narrative style in which they have ignored proportion and perspective. What we have

here is a case of certain modes of representation being used for different purposes: the self-conscious Hellenistic manner of the portraits, inspired by the quiet dignity of the Ara Pacis frieze, a mode that tended to be restricted to official, imperially commissioned works made for the Roman upper class close to the court circle, and a lively but unselfconscious narrative style that was not based on Greek models and was favored by freedmen.

Artists in the Age of Augustus

The names of some sculptors working in the age of Augustus are attested. Cleomenes, who resided in Rome but was the son of Cleomenes of Athens, signed in Greek the Augustan portrait statue of a Roman man now in the Louvre. Another Athenian, Diogenes, was responsible for carving the caryatids from the porch of Agrippa's Pantheon. Theodorus, still another Greek, signed what are now fragments of the Tabula Iliaca, a work of relief sculpture ostensibly intended to narrate the Iliad but that also honors the Augustan court through its reference to Aeneas, the descendant of Augustus, and his flight from Troy and arrival in Italy. It is clear that Greek artists, many from Athens, had come to Rome in search of lucrative commissions. Greek metalworkers – for example, the freedmen Protogenes and Zeuxis – also worked in the employ of the emperor. The Augustan Hoby Cups, now in Copenhagen, are signed by a Greek artist working in the West. Pliny and Suetonius attribute a portrait of Augustus on a signet ring to the gem cutter Dioscurides, who is the only Augustan artist whose name is attested to have had close associations with the imperial house, with the one exception of the architect Vitruvius, who

dedicated his *De Architectura* to the emperor. The base of one of the caryatids from the Forum of Augustus retains the signature C. Vibius Rufus, an artist of Italian origin.

Augustan Sculpture in the Provinces

Roman colonization began in the republic with the founding in the fourth century B.C. of colonies in Italy such as Ostia, the port of Rome. Numerous others were added as the empire expanded. The first colonies outside Italy were in Africa, Carthage, and Provence, but extensive colonization outside the mother country began only under Julius Caesar and Octavian Augustus. The colonies were made up of Romans from Italy and local inhabitants. The former were responsible for transporting Roman customs and for implanting them in the new province, a process known as Romanization. The local inhabitants sometimes tenaciously held to their indigenous customs, and what is known as provincial art is characterized by the combination of Roman and local features.

Augustus was responsible for establishing colonies in Africa, Narbonensis, Spain, and in the East, especially Asia Minor, as well as in Italy itself. In each of these colonies, Augustus built cities. Local governments resembled Rome's, and municipal magistracies were smaller versions of the Roman constitution. So, too, the cities built by the Romans in the provinces were small-scale versions of the city of Rome. In some cases, Roman buildings were carefully replicated; in others, local tradition affected the final configuration of a city, a building, or a monument. The cities and their edifices and public spaces were, as in Rome, embellished with sculpture.

The Arch of Augustus at Susa

Located in northwestern Italy not far from Turin, the Arch of Augustus at Susa (fig. 96) was dedicated, according to the arch's inscription, in either 9 or 8 B.C. to commemorate a treaty between Augustus and fourteen Alpine tribes led by a king, Marcus Cottius, who took a Roman name and relinquished his kingship to become a Roman magistrate. It was another of Augustus's negotiated victories, like that over the Parthians. The arch was fashioned of marble from local quarries and was erected in honor of Augustus and Cottius. The architect was clearly a man who had been well trained, possibly in Rome. The Susa arch, with its single bay and engaged Corinthian columns, has the fine proportions and handsome detailing of Augustan monuments in Rome.

96 Susa, Arch of Augustus, general view, dedicated 9 or 8 B.C. Photo: DAIR 70.1287

The frieze, which runs around it, is however, clearly the work of local craftsmen. The most significant scene – the signing of the treaty between Cottius and Augustus – is represented twice, once on the east and again on the western, short side of the arch (fig. 97). Augustus, centrally positioned behind a table, is immediately recognizable with the distinctive pattern of locks across the forehead, but the figure lacks all the finesse of Augustan portraits made in Rome. The frieze is, characteristically, rigidly symmetrical, with a series of static, uniformly distributed upright figures to the left and right. The carving is crude, the togas being simply a series of striped grooves, lacking the full modeling in the round of contemporary figures in Roman state monuments.

The *lustratio* (lustration) or purification of the army of Cottius, which – according to Roman custom – had to be purified before serving under new Roman command, was represented twice, once on the north and again on the southern, long side of the monument. The lustratio was always accompanied by a suovetaurilia. In the center of the frieze is a great altar, too tall for the human figures but characteristic of the naive approach of the provincial designer. He seems to have been afraid to leave any blank space, and everywhere everything is almost the full height of the frieze. To the left and right of the altar on the north side are depicted the sacrificial animals, the musicians, and the army that is being purified. The animals are

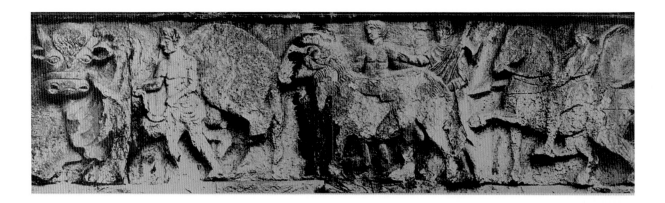

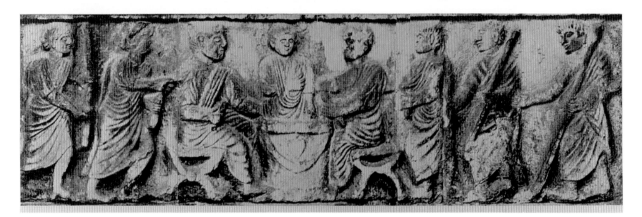

97 Susa, Arch of Augustus, frieze with treaty signing of
Augustus and Marcus Cottius and suovetaurilia, dedicated 9 or
8 B.C.. Photo: A. M. Cavargna Allemano, "Il fregio dell'arco di
Susa," *Segusium* 7 (1970), fold-out pls. 2–3

of monstrous size – a bull that looks out at the spectator,
a gross fat pig, and an overlarge sheep. The costumes of
the togati and the musicians are crudely striated as on the
treaty frieze.

The Susa frieze is obviously the product of artists un-
acquainted or, more likely, uninterested in the contrived
and self-conscious imported Hellenistic mode – they did
not even try to imitate it. The classical mode, seen in such
contemporary monuments as the Ara Pacis Augustae,
tends to be restricted to official imperial commissioned
art and works made for the Roman upper class who were
close to the court circle. They are imported affectations,
sometimes Roman in content but Greek-inspired in style,
and must be seen as a corollary phenomenon to the col-
lection of Greek statues and the ability of upper-class
Romans to read and speak Greek. The style of the Susa
frieze is, however, an unself-conscious style not based on
Greek models but one that combined native and Roman
elements in novel ways. This style was preferred by local
inhabitants in the provinces and has similar goals and a
general resemblance to the narrative relief style favored
by freedmen in Rome.

The Arch of the Sergii at Pola

While the Arch of Augustus at Susa commemorates
an historical event, honorary arches erected elsewhere
under Augustus and his successor Tiberius sometimes
celebrate private individuals. A case in point is the Arch
of the Sergii built at Pola in Istria (Yugoslavia) by a
woman named Salvia Postuma Sergius in honor of three
deceased male members of her family (fig. 98). Postuma's
dedicatory inscription, which indicates that she paid for
the arch from her own funds (*de sua pecunia*), is located
at the center of the arch's frieze. The attic of the arch in-
corporates three bases that originally supported the now
missing statues of the arch's honorands and are inscribed
with their names and titles: Lucius Sergius (*aedilis* and
duovir), Lucius Sergius Lepidus (aedilis and *tribunus mili-
tum legionis XXIX*), and Gnaeus Sergius (aedilis and *duovir
quinquennalis*). The arch served as the men's cenotaph,
although Postuma's name was added to the monument
after her own death. The date of the construction of the
arch is debated. Epigraphical evidence makes it apparent

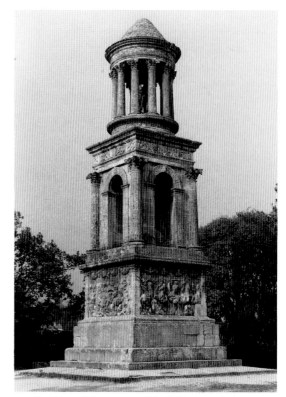

98 Pola, Arch of the Sergii, model, late Augustan or early Tiberian. Photo: DAIR 73.1107

99 St-Rémy, Monument of the Julii, general view, ca. 30–20 B.C. Photo: D.E.E. Kleiner and F.S. Kleiner, 72.18.194

that Lucius Sergius Lepidus served in a legion created by Augustus after Actium, and the ornamental details – for example, the acanthus scrolls that decorate the arch's piers – seem to postdate the Ara Pacis. For these reasons, some scholars favor a date for the arch of 25–20 B.C.; others place it after A.D. 2, and still others date it to the early years of Tiberius's principate. A date in late Augustan or early Tiberian times seems most likely.

The arch is relatively simple in form and with its single bay resembles Augustan arches in Rome and elsewhere. Paired engaged Corinthian columns on a shared pedestal flank the central bay, and there are Victories in the spandrels similar to those on Augustus's Parthian Arch. The pilasters are covered with acanthus scrolls that are, as noted, like those on the Ara Pacis. As at Susa, a frieze encircles the structure. The frieze is ornamented with motifs familiar from private and state monuments of Augustan date: garlands supported by *erotes* or bucrania, racing chariots, and piles of arms and armor. Although garlands and bucrania decorate such state-sponsored works as the Ara Pacis, they are probably included here as a reference to funerary rites. The arms and armor might refer both to the military careers of the Sergii and to victory over death. The moving chariots parallel the race of life. Furthermore, the apotheosis of the deceased is directly alluded to in the vault of the arch that is ornamented with a central diamond-shaped

frame enclosing a scene of an eagle carrying a serpent heavenward. The serpent symbolizes death and the eagle rebirth. The frame is encircled with dolphins, and the remainder of the vault is carved with rosettes inside smaller diamond-shaped frames.

The Pola arch was erected in front of an earlier gate in the walls of the city. Consequently, the back of the arch was left relatively plain. It has no sculptural decor and the column shafts were fluted only in part. Furthermore, the column capitals were left in an unfinished state, making it apparent that the arch was intended to be viewed only from the front.

The Monument of the Julii at St-Rémy

Like the Arch of the Sergii at Pola, the Monument of the Julii at St-Rémy (ancient Glanum) in southern France (fig. 99) – once thought to be a triumphal monument erected in honor of Augustus and Julius Caesar and still sometimes referred to as the cenotaph of Augustus's grandsons and heirs, Gaius and Lucius Caesar – served as a cenotaph for male members of a local family. In fact, an inscription on the north architrave of the second-story quadrifrons indicates that the structure was dedicated by the three sons of a Gaius Julius to their ancestors, undoubtedly their father and grandfather. The Gallic Julii

were probably the sons of an army veteran who owed his citizenship to Julius Caesar. They were honored in Augustan times with a monument, made of locally quarried limestone, which included not only the portraits of their two male ancestors, but also four relief panels with scenes crowded with mythological and personal subject matter. Although there has been some disagreement in the past over the date of the monument, with suggestions ranging from the second century B.C. to Late Antiquity, scholars now favor a date of 30–20 B.C. for the cenotaph.

The Monument of the Julii, located just outside an Augustan gate, is a tall and narrow structure that consists of three stories above a stepped podium: a socle, a quadrifrons, and a tholos housing the two portrait statues. The cenotaph is actually a Gallic version of a type of tower tomb well documented in North Italy in the first century B.C. at such places as Aquileia, Nettuno, and Terni. The sculptural program of the monument includes, from top to bottom: the portrait statues, the tholos frieze with acanthus ornament, the quadrifrons frieze with sea monsters and tritons, and the four socle reliefs framed at left and right by pilasters and with a garland suspended from erotes across the top of each panel. It is the four socle panels that are the most distinctive and that have engendered the most controversy. Dispute has centered on what have been called the Greek or Roman elements of the reliefs. Proponents of the Greek theory see the Julii reliefs as near replicas of lost Hellenistic paintings, while the Roman supporters recognize what one scholar has called the designer's Italic "artistic language." It has recently been suggested that the two positions can be reconciled because, although the artist who has been called the Glanum Master relied heavily on Greek prototypes, his reliefs are not slavish copies of Greek models. The Glanum Master has his own distinctive style, which is characterized by a preference for the eclectic borrowing of motifs, crowds of tightly packed figures, and a pictorial sensibility accentuated by the use of heavily outlined figures. The latter technique was popular in Gaul under Augustus and the Julio-Claudians (for example, in the Arch of Tiberius at Orange, see fig. 130), and was not paralleled in Rome until Late Antiquity. The Glanum Master drew on Greek models, probably in the form of Hellenistic drawings, but personalized them by adding references to the virtues and career of the Julii.

The north and west reliefs represent cavalry and infantry battles, respectively, and both appear to have been based on Greek paintings with similar subject matter. Some scholars have even identified the north relief as a near copy of a late fourth-century B.C. painting. The south and east reliefs also appear to draw on Greek sources, but these are more liberally combined with other motifs. The south relief focuses on a boar hunt, with ele-ments derived from Greek representations of the Calydonian hunt, the death of Meleager, and the slaughter of the Niobids. The scenes from the north, west, and south sides of the monument allude to the moral excellence or *virtus* of the deceased Julii who, during their lifetimes, had excelled in battle and in the hunt. The close association of victory in battle and the hunt became a central theme of both public and private art of the High Empire, with the most outstanding examples – such as the Hunting Tondi of Hadrian (see figs. 219–220) – produced in the second century. The east panel of the Julii monument is the most complex of the four. The artist's reliance on Hellenistic Greek models is still apparent in his use of motifs from the Greek Amazonomachy, but these are combined with a host of contemporary figures, including members of the Julii family. It has been suggested that the east panel probably makes reference to the Julii family's main claim to fame – their personal contribution to Julius Caesar's victory over the Gauls.

The Augustan Legacy

Augustus was emperor of Rome for around forty years, and the artistic accomplishments of his principate were considerable. Luna or Carrara marble became the standard Roman stone for both architecture and sculpture. During Augustus's principate the water system, central market and meeting place (the Roman Forum), the Palatine hill, and the Campus Martius were all redesigned, and some were embellished with sculptural decoration. New cities were founded and planned by Augustus, and by his death these were thriving; some retained their Augustan form; others were transformed in later times.

As discussed, under the republic, dictators and generals like Julius Caesar and Pompey were beginning to use art in the service of their political ambitions. Pompey fancied himself Alexander the Great reincarnate, affecting in his lifetime portraiture the Hellenistic king's melting gaze and distinctive anastole. Julius Caesar struck coins with a lifetime portrait and went as far as the times permitted in presenting himself as a descendant of a divinity. Although the first exploration of the synthesis of politics and art was a republican phenomenon, it was Octavian Augustus who combined politics, social policy, law, literature, religion, art and architecture, and even his own persona, in a seamless whole that reflected his ideology. Augustus's personal vision of the major circumstances and events of his life are mirrored in his monuments. Portraits and state reliefs accentuate his close rapport with his grand uncle and divine adoptive father, Julius Caesar, with his natural father, Gaius Octavius, and with his

divine progenitor, Apollo. Other works trace the ancestry of the Julian family to Venus through Aeneas.

One of the most outstanding characteristics of Augustan art is what might be called its Greek component. Augustus's admiration for Greece and the products of its culture was underscored by his interest in plundered Greek statuary, Greek mythology, and statues and reliefs that were depicted in the neo-Attic, classical, or Hellenistic styles. Lysias's statues of Apollo and Diana were placed on the attic of the Arch of Gaius Octavius on the Palatine; the Apollo of Scopas, the Leto of Cephisodotus, and the Diana of Timotheus were combined in a cult group in the cella of the Temple of Apollo Palatinus; and the Temple of Apollo Sosianus (possibly a private commission of the consul Gaius Sosius) had in its pediment Greek statues of Athena, Theseus, and Hercules. Augustus decorated his forum with exact replicas of the caryatids of the fifth-century B.C. Athenian Erechtheion; and the great friezes of the Ara Pacis betray their indebtedness to the Panathenaic procession of the Parthenon and to fifth- and fourth-century B.C. Greek funerary stelae. Hellenistic reliefs and architectural ornament served as models for the Aeneas panel and the acanthus scrolls of the Ara Pacis, respectively. The eternally youthful portraits of Augustus were modeled on the idealized athlete statues of the fifth century B.C., and the ageless likenesses of Augustus's wife Livia show the empress coiffed like a Greek goddess. Nonetheless, this Greek gloss is a superficial veneer, because Augustan art is above all a reflection of the emperor's political, social, and religious ideology. The neo-Attic reliefs that decorated the Temple of Apollo Palatinus allude to the struggle between Apollo (Octavian) and Hercules (Mark Antony) at Actium; the classicizing north and south friezes of the Ara Pacis commemorate the procession in honor of the laying of the altar's foundation stone on 4 July 13 B.C.; the Hellenistic Aeneas panel refers to Augustus's divine ancestry and to the legendary founding of Rome. Livia adds a Roman nodus to her wavy Greek goddess hair, and the scene on the breastplate of the Primaporta statue of Augustus focuses on another specific historical event, the return of the Parthian standards in 20 B.C.

Augustus's proximity to Julius Caesar undoubtedly fueled his political ambitions, and it was his familial connection to the Julian family that eased his entrance into public life. This relationship also served as the subject of portraits and reliefs commissioned by him both at the outset and the end of his career. Augustus's first major military confrontation at Philippi allowed him to avenge Caesar's death at the hands of Cassius and Brutus, and his earliest portraits on coins and in the round depict him with the beard of mourning for his deified adoptive father. The temple to Mars the Avenger was dedicated in

2 B.C. At that time, a cult statue depicting Divus Julius with Mars and Venus was also set up. The Belvedere Altar depicting Caesar's apotheosis, witnessed by Augustus, Livia, and Gaius and Lucius Caesar, was carved contemporaneously.

Augustus's use of Apolline imagery was even more pervasive. Already in the early 30s, Octavian placed himself under the god's protection. The emperor's youthful portraits show him assimilated to his divine father whom he honored, along with his natural father, on the Arch of Gaius Octavius on the Palatine. The arch also served as the entrance gate to a complex that united the Temple of Apollo Palatinus with Augustus's private residence. Apollo figures prominently in the temple's terracotta decoration, where Octavian is seen in his guise. The later Augustan complex on the Via Flaminia, which included the emperor's mausoleum, ustrinum, Ara Pacis, and an Egyptian obelisk-sundial, also honored Apollo, whose swans are intertwined with the acanthus leaves of the Ara Pacis and who is referred to in the inscription on the base of the obelisk.

Although Octavian's vow before the Battle of Philippi led to the construction of the Temple of Mars Ultor and the Forum of Augustus, it was Augustus's naval engagement at Actium that inspired a wide variety of Augustan monuments. Although Actium, like Philippi, was – first and foremost – an encounter between Italian foes, the conflict included a foreign enemy in the person of Cleopatra of Egypt, Antony's lover and political ally. In fact, the contest for control of the Roman empire was represented in literary and visual propaganda as a conflict between Rome and evil Egyptian forces. The terracotta plaques that decorated the Temple of Apollo Palatinus were bordered with Egyptian lotus blossoms, and the Danaids may have been intended as surrogates for Cleopatra. The Egyptian obelisk, which cast a shadow on the Ara Pacis on Augustus's birthday, served as a victory monument celebrating Octavian's triumph over Cleopatra at Actium. The naval battle at Actium is also alluded to in the dolphin statuary support of the statue of Augustus from Primaporta. Furthermore, it was at the time – or not long before the Actium victory – that a new portrait type, the Actium type, was commissioned. It was followed shortly thereafter by the Primaporta type.

Nonetheless, it was peace more than war that was the cornerstone of Augustus's ideology. Battle scenes are rare in Augustan art, and those that survive depict Roman battles in mythological or allegorical guise – for example, the Greeks versus the Amazons of the Temple of Apollo Sosianus and the Romans versus the Gauls of the Mantua Relief. The conflict between Octavian and Antony at Actium is reflected in the contest between Apollo and Hercules for the Delphic tripod. Although

the Temple of Mars Ultor was dedicated to Mars the Avenger, Octavian's victory over Caesar's assassins is nowhere alluded to in the sculptural program of the temple and the forum. The statuary that lines the porticoes refers to the unity of all Italians under the Augustan peace and to military and civic virtues. The blessings of the Augustan peace are nowhere better expressed than on the Ara Pacis. Although it is true that Octavian's conflict with Antony and Cleopatra is referred to in the nearby obelisk, battle imagery is not found on the Ara Pacis. The presence of Mars alludes to a war that was necessary to bring peace to Rome and Italy, but the primary function of Mars is as the father of Romulus and the father of the Roman people. Furthermore, Mars was an agricultural deity before being assimilated to Ares, and in republican times, for example, was the deity of the *lustratio agri*. This agricultural role corresponds to the rest of the imagery of the Ara Pacis, which focuses on peaceful processions and sacrifices, loving families, and the bounties of the earth and Italy.

Augustus's diplomatic successes were judged to be as significant as his military encounters. The Ara Pacis honored Augustus's return from Spain and Gaul; and the return of the Roman standards from Parthia in 20 B.C. was also regarded as a subject worthy of commemoration in Augustan art (for example, the Parthian Arch and the breastplate of the statue of Augustus from Primaporta). A treaty signing between Augustus and Marcus Cottius was depicted twice on the Arch at Susa.

The participants in the peaceful scenes on the Ara Pacis are important personages of the day. In Augustan times, these individuals were identifiable, but their features were also assimilated to one another through the classicizing and idealizing gloss favored by the emperor. It was Augustus who introduced to Rome a new kind of portraiture based both stylistically and ideologically on Greek art of the fifth and fourth centuries B.C. The portraits of Augustus were revolutionary in their time because they depicted the emperor as eternally youthful. Statesmen and generals of the republic had proudly displayed their lined visages in portraits that accentuated their subjects' seniority and experience. Augustus favored a youthful imagery that better suited him because he was young when he began his rise to power and still youthful when he became emperor of Rome. He used his portraiture to underscore the vitality of his new regime. With the exception of Marcus Agrippa, Augustus's obvious successors, Marcellus and Gaius and Lucius Caesar, were also young. From their infancy on, Augustus demonstrated a profound devotion to his two grandsons. Having looked to the progeny of his daughter to solve the problem of the imperial succession, he tried to regulate adultery and encourage procreation to ensure the con-tinued strength of the aristocracy. Since the portraits of the eternally young Augustus and his boy heirs were the first of their kind in Roman art, the portraiture of the republic did not provide adequate models for the emperor's court portraitists. Although Greek body types, for example, that based on the Doryphoros of Polykleitos, were already used in the late republic as props for veristic heads (such as the Pseudo-Athlete and Tivoli General), a consistent image that combined youthful head and body was new to Roman art in the age of Augustus. Augustus's statuary types, demonstrating the emperor's many roles as imperator, pontifex maximus, deity, and so forth, were fully developed under Augustus and fixed for centuries. The female portraits of the Augustan court also showed their subjects in several roles and depicted them as comparably ageless. The portraits of Livia and Octavia, with their firm smooth skin, were coiffed in a manner befitting Greek goddesses that betrays that they too were derived from Greek prototypes.

Augustus's obsession with the succession and with the concordia of the imperial family led to the commissioning of countless works of art honoring women and children. Although the features of aging women were recorded along with those of their husbands during the republic, children were excluded as subjects for republican portraiture and relief sculpture. Under Augustus, numismatic portraits of Gaius and Lucius Caesar, sometimes alone and sometimes in concert with their mother Julia, were circulated. Dynastic groups displaying the boys with the imperator himself were also erected in Rome and elsewhere. Gaius and Lucius appear to be depicted with Livia and Augustus on the Belvedere Altar, but it was the Ara Pacis Augustae that was the first Roman monument of state to include contemporary women and children. Their incorporation in the north and south friezes of the altar underscored Augustus's dynastic hopes and encouraged fidelity and fecundity among the nobility, as well as for the freed class. Since Augustus's marriage laws were also directed at Roman freedmen, the eminence of the Altar of Augustan Peace transformed its imperial family groups into immediate symbols of familial unity; these were imitated by libertini who began to commission family portraits that included children for their tombs. Female morality and correct behavior were more subtly alluded to in the scenes of the Rape of the Sabines and the Punishment of Tarpeia from the Basilica Aemilia, a contemporary commission.

The Basilica Aemilia Frieze presents its moral lessons beneath the veil of Rome's legendary and mythological history. The history of Rome was a popular subject under Augustus with a focus on Rome's legendary founders, Romulus and Aeneas. The building of the walls of Lavinium is featured in the Basilica Aemilia Frieze;

and Romulus, his father Mars, and Aeneas figure prominently in the west panels on the Ara Pacis and in the elaborate sculptural program of the Forum of Augustus. In the latter, Romulus is depicted in the pediment, Mars in the cult statue, and both Romulus and Aeneas in statues in the exedrae of the forum. Venus is included among the figures in both the pediment and the cult statue.

It was also the age of Augustus that witnessed the crystallization of the art of freedmen in Rome and of what is often referred to as "provincial" art. The foreigners brought to Rome as slaves during the republic and under Augustus were commissioning funerary monuments in great numbers, and public and private monuments were erected in cities colonized by Caesar and Augustus. Some of these, like the Arch at Susa, honored Augustus himself; others, like the Arch at Pola and the Julii Monument, were built to commemorate local inhabitants. In both cases, Augustus's state monuments and portraits served as the primary models. The treaty signing, lustration, and suovetaurilia of the Arch at Susa are based closely on imperial models; the portraits of Eurysaces and Atistia are similar to imperial counterparts; and the acanthus scrolls and garlands and bucrania of the Arch at Pola betray the influence of the architectural decoration of the Ara Pacis. Nonetheless, freedmen in Rome and provincial patrons exhibited distinctive personal predilections that led to an art that diverged in significant ways from the court norm. These monuments were also made by inferior artists or at least by artists who were not as well versed in the carving of marble or in the artistic language of the Greek art that served as the stylistic basis for all Augustan court commissions. These freedman and provincial monuments are almost always less well crafted than those done in Rome contemporaneously for aristocratic patrons. Nonetheless, they are just as expressive as their imperial counterparts and sometimes make use of artistic devices and techniques that are unparalleled in their time but that were to become popular later, even among artists working for the imperial circle. These include the use of scale distinctions to express hierarchy and space, space depicted by stacked turf segments rather than by perspective, repetitive postures and gestures of figures, and drapery defined by pattern rather than by the body beneath the garment.

By 12 B.C., Augustus had become the primary civic and religious leader of Rome and had brought peace to a world earlier shaken by civil and foreign wars. He exploited the opening of the quarries at Luna and built a marble city on the banks of the Tiber mirrored in the miniature versions constructed in the eastern and western provinces. The artistic eclecticism that had been a hallmark of republican art remained popular. Plundered Greek statuary continued to be brought to Rome and was incorporated into novel settings; new statues and reliefs with thoroughly Roman subject matter were depicted in a variety of Greek styles. Egyptian motifs were also favored with some enhancing public settings and others decorating private residences and mausolea. The obelisk-sundial of Augustus made reference to Octavian's victory over Antony and Cleopatra at Actium, the walls of the imperial Villa Farnesina in Rome were frescoed with an Egyptianizing theme, and a tomb in the form of an Egyptian pyramid was built to house the remains of Gaius Cestius, a relative of Marcus Agrippa.

The age of Augustus heralded the birth of an imperial art in which art and ideology were inextricably bound. The emperor's high regard for Greek civilization, his tripartite political program based on war, peace, and divine descent, his social legislation, his religious reforms, and his dynastic ambitions were openly expressed in his portrait statues and state reliefs. Although public monuments commissioned by Augustus were first and foremost vehicles of his ideology, nonetheless, they were often splendid works of art in their own right. The Ara Pacis Augustae and the Gemma Augustea, for example, are masterworks of their own or any time. What sets the age of Augustus apart from many other eras is the successful confluence of message and medium. It is perhaps in this way more than any other that the art of the Augustan age is the equal of that of Periclean Athens.

Augustus's life and principate were marked by personal and public successes. Augustus chose to record these in his *Res Gestae Divi Augusti*. It is notable that the *Res Gestae* was the emperor's personal account of historical events. Careful study of the document demonstrates that it was calculated to preserve for posterity Augustus's particular version of his principate. Mark Antony's indispensable contribution at Philippi is, for example, nowhere mentioned, undoubtedly because of the enmity that eventually developed between the two men and culminated in Octavian's defeat of Antony at Actium. Augustus's crafted legacy was adhered to by his Julio-Claudian successors and by the emperors of the High Empire as well, yet Augustus's personal vision of his principate masked its failures. An outstanding example is the emperor's moral legislation. The reliefs of the Ara Pacis and the Basilica Aemilia preserve for posterity the Augustan view of the aristocratic woman as a faithful wife who valued correct behavior and thrived in her role as fecund mother. In reality, aristocratic women in the age of Augustus refused to accept the emperor's moral legislation. Even his own daughter openly flouted his moral laws by engaging in adulterous relations that forced Augustus to banish her from Rome. In fact, although women were represented for the first time in Roman state relief sculpture under Augustus, and although Livia

commanded great respect and wielded more power than hitherto possible for women in Graeco-Roman society, women did not fare well in the age of Augustus. Neither did foreigners like Cleopatra – who, paradoxically, is never depicted in a surviving work of Augustan state relief – nor did slaves brought to Rome in great numbers. Moreover, Augustus feared a pluralistic society, and his moral and social legislation was enacted, in part, to prevent one from evolving. Augustus controlled the subject matter and style of the works of art produced during his principate. He favored images of peace over depictions of war and the appearance of youth to the ravages of age. His physical ideal was of a bland, classicized beauty shared by all members of the imperial family and adopted by the rest of the Roman citizenry. He wanted women to be virtuous and punished those who did not follow his moral codes. Augustus's full control over the artistic expression of his age resulted in some of the greatest masterworks ever produced by man. Yet under Augustus the rights of women, slaves, and foreigners were repressed. In the last years of his principate, he even sponsored censorship by encouraging the burning of what he identified as libelous books. Augustus wanted his legacy to Rome and to posterity to be the glorious accomplishments that he chose to list in the *Res Gestae*. And indeed they were. The art of the Roman empire is inconceivable without the contribution of Augustus. His use of art in the service of ideology, however – even if it meant altering the actual historical record in favor of a fictional account – also made a strong impression on his imperial successors and will be seen to have had a lasting impact not only on the Julio-Claudian dynasty, but on all Roman emperors through Constantine the Great.

Bibliography

General studies on the period include: G. Rodenwaldt, *Kunst um Augustus* (Berlin, 1943). J. Charbonneaux, *L'art au siècle d'Auguste* (Lausanne, 1948). H.T. Rowell, *Rome in the Age of Augustus* (Norman, Oklahoma, 1962). H. Laubscher, "Motive der augusteische Bildpropaganda," *JdI* 89 (1974), 242–59. R. Winkes, ed., *The Age of Augustus* (Louvain, 1986). E. Simon, *Augustus: Kunst und Leben in Rom um die Zeitenwende* (Munich, 1986). P. Zanker, *The Power of Images in the Age of Augustus* (Ann Arbor, 1988). *Kaiser Augustus und die verlorene Republik* (Mainz, 1988). K. A. Raaflaub and M. Toher, *Between Republic and Empire: Interpretations of Augustus and His Principate* (Berkeley, 1990). D. E. E. Kleiner, *Art in the Age of Augustus: A Revisionist View*, in preparation.

The Portraiture of Augustus: O. Brendel, *Ikonographie des Kaisers Augustus* (Nuremberg, 1931). I. Montini, *Il ritratto di Augusto* (Rome, 1938). H. Kähler, *Die Augustusstatue von Primaporta* (Cologne, 1959). W.H. Gross, "Zur Augustusstatue von Prima Porta," *NakG* 8 (1959), 143–68. G. Zinserling, "Der Augustus von Primaporta als offiziöses Denkmal," *Acta Antiqua* 15 (1967), 327–39. H. Ingholt, "The Prima Porta Statue of Augustus," *Archaeology* 22 (1969), 177–87, 304–18. P. Zanker, *Studien zu den Augustus-Porträts I. Der Actium-Typus* (Göttingen, 1973). F. Johansen, "Le portrait d'Auguste de Prima Porta et sa datation," *Studia Romana in Honorem Petri Krarup Septuagenarii* (Odense, 1976), 49–57. J. Pollini, *Studies in Augustan "Historical" Reliefs* (Diss., University of California, Berkeley, 1978), 8–74 (Primaporta statue). K. Vierneisel and P. Zanker, *Die Bildnisse des Augustus: Herrscherbild und Politik im kaiserlichen Rom* (Munich, 1979). A. K. Massner, *Bildnisangleichung: Untersuchungen zur Entstehung und Wirkungsgeschichte des Augustusporträts* (Berlin,

1980). J.D. Breckenridge, "Roman Imperial Portraiture from Augustus to Gallienus," *ANRW* 2, 12, 2 (1981), 483–86, 495. W.H. Gross, "Augustus als Vorbild," *ANRW* 2, 12, 2 (1981), 599–611. U. Hausmann, "Zur Typologie und Ideologie des Augustusporträts," *ANRW* II, 12, 2 (1981), 513–98. K. Fittschen and P. Zanker, *Katalog der römischen Porträts in den Capitolinischen Museen und den anderen kommunalen Sammlungen der Stadt Rom*, 1 (Mainz, 1985). E. Touloupa, "Das bronzene Reiterstandbild des Augustus aus dem nordägäischen Meer," *AM* 101 (1986), 185–205. J. Pollini, "The Findspot of the Statue of Augustus from Prima Porta," *BullCom* 92 (1987–88), 103–8. M. Hofter, "Porträt," in *Kaiser Augustus und die verlorene Republik* (Mainz, 1988), 291–343. E. Touloupa, "La statua equestre in bronzo di Augusto rinvenuta nel Nord dell'Egeo," *BdA* 53 (1989), 67–78. J. Bergemann, *Römische Reiterstatuen* (Mainz, 1990), 57–59.

The Gemma Augustea: C. Küthmann, "Zur Gemma Augustea," *AA*, 65–66 (1950–51), 89–103. A. Zadoks-Josephus Jitta, " Imperial Messages in Agate," *BABesch* 39 (1964), 156–61. H. Kähler, *Alberti Rubeni Dissertatio de Gemma Augustea* (Berlin, 1968). E. Dwyer, "Augustus and the Capricorn," *RM* 80 (1973), 59–67. J. Pollini, *Studies in Augustan "Historical" Reliefs* (Diss., University of California, Berkeley, 1978), 173–254. E. Simon, *Augustus: Kunst und Leben in Rom um die Zeitenwende* (Munich, 1986). , 156–61. T. Hölscher, "Historische Reliefs," in *Kaiser Augustus und die verlorene Republik* (Mainz, 1988), 371–73. J. Pollini, "The Gemma Augustea: Ideology, Rhetorical Imagery, and the Creation of a Dynastic Narrative," in P. Holliday, ed., *Narrative and Event in Ancient Art,* in press.

The Portraiture of Gaius and Lucius Caesar: L. Curtius, "Ikonographische Beiträge zum Porträt der römischen Republik und der iulisch-claudischen Familie 13: Die Söhne des Agrippa," *MdI* 1 (1948), 53–67. F. Chamoux,

"Gaius Caesar," *BCH* 74 (1950), 83–96. F. Chamoux, "Un portrait de Thasos, Lucius Caesar," *MonPiot* 44 (1950), 83–96. F. Chamoux, "Nouveaux portraits des fils d'Agrippa," *RA* 37 (1951), 218–20. E. Simon, "Das neugefundene Bildnis des Gaius Caesar in Mainz," *MainzZ* 58 (1963), 1–18. J. Borchhardt, "Ein Kenotaph des Gaius Caesar," *JdI* 89 (1974), 217–41. Z. Kiss, *L'iconographie des princes julio-claudiens au temps d'Auguste et de Tibère* (*Travaux du Centre d'archéologie méditerranéenne de l'académie polonaise* (Warsaw, 1975), 35–70. J. Pollini, *The Portraiture of Gaius and Lucius Caesar* (New York, 1987).

The Portraiture of Marcus Agrippa: F. S. Johansen, "Ritratti marmorei e bronzei di Marco Vipsanio Agrippa," *AnalRom* 6 (1971), 17–48. L. Fabbrini, "Marco Vipsanio Agrippa: Concordanze e discordanze iconografice – nuovi contributi," *Eikones, AntK-BH* 12 (1980), 96–107.

The Portraiture of Livia, Octavia, and Julia: L. Furnée-van Zwet, "Fashion in Women's Hair-dress in the First Century of the Roman Empire," *BABesch* 31 (1956), 1–22. W. H. Gross, *Iulia Augusta: Untersuchungen zur Grundlegung einer Livia-Ikonographie* (Göttingen, 1962). H. Bartels, *Studien zum Frauenporträt der augusteischen Zeit* (Munich, 1963). K. Polaschek, "Studien zu einem Frauenkopf im Landesmuseum Trier und zur weiblichen Haartracht der iulisch-claudischen Zeit," *TrZ* 35 (1972), 141–210. G. Grimm, "Zum Bildnis der Iulia Augusti," *RM* 80 (1973), 279–82. V. Poulsen, *Les portraits romains*, 2d ed., 1 (Copenhagen, 1973). W. Trillmich, *Das Torlonia-Mädchen: Zur Herkunft und Enstehung des kaiserzeitlichen Frauenporträts* (Göttingen, 1976). K. P. Erhart, "A New Portrait Type of Octavia Minor (?)," *GettyMusJ* 8 (1980), 117–28. K. Fittschen and P. Zanker, *Katalog der römischen Porträts in den Capitolinischen Museen und den anderen kommunalen Sammlungen der Stadt Rom*, 3 (Mainz, 1983), 1–5 (Livia). M. Hofter, "Porträt," in *Kaiser Augustus und die verlorene Republik* (Mainz, 1988), 291–343. R. Winkes, "Bildnistypen der Livia," in N. Bonacasa and G. Rizza, eds., *Ritratto ufficiale e ritratto privato* (Rome, 1988), 555–61. R. Winkes, forthcoming volume on the portraiture of Livia in *Das römische Herrscherbild* series.

The Portraiture of Freedmen: A. N. Zadoks-Josephus Jitta, *Ancestral Portraiture in Rome* (Amsterdam, 1932). O Vessberg, *Studien zur Kunstgeschichte der römischen Republik* (Lund, 1941). P. Zanker, "Grabreliefs römischer Freigelassener," *JdI* 90 (1975), 267–315. D. E. E. Kleiner, *Roman Group Portraiture: The Funerary Reliefs of the Late Republic and Early Empire* (New York, 1977). H. G. Frenz, *Untersuchungen zu den frühen römischen Grabreliefs* (Frankfurt a.M., 1977). H. Wrede, "Städtrömische Monumente, Urnen und Sarkophage des Klinentypus in den beiden ersten Jahrhunderten n. Chr.," *AA* (1977), 395–431. H. Wrede, "Klinenprobleme," *AA* (1981), 86–131. D. E. E. Kleiner, "Private Portraiture in the Age of Augustus," in R. Winkes, ed., *The Age of Augustus* (Louvain, 1986), 107–35.

The Actium Monument: W. M. Murray, "Octavian's Victory Monument at Nikopolis," abstract, *AJA* 91 (1987), 317. W. M. Murray and P. M. Petsas, "The Spoils of Actium," *Archaeology* 41 (1988), 28–35. W. M. Murray and P. M. Petsas, *Octavian's Campsite Memorial for the Actian War, TAPS* 79 (1989).

The Arch of Gaius Octavius on the Palatine: F. S. Kleiner, *The Arch of Nero in Rome: A Study of the Roman Honorary Arch Before and under Nero* (Rome, 1985), 22–23. S. De Maria, *Gli archi onorari di Roma e dell'Italia romana* (Rome, 1988), 268–69, no. 57. F. S. Kleiner, "The Arch of C. Octavius and the Fathers of Augustus," *Historia* 37 (1988), 347–57.

The Actian Arch of Augustus: F. S. Kleiner, *The Arch of Nero in Rome: A Study of the Roman Honorary Arch Before and Under Nero* (Rome, 1985), 23–25. F. Coarelli, *Il foro romano* (Rome, 1985), 258–68. D. De Maria, *Gli archi onorari di Roma e dell'Italia romana* (Rome, 1988), 267–68, no. 56. E. Nedergaard, "Zur Problematik der Augustusbögen auf dem Forum Romanum," in *Kaiser Augustus und die verlorene Republik* (Mainz, 1988), 224–39. F. S. Kleiner, "The Study of Roman Triumphal and Honorary Arches Fifty Years after Kähler," *JRA* 2 (1989), 198–200.

The Temple of Apollo Palatinus: M. T. Picard-Schmitter, "Bétyles hellénistiques," *MonPiot* 57 (1971), 43–89. G. Sauron, "Aspects du neo-atticisme à la fin du Ier s. av. J.-C.: Formes et symboles," in *L'art décoratif à Rome à la fin de la république et au début du principat (CEFR* 55) (Rome, 1981), 286–94. B. Kellum, *Sculptural Programs and Propaganda in Augustan Rome: The Temple of Apollo on the Palatine and the Forum of Augustus* (Diss., Harvard University, 1981). P. Zanker, "Der Apollontempel auf dem Palatin: Ausstattung und politische Sinnbezüge nach der Schlacht von Actium," *AnalRom*, supp. 10 (Odense, 1983), 21–40. B. Kellum, "Sculptural Programs and Propaganda in Augustan Rome: The Temple of Apollo on the Palatine," in R. Winkes, ed., *The Age of Augustus* (Louvain, 1986), 169–76. G. Carettoni, "Die Bauten des Augustus auf dem Palatin," in *Kaiser Augustus und die verlorene Republik* (Mainz, 1988), 263–67. G. Carettoni, "Die 'Campana'-Terrakotten von Apollo-Palatinus-Tempel," in *Kaiser Augustus und die verlorene Republik* (Mainz, 1988), 267–72. E. Lefèvre, *Das Bild-Programm des Apollo-Tempels aud dem Palatin* (Constance, 1989).

The Relief of Actian Apollo: A. Hekler, *Die Sammlung antiker Skulpturen* (Budapest, 1929), 116, no. 107. J. Szilagyi, *Griech. u. röm. Sammlung d. Mus. in Budapest* (Budapest, 1957). V. M. Strocka, "Neues zum Actiumrelief," *AA* (1964), 823–34. A. Bonanno, *Portraits and Other Heads on Roman Historical Relief up to the Age of Septimius Severus* (Oxford, 1976), 20–22. E. Simon, *Augustus: Kunst und Leben in Rom um die Zeitenwende* (Munich, 1986), 36, 236.

The Porticus Octaviae Reliefs: Helbig, 4th ed., vol. 2, 187–90, no. 1382 (E. Simon); 453–54, no. 1664 (E. Simon). H. Laubscher, *BullCom* 87 (1980–81) 44, 47–48 (belongs to Temple of Jupiter Stator). T. Hölscher, "Actium und Salamis," *JdI* 99 (1984), 205–14. E. Simon, *Augustus: Kunst und Leben in Rom um die Zeitenwende* (Munich, 1986), 106, 243. T. Hölscher, "Historische Reliefs," in *Kaiser Augustus und die verlorene Republik* (Mainz, 1988), 364–66.

The Temple of Apollo Sosianus: A. M. Colini, "Il tempio di Apollo," *BullCom* 68 (1940), 9–40. A. Bonanno, *Portraits and Other Heads on Roman Historical Relief up to the Age of Septimius Severus* (Oxford, 1976), 16–19. E. La Rocca, *Amazzonomachia: Le sculture frontonali del tempio di Apollo Sosiano* (Rome, 1985). E. Simon, *Augustus: Kunst und Leben*

in Rom um die Zeitenwende (Munich, 1986), 104–9, 243–44.
E. La Rocca, "Der Apollo-Sosianus-Tempel," in *Kaiser Augustus und die verlorene Republik* (Mainz, 1988), 121–36.
A. Viscogliosi, "Die Architektur-Dekoration der Cella des Apollo-Sosianus-Tempels," in *Kaiser Augustus und die verlorene Republik* (Mainz, 1988), 136–48.

Mantua Relief from the Temple of Castor: A. Levi, *Sculture greche e romane del Palazzo Ducale di Mantova* (1931), 75–78.
D. Strong, "The Temple of Castor in the Roman Forum," *BSR* 30 (1962), 28–30. G. Koeppel, "Die historischen Reliefs der römischen Kaiserzeit I: Stadtrömische Denkmäler unbekannter Bauzugehörigkeit aus augusteischer und julisch-claudischer Zeit," *BonnJbb* 183 (1983), 81–82, 129–33.

The Parthian Arch: F. Coarelli, *Roma, Guide archeologiche Laterza* 6 (Rome, 1980), 76–77. F. S. Kleiner, *The Arch of Nero in Rome: A Study of the Roman Honorary Arch before and under Nero* (Rome, 1985), 25–28. F. Coarelli, *Il foro romano* (Rome, 1985), 269–308. S. De Maria, *Gli archi onorari di Roma e dell'Italia romana* (Rome, 1988), 269–72, no. 59.
E. Nedergaard, "Zur Problematik der Augustusbögen auf dem Forum Romanum," in *Kaiser Augustus und die verlorene Republik* (Mainz, 1988), 224–39. F. S. Kleiner, "The Study of Roman Trumphal and Honorary Arches Fifty Years after Kähler," *JRA* 2 (1989), 198–200.

The Sorrento Base: G. E. Rizzo, "La Base di Augusto," *BullCom* 60 (1932), 7–109. I. S. Ryberg, *Rites of the State Religion in Roman Art, MAAR* 22 (Rome, 1955), 49–51. N. De Grassi, "La dimora di Augusto sul Palatino e la base di Sorrento," *RendPontAcc* 39 (1966–67), 77–116. E. Simon, *Augustus: Kunst und Leben in Rom um die Zeitenwende* (Munich, 1986), 24–25. T. Hölscher, "Historische Reliefs," in *Kaiser Augustus und die verlorene Republik* (Mainz, 1988), 375–78.
B. O. Aicher, "The Sorrento Base and the Figure of Mars," *ArchNews* 15 (1990), 11–16.

The Basilica Aemilia Frieze: A. Bartoli, "Il fregio figurato della Basilica Aemilia," *BdA* 35 (1950), 289–94. H. Furuhagen, "Some Remarks on the Sculptured Frieze of the Basilica Aemilia in Rome," *OpRom* 3 (1961), 139–55. G. Carettoni, "Il fregio figurato della Basilica Aemilia," *RivIstArch* 10 (1961), 5–78. D. Strong, *Roman Art* (Harmondsworth, 1976), 78–79. N. B. Kampen, "The Muted Other," *ArtJ* (Spring 1988), 15–19. T. Hölscher, "Historische Reliefs," in *Kaiser Augustus und die verlorene Republik* (Mainz, 1988), 380–82. F. C. Albertson, "The Basilica Aemilia Frieze: Religion and Politics in Late Republican Rome," *Latomus* 49 (1990), 801–15.

The Ara Pacis Augustae: E. Petersen, *Ara Pacis Augustae* (Vienna, 1902). J. Sieveking, "Zur Ara Pacis Augustae," *ÖJh* 10 (1907), 175–90. G. Moretti, *Ara Pacis Augustae* (Rome, 1948). I. S. Ryberg, "The Procession of the Ara Pacis," *MAAR* 19 (1949), 77–101. T. Kraus, *Die Ranken der Ara Pacis* (Berlin, 1953). J. M. C. Toynbee, "The Ara Pacis Reconsidered and Historical Art in Roman Italy," *ProcBritAc* 39 (1953), 67–95. H. Kähler, "Die Ara Pacis und die augusteische Friedensidee," *JdI* 69 (1954), 69–100. K. Hanell, "Das Opfer des Augustus an der Ara Pacis," *OpRom* 2 (1960), 31–123. S. Weinstock, "Pax and the 'Ara Pacis,'" *JRS* 50 (1960), 44–58. J. M. C. Toynbee, "The 'Ara Pacis Augustae,'" *JRS* 51 (1961), 153–56. E. Simon, *Ara*

Pacis Augustae (Tübingen, 1967). A. Borbein, "Die Ara Pacis Augustae. Geschichtliche Wirklichkeit und Programm," *JdI* 90 (1975), 242–66. E. Buchner, "Solarium Augusti und Ara Pacis," *RM* 83 (1976), 319–65. H. Büsing, "Ranke und Figur an der Ara Pacis Augustae," *AA* 92 (1977), 247–57. J. Pollini, *Studies in Augustan "Historical" Reliefs* (Diss., University of California, Berkeley, 1978), 75–172. D. E. E. Kleiner, "The Great Friezes of the Ara Pacis Augustae: Greek Sources, Roman Derivatives, and Augustan Social Policy," *MEFRA* 90 (1978), 753–85. M. Torelli, *Typology and Structure of Roman Historical Reliefs* (Ann Arbor, 1982), 27–61. E. Buchner, *Die Sonnenuhr des Augustus* (Mainz, 1982). E. La Rocca, *Ara Pacis Augustae* (Rome, 1983). M. K. Thornton, "Augustan Geneaology and the Ara Pacis," *Latomus* 42 (1983), 619–28. L. Berczelly, "Ilia and the Divine Twins: A Reconsideration of Two Relief Panels from the Ara Pacis Augustae," *ActaAArtHist* 5 (1985), 89–149. E. Simon, *Augustus: Kunst und Leben in Rom um die Zeitenwende* (Munich, 1986), 26–46. G. Koeppel, "Die historischen Reliefs der römischen Kaiserzeit V. Ara Pacis Augustae I," *BonnJbb* 187 (1987), 101–57. G. Koeppel, "Die historischen Reliefs der römischen Kaiserzeit V: Ara Pacis Augustae 2," *BonnJbb* 188 (1988), 97–106. S. Settis, "Die Ara Pacis," in *Kaiser Augustus und die verlorene Republik* (Mainz, 1988), 400–426. C. B. Rose, "Princes and Barbarians on the Ara Pacis," *AJA* 94 (1990), 453–67. N. DeGrummond, "The Goddess of Peace on the Ara Pacis," *AJA* 94 (1990), 663–77. P. J. Holliday, "Time, History, and Ritual in the Ara Pacis Augustae," *ArtB* 72 (1990), 542–57. J. Elsner, "Cult and Sacrifice: Sacrifice in the Ara Pacis Augustae," *JRS* 81 (1991), 50–61. G. K. Galinsky, "Venus, Polysemy, and the Ara Pacis Augustae," *AJA* 96 (1992), 457–75.

The Forum of Augustus and its Sculptural Program: P. Zanker, *Forum Augustum* (Tübingen, 1968). C. J. Simpson, "The Date of the Dedication of the Temple of Mars Ultor," *JRS* 67 (1977), 91–94. B. Kellum, *Sculptural Programs and Propaganda in Augustan Rome: The Temple of Apollo on the Palatine and the Forum of Augustus* (Diss., Harvard University, 1981). E. Simon, *Augustus: Kunst und Leben in Rom um die Zeitenwende* (Munich, 1986), 46–51. J. Ganzert and V. Kockel, "Augustusforum und Mars-Ultor-Tempel," in *Kaiser Augustus und die verlorene Republik* (Mainz, 1988), 149–99. M. Siebler, *Studien zum augusteischen Mars Ultor* (Munich, 1988).

The Belvedere Altar: I. S. Ryberg, *Rites of the State Religion in Roman Art, MAAR* 22 (Rome, 1955), 58–59. P. Zanker, "Die Larenaltar im Belvedere des Vatikans," *RM* 76 (1969), 205–18. J. Pollini, *Studies in Augustan "Historical" Reliefs* (Diss., University of California, Berkeley, 1978), 299–304.

The Amiternum Reliefs: L. Franchi, "Rilievo con pompa funebre e rilievo con gladiatori al museo dell'Aquila," in R. Bianchi Bandinelli, *Sculture municipali dell'area sabellica tra l'età di Cesare e quella di Nerone, StMisc* 10 (1963–64), 23–32. B. M. Felletti Maj, *La tradizione italica nell'arte romana* (Rome, 1977), 119–26.

The Tomb of Marcus Vergilius Eurysaces: P. Ciancio Rossetto, *Il sepolcro del fornaio Marco Virgilio Eurisace a Porta Maggiore* (Rome, 1973). F. Coarelli, *Roma (Guide archeologiche Laterza,* 6) (Bari, 1980), 225–27. D. E. E. Kleiner, "Private

Portraiture in the Age of Augustus," in R. Winkes, ed., *The Age of Augustus* (Louvain, 1986), 123–26.

Artists in the Age of Augustus: J.M.C. Toynbee, *Some Notes on Artists in the Roman World, Latomus* 6 (Brussels, 1951). F.S. Kleiner, "Artists in the Roman World: An Itinerant Workshop in Augustan Gaul," *MEFRA* 89 (1977), 661–86.

The Arch of Augustus at Susa: E. Ferrero, *L'arc d'Auguste à Suse* (Turin, 1901). B.M. Felletti Maj, "Il fregio commemorativo dell'arco di Susa," *RendPontAcc* 33 (1960–61), 129–53. A.M. Cavargna Allemano, "Il fregio dell'arco di Susa," *Segusium* 7 (1970), 5–23. S. De Maria, "Apparato figurativo nell'arco onorario di Susa," *RdA* 1 (1977), 44–52. S. De Maria, *Gli archi onorari di Roma e dell'Italia romana* (Rome, 1988), 329–30.

The Arch at Pola: G. Traversari, *L'arco dei Sergii* (Padua, 1971). F.S. Kleiner, *The Arch of Nero in Rome: A Study of the Roman Honorary Arch before and under Nero* (Rome, 1985), 36–37.

The Monument of the Julii: H. Rolland, *Le mausolée de Glanum* (Paris, 1969). F.S. Kleiner, "Artists in the Roman World: An Itinerant Workshop in Augustan Gaul," *MEFRA* 89 (1977), 662–66. F.S. Kleiner, "The Glanum Cenotaph Reliefs: Greek or Roman?" *BonnJbb* 180 (1980), 105–26.

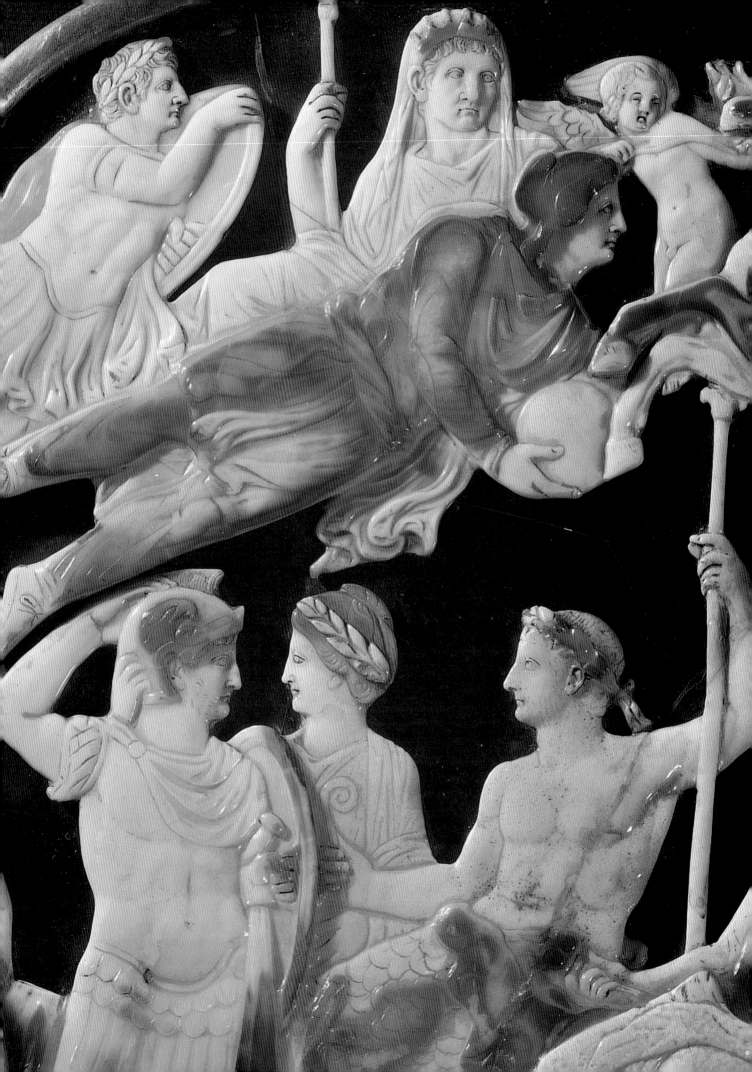

ART UNDER THE JULIO-CLAUDIANS

CHAPTER III

Imperial Portraiture

Tiberius

When Augustus died in 14 his successor, Tiberius Julius Caesar Augustus, the elder son of Livia by an earlier marriage to Tiberius Claudius Nero, had already been adopted as his heir. This happened in 4 but Tiberius was not Augustus's first choice. The emperor's sights had been set on Marcellus, Marcus Agrippa, and Gaius and Lucius Caesar in turn and, it was only after their deaths that he was compelled to choose Tiberius as his successor. Even then, it seems he did so half-heartedly since he had simultaneously adopted Agrippa Postumus.

Tiberius, born in Rome in 42 B.C., was only four years old when Livia married Octavian in 38. Both he and his younger brother Drusus were therefore raised in Augustus's household.

Tiberius had an illustrious military career. Already in 20 B.C., he accompanied Augustus to the East and, after the emperor's negotiated settlement with the Parthians, received the Roman standards. A depiction of this momentous event was chosen by Tiberius as the centerpiece of the breastplate of the statue of Augustus from Primaporta (see fig. 42). The standards had been lost by the Roman general Crassus to the Parthians at a battle near Carrhae in 53 B.C. In the Augustan context, these same standards were highly charged symbols of the new emperor's successful foreign policy. Tiberius also participated in campaigns in Germany, Illyricum, and Pannonia, and in 12 salvaged the Roman position on the Rhine after the disastrous defeat of Varus's three legions. Tiberius's retrieval of Varus's standards is commemorated in an arch facing Augustus's Parthian Arch in the Roman Forum.

Tiberius was emperor between 14 and 37, and these years were marked by Tiberius's complete loyalty to Augustus's domestic and foreign policies. Augustus was proclaimed a divus, and a temple honoring him as such was immediately erected. Tiberius disavowed personal deification in his lifetime and did not embark on a major building program in Rome, although it was during the Tiberian period that an imperial palace on the Palatine

Detail. Grand Camée de France, ca.50. Paris, Bibliothèque Nationale, Cabinet des Médailles. Photo: Phot. Bibl. Nat. Paris

hill (Augustus had lived in a modest house nearby) and a camp for the Praetorian guard were constructed. It was under Tiberius that the German campaigns were halted, the revolt of Sacrovir in Gaul was crushed, and diplomatic efforts put a stop to two uprisings in Parthia.

Tiberius was first married to Vipsania Agrippina, the daughter of Marcus Agrippa, who bore him a son, Drusus the Younger. At Agrippa's death in 12 B.C., Tiberius was coerced into divorcing her and marrying Augustus's daughter. Their infant son died soon after birth. Agrippa Postumus was disinherited by Augustus because of his depravity and sent into exile in 7; he was put to death after Augustus's demise. Germanicus had been adopted by Tiberius at the time of his own adoption in 4. Germanicus, however, died in 19, and the mantle fell to Tiberius's son Drusus who died in 23. Next in line were the sons of Germanicus and Agrippina: Nero, Drusus, and Gaius. Only Gaius was spared the assassinations plotted by Tiberius's chief adviser and prefect of the Praetorian guard, Lucius Aelius Sejanus, and by process of elimination Gaius became emperor of Rome on Tiberius's death. Sejanus, who was eventually found guilty of conspiracy, convinced Tiberius that he too would be assassinated and encouraged him to seek refuge on Capri, to which he retired in 26, communicating with the senate from there. Augustus and his family had several villas on the island that itself was imperial property. Tiberius constructed twelve villas of his own, including the famous Villa Jovis, a retreat terraced out over the sea, intentionally isolated. The substructures and foundations of this spectacular villa are still preserved. Tiberius spent the last ten years of his life on Capri and died there in 37.

The portraits of Tiberius were based closely on those of Augustus. This is because the earliest images of the new emperor were created by his predecessor's court artists and also because Tiberius wanted to stress his familial tie to Augustus. Tiberius and Augustus were, of course, not actually related but a father-son kinship was implied through a fictional resemblance in portraiture. Tiberius was not only the adoptive son of Augustus but was also, after Augustus's death, the son of a divus. Most of Tiberius's portraits show him with the unlined face of a youth even though he was already fifty-six when he became emperor of Rome. His youthfulness is therefore a deliberate affectation meant to link him visually with his illustrious predecessor. Tiberius's hairstyle is also modeled on that of Augustus and is meant to accentuate the same visual connection. It consists of a cap of full hair arranged in comma-shaped locks across his forehead. The coiffure is distinguishable, however, from Augustus's because the configuration of forehead locks is not identical, and Tiberius's cranium is broader than that of Augustus. A broad cranium was a Claudian characteristic, and

Tiberius was by birth a member of the Claudian rather than the Julian family. According to Suetonius, the habit of wearing the hair long on the nape of the neck was also a Claudian trait. In his biography of Tiberius, Suetonius describes the emperor as a stern and silent man who was tall, well proportioned with a strong and heavy build, handsome, and with remarkably large eyes (Suet., *Tib.*, 68). Although the portraits of Tiberius are smooth and idealized in the Augustan manner, the oversized eyes give the heads a striking imbalance that begins to herald a departure from the perfection of Augustan classicism.

A series of portrait types of Tiberius were created to mark the major events of his public life: his adoption by Augustus, his assumption of increased power (the *imperium maius* type), and his designation as imperator. Posthumous versions, based on these lifetime types, were also produced. There are, however, some correspondences among the various types, and scholars have found it difficult to order the portraits of Tiberius into a strict typology.

A portrait of Tiberius (fig. 100), discovered in the eastern provinces but made in the city of Rome, has been called the finest example of the adoption type or the first portrait type of Tiberius commissioned after 4. The portrait was found in the Roman amphitheater in Arsinoe in the Fayum and is now in Copenhagen. The adoption type is known today in nineteen replicas and five provincial variations and shows Tiberius in his mid-forties, although it has been suggested that the portrait type was created already in the 20s B.C. and only widely circulated after the adoption. In the Fayum portrait, Tiberius's head is turned sharply to his left. It is oval with a broad cranium and a narrow chin. He has a high forehead, large eyes, sharply delineated brows, rounded mouth with a slightly protruding upper lip, and a cap of layered hair arranged in comma-shaped locks over the forehead and growing long on the nape of the neck. The forehead locks are parted off center. The framing curls are brushed away from the part, but those closer to the temples are brushed back toward the center. The face of the Copenhagen portrait is unlined. The portrait of Tiberius was discovered in conjunction with marble portraits of Augustus and Livia, also now in Copenhagen, which must have constituted a dynastic group in the Arsinoe amphitheater. The portrait of Augustus is of the Primaporta type but has a fuller hairstyle with deep pockets of shadow undercutting the central triple locks and with longer hair on the nape of the neck. The portrait of Livia (see fig. 54) depicts her with the nodus coiffure in an image created after her marriage to Augustus in 39 B.C. The sophistication of these heads and their close stylistic affinities to counterparts from the city of Rome indicate that this group was not executed by local artists but must have been imported

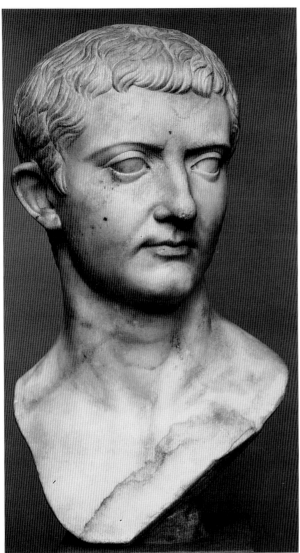

100 Portrait of Tiberius, from the Fayum, after 4. Copenhagen, Ny Carlsberg Glyptotek. Photo: Courtesy of the Ny Carlsberg Glyptotek, Copenhagen

ing facial features, continue to be stressed in the succeeding numismatic series, but the portrait type changes little from year to year. The numismatic evidence is, therefore, inconclusive and does not allow a corresponding sequence of portraits in the round to be established.

Related, however, to both the Rome coin series of 10 and the Lyons one of 13 is the so-called imperium maius type of Tiberian portraits. In 10, Tiberius was voted his second triumph and his first as the adoptive son of Augustus. In 13, the *tribunicia potestas* and *imperium proconsulare,* bestowed on Tiberius in 4, were renewed. The imperium maius type (more recently called the Berlin-Naples-Sorrento type after replicas now in museums in those cities) was created around 13 or perhaps slightly earlier to reflect Tiberius's elevated status, and, when Augustus died in the next year, it became Tiberius's official type. At least six replicas of the type are known and many more variants; some can be dated to the Tiberian period. An example of the type is the marble portrait of Tiberius from Rome (fig. 101) that depicts Tiberius with his characteristic broad cranium and narrow chin, high forehead, large eyes with relatively straight brows that are sharp ridges, aquiline nose, rounded mouth with slightly protruding upper lip, smooth skin, and full cap of layered hair. The configuration of forehead locks is slightly different from that of the adoption type. The locks to the right of the subject's part are brushed in the

from Rome. Near to the portraits in the Arsinoe amphitheater was found a marble statuette of Victory who held in her right hand a bronze statuette representing the suicide of Cleopatra. This reference to Augustus's victory over Cleopatra and, by association, over Mark Antony at Actium, was a fitting subject for a provincial group made in Rome that celebrates not only Augustus's great military victories but also the dynastic succession. The adoption of Livia's son Tiberius in 4, which ensured the continuation of the Julio-Claudian line, was undoubtedly the occasion for the commission of this family group.

It was in 10 that the first coins with Tiberius's portrait were struck in Rome; the Lyons mint began striking coins with his image in 13. These depict a youthful Julio-Claudian with smooth face and full cap of hair. Such characteristics, along with the emperor's most outstand-

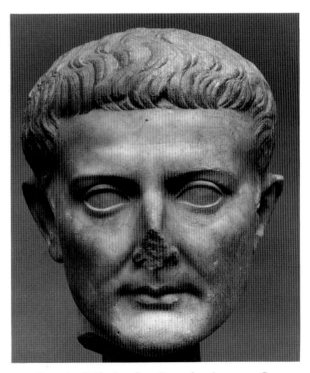

101 Portrait of Tiberius, from Rome, late Augustan. Copenhagen, Ny Carlsberg Glyptotek. Photo: Courtesy of the Ny Carlsberg Glyptotek, Copenhagen

same direction as those on his left and those at the right temple are brushed away from the part.

Although the imperium maius type was greatly admired and widely circulated throughout the empire, there were other types created while Tiberius was emperor. Some of these, for example, the so-called last portrait type, were based on the imperium maius type. The last portrait type, seen in a Luna marble head now in Benghazi, incorporates some of the signs of age. Tiberius is no longer the fictional youth but an aging emperor in his seventies, with squarer cranium, pinched and lined cheeks, and a thin neck. Nonetheless, some of these aberrations may be because the head is a provincial variation of its prototype.

Some of the posthumous portraits of Tiberius are also later versions of lifetime types, but others – for example, a seated statue of the emperor as Jupiter from a Claudian dynastic group in Cerveteri (see fig. 109), are original creations. The Cerveteri piece is of some importance and will be discussed in the context of Claudian dynastic commemorations.

Caligula

Gaius Julius Caesar Germanicus, emperor of Rome between 37 and 41, was born in 12, probably at Antium. As a toddler, he accompanied his father and mother to the Rhine where he was nicknamed Caligula or little boot (*caliga*) by the soldiers because he wore a miniature military uniform in the camp. He also traveled to the East with his parents. After the deaths of his father Germanicus in 19 and his brother Drusus in 33, he and Tiberius's grandson, Tiberius Gemellus, were the sole contenders for imperial power and were jointly named in Tiberius's will. The prefect of the Praetorian guard, Macro, threw his support behind Caligula, who was proclaimed emperor. At the same time, the senate invalidated Tiberius's will, and Caligula became not only sole emperor but sole recipient of Tiberius's estate. Caligula's accession was greeted with enthusiasm and high hopes for the future by the Roman populace because they had great admiration for Germanicus and happy memories of Caligula as a child. At the beginning of his principate, Caligula exercised his devotion by profusely honoring members of his family. The month of September, for example, was renamed Germanicus after his father. The Temple of Augustus, begun by Tiberius, was dedicated in 37. Nevertheless, Caligula soon ordered the murders of both Tiberius Gemellus and his former supporter, Macro.

Caligula himself lived in constant fear of assassination because he was an autocratic monarch who abandoned the ideals of the Augustan principate. Unlike his two predecessors, Caligula openly expressed his desire to be worshipped as a god. In Rome, the heads of statues of Greek divinities were replaced with his own portraits, and a golden statue of Caligula in a shrine was daily outfitted in a garment matching that of the emperor. He was tolerant of some eastern religions, allowing the cult of Isis, for example, to establish a firm foothold in Rome. Surviving ancient sources depict him as a depraved individual who committed incest with his three sisters and who practiced acts of deliberate cruelty to family, friends, and acquaintances alike. Gaius Caligula was assassinated in 41. His sole heir, a daughter Julia Drusilla, and his fourth wife, Milonia Caesonia, were also murdered. After his death, he was not deified by the senate.

Caligula's portraits depict him as the idealized Julio-Claudian youth, but in his case this is not owing to the Augustan fiction but to the fact that he was young when the portraits were produced. He became emperor in his mid-twenties and was assassinated at twenty-nine. What is of greater interest is whether his much-touted madness emerges in his portraits. In other words, did the artists responsible for Caligula's court portraits reveal the deranged persona behind the classicizing mask?

Few portraits of Caligula survive, not only because of his brief tenure as emperor but also because he was not divinized at his death. After his murder, many portraits on view in Rome and elsewhere were destroyed or recarved, and Caligula was not commemorated in posthumous images. The surviving portraits have been divided into a series of types that depict Caligula as the young prince, the youthful emperor, the mourning emperor, and the mad despot – although some scholars have suggested that there is an overlap of types. Careful study of the surviving portraits of Caligula suggests that the latter is the case. Caligula's three years as emperor may have allowed for the creation of several different portrait types but not for their systematic replication.

The portraits of Caligula as prince would have been produced between 31 and 37. There is, however, no uncontested example of this type. One possibility is a marble portrait now in Worcester (fig. 102). Caligula's head is turned abruptly to the left. He has the broad Claudian cranium and a narrowing chin, deep-set eyes, hollow temples, and a protruding upper lip. The hair is worn in a Julio-Claudian cap but the locks are fuller over the forehead and deeply undercut. In fact, there is an overriding interest in an increased plasticity that will find its fullest expression in the portraits of Nero, the last of the Julio-Claudians. It has even been suggested that the Worcester head is a posthumous creation from the Neronian period.

The accession portraits were produced between 37 and 38, and it is in them that we find a less experimental and more canonical image of the new emperor. Surviving examples are identified on the basis of their similarity to coins struck in the Rome mint in those same years and

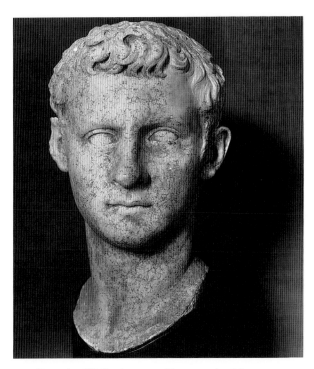

102 Portrait of Caligula, 31–37. Worcester Art Museum. Photo: Courtesy of the Worcester Art Museum, Worcester, Massachusetts

include marble portraits in New Haven, Pozzuoli, and Fossombrone, and elsewhere. All belong to what has recently been called the New Haven type, of which there are seven replicas, including a portrait on a cameo in New York. The New Haven head (fig. 103) was discovered in Rome near the Milvian Bridge and is now in the Yale Art Gallery. It depicts Caligula with the broad Claudian cranium, a square face, a high forehead, hollow temples, deep and closely set eyes, a straight nose with broad nostrils, and narrow mouth with a protruding upper lip. The cap of layered hair is arranged in a series of comma-shaped locks across the forehead. These are all brushed to the emperor's right. Full locks are also brushed in front of Caligula's ears. The Pozzuoli and Fossombrone heads of Caligula differ slightly from the one in New Haven because in them the emperor wears the corona civica. The oak wreath graced the reverse of a series of coins struck in 38 in honor of Caligula's assumption of the title pater patriae. The portrait of the emperor on the obverse shows him with a somewhat different coiffure in which the forehead locks are parted in the center.

The Schloss Fasanerie type, after the best example in that collection, overlaps with Caligula's mourning emperor type. In the Schloss Fasanerie variation, which is the primary imperial portrait type of Caligula, the emperor is depicted with the same physiognomic peculiarities as in the New Haven type, but with the parted

forehead locks and with the hair very long on the nape of the neck. Examples of this type also include two heads from toga statues now in Gortyna and Richmond.

It is the marble portrait of Caligula from Asia Minor and now in Copenhagen (fig. 104) that is traditionally referred to as the "crazy Caligula" portrait. The head probably represents Caligula toward the end of his life and is therefore an example of the despot type, but it also demonstrates its indebtedness to the accession type in the overall structure of the head and the configuration of the coiffure. Caligula's broad cranium, high forehead, hollow temples, close-set eyes beneath straight brows, straight nose, and narrow mouth with protruding upper lip are all apparent. The Copenhagen coiffure is comparable to that of the portrait in New Haven, but it is fuller, more layered, and more deeply undercut, and the emperor wears long sideburns not apparent in the earlier portrait. The Copenhagen portrait does seem to possess a pronounced asymmetry, which has caused scholars to suggest that it reveals Caligula's unbalanced personality. What gives the portrait its cross-eyed look, however, is not a deliberate lack of balance but a fact of preservation. This portrait, like all other Roman marble heads, was originally painted. The pupils, irises, and eyelashes were added in paint, but only those on the left are still preserved. The artists who fashioned the Copenhagen head and the prototype on which it was based have not incorporated the emperor's aberrant personality in his portraiture but have instead created an image that is in the tradition of the portraiture of his predecessors.

In his *Life of Caligula,* Suetonius describes the emperor as tall and pallid, with a hairy body and a poor physique. He mentions that Caligula's eyes were hollow and his forehead broad and forbidding, the latter two characteristics being apparent in the portraits. He also mentions on at least two occasions that Caligula was balding. In fact, Caligula was so self-conscious about his baldness that it was considered a capital offense in Rome for anyone to look down on him (Suet., *Calig.,* 50). And yet in all of Caligula's portraits, irrespective of type, he is depicted with a full cap of hair that is clearly modeled on the layered coiffures of his imperial predecessors. It is here that we see that Caligula's portraits are as fictional (or, at the very least, as enhanced) as those of Augustus and Tiberius (except perhaps in Augustus's Forbes type and Tiberius's last portrait type), and that in portraiture he was endowed with assets that he did not possess in life. Furthermore, in some of the surviving portraits of Caligula made in the provinces, he is depicted with the upward gaze of Alexander the Great, with whom he may have on occasion tried to associate himself. In fact, Suetonius mentions that Caligula "sometimes wore the breastplate of Alexander the Great, which he had taken from his sarcophagus" (Suet., *Calig.,* 52).

Art under Julio-Claudians 127

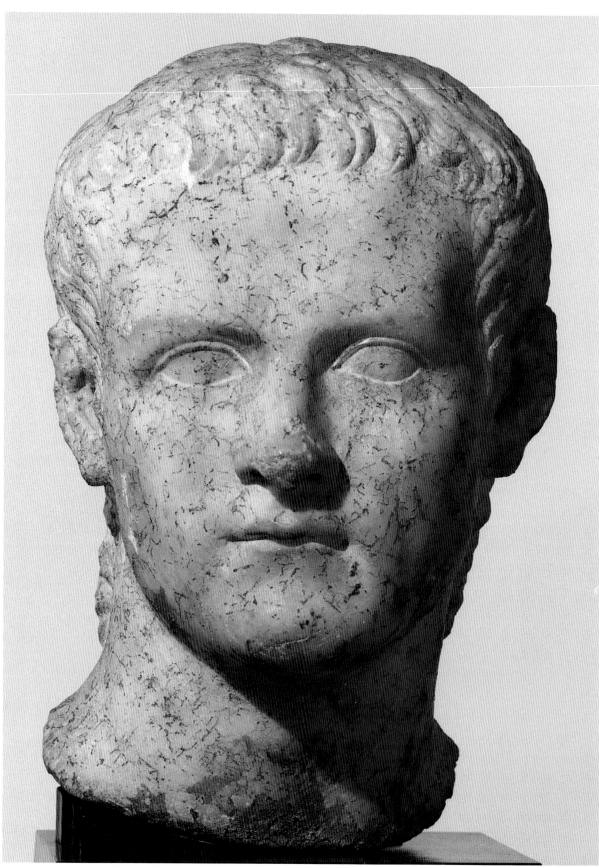

103 Portrait of Caligula, from Rome, 37–38. New Haven,
Yale University Art Gallery. Photo: Courtesy of the Yale
University Art Gallery, by Joseph Szaszfai, 1987.70.1

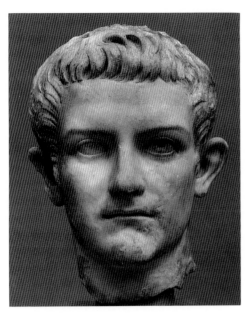

104 Portrait of Caligula, from Asia Minor, 37–38. Copenhagen, Ny Carlsberg Glyptotek. Photo: Courtesy of the Ny Carlsberg Glyptotek, Copenhagen

Claudius

Although the son of Drusus the Elder and Antonia, the brother of the beloved Germanicus, nephew of Tiberius, and the uncle of Gaius Caligula, Tiberius Claudius Nero Germanicus became emperor of Rome quite by accident. His family and friends viewed him as dim-witted – in part because he was in poor health and had a pronounced stammer – and thought he would never amount to anything. Even his mother referred to him as "a monster: a man whom Mother Nature had begun to work upon but then flung aside" (Suet., *Claud.*, 3). For that reason, he was appointed to no major posts under Augustus and Tiberius and could claim no military distinction. Under Caligula, Claudius gained some favor. He served a brief consulship and presided in the emperor's absence at the public games. Caligula died with no male heirs. Even if he had had any, it was unlikely that the senate would have appointed one emperor; in any case, senatorial opinion favored a restoration of the republic. At the news of Caligula's assassination and the murder of his wife and daughter, Claudius feared that, as Gaius's uncle, he would be next. It is reported that he therefore hid behind a curtain in the palace but was discovered by a member of the Praetorian guard who escorted him to the Praetorian camp where he was saluted as the fourth emperor of Rome. By accepting the honor, Claudius antagonized the senate but remained in the guard's favor by paying special attention to the army (in fact, he literally purchased their loyalty) and by participating personally in the invasion of Britain, for which he was awarded a triumph.

Claudius was born in 10 B.C. in Lyons and thus was fifty-one years old at his accession. His tenure as emperor lasted from 41 to 54 and was marked by a fairly liberal attitude toward the provinces and by the foundation of important new colonies not only in Britain but also in Mauretania and Thrace. In the early years of his principate, he governed Rome with fairness and good sense, but his health failed him as he aged. In his last years his domestic and foreign policies were heavily influenced by his wives and his freedmen – Narcissus, his secretary, and Pallas, his treasurer. In fact, the Claudian period is memorable in part for the emergence of individual freedmen as powerful forces in the governing of Rome and the empire.

Claudius had four wives. The first was Plautia Urgulanilla, who produced two children, Drusus and Claudia, both of whom died in infancy. The second was Aelia Paetina, who bore one daughter, Claudia Antonia. His third wife was Valeria Messalina, to whom he was married at the time of his accession. Two children, Octavia and Britannicus, were the product of their union. The machinations of Narcissus led to the death of Messalina in 48. Claudius then married his niece Agrippina, the daughter of his brother Germanicus and the mother of Nero, who in 50 persuaded her new husband to adopt her son as the legal guardian of Britannicus, who was four years younger than Nero. Claudius died in 54, and it was widely reported that he was murdered. His wife, Agrippina, who may have given him poisoned mushrooms, was one of the suspects. Agrippina's desire to see her young son Nero become the emperor of Rome may have served as a motive for murder. Furthermore, Agrippina, a domineering woman, probably thought that she could participate more fully in shaping the policies of state with her seventeen-year-old son rather than her husband as emperor.

Even though Claudius was not a favorite of the senate, he was divinized at his death, the first emperor after Augustus to be so consecrated. His deification is satirized by Seneca in the *Apocolocyntosis* or the pumpkinification of Claudius.

Claudius was tutored by Livy, who instilled in him great respect for history and Roman religion. The former was reflected in Claudius's own scholarly writings. During his life, he wrote histories of Rome, of the Carthaginians (in eight volumes), and of the Etruscans (in twenty volumes). Claudius was able to read and write Etruscan and also studied Greek, wrote a biography of Augustus, and an eight-volume autobiography.

Claudius's scholarly leanings and antiquarian interests are reflected in his portraiture. Although his earliest portraits as emperor continue the Augustan fiction of the eternal youth, he soon commissioned a portrait type

that depicts him as a middle-aged ruler. Paradoxically, the portraits of Claudius are also the first surviving examples to represent an emperor in Rome in the guise of a god during his lifetime. Despite the fact that he was treated with disdain by the imperial family, Claudius demonstrated profound familial devotion once emperor of Rome. Suetonius reports that Claudius's favorite oath was "By Augustus!" and that at his urging the senate made Livia a diva, and her image was transported in Rome in a carriage drawn by elephants. Furthermore, games were held on Drusus's birthday, and public sacrifices offered to both Drusus and Antonia, now an *Augusta* (Suet., *Claud.*, 11). Claudius's deep respect for Augustus and his desire to link himself with Rome's first emperor, as well as with his uncle Tiberius and members of his immediate family, caused the emperor to honor the Julio-Claudian family by commissioning numerous dynastic group portraits.

Claudius initiated a number of major public works, some begun by his predecessors. He drained the Fucine Lake and built a harbor at Ostia. The harbor included breakwaters with a colonnade that partially survives. The travertine columns are made up of unfinished drums and dressed bases and capitals – a curious blend of rough and finished masonry that has no earlier precedent and no successor until the Renaissance when a decided taste for combining rusticated and dressed masonry can be seen in Michelozzo's Palazzo Medici-Riccardi in Florence and elsewhere. Claudius completed two aqueducts, the Aqua Anio Novus and the Aqua Claudia, begun by Caligula, and commissioned a great travertine gate, the Porta Maggiore, to mask their crossing. This gate is also done in the highly individual style favored by Claudius. The attic, behind which the two conduits flowed and which is carved with a lengthy inscription, is made of dressed masonry. The cornices, entablatures, and capitals below are also dressed smooth, but the columns, drums, and other masonry are left in a rough state.

This highly personal and even eccentric style of architecture, characterized by a taste for what was by now old-fashioned cut-stone construction, underscores Claudius's interest in the past, a past that is also wistfully alluded to in the emperor's earliest numismatic portraits. An aureus from Rome, struck between 41 and 42, with a portrait of Claudius on the obverse (fig. 105), does not depict him as a fifty-one-year-old man but as a Julio-Claudian youth with smooth skin, strong jaw and neck, even features, and a full cap of layered hair that grows long on the nape of the neck. In this early portrait, Claudius has adopted Augustus's eternally youthful imagery as his own. This is not surprising since Claudius's elevation to emperor meant the continuation of the Julio-Claudian dynasty founded by Augustus. Nonetheless,

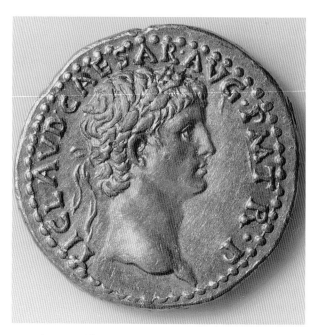

105 Aureus with portrait of Claudius as a youth, 41–42, private collection. Photo: Hirmer Verlag München, RMGd 210024V

the choice of this youthful imagery must have had special significance for Claudius, whose own childhood was filled with scorn and humiliation. In fact, few if any portraits of Claudius were erected of him in his youth, even though he was a member of the imperial family and – theoretically at least – a possible heir to power. Scholars have been able to marshal evidence for only one youthful portrait of Claudius that depicted him at the age of seventeen or eighteen and surmounted the attic of the Arch at Ticinum in North Italy. The existence of such a statue is purportedly attested by an inscription on the Arch of Ticinum (*CIL* V, 6416.10) that was erected in honor of the imperial family between 7 and 8. Nonetheless, the existence of the arch has recently been called into question by a demonstration that inscriptions naming Claudius and nine other members of the Julio-Claudian family were reused on a gateway in Rome and did not belong to an Augustan arch in North Italy. Other portraits of Claudius are not attested until the principate of Caligula, and there are only two inscriptions recording them. Claudius's accession gave him a chance to rewrite his own history by allowing him to present himself on the imperial coinage as the highly esteemed, handsome, vital, and youthful successor to Augustus.

It was 41, the year of Claudius's accession, that first witnessed the production in significant numbers of portraits of Claudius in the round, and an accession portrait was surely created in Rome to mark the occasion. Other portrait types may have been produced to mark the conquest of Britain in 43, on the occasion of Claudius's

marriage to Agrippina in 48, and posthumously to honor divus Claudius. Some of the posthumous portraits were commissioned under Vespasian, which is not surprising because it was the founder of the Flavian dynasty who completed the Temple of Divine Claudius – the Claudianum – in Rome. Claudius's portrait types have been recently studied by several scholars who have focused on both the numismatic portraits (dividing Claudius's portraits on coins into several types) and Claudius's portraits in the round (dividing them into three basic types: the youthful portrait, the realistic portrait with the coiffure with the pincer motif, and the realistic portrait with a simpler hairstyle). The study of Claudius's portraits is, however, complicated, in part because many were recut from heads of Caligula.

The best-known portrait of Claudius is certainly the full-length statue of the emperor, with the attributes of Jupiter, from Lanuvium (fig. 106). A dedicatory inscription, which was found near the piece and is today lost, may belong to the statue, although this is still disputed. The inscription stated that the statue was erected in honor of Claudius in 42–43 by the senate and the people of Lanuvium, although its exact location within the city is unknown. It may have been put up in connection with the municipal cult that would not have been considered official in the eyes of Rome. Since the statue is only summarily worked in the rear, it must have been placed in the niche of a public building, perhaps the Basilica of Lanuvium.

Close examination of the head of the Lanuvium statue makes it apparent that the portrait is very different from that on the slightly earlier Rome aureus. In the Lanuvium portrait, Claudius is shown with a Julio-Claudian cap of layered hair with comma-shaped locks parted near the center and brushed to either side and with the characteristic broad Claudian cranium and tapering chin, but these features are not accompanied by the traditional Augustan and Julio-Claudian youthfulness. Instead, Claudius is represented as a man in his fifties with bags under his eyes, sagging jowls, furrows in his forehead, and creases in his cheeks and neck. By commissioning the portrait upon which the Lanuvium statue is based, Claudius made the momentous decision to desist from propagating the Augustan fiction of the eternal youth in favor of a realistic portrayal of his face. This decision was to alter significantly the development of his own portraiture and that of the imperial image in general. Moreover, the realistic portrait head is combined with an idealized body type. Although Suetonius reports that Claudius was "tall, well-built, handsome, with a fine head of white hair and a firm neck" (Suet., *Claud.*, 30), he did not have the muscular body of a youth when he was in his midfifties. In the Lanuvium statue, Claudius, nude from the waist up and with a mantle draped over the lower part of his body and across his left shoulder, stands in a contrapposto pose with his weight on his right leg, his left leg bent, and left heel raised. His left arm is upraised, and he holds a scepter in his left hand (correctly restored); his left arm is outstretched and he carries a patera (incorrectly restored). Next to his right leg is an eagle with outstretched wings. Both the eagle and scepter are the attributes of Jupiter; the oak wreath worn by the emperor is not. The youthful muscular body with the accoutrements of Jupiter thus serves as a prop for the realistic portrait head of the emperor of Rome. The inconsistent image thus created resuscitates a type popular in the late republic, seen for example, in the statue of the Tivoli general (see fig. 12), which had been rejected by Augustus in favor of a consistent idealization. The Claudian revival of the idealized body type as a base for the realistic portrait can be seen as a parallel development to the renewed interest in realistic portraiture. At the death of Caligula, the senate favored a restoration of the republic rather than the continuation of a monarchy, and Claudius's revival of republican values in portraiture may have been a parallel development.

The prototype, probably in bronze, for the Lanuvium statue of Claudius also served as the model for an almost identical marble statue of the emperor from the Metroon in Olympia (fig. 107). Although executed by two Athenian artists, Philathenaios and Hegias (whose signatures are carved on the marble support behind the eagle) – who have imbued the statue with such Hellenistic devices as the pronounced turn of the neck and head and more dynamic drapery folds – the Olympia statue is of the same scale as the Lanuvium statue and is represented in the same contrapposto posture with the mantle draped over the lower part of the body and across the left shoulder. The arms are similarly positioned, the eagle has the same wingspread, and the emperor's parted coiffure is also comparable. The Claudius from Olympia is one of seven marble statues that stood on bases in the intercolumniations of the interior of the city's Metroon. The over-life-size statues of Claudius and his last wife, Agrippina, flanked the even larger cult statue of Augustus and were accompanied by statues of Vespasian, Titus, and two Flavian women. The Metroon statuary group was commissioned in the early years of Vespasian's principate, that is, about 71–73, at which time Vespasian was attempting to link his new dynasty with that of the two deified members of the previous dynasty.

The Lanuvium portrait is one of several heads that seem to belong to type 2, the most widely circulated portrait type of Claudius, characterized by a distinctive coiffure and aging features. Some of the replicas differ in detail, however, as, for example, a marble head in the

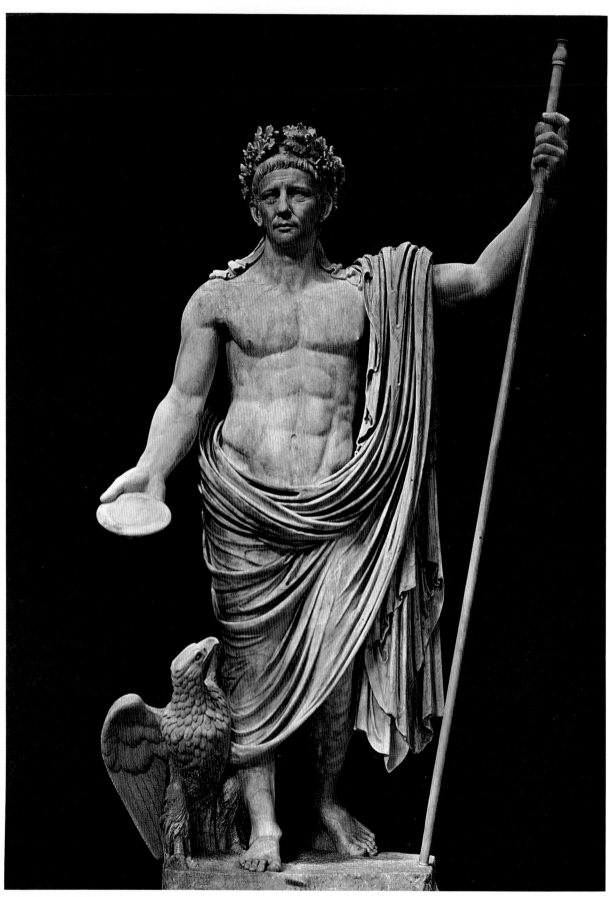

106 Portrait of Claudius with the attributes of Jupiter, from Lanuvium, 42–43. Rome, Vatican Museums. Photo: DAIR 33.136

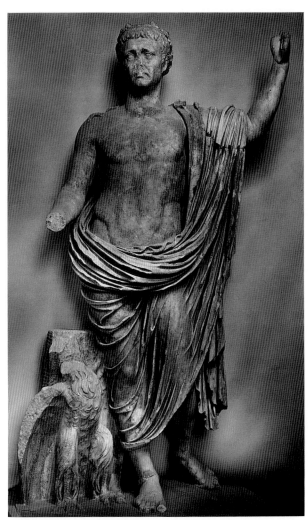

107 Portrait of Claudius with the attributes of Jupiter, from Olympia, 41–43. Olympia, Museum. Photo: Deutsches Archäologisches Institut Athen

Museo del Palazzo dei Conservatori that is a portrait of Claudius recarved from one of Caligula. Coins with a comparable portrait have not been dated with certainty, the years around 41 or 48–49 alternatively suggested. It has been pointed out correctly that a new emperor was more likely to be commemorated with a reworked head of his predecessor at the very beginning of his principate, and such a date in the first years of the 40s for the prototype of the Lanuvium portrait would accord well with the evidence of the statue's inscription.

One of the only surviving portraits of Claudius that can be dated with certainty is the full-length bronze statue of the emperor from Herculaneum. The date of 48–49 is given in the accompanying bronze inscription, which also indicates that the statue was erected with funds provided in the will of a soldier of the thirteenth urban cohort. It too belonged to a group, being one of a pair with a bronze statue of Augustus. The statue of Augustus depicts him in partial nudity with a mantle

draped around the lower part of his body and over his left shoulder. His head is upturned and his feet are bare. He carries the attributes of Jupiter: a scepter in his upraised right hand and a thunderbolt in his left. Claudius is depicted in heroic nudity and with a lance in his upraised right hand. He is not endowed with the trappings of Jupiter, and the idealized muscular body supports a realistic portrait head. Apparent is the broad Claudian cranium and the layered cap of hair parted near the center but with the slight variation of the parted locks turning back toward the center at the temples. The emperor is shown with his distinctive facial features combined with the artist's interest in the effects of aging on the face. The emperor's forehead is lined, and his cheeks and neck are deeply creased.

Another portrait of Claudius that seems to be dated by epigraphical evidence is the seated marble statue from the theater in Cerveteri (fig. 108). It is part of a Claudian dynastic group of about 45–50 that depicted, among others, Claudius, Tiberius, Agrippina, and Britannicus. The portrait of Tiberius, which is also extant, portrays the second emperor of Rome in the same seated pose (fig. 109). Both have bare chests, and their mantles are draped across their laps and over their left shoulders. Both wear the corona civica on their heads. Their muscular torsos are similarly posed, and both turn their heads sharply to the left. The arms are missing, but the surviving musculature of the shoulders indicates that both had their left arms upraised, probably to hold a scepter or lance. The seated pose, upraised arms, and bare chests have led scholars to identify them as portraits of Claudius and Tiberius as Jupiter, although the chief god's attributes are lacking. The oak wreath identifies the emperors as the saviors of Roman citizens and is not an attribute of Jupiter. The idealized torso of Claudius supports a realistic head with broad cranium, narrow chin, forehead lines, cheek creases, and a Julio-Claudian cap of hair parted in the center, with locks brushed away from, toward, and then again away from the direction of the part. The portrait of Tiberius is a more consistent image, matching the vigorous body with a youthful idealized face. Fragments of the right side of the throne on which Claudius sat are also preserved with depictions of personifications of the three Etruscan cities of Tarquinia, Vetulonia, and Vulci, appropriate for a portrait set in the theater of another Etruscan city, Cerveteri, and for an emperor who knew the Etruscan language and who had written a history of the Etruscans.

Of special significance is that many of the extant lifetime statues of Claudius depict him with the attributes of Jupiter. The cult of Jupiter had been important in Rome since the republic. Jupiter was the chief god of the Roman pantheon, and his abode in Rome was at the apex of the

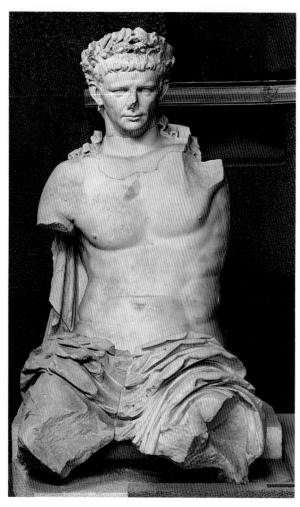

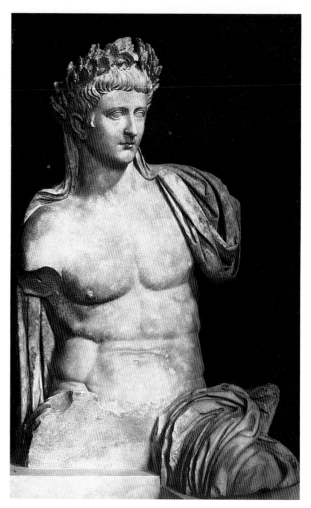

108 Portrait of Claudius, from the theater in Cerveteri, 45–50. Rome, Vatican Museums. Photo: DAIR 81.2848

109 Portrait of Tiberius, from the theater in Cerveteri, 45–50. Rome, Vatican Museums. Photo: Alinari/Art Resource, New York, 6376

Capitoline, the most sacred of the seven hills. The Temple of Jupiter and the altar that fronted it were the goal of the triumphant emperor who, carrying Jupiter's attributes, paid homage to the god who had invested the victorious general with his powers. Such an investiture is depicted later on two panels from the attic of the Arch of Trajan at Benevento (see figs. 192–193). These represent Jupiter transferring power in the form of a thunderbolt to the emperor Trajan. Augustus was depicted in the guise of Jupiter only in posthumous portraits, but the autocratic Caligula demanded that he be venerated during his lifetime as a god and, according to Suetonius, insisted that heads of famous Greek statues of deities, including that of Zeus at Olympia, be replaced with those that bore his own features (Suet., *Calig.*, 22). Although Roman statues of Caligula as Jupiter do not survive, this does not mean that they were not manufactured in antiquity. Unlike Caligula, Claudius disavowed divine honors during his life and was opposed to the establishment of a divine cult in his honor. He was not, however, averse to having

statues of himself and members of his family, some of which possessed divine attributes, erected. There are no surviving representations of Claudius with the attributes of Jupiter on coins struck by the Rome mint during his principate, which suggests that the emperor did not consider such images to be part of his imperial ideology. It is therefore likely that lifetime portraits depicting Claudius as Jupiter were intended to be understood as portraits of the emperor invested with the powers of Jupiter, rather than as replacements for the god. Note that the group from Cerveteri represents both Claudius and Tiberius with the attributes of the same god and that the Jupiter body type is accompanied by a realistic portrait head of Claudius. The spectator could not possibly confuse Claudius's distinctive physiognomy with that of the chief god of Rome's pantheon.

The portrait of Claudius from the Olympia Metroon (see fig. 107) may be cited as an example of a posthumous portrait of Claudius. This portrait is a version of an earlier city of Rome prototype, which more closely ap-

proximated the Lanuvium portrait. Although the body type is nearly identical, the facial features of the Olympia portrait have been smoothed over and idealized. This is partly because of the stylistic predilections of the statue's Greek artists but also because Claudius was a divus when the portrait was made.

Another Julio-Claudian statuary group stood in the Basilica at Velleia. Added to in two Tiberian phases and one Claudian phase, it consists of standing statues of Drusus the Elder, Drusus the Younger, Agrippina the Elder, Agrippina the Younger, Claudius, possibly Germanicus, and the young prince Nero. Some of the male figures are in military dress, others in togas. Claudius is one of the veiled and togate figures, with the portrait head worked separately for insertion into the body. The head of Claudius replaced one of Caligula originally fashioned, along with the togate body, of a single piece of marble. This portrait of Claudius differs from the other just discussed because the emperor is depicted in his role as magistrate or priest rather than as a divine representative on earth; the group is also important because it includes a togate portrait of the boy Nero. It is with Nero's earliest portraits that we can speak for the first time in Roman art of a true prince portrait.

The Portraiture of Nero

Nero Claudius Caesar, emperor of Rome between 54 and 68, was the son of Gnaeus Domitius Ahenobarbus and Agrippina the Younger. He was born at Antium in 37, the same year as Caligula's accession. His father was consul in 32, and his mother became the fourth and last wife of the emperor Claudius. Agrippina assured Nero's succession by seeing to it that he was formally adopted by Claudius in 50. This adoption gave Nero precedence over Claudius's own son by Messalina, Britannicus. Furthermore, Agrippina saw to it that those loyal to Britannicus were dismissed from court and – most drastically of all – was rumored to have engineered Claudius's death. Stories about Nero's miraculous childhood were spread throughout the empire, and great emphasis was placed on his divine descent from Augustus. The seventeen-year-old Nero became emperor of Rome at Claudius's death and at first displayed his devotion by having Claudius deified and by personally delivering the former emperor's funeral oration. He also announced that that he would follow Augustus's policies. At seventeen Nero was certainly not a fully formed human being and was in danger of being totally dominated by his mother in the early years of his principate, had it not been for his close advisers, Seneca (his former tutor) and Burrus, prefect of the Praetorian guard. Nero eventually repaid his mother by having her murdered in 59 (Britannicus had already

been poisoned in 55). Nero, who simply got rid of those he disliked, also divorced and murdered his first wife, Octavia. She was replaced by Poppaea, the former wife of Marcus Salvius Otho, who bore Nero a daughter, Claudia Augusta, who died in infancy. Poppaea died, killed by Nero in 65, and Nero then married Statilia Messalina.

Nero loved the arts. He played the lyre and enjoyed singing and reciting his own poetry. According to Suetonius, his first public appearance was at Naples, and it was rumored that even the tremors of an earthquake did not keep him from finishing his recital (Suet., *Nero, 20*). Furthermore, Suetonius asserts that spectators, including pregnant women about to give birth, were not allowed to leave the theater during the emperor's performances (Suet., *Ner., 23*).

Nero believed in the interrelation of a life of the mind and a life of the body and was especially fond of horsemanship and chariot racing. Because of both his singing and his chariot racing, he was hailed by his flatterers as Apollo. He made a personal appearance at the circus and also went to Greece to participate in the Olympic games, which were, of course, fixed in his favor. While there he began a canal at Corinth and collected works of Greek art to bring back to Rome. Tutored by Seneca in a wide variety of subjects, he had a special interest in painting and sculpture and must have been involved personally with the choice of the Greek masterworks, either intentionally plundered or perhaps (more likely) presented to him by sycophantic Greek authorities.

He built two magnificent bathing establishments in the Campus Martius that were open to the public but took advantage of a serious fire that raged through Rome in 64 to expropriate half the central city for his private use. The fire had a number of significant consequences. The first benefited the Roman populace because new fire laws were enacted involving the careful regulation of the height of buildings and the width of streets, and new structures had to be constructed in fireproof, brick-faced concrete. The second consequence benefited only Nero and, in fact, helped to turn public opinion against him. Nero took advantage of the fire's devastation, turning it to personal gain. With an earlier architectural scheme, he had hoped to link the Palatine with the Esquiline by building a transitional palace, the Domus Transitoria, two rooms of which survive beneath the Velia and on the Palatine. This project was canceled by the fire, but the damage inflicted on downtown Rome by the conflagration allowed Nero to raze the blighted area and construct a second pleasure palace. He commissioned an artificial lake and a palace called the Domus Aurea, or Golden House, because of its gilded facade. Built by the Roman engineers Severus and Celer, it possessed many

spectacular details such as a banqueting hall with a rotating roof, dining rooms with tiled ceilings that had sliding panels that opened to release flowers or perfume on the emperor's invited guests, and a bath that provided a choice of sea water or sulphur water. The foremost painter of the day, Fabullus, whose claim to fame was that he painted in a toga, was responsible for decorating the walls of the palace with magnificent white-ground frescoes of the third and fourth style. In fact, Fabullus is usually credited with having invented the fourth style with its fragments of buildings and pseudo-illusionism. The shapes of the rooms of the Domus Aurea were also revolutionary, and Nero's architects were true masters of the new cement medium. The architectural experiments in cement that began in the republican and Augustan periods saw their culmination in the so-called octagonal room of the Domus Aurea. Its eight-sided walls are crowned with a dome, and both create a sculptured space that is illuminated by natural light from the central oculus. The walls and dome were originally covered with frescoes and sheathed with mosaics. A statue of the emperor, 120 feet tall, stood not too far away. After the construction of the Domus Aurea, Nero is quoted by Suetonius as saying: "Good, now I can at last begin to live like a human being!" (Suet., Ner., 31).

In 65 the so-called Pisonian conspiracy was discovered. It was planned in the interest of Gaius Calpurnius Piso, after whom it is named, and Seneca, Lucan, and many others were caught up in it. Its purpose was to assassinate Nero and make Piso emperor. It was discovered by Nero, and all the accomplices were forced to commit suicide. These plots, however, were but an omen of what was to come. While Nero was participating in the Olympic games, other Romans, including Galba, spearheaded revolts. Even the Praetorian guard deserted Nero in favor of Galba, and Nero was forced to flee Rome. Nero committed suicide in June 68 at the age of thirty-two. The Roman populus rejoiced. It is reported by Suetonius that citizens appeared on the streets of the city wearing freedmen's caps of manumission, as if they had just been granted their liberty (Suet., Ner., 57). The senate issued a damnatio memoriae, and an attempt was made to eradicate Nero from memory by destroying his monuments.

The willful destruction of Nero's portraits after his death means that there are few surviving images from which to construct a chronological and typological sequence. Complications also arise because some of Nero's portraits are reworked heads of earlier emperors such as Augustus. Furthermore, some Neronian portraits were reworked into portraits of Nero's successors, such as Vespasian. Still, the establishment of a portrait series of Nero should be simplified since posthumous portraits of

him were not commissioned by his successors, although Suetonius reports that a few faithful friends honored him with posthumous images, which were set up on the Rostra in the Roman Forum (Suet., Ner., 57). Otho also replaced condemned statues and bust-length portraits of Nero (Suet., Oth., 7).

The portraits of Nero have been divided into five portrait types, their creation corresponding to the years 51, 54, 55, 59, and 64. Coins with portraits of all five types are preserved, and seventeen sculptured replicas – fifteen of types 1–3 and one each of types 4 and 5. The creation of each of the five types has been linked to an event in the life of Nero.

Nero's adoption by Claudius in 50 was the occasion for the production of the first, or boy, portrait type that is attested on the coins of 51. It was, in fact, in 51 that Nero assumed the toga virilis and was voted numerous other honors. Coins of 51–54 depict him with a youthful countenance, high cheekbones, fleshy jaw and neck, and a full head of tousled hair that is brushed from the crown of his head, low on his forehead. It also grows long on the nape of the neck, following the trend established by his Julio-Claudian predecessors.

Two full-length portraits of the boy Nero in tunic and toga and wearing the bulla in Paris and Parma (fig. 110) – the latter part of the Velleia dynastic group discussed above – were undoubtedly commissioned before his assumption of the toga virilis in 51, the bulla being a sign that Nero had not yet come of age. The portraits depict a young boy with a round, fleshy face and even features. The hair is brushed in long strands from the crown of the head, low on the forehead and parted slightly in the center, with the remaining strands following the direction of the part on either side. A high quality marble head in Copenhagen also corresponds to this type, and all three are fine examples of the portrait of a prince destined to become the emperor of Rome.

A new coin type was issued at Nero's accession in 54 that depicted him in a profile portrait facing his mother, Agrippina, and attests to her dominance over Nero at the beginning of his principate. The hairstyle and portrait features are essentially the same as those in type 1, although the die-cutter has attempted to make Nero look a little more mature. A marble portrait in Detroit is comparable to coin type 2, with the same coiffure and facial features but with an added maturity.

Nero gains prominence over his mother in the coin issues of 55. The portraits now overlap with Nero in the foreground, and his mother's profile features are silhouetted beneath his own. Although his coiffure remains unchanged in this new type, the cheeks, chin, and neck are fleshier than in the two earlier types. It was this last coin type that continued to be used until 59 and is referred

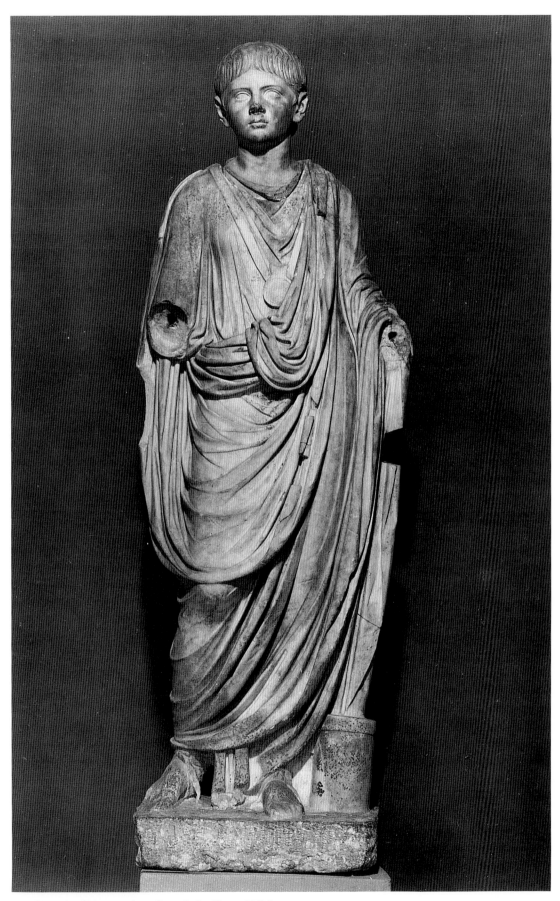

110 Portrait of Nero as a boy, from the basilica at Velleia,
before 51. Parma, Archaeological Museum. Photo: DAIR
67.1587

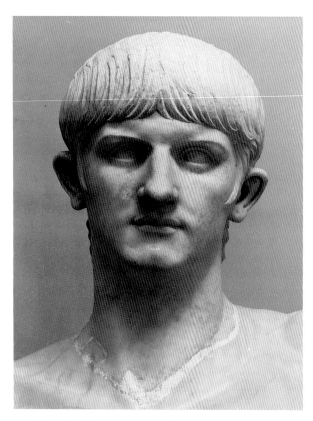

111 Portrait of Nero, 55–59. Cagliari, Museo Nazionale. Photo: DAIR 66.1946

head where they are arranged in parallel strands facing left and turning right only at the corner of the right eye. In the sculptured portrait, the forehead curls are pushed up somewhat to form a kind of crest over the forehead.

Coin type 5 was initiated in 64, probably in honor of the celebration of Nero's ten years of imperial power, the *decennalia,* and was in use at Nero's death in 68. The parallel series of curls is the same as in coin type 4 but without the part over the right eye. It forms an even more prominent crest of hair and conjures up Suetonius's description of the emperor's hairstyle as *coma in gradus formata* (shaped into terraces). Furthermore, Suetonius describes Nero as being of average height, although with squat neck and protuberant belly, and with brownish-blond hair, gray-blue eyes, and pretty features (Suet., *Nero, 51*). The sculptured portrait that belongs to this type (the Munich type, after a portrait in the Glyptothek in Munich) is the marble bust in Worcester (fig. 113), which portrays Nero with a massive neck and chin, deep-set eyes, and crested coiffure.

The latest portraits of Nero are sometimes accompanied by attributes that make reference to his divine investiture. This relation between an emperor and his patron god had already been explored by Claudius and his artists in portraits of him with the attributes of Jupiter. The radiate crown and the aegis of Jupiter were some-

to as the accession or Cagliari type after a head of Nero now in Cagliari (fig. 111). Scholars assign a portrait of Nero now in the Museo Nazionale Romano to a third type, which conforms to coin type 3, the accession type, with the same hairstyle as types 1 and 2 but with fleshier features.

A new type was initiated on coins and for portraits in the round in 59, possibly in celebration of Nero's *quinquennium,* his fifth year of rule. Most striking is the introduction of a new coiffure that was to appear on coins until 64 and consists of curls combed leftward in a parallel pattern broken only over the right eye where they change direction. The features are increasingly fleshy versions of those of the younger Nero. The only extant marble example of this type is the well-known portrait of Nero found on the Palatine hill and now in the Museo Nazionale delle Terme (fig. 112). For this reason, the type is sometimes referred to as the Terme Museum type. The portrait differs from the numismatic image in that Nero is shown with long sideburns that become a light beard beneath his chin, but in other ways the depictions are comparable. Nero has a round, fleshy face with full cheeks, chin, and neck. His eyes are deeply set beneath slightly protuberant brows, and his lips are rounded with slight dimples at the corners. The hair is very full and is brushed in thick waves from the crown of the head to the fore-

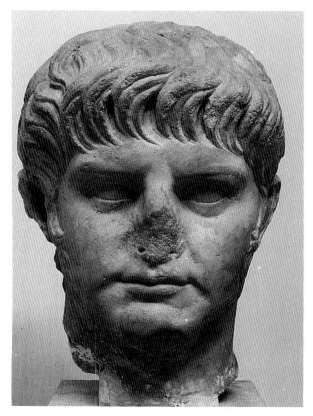

112 Portrait of Nero, from the Palatine, 59. Rome, Museo Nazionale delle Terme. Photo: DAIR 62.536

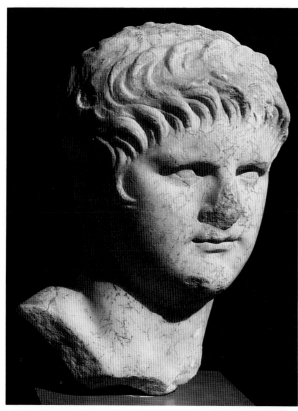

113 Portrait of Nero, 64–68. Worcester Art Museum. Photo: Courtesy, Worcester Art Museum, Worcester, Massachusetts

both the thick waves of the hair and the disorderly curls that grow from the cheeks and chin in the Terme portrait are masterfully contrasted with the softness of bountiful flesh. In fact, in the Worcester portrait Nero's eyes seem smaller, almost entirely lost in the mountain of flesh of his cheeks and chin.

Portraits of Women of the Julio-Claudian Court

The gradual rejection of the eternal-youth imagery of Augustus in favor of a more realistic imperial likeness and the simultaneous interest in increased plasticity and texture in the portraits of male members of the imperial court are only partially paralleled in the portraiture of their female counterparts. Portraits of women of the Julio-Claudian court in the Claudian and Neronian periods continued to evidence smooth ageless faces, but their more elaborate coiffures gave the artists of the day an opportunity to experiment with the contrast of the texture of the more deeply shadowed hair and the softness of unlined flesh.

Female hairstyles of the Julio-Claudian period have been carefully studied and categorized. The parted and waved coiffure of the Augustan age, based on that of classical and Hellenistic goddesses, continued to be worn by women during the principate of Tiberius. The waves usually covered the upper part of the ear and were fastened in a knot at the nape of the neck. One woman who helped to popularize this style was Antonia the Younger, daughter of Mark Antony and Octavia, mother of Germanicus and Claudius, and the grandmother of Caligula. She was given the title Augusta during the principate of her grandson, but portraits made of her in Tiberian times – like the one formerly in Wilton House (fig. 114) – show her with a parted and waved hairstyle.

During the principate of Caligula, this simple hairstyle was elaborated by the addition of a cluster of corkscrew curls below the part and above the ear that necessitated a change in the sculptors' technique and tools. Each curl was accentuated with a drilled hole that emphasized the plasticity and texture of the hair. Livia, whose estate was settled by Caligula and who was divinized by Claudius and thus honored with portraits while both were emperors, was represented with such an updated coiffure in her posthumous portraits. An example is a highly controversial portrait of Livia from the Tomb of the Licinians in Rome and now in Copenhagen (fig. 115). Although it depicts Livia later in life, the physiognomic similarity to her Augustan portraits makes the identification possible. She is depicted with almond-shaped eyes, straight brows that are sharp ridges, a hooked nose, a small rounded mouth, and a smooth face. Gone, however, is the distinctive Augustan nodus coiffure in favor

times included in portraits in the round. A marble portrait of Nero in Cagliari (see fig. 111), for example, which was originally fashioned between 55 and 59 and is an example of the accession type, was later updated by the addition of a radiate crown and aegis. The Worcester head seems to have been similarly altered.

In Neronian portraits of types 4 and 5, the growing Julio-Claudian interest in increased realism is immediately apparent. The artists responsible for fashioning the portraits of Nero were building on the experiments of Claudius's artists, and it was, after all, in the last years of Claudius's principate that portraits of the young Nero began to be manufactured. Because Nero was only seventeen when he became emperor and only thirty-two when he died, it was easy for him to perpetuate the Augustan and early Julio-Claudian myth of eternal youth in his portraits. Although Nero never reached the age where he could be depicted as old, however, the aging process is incorporated in his portraiture. He is portrayed as the bland Julio-Claudian prince in 51, as a more mature youth in 54 and 55, and as a corpulent and debauched megalomaniac between 59 and 68. The vicissitudes of Nero's life are, therefore, mirrored in his portraits, which also exhibit the artists' interest in increased plasticity and textural contrast. The individual strands of hair that constitute a crest of curls are undercut by deep shadow, and

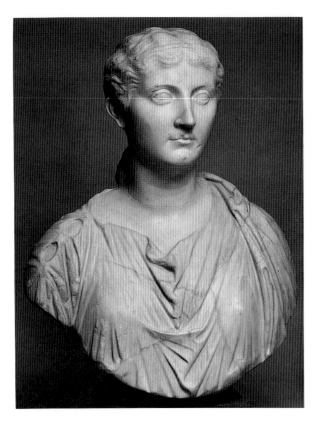

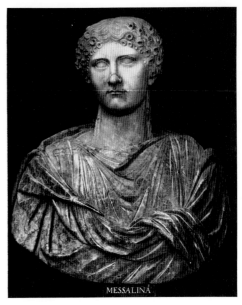

116 Portrait of Agrippina the Younger, 50s. Florence, Galleria degli Uffizi. Photo: Alinari/Art Resource, New York, 1263

114 Portrait of Antonia the Younger, formerly in Wilton House, Tiberian. Cambridge, Massachusetts, Arthur M. Sackler Museum, John Randolph Coleman Memorial Fund. Photo: Courtesy, Arthur M. Sackler Museum, Harvard University

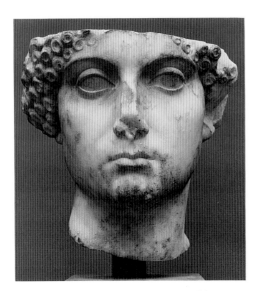

115 Portrait of Livia, from the tomb of the Licinians, Rome, Claudian. Copenhagen, Ny Carlsberg Glyptotek. Photo: Courtesy of the Ny Carlsberg Glyptotek, Copenhagen

of a hairstyle that is parted in the center and brushed in waves over the ears and fastened in a knot at the nape of her neck. What is especially significant is the cluster of corkscrew curls arranged over each ear. Each tight lock is individually drilled and tendrils in lower relief are carved at the temples. Similarly coiffed women from the court of Caligula include two of his sisters, Drusilla and Livilla.

In early Claudian times, the waves surrounding the part were confined to the top of the forehead and the back of the head; the rest of the front hair was divided into a series of circular curls. Long, circular curls also sometimes fell on the shoulder, and the hair was gathered at the nape of the neck and twisted in a double knot. In the mid- and late Claudian periods, the parted hair continued to be waved only at the forehead and in the back, and the hair on the side of the face was cut shorter and arranged in a profusion of large, corkscrew curls that were no longer confined to the area between the ear and temple but sometimes covered the entire side of the head. A double knot continued to be tied at the nape of the neck. Agrippina the Younger, Caligula's third sister, mother of Nero, and the last wife of Claudius, who was named Augusta during Claudius's principate, was portrayed with such a coiffure. One surviving example, which dates to the 50s and is now in Florence (fig. 116), shows her with a profusion of short, corkscrew locks that cover the side of her face; two circular coils fall on either shoulder. The rest of the hair is twisted and divided into thin braids at the nape of her neck.

Variations of this last style continued to be popular during the Neronian period. Nero's second wife, Poppaea, who was given the title Augusta by her husband

after the birth of their daughter and was also divinized at her death, is depicted with this variation in portraits during her lifetime. One now in the Vatican Museums, for example, depicts a Neronian woman, possibly Poppaea, with a triple row of loose corkscrew curls on either side of her head and with the rest of the hair neatly rolled and fastened at the nape of the neck.

Julio-Claudian State Relief Sculpture

The Louvre Suovetaurilia

Both Tiberius's policies and his portraiture were based closely on those of his immediate predecessor. The same can be said of the relief sculpture that was commissioned during his principate. It seems not to have been plentiful. State relief is carved as a complement to public architecture, and Tiberius was not a great builder of monuments. The fragments of one Tiberian state monument have, however, come to light. Although the precise findspot is not known, the fragments are attested in Rome in the sixteenth century. What survives consists of two marble blocks with the same dimensions and carved with stylistically comparable figures of approximately half-life-size. The larger fragment (fig. 117) depicts, on the right side, a togate and veiled male figure, who is taller in height than his companions and surrounded by attendants, also in togas and with incense box and pitcher, sacrificing at a garlanded and fruit-laden rectangular altar in the shade of a laurel tree. The left side of a second altar is barely visible at the right edge of the fragment, as are the branches of a second laurel tree. The togatus thus officiates as a priest and is followed by a procession moving from left to right that comprises a number of other togate men, most of whom wear laurel wreaths. Also included are two lictors with rods and the three sacrificial animals of the Roman suovetaurilia – the pig, sheep, and bull – in correct ritual order and accompanied by victimarii in tunics rather than their traditional dress. The smaller fragment represents the hind leg of a sheep, a bull, and two attendants moving from right to left. Surviving evidence suggests that the original relief comprised two processions, each led by an officiating priest of equal stature, moving from left and right and converging at the center of the panel, where there were two altars in front of two laurel trees. Unfortunately, the face of the one surviving sacrificant is restored and therefore does not aid in his identification. It has been suggested that the presence of two sacrificants of equal stature at a suovetaurilia may signify that the scene depicts the closing of a lustrum by two censors or by two men possessing censorial power. Augustus and Tiberius closed the lustrum in 14, and it is likely that that event is commemorated in the Louvre

relief. The next censors were Claudius and Vitellius (A.D. 47–48) and after them, Vespasian and Titus (A.D. 72–73). Stylistic criteria must therefore be used to determine the date of the relief. Close study of the coiffures and drapery folds has led one scholar to date the relief to Claudian times and to identify the main protagonists as Claudius and Vitellius; other scholars have suggested that Tiberius or Caligula are represented. Most recently, the Claudian date (shortly after 48) has been reaffirmed for the Louvre Suovetaurilia, and the sacrificants have been identified as Claudius and Vitellius. In support of this latest hypothesis, the figures on the Paris relief have been compared to those on the Ara Pietatis and a relief fragment in Hever Castle that dates to 51. The stylistic evidence, however, points to an early Tiberian date for the Louvre Suovetaurilia. The style is very close to that of the Ara Pacis, with somewhat more attention paid to plasticity, the play of light and dark, and texture – all of which were to become of paramount importance in the reliefs commissioned by Claudius. The figures are carved in very low relief against a blank background. Although the heads point in a variety of directions, they are all rendered in profile. The togas are generous without being voluminous, and although there is some attempt by the artist to create pockets of shadows between the folds, it is not pronounced. The mens' hair grows long on their necks, and there is a somewhat more plastic treatment of the locks than in the Ara Pacis. A date of 14 and the identification of the two main protagonists as Augustus and Tiberius are supported because two laurel trees grew next to Augustus's house on the Palatine hill, and it is there that the lustrum may have taken place.

The "Ara Pietatis Augustae" (Ara Gentis Iuliae?)

The portraits of Claudius, with his broad cranium and full, layered hair, show him to be an emperor in the Julio-Claudian mold. At the same time, the portraits commissioned not long after he became emperor are imbued with a vivid realism absent in the somewhat vacuous visages of his never-aging predecessors. Claudius's revival of realistic portraiture, with its republican prototypes, was accompanied by a concurrent interest in plasticity and the contrast between the texture of the hair and the softness of the flesh. Similar changes are apparent in Claudian relief sculpture, which, although still firmly grounded in the Augustan tradition, departs from it in significant ways.

The best example of this are the reliefs from the so-called Ara Pietatis Augustae, the Altar of Augustan *Pietas* or better yet, respect toward gods, one's country, and one's family (figs. 118–120), which, if its traditional designation is correct, makes apparent its indebtedness to

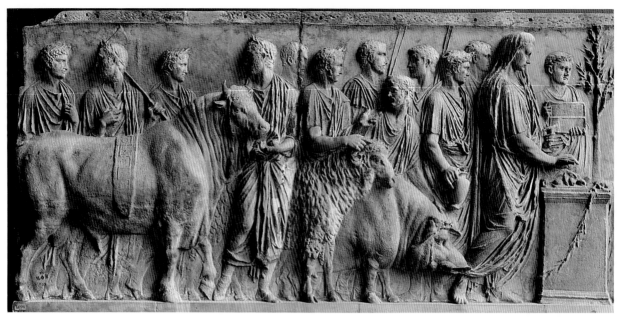

117 Suovetaurilia, 14. Paris, Musée du Louvre. Photo: Alinari/Art Resource, New York, 22685

118 Ara Pietatis Augustae, togati and flamen, dedicated 43. Rome, Villa Medici. Photo: DAIR 2377

the Augustan past. It was, in fact, Tiberius who vowed the altar in 22. As a dutiful son, he promised to build a monument in honor of his mother, Livia, after her recovery from a serious illness. Alternatively, the occasion may have been the award of the tribunician power to Drusus and the establishment of Tiberius's dynastic line. Whichever event precipitated his vow, Tiberius never built the monument, possibly because of the intense friction that had developed between him and his mother. It became so serious that Tiberius refused both to settle Livia's estate at her death in 29 and to have her divinized. It was Caligula who probated her will, and Claudius who had her consecrated as a diva. Claudius, who commissioned many monuments celebrating his famous family – including a great number of dynastic groups – made good Tiberius's vow and ordered the construction of the Ara Pietatis Augustae, which was dedicated in 43. His decision to do so may have been motivated as much by his desire to link himself with Tiberius as with Livia, because, as we have seen, it was traditional and politically advantageous for a new emperor to associate himself with his illustrious predecessor (in this case, certainly not Caligula) through deed and in art. Examples are the divi filius coins of Augustus and Tiberius's Primaporta statue of Augustus. In fact, the message of the Ara Pietatis may have been one of general loyalty toward Augustus and the Julio-Claudian dynasty because in the monument's reliefs sacrifices take place in front of temples built by Rome's first emperor.

The Ara Pietatis reliefs have recently been identified as belonging instead to the Ara Gentis Iuliae on the Capitoline hill in Rome, which was a monument to Claudius's pietas toward the Julian family and more

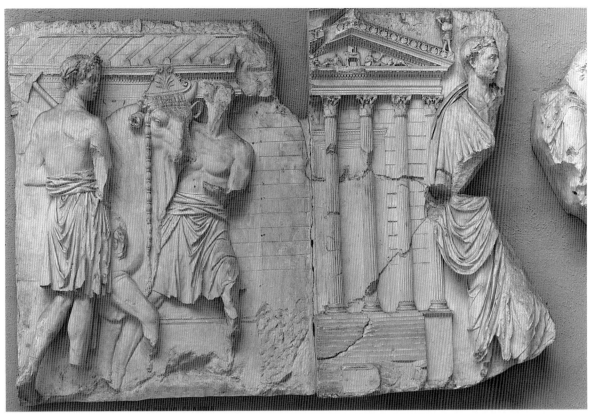

119 Ara Pietatis Augustae, sacrifice and Temple of Magna
Mater, dedicated 43. Rome, Villa Medici. Photo: DAIR 77.1750

120 Ara Pietatis Augustae, sacrifice and Temple of Mars
Ultor, dedicated 43. Rome, Villa Medici. Photo: DAIR 77.1739

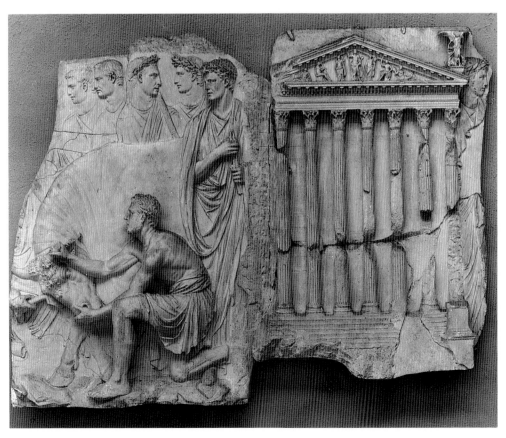

specifically toward the new diva, Livia, whose consecration may have been among the scenes decorating the altar. Furthermore, it has been suggested that Livia's apotheosis served to assimilate her to the personification of Pietas herself.

The altar is more traditionally thought to have stood on the Via Flaminia near the modern Church of S. Maria in Via Lata because of the findspot of some of the reliefs. The monument no longer survives, but a number of extant marble relief fragments have been associated with it. These suggest that the monument was close in architectural form and sculptural embellishment to the Ara Pacis Augustae, which must have served as its formal model. The Ara Pietatis consisted of a marble altar surrounded by a great marble precinct wall, its interior decorated with garlands suspended from candelabra, and its exterior divided into two zones with a figural frieze in the upper zone and a flowering acanthus plant below. The fragment with a garland laced with fruit and a ritual patera is now in the Museo del Palazzo dei Conservatori, and the fragment with the base of an acanthus plant is in the Sir John Soane Museum in London.

Most of the fragments, however, were known already in the sixteenth century and are now embedded in the walls of the Villa Medici. Their proximity in style and subject matter to the Ara Pacis caused the first scholars who published them to suggest that they were part of that Augustan altar. Shortly thereafter, however, it was suggested that the Medici reliefs, which depict part of a procession, two sacrifices, and the facades of two temples, did not belong to the Ara Pacis but were instead connected with the Ara Pietatis, an association that was for some time universally accepted by scholars. The new identification of the monument as the "Ara Gentis Iuliae" has provoked increased speculation about the identity of the monument, and one scholar in particular has pointed out that there is no extant ancient source that confirms the existence of a Claudian Ara Pietatis Augustae. Nevertheless, there seems to be consensus that the original structure from which the reliefs came was an altar in Rome resembling the Ara Pacis.

Other fragments of identical material, scale, and style were discovered in excavations in the Via Lata in 1923 and 1933 and are now in the Museo del Palazzo dei Conservatori. These include the garland fragment, a temple facade, and other fragments of partially preserved togati who participated in the procession. These togate figures and those on the Medici reliefs move in at least two directions, suggesting that the monument had processions on two long sides, one moving from right to left and the other from left to right, and thus toward a common goal – a scheme identical to that of the Ara Pacis.

The best-preserved Villa Medici fragment with togati (see fig. 118) depicts a frontally positioned flamen dressed in a double toga and wearing the traditional spiked cap. His head is turned to his left, and he is thus viewed by the spectator in a three-quarter position. He has a wide cranium, narrow chin, young, idealized face, and a Julio-Claudian cap of hair with comma-shaped locks parted in the center and neatly arranged across his forehead. Most scholars have identified him as Claudius because of the hairstyle, physiognomy, and his key position in the center of the relief, but more recently it has been demonstrated that Claudius never served as a flamen and that the hairstyle, although generally comparable to Claudius's coiffures, cannot be precisely paralleled in extant heads. Furthermore, in view of Claudius's decision to have himself depicted in realistic middle-aged portraits, it is unlikely that he would have himself portrayed as a smooth-faced youth in the most important state commission of his day. If there was a portrait of Claudius on the altar, it must have appeared elsewhere on the frieze. The flamen has instead been identified as Lucius Iunius Silanus. Silanus is surrounded by a host of other togati. Those in the background are carved in low relief like most of the figures on the Ara Pacis, but those in the foreground, including Silanus, are depicted in relatively high relief. Their togas are more voluminous than those on the Ara Pacis, and deeper channels are carved between the folds, enhancing the contrast of light and shadow and making the surface more plastic – a parallel development to the interest in plasticity and texture in contemporary court portraiture. In fact, the coiffures of the togate men are fuller and have looser curls over the forehead and longer hair on the nape of the neck than the male protagonists on the Ara Pacis. Some even wear slight beards, which adds an additional texture to the face and also contrasts with the soft flesh of the face.

The surviving scenes of sacrifice take place in front of two of the temple facades. One represents a bull in elaborate headdress led in procession by two bare-chested victimarii, one of whom carries the sacrificial ax (see fig. 119). The scene takes place next to the Palatine Temple of Magna Mater or Cybele, restored by Augustus in 3 and identifiable by its pedimental decoration. The goddess's turreted crown is displayed on a throne in the center of a triangular field, flanked at left and right by galli (priests of Cybele) with tambourines. The acroteria of the Corinthian temple consist of dancing figures clad in Phrygian costume. The other sacrifice scene (see fig. 120) depicts several togati standing next to a bull whose head is twisted downward by another bare-chested victimarius who readies the bull for the blow of the ax by a missing attendant. The octastyle temple with Corinthian columns can be identified by its pedimental decoration of Mars the Avenger flanked by Venus and Fortuna as the

Temple of Mars Ultor in the Forum of Augustus dedicated by Augustus in 2 B.C. These two sacrifices may well have been made in honor of Divus Augustus.

The fragment of a third temple with Ionic columns is now in the Museo del Palazzo dei Conservatori. Its pediment is filled with warriors and fallen figures identified by most scholars as an Amazonomachy or a Celtomachy. The temple has been identified as one of various Augustan temples, including the Temple of Apollo on the Palatine and the Temple of Fides on the Capitoline, and most recently as an eclectic work based on prominent Greek prototypes.

That at least two, and possibly three, temples restored or commissioned anew by Augustus are used as a backdrop for Claudian scenes of procession and sacrifice in 43 is an early indication of Claudius's political ideology. What is even more significant and what sets the Ara Pietatis apart from the Ara Pacis is the manner in which those temples are represented and the spatial relations of the architecture and the human protagonists. The processional friezes of the Ara Pacis and the Louvre Suovetaurilia depict figures in low relief against a blank background. There are no architectural elements in the north and south friezes of the Ara Pacis, and in the Louvre Suovetaurilia, it is only the two laurel trees behind the altars that indicate that the event takes place in front of Augustus's house on the Palatine. Architecture is included in only one scene on the Ara Pacis – the southwest panel depicting the sacrifice of Aeneas – where a small shrine to the penates is depicted in the upper left side of the relief (see fig. 78). Its diminutive size and position at the top left indicate that it is located in the background. In contrast, the Ara Pietatis temples are depicted in the foreground and at the same height as the human figures. The members of the procession and their sacrificial animals would, of course, have actually been dwarfed by the Temples of Magna Mater and Mars Ultor. This unrealistic depiction of the relative scales of people and buildings seems out of character in an age that valued realism in portraiture and natural rustication in architecture. The artists' goal was to signify that the buildings were as important as the figures and the animals. In fact, the temples serve in this context as symbols rather than as scene locators. What is important is not that a sacrifice takes place in front of a miniature temple, but that the temple is that of Mars Ultor or Magna Mater. Instant identification by the viewer was assured by the artists' careful attention to the delineation of the sculptural program of the temple pediments. The primary message of Claudius's Ara Pietatis is Claudius's devotion toward Augustus, Livia, and Tiberius. This pietas is demonstrated by Claudius's decision to build an altar vowed by Tiberius in honor of Livia that depicts religious rituals that take place in front of temples built or restored by Augustus. That the form of the altar and the general style of the Ara Pacis were also adhered to in the Ara Pietatis is also significant and intentional on Claudius's part. It is also under Claudius's patronage that the blank backgrounds of Augustan state relief are abandoned in favor of those populated with identifiable Roman buildings that serve as political symbols. In sum, the Ara Pietatis Augustae both demonstrates its indebtedness to the art of the age of Augustus and proclaims its freedom from it. The preference for symbolic emblems with immediate messages over an accurate depiction of reality will prove to have been the wave of the future in Roman art. The first signs of such a preference in state-sponsored art can be seen in Claudius's Ara Pietatis Augustae.

The Ravenna Relief

Two marble relief fragments from a Claudian monument, possibly an altar, honoring the imperial family are today on display in the Museo Nazionale in Ravenna. They were excavated near or in the Mausoleum of Galla Placidia in Ravenna in the sixteenth century and are similar in measurement and style and share the same lower decorative border. The smaller of the two fragments represents part of a sacrifice – probably in honor of the imperial cult – in which a sacrificial bull with a broad band or *dorsuale* around his body is escorted by two victimarii. The bare chests of the victimarii are frontally positioned, and their heads are turned in three-quarter views. They are portrayed in relatively high relief in the foreground and are accompanied by other attendants and musicians in profile and in low relief against a blank background. The overlapping of the figures is intentional and is meant to suggest spatial depth.

The second fragment (fig. 121) has a series of frontally positioned imperial figures against a blank background and is intended as a depiction in relief of a dynastic statuary group. The figures are discrete entities, and there is no overlapping whatsoever. Although figures of freedmen are prominently displayed in full frontality on funerary reliefs from the late republic on (see fig. 21), the Ravenna Relief is the first example of a public Roman monument that depicts imperial personages in frontal positions. Augustus, identified by his distinctive coiffure and characteristic facial features and wearing the corona civica, is depicted at the right edge. In front of the crown of oak leaves is a hole drilled for the attachment of a gilded bronze star signifying Augustus's status as divus. He stands with his weight on his right leg and his left foot supported by a globe with the signs of the zodiac, another reference to his divine status. He is also represented in the guise of Mars with a short sword in a scabbard (*para-*

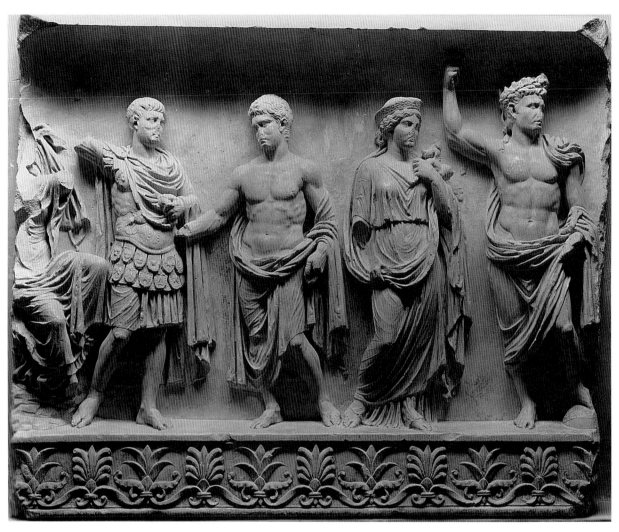

121 Dynastic relief from a Claudian monument, ca.45–50.
Ravenna, Museo Nazionale. Photo: DAIR 38.1407

zonium) in his left hand and a spear, probably originally added in bronze, in his upraised right hand. His chest is bare, and a mantle is wrapped around the lower part of his body and over his left shoulder. In fact, the figure of Augustus bears a close resemblance to that of Mars the Avenger in the center of the pediment of the Temple of Mars Ultor in Rome (see fig. 120). At his right is Livia, assimilated to Venus, with Eros on her left shoulder. She wears a tiara, and her posture and drapery are based on those of the Venus Genetrix type of the fifth century B.C. At her right is a Julio-Claudian youth with a full cap of layered hair, bare chest, and mantle draped over the lower part of his body. Like Augustus, he has a drill hole in his forehead for the attachment of a bronze star. He has been identified as Germanicus, the younger brother of Claudius and grandson of Livia. At Germanicus's right an older man in cuirass and paludamentum, who originally held a sword hilt and a spear, appears to be Drusus the Elder, Claudius's father, and to his right is a seated,

draped, and headless woman who is probably Claudius's mother, Antonia – although one scholar has recently identified her as the goddess Pietas. Augustus and Germanicus are essentially frontal, and Livia, Drusus, and Antonia are turned slightly to face the others. All of the heads are placed in three-quarter positions, and the figures do not occupy the full height of the relief. All of the figures are represented with bare feet, probably indicating that they were all deceased and deified at the time the relief was made. The directions of the heads of Augustus and Livia to the right and the slightly larger scale of Augustus suggest that the figure of Augustus served as the focal point of the relief and that there was a series of additional figures, probably including Claudius himself but excluding Caligula, as in the freestanding groups to Augustus's left.

One scholar has recently attempted to demonstrate that the Ravenna Relief was not commissioned during the Claudian period but during the principate of Nero and

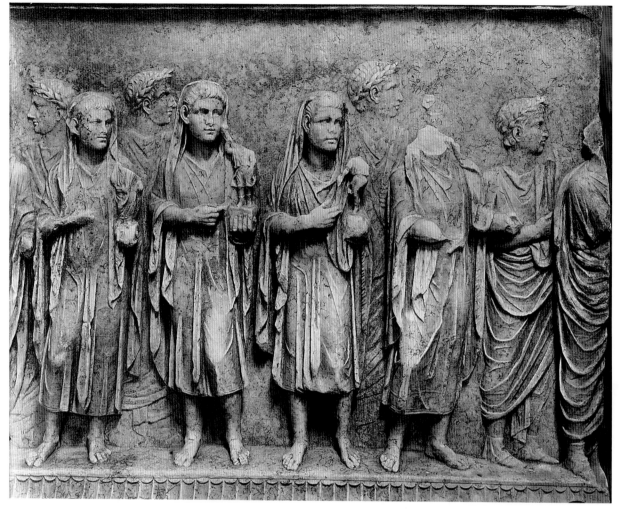

122 Altar of the Vicomagistri, Claudian. Rome, Vatican Museums. Photo: Archivio Fotografico Musei Vaticani, XXV-9-33

that the cuirassed figure represents not Drusus the Elder but Nero's natural father, Gnaeus Domitius Ahenobarbus. Still, most scholars favor a Claudian date between about 45 and 50 for the relief, the dynastic content of which is in keeping with Claudius's pietas and antiquarian interests.

The Vicomagistri Reliefs

Two reliefs from another Julio-Claudian altar were discovered in Rome on two different occasions. The first was found in 1937, along with the Flavian Cancelleria Reliefs, leaning against a wall of the republican Tomb of Aulus Hirtius. The second slab was excavated in 1939 about one meter from the first relief. The two were long thought to join – with the relief found first at the right – but it has recently been suggested that a section of the frieze with half of two foreground figures and one background figure is missing. The full relief would have

constituted one long side of a Claudian altar modeled on that of the Ara Pacis. The reliefs (fig. 122), which are bordered by elaborate moldings at top and bottom, represent a double row of figures in a procession moving to the right and comprising magistrates, lictors, three sacrificial animals with dorsualia – a bull, a steer, and a heifer – escorted by attendants and victimarii, musicians, four tunicate figures, three of whom carry statuettes of the lares and the Genius Augusti, and four togate magistrates. The last are the vicomagistri who give the monument its modern name – the Altar of the Vicomagistri. Small sections of the left side of the left slab and the right side of the right relief are preserved, which indicates that the reliefs turned the corners and that the altar was certainly four-sided. The left side preserves part of a camillus who either continued the procession or took part in a scene of sacrifice, and the right side preserves part of a throne, possibly intended for a divinity.

Special prominence is given to the three statuette

bearers who are frontally positioned, carved in higher relief than the other figures, and clad in distinctive costumes of unbelted tunics and fringed shawls; their feet are bare. A fourth figure, the leader of the group, who is similarly depicted and dressed, appears to have held a scroll. The heads of the four are more carefully differentiated than the others in the relief, and their similarity to portraits of the Julio-Claudian princes has been noted, as has the relevance of Tacitus's report that in 14 the *sodales Augusti,* who aided the flamen in the service of the cult of the divine Augustus, was expanded to include male members of the imperial house. The four male figures also wear slight beards, which may indicate that they were too young to have yet assumed the toga virilis.

The four youths are followed by the four vicomagistri, minor magistrates of freedman rank, who were present at the celebration of religious rites in their district, especially those of the *lares Augusti* and the *genius* or spirit of the current emperor. They are also frontally positioned and wear the high shoes or *calcei patricii* of their priestly function, and their heads are encircled with laurel wreaths. They are probably the magistrates who had jurisdiction over the precinct in which the altar stood.

Although the ultimate model for such a procession is the small frieze on the altar of the Ara Pacis (see fig. 72), the Vicomagistri Reliefs exhibit characteristics of the new Claudian relief style. These include the frontality of some of the figures, the more voluminous and plastically rendered togas, and the fact that the figures do not occupy the full height of the relief and that some space is left above their heads. Close examination of the heads shows that the hair is also fuller, looser, and more deeply undercut than in Augustan reliefs and that some of the figures have slight beards, which adds a new texture to their faces.

The Claudian style of the reliefs suggests that it is the *genius* of Claudius himself that is carried by one of the statuette bearers, but it is unlikely that the altar was commissioned by the emperor himself. A more plausible explanation is that the monument was erected at the behest of the four vicomagistri, its purpose to serve as the centerpiece of the cult of the lares Augusti and *genius* of the emperor in their region. The likelihood of this interpretation is underscored by the prominent position of freedmen in the relief, which is unprecedented in state-sponsored monuments of the Julio-Claudian period.

The Art of Freedmen
The Monument of Lusius Storax

The Vicomagistri Reliefs are not the only extant Julio-Claudian reliefs commissioned by minor magis-

trates of freedman status. Many survive, but the most extensive series honors the *sevir* Gaius Lusius Storax and decorates a monumental tomb built in Chieti (ancient Teate Marrucinorum) in the early Claudian period. Excavations of the late nineteenth century produced a fragmentary dedicatory inscription and a portrait of Storax, along with reliefs from the pediment and a frieze, all fashioned of local stone. The frieze (fig. 123) depicts gladiatorial combat with the numerous gladiators arranged in pairs. The figures occupy the full height of the frieze and are represented in a variety of lively postures. Figures are depicted frontally, from the rear, and in three-quarter view; careful attention is paid to the rendition of costumes, helmets, and weaponry. The relief is clearly related to other surviving gladiatorial cycles in Pompeii and elsewhere and must be based on similar prototypes.

Of even greater interest is the tympanum relief (fig. 124), depicting in the center a tribunal with the togate *sevir* Storax seated frontally on a tall chair with his feet on a footstool. He is surrounded by a host of other togati, including four seated local magistrates on bisellia and two servants of magistrates (*apparitores*). Standing behind them is another row of twelve togati, probably groups of outgoing and incoming sevirs, and a lictor. Because

123 Monument of Lusius Storax, gladiator relief, early Claudian. Chieti, Museo Nazionale. Photo: DAIR 67.866

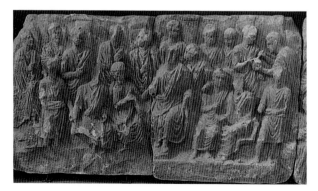

124 Monument of Lusius Storax, tympanum relief with Storax and other togati, early Claudian. Chieti, Museo Nazionale. Photo: DAIR 62.1069

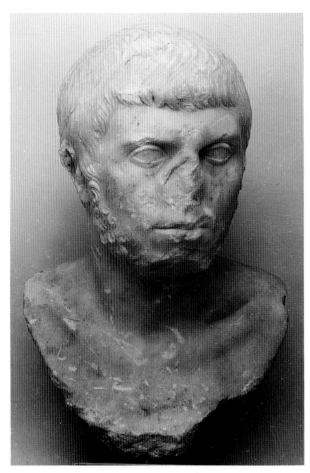

125 Portrait of Lusius Storax, early Claudian. Chieti, Museo Nazionale. Photo: DAIR 67.855

ably of Italian marble. It was probably placed inside the tomb and depicted Storax in the same posture and costume as in the tribunal scene on the tomb's facade. The portrait of Storax is sensitively rendered by a talented artist, probably of Greek origin, who has captured the essence of this former slave who was proud of his accomplishments and eager to record them for posterity. He has an oval face, deep-set, almond-shaped eyes, and rounded lips. The surface of the marble of his face is delicately modulated with a subtle contrast of light and dark. His full cap of hair is brushed forward from the crown of his head and arranged in comma-shaped locks across his forehead. They are slightly undercut, and both the carving technique and pattern of hair are consistent with imperial male portraits of Claudian date. Storax's hair grows long on the nape of his neck, and he wears a curly beard that seems to grow naturally from his cheeks and chin and adds another texture to his face that is played off by the artist against the softness of the flesh of his face. Such a full beard was not worn by members of the imperial house in contemporary portraiture in the round in the city of Rome, but some bearded men are depicted, as we have seen, on both the Ara Pietatis and in the Vicomagistri Reliefs, both of Claudian date. Nero is depicted with a slight beard in sculptured portraits of 59–64, as were other youthful members of the imperial house before him.

Julio-Claudian Cameos and Metalwork

The Grand Camée de France

Costly cameos used as imperial presentation pieces continued to be manufactured in Julio-Claudian times. Despite their small scale, these were sometimes decorated with multitiered historical scenes with complex political messages based on those of the Gemma Augustea. An example is the highly controversial Grand Camée de France, a sardonyx cameo now in the Cabinet des Médailles in the Bibliothèque Nationale in Paris (fig. 126). The identities of the many figures crowded into tiers that represent the celestial and earthly realms are much disputed, as is the sardonyx cameo's date of manufacture, but what is most significant is that the message of the gem as a whole is the glorification of the past, present, and future Julio-Claudian dynasty.

The interpretation of the gem is dependent in large part on the identification of the seated figure in the center. Scholarly consensus favors Tiberius and a date of about 26–29. Divus Augustus, founder of the dynasty, is above Tiberius and near the center of the celestial sphere. He can be recognized by his distinctive physiognomy and his coiffure. He is dressed in toga and wears a mantle over

he is the most important figure in the scene, Storax is portrayed in larger scale than his companions, an already established tradition in freedman art. The hierarchical scene of Storax and the other togati is, however, by no means a static presentation. Although Storax seems rigidly frontal, many of the other togati gesture and turn toward one another as if conversing, and the spectators to the left of the tribunal scene serve as a cheering section for the gladiators below. The central scene is flanked by musicians, playing trumpets and horns, who sit or kneel in order to conform to the sloping shape of the pediment. As on the reliefs of the Ara Pietatis in Rome, the scene is topographically situated, in this case in the local forum alluded to by the Doric colonnade in the background.

The portrait of Lusius Storax (fig. 125) was made of imported Greek marble rather than local stone. The Augustan tradition in Rome – seen, for example, in the Tomb of the baker Eurysaces – of using a more expensive marble for the portrait and a less expensive local stone for the tomb and its relief sculpture is thus continued in Claudian Chieti. The extant head of Storax originally belonged to a seated and togate funerary statue, prob-

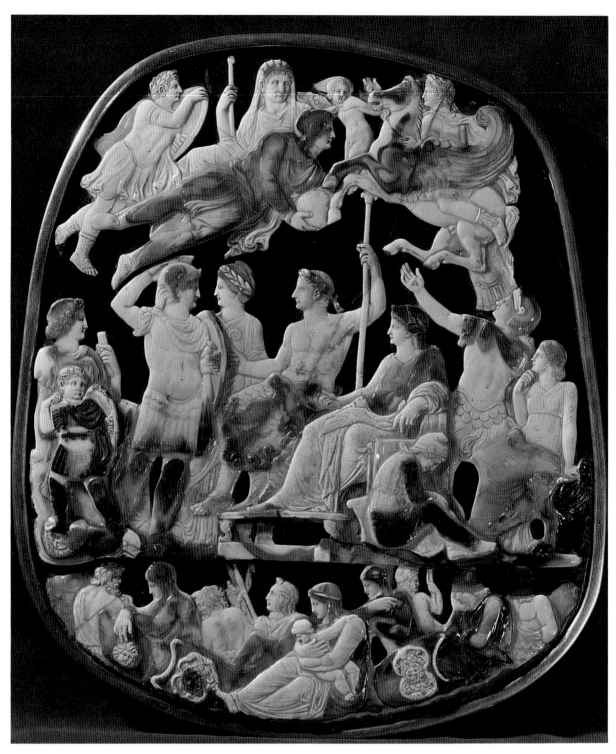

126 Grand Camée de France, ca.50. Paris, Bibliothèque
Nationale, Cabinet des Médailles. Photo: Phot. Bibl.
Nat. Paris

his head and radiate crown and carries a scepter. He is thus depicted simultaneously as chief priest and apotheosized god. He is transported through the skies by a male personification identified by many as Aion or Eternity in belted tunic and leggings and a cap and carrying an orb in both hands. He is flanked by a flying male figure wearing a laurel wreath and in military dress and carrying a shield (Tiberius's son Drusus, who died in 23?) and a winged putto leading a Pegasus carrying another male figure with laurel wreath and in military costume (Germanicus?). Below Aion's orb and in the center of the earthly realm is the seated figure of Tiberius with bare chest and an aegis wrapped around the lower part of his body. He wears a laurel wreath and, like Augustus, carries a scepter in one hand. In his right hand Tiberius grasps the lituus, a reference to the priestly powers that he, like his divine adoptive father, possesses. Like Augustus in the Gemma Augustea, Tiberius is portrayed in the guise of Jupiter and has thus been invested with divine powers in life as Augustus was in death. His mother and Augustus's wife, Livia, is seated at his side. She holds sheaves and poppies in her right hand and is thus assimilated to Ceres, goddess of the earth and agriculture, to whose fertility Tiberius owes his life and principate and who, as the wife of Augustus and the mother of Tiberius, unified the Julian and the Claudian houses. Livia's husband, Augustus, was also the great grandfather of Nero Germanicus, Drusus Germanicus, and Gaius Germanicus, the sons of Germanicus Caesar and Agrippina the Elder. The occasion for the commission of this cameo may have been Nero Germanicus's investiture as *quaestor* in 26. Tiberius and Livia, their feet resting on footstools and accompanied by a standing young woman in profile (Julia, granddaughter of Tiberius?), both face an upright young man clad in a cuirass, greaves, and helmet and carrying a shield, who may be Germanicus's son and Julia's husband, Nero Germanicus. He stands before the emperor to be appointed quaestor and to receive a military command to subjugate the barbarians represented below. Behind him is a boy in comparable military costume with a shield but without a helmet (possibly Gaius Germanicus [Caligula] in his miniature military costume) and a seated woman with a scroll (a personification or sibyl with a scroll inscribed with the future of the dynasty?). Behind Tiberius and Livia is another woman seated on a chair in the form of a sphinx (Agrippina the Elder?) and a man in military costume and helmet reaching toward the celestial realm with his left hand and raising a trophy with his right (Drusus Germanicus?). The trophy serves to link the celestial realm with the world of the living. At the base of Livia's chair is a seated barbarian with leggings, tunic, and pointed cap who serves to link the imperial personages in the central tier with the barbarians, crowded together and depicted with lowered heads and mournful expressions, in the lowest register. Some are in profile, some are represented from the rear, and the figure of central focus is a young woman with an infant.

The cameo, however, has also been attributed to Claudian times by those who have identified the seated emperor as Claudius with Agrippina at his side and the three flying Augusti as Augustus in the center with Tiberius and Caligula at left and right, respectively. The winged horse associates Caligula with Alexander the Great, who is identified as the flying figure carrying Augustus. The inclusion of Alexander holding the globe is thought to be a reference to Julio-Claudian aspirations for worldwide dominion. The aegis on Claudius's lap was also worn by Alexander and is paralleled in other portraits of Claudius. The putto between Augustus and Caligula is thought to refer to their Julian heritage from Venus since Caligula, unlike Tiberius, was related to Augustus by blood. If the cameo was Claudian, the occasion for its manufacture may have been the adoption of Nero by Claudius in 50. The young man in military garb standing in front of Claudius and Agrippina might then be identified as Nero, to whom he bears a remarkable resemblance. Furthermore, the trophy-bearing figure is identified as Claudius's brother Germanicus, with his wife Agrippina the Elder at his side. To the left of Nero is Claudius's son, Britannicus, and Britannicus's older sister, Octavia, who faces Nero, to whom she was affianced. Behind Britannicus is Claudius's mother, Antonia the Younger, who was also related to Nero. The seated barbarian figure is identified as Mithridates, king of the Bosphorus, pardoned by Claudius and transported to Rome as a special prisoner in 49. The barbarians in the lowest register refer to Claudius's generic victories. The controversy over the date of the cameo's manufacture may never be resolved, (although a Claudian date seems most plausible), but what is important in this context is that it encapsulates the political ideology of the Julio-Claudians and again underscores the close association of political and familial ties in the first century.

Another gem of certain Claudian date is the so-called Marriage Cameo (fig. 127), made in about 50. It depicts four imperial portraits and a double cornucopia surmounted by an eagle and crowning a pile of arms and armor. Imperial victories over barbarian enemies are certainly alluded to, as is the *pax Romana* brought to the empire by those very victories. On the left, a bust-length portrait of the current emperor, Claudius, wearing an aegis, emerges from the cornucopia. Below his profile portrait is silhouetted a portrait of Agrippina the Younger and facing them are portraits of Tiberius and his mother, Livia. It is not only Claudius but the Claudian family that is here honored, and this cameo is an example of

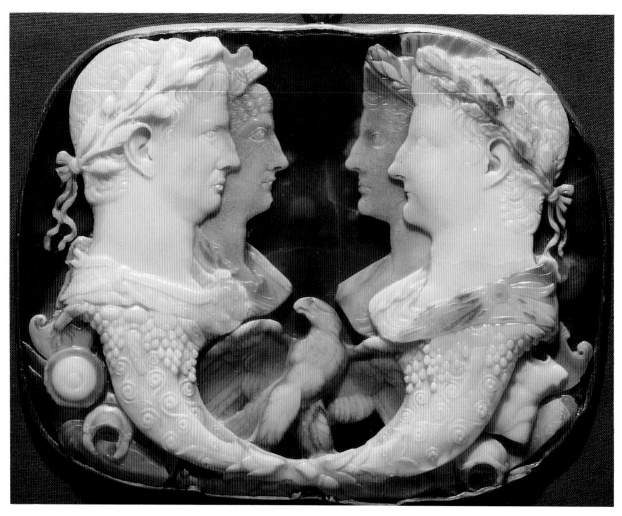

127 Marriage cameo, ca.50. Vienna, Kunsthistorisches
Museum. Photo: Courtesy of the Kunsthistorisches Museum

Claudius's veneration of the past as well as the Julian
and Claudian sides of his illustrious family. The mes-
sage of the Grand Camée de France is comparable, and
it too may therefore be a Claudian commission. A Clau-
dian date for both gems is underscored by the layers of
white and brown agate that are masterfully manipulated
to create contrasts between light and dark. The rendi-
tion of space in both gems is also sophisticated and closer
in its complexity to state relief of Claudian rather than
Tiberian date.

The Boscoreale Cups

Two silver cups with Roman historical scenes from
the villa at Boscoreale are part of a treasure of over one
hundred pieces acquired in 1895 by Baron Edmond de
Rothschild. They celebrate Augustus and Tiberius and
thus probably date to the early Tiberian period. The cup
honoring Augustus was destroyed, and that depicting
Tiberius seriously damaged during World War II. An

evaluation of them is thus dependent on the photographs
that accompanied the first publication of the cups in 1899.

The cup commemorating Augustus (fig. 128) depicts
the emperor in two scenes that take place in a military
camp and amid divinities and personifications. In the
former, Augustus is dressed in a toga and seated on a
sella castrensis. He is accompanied by lictors with their
fasces and by Roman soldiers, who present to him sup-
plicant barbarian chieftains and their children, including
one who stands immediately in front of the emperor and
another who is carried piggyback by his father. The em-
peror stretches forth his right hand in a gesture of mercy,
and the scene is undoubtedly one of clementia, although
the children are not depicted as bound captives but as
honored members of their tribe who will be raised as
future leaders with a pro-Roman attitude. The appear-
ance of children in this scene is of special interest because
it was in the age of Augustus that children were first in-
cluded in reliefs depicting official events. The imperial
children on the north and south friezes of the Ara Pacis,

for example, were meant to reflect Augustus's dynastic and social policies. It was not until the time of Trajan that children were again incorporated into official scenes. Barbarian children appear with their parents in scenes of supplication and clementia on the Column of Trajan, and poor Italian children ride on their fathers' shoulders in the *alimenta* (or alimentary system) scene in the central bay of the Arch of Trajan at Benevento (see fig. 190).

Attempts to associate the clementia scene on the Boscoreale cup of Augustus with a specific historical event center on the identification of the military personage who presents the barbarians to the emperor. The young man appears to be a member of the Julio-Claudian family. It has been suggested that he is Drusus the Elder or Germanicus rather than Tiberius. Drusus the Elder celebrated victories in the north on behalf of Augustus between 15 and 9 B.C., and Augustus was himself in the north between 15 and 13 B.C., at which time he could have participated in such a presentation of barbarian captives. Germanicus was also victorious over northern tribes in Pannonia, Dalmatia, and Germany in the years 6–12, but Augustus, already in his late sixties and early seventies, appears not to have visited the front during that period.

The scene on the other side of the cup of Augustus represents the emperor again in a toga but this time seated on a chair of state (*sella curulis*) and surrounded by divinities and personifications. At the right an armored Mars presents four female personifications of captured provinces to Augustus. To the left is Virtus in Amazo-nian costume, Honos with patera and cornucopia (or the Genius Populi Romani), and Venus and Eros. It is Venus who gives Augustus a statuette of Victory on a globe holding a laurel wreath with which she is about to crown the emperor.

The other cup portrays, on one side, Tiberius in a toga worn by generals in triumphs (*toga picta*), holding a scepter, crowned by an eagle and a laurel branch, and riding in the triumphal chariot (fig. 129). He is accompanied in a four-horse chariot by a state slave who crowns him with a wreath during his triumph of either 7 B.C. or A.D. 12. The chariot is decorated with a scene of Victory affixing weapons to a trophy. Lictors precede the chariot, as does a sacrificial bull with dorsuale and a headdress escorted by attendants, one of whom is the popa with his ax. Soldiers who have been awarded military honors follow the chariot. On the other side of the cup is a scene of sacrifice that takes place in front of a temple elevated on a double podium. It is tetrastyle prostyle with Ionic columns and has an eagle in the pediment and a long garland suspended from the eaves. The eagle, an attribute of Jupiter, has suggested to some scholars that the temple must be that of Jupiter Optimus Maximus Capitolinus on the Capitoline hill in Rome, the goal of the triumphant general. The head of the bull is secured by one kneeling attendant, while the popa swings an ax toward the victim's neck. Another kneeling attendant brandishes a knife while a fourth attendant watches the proceedings. To the left is a Roman general in cuirass and

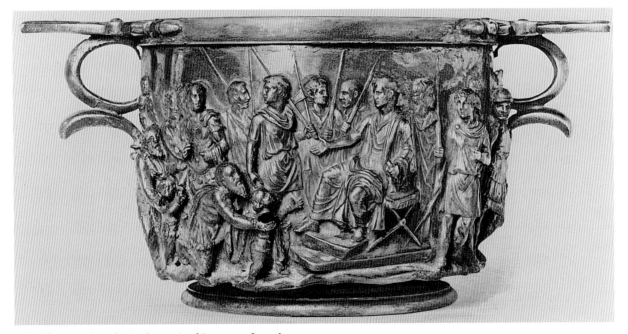

128 Silver cup (now lost), clementia of Augustus, from the villa at Boscoreale, early Tiberian. Photo: A. Héron de Ville-fosse, *Le trésor de Boscoreale, Fondation Eugène Piot. Monuments et Mémoires* 5 (supplement) (Paris, 1902), pl. XXXI.2

paludamentum with a spear over his left shoulder who is in the act of offering a sacrifice at an altar. He is surrounded by attendants, lictors, and Roman soldiers and is usually identified as the same triumphant general as in the chariot, that is, as Tiberius, who offers a sacrifice at the altar of Jupiter in front of the god's temple after the triumphal procession. Controversy surrounds the identification of the temple. Some scholars identify it as the Capitoline temple in Rome; others contend that a military commander was not permitted to wear battle attire inside the city's symbolic wall (pomerium) and that the sacrifice must have been performed by the emperor outside the pomerium in the field, possibly in front of the Temple of Bellona, with the Temple of Jupiter in the distance on a hill (depicted on the cup) before he departed Rome for his military campaign. In this way, it forms a pendant to the scene of Augustus seated in a military camp on the companion cup. What seems certain, however, is that the scenes of clemency, triumph, and sacrifice occur during the lives of Rome's first two emperors, whereas the scene of Augustus surrounded by divinities and personifications must be a posthumous glorification of him as a new divinity.

It has been suggested that the scenes on the Boscoreale cups were not designed for the sides of a pair of small silver cups but must reflect lost reliefs from an official public monument in Rome – for example, the Arch of Tiberius erected in Rome in 16. The hypothesis is a sound one, but the identification of the monument to which the original reliefs belonged is purely speculative.

The Tiberian Arch at Orange

The grandiose Arch at Orange (fig. 130) is dated by epigraphical evidence (discounted by some) to 20–26 and served as the north gate of the ancient city of Arausio. What sets it apart from earlier arches is its triple-bay design, which began to gain popularity in Flavian and Trajanic times and is best known in the surviving arches of Septimius Severus and Constantine in Rome. Although the similarity of the Orange arch to the Arch of Septimius Severus has caused some scholars to favor a date in the Severan period for the Gallic arch, this hypothesis has not received widespread support.

A large, central arcuation, enclosed in a projecting aedicula with triangular pediment, is flanked by two smaller arcuated bays. The arch has a double, superimposed attic. The profusion of its sculptural decoration is noteworthy. The area above the smaller bays on both long sides of the arch is carved with reliefs that represent Gallic spoils, consisting of shields, spears, swords, breastplates, and so on. The inscription, the letters of which no longer

survive, was flanked by recessed panels with naval spoils at the level of the first attic. A battle frieze encircles the arch. The second attic consists of tall statuary bases on either side of a broad element carved with a Gallic battle, possibly based on Pergamene sources. The monument was probably surmounted by a bronze statuary group of Tiberius in a horse-drawn quadriga. The short sides of the arch are of special interest. A single tall base supports four Corinthian columns surmounted by an arcuated lintel within a triangular pediment. Between the columns are trophies with captives in relief. A bust of the sun god and two cornucopiae are contained within the pediment, and there are tritons above. The message of the Arch of Orange is that the emperor Tiberius is not only triumphant over the Gauls but victorious over land and sea at all times.

Another feature of the Tiberian arch at Orange is that both the figures in the battle scenes and the weaponry are carved with deep outlines. The outlining technique was popular in Gaul in Augustan and Julio-Claudian times (used, for example, on the Monument of the Julii in St.-Rémy; see fig. 99), and some scholars have suggested that it was the result of the use of Hellenistic line drawings or paintings as models by local artists. The technique was not used in contemporary Rome and appears only sporadically in the capital and elsewhere in the Roman world before the late third century when it became a popular procedure. Until that time, it was confined primarily to Gaul.

The Britannic Arch of Claudius

An Arch of Claudius was erected over the Via Lata to carry the Aqua Virgo in Rome in 51–52 and to celebrate Claudius's British victories. The arch no longer stands but was a single-bay marble structure with Corinthian columns. Several extant sculptural fragments have been attributed to it, and these may have been displayed in panel format on the arch's facade. The lost arch has been discussed in detail by scholars who associate with it surviving architectural blocks, fragments of a spandrel victory, a battle frieze drawn by Pierre Jacques, and four sections of a large relief or reliefs now in the Villa Medici in Rome, thought to represent Virtus, Claudius himself, a Roman province, Venus, Eros, and a kneeling personification of Britannia (see fig. 376). Although the Medici fragments are dated by most scholars to the second century, at least one scholar maintains that the Medici reliefs decorated the piers of the arch and that the battle relief of Romans against Britons was part of the arch's small frieze. Recently, additional fragments in Hever Castle and the Louvre depicting a trumpet player

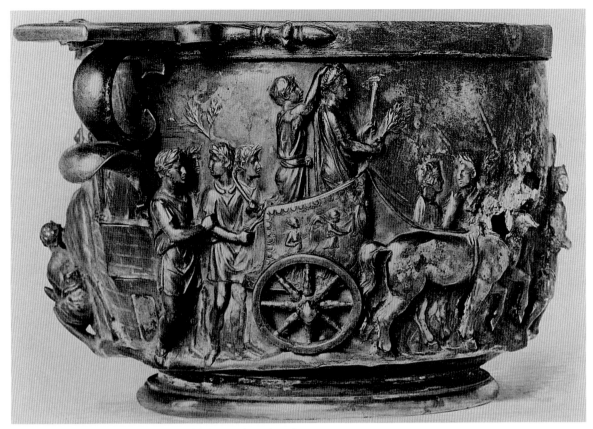

129 Silver cup (now lost), Triumph of Tiberius, from the villa at Boscoreale, early Tiberian. Photo: A. Héron de Villefosse, *Le trésor de Boscoreale* (Paris, 1902), pl. XXXV. I

130 Orange, Arch of Tiberius, general view, 20–26. Photo: DAIR 62. 1801

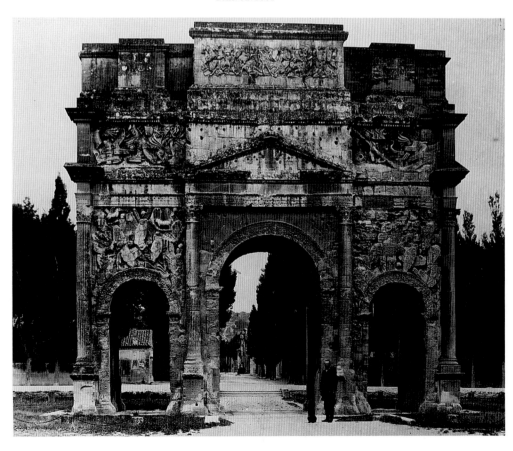

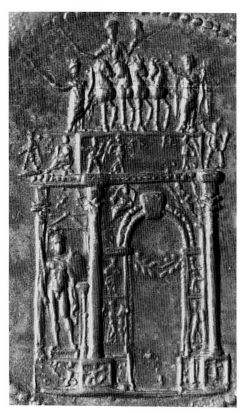

131 Sestertius with Arch of Nero, Rome, 64. Photo: Courtesy of F. S. Kleiner

the Parthians in Armenia. The arch is recorded in the *Annals* of Tacitus, who reports that it was constructed on the Capitoline hill in Rome in 62. The bronze *sestertii* that register the existence and appearance of the arch were struck by Nero between 64 and 67. Over four hundred surviving Neronian coins with the imprint of this arch have recently been collected. The first few coin dies (for example, fig. 131) were produced in the mint of Rome not far from the location of the Parthian Arch of Nero. The depiction of the arch on these has allowed a reconstruction of the arch and its sculptural decoration.

The Arch of Nero was a single-bayed structure with freestanding columns with ressauts on tall, projecting, decorated pedestals. The columns supported statues of Roman soldiers at the four corners of the arch (the first instance of unidentifiable Romans on an arch), and the attic carved with a dedicatory inscription was crowned by a bronze statuary group depicting Nero in toga with a palm branch and a scepter with an eagle in a four-horse chariot flanked by personifications of Peace and Victory. Pax held a cornucopia and Victoria a palm branch and a wreath, with which to crown the emperor. This is the first example of a human accompanied by a personification other than Victory on a Roman honorary arch. In addition, there were Victories on the attic and river gods in the spandrels and a double row of framed, rectangular panel reliefs with single figures on the piers of the arch's facade. In the lower panels were representations of Victories crowning trophies of Parthian spoils. Niches on the short sides of the arch housed colossal statues, one of which represented Mars – an appropriate choice for Nero because it was in Augustus's Temple of Mars Ultor that Nero erected a colossal statue of himself after his Parthian victory. The attic inscription was flanked by panel reliefs with striding Victories with the standards of cohorts (*vexilla*). The reconstruction of the Arch of Nero thus shows it to have been a revolutionary work of art, with some features known only on second- and third-century preserved arches like those of Trajan at Benevento (see figs. 188–189), Septimius Severus in Rome (see figs. 293–294), and others unparalleled in extant commemorative arches. The display of sculptured reliefs in square or rectangular panels on the two primary sides of a commemorative arch is suggested by the possible remains of the Britannic Arch of Claudius. It is, however, the surviving series of sestertii of Nero, which records the architectural form and sculptural program of his Parthian Arch, that demonstrates that by the time of Nero panel reliefs were favored for arch design. It is thus in the late Julio-Claudian period that the idea of the Roman arch as a kind of billboard for the display of political messages in the form of sculptured panels seems to have been born.

or *tubicen* and a group of Roman soldiers, respectively, have also been attributed to the Britannic arch. These too may have been part of the pier decoration. The arch appears to have been crowned with the kind of dynastic group popular under Claudius that included statues of the emperor, Germanicus, Drusus the Younger, Antonia, Agrippina the Younger, Britannicus, Octavia, and Nero.

The Arch of Nero in Rome

A lost Julio-Claudian arch, of which no surviving fragments have yet come to light, is the Arch of Nero in Rome. We have already seen that few portraits of Nero have come down to us because of the damnatio memoriae issued after his suicide in 68. The damnatio memoriae is also undoubtedly responsible for the destruction of monumental works of state relief sculpture fashioned at the emperor's direction during his principate. There is no complete record of these lost monuments of Nero, but we do have the reflection of what must once have been one of the most important in a series of extant bronze coins. The Arch of Nero in Rome was vowed by Nero in 58 in commemoration of his successful campaigns against

Provincial Art

The Jupiter Column at Mainz

Another important development in Roman state relief sculpture seems to have had its inception during the principate of Nero, but in this instance in the provinces rather than in Rome. Sometime between 59 and 67 a group of citizens commissioned a column *pro salute Neronis* in ancient Mogontiacum, modern Mainz, important from the time of Nero to that of Domitian as a military base from which to exercise control over the Germanic tribes. Monumental columns with honorific statues were erected in public places as early as the republic, but what sets the Mainz column apart from its predecessors is that its base and shaft are covered with relief figures. In this way, it is something of a forerunner for the historiated columns of Trajan and Marcus Aurelius in Rome (see figs. 179, 263), although, unlike those, it does not have a spiral frieze. Nonetheless, the Jupiter Column at Mainz (fig. 132) unquestionably served as the prototype for hundreds of Germanic Jupiter columns and piers, most of which were erected between 170 and 260. For the most part, these Jupiter columns also had sculptured bases and shafts and were crowned with a statue of Jupiter, standing, enthroned, or on horseback. Most were set up in conjunction with an altar, which was also dedicated to Jupiter Optimus Maximus.

The Jupiter Column at Mainz was designed by two local sculptors whose names are recorded: Samus and Severus. It was fashioned out of local limestone and rose to a height of approximately nine meters without its crowning statue. Two thousand fragments from the devastated monument are preserved, and a replica has been erected in the courtyard of the Landesmuseum in Mainz. The column originally consisted of a double-stepped base, large and small pedestals with relief panels, a shaft with sculptured drums, Corinthian capital, and a rectangular base for the statue of Jupiter. The lower, larger pedestal has four sculptured panels of rectangular format depicting Jupiter (side a), Fortuna and Minerva (side b), Hercules (side c), and Mercury and Salus (side d). The names of the two sculptors are inscribed in Latin on the cornice above side b. The upper, smaller pedestal has a more extensive Latin inscription carved on side a, which served as the front of the monument. It gives the names of the citizens, including the governor of Mogontiacum, the patrons of the monument, and indicates that it was dedicated to Jupiter Optimus Maximus and to the health of the present emperor, Nero. (Nero's name was erased after his damnatio memoriae.) The square panels on sides b and d represent the Dioscuri with their horses,

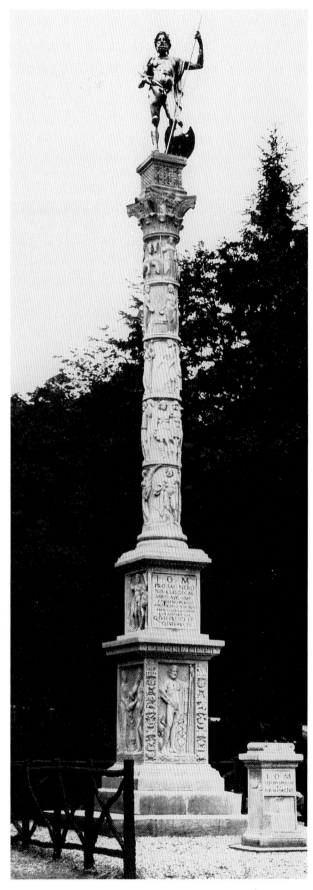

132 Mainz, Jupiter column, general view, 59–67. Photo: DAIR 39.106

whereas side c depicts Apollo with his lyre and swan. The five column drums are divided from one another by a series of circular bands. The lowest drum depicts frontal images of Mars, Victory, Neptune, and Diana. The second drum is carved with figures of the personification of Lugdunum or Honos in Amazonian costume, Vulcan, Roma or Virtus, also in Amazonian costume, and Ceres. The third drum represents a series of figures of goddesses or personifications whose identities are controversial. One scholar, for example, identifies them as Venus, Vesta, Proserpina, and Pax; another as Aequitas, Gallia, Italia, and Pax. The fourth drum is of special interest because it is carved with a figure of a *genius*, sometimes identified as the *genius* of Nero, as Nero himself, or as the Genius Canabensium, with a Lar or Liber. The fifth drum depicts Juno, and Sol and Luna with their solar and lunar chariots. The base above the capital supported a gilded bronze statue of a standing Jupiter with an eagle.

Study of these reliefs indicates that Samus and Severus were competent artists, seemingly well versed in the iconography and style of the city of Rome. The postures, costumes, and attributes of the divine figures are clearly based on models from the capital. Most noteworthy is the artists' use of the panel format for the pedestal decoration, similar to the simultaneous use of the same on the Arch of Nero in Rome and frontality for some of the panel figures and for all the figures sculpted on the drums. The scenes can be read from bottom to top with Jupiter in both positions and the *genius* of Nero near the top with the cosmic deities.

The Sebasteion at Aphrodisias

Monuments commemorating the Julio-Claudian emperors were also erected in the eastern provinces. The most striking example is the Sebasteion at Aphrodisias, a complex devoted to the worship of Aphrodite and the divine Augustus and his Julio-Claudian successors and consisting of a propylon, two parallel triple-storied porticoes flanking a paved processional way and a temple – the overall scheme derived from those of the fora of Caesar and Augustus in Rome. The porticoes were decorated with large reliefs displayed between the columns of the upper stories, which had parallels in their lower story but were innovative in their triplication. Although the complex honored the imperial dynasty, it was not an imperial commission. It was instead the project of two Aphrodisian families, possibly related, one who paid for the propylon and north portico, and the other who funded the south portico and the temple. Their identities and the dates of their dedications are gleaned from the

buildings' architrave inscriptions. Aphrodisias appears to have received imperial favor under the Julio-Claudians because of its veneration of Aphrodite, also the divine antecedent of the Julian family, and the architrave inscriptions indicate that the Sebasteion was probably begun, or at least planned, under Tiberius and completed under Nero. A serious earthquake caused damage while Claudius was emperor and led to a major rebuilding during his principate. Mythological panels depicting Leda and the swan, the infant Dionysus, Meleager and the boar, Achilles and Penthesilea, the liberation of Prometheus by Hercules, and so forth, were displayed on the second story of the south portico. These traditional Greek themes were placed alongside others on the south portico that were drawn from the mythology of Rome, as for example, Aeneas and his father Anchises, and the she-wolf and Romulus and Remus. Another panel depicted the birth of Eros from Venus, patron goddess of Aphrodisias. Reliefs with depictions of gods and Victories were exhibited with those representing Augustus and the Julio-Claudian emperors, as well as male and female members of the imperial house, on the third story. Surviving vignettes include those of a nude Augustus Sebastos (the Greek word *Sebastos* is the equivalent of the Latin Augustus) (fig. 133) striding purposefully to the right with a voluminous mantle billowing up behind him and receiving in his outstretched arms the bounty of the earth (the cornucopia) and the sea (the oar); his youthful heirs, Gaius and Lucius Caesar (or Nero and Britannicus), in a group portrait; Claudius, heroically nude but with a helmet and flowing mantle, vanquishing the female personification of the province of Britannia by leaning on her flank and pulling her by the hair (fig. 134); and Nero, also in heroic nudity, but with a mantle and shoulder belt (*balteus*), triumphing over the crumpled personification of Armenia. The last two reliefs belong to the part of the south portico that was completed under Claudius and Nero, and both rulers were originally identified by accompanying inscriptions with their names. although that of Nero was removed and the figure's head defaced after the emperor's suicide and damnatio memoriae. Female members of the Julio-Claudian house were also prominently displayed. Agrippina the Younger, with the corn ears of Demeter, is joined in a dextrarum iunctio with her husband Claudius. Agrippina the Younger, cornucopia in her left hand, is also depicted next to her son Nero, whom she crowns with a laurel wreath. A headless empress, possibly Livia, pours a libation at an altar.

The north portico was more severely damaged than the south in an earthquake of the seventh century but, nonetheless, many reliefs and accompanying inscriptions survive. The latter indicate that the reliefs depicted personifications of peoples conquered by Augustus (for ex-

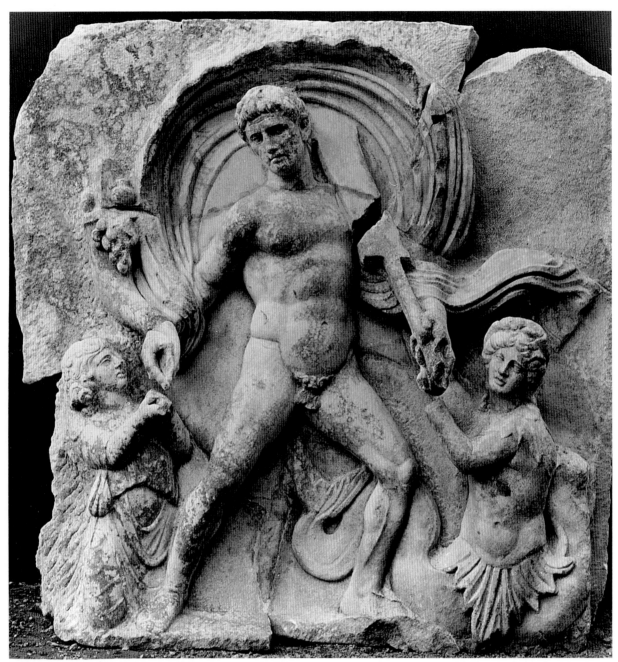

133 Aphrodisias, Sebasteion, Augustus Sebastos relief, begun under Tiberius and completed under Nero. Photo: M. Ali Dögenci

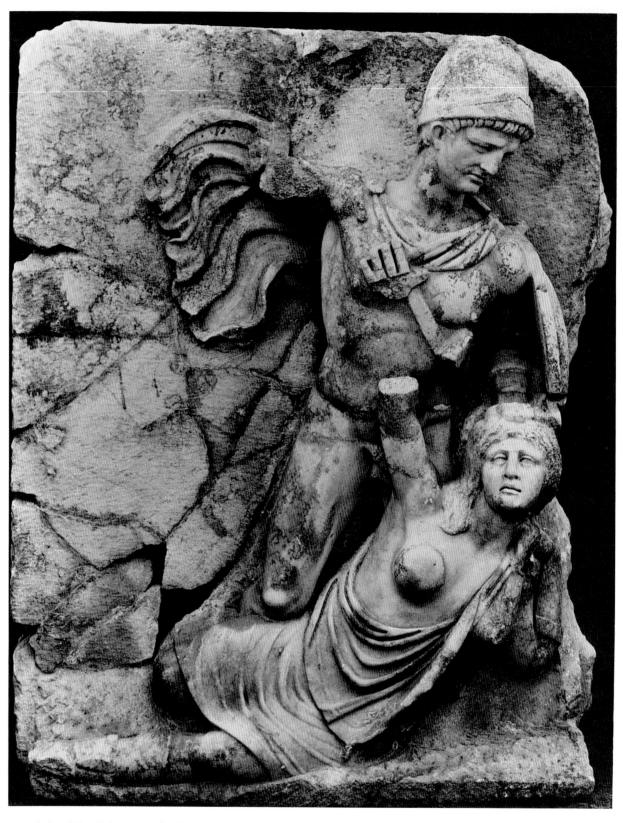

134 Aphrodisias, Sebasteion, Claudius vanquishing Britannia, begun under Tiberius and completed under Nero. Photo: M. Ali Dögenci

ample, the Dacians, Judaeans, Egyptians, and Bessi); those personified figures that do survive (only three complete examples) show frontal draped female figures on inscribed bases that prefigure those of the province series of the later Hadrianeum in Rome (see fig. 251). The general concept of those at Aphrodisias must be based on the statuary groups of vanquished provinces that stood in the Theater of Pompey or in the Porticus ad Nationes in Rome, or on the figures in relief from the altar of the Ara Pacis Augustae. The description of Augustus's funeral in the writings of Cassius Dio (56.34.2) and Tacitus (*Ann.*, 1.8.4) indicates that a series of province statues were carried in the procession. Also on the north portico of the Sebasteion were reliefs with figures of cosmic significance such as Day (*Hemera*) and the Ocean (*Okeanos*). A platform and temple, probably built during the principate of Tiberius, were located on the eastern end of the Sebasteion complex. On the west end was a propylon with aediculae housing statues of Gaius and Lucius Caesar, Drusus the Younger, Agrippina the Younger, and their legendary and divine ancestors, Aeneas and Aphrodite. The inscription of the propylon indicates that it was dedicated to Aphrodite, the divine Augusti, and the people of Aphrodisias by its local benefactors.

The Sebasteion complex was brought to light again between 1979 and 1983. Although the architectural format of the Sebasteion in Aphrodisias is the multitiered columnar display characteristic of Roman architecture in the eastern provinces, its sculptural decoration is more closely tied to that of early imperial Rome in its combination of mythological, historical, and even emblematic subject matter. In the Ara Pacis Augustae there are references to contemporary historical events such as Augustus's return from Spain and Gaul and the laying of the altar's foundation stone, as well as to what might be called historical mythology, that is, mythological scenes that purport to recount the early history of Rome, such as those of the suckling of Romulus and Remus or Aeneas's sacrifice to the penates after his arrival in Latium. The frieze of province figures originally embellishing the altar proper stood for those areas under the sway of Rome. Mythology (Aphrodite), history (Claudius's victory over Britain), and emblematic symbol (the province or cosmic reliefs) are similarly integrated in the Sebasteion at Aphrodisias. In both Rome and Aphrodisias, it is Venus who is honored above all as "the ancestral mother of the divine Augusti," words that are inscribed on the base of her statue on the eastern propylon. It has, nevertheless, been demonstrated that although individual portrait types and some of the figural compositions are derived from prototypes from the city of Rome, the overall conception of the Sebasteion is thoroughly Greek. Of overriding importance to patron and artist was the message

that the Greek world continued to thrive under Roman rule and under the aegis of the Julio-Claudian dynasty, with its ties to the Greek pantheon of divinities and Greek repertory of mythology.

Sculptors from the school of Aphrodisias were justifiably renowned in the second century. The name of Antoninianus from Aphrodisias is preserved, for example, on a relief portrait of Hadrian's favorite, Antinous (see fig. 209), and Hadrian commissioned or purchased expert works by Antoninianus's compatriots for his villa at Tivoli (see figs. 211–212). The style of the Sebasteion reliefs is, however, less accomplished than that of imperial reliefs produced in Julio-Claudian Rome. An example is the relief of Claudius triumphing over Britannia (see fig. 134). Although the pair is based on a late Hellenistic statuary group of Achilles and Penthesilea, the postures of both protagonists are awkward and the emperor's head is proportionally too large for his body. The figures are also not situated in the center of the relief but are too far to the right side of the panel. Another relief with Augustus receiving the bounties of earth and sea (see fig. 133) depicts the emperor as a nude figure with anatomically correct musculature but with an oversized head and hands. These two reliefs and the many others from the Sebasteion suggest that the artists who belonged the the Julio-Claudian School of Aphrodisias had not yet achieved a successful fusion of local style and Roman subject matter.

The Revolution in Julio-Claudian Art

Augustus's persona, politics, and classical style exerted a profound impact on his Julio-Claudian successors. It might even be said that all Julio-Claudian art is based on that of Augustus. Augustus's eternal youth imagery was adhered to by Tiberius, Caligula, and even by Claudius in his earliest portraits; and the prince portraits of Nero show him as a handsome, if somewhat vacuous, heir to the Augustan tradition. The Ara Pacis Augustae served as the architectural model for the Ara Pietatis Augustae and other Julio-Claudian altars such as those to which the Ravenna and Vicomagistri Reliefs belonged. The friezes with processions of profile figures in low relief against a blank background on such altars were based on the north and south friezes of the Ara Pacis. Augustus's Actian and Parthian arches in Rome and provincial arches like that at Susa served as the formal architectural models for Claudius's Britannic arch and the Parthian Arch of Nero, both in Rome. Elegant Tiberian and Claudian cameos, which served as presentation pieces within court circles, were based on Augustan prototypes such as the Gemma Augustea. The art of Julio-Claudian freedmen, like the Tomb of Gaius Lusius Storax at Chieti,

follows the same principles as those of monuments commissioned by freedmen in Rome under Augustus.

Yet, subtle alterations of Augustan classicism already evident under Tiberius became even more apparent under Caligula and in the early Claudian period. It would be fair to say that by late Claudian and Neronian times there was a full-scale revolution in Julio-Claudian portraiture and state relief. Claudius decided to stop propagating the fiction of the eternal youth and had himself depicted as the middle-aged man he was in a series of exceptional portraits that also shows him with a muscular body and invested with the attributes of Jupiter. Both the style of the portraits and the inconsistency of the image were based on republican prototypes such as the Pseudo-Athlete from Delos and the general from Tivoli. Claudius's preference for the art of the republic and for old-fashioned cut-stone masonry may have reflected his scholarly and antiquarian interests. In fact, biography and portraiture were inextricably bound in the Julio-Claudian period. Tiberius, who continued to follow Augustus's foreign and domestic policies, was portrayed with the same unlined countenance and full cap of layered hair even though he was fifty-six when he became emperor. Caligula, an autocrat, who openly expressed his desire to be worshipped as a god, replaced the heads of statues of divinities with his own portraits, which were youthful and idealized in the Augustan mold. The youthfulness of these portraits was not fictional because Caligula was in his twenties when they were produced. What was untruthful, however, was the inclusion of the Julio-Claudian cap of hair. According to Suetonius, Caligula was balding. It was in the portraiture of Nero, the last of the Julio-Claudians, that life and art were most intimately linked. His earliest portraits, the first real Roman prince portraits, show him as a handsome boy destined to be emperor, while the latest images depict an overweight autocrat with a radiate crown and the aegis of Jupiter. What is astonishing about Nero's portraits, especially when they are viewed against the backdrop of the ageless perfection of Augustan classicism, is that the aging process is explored by Nero's court artists even though he died at only thirty-two. The artists' interest in advancing age is accompanied by an increased realism in portraiture and by a concomitant interest in increased plasticity and textural contrast.

Julio-Claudian court females were not represented with the same signs of age as their male counterparts. They were depicted with unlined faces, and it is instead the ornate coiffures worn during the principates of Caligula, Claudius, and Nero – with their contrast of light and shadow, plasticity, and textural contrast – that are the focus of artistic attention.

The earliest example of Julio-Claudian state relief sculpture is also closely based on Augustan models. The relief figures on the Louvre Suovetaurilia are depicted in profile and in low relief against a blank background in the manner of those of the Ara Pacis. The Ara Pietatis Augustae also demonstrates its indebtedness to the Ara Pacis in its architectural form, its depiction of Augustan temples, and in its general style, but careful examination of the reliefs indicates that the togas are more voluminous and are carved with deeper channels, showing a greater plasticity. The protagonists' hair is looser, and there is a greater contrast of light and dark; some wear beards, which adds additional texture to the face. More significant is the new relation of figure and architecture. The blank background is replaced with scenes with temples in the foreground that are of the same scale as the figures. The architecture is thus as important as the human protagonists and serves as symbolic emblems as well as elements that set the scene.

Additional changes are seen in the Ravenna Relief and the Vicomagistri Reliefs, both of which include figures represented in full frontality; the flamen on the Ara Pietatis is also essentially frontal. The figures in the Ravenna Relief are imperial personages posed as if part of a sculptured dynastic group. The frontality of the protagonists in the Vicomagistri Reliefs may be due to the fact that the monument to which they belonged was probably a freedman commission. Since the republic, frontality was common in freedmen reliefs. So, too, was the hierarchy of scale. Gaius Lusius Storax is depicted both frontally and in larger scale in the tribunal scene from his Claudian tomb in Chieti.

Increased realism in portraiture, along with a growing interest in increased plasticity and textural contrast, was therefore a development of the Claudian and Neronian periods. Furthermore, it was under Claudius that the first commemorative arch (Claudius's Britannic Arch) with figural panel decoration seems to have been commissioned. Panel reliefs also ornamented Nero's Parthian Arch, and it is apparent that such panel reliefs were actually favored for arch design by Nero's principate. Such ornate arches are very different from Augustan arches, which were severe and had minimal sculptural ornamentation.

It was during the Neronian period that the first surviving column with figural reliefs on the drums and base was erected. The Jupiter Column at Mainz was an experimental work that set the stage for the bolder and artistically more successful Columns of Trajan and Marcus Aurelius in Rome. Although the Jupiter Column had no spiral frieze, which seems to have been the invention of Trajan's architect, Apollodorus of Damascus, the figural scenes are divided from one another by concentric bands, and frontal figures are displayed in vertical rows read

from bottom to top. The pedestals are carved with scenes arranged in panels comparable in format to those on the arches of Claudius and Nero.

In sum, early Julio-Claudian art preserved the classical tradition of the Augustan age that was later to be resuscitated by such emperors as Trajan, Hadrian, and Constantine the Great. Under Claudius and Nero, revolutionary changes were introduced that were to form the basis for the art of the emperors of 68–69 and of the new Flavian dynasts. Their lessons were also heeded by imperial patrons of the second, third, and fourth centuries.

Bibliography

Suetonius, secretary to the emperor Hadrian, wrote biographies of the Julio-Claudian emperors: *The Twelve Caesars,* trans., R. Graves (Harmondsworth, 1957). The modern encapsulated biographies in *The Oxford Classical Dictionary,* 2d ed. (Oxford, 1970), are also invaluable.

For the architectural accomplishments of the Julio-Claudian emperors, see especially J.B. Ward-Perkins, *Roman Imperial Architecture* (Harmondsworth, 1981), and W.L. MacDonald, *The Architecture of the Roman Empire I,* 2d ed. (New Haven, 1982) (Nero's reorganization of Rome and the Domus Aurea).

Julio-Claudian Portraiture (General Studies): L. Curtius, "Ikonographische Beiträge zum Porträt der römischen Republik und der julisch-claudischen Familie," *RM* 48 (1933), 192–243; 50 (1935), 260–320; 55 (1940), 36–64; *MdI,* 1 (1948), 53–67, 69–94. D.K. Hill, "A Cache of Bronze Portraits of the Julio-Claudians," *AJA* 43 (1939), 401–9. V. Poulsen, "Studies in Julio-Claudian Iconography," *ActaArch* 17 (1946), 1–48. V. Poulsen, "The Julio-Claudian Portraits from Béziers," *ActaArch* 17 (1949), 1–14. V. Poulsen, *Claudische Prinzen* (Baden-Baden, 1960). H. Niemeyer, *Studien zur statuarischen Darstellung der römischen Kaiser* (Berlin, 1968). Z. Kiss, *L'iconographie des princes julio-claudiens au temps d'Auguste et de Tibère* (Warsaw, 1975). U. Hausmann, "Bemerkungen zur julisch-claudischen Ikonographie," *Eikones: AntK-BH* 12 (Basel, 1980), 135–40. H. Jucker, "Iulisch-claudische Kaiser- und Prinzenporträts als 'Palimpseste,'" *JdI* 96 (1981), 236–316. D. Hertel, *Untersuchungen zu Stil und Chronologie der Kaiser- und Prinzenporträts von Augustus bis Claudius* (Diss., University of Bonn, 1982).

The Portraiture of Tiberius: L. Polacco, *Il volto di Tiberio* (Rome, 1955). N. Bonacasa, "Contributi all'iconografia di Tiberio," *BdA* 47 (1962), 171–79. L. Fabbrini, "Il ritratto giovanile di Tiberio e la iconografia di Druso Maggiore," *BdA* 49 (1964), 304–26. V. Poulsen, *Les portraits romains,* 1 (Copenhagen, 1973), 81–85. K. Fittschen and P. Zanker, *Katalog der römischen Porträts in den Capitolinischen Museen und den anderen kommunalen Sammlungen der Stadt Rom,* 1 (Mainz, 1985), 10–16.

The Portraiture of Caligula: V. Poulsen, "Portraits of Caligula," *ActaArch* 29 (1958), 175–90. L. Fabbrini, "Caligola: Il ritratto dell'adolescenza e il ritratto della apoteosi," *RM* 73–74 (1966–67), 134–46. R. Brilliant, "An Early Imperial Portrait of Caligula," *ActaAArtHist* 4 (1969), 13–

17. V. Poulsen, *Les portraits romains,* 1 (Copenhagen, 1973), 89–90. H. Jucker, "Caligula," *Arts in Virginia* 13 (1973), 17–25. J. Ternbach, "Further Comments on Caligula," *Arts in Virginia* 14 (1974), 29–31. F. Johansen, "Portraetter af C. Iulius Caesar Germanicus kaldet Caligula," *MedKob* 37 (1981), 70–99. D. Hertel, *Untersuchungen zu Stil und Chronologie der Kaiser- und Prinzenporträts von Augustus bis Claudius* (Diss., University of Bonn, 1982). J. Pollini, "A Pre-Principate Portrait of Gaius (Caligula)?" *JWalt* 40 (1982), 1–12. D. Hertel, "Caligula-Bildnisse vom Typus-Fasanerie in Spanien," *MM* 23 (1982), 258–95. F. Johansen, "The Sculpted Portraits of Caligula," *Ancient Portraits in the J. Paul Getty Museum* (Malibu, 1987), 87–106. D. Boschung, *Die Bildnisse des Caligula* (Berlin, 1989).

The Portraiture of Claudius: M. Stuart, *The Portraiture of Claudius* (New York, 1938). A. Giuliano, *Catalogo dei ritratti romani del Museo Profano Lateranense* (Vatican City, 1957) (Cerveteri group). C. Saletti, *Il ciclo statuario della Basilica di Velleia* (Milan, 1968) (Velleia group). V. Poulsen, *Les portraits romains,* 1 (Copenhagen, 1973), 90–96. D. Salzmann, "Beobachtungen zu Münzprägung und Ikonographie des Claudius," *AA* (1976), 252–64. K. Fittschen, *Katalog der antiken Skulpturen in Schloss Erbach* (Berlin, 1977). H. Jucker, "Iulisch-Claudische Kaiser- und Prinzenporträts als 'Palimpseste,'" *JdI* 96 (1981), 254–84. S. Stone, "The Imperial Sculptural Group in the Metroon at Olympia," *AM* 100 (1985), 377–91. K. Fittschen and P. Zanker, *Katalog der römischen Porträts in den Capitolinischen Museen und den anderen kommunalen Sammlungen der Stadt Rom,* 1 (Mainz, 1985), 16–17. C.B. Rose, *AJA* 90 (1986), 189 (Arch at Ticinum) (abstract). S. Stone, "Divus Claudius," *AJA* 91 (1987), 300 (abstract). H.-M. von Kaenel, *Münzprägung und Münzbildnis des Claudius* (Berlin, 1986).

For Jupiter imagery among the emperors, see R. Fears, "The Cult of Jupiter and Roman Imperial Iconography," *ANRW* II, 17, 1 (Berlin, 1981), 3–141. C. Maderna, *Iuppiter Diomedes und Merkur als Vorbilder für römische Bildnisstatuen* (Heidelberg, 1988). J. Pollini, "Man or God: Divine Assimilation and Imitation in the Late Republic and Early Principate," in K. Raaflaub and M. Toher, *Toward a Reassessment of Augustus and His Principate* (Los Angeles, 1989).

The Portraiture of Nero: E.A. Sydenham, *The Coinage of Nero* (London, 1920). V. Poulsen, "Nero, Britannicus and Others: Iconographical Notes," *ActaArch* 22 (1951), 119–35. V. Poulsen, "Once More the Young Nero, and other Claudians," *ActaArch* 25 (1954), 294–301. C. Saletti, *Il ciclo statuario della Basilica di Velleia* (Milan, 1968). V. Poul-

sen, *Les portraits romains,* 1 (Copenhagen, 1973), 98–101.
U. Hiesinger, "The Portraits of Nero," *AJA* 79 (1975), 113–24. D. W. MacDowall, *The Western Coinages of Nero* (New York, 1979). M. Bergmann and P. Zanker, " 'Damnatio memoriae.' Umgearbeitete Nero- und Domitiansporträts: Zur Ikonographie der flavischen Kaiser und des Nerva," *JdI* 96 (1981) 321–32. H. Jucker, "Iulisch-Claudische Kaiser- und Prinzenporträts als 'Palimpseste,' *JdI* 96 (1981), 284–95. J. Pollini, "*Damnatio Memoriae* in Stone: Two Portraits of Nero Recut to Vespasian in American Museums," *AJA* 88 (1984), 547–55. P. Zanker and K. Fittschen, *Katalog der römischen Porträts in den Capitolinischen Museen und den anderen kommunalen Sammlungen der Stadt Rom,* 1 (Mainz, 1985), 17–19. S. Maggi, "Il ritratto giovanile di Nerone: Un esempio a Mantova," *RdA* 10 (1986), 47–51.

For the *bulla* in art, see H. R. Goette, "Die Bulla," *BonnJbb* 186 (1986), 133–64.

Portraits of Women of the Julio-Claudian Court:
K. Polaschek, "Studien zu einem Frauenkopf im Landesmuseum Trier und zur weiblichen Haartracht der iulisch-claudischen Zeit," *TrZ* 35 (1972), 141–210. K. Polaschek, *Studien zur Ikonographie der Antonia Minor* (Rome, 1973). K. Polaschek, *Porträttypen einer claudischen Kaiserin* (Rome, 1973). V. Poulsen, *Les portraits romains,* 1 (Copenhagen, 1973), 76–79, 96–98. K. P. Erhart, "A Portrait of Antonia Minor in the Fogg Art Museum and Its Iconographical Tradition," *AJA* 82 (1978), 193–212. K. Fittschen and P. Zanker, *Katalog der römischen Porträts in den Capitolinischen Museen und den anderen kommunalen Sammlungen der Stadt Rom,* 3 (Mainz, 1983), 5–7.

The Louvre Suovetaurilia: I. S. Ryberg, *Rites of the State Religion in Roman Art, MAAR* 22 (1955), 106–9. M. J. Vermaseren, "The Suovetaurilia in Roman Art," *BABesch* 32 (1957), 7. A. Alföldi, *Die Zwei Lorbeerbäume des Augustus* (Bonn, 1973), esp. 39–44. A. Bonanno, *Roman Relief Portraiture to Septimius Severus* (Oxford, 1976), 45–46. G. Koeppel, "Die historischen Reliefs der römischen Kaiserzeit I: Stadtrömische Denkmäler unbekannter Bauzugehörigkeit aus augusteischer und Julisch-claudischer Zeit," *BonnJbb* 183 (1983), 80–81, 124–29.

The "Ara Pietatis Augustae": J. Sieveking, "Zur Ara Pacis Augustae," *ÖJh* 10 (1907), 175–90. F. Studniczka, "Zur Ara Pacis," *AbhLeip* 27 (1909), 901ff. R. Bloch, "L'Ara Pietatis Augustae," *MEFRA* 56 (1939), 81–120. M. Cagiano de Azevedo, *Le antichità di Villa Medici* (Rome, 1951). I. S. Ryberg, *Rites of the State Religion in Roman Art, MAAR,* 22 (1955), 65–75. F. S. Kleiner, "The Flamen of the Ara Pietatis," *AJA* 75 (1971), 391–94. S. Lattimore, "A Greek Pediment on a Roman Temple," *AJA* 78 (1974), 55–61. A. Bonanno, *Roman Relief Portraiture to Septimius Severus* (Oxford, 1976), 35–40. M. Torelli, *Typology and Structure of Roman Historical Reliefs* (Ann Arbor, 1982), 63–88. G. Koeppel, "Die 'Ara Pietatis Augustae': Ein Geisterbau," *RM* 89 (1982), 453–55. G. Koeppel, "Two Reliefs from the Arch of Claudius in Rome," *RM* 90 (1983), 103–9. G. Koeppel, "Die historischen Reliefs der römischen Kaiserzeit I: Städtrömische Denkmäler unbekannter Bauzugehörigkeit aus augusteischer und Julisch-claudischer Zeit," *BonnJbb* 183 (1983), 72–80, 98–116.

L. Cordischi, "Sul problema dell'*Ara Pietatis Augusti* e dei rilievi ad essa attribuiti," *ArchCl* 37 (1985), 238–65.

The Ravenna Relief: G. Hafner, "Zum Augustus Relief in Ravenna," *RM* 62 (1955), 160–73. H. Jucker, "Die Prinzen auf dem Augustus-Relief in Ravenna," *Mélanges d'histoire ancienne et archéologie offerts à Paul Collart, Cahiers d'archéologie romande* 5 (1976), 237–67. A. Bonanno, *Roman Relief Portraiture to Septimius Severus* (Oxford, 1976), 41–44. J. Pollini, "Gnaeus Domitius Ahenobarbus and the Ravenna Relief," *RM* 88 (1981), 117–40.

The Vicomagistri Reliefs: F. Magi, *I rilievi flavi del Palazzo della Cancelleria* (Rome, 1945). I. S. Ryberg, *Rites of the State Religion in Roman Art, MAAR* 22 (1955), 75–80. A. Bonanno, *Roman Relief Portraiture to Septimius Severus* (Oxford, 1976), 47–51. M. L. Anderson, "A Proposal for a New Reconstruction of the Altar of the Vicomagistri," *Bollettino dei musei e gallerie pontificie* 5 (1984), 33–54.

The Monument of Lusius Storax: R. Bianchi Bandinelli, M. Torelli, F. Coarelli, and A. Giuliano, "Il monumento teatino di C. Lusius Storax al museo di Chieti, " *Sculture municipali dell'area sabellica tra l'età di Cesare e quella di Nerone, StMisc* 10 (1963–64), 57–102. H. Gabelmann, *Antike Audienz- und Tribunalszenen* (Darmstadt, 1984), 201–4.

The Grand Camée de France: G. Bruns, "Der Grosse Kameo von Frankreich," *MdI* 6 (1953), 71–115. A. N. Zadoks-Josephus Jitta, "Imperial Messages in Agate," *BABesch* 39 (1964), 156–61. H. Jucker, "Der Grosses Pariser Kameo," *JdI* 91 (1976), 211–50.

Vienna Marriage Cameo: F. Eichler and E. Kris, *Die Kameen im Kunsthistorischen Museum, Wien* (Vienna, 1927). W. Fuchs, "Deutung, Sinn und Zeitstellung des Wiener Cameo mit den Fruchthornbüsten," *RM* 51 (1936), 212ff. D. Salzmann, "Beobachtungen zu Münzprägung und Ikonographie des Claudius," *AA* (1976), 264.

The Boscoreale Cups: A. Héron de Villefosse, *Le trésor de Boscoreale, MonPiot* 5 (1899). L. Polacco, "Il trionfo di Tiberio nella tazza Rothschild da Boscoreale," *Atti e Memorie dell'Accademia Patavina di Scienze Lettere ed Art: Memorie della Classe di Scienze Morali Lettere ed Arti,* 67, 3 (1954–55), 253–70. I. S. Ryberg, *Rites of the State Religion in Roman Art, MAAR* 22 (1955), 140–44. C. C. Vermeule, "Augustan and Julio-Claudian Court Silver," *AntK* 6 (1963), 35–36. C. C. Vermeule, *Roman Imperial Art in Greece and Asia Minor* (Cambridge, Mass., 1968), 133–34. J. Pollini, *Studies in Augustan "Historical" Reliefs,* (Diss., University of California, Berkeley, 1978), 285–91. F. S. Kleiner, "The Sacrifice in Armor in Roman Art," *Latomus* 42 (1983), 287–302. H. Gabelmann, *Antike Audienz- und Tribunalszenen* (Darmstadt, 1984), 127–31. A. Kuttner, "Lost Episodes in Augustan History: The Evidence of the Boscoreale Cups," *AJA* 91 (1987), 297–98 (abstract).

The Arch of Tiberius at Orange: P. Mingazzini, "Sulla datazione di alcuni monumenti comunemente assegnati ed eta augustea," *ArchCl,* 9, 2 (1957), 193–205. R. Amy et al., *L'Arc d'Orange* (Paris, 1962). P. Mingazzini, "La datazione dell'arco di Orange," *RM* (1968), 163–67. J. C. Anderson, Jr., "The Date of the Arch at Orange," *BonnJbb* 187 (1987), 159–92.

Britannic Arch of Claudius: F. Castagnoli, "Due archi trionfali della via Flaminia presso Piazza Sciarra," *BullCom* 70 (1942), 57–82. H.P. Laubscher, *Arcus Novus und Arcus Claudii, Zwei Triumphbögen an der Via Lata in Rom* (Göttingen, 1976). G. Koeppel, "Two Reliefs from the Arch of Claudius in Rome," *RM* 90 (1983), 103–9. G. Koeppel, "Die historischen Reliefs der römischen Kaiserzeit I: Städtrömische Denkmäler unbekannter Bauzugehörigkeit aus augusteischer und Julisch-claudischer Zeit," *BonnJbb* 183 (1983), 78–80, 119–23. S. De Maria, *Gli arch onorari di Roma e dell'Italia romana* (Rome, 1988), 280–82.

The Arch of Nero in Rome: F.S. Kleiner, *The Arch of Nero in Rome* (Rome, 1985). S. De Maria, *Gli archi onorari di Roma e dell'Italia romana* (Rome, 1988), 285–86.

The Jupiter Column at Mainz: F. Quilling, *Die Jupitersäule des Samus und Severus. Das Denkmal in Mainz und seine Nachbildung auf der Saalburg* (Leipzig, 1918). F. Quilling, *Die Nero-Säule des Samus und Severus. Nachtrag* (1919). H. Schoppa, *Die Kunst der Römerzeit in Gallien, Germanien, und Britannien* (Munich, 1957), 18, 52–53, pls. 57–59. G. Bauchhenss and P. Noelke, *Die Iupitersäulen in den germanischen Provinzen* (Cologne, 1981), 162–63.

The Sebasteion at Aphrodisias: J.M. Reynolds, "New Evidence for the imperial cult in Julio-Claudian Aphrodisias," *ZPE* 43 (1981), 317–27. J.M. Reynolds, "Further Information on imperial cult at Aphrodisias," *Festschrift D.M. Pippidi* = *Studii Clasice* 24 (1986), 109–17. K. Erim, *Aphrodisias: City of Venus Aphrodite* (New York and Oxford, 1986). R.R.R. Smith, "The Imperial Reliefs from the Sebasteion at Aphrodisias," *JRS* 77 (1987), 88–138. R.R.R. Smith, "Simulacra Gentium: The Ethne from the Sebasteion at Aphrodisias," *JRS* 78 (1988), 50–77.

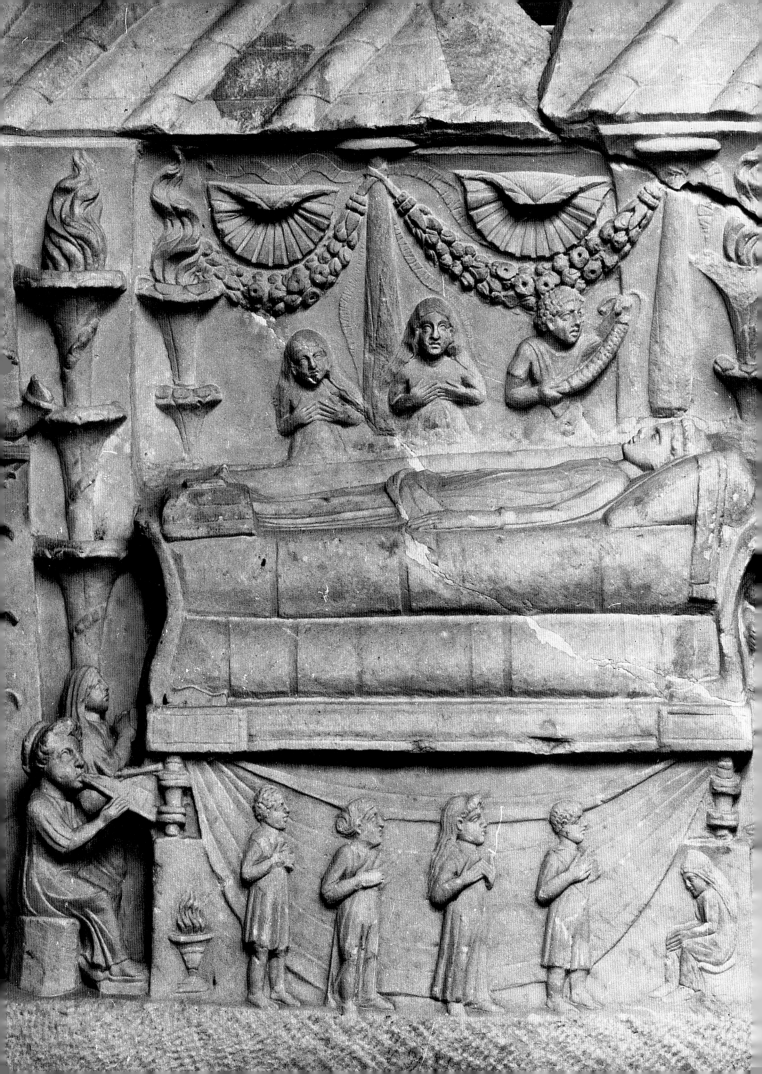

THE CIVIL WAR OF 68-69, THE FLAVIAN DYNASTY & NERVA

CHAPTER IV

The Civil War of A.D. 68–69
Art under Galba, Otho, and Vitellius

While Nero was in Greece in 67 participating in the athletic games and amassing additional works for his growing art collection, opposition to the emperor who had left his freedman, Helius, in charge of the capital grew at a rapid pace. Rome found itself suffering under a severe famine exacerbated by the diversion of corn ships to Nero's beloved Greece. Revolts broke out in the western provinces spearheaded by Gaius Julius Vindex, Galba, and Clodius Macer. It was rumored by Suetonius that Nero concocted a wide variety of fantastic schemes to deal with these uprisings, including poisoning every member of the senate and setting fire to Rome while simultaneously freeing wild beasts to hamper a rescue effort. Realizing that these tactics would not succeed, Nero resolved to regain the loyalty of his foes through heartfelt tears and the dulcet tones of his voice (Suet., *Ner., 43*). Finally, it was the defection of the Praetorians to Galba that led to Nero's suicide outside Rome on 9 June 68. With Nero's death, Rome was plunged into a series of civil wars that lasted a full year until Vespasian was able to restore peace to the empire and found a new dynasty. During 68, three emperors, beginning with Galba and followed by Otho and Vitellius, emerged from the military and replaced one another in rapid succession; their brief regimes did not allow them to initiate public or private projects on a grand scale. There is little surviving evidence for major commissions, with the exception of the numismatic depictions of two arches honoring Galba from the mints of Gaul and Spain. Yet, each commander had to pay his troops, and each chose to have coins embellished with his own portrait rather than with that of Nero or one of his rivals. Coins of all three emperors of 68–69 survive. They show a series of distinctive portraits. The coins of Otho are still in the Neronian tradition, but those of Galba and Vitellius represent a new image of the emperor that was to serve as the prototype for the veristic portraiture of the first two Flavian dynasts. It is for this reason that, despite the brevity of their principates, Galba and Vitellius and their court portraitists

bequeathed a significant legacy to the development of Roman portraiture.

Servius Sulpicius Galba was born in about 3 B.C. between Terracina and Fondi, the son of Gaius Sulpicius Galba and Mummia Achaica. His rise to prominence was not surprising because he came from aristocratic roots and long enjoyed favor with the imperial family, beginning with Augustus and culminating with Claudius. His illustrious administrative career is attested to by his service in several important posts, among them the governor of Aquitania, of Greater Germany, and later of Tarragonian Spain. With the support of the Praetorians, Galba took the title of *Caesar* (which he only accepted formally when it was also approved by the senate) and, after Nero's death, entered Rome in the company of Otho, the governor of Lusitania. Otho was surprised and hurt when Galba chose another man as his successor, and in retaliation Otho turned the Praetorians against their leader. Galba was murdered on 15 January 69, after serving as emperor for only a little more than seven months. In any case, Galba left no heirs. Although his wife, Aemilia Lepida, had borne him two sons, both died, as did his wife, and Galba never remarried. He chose instead a young man by the name of Lucius Calpurnius Piso Frugi Licinianus as his successor.

Galba was already in his early seventies when he became emperor. Suetonius's physical description of him records that he was of medium height with blue eyes, a hooked nose, and a bald head (Suet., *Gal.*, 21). Galba's first numismatic portraits were probably based on those of his immediate predecessor, Nero, but shortly thereafter a portrait that expressed the emperor's personal vision of himself was carved on a new die. Three numismatic types for Galba's portraits have been identified, and it is type 3 that best exemplifies the emperor's chosen image. In a sestertius minted in Rome in 68 (fig. 135), for example, Galba is not a youthful Julio-Claudian but a tough military commander with a closely cropped hairstyle that recedes at the temples and has a thinning fringe of hair over the forehead. The major distinguishing feature of his face – his prominent hooked nose – is accentuated by the die-cutter, and he is represented with small eyes and a strong but sagging chin. The slackness of his aging musculature is also emphasized in the artist's rendition of his cheeks and neck; his forehead is deeply furrowed, and he has noticeable pouches under his eyes. His tightly closed mouth probably held few, if any, teeth. Galba has chosen to have himself represented in what is a frankly realistic style for a variety of reasons. First, because artists of the day were already working in a more veristic portrait style than they had previously. The mature portraiture of Claudius, for example, depicted an

aging emperor, and even Nero's portraits were candid renditions of their subject. Both Claudius's and Nero's portraits, however, with their mythological allusions and layered caps of hair, still possessed what might be termed Hellenistic artificialities. Second, Galba's more straightforward military persona rejected these conceits in favor of a direct message that was immediately understood by aristocrats and soldiers alike, but that appealed especially to the latter, who were the new emperor's most important constituency. Third, such a style was diametrically opposed to that used for Neronian portraits, and Galba's images may be interpreted as symbols of the anti-Neronian sentiment of the new emperor and his supporters. Identifying surviving bronze and marble heads or statues of Galba on the basis of their similarity to his coin portraits has proved disappointing. Furthermore, it has been pointed out that portraits of old men were popular under the Flavian emperors, and many heads that have been associated with Galba probably represent private citizens of the day.

Marcus Salvius Otho, born in 32, was declared emperor of Rome on 15 January 69, the day of Galba's murder. Otho, like Galba, had close ties with the Julio-Claudian family. His father was raised to patrician rank by Claudius, and his contemporary, Nero, was a close friend. Otho married Poppaea Sabina but eventually divorced her when she and Nero became enamored. To get Otho out of the way, Nero sent him to Lusitania as governor, where he remained until the emperor's death. In retaliation, Otho came back to Rome as a staunch supporter of Galba. In return for his aid, Otho hoped

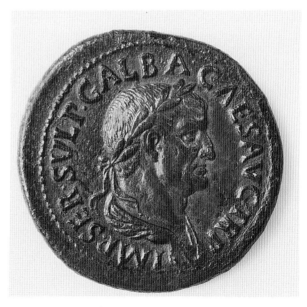

135 Sestertius with portrait of Galba, from Rome, 68. Private collection. Photo: Hirmer Verlag München, 21.0028

that he would be designated as Galba's heir, but his loyalty went unrewarded when Galba chose Piso. The only path opened to Otho was to oppose Galba openly, which he did by conspiring with the Praetorians to overthrow him; Otho was himself hailed emperor on 15 January. Otho modeled himself on the friend of his youth, Nero, and gained popularity in some of the provinces that had looked favorably on his Julio-Claudian predecessor. He was also as profligate as his idol. It is rumored by Suetonius, for example, that the first act of Otho's principate was his allotment of half a million gold pieces to fund the completion of Nero's Domus Aurea (Suet., *Oth.*, 7). But highly skilled troops on the Rhine had a different leader in mind. They engineered a decisive victory over Otho near Cremona, causing him to resort to suicide on 16 April 69. He was as true to his model in death as he had been in life.

Otho died at the age of thirty-seven. According to Suetonius, he was of medium height with bow legs and splay feet. He paid a great deal of attention to his appearance, having his body totally depilated and wearing a wig to hide his baldness (Suet., *Oth.*, 12). In his numismatic portraits, for example, on a gold aureus of 69 from the mint of Rome (fig. 136), Otho is depicted as a youthful dandy with tight curls arranged in rows from his forehead to the crown of his head. The coiffure is perfectly arranged and looks wiglike. He has a full, fleshy face with a second chin. His brows are slightly arched and his nose aquiline. Otho's resemblance to Nero in these portraits is striking and intentional and represents a departure from the return of Roman verism in the portraits

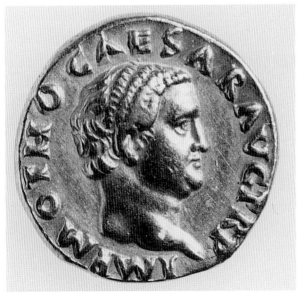

136 Gold aureus with portrait of Otho, from Rome, 69. London, British Museum. Photo: Courtesy of the Trustees of the British Museum

of Galba. There are no portraits in the round that have been identified with certainty as Otho.

Aulus Vitellius, born in 15, was also a friend of the Julio-Claudian emperors, specifically, Caligula and Claudius. He served as proconsul in Africa, and it was Galba who put him in charge of the German legions in 68. Since the German contingent was already in revolt against Galba, they saluted their new commander as emperor; support spread to Gaul, Spain, and Britain. Galba's death was followed not long after by the defeat and suicide of Otho, and Vitellius entered Rome with great celebration. Like Otho, Vitellius viewed himself as the legitimate successor of Nero, and also like Otho, he displayed a profligate side that made him Nero's soulmate. He also lived a life most notable for its vices that included cruelty and, above all, gluttony. Suetonius recounts three or four banquets a day, as well as drinking bouts. His appetite was so voracious that it was rumored that he even grabbed chunks of meat and pieces of cake from sacrificial altars (Suet., *Vit.*, 13). Within a short time, a fickle army turned its allegiance to another commander, Vespasian, and on 20 December 69, Vitellius was brutally dragged through the Roman Forum and murdered, his body unceremoniously dumped into the Tiber River.

Vitellius was fifty-six at the time of his death. According to Suetonius, he was very tall and had a huge paunch (Suet., *Vit.*, 17). Numismatic portraits of him – for example, a sestertius from Rome of 69 – are an interesting blend of Neronian and Galban features. Vitellius's extravagant and gluttonous life-style is reflected, as was Nero's, in his fleshy cheeks and double chin. His small eyes are almost lost in the pouches of flesh above and beneath his eyes. He has a sloping forehead, arched brows, large nose, and full lips. Yet his forehead and cheeks are not those of a smooth-cheeked youth. He has deep furrows in his forehead, and there are significant naso-labial creases. Like Galba, Vitellius thought it an advantage to admit his age in his portraits. Furthermore, although Vitellius envisioned himself as a neo-Nero, he did not adopt the former emperor's tiaralike coiffure. Instead, he is depicted with a short, military hairstyle that recedes at the temples and closely approximates that of Galba.

On the basis of its size and similarity to the coin portraits of Vitellius from the Rome mint, a colossal marble head in Copenhagen (fig. 137), has justifiably been associated with the emperor. He is portrayed with full fleshy face, eye pouches, deep forehead, naso-labial lines, short military coiffure, and multiple chins that effectively follow the pronounced sag of his thick neck. The neck is worked for insertion into a full-length statue, but it is impossible to say whether it was of normal proportions or revealed the emperor's huge paunch.

137 Portrait of Vitellius, 69. Copenhagen, Ny Carlsberg
Glyptotek. Photo: Courtesy of the Ny Carlsberg Glyptotek,
Copenhagen

The Flavian Dynasty

It was Vespasian, the last of the emperors of 68–69, who was able to hold onto power for ten years, long enough to fulfill his dream of founding a new dynasty, called the Flavian dynasty after his family name, Flavius. What made the dream possible was that Vespasian had two sons, Titus and Domitian, to succeed him; and both did. His two sons, along with a daughter, Flavia Domitilla, were produced by his wife, also called Flavia Domitilla. Both wife and daughter died before he became emperor, and from then on he lived with a freedwoman named Caenis.

Vespasian, emperor of Rome between 69 and 79, was born Titus Flavius Vespasianus in 9 at Sabine Rieti. He was the son of Flavius Sabinus, a tax collector, and a woman from a family of equestrian rank. His mother's brother served in the senate. Vespasian was a military commander in Claudius's war in Britain and much later subdued Judaea, with the exception of Jerusalem, at Nero's order. After the short-lived principates of Galba, Otho, and Vitellius, Vespasian was acclaimed emperor by two Egyptian legions on 1 July 69. Other legions supported him in turn, and Vespasian was declared emperor by the senate in December of the same year; he was sixty at the time.

While he was emperor, Vespasian continued to pay special attention to Britain and Judaea. He annexed northern England, pacified Wales, and made military advances into Scotland. Jerusalem was captured in 70; the officer in charge was the emperor's elder son, Titus. A joint triumph was voted for Vespasian and Titus, and the victory in the Jewish Wars became the capstone of both mens' careers. Because Vespasian came to power after a civil war, he – like Augustus – needed a foreign victory to give his rule and his new dynasty legitimacy. War booty from the temple in Jerusalem was displayed in Vespasian's Temple of Peace (Templum Pacis); the event was memorialized on Flavian coins, some with the legend *Judaea capta;* and the triumph served as the subject of the panel reliefs of the Arch of Titus.

Because Vespasian came to power after a divisive civil war and after the imperial treasuries had been depleted by Nero, he had to enact unpopular but essential legislation. Provincial taxes, needed to help fund building in Rome, for example, were increased. Still, Vespasian used the revenues for projects that not only glorified his new dynasty but that also benefited the Roman people. Among these were the Flavian Amphitheater or Colosseum – begun by Vespasian and finished by Titus and intended to serve as an arena for animal and gladiatorial combat – and the Templum Pacis. The Colosseum,

like so many Flavian edifices, was constructed on land earlier occupied by Nero's artificial lake near his extravagant pleasure palace with its golden facade and revolving banqueting hall. By building structures that were open to the public on the remains of Nero's private domicile, Vespasian returned to the Romans the land that was rightfully theirs. Vespasian was a shrewd politician as well as a successful military commander who artfully used architecture as political propaganda. An additional undertaking in the same vein was Vespasian's completion of the Temple of Divine Claudius (the Claudianum). Begun by Claudius's wife, Agrippina, after his death and deification, the project lay dormant under Nero, who appears to have partially dismantled it. Vespasian's decision to complete it signaled his desire to associate himself and his sons with the Julio-Claudian dynasty, but not with Nero.

Titus Flavius Vespasianus, the emperor's elder son, was born in 39. He served as a military tribune in Germany and Britain before accompanying Vespasian to Judaea. He played an important part in acquiring imperial authority for his father and brought Vespasian his greatest military victory – the capture of Jerusalem in 70 – the event that solidified the Flavian claim to power. The victory over Judaea led to a triumph for Titus that was rapidly converted to a joint triumph for him and his father, but in gratitude Vespasian made Titus a co-regent. Titus's military prowess was so great that Vespasian also appointed him Praetorian prefect, which meant that he ran the military side of his father's government. Titus displayed considerable ruthlessness in this post, which led to unpopularity enhanced by his affair with Berenice, whom he had met in Judaea. She was sent back home before Vespasian's death of natural causes in 79. Vespasian was subsequently deified. Titus's first wife was Arrecina Tertulla; after her death, he married Marcia Furnilla, who bore their only child, Julia Titi. Titus succeeded his father without contest. After becoming emperor, Titus's popularity grew. He was admired for his good looks and his affable personality as well as his generous commissioning of public works, including the completion of the Colosseum and the construction of the Baths of Titus. Titus was emperor of Rome for less than three years. He died of natural causes in 81 and was immediately deified.

The short principate of Titus lasted from 79 to 81 and is remarkable for three major catastrophes: the destruction of Pompeii and Herculaneum by the eruption of Vesuvius in 79, and a fire and plague in Rome in 80. Titus spent most of his time attempting to repair the damage, and, in fact, it is for an event that happened in his father's principate rather than in his own that he is remembered – the victory over Jerusalem and the destruction of the Jewish temple.

Titus was succeeded by his younger brother, Titus Flavius Domitianus, who was born in 51. Domitian remained in Rome while Vespasian staged his coup against Vitellius. With Vespasian's success came Domitian's salutation as Caesar, and it was Domitian who ensured that his father would become emperor upon his return to Rome in 70. Once emperor himself (81–96), Domitian exercised his imperial prerogatives to the fullest and became a despot in the manner of Caligula and Nero. He controlled the senate and insisted on being addressed as *dominus et deus,* lord and god, a far cry from Augustus's first citizen (princeps) image. He depleted the imperial treasury by increasing legionary pay, financing major military campaigns against the Chatti, Dacians, and Sarmatians, distributing *congiaria* (largess), and undertaking a major building program in Rome that included both public structures like the Forum Transitorium and public and private palaces, the most spectacular of which was the one on the Palatine hill. He enacted strict moral laws, as had Augustus, but these were not in keeping with Domitian's own life of luxury and licentiousness and contributed to his unpopularity. He took his brother's daughter, Julia Titi, as his mistress. Not surprisingly, Domitian was murdered in 96, the victim of a plot that was planned by highly placed officials, his wife Domitia, and probably also by his successor, Nerva, who was named emperor by the senate on the same day. In any case, Domitian had no sons of his own to succeed him, and with his assassination the Flavian dynasty came to an end. The dynasty had come a long way from its popular beginnings because the senate voted Domitian a damnatio memoriae.

The Portraiture of Vespasian, Titus, and Domitian

The portraiture of Vespasian marks a major break with the portraiture of Julio-Claudian times, but it continues a trend begun under Galba and Vitellius. Like Galba before him, Vespasian is depicted realistically as a strong military leader, and Vespasianic portraiture can be thought of as a resuscitation of republican verism. Gone are the smooth, bland but beautiful Julio-Claudian features, the long tousled hair, and the youthfulness. Vespasian is depicted as the sixty-year-old he was, with balding pate and lined face and neck. His distinctive facial characteristics include a broad forehead, closely set eyes, arched brows, and hooked nose. The thin, tightly closed lips give a powerful sense of control to his portraiture that accords well with Suetonius's description of the emperor that he "always wore a strained expression on his face" (Suet., *Vesp.*, 20).

The portraits of Vespasian have been variously cate-

gorized, with most scholars now favoring a division into two basic types: a younger one produced before the emperor's principate, and a main type, created after his accession. Most of the surviving portraits belong to the latter type, as do all of the numismatic likenesses. Posthumous versions were based on the same two types. The study of Vespasianic portraiture has been further refined by the identification of those heads of the emperor that are reworked versions of portraits of Nero (mostly Nero's Cagliari and Terme types) and Vitellius.

An over-life-size marble head from Carthage (fig. 138) is a reworked head of Nero of the Terme type and can be associated with the younger Vespasianic portrait. Although it was found in North Africa, the portrait appears to have been made in a city of Rome workshop. Despite the flatness of the face and the smooth area where hair should be above the right ear – both aspects caused by the recarving of the head – the most outstanding features of Vespasian's physiognomy are apparent. The emperor has a broad, lined forehead, closely set eyes framed by crow's feet, a hooked nose, thin lips, and a creased chin and cheeks. His hair is combed in thin strands down over his forehead and grows relatively long on his neck, undoubtedly a holdover from the Neronian original.

What is especially interesting and significant about the portraits of Vespasian is that the artist appears to have incorporated the aging process into the imperial image. A masterful portrait of Vespasian in Copenhagen (fig. 139), is an example of the emperor's main type. The hooked nose and powerful chin are both apparent, as is the tautly controlled facial expression; but the forehead and cheek creases and the crow's feet are more deeply etched, the fringe of forehead hair has vanished, the eyelids sag, and the emperor's characteristic thin lips have narrowed still further. They seem to conceal a toothless mouth.

The best-known and one of the two finest surviving portraits of Vespasian was discovered in Ostia (fig. 140). It appears to be a posthumous portrait of Vespasian fashioned while Titus was emperor but is possibly based on the younger Vespasian type. The emperor's forehead is deeply lined, his cheeks are creased, and rings of lines encircle his neck. His hair recedes at the temples; the few remaining thin strands on top are combed toward his forehead, and the hair grows long on the neck. It is a vibrant portrait of the founder of a new dynasty and the one closest in type and style to the head in the adventus panel of the Domitianic Cancelleria Reliefs (see fig. 158).

Titus was forty years old when he succeeded his father in 79. The family resemblance to Vespasian is effectively captured in his portraits. In fact, he might be described as a younger version of his father, who was now a divus. Like Vespasian, Titus had a broad face and forehead, closely set eyes, arched brows, and a hooked

138 Portrait of Vespasian, from Carthage, just after 70. London, British Museum. Photo: Courtesy of the Trustees of the British Museum

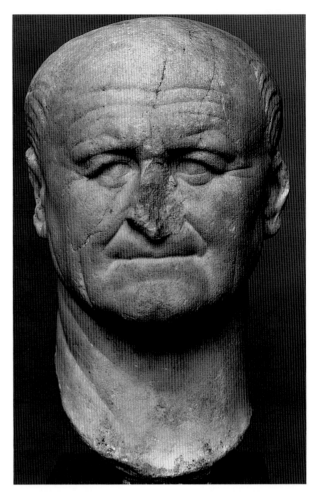

139 Portrait of Vespasian, 70–79. Copenhagen, Ny Carlsberg Glyptotek. Photo: Courtesy of the Ny Carlsberg Glyptotek, Copenhagen

nose. This is apparent in a portrait of the emperor from Herculaneum (fig. 141), which is an example of Titus's first portrait type sometimes called the type of the Statue from Herculaneum. His lips are fuller than his father's, and because of his relative youth, he lacks the crow's-feet and cheek creases. A few sinuous lines across his forehead effectively add experience and maturity to his face. He has a cleft chin. It is in the rendition of his hair that Titus's portraits depart most significantly from those of Vespasian. Although the hairline is similar – the hair recedes at the temples and grows relatively straight across the forehead – it is fuller and much curlier, the curls sometimes accentuated lightly by the drill.

Portraits were undoubtedly made of Titus before he became emperor but while he was co-regent with Vespasian. He was, after all, a highly successful military commander. The full-length statue of Titus in cuirass, to which the head just described belongs, may have been manufactured before the accession since it comes from Herculaneum and therefore predates 24 August 79, the day of the fateful eruption of Mount Vesuvius. However, Titus became emperor of Rome in June of the same year; the portrait could therefore have been one of the first

made of the new emperor. He is portrayed as a great military man, clad in cuirass and paludamentum. The cuirass is decorated with two heraldic griffins flanking a candelabrum, a favorite motif of Julio-Claudian and Flavian times that is probably ornamental and does not seem to have any political connotations.

The portraits of Titus have been divided into two types: the type of the Statue from Herculaneum, described above, and the Erbach type, after its best replica, now in the Schloss Erbach Collection in Berlin (fig. 142). The Herculaneum type is the earlier of the two, created at Titus's accession or possibly when he was co-regent; the other was devised during his brief principate. Despite differences in detail, both types may be derived from the same prototype that may have originated when Titus was co-regent. The Erbach head possesses the same general features as the Herculaneum portrait: broad face, high forehead, closely set eyes, arched brows, sinuous forehead creases, hooked nose, and cleft chin. His hair recedes at the temples but is otherwise arranged in curls

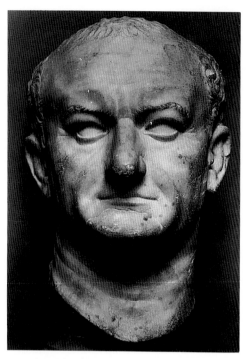

140 Portrait of Vespasian, from Ostia, 79–81. Rome, Museo Nazionale delle Terme. Photo: DAIR 54.797

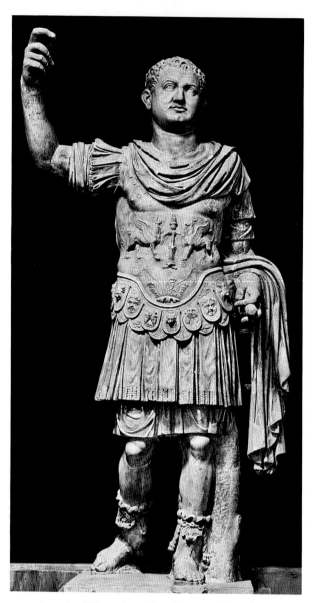

141 Portrait of Titus, from Herculaneum, before 79. Naples, Museo Nazionale. Photo: Alinari/Art Resource, New York, 23198

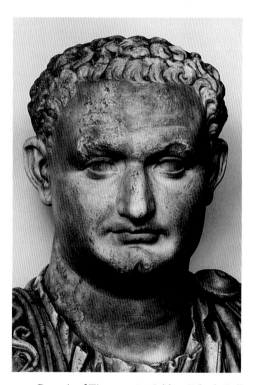

142 Portrait of Titus, 79–81. Schloss Erbach Collection. Photo: Gisela Fittschen-Badura

in front of his ears, on his neck, and across his forehead, where the crescent-shaped waves are combed from the right to the left in a more consistent pattern than in the Herculaneum head.

Another important statue of Titus depicts the emperor as a magistrate in a toga (fig 143). He carries a rotulus in his left hand and gestures in address with his right. The statue was found in a garden near the Lateran. The back of the statue is only summarily worked, which suggests that it was originally placed against a wall or in a niche, and there are remaining flecks of red paint on the toga. The head, possibly reworked from a portrait of Domitian in the late first century, is closer to the Herculaneum than the Erbach type, but the distinction is slight

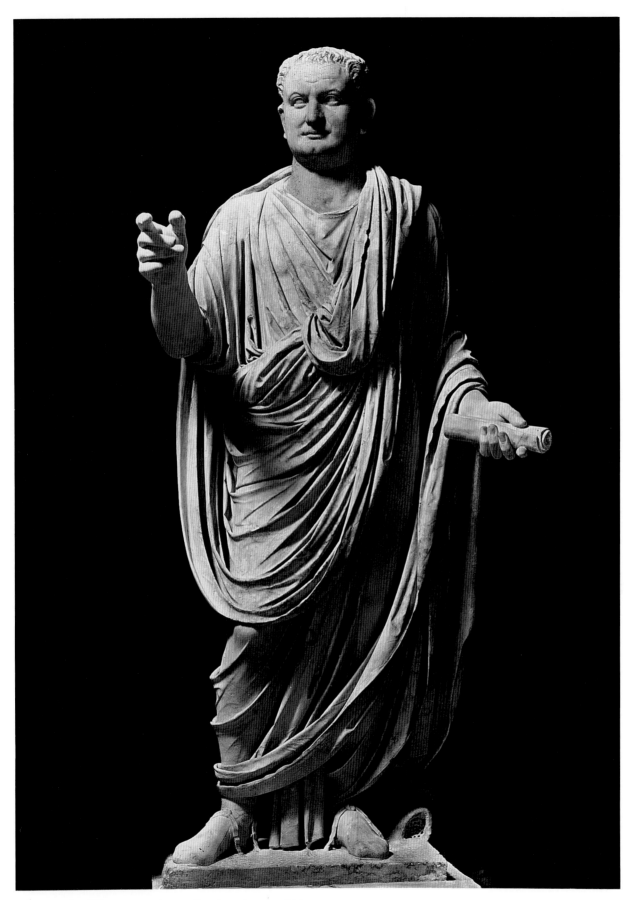

143 Portrait of Titus as a magistrate, from a garden near the
Lateran, late first century. Rome, Vatican Museums. Photo:
Alinari/Art Resource, New York, 6665

and underscores the likelihood that all of Titus's portraits were derived from a common prototype.

The brevity of Titus's principate and the fact that he died when he was only forty-three make it impossible to know whether he, like his father, would have aged in his portraits. It is interesting that although the portrait of Titus in a chariot in the Triumph panel on the Arch of Titus (see fig. 156) (commissioned after his death by his younger brother) depicts him during his life in a manner comparable to the portraits just described, his features are simplified and even idealized and his hair straighter and more like a Julio-Claudian cap in the portrait in the vault of the arch that purports to show him as he looked after he became a god (see fig. 157).

After Domitian was assassinated in 96 at the age of forty-five, he was accorded a damnatio memoriae. For that reason, many of his portraits were destroyed, and no posthumous images were made. All of the surviving portraits of Domitian must therefore have been created during his lifetime.

Domitian's portraits have been divided into three main types. The first type was developed on coins of 72–75 and depicts the emperor with the broad Flavian face but with hair lower on his forehead than was characteristic of the two previous Flavian dynasts. In fact, the hair is arranged across the forehead in a pattern of locks that is closer to that of Nero than to those of Vespasian or Titus. This may be largely because some of the portraits of all of Domitian's three types were reworked from those of Nero. Moreover, Domitian would have wanted to associate himself with Augustus and the Julio-Claudians, and the most recent models for artists to emulate were those of Neronian date. Otho also favored a Neronian coiffure.

The earliest portraits of Domitian, those of him as a crown prince, were manufactured while he was still in his teens. An example is a full-length over-life-size heroic statue, found in 1758 in the villa of a freedman of Domitian in Labicum (fig. 144), which dates to about 75 and corresponds to contemporary coin portraits. The portrait head clearly shows Domitian's family resemblance to his father and brother. Especially striking in this regard are his full face, deep-set eyes, and hooked nose, although Domitian has one distinctive feature that neither of his relatives possesses – a protruding upper lip – a facial feature he shares with Caligula. Domitian also has straight and not arched brows. Although a primary example of Domitian's type 1 portraits, the Labicum statue has been identified by some scholars as a reworked version of a Neronian original. For this reason, among others, Domitian's hair is fuller than the other Flavians, layered, and most importantly, strands of hair are arranged across his forehead in comma-shaped locks that are slightly indented to create the Neronian tiara effect.

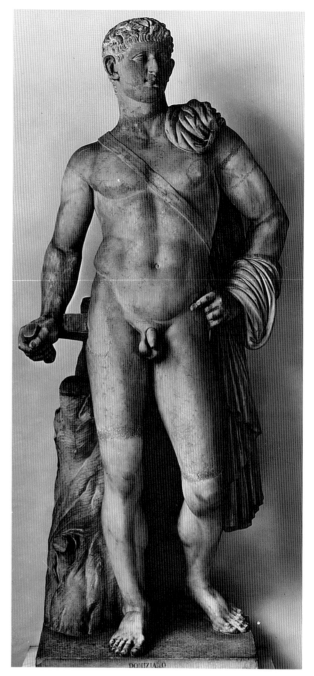

144 Portrait of Domitian, from a villa in Labicum, ca. 75. Munich, Staatliche Antikensammlungen und Glyptothek. Photo: Courtesy of Staatliche Anitikensammlungen und Glyptothek, Munich, G1 394.

Domitian must have preferred such a coiffure; by allowing himself to be represented with it, he appears to have rejected the Flavian male hairstyle in favor of one of late Julio-Claudian date.

Domitian's type 2 portraits correspond to likenesses of the emperor on coins of 75 in which the hair recedes somewhat at the temples and creates an angled effect that corresponds to that in Titus's portraits.

The third type can be seen on coins struck when

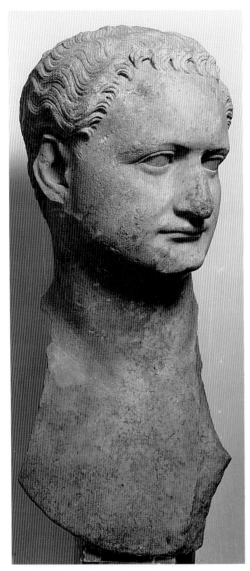

145 Portrait of Domitian, from Rome, ca.88. Rome, Museo del Palazzo dei Conservatori. Photo: DAIR 63.19

brushed in waves from the crown of his head over his forehead and arranged in comma-shaped locks. Despite the regular pattern of locks, Domitian's hair recedes at the temples and appears to be sparser on top than it was in the two earlier types. It is clear that Domitian, like the other Flavians, had a tendency to baldness. In fact, Suetonius reports in his life of Domitian that "later, he lost his hair and developed a paunch." Furthermore, according to Suetonius, "he took as a personal insult any reference, joking or otherwise, to bald men, being extremely sensitive about his own appearance" (Suet., *Dom.*, 18). Domitian's decision to have himself portrayed with a full head of hair in his portraits underscores his personal vanity but also illustrates the Roman practice of retrospective association. Only a full cap of hair with comma-shaped locks would allow Domitian to ally himself with his Augustan and Julio-Claudian predecessors.

Flavian Female Portraiture

Because Vespasian's first wife, Flavia Domitilla, and his daughter of the same name, died before he became emperor, no official portraits of them were ever made, nor were there, not surprisingly, any portraits made of his mistress, Caenis. Titus's first wife, Arrecina Tertulla, also seems to have been excluded from the Flavian portrait gallery. Portraits of Titus's second wife, Marcia Furnilla, have, however, been identified, as have portraits of their daughter, Julia Titi. Domitian's wife, Domitia, was also honored with portrait commemorations. Julia Titi, Domitia, and other female members of the Flavian court were, like their Julio-Claudian counterparts, included in group portraits of the Flavian family – for example, the group from the Metroon in Olympia that has Julio-Claudian and Flavian emperors, as well as either Vespasian's wife and daughter, the two Flaviae Domitillae, or Julia Titi and Domitia.

The study of female portraiture of this period is a more straightforward enterprise than that of male portraiture because all of the surviving marble portraits of Flavian court females appear to be originals and not, like their male counterparts, recarved heads of Julio-Claudian predecessors who had fallen from grace. Yet, a study of the coins struck in honor of both Julia Titi and Domitia makes it apparent that the establishment of a precise chronology is impossible at present. Many of the coins cannot be dated with certainty, and there is considerable variety of detail in both physiognomic peculiarities and in the arrangement of the hair.

Perhaps the most interesting extant statue of a Flavian court female is the full-length marble portrait that was discovered in what was possibly a Flavian villa near Lake

Domitian was sole emperor of Rome and in such major works as the portrait in the Museo del Palazzo dei Conservatori (fig. 145) and the head of Domitian/Nerva in the profectio scene of the Cancelleria Reliefs (see fig. 159) (discussed below).

The former, a marble portrait of Domitian from Rome, portrays him as emperor. Although some of the surviving examples of type 3 were reworked portraits of Nero, the Conservatori head appears to be an original Domitianic portrait. It was made in about 88 and extends to the breastbone. Domitian's chest is bare, but the remains of a small fold of drapery on his left shoulder indicate that he wore a paludamentum and that this is thus a military portrait. Domitian, who turns his head sharply to the left, continues to be portrayed with the hooked nose of the Flavian family and with his own characteristic straight brows and protruding upper lip. His hair is

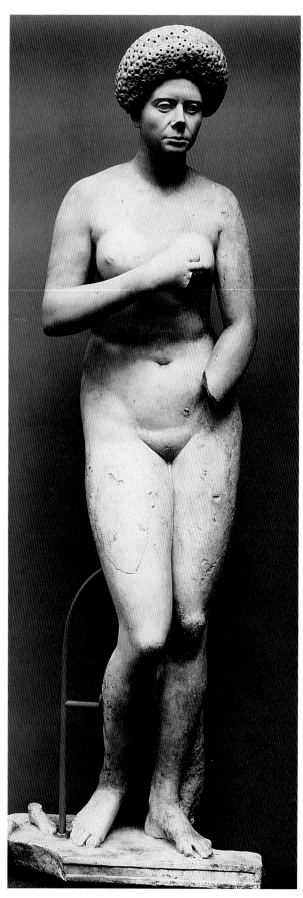

146 Portrait of Marcia Furnilla, from a villa near Lake Albano, 79–81. Copenhagen, Ny Carlsberg Glyptotek. Photo: Courtesy of the Ny Carlsberg Glyptotek, Copenhagen

Albano (fig. 146). The body is a replica of the Capitoline Venus type that serves as a prop for the realistic head of a middle-aged Roman matron, possibly Marcia Furnilla. The figure's weight rests on her left leg, and her right leg is slightly bent. Her arms are modestly positioned to cover partially her nudity. The goddess was originally accompanied by Eros; all that survives of him are two small feet next to the empress's right leg. The portrait head shows Marcia Furnilla to be neither young nor beautiful. She has large eyes and straight brows, a long nose, and large mouth. Deep lines crease her face from her nostrils to her cheeks. Her hair is made up of a mass of marble that forms a halo around her face. It has been drilled into by the artist to create individual corkscrew curls neatly arranged in regular rows. The rest of the hair is divided into individual strands that are braided, the many braids fastened together in a large bun at the back of the head. A few strands of loose hair escape the elaborate coiffure and fall onto the back of her neck. The portrait was probably commissioned during Titus's principate and demonstrates that Roman imperial women could indulge in the same role playing as their husbands.

Another portrait of a Flavian court female that was probably made between about 80 and 81 is the best-known likeness of Marcia Furnilla's and Titus's daughter, Julia Titi, a lovely young woman who also went on to become Domitian's mistress. Born probably in 63, Julia Titi is shown in a portrait in the Museo Nazionale delle Terme (fig. 147) as a delicate young woman of approximately seventeen years with an oval face, large almond-shaped eyes, and rounded lips. Like her mother's, her hair is made up of a fluffy mass of curls, drilled into by the artist. Only the hair near the face is arranged in corkscrew curls, the rest is braided in long strands that are fastened in a bun placed high at the back of her head. A few loose curls fall on her neck. This portrait corresponds to Julia Titi's portrait on coins struck in about 80 in which she is designated as Augusta, a title she was awarded when her father became emperor of Rome. Some of her numismatic portraits depict her with a diadem in her hair, making her the first imperial women to be so represented during her lifetime.

The shape of the halo of hair in both the portraits of Marcia Furnilla and that of Julia Titi is rounded like a dome. During the Domitianic period, the hair is piled high in such a way as to form a peak at the apex. This is a coiffure popularized by Domitian's wife, Domitia, and worn as well by other aristocratic women of the day. It is this peaked hairstyle that was emulated by women of Trajan's court, such as the emperor's wife Plotina, who took the style one step further by creating multitiered coiffures. The Domitianic version of the peaked hairstyle can be seen in the portrait of Domitia from Terracina

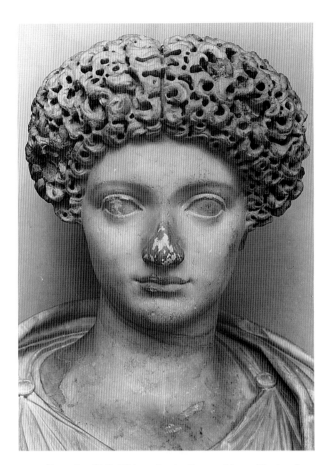

147 Portrait of Julia Titi, ca.80–81. Rome, Museo Nazionale delle Terme. Photo: DAIR 57.618

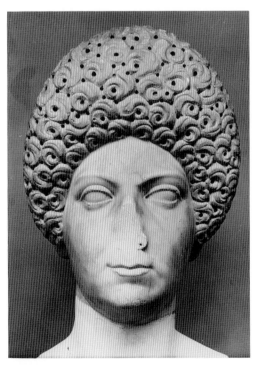

148 Portrait of Domitia, from Terracina, late Flavian or early Trajanic Rome, Museo Nazionale delle Terme. Photo: DAIR 57.621

(fig. 148), which dates to the late Flavian or early Trajanic period. The corkscrew curls are individually carved and form a fairly regular pattern of spirals. In this case, the drill holes are located in the center of some curls and as a border around others, indicating that the artist who executed this portrait probably did so in careless haste. The braids, which are fastened at the back of the head in a large bun, are also summarily carved. There is no attempt in this portrait to beautify or idealize the empress. She is depicted as a mature woman with sagging skin, as was Marcia Furnilla. The new Flavian realism, based at least in part on republican verism, was no more sympathetic to women than it was to men.

The tour de force of extant Flavian female portraiture (fig. 149) may also be a portrait of a Flavian court luminary. Two replicas based on the same prototype survive, suggesting that it depicts a woman of imperial rank; she is sometimes identified as Trajan's niece, Vibia Matidia. The head in question belongs to a bust-length portrait that is now in the Museo Capitolino. It extends to the breastbone, and a few folds of drapery delicately embrace the lady's shoulders. The woman's features – oval face, almond-shaped eyes, straight feathery brows, aquiline nose, and delicately modeled mouth – are sensitively captured by a first-rate portraitist. The noble beauty is depicted with a swanlike neck that, along with her head, is tilted to her left. The woman's hair is literally her crowning glory. It is piled high on the top of her head and is taller than it is wide suggesting a late Flavian or early Trajanic date. The artist has succeeded in transforming the marble into hair through his virtuosity in handling the drill and by his careful attention to the dark shadows between the full plastic curls.

The Flavian Art Museum and the Display of Sculpture

Not enough consideration is given in the modern literature on Roman art to the original placement of works of sculpture. Roman portraits were displayed in public settings like fora, basilicas, and at the crossroads of city thoroughfares, or in private contexts like the atria or gardens of modest houses or luxurious villas. The Romans also had museums that, like those of modern times, were built with the express purpose of displaying art. The museum was not a Roman invention. The word is Greek in origin, and ancient Greek museums, such as the Pinakotheke in Athens, are known. The Pinakotheke, or picture gallery, was part of the Propylaea on the Athenian Acropolis specifically for the display of painted pictures. The room in which the paintings were exhibited was outfitted with dining couches so that visitors to the religious

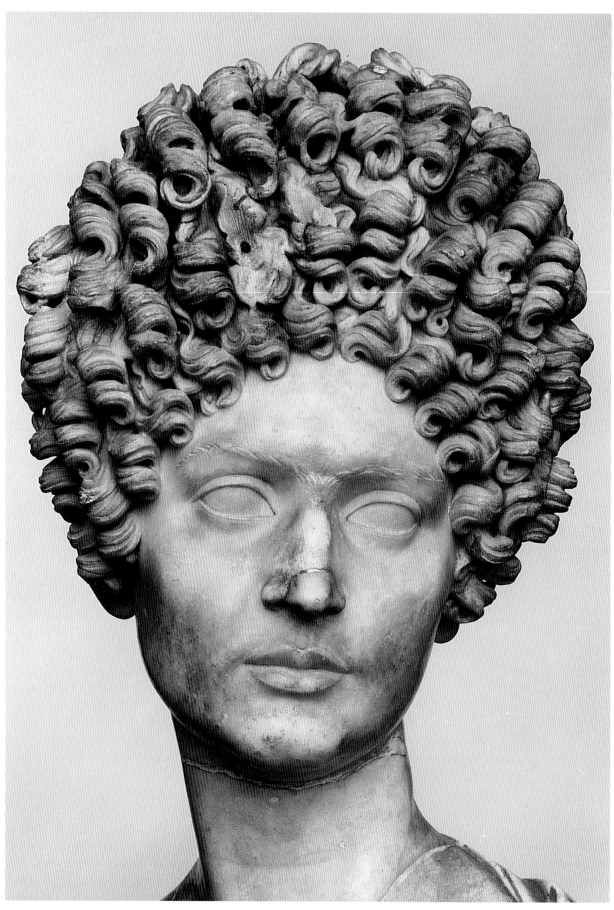

149 Portrait of Vibia Matidia (?), ca.90–100. Rome, Museo
Capitolino. Photo: Gisela Fittschen-Badura

shrines on the hill could have a place to relax and for refreshment. In the Greek context, works for public display normally included not only paintings and sculpture but also war spoils. Alexander the Great hung shields in the Parthenon after his victory at the Battle of Granikos.

The tradition of exhibiting artistic masterpieces in a special setting continued in Roman times. In fact, the need for places of both public and private display increased under the Romans because of the thousands of artworks brought to Italy as spoils of war by conquering Roman generals. Captured arms and armor and famous Greek statues were paraded side by side in Roman triumphal processions and afterward were deposited in fora, temples, basilicas, and museums.

One such a museum was Vespasian's Templum Pacis, even though it was built first and foremost as a monument to the peace brought to Rome and the empire by the Flavian dynasty after both a civil and a foreign war. In this way, its message was comparable to that of Augustus's Ara Pacis Augustae. Reference to another Augustan monument is also apparent in the structure's location. The Templum Pacis faced the Forum of Augustus, from which it was divided only by the Argiletum, which connected the Roman Forum with a residential area of Rome called the Subura. Although it was a temple, the Templum Pacis was layed out like a forum (it is sometimes mistakenly called the Forum Pacis), with a great open rectangular space bordered on three sides by porticoes. The temple itself was located on one of the precinct's short sides, and its six columns were reiterated in the six projecting columns of the complex's entrance gate. The rectangular space between the temple and the gate was planted like a formal garden with regular rows of trees. In terms of its architectural design, the Templum Pacis has much in common with the Claudianum of Claudius, completed by Vespasian, and with the later Library of Hadrian in Athens. What separates it from the other two and from the nearby Fora of Julius Caesar and Augustus, however, is the fact that it served as a museum for pilfered Greek masterpieces, such as Myron's cow and the reclining statue of the personification of the Nile River, and as a backdrop for the display of Flavian war spoils, including the seven-branched candelabrum and the Ark of the Covenant from the temple in Jerusalem.

The Flavian Templum Pacis had Roman as well as Greek prototypes, and its roots can be traced back to republican and Augustan times. A case in point is the Porticus Octaviae, originally built as the Porticus Metelli by Quintus Caecilius Metellus in 147 B.C. but replaced by Augustus during his principate and named for his sister, Octavia. The porticus consisted of a library and two temples but was richly ornamented with works of art by renowned Greek sculptors displayed as if in a museum.

Works exhibited there included an Eros by Praxiteles, the Crouching Aphrodite by Doidalsas, and statues of Jupiter, Juno, and Apollo by Timarchides and his sons, Polykles and Dionysios.

Classicizing Statuary under Domitian

The taste for statues of divinities, both plundered and created anew, continued under the Flavians. A colossal marble cult statue of Mars (fig. 150) was carved under the Flavian dynasts either as a companion for the statue of Minerva in the Temple of Minerva in the Forum of Nerva in which it was discovered or as a replacement for the cult statue of Mars in the Temple of Mars Ultor in the Forum of Augustus. The statue depicts the god in full military regalia with a cuirass decorated with pendant griffins – a favorite Julio-Claudian and Flavian motif found on the breastplate of the statue of Titus from Herculaneum (see fig. 141) – high boots, a shield, and an ornate Corinthian helmet with two flanking pegasi. Although the divinity's even facial features are classically conceived, his face is framed with a tousled coiffure and a long, curly beard. These are articulated with the drill, which is used by the artist to create deep pockets of shadow among the thick curls. The textured hair and beard are played off against the smooth softness of Mars's face in a manner that is reminiscent of female portraiture of the period.

Other statues of divinities were displayed in Domitian's extension of the imperial palace on the Palatine hill begun under Tiberius. Domitian and his architect Rabirius can be credited with designing the new palace, which served as the residence for all future emperors of Rome and carried further the architectural innovations of Nero's architects, Severus and Celer. Domitian's Palatine palace had the same sweeping vaults made of brick-faced concrete as Nero's residence in Rome and was ornamented with a profusion of statuary, most of which no longer survives. The palace was divided into a residential and a public wing; the main audience hall or the *aula regia* of the public wing had aediculated niches for colossal statues, two of which survive and were taken from Rome in the eighteenth century by the Farnese family for their palace in Parma. The statues, made of a striking dark green stone, represent Dionysus and Hercules and may have been displayed in conjunction with statues of other gods and alongside white marble statues of members of the Flavian dynasty. Fragments of statues of a nude male with a cloak and a cuirassed figure, the latter now in the Palazzo Farnese in Rome, have been associated with the same sculptural program, as have sculpted column bases with depictions of trophies and other military symbols.

The statue of Dionysus (fig. 151) depicts him leaning

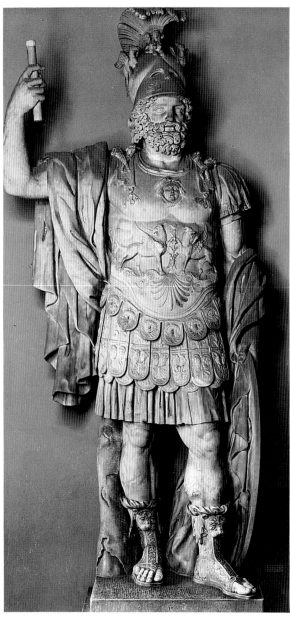

150 Cult statue of Mars, ca.90. Rome, Museo Capitolino.
Photo: DAIR 75.2253

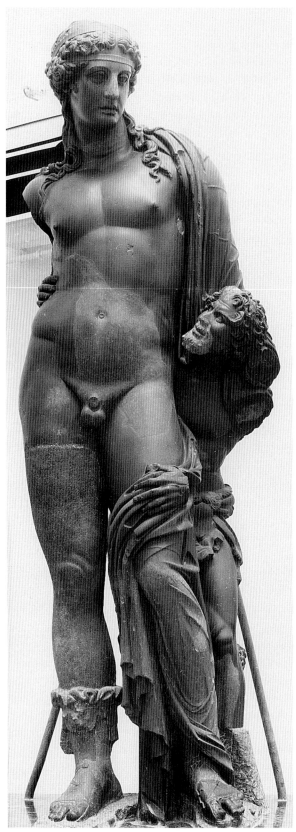

151 Dionysus, from the Aula Regia of the imperial palace on
the Palatine hill, 81–96. Parma, Palazzo Farnese. Photo: DAIR
67.1558

on a small satyr. His weight is on his right foot and his body is sinuously posed. His musculature is soft, emphasizing his sensuality and the image, which emphasizes the relationship between the god and the satyr, seems self contained and even dreamy.

The statue of Hercules (fig. 152) is quite different in spirit. It shows the hero in a contrapposto pose with his weight on his right leg. His right hand, now lost, held the club, the left, also lost, held the apples of the Hesperides, the attribute of Hercules's final labor. The lion skin is draped over a pillar, the bottom of which is restored. The head is turned sharply to the left, and the hero is portrayed with full, tousled hair, large, uplifted eyes, long sideburns, and a thick neck. The artist has exaggerated the musculature of the massive torso and the strong legs, the former consisting of a profusion of bulging rectangular and circular protrusions of solid flesh. The artist's emphasis on the brute power of the hero must have been in keeping with Domitian's view of himself as dominus et deus. It was in the aula regia that Domitian, seated beneath an apse with cosmic connotations, welcomed visiting embassies in the midst of the divi Vespasian and Titus, the Olympian deities, and heroes, like Hercules, who gained immortality through their celebrated deeds. This carefully orchestrated sculptural program must have been intended as an awe-inspiring display of imperial authority.

Flavian State Relief and Domitianic Eclecticism

Also from Domitian's Palace is the so-called Nollekens Relief, which was found east of the state dining hall, the Coenatio Jovis. It is today lost and known only through drawings (for example, fig. 153), but it appears to have been manufactured while Domitian was emperor. It depicts a sacrifice that is in the tradition of earlier sacrifice scenes such as those in the Louvre Suovetaurilia Relief (see fig. 117), but with two noticeable differences. The figures of the sacrificant – probably the emperor – and his companions are almost frontal, and the human emperor interacts with divinities and personifications (Roma or Virtus and the Genius Senatus); such interactions would become one of the hallmarks of Domitianic art.

The three great surviving works of Flavian state relief sculpture are all Domitianic commissions, even though at least two commemorate great events from the principates of Domitian's father and brother – the civil war victory and the subsequent founding of the dynasty, and the victory over Jerusalem. This is not to say that other state reliefs may not have been commissioned under Vespasian and Titus. All the surviving fragments of Flavian state reliefs, including heads of Vespasian and Titus, parts of triumphal processions and sacrifices, and miscellaneous heads of soldiers, and so forth, have been collected. Although some of these are clearly Domitianic in date, others are uncertain. Some of these fragments seem to come from fairly conventional schemes and are closely based on Julio-Claudian prototypes. The Nollekens Sacrifice Relief, just described, as well as fragments depicting a flamen in front of the Augustan Temple of Quirinus, are closely based, respectively, on the Louvre Suovetaurilia (see fig. 117) and the Ara Pietatis Augustae (see fig. 118). The flamen relief, one of several of the so-called Hartwig-Kelsey fragments (after the collectors who acquired them) representing soldiers and idealized figures such as the Genius Populi Romani, and the emperor Vespasian himself, may have been part of scenes of sacrifice and adventus and may have decorated a small structure associated with the Templum Gentis Flaviae on the Quirinal hill. The larger monument comprised a family shrine and mausoleum next to Vespasian's private dwelling. Others, like the great reliefs from the Arch of Titus, are completely innovative.

The Arch of Titus

The earliest of the three major Domitianic state monuments is the Arch of Titus (figs. 154–157), which was erected by Domitian in honor of his brother after Titus's death in 81. The arch is built on the Velia, the spur hill in the Roman Forum that connects the Palatine with the Esquiline, and the site of Nero's Domus Transitoria. Domitian's choice of the location for Titus's arch was not coincidental. Both the Flavian Amphitheater and the Baths of Titus had earlier been erected on the site of Nero's Domus Aurea and served as a symbol of the Flavian policy of returning to the Roman people land expropriated by Nero for his personal use. One of Nero's goals was to link the Esquiline with the Palatine by building the Domus Transitoria on the Velia. The Flavians razed to the ground what survived of the palace after the fire of 64 (the remains of two rooms lie buried underground) and erected the Arch of Titus on the site. The arch is also bypassed by the Via Sacra and, as we shall see, the two relief panels in the central bay are oriented toward the Capitoline hill, the goal of the triumphant general whose procession traversed the Sacred Way.

The inscription on the attic of the Arch of Titus indicates that the monument was erected by the senate and people of Rome in honor of the divine Titus, son of the divine Vespasian. The clear statement is that the arch was therefore put up after Titus's death, but how long after has been the subject of much scholarly controversy. It has

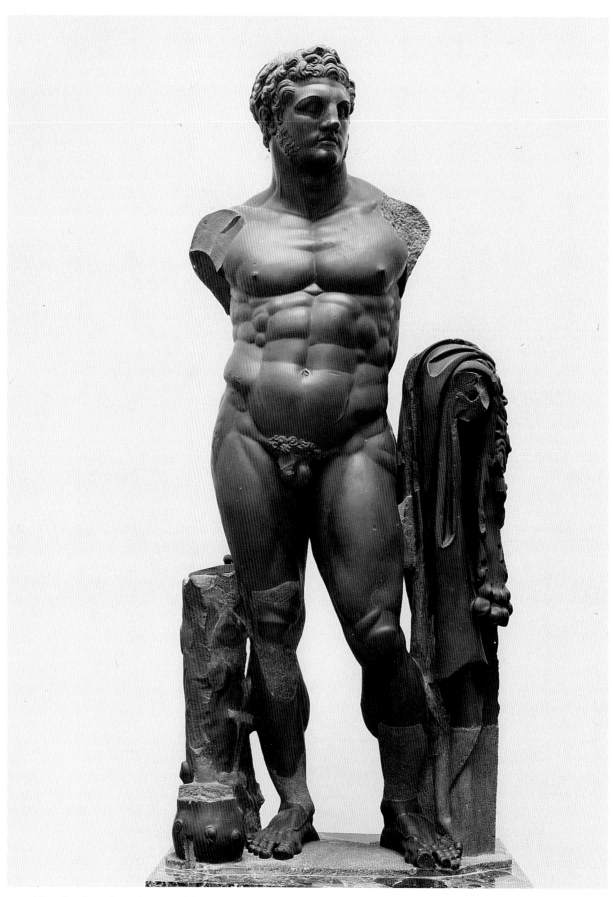

152 Hercules, from the Aula Regia of the imperial palace on
the Palatine hill, 81–96. Parma, Palazzo Farnese. Photo: DAIR
67.1547

153 Drawing of Nollekens Relief, from the Coenatio Jovis
of the imperial palace on the Palatine hill, 81–96. London,
Victoria and Albert Museum. Photo: Courtesy of the Victoria
and Albert Museum

been suggested that the general form of the arch, with
its single bay design and engaged columns, is so close to
that of the Arch of Trajan at Benevento of 114–18 (see
figs. 188–189) that the two must have been executed by
the same workshop. This has led other scholars to posit
a Trajanic date for the Arch of Titus. Nonetheless, the
monument's location on Neronian private property ac-
tively developed by the Flavian dynasty and the subject
of the two great panels in the central bay and of the frieze
that encircles the monument – the joint triumph of Ves-
pasian and Titus after the victory in 70 in the Jewish Wars,
the event that legitimized the Flavian dynasty – make it
more likely that the arch was an early Domitianic project
erected just after Titus's death and deification in 81. We
have seen that it was traditional for a new emperor to
choose as his first major commission a monument that
linked him to his illustrious predecessor, and the idea of
dynasty was as important to Domitian as it had been to
Vespasian and Titus. That the arch was erected by Domi-
tian seems to be proved, however, by the attic decoration

of the arch in the spoils scene – which depicts a man
with a horse flanked by two, four-horse chariots, each
with a driver (see fig. 155). This attic group purports to
represent Domitian as the central figure in a statuary
group that includes Vespasian and Titus in different four-
horse chariots. The description of the Jewish historian
Flavius Josephus of the joint triumph of Vespasian and
Titus, some of which is related below, with Vespasian in
a chariot followed by Titus in another chariot and Domi-
tian riding beside them on a horse, comes immediately
to mind, but the decision to give Domitian a prominent
place is due to the Domitianic date of the commission.
Trajan would never have erected a monument with a re-
lief depicting an arch with attic statuary commemorating
an emperor who had been voted a damnatio memoriae
by the senate.

The Arch of Titus on the Velia is largely the work
of the nineteenth-century restorers Raffaele Stern and
Giuseppe Valadier, who dismantled and reerected it in
1822. The restored sections of the Parian marble arch

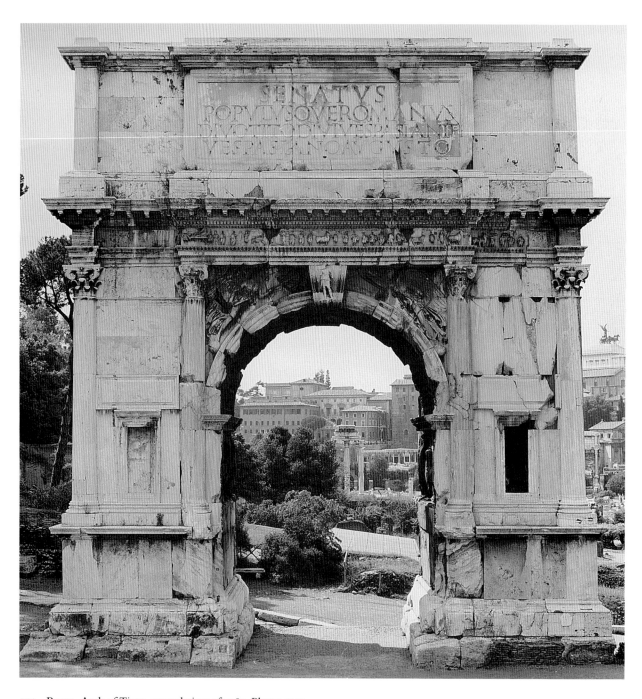

154 Rome, Arch of Titus, general view, after 81. Photo: DAIR
79.2000

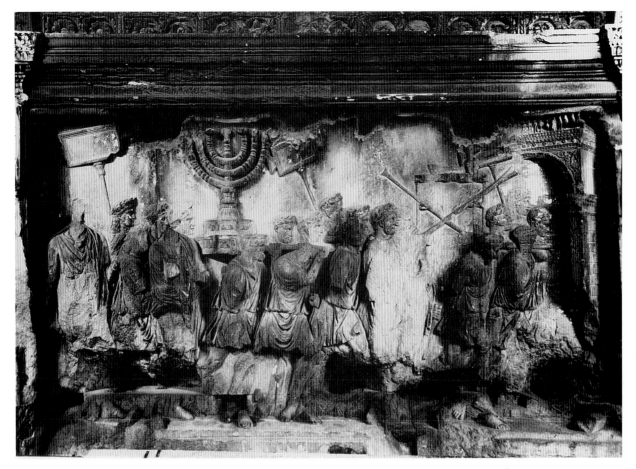

155 Rome, Arch of Titus, spoils relief, after 81. Photo: DAIR
57.893

were added in travertine so that old and new could be differentiated. What led to the damage of the arch was its incorporation into a fortress for the Frangipani family in the Middle Ages. All that survives of the ancient structure is the central bay, including the two great relief panels and the vault, the spandrels, the encircling small frieze, the keystones, two composite capitals, and the dedicatory inscription.

The spandrels are carved with Victories carrying Roman banners, trophies, laurel wreaths, and palm branches. The small frieze depicts in great detail the joint triumph of 71 of Vespasian and Titus. The figures of the small frieze are carved in very high relief. Each one is also separately worked, and there is little overlapping. For these reasons, the figures stand out distinctly from the background and can be seen from a considerable distance.

It is the two large, horizontally oriented relief panels in the central bay that are of the greatest interest. They depict the two key scenes of the triumphal procession – the display of the spoils and Titus in his triumphal chariot. In the spoils panel, the figures march from left to right; in the triumph panel from right to left. In other words, both scenes are deliberately oriented in the direction of

the Temple of Jupiter on the Capitoline hill, the goal of the triumphator.

The Spoils relief (see fig. 155) depicts Roman attendants in short tunics carrying the seven-branched candelabrum and table with ritual objects pilfered from the Temple in Jerusalem that were ultimately displayed in Vespasian's Templum Pacis. The weight of the booty bends the backs of some of the attendants, who proceed with a rush through an archway that is indicated in detail by the artist. The Victory in the right spandrel of the arch, which disappears in an illusionistic haze into the background, carries a palm branch and laurel wreath, as does one of the Victories on the Arch of Titus herself, and the attic of the relief arch is crowned with four figures, three of which are Domitian, Titus, and Vespasian; the fourth and only female figure is probably Domitian's patron goddess, Minerva. The four figures are accompanied by nine horses. One horse belongs to Domitian and the other eight pull the chariots of Vespasian and Titus.

In the accompanying panel (see fig. 156), Titus, carrying Jupiter's scepter and holding a palm branch, stands in a chariot. He is accompanied by Victory, who crowns him with a laurel wreath. The chariot is accompanied by

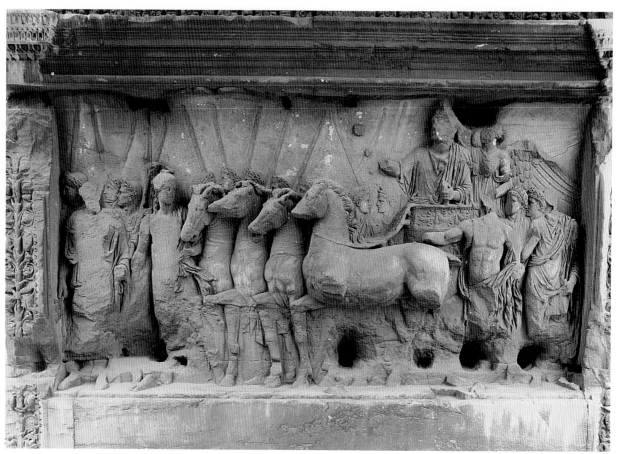

156 Rome, Arch of Titus, triumph relief, after 81. Photo: DAIR 79.2491

the Genius Populi Romani (or perhaps Honos) and the Genius Senatus and is led by four horses. They in turn are guided by Roma (some scholars identify her as Virtus) who welcomes home the triumphant general. His presence is announced by twelve lictors holding their fasces, which seem to flutter in the breeze created by the speeding chariot.

What is of special interest is that the protagonists of the scene are both human and divine, and the triumph panel of the Arch of Titus is the first monumental state relief in which the two coexist (there are earlier numismatic examples). That divine as well as human actors take part in Titus's military triumph indicates that the scene is not a representation of a specific historical event. There are additional indications of this. The triumph of 71 was initially voted for Titus alone but was immediately changed to a joint triumph for Vespasian and Titus. They would have appeared together in the procession, and indeed Josephus describes the scenes of spoils and triumph and indicates that both Vespasian and Domitian were active participants in the event:

The rest of the spoils were borne along in random heaps.

The most interesting of all were the spoils seized from the temple of Jerusalem: a gold table weighing many talents, and a lamp stand, also made of gold, which was made in a form different from that which we usually employ. For there was a central shaft fastened to the base; then spandrels extended from this in an arrangement which rather resembled the shape of a trident, and on the end of each of these spandrels a lamp was forged. There were seven of these, emphasizing the honor accorded to the number seven among the Jews. The law of the Jews was borne along after these as the last of the spoils. In the next section a good many images of Victory were paraded by. The workmanship of all of these was in ivory and gold. Vespasian drove along behind these and Titus followed him; Domitian rode beside them, dressed in a dazzling fashion and riding a horse which was worth seeing. (Flavius Josephus, *Jewish War* VII, 5, 132ff., trans. Pollitt, *Rome: Sources and Documents*, p. 159.)

The great panels of the Arch of Titus thus constitute another example of the Roman penchant for selective storytelling. The wealth of detail in both scenes suggests that they are historically accurate and that in most details the sculpted scenes correspond to historical fact as reported by Josephus. But what is omitted is as interesting

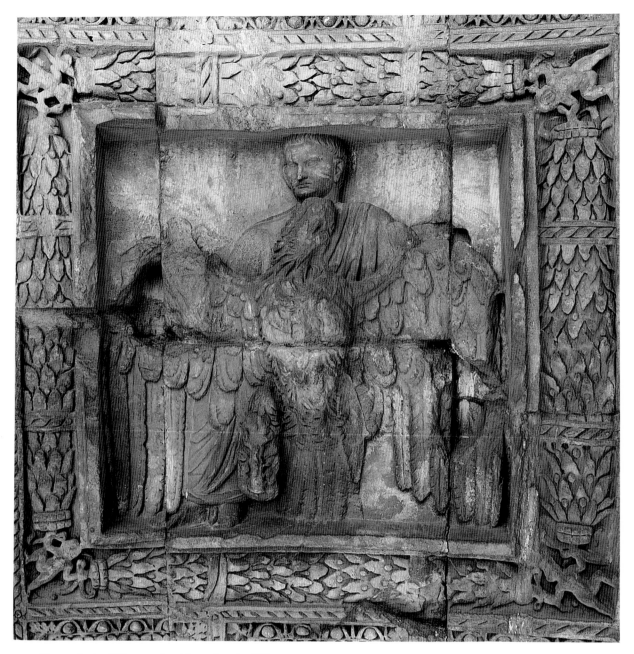

157 Rome, Arch of Titus, vault with apotheosis of Titus, after 81. Photo: DAIR 79.2393

as what is included. Both Vespasian and Domitian were active participants in the triumph, and yet portraits of both are excluded in the two great panels and in the small frieze. They are included, however, as we have seen, in the attic statuary group crowning the arch in the spoils panel. This distinctive arch has recently been identified as a lost Flavian arch that commemorates the same event and could not have been standing at the time of the actual triumph. Its inclusion in this scene is thus another example of the way in which Roman artists took liberties with historical accuracy.

The vault of the Arch of Titus is ornamented with coffers with central rosettes. At the very apex of the vault

is a square panel (see fig. 157) framed with garlands held at the corners by four naked erotes. The panel includes a scene of Titus, dressed in tunic and toga, borne to heaven on the back of an eagle with outstretched wings. It is a representation of Titus's apotheosis because it depicts the emperor's soul carried heavenward by the eagle that was let go by an imperial slave at the very moment of the emperor's cremation. And it is this very apotheosis scene that is the true subject of the Arch of Titus because the arch is a consecration monument, not a victory monument or "triumphal" arch. The apotheosis is the first such extant scene in monumental Roman state relief sculpture, although a gem with a comparable scene of

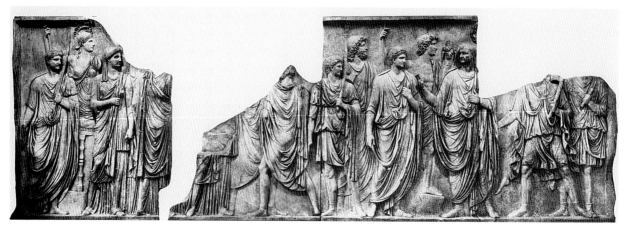

158 Cancelleria Reliefs, adventus of Vespasian, 93–95. Rome, Vatican Museums. Photo: Archivio Fotografico Musei Vaticani, xxv.9.47

159 Cancelleria Reliefs, profectio of Domitian, 93–95. Rome, Vatican Museums. Photo: Archivio Fotografico Musei Vaticani, xxv.9.48

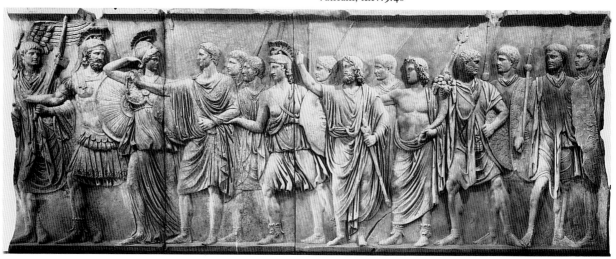

Nero's apotheosis on the back of an eagle has also survived. The portrait of Titus is of special interest because it depicts the emperor with a hairstyle that departs somewhat from its usual configuration. A comparison of the head with the partially preserved portrait of Titus in the triumph panel is instructive. In the triumph relief, Titus is portrayed with his usual full face, rounded lips, and wavy hair. In the vault panel, his distinctive facial characteristics have been somewhat smoothed over, but more important, the curly hair has been replaced with straight comma-shaped locks forming a cap that is roughly comparable to that of Trajan. This correspondence might be used to substantiate further a Trajanic date for the arch, but the idealization and increased abstraction of the portrait of Titus can be more convincingly explained as the result of the emperor's new status as divus.

Thus there is a portrait of Titus as a god in the vault of his arch and one of him at the high point of his life in the chariot scene just below. Eleven years separated Titus's triumph over Jerusalem, and his apotheosis and that passage of time is visually alluded to by the placement of the lifetime relief in the arch's passageway and the apotheosis scene at the arcuation of the vault. The funerary content of the apotheosis scene, the attic inscription referring to Titus as divus, and the discovery of a hollow chamber in the arch's attic has led to the suggestion that the arch served as Titus's tomb. This suggestion is, however, highly unlikely. Even though arches had earlier served as funerary monuments or cenotaphs, Titus appears to have been laid to rest, along with the other members of the Flavian dynasty, in the Mausoleum of Augustus.

The style of the two great panels was termed "illusionistic" by Franz Wickhoff, who described them as the culmination of the most significant achievement of Roman art – the depiction of spatial illusionism. It is certainly true that in the spoils panel in particular the

spectator gets the impression that the Roman attendants, their backs laden with temple spoils, are marching from the foreground to the background through an arch, one side of which also seems to disappear into thin air. That one-third of the relief panel, that which is located above the heads of the figures, is left blank, also contributes to the illusion that there is airy space behind the figures. The relief panel itself is slightly curved at its apex, which casts a shadow across the relief and enhances the illusion of depth.

This illusionistic style is in strong contrast to the classicizing style of the other major state relief sculpture of the period – the so-called Cancelleria Reliefs. The styles are so disparate that some scholars believed that they could not have been commissioned at the same time by the same patron but others have noted the strong eclecticism of the Domitianic period.

The Cancelleria Reliefs

Two well-preserved marble reliefs (figs. 158–159) were discovered in 1937 and 1939 under the Palazzo della Cancelleria in Rome. The two panels, called the Cancelleria Reliefs because of their findspot, were found leaning against the walls of the republican Tomb of Aulus Hirtius. Their position suggests that they were deliberately discarded in what had become a dump by the late first century. The first major publication of the Cancelleria Reliefs was in 1945, and controversy still surrounds them. The date of their manufacture, the identity of their main protagonists, and the appearance of the building for which they were fashioned, continue to be debated. It seems best to present the traditional view and then dissenting opinions since there is little about the Cancelleria Reliefs that is incontrovertible.

The style of the Cancelleria Reliefs is classicizing. The figures are depicted in two relief planes: high relief in the foreground and relatively low relief in the background. The background is completely blank; there are no landscape or architectural elements. Although the bodies of the figures are often represented in frontal or three-quarter views, the heads are always in profile or three-quarter view. As in the two great panels from the Arch of Titus, the heads of the figures do not reach to the top of the frieze, although in the panel that is known as frieze B, the heads of the divinities and personifications in the lower relief tier are higher than those in the foreground.

The first panel, which is usually referred to as frieze B (see fig. 158), has traditionally been interpreted as Vespasian's return to Rome (adventus) in 70 after his victory in the Civil War of 68–69. Domitian is there to greet him

as is Roma, the Genius Senatus, and the Genius Populi Romani. Roma (some scholars identify her as Virtus) is at the far left of the panel. She is seated on a throne further raised on a pedestal, perhaps intended as one of Rome's seven hills. She is dressed in the short tunic of an Amazon with one breast bare. She wears a helmet and holds a spear in her right hand. Below and behind her is the *apparitor* or Vestal's attendant dressed in a tunic and toga. In front of Roma are at least five Vestal Virgins; the head of only one of them is preserved. The Vestals are followed by two lictors in short tunics and mantles and with axes attached to their rods. The one farthest left has his back to the spectator; the one on the right faces front and, along with another lictor on the far right of the relief panel, flanks the central group of Domitian and Vespasian. Domitian, identifiable by his youthfulness, his slightly protruding upper lip, and especially by his hairstyle, which is full, plastically rendered, and arranged in a tiaralike configuration across his forehead, wears a tunic and toga, the folds of which he grasps with both hands. He has a slight beard on his cheeks and chin, which was probably worn by young men before the traditional first shave at age twenty. Even though Domitian's body is depicted in an almost frontal position, his head is turned far to his left to face his approaching father. Vespasian, also in tunic and toga and also frontally positioned, turns his head sharply to his right toward his younger son and greets him by placing his right hand on Domitian's shoulder. Vespasian's portrait shows him with his characteristic short coiffure receding at the temples, lined forehead, cheeks and chin, crow's-feet, arched brows, thin lips, and a tightly controlled expression. Behind Domitian is the mature, bearded, and togate Genius Senatus, and between father and son the youthful, clean-shaven, and seminude Genius Populi Romani. He cradles a cornucopia in his left arm and with his bare feet steps on a raised base. Some scholars identify him as Honos because he carries a lance; otherwise he is almost indistinguishable from the Genius Populi Romani. Above the head of Vespasian are the remains of a laurel wreath, undoubtedly raised above his head by a flying personification of Victory.

Frieze A (see fig. 159) depicts an event that took place around twenty-three years later when Domitian was emperor of Rome – Domitian's departure (profectio) for his Sarmatian War in 92–93. Domitian's Sarmatian War gives a terminus post quem of 93 for the reliefs. They were probably completed by about 95, although at least one scholar connects this panel with Domitian's triumph over the Chatti in 83, and on stylistic and iconographic grounds others date both panels to the Hadrianic period. One of the most recent studies of the reliefs confirms the late Domitianic date, and the portrait of Domitian

in frieze A is identified as an example of his last portrait type. In frieze A, Domitian is led by Victory (only her left wing still survives), by a lictor with a fasces with an ax, by Mars, the god of war, dressed in cuirass and with helmet and shield, and Minerva, goddess of war, clad in aegis and helmet. Minerva was Domitian's divine patroness, and panel A depicts visually their special bond. They gaze at one another intently, and Domitian's right arm projects forward and seems to become one with the upper part of Minerva's right arm; the lower part of her arm bends back toward the emperor. Domitian's relationship with the goddess Roma is also a close one. The emperor, dressed in a short tunic covered by a mantle (his traveling costume), is propelled forward by Roma (or possibly Virtus), identified by her short Amazonian costume, with one breast bare, and her helmet. She places her right hand under the emperor's left elbow and urges him on his way. She is followed by the Genius Senatus, with beard, toga, and scepter, and the Genius Populi Romani, with bare chest and cornucopia, who wave good-bye to Domitian. They are both accompanied and followed by Roman soldiers traveling with the emperor.

Careful examination of the figure of Domitian reveals that although the hairstyle is clearly the Neronian coma in gradus formata that he favored, the head is too small for the body, and the facial characteristics – slanting forehead, thin lips, and hooked nose – are not those of Vespasian's younger son. Comparison of the head with a portrait of Domitian's successor, Nerva, from Tivoli (see fig. 170), indicates that the head was recarved with the later emperor's features.

Both panels have dowel holes and must have originally been attached to a building in Rome. One scholar believes that the reliefs were recarved before their removal from the monument; another has convincingly refuted this theory. Suggested locations include the Temple of Fortuna Redux, the Porticus Divorum, and the Porta Triumphalis. In any case, what is of special interest is that subsequent to the assassination and damnatio memoriae of Domitian, Nerva decided to alter the reliefs for reuse in a monument commemorating his new regime. Frieze A was recut, and the imperial protagonist given the features of Rome's new emperor, a man favored by the senate. Nerva was, in fact, one of the senate's most respected and eldest members. He was also not in the best health, and it was, therefore, not surprising that he died sixteen months later. Frieze B had not yet been recarved; the emperor's head in frieze A was too small to be recut again. Despite the high artistic quality of the Cancelleria Reliefs, the decision was made to discard them. There is no better example in Roman sculpture of the overriding political significance of an imperially sponsored state relief.

This standard interpretation of both friezes A and B has been increasingly challenged in recent years, with emphasis shifting from frieze A to frieze B. That Domitian's head was recarved as Nerva has long been accepted, and dispute about frieze A has focused on whether the scene was a profectio or an adventus and whether it took place in the 80s or 90s. Frieze B, with what were identified as original portraits of Vespasian and Domitian, seemed less controversial until it was suggested that the head of Vespasian had been reworked, which seems to be confirmed by careful stylistic analysis of the head in question. This keen observation is of the greatest significance because, if correct, it means that the emperor crowned by Victory in frieze B – the most important figure in the frieze – was originally someone other than Vespasian. The recarving presumably also took place under Nerva, who chose to have the head of the emperor in frieze B replaced with Vespasian's rather than his own. Scholars who believe that the head of the emperor was recarved as Vespasian under Nerva suggest that the original head depicted Domitian and that the youthful togatus is to be identified as someone else, possibly a young priest. Nerva's decision to transform the head of Domitian into one of Vespasian was done in order to bind the new emperor to the founder of the Flavian dynasty rather than to his immediate predecessor – the despot Domitian – just as Vespasian bound himself in dynastic groups and other monuments to Augustus and Claudius rather than to Nero. One scholar, who also identifies frieze A as Domitian's adventus into Rome after his Sarmatian victory rather than his profectio, believes that both friezes A and B originally depicted Domitian and extolled his imperial virtues. Frieze A honored the virtus of the imperator in battle, and frieze B the pietas of Domitian as pontifex maximus. The religious nature of the scene in frieze B is attested by the presence of the Vestals. The jury is still out, so to speak, on the Cancelleria Reliefs, but it becomes increasingly apparent that the careful study of the heads of the main protagonists on state reliefs for evidence of reworking will have as critical an effect on their interpretation as the study of reworked heads has already had on understanding the chronology and political iconography of imperial portraiture.

The Forum Transitorium

The Forum Transitorium was constructed in Rome in the late 80s or early 90s as part of Domitian's building program. It enclosed the Argiletum, and was bordered

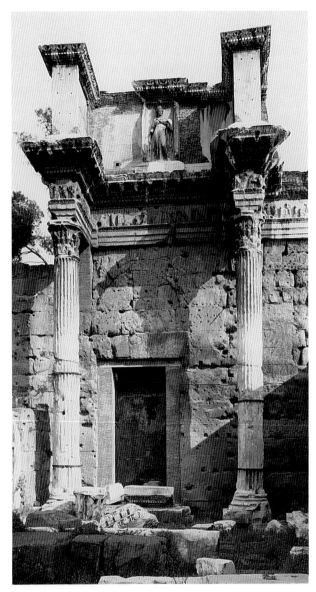

by the Forum of Augustus and the Templum Pacis. Its name, which clearly makes reference to its location, was changed in 97 to the Forum of Nerva (Forum Nervae) when it was dedicated by Nerva after Domitian's assassination and damnatio memoriae.

Although all that survives of the Forum is the single bay of a colonnade, known in modern times as Le Colonnacce, the monument originally encompassed a long and narrow rectangular space open to the sky and bordered by colonnades on the two long sides and the short side closest to the Roman Forum. The other, short side was occupied by the Temple of Minerva, which no longer survives because the building stones were incorporated in 1606 into a fountain in Rome for Pope Paul v. Although the architectural scheme of the Forum Transitorium was clearly based on those of the fora of Julius Caesar and Augustus, there is one significant difference. The roofed colonnades of the earlier fora have been replaced by a series of shallow bays and an engaged colonnade with projecting ressauts bracketed out from the walls. This solution was clearly devised by an architect who wanted to give the illusion that the Forum Transitorium was the traditional forum he lacked the space to build.

Le Colonnacce consist of two Corinthian columns crowned by a figural frieze and an attic panel representing a warlike Minerva clad in a paludamentum and a military belt or *cingulum* (fig. 160). While her face is classically conceived with even perfect features, her coiffure is deeply drilled to accentuate the contrast between the soft flesh and the texture of the hair. Her costume is voluminous and is used by the artist to display his virtuosity in portraying drapery that both reveals the body and creates its own patterns. The frieze (fig. 161) is located on the bracketed entablature and is unfortunately poorly preserved, but some of its stock mythological figures and personifi-

160 Rome, Forum Transitorium, view of colonnade, 80s–90s. Photo: DAIR 67.960

161 Rome, Forum Transitorium, detail of frieze, 80s–90s. Photo: DAIR 77.238

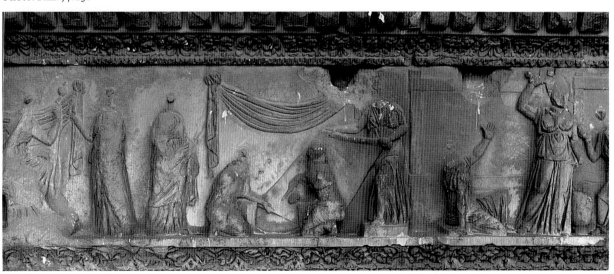

cations of nearby locales can be identified. The emphasis on these is not surprising in the Domitianic context because, as we have seen, the relief panels from both the Arch of Titus and the Cancelleria Reliefs have human and divine protagonists intermingling. There is clearly a significant mythological component in Domitianic state relief sculpture undoubtedly a result of Domitian's phil-hellenic leanings and Julio-Claudian pretensions. The key surviving scene in the frieze is located directly below the attic panel of Minerva and depicts Minerva's punishment of Arachne. It serves as a warning to the spectator of the fate that befalls someone who defies the goddess's authority. Flanking scenes depict women spinning and weaving under the tutelage of Minerva. It has been demonstrated that these are not straightforward genre scenes but moralizing exempla of virtues. Imperial virtues, like pietas, pudicitia, and iustitia (justice) are celebrated in other sections of the frieze. The choice of the Arachne myth as the centerpiece of the frieze may also reflect Domitian's moral legislation that reinforced the earlier moral laws of Augustus. Under Domitian, the feminine virtue of chastity was highly prized, and a woman's skill at weaving signified that she embodied the traditional ideals of a Roman matron – including a devotion to her family and home, modesty, and above all chastity.

The style of the Forum Transitorium frieze is not the illusionism of the great panels of the Arch of Titus, nor is it the classicism of the Cancelleria Reliefs. Space is left blank above the figures' heads to connote an airy setting, as in the two other Domitianic commissions. Unlike them, however, the background of the Forum Transitorium frieze is filled with landscape elements like trees, and deities and river gods sit on rocky outcroppings. The figures are small and compact and are depicted in relatively high relief, and most are aligned side by side with little overlapping.

It is apparent from our discussion of Domitianic state relief sculpture that there was no one distinctive style used by artists and workshops in the imperial employ. Furthermore, Roman eclecticism under Domitian includes still another distinctive style used by Domitianic artists working for freedmen and not imperial patrons. This style is especially apparent in the narrative scenes from the Tomb of the Haterii.

The Art of Freedmen
The Funerary Altars of Freedmen
and the Tomb of the Haterii

The Funerary Altars of Freedmen
Roman funerary altars with portraits are among our most important documents of the family life of freed-

men in ancient Rome. They were originally set up in open-air precincts or in front of or inside monumental tombs lining the roads leading from the city. They bear inscriptions that provide abbreviated biographies of the deceased, giving such details as age, profession, family lineage, and so on, and sometimes include pictorial illustrations of characteristic activities of the deceased during his or her lifetime.

The altars are generally about a meter high, although some exceed two meters and appear almost as miniature tombs. The portrait or portraits are usually placed at the top of the altar in a niche or pediment or in a rectangular windowlike frame at the center of the front side. Below is inscribed the epitaph, which usually has its own frame. Beside or beneath the epitaph, or on the sides of the altar, may also be depicted a scene from daily life.

The epitaphs are of special interest because they reveal that the families who commissioned these monuments were almost always recently enfranchised slaves or their immediate offspring. Their familial relations are emphasized in the epitaphs, but the inscriptions also provide status designations for the honorees and dedicants and occasionally refer to their social and ethnic background or to their professions and religious beliefs. Most of those who were honored by funerary altars with portraits or who commissioned them were slaves or freedmen. Their professions were those usually pursued by freedmen; they were teachers, magistrates, bankers, architects, artisans, writers, musicians, and so on. Most prominent among these were members of the familia Caesaris – imperial slaves and freedmen who conducted business for the emperors and often owned their own slaves. They worked in the domestic sphere or as civil servants.

The Roman funerary altars with portraits began to be commissioned in the Tiberian period, and production continued until the fourth century, but the majority of pieces – at least one-half of those surviving – were manufactured in the Flavian and Trajanic periods. A case in point is the Altar of Cornelia Glyce from Rome (fig. 162). It dates to about 80, that is, to the principate of Titus, and all four corners of the stone are decorated with palm trees, which in the imperial context referred to the emperor's military victories in Judaea. Dates are suspended from the two trees on the front of the altar. They were probably included as an illustration of the woman's name, Glyce, and express the conceit of sweetness. The altar was erected by Quintus Petillius Secundus in honor of his mother whose portrait is contained in a rectangular niche on the front of the altar. Like the portrait of the woman from the Haterius family discussed below (see fig. 168), Glyce's portrait is bust-length. It extends to the breastbone, and she is draped in tunic and palla. Glyce has an oval face and large eyes with heavy lids, and she

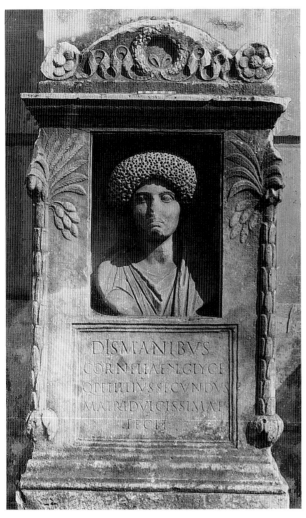

162 Funerary altar of Cornelia Glyce, ca.80. Rome, Vatican Museums. Photo: DAIR 1161

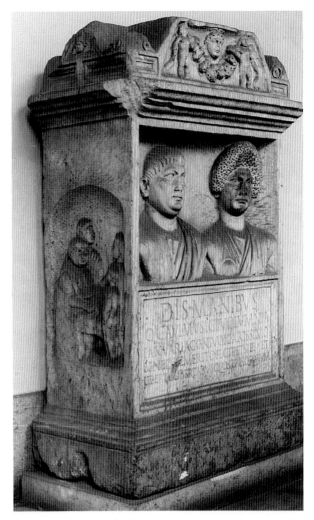

163 Funerary altar of Q. Gavius Musicus, late Flavian or early Trajanic. Rome, Vatican Museums. Photo: D. E. E. Kleiner and F. S. Kleiner, 72.26.18

wears a coiffure popular in contemporary court circles – the domed halo – with its marble mass penetrated by the artist with the drill, a coiffure that finds its closest analogy in that of Julia Titi in the well-known portrait in Rome of about 80–81 (see fig. 147).

The Altar of Quintus Gavius Musicus (fig. 163) was produced during Domitian's principate or in the early Trajanic period. It was erected by Musicus's wife, Volumnia Ianuaria, in honor of her husband, herself, their freedmen, and their descendants. Even though he had died and she was still alive, they are depicted as a married couple reunited in perpetuity.

Husband and wife are represented together as bust portraits in a rectangular windowlike frame on the front of the altar resembling late republican and Augustan funerary reliefs. Ianuaria has an oval face, thin lips, broad nose, and almond-shaped eyes. Lines in her forehead, jaw, and neck suggest middle age. She wears her hair

in a tall, full coiffure that almost reaches a point at the apex. A series of corkscrew curls accentuated by the drill are piled one upon another in a fairly regular manner. The height of the pointed coiffure and the regularity of the drilled holes are paralleled in the portrait of Domitia from Terracina (see fig. 148). Musicus has a round fleshy face with heavy chin. His lips are narrow, his eyes almond-shaped. He wears his hair combed down from the crown of his head over his forehead in slightly curved strands in a manner that was popular among men in the Trajanic period.

Musicus's cognomen suggests that he was a musician or a music teacher. A scene on the left side of the altar depicts him with his students, whereas the scene on the monument's right side represents the couple's slaves in a funerary procession led by Proserpina who, as goddess of the underworld, welcomes the deceased to her abode.

The Tomb of the Haterii

Few, if any, Roman tombs survive intact. The Mausolea of Augustus and Hadrian, the great burial chambers of the emperors from Augustus to the Antonines, for example, were long ago stripped of their marble revetments and commemorative statuary. Aristocratic tombs and the tombs of freedmen on the Via Latina at Rome or at Ostia have fared somewhat better with their preserved stuccoed ceilings, painted walls, and interior sculpture. Still, the relief sculpture from the late Flavian or early Trajanic Tomb of the Haterii is an exceptional document of tomb decor, funerary portraiture, and sepulchral symbolism in the late first century.

The Tomb of the Haterii, which stood in a walled funerary garden ornamented with sculpture, was first discovered in 1848 in excavations of an ancient wall a few miles from the Porta Maggiore in Rome. The tomb was carved with sepulchral inscriptions identifying its patrons as freedmen and was decorated with portrait busts and reliefs. Altars and tombstones also enhanced the complex. The site of the mausoleum was accidentally uncovered again in 1969–70, and additional inscriptions and relief sculptures were unearthed.

Scholars have posited that three of the reliefs with scenes of the lying-in-state, a monumental tomb, and buildings along the Sacra Via, were intended as a narrative sequence. The lying-in-state relief (fig. 164) shows a scene of a deceased female member of the Haterius family lying on a funerary bed or *lectus*. The representation of the deceased on a couch has a long history in ancient art and can be traced to Greek and Etruscan precedents, although the scene of an actual lying-in-state is rare; that on the Haterii monument is the only surviving depiction in Roman art. The scene appears to take place in the atrium of a private house because there are columns behind the bed, perhaps belonging to a tetrastyle atrium seen longitudinally, from which are suspended funerary garlands. The scene is lighted by flaming torches and candelabra. The reclining bejeweled matron is tall in stature because of her important status, and at her feet are the four tablets of her last will and testament. The funerary bed is surrounded by a host of less significant and thus diminutive figures: a male slave about to place a garland around the deceased's neck, the woman's two daughters beating their breasts in grief and leading the other mourners, a female flute player and a female dirge singer, and a procession of male and female mourners, probably domestic slaves or freedmen, and at the foot of the bed, four additional grieving women wearing *pillei* or conical caps, the sign of manumission. These are undoubtedly the woman's loyal slaves freed in her will. At the upper right is a small square panel depicting the same woman seated at a desk and in the act of composing her will, with

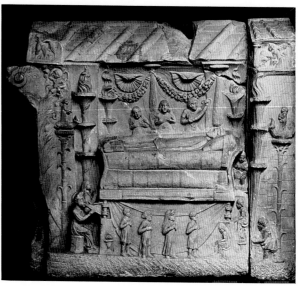

164 Tomb of the Haterii, lying-in-state relief, late Flavian or early Trajanic. Rome, Vatican Museums. Photo: DAIR 81.2858

an attendant present as witness. The spectator is thus at the same time viewing the woman in life and death, a simultaneous presentation not unlike that of Titus on his arch in the triumphal chariot and as a divus (see figs. 156–157). The corresponding scenes on the upper left, which depict a battle between Pan and Eros and below a herdsman with a large ram's head, have been associated with Dionysiac symbolism and probably refer to the woman's hope for a Bacchic resurrection. Most striking perhaps is the contrast in scale among figures. As already mentioned, the deceased matron is the largest figure; if she were to rise from her funerary bed she would dwarf the others. The man with garland, the woman's two daughters, and the flute player are of intermediate size, and the slaves, freedmen and freedwomen, and dirge singer are of miniature scale. Clearly, the artist has used comparative size to establish a hierarchy among figures, a technique not used contemporaneously in state relief sculpture but apparent in freedman reliefs as early as the late republican and Augustan periods, as, for example, in the funerary relief from Amiternum (see fig. 88) and in the Tomb of Eurysaces in Rome (see fig. 95). As in those reliefs, the artist's primary concern is to tell his story; what better way to denote importance than through relative scale. We will see that it is an effective convention eventually adopted by Late Antique court artists as well.

The second relief in the possibly narrative series is the Sacra Via Relief (fig. 165), depicting five buildings and parts of two others in a narrow rectangular panel. Some scholars interpret the scene as a view of the buildings along the route of the funerary cortege, others as a display of key Flavian monuments, and still others as the Flavian building projects in which Quintus Haterius Tychicus,

a contractor and a member of the Haterius family, participated. At present, the last suggestion is the one most widely accepted; its likelihood is underscored by the inclusion of a building crane in one of the tomb's other reliefs. The first hypothesis is also plausible. It has been pointed out that the buildings are depicted in different relief planes and are of disparate heights, and the artist may have been employed a perspective scheme to give the impression that the edifices were located in different positions along the route of the funerary cortege that began, by reading the buildings in the relief from right to left, near the Temple of Jupiter Stator in the Roman Forum, went under the Arch of Titus on the Velia, descended toward a Domitianic quadrifrons, encircled the Colosseum, followed the Via Labicana, passed beneath the Arch to Isis, winding up at the Porta Maggiore, and then followed the Via Casilina to the family burial precinct – visually alluded to in the ornamented pilaster on the far left of the relief, similar to that on the right corner of the tomb depicted in the tomb-crane relief. The identifications of the two arches that are labeled in the Sacra Via Relief as the "arcus in sacra via summa" and the "arcus ad Isis," the Arch of Titus and Arch to Isis, are highly controversial. The Arch of Titus differs in a number of significant details from the arcus in sacra via summa on the Haterii Relief, but exact correspondence was not intended by the artist, who had clearly identified the monument by giving its precise location in the attic inscription.

The tomb-crane relief (fig. 166) is the third of the so-called narrative panels. Most of the relief is occupied by the representation of a temple tomb in a precinct clearly intended to stand for the actual Tomb of the Haterii that was also of the temple-tomb type and surrounded by an enclosure wall. The relief tomb has a high podium, a single staircase, four columns along the porch, and pilasters decorating the podium and the tomb's second story. A portrait of the Haterius matron, undoubtedly

the same woman as the deceased in the lying-in-state relief, is located in the monument's pediment; portraits of the woman's three children, two boys and a girl, are enclosed in shell niches on the side of the mausoleum. The children probably predeceased her since they are shown playing at the foot of her funerary bed and as busts on the top of a funerary arch honoring her at the top right of the relief. The deceased is again depicted beneath the arcuated bay of the arch. She is totally nude, and the portrait is a type of Venus deification that was popular with freedwomen. These scenes are separated from the tomb below by a ledge supported by eagles carrying a garland; it has been suggested that they reflect the sculptural decoration inside the tomb. Perhaps the most controversial detail is the large crane at the left of the tomb, thought by most to refer to the profession of the deceased's husband, a building contractor in Flavian Rome. But the object decked with laurel and palm branches at the crane's apex has also been identified as the *liknon* or winnowing basket that held the phallus, the focus of the Dionysiac mystery rites. That it is lifted on a crane may refer to the apotheosis of initiates into the popular mystery religion.

The symbolism of death and rebirth is also apparent in the mythological scenes from the Tomb of the Haterii that depict the rape of Proserpina and Proserpina's reunion with her parents in heaven (the relief of Mercury, Proserpina, Jupiter, and Ceres).

Bust-length portraits in aediculae of the deceased matron and her husband, Quintus Haterius, were also part of the sculptural program of the Tomb of the Haterii. The woman (fig. 167), undoubtedly the deceased in the lying-in-state and tomb-crane reliefs, wears a tunic and palla, and the bust extends below the breasts. It rests on a small, round pedestal. Her face is that of a mature woman, although it is still unlined and she wears her hair not in the Flavian corkscrew curl halo but in a simpler style that was also favored by some Flavian women, especially freedwomen. It is parted in the center and brushed

165 Tomb of the Haterii, Sacra Via Relief, late Flavian or early Trajanic. Rome, Vatican Museums. Photo: DAIR 81.2859

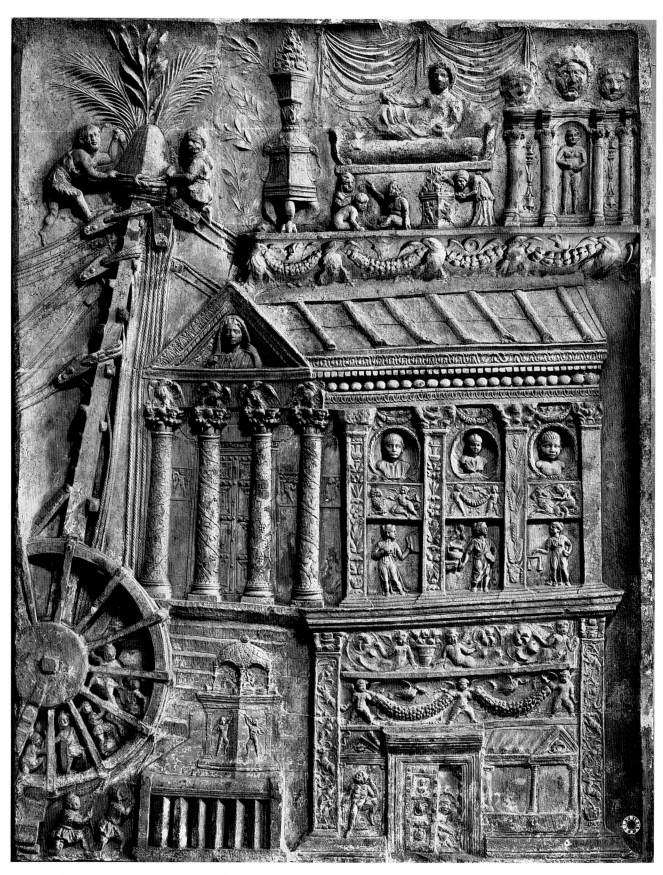

166 Tomb of the Haterii, tomb-crane relief, late Flavian or early Trajanic. Rome, Vatican Museums. Photo: Alinari/Art Resource, New York, 1875b

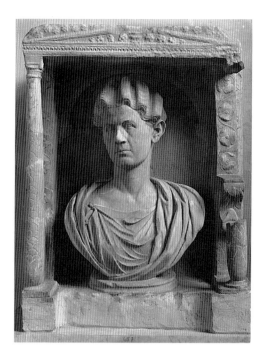

167 Tomb of the Haterii, portrait of the deceased wife of Quintus Haterius, late Flavian or early Trajanic. Rome, Vatican Museums. Photo: Alinari/Art Resource, New York, 29908

in deep waves back behind the ears and swept into a large bun at the back of the head. She has a long swanlike neck, not unlike that of the woman sometimes identified as Vibia Matidia (see fig. 149), and her head is turned sharply to her right and toward her husband whose portrait is enclosed in a companion aedicula (fig. 168). His chest is bare, and a mantle is draped across his left shoulder. The bust, which extends below the breastbone, rests on a serpent, the symbol of death and rebirth. His face is turned abruptly to his left to face his wife and is done in the Flavian veristic style of male portraiture. The man's curly hair is receding at the temples, the veins in his forehead are visible, as are the furrows and creases that mar his aging cheeks and brow. There are crow's-feet at the corners of his eyes. Busts of both husband and wife were executed by a talented portrait artist who was well versed in the current court style. It is apparent that in Flavian times, portraits of freedmen continued to be closely based on imperial and aristocratic prototypes, with their roots in Hellenistic portraiture, while narrative scenes conformed to a tradition that favored storytelling and symbol over form and classical grace.

The Period of Transition
Art under Nerva

Marcus Cocceius Nerva, possibly involved in the successful plot to assassinate Domitian, became his successor in September of 96. Nerva, born at Narnia in Italy in about 30, was already sixty-six at his accession. He was also feeble, and it came as a surprise to no one that he died of natural causes after only sixteen months in office. Despite his age and infirmity, Nerva was selected by the senate as the new emperor because he himself was one of its respected members and was deemed likely to uphold its values. A man with senatorial experience and connections who was praised for his oratorical skills and evenhanded justice was just the kind of person who could provide stability to Rome after the excesses of Domitian's principate. Domitian's autocratic regime was replaced by Nerva with a return to the Augustan model of government and a relaxation of censorship. Nerva instituted an alimentary program to benefit the poor and set aside funds for the repair of aqueducts and to build corn granaries. His social programs were continued and further expanded by his successor, Trajan. In fact, it was Nerva's choice of his successor that was probably his greatest contribution because it was under Trajan and the other "good" emperors of the second century that Rome and its empire witnessed an artistic efflorescence even greater than experienced under the Flavians. Nerva's adoption of Trajan as his son and successor also set the stage for the

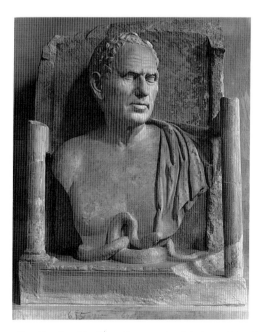

168 Tomb of the Haterii, portrait of Quintus Haterius, late Flavian or early Trajanic. Rome, Vatican Museums. Photo: Alinari/Art Resource, New York, 29907

dynastic practices of the second century when the ruling emperor chose a successor who was not necessarily his blood relative. Nerva was childless as well as infirm, and his other significant liability was a lack of the popularity with the military that had brought Vespasian to power; the Praetorians were openly hostile to him. To placate them, Nerva adopted Trajan, an illustrious Roman general, as his son in September 97 and invested him with powers almost equal to his own. Just a few months later, Nerva died and was deified.

During the brief time he was emperor, Nerva did not initiate any major building projects, in part because funds from the imperial treasury were seriously depleted by Domitian's extensive building and military campaigns. Nerva did, however, expropriate at least two of his predecessor's monuments. These included the Forum Transitorium, which was renamed the Forum of Nerva and dedicated in 97 (see fig. 160), and the Cancelleria Reliefs, in which the head of Domitian in the profectio scene was recarved as that of Nerva (see fig. 159). The head retains Domitian's wavy coiffure, which was recut only over the forehead to remove the characteristic Domitianic tiara of comma-shaped locks. Otherwise, the portrait exhibits Nerva's features: a squarish face with prominent cheekbones, large hooked nose, closely set eyes, deeply shadowed beneath straight brows, high furrowed forehead, creases above the nose next to the rounded mouth and around the jaw, and a prominent Adam's apple. The features are imbued with a serious expression befitting a highly regarded elder statesman. It is apparent that the artist who recarved this head was attempting to create a realistic likeness of Rome's new emperor that would clearly follow in the tradition of Flavian verism.

Nerva's brief principate gave him little time to commission new monuments according to his own specifications. Yet, there are surviving numismatic portraits and portraits in the round of the emperor.

The sestertii of Nerva, struck in Rome in 97 also show Nerva as a serious statesman with a distinctive profile composed of a sloping forehead, large hooked nose, piercing eyes, thin lips, and a small but firm chin. He has a prominent Adam's apple and a long, thin neck. The face is that of a mature man, but there are few visible facial lines with the exception of a crease across the forehead and short, naso-labial lines. Most striking is the hair, which is not the Neronian tiara or the short military coiffure. Instead, it is a full cap of tousled hair that radiates from the crown of the head, grows relatively long on the neck, and is arranged in curls across the forehead. The coiffure is intentionally reminiscent of those of Augustus and the Julio-Claudians. Thus, although Nerva had himself depicted as the mature elder statesman of the senate whose portraits draw on the veristic tradition of

Galba, Vitellius, Vespasian, and Titus, he – like Domitian – made visual allusion to his desire to resuscitate Augustan ideals by adopting what could only be recognized as an Augustan and Julio-Claudian cap of hair. Trajan rejects the former but retains and even emphasizes more emphatically the latter. Nerva's portraits, like his imperial policies, thus serve as a bridge between those of the Flavian age and those of Trajanic times.

Only fifteen marble portraits of Nerva survive, and only three were newly manufactured during Nerva's principate. These include heads in Copenhagen, Florence, and Rome. The others were recarved from portraits of earlier imperial personages, which explains the deviations apparent in the extant portraits of Nerva and probably makes a precise typology of Nerva's portraits virtually impossible. It has nevertheless been suggested that most of the heads are based on a single prototype. Those heads reworked from a Domitianic core are probably lifetime versions, whereas others that have more pronounced stylistic affinities with Trajanic portraiture were probably posthumous creations. That the latter were commissioned is not surprising since Nerva adopted Trajan as his son and was honored by his successor as one of his two "fathers."

The marble portrait of Nerva in Copenhagen (fig. 169) seems to be an original produced during Nerva's lifetime and not a recarved Domitianic head. In profile, it is strikingly similar to Nerva's coin portraits of 97. The emperor is depicted with a sloping, slightly creased forehead, a hooked nose, small lips, strong chin, and prominent Adam's apple. His hair is long and tousled with layered curls arranged across his forehead, brushed in front of his ears and relatively long on his neck.

The best-known portrait of Nerva and the one that is traditionally compared to the recut head of the emperor in the Cancelleria Reliefs (see fig. 159) is an over-life-size marble portrait from Tivoli (fig. 170). Considered by most scholars to be a posthumous version carved in Trajanic times and by others as a Domitianic head recarved as Nerva during Nerva's lifetime, it captures the emperor's most distinctive features – the sloping, lightly creased forehead, small eyes beneath straight brows, hooked nose, small, rounded mouth, and long neck with prominent Adam's apple. The emperor is depicted as a man of advancing years whose head is crowned with a full coiffure, with the hair brushed from the crown of the head in front of the ears and long on the neck. The hair across the forehead is arranged in individual comma-shaped locks that closely approximate their Augustan and Julio-Claudian prototypes. It is thus apparent from a close examination of the hairstyle that something new was beginning to happen in imperial portraiture at the very end of the first century. What was innovative was

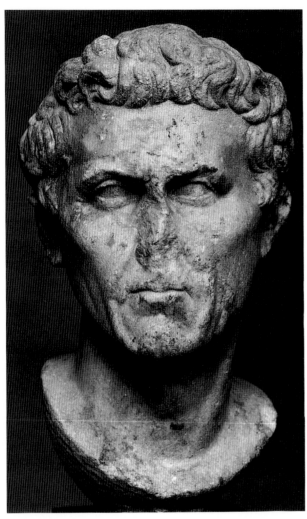

The Domitianic breastplate, decorated with sea creatures, vegetal motifs, an aegis, and the infant Hercules strangling serpents, was not altered under Nerva. Scholars have posited that these various motifs make general reference to Domitian's dominance over land and sea and refer specifically to Domitian's planned offensive against Parthia. In its original form, the statue was probably erected to commemorate the opening of the Via Domitiana that ran through Misenum.

The figure of the rider, although found in pieces, is fully preserved, as is the head of the horse and its forelegs and hind hoof. The group may be distinguished from all other surviving examples of its type by the rearing action of the galloping horse held in check by the emperor who leans backward as he balances the animal's forward motion. Although the horse's forelegs were both raised above the ground, it has thus far been conjectured that the emperor was not in the act of trampling a barbarian. Rather, it has been suggested that such a barbarian or the figure of a river god may have ornamented a strut, now missing, beneath the belly of the horse.

169 Portrait of Nerva, ca.97. Copenhagen, Ny Carlsberg Glyptotek. Photo: Courtesy of the Ny Carlsberg Glyptotek, Copenhagen

that the models for some of Nerva's and Trajan's lifetime portraits were not the portraits of the Flavians but those of Rome's first emperor, Augustus, and his immediate successors.

The remains of a bronze equestrian statue of late first-century date were discovered in the early 1970s near the shrine of the Augustales in the Forum at Misenum. Although originally commissioned to commemorate Domitian and still possessing the back of his head, the front of the head of the statue was replaced after Domitian's death with a bronze mask with Nerva's features. The portrait of Nerva appears to have been based on the same prototype as those preserved in marble and depicts him with sloping brow, hooked nose, small chin, furrowed forehead, and facial creases above the nose and around the mouth. A full coiffure with curly locks carefully arranged across the forehead and hair long on the nape of the neck displays its indebtedness to Augustan and Julio-Claudian models.

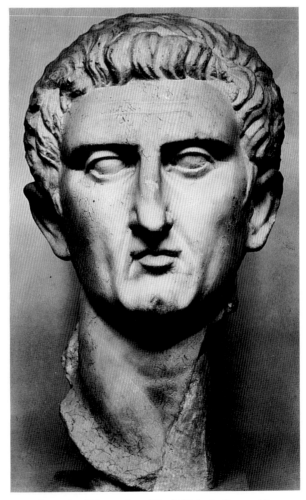

170 Portrait of Nerva, from Tivoli, Trajanic. Rome, Museo Nazionale delle Terme. Photo: DAIR 70.233

The Contribution of Flavian Art and the Significance of Domitianic Eclecticism

It is apparent from the preceding discussion that the Flavians made a significant contribution to the stability of Rome and to the development of Roman art. Vespasian put an end to a divisive civil war and brought peace and prosperity to the empire. During Vespasian's ten-year rule, he established a new dynasty, and his elder son Titus celebrated a major foreign victory over Jerusalem. Titus's success in the Jewish Wars, shared with his father in a joint triumph, gave legitimacy to the new dynasty and became the focus of the new imperial iconography on coins, in portraiture, and in state relief sculpture. In fact, art and ideology were closely intertwined in monuments that celebrated war and peace, civil and foreign victory, hereditary rule, and – under Domitian – social reform. Vespasian's Templum Pacis, for example, commemorated the peace brought to Rome after civil and foreign wars and served as the place of display for the Jewish War spoils. The Flavian Amphitheater, the Baths of Titus, and the Arch of Titus were built over the remains of Nero's two pleasure palaces, a symbol of the Flavian attempt to return to the Roman people that which the despot had expropriated. Furthermore, it is in the relief sculpture on the Arch of Titus that the victory over Jerusalem finds its most detailed visual explication. War and its aftermath are also the subject of the Domitianic Cancelleria Reliefs, and the reliefs from the Forum Transitorium make reference to Domitian's social legislation and the feminine virtues of devotion to home, modesty, and chastity.

Despite Domitian's moral laws, which established stringent rules for female behavior, and the Flavian focus on war and dynastic entitlement, both the purview of men, women played an important part in Flavian art. Female, as well as male, divinities and personifications interact with the imperial protagonists in the reliefs on the Arch of Titus and the Cancelleria Reliefs. Roma or Virtus, for example, welcomes Vespasian home from the civil war and Titus home from the war in Judaea, and Victory crowns Titus during his triumph and predicts Domitian's victory in the Sarmatian War. Minerva leads Domitian to his Sarmatian victory and is honored as the emperor's divine patroness in the temple and relief sculpture of the Forum Transitorium. The empresses are not included in any surviving Flavian state relief as they are in the earlier Ara Pacis Augustae and in the later "Arco di Portogallo." As in the Julio-Claudian period, they *are* honored in the imperial coinage, in dynastic groups, and with individual portraits in the round, where they are depicted masquerading as goddesses and with the elaborate hairstyles of the day. It is, nevertheless, among the upwardly mobile class of former slaves and not in the imperial or aristocratic sphere that we learn most about Flavian women. The narrative and portrait sculpture of the Tomb of the Haterii, erected by and commemorating libertini, gives a relatively complete picture of the life of a Flavian woman who is devoted to her children and her religion and epitomizes Domitian's ideal of a virtuous Roman matron. The tomb reliefs also serve as a record of Roman funerary rites and of the skyline of Flavian Rome.

Vespasian and Titus commissioned imperial portraits in a veristic style that resuscitated a republican realism that had already been exploited in the portraits of Galba and Vitellius. Domitian's resemblance to his father and brother is reflected in his portraiture, but his affinity to the Julio-Claudians is also stressed by his court artists. The study of Flavian portraiture is complicated by the fact that untold numbers of Neronian portraits, which had been removed from public display after the emperor's suicide and damnatio memoriae, were available for re-carving under the Flavians. While the court artists in the employ of Vespasian and Titus altered these considerably, Domitian's sculptors intentionally accentuated the relation between him and his Julio-Claudian predecessors. Although the carving style of male portraits of the Flavian period is relatively restrained, the artists of the day were allowed free rein in their depiction of female members of the Flavian court. The portraits of Flavian women are not as veristic as their male counterparts, but female members of the Flavian court were depicted in a frank manner. Wrinkles and sagging skin were incorporated into some of the portraits. From the stylistic standpoint, however, the portraits of Flavian men and women did not develop in tandem. Fashionable Flavian ladies had a taste for elaborate coiffures, and the ornate configurations of curls were probably achieved through wigs. These allowed sculptors to experiment with the way the texture of hair could be played off against the softness of smooth female skin, a contrast that was to be exploited even more fully under Hadrian and the Antonines. While the portraiture of Nerva continued the veristic tradition of Galba, Vitellius, Vespasian, and Titus, Nerva wore a looser coiffure, which – like that of Domitian – is indebted to Julio-Claudian models.

Something should also be said of what I have termed Domitianic eclecticism. It has already been suggested that Roman art was eclectic from its beginnings and in that sense was modern in its approach. The Romans inherited and learned from the artistic experiments of the Egyptians, Greeks, and Etruscans. Roman patrons and artists adapted what was useful to them, rejected the rest, and

added to the recipe the subject matter of Roman civic and religious life, as well as significant formal and iconographic innovations. It is, perhaps, freedom of artistic choice that is the hallmark of Roman art, and there is no better example of that freedom than the disparate styles employed in the imperial sculpture of Domi-

tian's principate: verism in the portraits of Vespasian and Titus, a Julio-Claudian revival in Domitianic portraiture, a highly ornate female portrait style, illusionism in the Arch of Titus, and neo-classicism in the Cancelleria Reliefs and in the statues of divinities.

Bibliography

Suetonius's *Twelve Caesars* includes biographies of the emperors of 68–69 and of the Flavian dynasts. The *Oxford Classical Dictionary*, 2d ed., provides abbreviated modern biographies. For the monumental architectural projects of the Flavian age, see J. B. Ward-Perkins, *Roman Imperial Architecture* (Harmondsworth, 1981).

The Portraiture of Galba, Otho, and Vitellius: V. Poulsen, *Les portraits romains* 2 (Copenhagen, 1974), 38. E. Fabbricotti, *Galba* (Rome, 1976).

The Portraiture of Vespasian, Titus, and Domitian: G. Förscher, "Das Porträt des Vespasian auf römischen Münzen," *Berliner Numismatische Zeitschrift* 25 (1959), 3–10; 26 (1960), 25–32. V. Poulsen, *Les portraits romains* 2 (Copenhagen, 1974), 38–44. G. Daltrop, U. Hausmann, and M. Wegner, *Die Flavier* (Berlin, 1966). R. Bianchi Bandinelli, *Rome: The Center of Power* (New York, 1970), 212. K. Fittschen, *Katalog der antiken Skulpturen in Schloss Erbach* (Berlin, 1977), 63–67, no. 21 (Titus). M. Bergmann and P. Zanker, "'Damnatio Memoriae' Umgearbeitete Nero- und Domitiansporträts: Zur Ikonographie der flavischen Kaiser und des Nerva," *JdI* 96 (1981), 317–412. H. Jucker, "Iulisch-Claudische Kaiser- und Prinzenporträts als 'Palimpseste,'" *JdI* 96 (1981), 311–13. G. Paladini, "Tradizione e intenzione nel ritratto di Vespasiano," *ANRW* II.12.2 (1981), 612–22. K. Fittschen and P. Zanker, *Katalog der römischen Porträts in den Capitolinischen Museen und den anderen kommunalen Sammlungen der Stadt Rom*, I (Mainz, 1985), 33–37. S. Stone, III, "The Imperial Sculptural Group in the Metroon at Olympia," *AM* 100 (1985), 377–91. W. Grünhagen, "Ein Porträt des Domitian aus Munigua," *MM* 27 (1986), 309–23.

Flavian Female Portraiture: U. Hausmann, "Bildnisse zweier junger Römerinnen in Fiesole," *JdI* 74 (1959), 164–202. G. Daltrop, U. Hausmann, and M. Wegner, *Die Flavier* (Berlin, 1966). V. Poulsen, *Les portraits romains* 2 (Copenhagen, 1974), 44–50. U. Hausmann, "Zu den Bildnissen der Domitia Longina und der Julia Titi," *RM* 82 (1975) 315–28. S. Stone, III, "The Imperial Sculptural Group in the Metroon at Olympia," *AM* 100 (1985), 377–91.

Ancient Museums: D. Strong, "Roman Museums," *Archaeological Theory and Practice* (London, 1973), 247–64. C. C. Vermeule, *Greek Sculpture and Roman Taste* (Ann Arbor, 1977). J. J. Pollitt, "The Impact of Greek Art on Rome," *TAPA* 108 (1978), 155–74.

Templum Pacis: A. M. Colini, "Forum Pacis," *BullCom* 65 (1937), 7–40. F. Castagnoli, "L'angolo meridionale

del Foro della Pace," *BullCom* 76 (1956–58), 119–42. J. C. Anderson, Jr., *The Historical Topography of the Imperial Fora* (Brussels, 1984), 101–18.

The Flavian Statue of Mars Ultor: C. C. Vermeule, "Hellenistic and Roman Cuirassed Statues," *Berytus* 13 (1959), 44, no. 78. Helbig, 4th ed., vol. 2, 46–48, no. 1198 (E. Simon). P. Zanker, *Forum Augustum* (Tübingen, 1968), 18, fig. 49. K. Stemmer, *Untersuchungen zur Typologie, Chronologie und Ikonographie der Panzerstatuen* (Berlin, 1978), 140, n. 489. R. A. Gergel, "A Julio-Claudian Torso in the Walters Art Gallery," *JWalt* 45 (1987), 22, fig. 10.

The Sculpture of Domitian's Aula Regia: J. Sieveking, "Symposionszene," *JdI* 56 (1941), 70–72. T. Kraus, *Das römische Weltreich* (Berlin, 1967), 247, pl. 16. K. Stemmer, "Fragment einer kolossalen Panzerstatue Domitians? Zur Kolossalität in flavischer Zeit," *AA* (1971), 563–80. B. Andreae, *The Art of Rome* (New York, 1977), 180, figs. 397–98. C. C. Vermeule, *Greek Sculpture and Roman Taste* (Ann Arbor, 1977), 53–54, fig. 53.

Nollekens Relief, Hartwig-Kelsey Fragments, and Fragments of Other Flavian Reliefs: G. Koeppel, "Fragments from a Domitianic Monument in Ann Arbor and Rome," *Bulletin: Museums of Art and Archaeology, The University of Michigan* 3 (1980), 15–29 (the Hartwig-Kelsey fragments). G. Koeppel, "Die historischen Reliefs der römischen Kaiserzeit II: Städtrömische Denkmäler unbekannter Bauzugehörigkeit aus flavischer Zeit," *BonnJbb* 184 (1984), 1–65 (esp. 12–13, 46–49 for the Nollekens Relief, and 13–15, 51–61 for the Hartwig-Kelsey fragments). M. R. Di Mino and M. Bertinetti, eds., *Archeologia a Roma: La materia e la tecnica nell'arte antica* (Rome, 1990), 138–42, no. 117 (R. Paris).

Arch of Titus: F. Wickhoff, *Wiener Genesis* (Vienna, 1895). K. Lehmann-Hartleben, "L'Arco di Tito," *BullCom* 62 (1934), 89–122. P. H. von Blanckenhagen, "Elemente der römischen Kunst am Beispiel des flavischen Stils," *Das Neue Bild der Antike* 2 (1942), 310–41. F. J. Hassel, *Der Trajansbogen in Benevent* (Mainz, 1966), 23–30. A. Bonanno, *Portraits and Other Heads on Roman Historical Relief up to the Age of Septimius Severus* (Oxford, 1976), 62–68. M. Pfanner, *Der Titusbogen* (Mainz, 1983). R. R. Holloway, "Some Remarks on the Arch of Titus," *AntCl* 56 (1987), 183–91. F. S. Kleiner, "The Arches of Vespasian in Rome," *RM* 97 (1990), 127–36.

Cancelleria Reliefs: F. Magi, *I rilievi flavi del Palazzo della Cancelleria* (Rome, 1945). J. M. C. Toynbee, *The Flavian Reliefs from the Palazzo della Cancelleria in Rome* (London, 1957). E. Simon, "Zu den flavischen reliefs von der Cancelleria," *JdI* 75 (1960), 134–56. E. Keller, "Studien zu den Cancelleria-Reliefs: Zur Ikonographie der Personifika-

tionen und Profectio- bzw. Adventusdarstellungen," *Klio* 49 (1967), 193–217. A. M. McCann, "A Re-dating of the Reliefs from the Palazzo della Cancelleria," *RM* 79 (1972), 249–76. F. Magi. "Brevi osservazioni su di una nuova datazione dei rilievi della Cancelleria," *RM* 80 (1973), 289–91. A. Bonanno, *Portraits and Other Heads on Roman Historical Relief up to the Age of Septimius Severus* (Oxford, 1976), 52–61. M. Pfanner, "Technische Beobachtungen an den Cancelleriareliefs," *AA* (1981), 514–18. M. Bergmann and P. Zanker, " 'Damnatio Memoriae' Umgearbeitete Nero- und Domitianporträts," *JdI* 96 (1981), 366. M. Bergmann, "Zum Fries B der flavischen Cancelleriareliefs," *MarbWPr* (1981), 19–31. H. W. Ritter, "Ein neuer Deutungsvorschlag zum Fries B der Cancelleriareliefs," *MarbWPr* (1982), 25–36. G. Koeppel, "Die historischen Reliefs der römischen Kaiserzeit II: Städtrömische Denkmäler unbekannter Bauzugehörigkeit aus flavischer Zeit," *BonnJbb* 184 (1984), 5–9, 28–34. E. Simon, "Virtus und Pietas: Zu den Friesen A und B von der Cancelleria," *JdI* 100 (1985), 543–55.

Forum Transitorium: P. H. von Blanckenhagen, *Flavische Architektur und ihre Dekoration: Untersucht am Nervaforum* (Berlin, 1940). H. Bauer, "Il foro transitorio," *RendPontAcc* 49 (1976–77), 118–48. J. Anderson, *The Historical Topography of the Imperial Fora* (Brussels, 1984), 119–39. E. D'Ambra, *Palladis Artes: The Frieze of the Forum Transitorium in Rome* (Diss., Yale University, 1987).

The Funerary Altars of Freedmen: W. Altmann, *Die römischen Grabaltäre der Kaiserzeit* (Berlin, 1905). G. Daltrop, "Bildnisbüsten von Ehepaaren an römischen Grabaltären," *Eikones AntK-BH* 12 (Bern, 1980), 85 (Altar of Q. Gavius Musicus). D. E. E. Kleiner, *Roman Imperial Funerary Altars with Portraits* (Rome, 1987). D. Boschung, *Antike Grabaltäre aus den Nekropolen Roms* (Bern, 1987).

Tomb of the Haterii: F. Castagnoli, "Gli edifici rappresentati in un rilievo del sepolcro degli Haterii," *BullCom* 69 (1941), 59–69. G. Rodenwaldt, "Porträtbüsten vom Hateriergrab," *AA* 56 (1941), cols. 766–77. A. Giuliano, "Documenti per servire allo studio del monumento degli Haterii, *MemLinc* ser. 8, vol. 13 (1968), 449–82. W. Jensen, *The Sculptures from the Tomb of the Haterii* 1–2 (Diss., University of Michigan, 1978). H. Wrede, *Consecratio in Formam Deorum* (Mainz, 1981), 71–72, 82–83, 89–90, 98, 123, 160–61, 164.

The Portraiture of Nerva: G. Daltrop, U. Hausmann, and M. Wegner, *Die Flavier* (Berlin, 1966), 43–48, 109–14. V. Poulsen, *Les portraits romains* 2 (Copenhagen, 1974), 61–63. A. Giuliano, ed., *Museo Nazionale Romano: Le sculture* I, I (Rome, 1979), 279, no. 172 (V. Picciotti Giornetti). M. Bergmann and P. Zanker, " 'Damnatio Memoriae,' Umgearbeitete Nero- und Domitiansporträts: Zur Ikonographie der flavischen Kaiser und des Nerva," *JdI* 96 (1981), 317–412. F. Zevi, "Die Pferde von San Marco," *Ausstellungskatalog, Berlin Staatliche Museen* 8.3–24.4 (1982), 192–93, no. 96 (bronze equestrian statue of Nerva from Misenum). F. Zevi, "Equestrian Statue of Nerva from Miseno," in *The Horses of San Marco* (New York, 1979), 45–47, fig. 62. K. Fittschen and P. Zanker, *Katalog der römischen Porträts in den Capitolinischen Museen und den anderen kommunalen Sammlungen der Stadt Rom,* I (Mainz, 1985), 37–38. *Domiziano/Nerva: La statua equestre da Miseno – Una proposta di ricomposizione* (Naples, 1987). J. Bergemann, *Römische Reiterstatuen* (Mainz, 1990), 82–86.

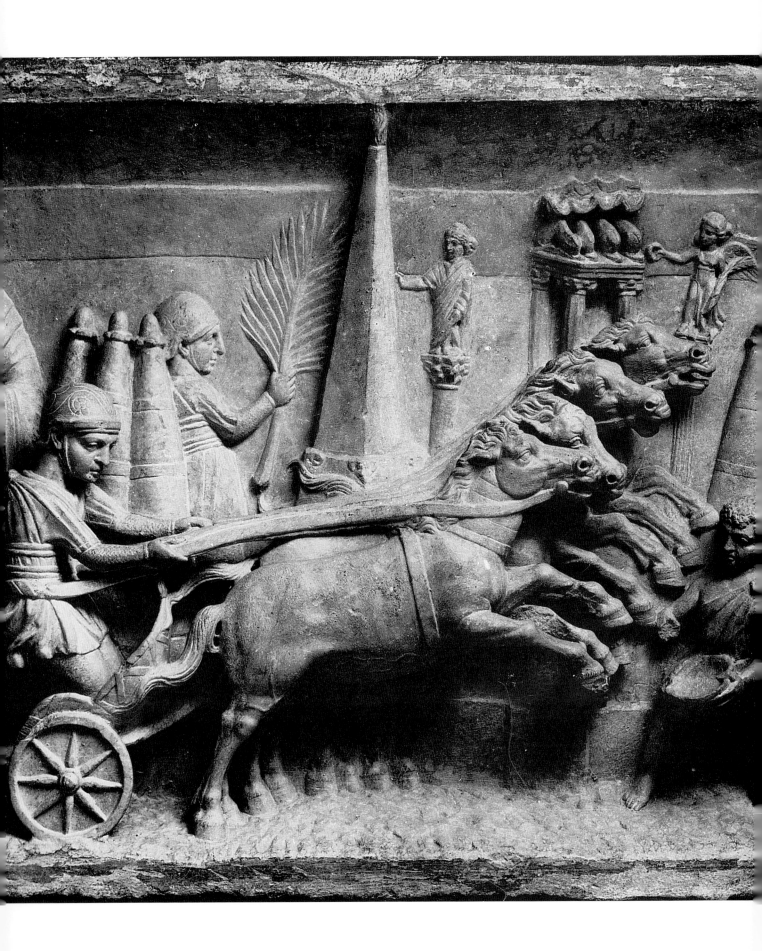

ART UNDER TRAJAN & HADRIAN

CHAPTER V

Military Expansion under Trajan and the Art of the Soldier-Emperor

Trajan (Marcus Ulpius Traianus), emperor of Rome between 98 and 117, was the first of the Roman emperors to be born in a province of the empire rather than in Italy. This in itself is of significance. He was born in Italica in Baetica, part of Hispania, the son of Marcus Ulpius Traianus – of Italic origin – and of a Spanish woman. Trajan had an important military career, and much of Trajan's art reflects his military exploits and their consequences for Rome. Some of his monuments, for example, his forum, column, and markets in Rome, were even funded from the spoils of war. Trajan held commands in Spain, the Rhine, and Danube, and fought the Dacians and the Parthians. He was triumphant over both. For his Dacian conquests, he was awarded the title *Dacicus*. Other titles bestowed on him were *Germanicus* and *Parthicus*. Like Augustus, Trajan professed to prefer the title princeps and did not want to be worshipped as dominus et deus as Domitian had been. His own virtuous persona was matched by that of his wife, Plotina, whose simple tastes, piety, and dignity, were widely praised. As a couple, they produced no heirs. Trajan's relations with the senate were harmonious, and Trajan, like Augustus before him, enacted important social legislation, founded colonies, and instituted a major public building program that concentrated on roads, gates, meeting and market-places, and so forth. He distributed congiaria in 99 and 102 and may have instituted the *institutio alimentaria* or alimentary system, attributed by some to his predecessor Nerva. Dacia was made a province, Arabia and Nabataea were annexed, and the emperor celebrated major victories over Parthia. These military campaigns led to the founding of colonies in a wide variety of locales around the world, many of which were embellished with structures in the Roman style for the first time. These colonies were overseen by provincial governors who had been chosen with greater care than under Nerva. Increasingly, men from the provinces were selected for senatorial posts in Rome.

At home, Trajan initiated public works, at first con-

Detail. Circus relief, perhaps from Ostia, Trajanic or early Hadrianic. Rome, Vatican Museums, Museo Gregoriano Profano. Photo: DAIR 39.557

centrating on repairs and the building of roads, but the vast cache of war spoils from the emperor's second Dacian campaign allowed Trajan to embark on a significant public building program in Rome that rivaled that of Augustus and the Flavians. The centerpiece of Trajan's Rome was the Forum of Trajan with its vast forecourt, grandiose basilica, Greek and Latin libraries, and its column, sculptured with scenes retelling in minute detail the emperor's Dacian exploits. Trajan also built the Baths of Trajan, which were fed by the Aqua Traiana. The Dacian victory was also celebrated in the provinces, as, for example, in a trophy to Trajan on the site of one of the battles, and Trajan's full career was summarized in the relief panels that covered his arch at Benevento, south of Rome.

Trajan was adopted by Nerva in 97. Nerva, himself unpopular with the army, undoubtedly chose Trajan as his successor because of Trajan's experience as a soldier and general. Trajan used his military expertise to expand the borders of the empire to their farthest reaches. It was left to his successors to consolidate and maintain his great conquests. The emperor fittingly died at Selinus in Cilicia in 117 while returning to Rome from the front. He was divinized, and his ashes were deposited in a golden urn in the base of his column in his forum in Rome. It was Trajan who was the first emperor since Augustus to possess the special aura that led to his designation as *optimus,* informally from 100 and officially from 114. The legacy of the man and his accomplishments were almost equal to those of Augustus, and it was to Trajan more than to Rome's first emperor that emperors of the second, third, and fourth centuries liked to make reference. In fact, Eutropius reports that in the late empire, emperors received acclamation in the senate as "more fortunate than Augustus, better than Trajan" (*felicior Augusto, melior Traiano*).

The Portraiture of Trajan

The portraits of Trajan are of considerable interest because – if Augustus was the eternal youth – Trajan was the ageless adult. Trajan came to power at the age of forty-five (he was most likely born in 53, less likely in 56); he is represented as being that age throughout his principate, as if his visage were frozen in time. The portraits made of Trajan during his lifetime have been divided into several types. These types include a first type that dates to the few years after his adoption by Nerva, a second type created in about 103, the Decennial type of 108 – celebrating his decennalia – and a few postdecennial types, including the Sacrifice type, so called because it appears time and again on the Column of Trajan in numerous sacrifice

scenes. The distinctions among the types are very subtle and have to do for the most part with the arrangement of the hair over the forehead and on the nape of the neck.

A portrait in the Museo Capitolino (fig. 171) represents Trajan in his type 1 portrait. His face is smooth and he is clean shaven, although deep lines etch either side of his mouth to suggest adulthood. His eyes are deeply shadowed beneath prominent brows that are more supple than the sharp ridges of Augustan portraiture. The hair is combed from the crown of the head in long strands arranged straight across the forehead with a division at the center. What is most significant about Trajan's cap of hair is that it is not Vespasian's bald pate, nor Titus's short but curly coiffure, nor even Domitian's late Julio-Claudian tiara. The individual strands are arranged in a pattern of comma-shaped locks over the emperor's forehead, a style reminiscent of early Julio-Claudian times. The reference to Augustus and to such Julio-Claudians as Tiberius and Claudius was certainly a deliberate one. Trajan's goal was to disassociate himself from the Flavians, especially Domitian, and to play up his connection to Augustus. This is not surprising since Trajan, like Augustus before him, chose to expand the empire, and both emperors enacted major social legislation. Military

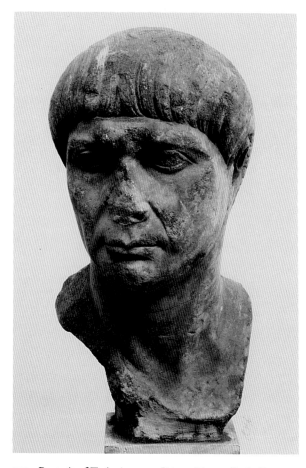

171 Portrait of Trajan, ca.100. Rome, Museo Capitolino. Photo: Gisela Fittschen-Badura

themes were popular in both Augustan and Trajanic art, as well as in the Flavian period. Trajan's military exploits are celebrated in his art, and he is often represented in his portraits in military guise. The Capitoline portrait is a case in point. The edge of a paludamentum is preserved on the left shoulder, and on the right part of a balteus can be detected.

The second type conforms to numismatic portraits of Trajan of 103–104 and has been designated the Paris 1250-Mariemont type after portraits today in those locations. The forehead locks are divided in the center as in type 1, but the hair is more plastically rendered in thicker, wavier locks, and the strands in front of the ears face in different directions. Another portrait in the Museo Capitolino with paludamentum and balteus (largely restored) belongs to this second type.

Trajan's Decennial type, initiated in 108, is well illustrated by another Capitoline portrait. A bust-length portrait of Trajan, formerly in the Albani Collection (fig. 172), represents the emperor in 108 at the age of fifty-five. The portrait is one of many preserved copies of the best-known portrait type of Trajan – the Decennial type – made to celebrate the decennalia of Trajan and comparable to portraits on coins of the same year. Although only a portrait that extends to the breastbone (the extension of the bust to this level is characteristic of Trajanic times, although the bust is heavily restored and therefore not completely reliable), the paludamentum and balteus of the Roman general are included in the image as in the two earlier portraits. The portrait is known in four high-quality replicas, including other heads in the Vatican, Venice, and London. It has been pointed out that although the head is a recognizable portrait of Trajan, his features have been ennobled and simplified but energized with a striking vibrancy, and the long strands of his cap of hair are all brushed in the same leftward direction.

The Sacrifice type of Trajan's portraits, comparable to those on the Column of Trajan and dating to about 112, maintains the simplified forms and energetic immediacy of the Decennial type, but there is a slight variation in the coiffure. Although most of the hair strands face left, those over the left ear curl to the right.

Full-length portraits of Trajan also show him as imperator in military guise, as, for example, a late Trajanic marble statue from the Schola of Trajan in Ostia (fig. 173). Trajan is displayed in a subtle contrapposto with his right leg straight and left leg bent. His left arm is at his side and his right arm raised. He probably held a staff or spear on which his weight rests. He is portrayed as the ageless adult with an Augustan cap of hair. A mantle is draped over his left shoulder, and he wears a decorated cuirass with an apotropaic Medusa head at the top. A scene in the center depicts two winged female personifi-

cations of Victory, each with one knee on the back of a bull. The Victories are heraldically arranged and pull back the necks of the bulls so that they can slit their throats. This is a motif with a long history and can, in fact, be traced back all the way to fifth-century Greece. On the parapet of the Temple of Athena Nike on the Acropolis of Athens were displayed numerous figures of Victory in the act of slaying bulls, arranging garlands, and so on. In both the Greek and the Roman context, two ideas are conflated. The Victories stand not only for the military victory achieved by Athens over the Persians and by the Roman emperor, but also for the sacrifice in which bulls are slain in honor of that victory. It was to become a popular theme in Trajanic art, appearing also in Trajan's Basilica Ulpia in Rome (see fig. 178) and on the Arch of Trajan at Benevento (see figs. 188–189).

The finest surviving portrait of Trajan and one of the greatest Roman portraits preserved from antiquity is the posthumous portrait of the emperor found near the Theater in Ostia (fig. 174). It depicts the emperor as an ageless adult with a cap of Augustan hair, and a shiny polished surface. It is made of Greek marble and was probably created in Hadrianic times by a Greek artist. The cap of hair is of special interest. The strands are brushed from the crown of the head over the forehead as in lifetime portraits of the emperor, but the three center curls are accentuated and framed by additional locks on either side in a coiffure that is based most closely on Trajan's Sacrifice type. It is in this portrait of Trajan, more than any other, that the emperor is assimilated to Augustus because this three-lock coiffure is the Trajanic version of Augustus's so-called Primaporta hairstyle (see fig. 42).

Trajan had a close relationship with his father and celebrated that kinship in art. At the death of the elder Trajan in 112, the emperor had him divinized and struck coins with his image. These are of special interest. They have a portrait of Trajan on the obverse and on the reverse a double portrait, one of Trajan's real father, divus Traianus pater, and one of Trajan's adopted father, Divus Nerva. This coin honors not only Trajan's two fathers, but is another fine example of political propaganda on coins among the Romans. The message of the deified pair on the coin's reverse is that Trajan, emperor of Rome, is of doubly divine descent.

A bronze portrait of a man on a shield (the *imago clipeata* type) in Ankara (fig. 175), often identified as a portrait of Trajan, is interesting in this regard. The man has Trajan's facial features and his cap of hair but is depicted as old, with deeply etched forehead, cheeks, and neck. Since Trajan is always depicted as a mature adult and not as an old man, a more likely identification for the portrait is the elder Trajan. The sharp turn of the head to the left suggests that the portrait was one of a pair of honorific

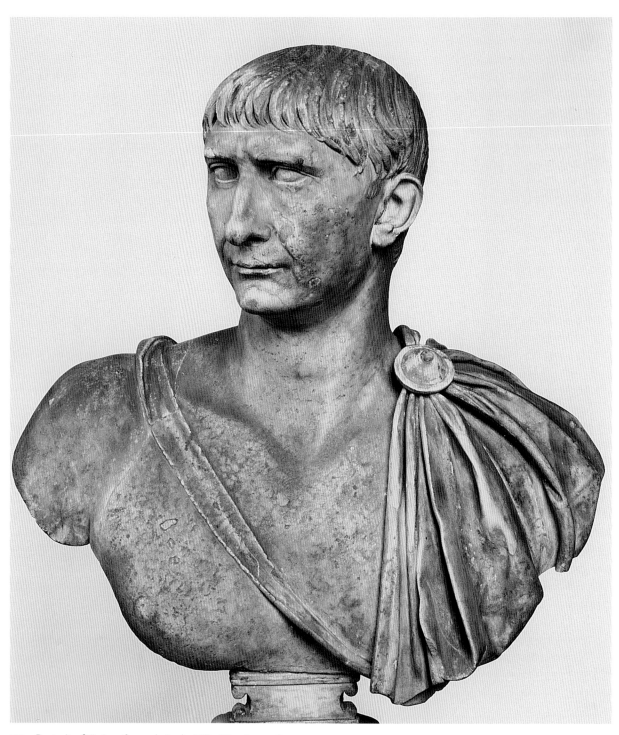

172 Portrait of Trajan, formerly in the Villa Albani, ca.108.
Rome, Museo Capitolino. Photo: Gisela Fittschen-Badura

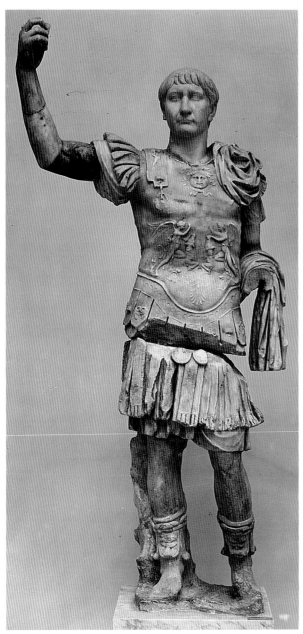

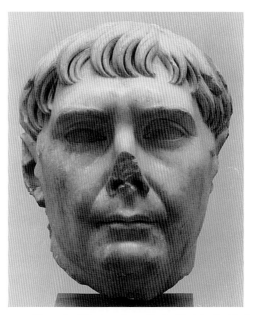

174 Portrait of Trajan, from Ostia, Hadrianic. Ostia, Museum. Photo: DAIR 67.825

173 Portrait of Trajan as imperator, from Ostia, late Trajanic. Ostia, Museum. Photo: Istituto Centrale per il catalogo e la documentazione, E 49899

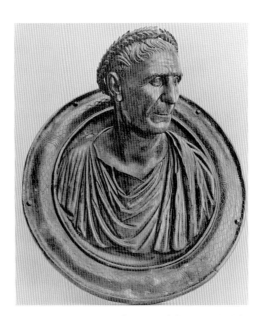

175 Bronze portrait of Trajan's father on a shield, ca.112–17. Ankara, Archaeological Museum. Photo: L. Budde, "Imago clipeata des Kaisers Traian in Ankara, *AntP* 4 (1965), pl. 58

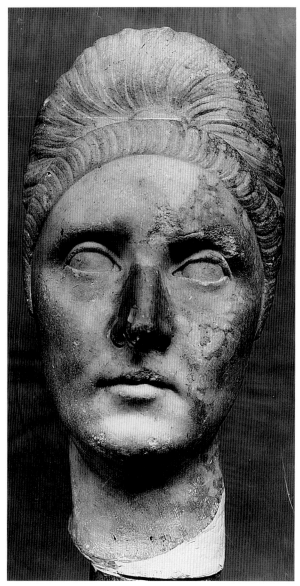

176 Portrait of Plotina, from Ostia, ca.112. Rome, Museo Nazionale delle Terme. Photo: DAIR 54.814

likely that portraits of both emperor and empress were produced by the same court artists.

The typology of Plotina's portraits is controversial, with scholars divided over whether there are one or more basic types. While some scholars posit multiple types and others favor a division between a lifetime and a posthumous type, it is most likely that the small number of surviving portraits of Plotina – whether made during her lifetime or posthumously – were all based on a common prototype. This prototype resembled the empress's canonical numismatic portrait, which first appeared on coins of 112 and continued to be issued posthumously. What is most important, however, is that the portraits of Plotina are reflections of their time, and their similarity to Trajan's images is noteworthy.

A portrait of Plotina, found in the Frigidarium of the Baths of Neptune in Ostia (fig. 176), is one of the best-known portraits of Plotina and appears to represent the empress during her lifetime. It has been grouped with three other heads now in the Museo Capitolino, and in Naples and Geneva. In the Ostia portrait, Plotina's face is a perfect oval, her eyes almond-shaped, her lips delicately rounded. Her face is unlined and she is seemingly ageless. Plotina's hair, like her husband's, forms an arc over her forehead, the arc made up of small comma-shaped locks of identical shape and length. The rest of her smooth hair is gathered in a knot placed high on her head and spread out like a fan.

An example of a posthumous portrait made in Hadrianic times is a colossal head of the empress now in the Vatican Museums. It is distinguished from others by its drilled eyes and more symmetrical coiffure, but otherwise seems to be based on the same prototype.

The Forum and Column of Trajan

While Trajan was emperor, Rome and the empire were enhanced with great public works, including major roads and bridges, a new harbor at Ostia, the large Baths of Trajan in Rome, and the truly grandiose Forum of Trajan, also in Rome (fig. 177), that was as large in size as all the earlier imperial fora together. Trajan's forum also reflects the military nature of his art and architecture. The Column of Trajan, on the north end of the forum, is exceedingly well preserved and is one of the greatest surviving examples of Roman relief sculpture. For that reason, it is usually studied in isolation. In any case, the column is but one part of a carefully orchestrated architectural space calculated to serve not only as a civic and religious center but also as an advertisement for Trajan's military successes.

The first comprehensive study of the forum as an

busts on shields; the other bust may well have depicted the emperor himself, or perhaps it belonged to a trio with Nerva as on coins.

The Portraiture of Plotina

Trajan's wife was Pompeia Plotina, whom he married before he became emperor. Although Plotina bore Trajan no children, she was greatly admired during Trajan's and Hadrian's principates as a woman of great virtue and dignity. Both emperors honored her on their coinage, and she appears to have been instrumental in ensuring Hadrian's succession. The fidelity for which she was known is underscored in her portraits because they are clearly modeled on those of her husband, and it is

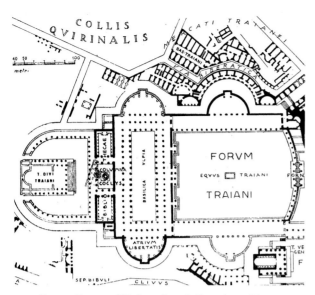

177 Rome, Forum of Trajan, plan, dedicated 112. Photo: DAIR 54.96

architectural and sculptural complex was made in 1970, but the Column of Trajan, an almost unique masterwork, has long captured the imaginations of scholars. The first publication of its relief sculpture appeared already in the late nineteenth century and the major monograph in 1926. Recent books and articles on the column have focused on a wide variety of issues. Foremost among these are controversies over the identification of specific battle and ceremonial scenes, cityscapes, and individual buildings; the origins of the spiral relief frieze and the individual tableaux; and the contribution of the master of the Column of Trajan, probably Apollodorus of Damascus. One interesting debate centers on Trajan's successor, Hadrian, and whether his portrait is included in the relief scenes. Hadrian is known to have taken an active part in Trajan's Dacian campaigns, although it was only on Trajan's deathbed that Hadrian was chosen as the emperor's heir, and Hadrian may therefore not have been considered important enough earlier to merit inclusion.

The Forum of Trajan was built on a vast tract of land located to the northeast of the Forum of Augustus and dedicated in 112. Domitian's architects had already begun to develop the land, but Nerva was emperor for too brief a time to begin any construction on the site. Instead, he expropriated the completed Forum Transitorium. Trajan's interest in the land grew undoubtedly from his desire to build his forum next to that of Augustus, whom he emulated in his portraiture. Although the available land was considerable, part of it was occupied by one of the original seven hills of Rome – the Quirinal. In fact, the Quirinal hill had to be cut back to make way for the new forum that was to bear Trajan's name. Apollodorus of Damascus, who as an engineer had ac-

companied Trajan on his military campaigns in Dacia, was Trajan's chief architect and engineer, and undoubtedly it was he who was responsible for the removal of part of the slope of the hill. Apollodorus was already renowned for the bridge he had built across the Danube River, which is carefully recorded in the spiral frieze on the Column of Trajan (see fig. 181) and also on coins – although the latter is disputed. This great engineering feat was commemorated by the height of the Column of Trajan, also 125 feet, which like the forum, was probably designed by Apollodorus himself.

From the Roman point of view, Trajan's great victory in Dacia had an important strategic consequence: the establishment of Dacia as a Roman province. For his victory, Trajan was awarded a triumph in Rome and the title Dacicus, and the Roman populace celebrated 123 days of games. The Forum of Trajan with its extensive sculptural program was constructed with the spoils of Trajan's Dacian campaigns of 101–102 and 105–106 and celebrated those very victories.

In its overall architectural form, Trajan's forum is modeled on the Augustus's (see fig. 82), although it is, as already mentioned, much larger in scale. It has the same vast, open, rectangular space and, more importantly, the same semicircular exedrae. It is traditional trabeated architecture, and it is built, like the Forum of Augustus, for the most part of Luna marble. The colonnades of the second story of Trajan's forum also have figures instead of columns – Dacian captives who take the place of Augustus's Greek caryatids. These were interspersed with shields, as were the Augustan maidens.

The Forum of Trajan was entered through a convex facade that is no longer preserved. A Trajanic coin with the reverse representation of a gate accompanied by the legend "Forum Traian" depicts it. The gate has a single doorway fronted by steps and flanked by six engaged columns interspersed with aediculae housing statuary. Each aedicula is crowned by a tondo (probably a shield of virtue or *clipeus virtutis*), also presumably containing portraits or figural reliefs. The engaged columns have projecting ressauts, and on the top of the attic there is a profusion of sculpture that seems to depict the emperor crowned by Victory – both in a six-horse quadriga flanked by Dacian prisoners manacled to trophies. The similarity of the form of the gate and its sculptural program to a Roman triumphal arch is unmistakable and underscores Apollodorus's attempt to announce in its facade that the Forum of Trajan was above all a victory monument.

The triumphal gate led into the great open rectangular space of the forum, with an equestrian statue of Trajan as its centerpiece and, as we have already seen, captive Dacians on the upper stories of the flanking colonnades

alternating with portraits on shields (*imagines clipeatae*). The exact form of the equestrian statue is controversial since two different equestrian types are displayed on Trajanic coinage. The first depicts Trajan, holding a lance and a small figure of Victory, on a standing horse. The second type is the more interesting of the two: Trajan, seated on a galloping horse, plunges his lance into a Dacian who is simultaneously being trampled beneath the horses's hooves. It is the same image as that of Trajan on the Great Trajanic Frieze of early Hadrianic date (see fig. 185). The galloping horse recalls the equestrian statue of Domitian/ Nerva from Misenum and indicates that, although it is the only example of its type surviving from antiquity, there were originally others like it.

The north end of the forum was not occupied by the traditional temple but by a law court or basilica, called the Basilica Ulpia from Trajan's family name – Ulpius. The placement of a basilica at one of the short ends of a forum was unique in Rome but had both precedents and copies in the provinces. The inclusion of a basilica placed transversely in a forum was a scheme known from the plan of legionary camps and may be explained by Apollodorus's expertise in military architecture. Like the forum proper, the Basilica Ulpia was fronted by a commemorative doorway in the form of a triumphal arch. This no longer survives but is preserved on the reverse of another coin of Trajan bearing the legend "Basilica Ulpia." This doorway was also monumental in scale, but the forum's single entrance is replaced by three openings framed by what seem to be columns in the round – a kind of open portico – with massive projecting ressauts. A staircase leads up to the triple doorway, and the attic is crowned by a crowded statuary group, difficult to discern but probably depicting a quadriga group of Trajan crowned by Victory, trophies, and captives (or Roman soldiers with standards). The Basilica Ulpia itself was a large, roofed structure with a central nave, two side aisles, a timber-trussed roof sheathed with gilded bronze, and an interior relief frieze. It is the frieze (fig. 178) that is of interest in this context because it depicted the same subject as the cuirass of Trajan's military portrait from Ostia (see fig. 173) – Victories slaying bulls and decorating candelabra. Fragments of this frieze are still preserved in such scattered collections as the Glyptothek in Munich and the Museo Nazionale in Rome. The motif of Victories slaying bulls has its ultimate source in the fifth century in Greece, but – although exceedingly popular in Trajanic times – it was not adopted by later emperors. It was nevertheless a motif that appeared on Augustan coins celebrating the emperor's victory over Armenia and may thus be seen here as another example of the revival of Augustan imagery under Trajan.

The Basilica Ulpia led to a small plaza that was flanked by Greek and Latin libraries and had the Column of Trajan as its centerpiece. There is some controversy surrounding the date of the libraries and the original location of the column. Brick-stamp evidence suggests that the two libraries may not have been completed until Hadrianic times, when the Temple of Divus Traianus on the north end was added. Furthermore, it has been maintained that the Column of Trajan was originally located in the east hemicycle of the forum and transferred to its present position by Hadrian, who intended it to serve as his divine adoptive father's tomb and as the focus of the court that fronted the temple of the new divus. This suggestion has not received widespread support, but one scholar has attempted to bolster it by arguing that a temporary column with a decorated base and inscription but a plain shaft (the column is shown on some coins with an undecorated shaft and a crowning eagle) may have been set up in the east hemicycle. The emperor's absence in Parthia in the final years of his life kept him from overseeing the project, but it was completed by his successor, who wanted to honor Trajan by burying him in the base of the column carved with scenes depicting Trajan's most spectacular accomplishment. It is likely that the decision to place the remains of both Trajan and Plotina in the base of the column was Hadrian's, but the iconography and style of the column's relief scenes are more in keeping with what we know of Trajanic than Hadrianic state relief; it seems likely that they were already carved before his death. Conclusive evidence for the location of the column will have to await further excavation of the forum's east hemicycle.

The Luna marble column (fig. 179–180), which dates to 113, is made of a base, shaft, and capital, and was capped by a gilded bronze, heroically nude statue of Trajan that no longer survives but is recorded on some Trajanic coins; other Trajanic coins show it surmounted by an eagle. The statue was replaced in 1588 by one of Saint Peter. The column stands 125 feet tall, commemorating the engineering feat that had made the construction of the Forum of Trajan possible. It was also a victory monument because the spiral frieze that encircles the monument from base to top depicts Trajan's two Dacian campaigns; the base is decorated with reliefs that depict piles of captured arms and armor; and the column was a funerary monument, serving as the tomb of Trajan and Plotina. Two golden urns housing their remains were found in a burial chamber at the base of the column and its spiral staircase of 185 steps.

Although columns were earlier used as pedestals for honorific statuary – the fora of Rome and cities like Pompeii were crowded with such monuments – there is no evidence for an earlier column with spiral frieze. The closest parallel is the Jupiter Column at Mainz (see fig.

178 Fragment of frieze of Basilica Ulpia, from Forum of
Trajan, Rome, dedicated 112. Rome, Museo Nazionale delle
Terme. Photo: DAIR 34.229

132) honoring Jupiter Optimus Maximus and dedicated
to the health of Nero; the emperor's name was removed
after his death. It had a gilded bronze statue of Jupiter
at the apex, and representations of other divinities and
personifications were carved on drums that are vertically
arranged along the length of the column and are read
from bottom to top. The spiral frieze of the Column of
Trajan appears, however, to have been the creation of
Apollodorus of Damascus. He was probably the chief
designer of the column with other artists – of varying tal-
ents – executing the actual scenes, which were probably
carved in place. When they were first executed, Apol-
lodorus neglected to plan for the lighting of the spiral
staircase. Once the reliefs were in place, numerous slit
windows were added – hence, their lack of full integra-
tion into the design. On what earlier sources did Apol-
lodorus draw? The column's individual scenes represent
traditional Roman military events: the building of cities,
the making of sacrifices, the adventus, the profectio, and
so on, and are depicted as such scenes were depicted
from the Augustan period on. Earlier state reliefs, there-
fore, must have served as prototypes. It is also likely
that Apollodorus drew on Roman triumphal paintings

for inspiration. As we have seen, such paintings were
made by artists who accompanied Roman generals on
their campaigns. The artist's job was to record the battles
and the exotic locales in which they took place. The
painted panels were carried aloft by soldiers in their tri-
umphal return to Rome. Although the wooden panels no
longer survive, they were described by ancient writers;
Renaissance artists, like Mantegna, have reconstructed
them according to the same literary sources. The scenes
in these painted panels appear to have been characterized
by the use of an aerial or bird's-eye perspective, which
is also used for the first time in state relief sculpture on
the Column of Trajan. A third source may have been the
illustrated scroll. We know that Trajan's war commen-
taries were recorded on scrolls, and a Latin version and
Greek translation were undoubtedly kept in the Greek
and Latin libraries that flank the column. It is possible that
illustrations of the events of the Dacian campaigns were
interspersed with the text. The two-hundred-meter-long
spiral frieze of the Column of Trajan can be interpreted
as a scroll unfurled from bottom to top – a scroll with the
text omitted.

Individual scenes of the Column of Trajan number

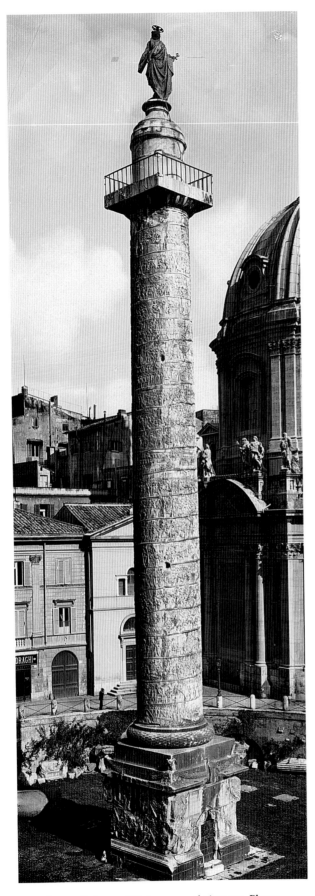

179 Rome, Column of Trajan, general view, 113. Photo: Alinari/Art Resource, New York, 7008

155, and there are over 2,500 figures and twenty-three superimposed spirals. The story unfolds from bottom to top. The emperor himself is depicted in most of the scenes, but the reliefs on the column are not examples of continuous narration in which the main actor appears more than once in a single scene. Here the scenes are clearly divided from one another by architecture or by landscape elements.

One of the curious features of the column is that one would expect the preponderance of scenes to be ones of battle. This is not the case. Only about one-quarter of the space is devoted to battle scenes. In fact, most of the scenes – sacrifice, adlocutio, the building of cities, the receiving of embassies and prisoners, the army on the march, the grazing of animals – might be described, from the military standpoint, as nonevents, and a considerable amount of attention is paid to anecdotal details, such as a barbarian falling off his mule. The Column of Trajan is not about battles alone but about all aspects of war. Special attention is paid to what happens before and after a battle: sacrifices are made to the state gods, new cities are founded and constructed, and the real subject of the column is the efficiency of the Trajanic war machine, invincible and even heroic. The Dacians are also heroically portrayed. They are worthy adversaries who can hold their own in such scenes of battle as scene XXXII (the numbering system follows that of Karl Lehmann-Hartleben), in which Roman soldiers, protected by a fort, shower stones on their Dacian attackers. Decebalus, leader of the Dacian tribes, is depicted almost at the column's apex as a courageous man who prefers to take his own life than be brought back in triumph to Rome by Trajan's soldiers (CXLV) (fig. 181). The pose of Decebalus – with one kneeling, bent leg, one outstretched leg, and upturned head – is an established Greek type, seen already in the classical period and popular in Hellenistic times in such figures as the Pergamene Gaul from Delos of about 100 B.C., now in the National Archaeological Museum in Athens, and a number of kneeling figures in the Gigantomachy frieze from the second-century B.C. Altar of Zeus from Pergamon.

The first campaign as depicted on the Column of Trajan begins on the Dacian frontier, where the Roman soldiers unload their provisions on the banks of the Danube. The scene of Trajan's troop detachments crossing a pontoon bridge over the Danube (fig. 182) is rendered in detail and identified by the presence of the personification of the Danube River, a half-length bearded male figure seen from the rear. He is one of only four personifications or gods on the column. The Praetorian guard is led by the emperor himself, who is depicted on horseback. A war council and sacrifice, both led by Trajan, follow, as does the anecdotal scene with a bar-

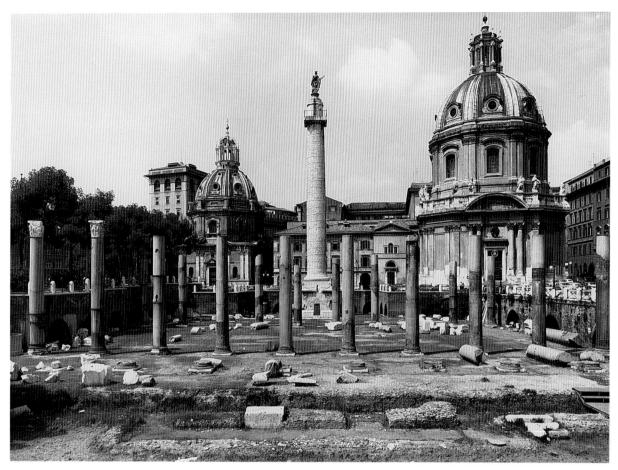

180 Rome, Column of Trajan, view through columns of
Basilica Ulpia, 113. Photo: DAIR 67.913

barian falling off his mule, possibly in reaction to the
musician who suddenly toots his horn above. The bar-
barian carries a large, perforated mushroom that is prob-
ably the mushroom on which, according to Cassius Dio,
the barbarian allies of Trajan wrote a message advising
Trajan to desist from military action in favor of peace
for the region. The scenes that follow depict battles, the
adlocutio of Trajan, the building of roads and military
camps, the presentation of captives to the emperor, and
so forth. Some scenes are quite powerful and indeed un-
forgettable, as, for example, scene LXXII (fig. 183), in
which Trajan's soldiers offer him the severed heads of his
enemy. The following scene depicts a major battle wit-
nessed by Jupiter, who emerges from the clouds and hurls
a thunderbolt at the foreign enemy. Jupiter aids Trajan
in his Dacian campaigns as Mars Ultor helped Augus-
tus at Philippi. In the same scene, a young Dacian falls
lifeless into his comrade's arms, and both Decebalus and
Trajan survey the bloody effects of their war. Carnage is
apparent on both sides. In the succeeding scene severed
Roman heads are seen impaled on posts in a Dacian fort.
At the end of the first campaign of the first Dacian War,

Trajan receives a Dacian embassy, Dacian families flee,
their flocks and herds lie dead in a heap.

At the beginning of the second campaign of the first
Dacian War, the Dacians move east. The Dacians, with
the help of allies depicted in scaled armor, attack a Roman
fort. (The Dacians use what looks like a Roman batter-
ing ram, which they must have adapted from those used
against them by Domitian's army.) Trajan follows his
armies by ship and comes upon a night battle presided
over by the goddess Nyx. Dacian wagons are shown in
the left background surrounded by vanquished Dacians,
and the body of a dead child is draped over one of the
wagon's wheels. It has been suggested that the night
battle takes place at Adamklissi, the site of the Trajanic
trophy commemorating the first Dacian campaign. Over
the years, scholars have proposed various identifications
for the major battles represented on the column, but
there is still not universal agreement. In the following
battle, some Dacians are taken prisoner and others flee.
The scene has been singled out because it is the only scene
on the column in which a wounded Roman soldier is de-
picted, here being aided by two of his fellow soldiers.

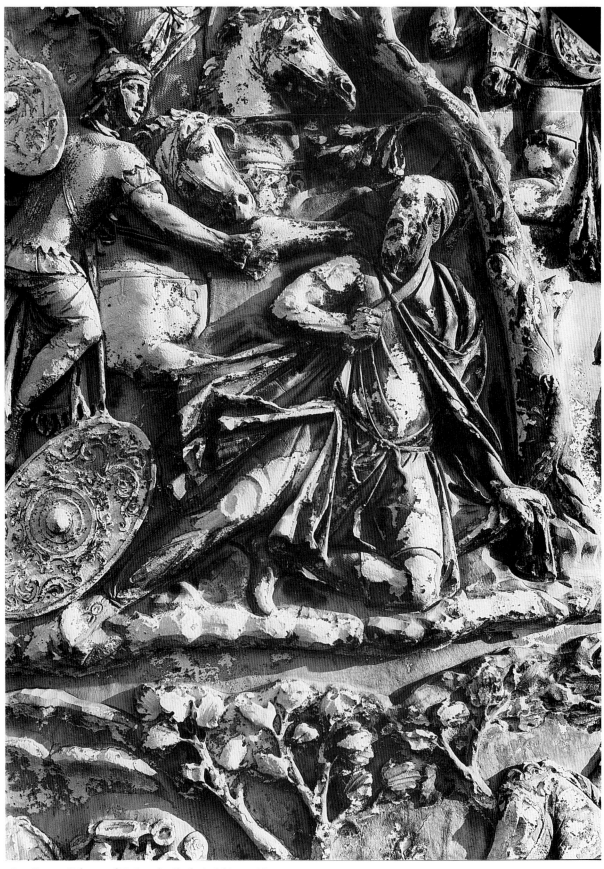

181 Rome, Column of Trajan, detail of spiral frieze with
suicide of Decebalus, 113. Photo: DAIR 41.1217

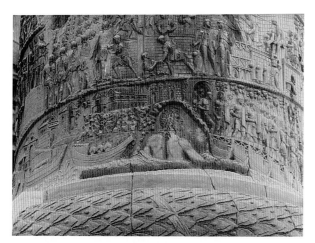

182 Rome, Column of Trajan, detail of spiral frieze with Roman army crossing bridge over Danube River, 113. Photo: DAIR 41.2072

The next two scenes show Trajan paying his auxiliaries and receiving homage from a soldier, but the second of the two also represents Dacian women torturing Roman prisoners, whom they mercilessly beat and burn with torches.

The second campaign of the first Dacian War ends and is followed by the third and last in which Trajan's armies march north from the Danube to Decebalus's capital. Along the way, sacrifices are made, and roads are built with Roman soldiers laboring beside impaled Dacian heads. The last battle of the first war consists of hand-to-hand combat. Trajan is once again presented with two severed Dacian heads, and the defeated Dacians kneel before the emperor and ask for clemency. Behind the throngs of standing and kneeling Dacians is the solitary figure of Decebalus. He stands alone on a cliff, but his hands are in the same position of surrender as the other Dacians. Behind Decebalus are Dacians who dismantle the walls of their city, as stipulated in the Dacian surrender to Trajan. The Dacians were also ordered to retreat from captured territory. This departure is also depicted on the column in the last scene of the first Dacian War, where there are men leading their sons and mothers with infants cradled in their arms. This last scene is depicted in conjunction with one of Trajan, already in travel costume, making an address to the army of occupation. Next comes the winged female personification of Victory (fig. 184), who describes Trajan's deeds and virtues on a shield and serves as the divider between the two Dacian Wars. She is flanked by two trophies piled high with captured Dacian arms and armor.

The need for the second Dacian War came about because Decebalus violated the terms of the treaty. Trajan declares war and departs for Dacia from an Adriatic port

city. He lands in Dalmatia and travels cross country to the Danube. Along the way, numerous sacrifices are offered in his honor. Upon arrival at his destination, he offers a sacrifice against the backdrop of the bridge designed by Apollodorus of Damascus. In the following scene, Trajan is greeted by embassies from around the world. Succeeding scenes represent Trajan's adlocutio, war councils and – most importantly – the Roman storming of the Dacian capital. A dramatic scene depicts either a mass suicide by poisoning among the Dacians or their sharing of the last cup of water. As before, some Dacians submit to the Romans; others flee. Trajan is acclaimed by his troops while the soldiers proceed to loot the city. The Romans move farther north to quell the last resisters and to find Decebalus's buried treasure, which is discovered and loaded onto mules for transport to Rome. Some of the last resisters decide to flee; others commit suicide. Decebalus (see fig. 181) chooses the latter, and afterward, his severed head and right hand are brought to Trajan and then sent to Rome for display in Trajan's triumph. The very last scene depicts the exile of Dacian families. Old men, youths, women, and children, some too young to walk on their own, leave their land with their belongings on their backs, their animals leading the way.

As mentioned at the outset, in antiquity the Column of Trajan was but one part of a carefully orchestrated architectural complex (see fig. 177). The forum was ostensibly a practical monument, built – as the fora before it – to serve as a law court and a meeting and marketplace. But like the earlier Forum of Augustus, it had a deeper significance. It was meant to serve as a political message in stone commemorating Trajan's military victories in Dacia and exalting Trajan as Dacicus. The message was first imparted in the forum's gateway and reiterated in the rectangular courtyard with the equestrian statue of Trajan surrounded by Dacian captives, and in the Basilica Ulpia with its sculptured doorway and its frieze of triumphant Victories. The spiral frieze of the column elaborated the details of the campaigns, which could be viewed from the plaza or from the second stories of the flanking Greek and Latin libraries. Most striking of all is that the helical frieze of the column could only be seen from these vantage points. When the visitor was standing in front of the forum or in the great, open, rectangular court, he could see only the heroic bronze statue of Trajan, gleaming in the light and hovering above the Basilica Ulpia. Since the column served as the emperor's tomb, it is likely that what the spectator was experiencing was the apotheosis of Trajan, twice victor in Dacia, builder of the forum that bears his name, and now divus. The emperor's cremated ashes may have remained in the base of his column, but his soul was transported to the heavens

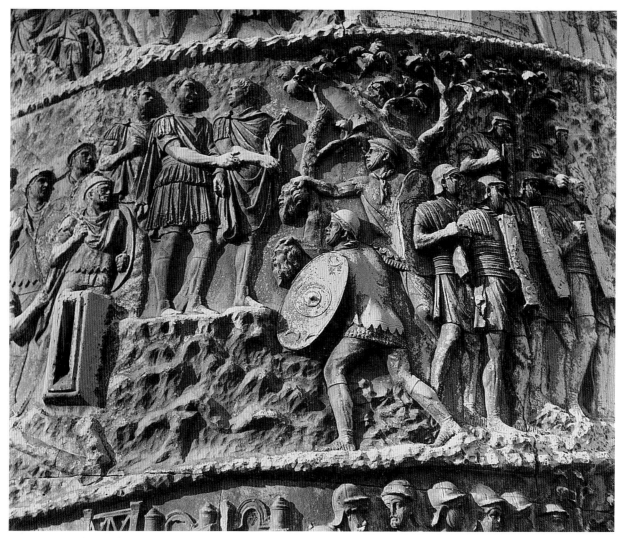

183 Rome, Column of Trajan, detail of spiral frieze with
Roman soldiers offering severed Dacian heads to Trajan, 113.
Photo: DAIR 41.1455

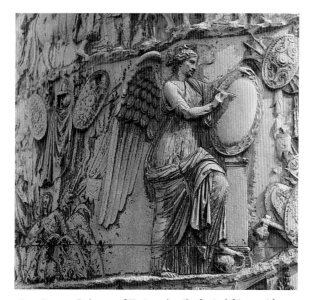

184 Rome, Column of Trajan, detail of spiral frieze with
Victory writing on a shield, 113. Photo: DAIR 41.1478

by eagles, the vehicles of apotheosis, which alight on the column's base. Such a theatrical presentation combining architecture, painting (the column and forum were painted), sculpture, and light was not equaled until Gian Lorenzo Bernini created comparable dramatic tableaux in the seventeenth century.

The Great Trajanic Frieze

We do not know exactly what Trajan had in mind for the north end of his forum – probably a temple – but we do know that his successor, Hadrian, built a temple on the spot after Trajan's death. Not surprisingly, it was called the Temple of Divus Traianus, and by building such a memorial to his divine adoptive father, Hadrian was doing what so many of his predecessors had done – closely associated himself with a new god. The temple

may have had a sculptured podium or precinct wall which is no longer in place. Indeed, the remains of the temple are buried beneath the sixteenth- and eighteenth-century churches of S. Maria di Loreto and SS. Nome di Maria. Nonetheless, fragments from the wall or podium (or, as some scholars say, a wall inside the porticoes of the forum proper or on the interior or exterior of the Basilica Ulpia) are preserved, the most outstanding of which were inserted into the fabric of the Arch of Constantine in the fourth century. Others are scattered among the Villa Borghese, the Villa Medici, the Forum Antiquarium, and museums in Berlin and Paris. Four slabs constituting two sections of what was a one-hundred-foot-long monumental frieze with figures ten feet tall, called today the Great Trajanic Frieze, are located on the short sides of the Constantinian arch just below the attic; four other slabs, also in two sections, face one another across the central bay. All are comparable in scale and workmanship and were originally joined (a cast of the whole was made in 1937 for the Mostra Augustea della Romanità and is now in the Museo della Civiltà Romana in Rome).

Although the Great Trajanic Frieze has been associated with Domitian and his Dacian campaigns, it is widely believed that the Great Trajanic Frieze celebrates Trajan's Dacian conquests. The frieze seems to have been carved in the early years of Hadrian's principate and thus to be contemporary to the Temple of Divus Traianus. Hadrian must have chosen this subject, essentially synonymous with that on the Column of Trajan, in order that the sculptural program of the temple complement that of the forum as a whole.

Although the basic subject of the slabs is the Dacian Wars – with the emphasis on battles between Romans and Dacians, the presentation of prisoners, and the Dacian surrender – the emperor himself appears in the two scenes now in the central bay of the Arch of Constantine, even though the heads have been recarved as those of Constantine. In one of these (fig. 185), Trajan, dressed in a cuirass and with his mantle billowing up behind him, is depicted on horseback, the hooves of his horse trampling a fallen Dacian. At the same time a Dacian kneeling before the emperor begs for and is undoubtedly granted clemency. The emperor is at once a world conqueror and a merciful man capable of forgiveness. He wears no protective helmet (it is carried by the armor-bearer at his side), but his right arm is positioned in such a way (the forearm is broken off) to indicate that he originally clasped a weapon (a spear?), which he was about to plunge into his victim. The message of Trajan's triumph over the Dacians is a clear one, and it is interesting to see Trajan participating directly in the fray. In the column, he does not take part in the individual battles but stands apart from them, supervising his soldiers, addressing his troops, sacrific-

ing in honor of the gods on the occasion of a victory, granting clemency to prisoners, and so forth. Trajan does appear on horseback in a few scenes on the Column of Trajan, where he is being welcomed by populations faithful to him or riding in concert with his troops; but he is never depicted trampling a Dacian. That such an image was chosen by his successor Hadrian is instructive. It was under Hadrian, a peace-loving man, that the borders of the Roman empire were consolidated and not expanded. Despite his nature, Hadrian's portrait sculpture is fraught with military connotations. Especially popular under Hadrian, although probably initiated under Trajan or perhaps even earlier, is the depiction of the emperor triumphant over a barbarian – for example, the emperor dressed in breastplate with his foot resting on a barbarian captive (see fig. 205). Extant coins struck in 104–107 represent Trajan on horseback trampling a Dacian, and it has been suggested that these were based on a well-known equestrian statue of Trajan in Rome, possibly the one in his forum. Such an equestrian would have provided an obvious model for Trajan on horseback in the Great Trajanic Frieze. Furthermore, the repetition of similar imagery would have served to link visually the statue in the main space of the forum with the horseman in the frieze decorating Hadrian's new Temple to Divus Traianus on the forum's north end. At the far right of the equestrian scene, Roman soldiers display severed Dacian heads before their commander, the same scene that is depicted on the Column of Trajan (see fig. 183).

The other scene in the central bay of the Constantinian arch depicts the adventus of Trajan (fig. 186). Trajan, crowned with a wreath by the female personification of Victory, returns to Rome. The emperor still wears his battle gear and originally carried a scepter or spear. He is greeted by Virtus in Amazonian costume and Honos in lion-skin boots and armor, who both personify imperial virtues. Contiguous with this scene is one of Roman soldiers on horseback battling Dacians who are trampled beneath them. What is of special significance is that the action in the battle moves from left to right, whereas the protagonists in the scene of adventus advance from right to left. Unlike those on the Column of Trajan, the scenes are not divided by architecture or landscape. These two disparate scenes, one on the battlefield and one in Rome, therefore appear to take place at the same time and in the same space, a conflation of time and space not seen before in imperially sponsored art, but common in both earlier and contemporary funerary reliefs of freedmen (see, for example, figs. 166, 201). This very important relief marks a critical change in state art and would prove to be the wave of the future. The scenes on the Great Trajanic Frieze are both synoptic and symbolic and must be distinguished from those on the

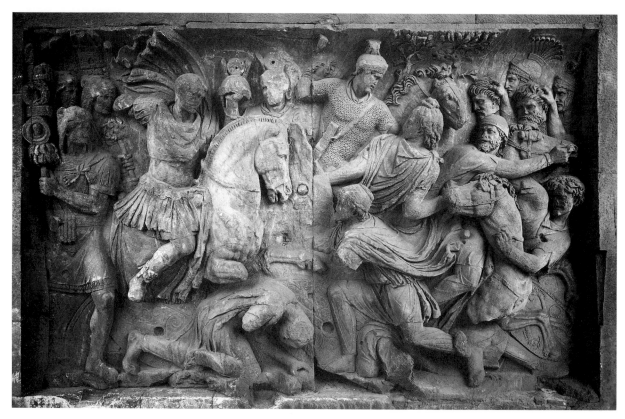

185 The Great Trajanic Frieze, Trajan on horseback, early
Hadrianic. Rome, Arch of Constantine. Photo: DAIR 37.328A

186 The Great Trajanic Frieze, adventus of Trajan, early
Hadrianic. Rome, Arch of Constantine. Photo: DAIR 37.329A

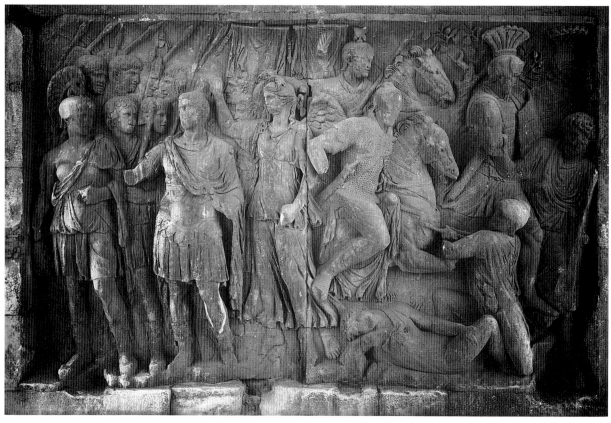

Column of Trajan, which follow one another in logical documentary fashion. Yet, the distinctions between the two should not be overemphasized. Scholars have questioned the continuity of the narration of Trajan's column, pointing to the ceremonial nature of some of the stock scenes. It was not an unimaginative retelling of historical events but a monument carefully calculated to combine narration and imperial symbolism.

The Extispicium Relief

The so-called Extispicium Relief, discovered in the east hemicycle of the Forum of Trajan (fig. 187), has been associated by some scholars with the Great Trajanic Frieze because of its findspot and because it is comparable in height. The scene takes place in front of a temple with three doorways and six Corinthian columns that has been identified as the Temple of Jupiter Optimus Maximus Capitolinus. The temple's pediment is now missing, but drawings record its original form and its elaborate sculptural embellishment consisting of the seated Capitoline triad – Jupiter, Juno, and Minerva – flanked by chariots driven by Sol and Luna. Standing in front of the temple

are eight togati whose bodies are essentially frontally positioned but who turn their heads toward their companions and engage in conversation. The central togatus, with a modern head, has been identified as Trajan. The left side of the relief depicts the *extispicium* rite. Victimarii and a popa with his ax are present. One victimarius examines the bull's entrails while a *haruspex* (diviner) in a toga interprets the signs. Such a rite would customarily occur at the beginning of a military enterprise and thus might be viewed as a prelude to the battles of the Great Trajanic Frieze. Such a combination of religious rite and military encounter has been likened to the pairing of sacrifice and procession on the Ara Pacis, but a more apt comparison perhaps is the allying of ceremonial and battle scenes on the Column of Trajan. A Victory with a vexillum flies above the extispicium scene. The relation of figure to architecture, the coiffures of the original heads, which resemble Trajan's neo-Augustan cap, the draping of the togas, and so on, all point to an early Hadrianic date, as does the relief's findspot, although it may never be possible to demonstrate the connection of the Paris Extispicium Relief to the Great Trajanic Frieze with certainty. Of greatest interest and significance is that, although the observation of the bull's entrails appears to take place

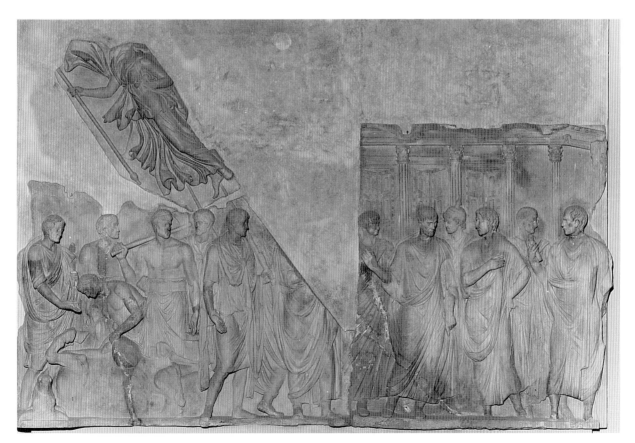

187 Extispicium relief, from the Forum of Trajan, Rome, early Hadrianic. Paris, Musée du Louvre. Photo: Cliché des Musées Nationaux

in front of the Temple of Jupiter, the orientation of that scene is from right to left, culminating in bull and haruspex and following the direction of the flying Victory, whereas the togati are framed at both left and right by inward facing figures that lead the eye toward the center of the relief and the figure of the emperor. The togati converse among themselves, oblivious to the extispicium taking place beside them. The popa and the togatus on the far left have their backs to one another, although the popa turns his head to glance toward the emperor. In this way, two scenes within the same panel are related in subject matter but seemingly separated by posture and gesture. The Paris relief artist's experimentation with the visual depiction of time and space in relief seems to be a hallmark of early Hadrianic art and ties this panel to the Great Trajanic Frieze.

The Arch of Trajan at Benevento

Trajan's social policies were generous and far-reaching. Donations or congiaria were distributed in 99 and 102; free corn was made available to those who needed it; the taxes on provincials were decreased. Trajan also decided to fund the alimentary system from the imperial treasury; it had earlier been supported by private philanthropists. Capital was invested in the mortgage on land, and the interest was paid to municipal or state officials to provide an allowance to feed the poor children of Italy. Coins with the legend "alim[enta] Ital[iae]" were struck by Trajan, and the program was prominently advertised on the Arch of Trajan at Benevento (figs. 188–189). One of the purposes of the program was to increase the birthrate among the poorer classes of Roman society – the opposite of Augustus's social legislation promoting increased procreation, especially among the aristocracy. Pliny (*Panegyricus* 26) posits that Trajan's aim was to have an increased constituency for the Roman legions, which, if true, would suggest that even Trajan's social policies had a military basis.

The scene depicting the alimenta of Trajan in Benevento appears in one of the horizontal panels in the arch's central bay (fig. 190). The emperor, dressed in a short tunic covered by a mantle, stands on the left side of the relief. Before him are four female personifications of cities (tyches) with crenellated crowns on their heads. Also portrayed are needy children, from babes in arms to five- or six-year-olds. One infant is cradled by one of the tyches; two sit piggyback style on their father's shoulders; the fathers are dressed in the short tunic of the lower classes. This relief is one of the rare examples in Roman art in which children are represented in a state

relief, the first since the south and north friezes of the Ara Pacis Augustae (see figs. 75, 77). What separates this panel from those on the Ara Pacis, however, is that here the children are not the progeny of the imperial family but the impoverished children of Italy.

The other horizontal panel across the central bay (fig. 191) represents Trajan in the act of sacrifice, that sacrifice commemorating the opening of the Via Traiana (the road that led from Brindisi to Rome and passed through Benevento) in 109. Trajan, on the right side of the relief, wears a toga, the upper edge of which is draped over his head as a veil. He pours a libation on the small, temporary altar before him, and on the left a bull is about to be sacrificed by a victimarius with an ax.

The Arch of Trajan at Benevento (see figs. 188–189) is a single-bayed arch resembling the earlier Arch of Titus in Rome (see fig. 154). The architectural details are so similar that at least one scholar has suggested that the two must have been designed by the same workshop. This has led some scholars to purport that the Arch of Titus must have been erected during Trajan's principate and not during the time of Domitian, although this hypothesis has not received widespread support. There is, however, one major difference between the two, which is that the Arch of Trajan at Benevento is covered on both the so-called city and country sides with square figural panels lacking in the much more conservative Arch of Titus. Nero's

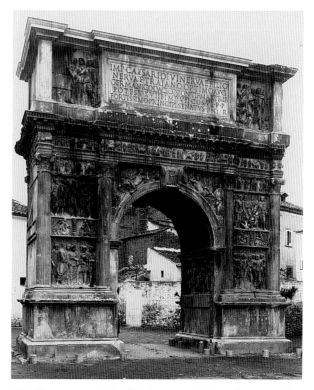

188 Benevento, Arch of Trajan, general view of country side, 114–18. Photo: DAIR 59.1258

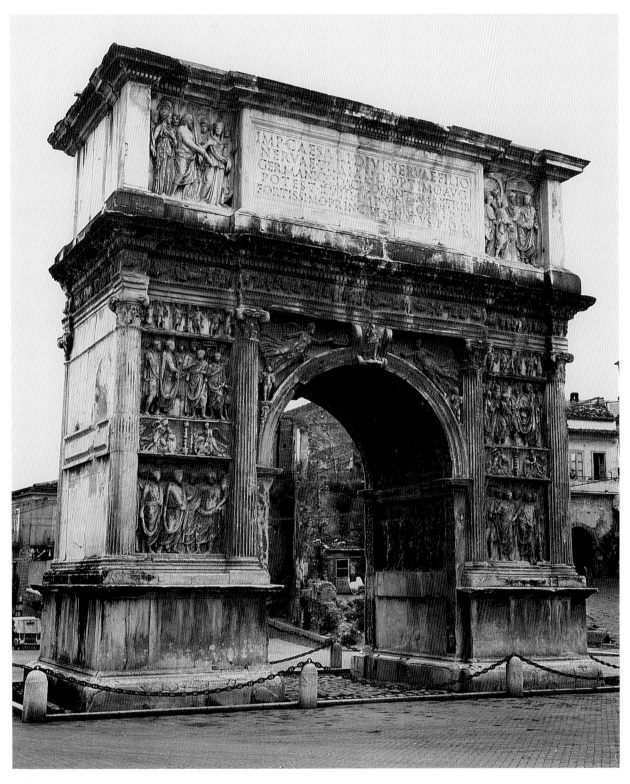

189 Benevento, Arch of Trajan, general view of city side,
114–18. Photo: DAIR 59.1255

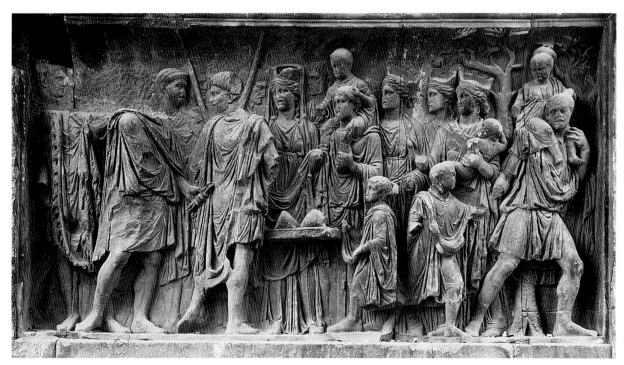

190 Benevento, Arch of Trajan, alimenta panel, 114–18.
Photo: Alinari/Art Resource, New York, 11496

191 Benevento, Arch of Trajan, sacrifice panel, 114–18.
Photo: Alinari/Art Resource, New York, 11497

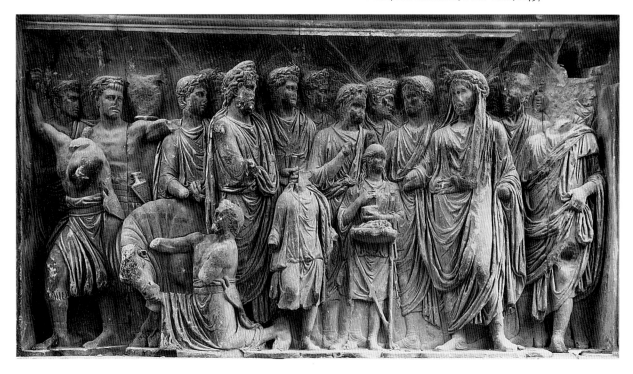

earlier Parthian arch (see fig. 131), notably, also had such panels and the designer of the Arch of Titus must have rejected this new scheme. There are four panels on each long side of the Arch of Trajan at Benevento below the encircling frieze, and these are divided from one another by smaller horizontal panels with the popular Trajanic motif of Victories slaying bulls and with camilli decorating candelabra. The frieze depicts Trajan's second Dacian triumph of 107, and Dacia herself is represented at the emperor's feet in still another panel flanking the attic inscription. There is, in fact, one figural panel on either side of the inscription plaque on both long sides of the arch. The inscription indicates that the Arch of Trajan dates to 114, because it records Trajan's titles of Germanicus and Dacicus but not of Parthicus, which he was awarded after 114. It is nonetheless difficult to determine whether 114 refers to the completion of the arch or to the laying of the foundation stone. The latter seems most likely. The arch was begun in 114 and completed by Hadrian in 118 after the death of his predecessor. The subject matter of the panels in the attic, which are discussed below, seems to substantiate such a date.

The eight panels on the main body of the arch appear to represent major events from the principate of Trajan both in Rome and Italy and in the provinces: the emperor's military campaigns in Dacia and Germany, the subsequent founding of military colonies, the building of a new harbor at Ostia, Trajan's triumphal entry into Rome, and the establishment of the alimenta. The left and right panels in the lowest register of the city side of the arch (see fig. 189) depict two parts of the same scene, which has been identified as the adventus into Rome of Trajan as the new emperor in 99. The togate emperor stands before the entrance to the city, surrounded by a full contingent of twelve lictors, and guided by the warden of the city (*praefectus urbi*). The Genius Senatus and the Genius Populi Romani, standing in front of the Curia Julia in the Roman Forum, are there to greet him. The scene in the upper left panel refers to the foundation of colonies by Trajan. The togate emperor with lictors meets with two veterans, also in togas, introduced to him by two allegorical female figures. What is most significant is that the two togati, both adult males, are much smaller in scale than the emperor, the artist using size to denote hierarchy. In the upper scene on the right pier, the togate emperor, the largest figure in the panel, holds out his right hand to three diminutive togati who are citizens of a port city, identified by the god of the harbor behind them. Clearly, Trajan's building of a port at Ostia is alluded to here. Hercules and Apollo are also present. It has been suggested that the scene also refers to the Annona Augusti, the Roman corn supply, to which Trajan paid special attention. The bottom left scene on the coun-

try side depicts a togate Trajan with his lictors meeting a group of barbarians. Jupiter stands in the center. The whole scene has been thought to refer to the security of the Roman people. It is balanced on the right by one that refers to the discipline of the Roman army. In the upper left, Mars or Honos presents two soldiers in civilian dress to Trajan. The scene is thought to refer to Trajan's reorganization of the army. The scene at the upper right is another alimentary scene. Trajan is present, as are a male and a female child and various gods and personifications.

It has been demonstrated that the Arch of Trajan at Benevento is not intended as precise historical reportage of the events of Trajan's principate but as an illustration of the emperor's policies in Italy and abroad. What is significant about these panels as a whole is that they continue the Flavian tradition of depicting the interaction of human beings and divinities. And Trajan is usually represented in larger scale than the other figures in the scene – the idea of the hierarchy of scale, that is, that the most important figure should be depicted as larger than the others. This is a device that has never before been used in state art but was already developed on earlier coins and in the reliefs of freedmen since the Augustan period.

The vault of the central bay has a decoration of coffers with rosettes. In the center is a square panel with a representation of Trajan in military breastplate crowned with a laurel wreath by Victory. The panel is surrounded by a border decorated with piles of arms and armor, undoubtedly the weaponry of the vanquished Germans and Dacians. Victories over these enemies earned Trajan the titles recorded in the attic inscription.

The four attic panels are of special interest. One is located on either side of the inscription plaque on both the city and country sides of the arch. The left panel on the country side represents the reception of the Dacian gods; the right depicts the vanquished Dacia kneeling at Trajan's feet. To the right of the emperor is a youthful, bearded man to whom we will return. The left and right attic panels on the city side (figs. 192–193) depict another adventus, in this case in 107, after the termination of the Dacian campaign. This time, Trajan is welcomed to Rome by two togate consuls, smaller than the other protagonists in scale, Roma, and the Capitoline Triad: Jupiter, Juno, and Minerva. Jupiter stands between the two goddesses. He holds his scepter in his left hand and with his right hand offers his thunderbolt to a togate Trajan who stands on the right side of the right panel. In other words, Jupiter reaches across or behind the inscription plaque to hand his thunderbolt to Trajan, who is now a divus.

Trajan is also now Optimus, a title that was bestowed on him in 114 and that he shared with Jupiter Optimus Maximus. The implication was not that Trajan was the equal of Jupiter but that Trajan's power came to him from

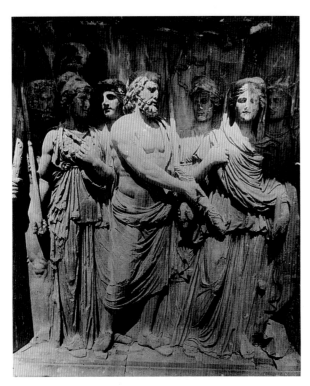

192 Benevento, Arch of Trajan, city side attic with Jupiter, Juno, and Minerva, 114–18. Photo: DAIR 29.459

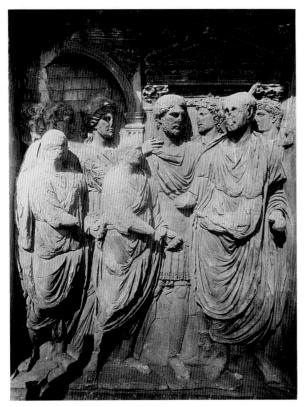

193 Benevento, Arch of Trajan, city side attic with Trajan receiving thunderbolt from Jupiter, 114–18. Photo: DAIR 29.460

the highest god of the Roman pantheon. The artist has taken considerable artistic license with regard to space since the events on the two panels are happening at the same time, despite the intervening inscription plaque. Such liberties were never before taken in an imperial relief but are apparent in earlier and contemporary funerary reliefs of freedmen. The best example is one that postdates the Arch of Trajan but that can stand for earlier examples – a funerary relief of about 161 (see fig. 255) that is now in the Villa Wolkonsky and depicts a man and wife. The woman has predeceased her husband but nonetheless they are depicted as reunited in perpetuity because their right hands are joined in the most important moment of the Roman marriage ceremony – the dextrarum iunctio. The two are, however, separated from one another by the epitaph plaque, and the husband, Apuleius Carpus, has to reach behind it to hold the hand of his wife, Apuleia Rufina.

In the Benevento attic panel, Trajan receives his power from Jupiter, with the backdrop of Rome behind him. He stands in front of the Capitolium with an arch nearby. Two smaller male figures stand before him, as does a city tyche, but most significant is the young, bearded male figure who is portrayed as equal to Trajan in stature and stands at Trajan's right. Both men turn their heads toward one another as if linked in a special way. The younger man is dressed in a breastplate, whereas Trajan is togate. The man's beard and physiognomy identify him as Hadrian (he is also the mysterious young man in the right country side relief), who participated in Trajan's military campaigns but seems not to be included in the scenes on the Column of Trajan or even in what survives of the Great Trajanic frieze. It is for this very reason that the Arch of Trajan at Benevento must have been completed after Trajan's death. Hadrian is included in these two scenes because he was responsible for completing the arch after Trajan's death and because he was eager to accentuate his close relationship with his divine adoptive father.

The facts surrounding the adoption of Hadrian by Trajan are mysterious. It is likely that Trajan wanted to adopt Hadrian, who was strongly supported by Plotina, but it was not actually done by the time of Trajan's demise on 8 August 117. Hadrian was adopted on 9 August, and it was not until 11 August that Trajan's death was announced to the general populace.

The attic statuary on the Arch of Trajan at Benevento is uncertain, although in 1936 two Pentelic marble statues, tentatively identified as Trajan (in cuirass) and Plotina, were discovered near the arch. These statues, now in the Museo del Sannio in Benevento, may have been part of a family group surmounting the attic. The attic statuary would have been added to the arch at its

completion, which took place under Hadrian. The group may have been commissioned earlier and thus ready and waiting at Trajan's death, but it is also possible that it was made under the new emperor's direction (he clearly had a hand in having his own portraits added to the attic relief panels). It is not surprising that Hadrian would choose a family group rather than a group of Trajan in quadriga, since Hadrian's fondness for Plotina was profound and his indebtedness to her for the support that made possible his succession was considerable. Furthermore, she was still alive when these statues were mounted on the arch's attic. The Temple of Divus Traianus in the Forum of Trajan was rededicated to include her after her death, and her golden urn was placed next to her husband's in the base of the Column of Trajan.

Hadrian struck coins with Plotina's portrait in 117–118 and had her consecrated at her death in 121–122. Numismatic evidence indicates that almost all of Trajan's arches were surmounted by quadriga groups. The sole exceptions are the Benevento arch and the Arch of Trajan at Ancona. Built in 115 to commemorate the renovations of the harbor and the building of the lighthouse or *pharos* at Ancona, the latter arch was surmounted by statues of Trajan, Plotina, and Trajan's sister, Marciana. They no longer survive, but inscriptions honoring all three are preserved on the arch's attic.

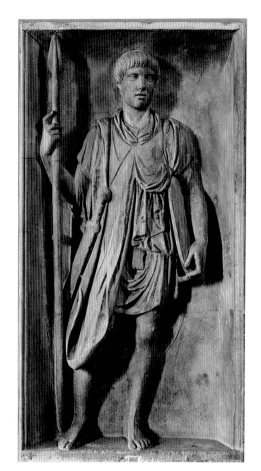

194 Pozzuoli Arch, Roman soldier, early Trajanic. Berlin, Staatliche Museen, Antikensammlung. Photo: Courtesy of the Staatliche Museen Antikensammlung, SK 6395

The Pozzuoli Arch

The Arch of Trajan at Benevento was not the only arch covered with sculpted panels that was erected in Campania in Trajanic times. Fragments of what appears to have been another arch with figured panel decoration are preserved in Berlin (fig. 194) and Philadelphia (fig. 195). The Berlin piece joins the Philadelphia piece at the right edge; the two fragments are displayed as one piece in a plaster cast in the Museo della Civiltà Romana. The two reliefs were already recognized as Trajanic in date in 1919, although they were wrongly attributed to the base of an equestrian statue of Trajan. The Trajanic date can be confirmed by the stylistic affinities among these reliefs and others of certain date. Most revealing is the coiffure of the soldier in the Berlin relief that consists of a cap of hair with straight locks combed forward over the forehead and in front of the ears in imitation of Trajan's distinctive hairstyle.

The four preserved figures all depict soldiers; the three in the foreground are frontally positioned. The reliefs can be no earlier than 96 since the back of the Philadelphia panel is carved with an inscription honoring Domitian, which was deliberately defaced after the emperor's damnatio memoriae and then carved on the other

195 Pozzuoli Arch, Roman soldiers, early Trajanic. Philadelphia, University of Pennsylvania Museum. Photo: Courtesy of the University Museum

Art under Trajan and Hadrian 229

side and reused in a Trajanic context. The two panels are now widely thought to have belonged to a commemorative arch that spanned an ancient road near the Pozzuoli amphitheater. The reliefs may have decorated the attic of the arch, or more likely may have served as decoration for the socle below one of the great piers of the monument. The vertical format of two of the sections would have been especially appropriate for socle design. It has been suggested that the entire arch must have been covered with sculpture, much like the earlier Arch of Nero in Rome (see fig. 131), which clearly served as the inspiration for both the Pozzuoli arch and the Arch of Trajan at Benevento.

Provincial Art under Trajan

It is not surprising that a period of great military exploits would bring with it an increased expansion of the Roman empire. In fact, under Trajan the empire reached its apogee; henceforth, the borders would be maintained but not extended further. Numerous new colonies were founded under Trajan, and these were either renovated or built afresh. Timgad in North Africa, for example, was laid out all at once in 109. These new miniature Romes had all the amenities and building types of the capital, and the new edifices were decorated with sculpture in the manner of Rome.

The Trophy of Trajan at Adamklissi

Unquestionably, the most interesting monument erected in the provinces in Trajanic times was the Trophy of Trajan at Adamklissi, which like the Column of Trajan in Rome, commemorated Trajan's Dacian campaigns. Some scholars think the monument instead honors soldiers who fell in Domitian's Dacian War of 85–89; others have dated it to Constantinian times. In recent years, consensus on a Trajanic date has been reached. What is significant about Trajan's trophy at Adamklissi is that it honored the victor and the victory in the land in which the battle took place since Adamklissi is in what is modern Rumania, the location of the Roman province of Dacia. The Adamklissi Monument, approximately the height of Trajan's column in Rome, consisted of a massive concrete drum one hundred feet in diameter, faced with limestone slabs of local provenance. Access to the drum was by a platform with nine steps. Fifty-four sculptured metopes, of which forty-nine survive, encircle the monument below the cornice. Above the cornice were twenty-six crenelations, each carved with the figure of a prisoner with his hands fastened behind his back and standing next to a tree. A conical roof topped the monument, it in turn

crowned by a two-story hexagonal pedestal supporting a stone trophy with three captives at its base. Two identical inscriptions on the pedestal date the monument to 109 and dedicate it to Mars Ultor, the Mars the Avenger of Augustus's Forum, who was the patron god of the Roman army.

The trophy's metopes were thrown to the ground in a later earthquake, and the order of their original placement is still controversial. A plausible arrangement, based on careful observation of the metopes' frames and consideration of their subject matter as well as their position on the ground around the drum after the earthquake, has been posited – although there have been alternative suggestions. Some of the scenes on the metopes are comparable to those on the Column of Trajan (Trajan and his retinue, Dacian prisoners), but the battles are represented in a very different fashion. The artist responsible for designing the overall scheme and the artists who carved the individual metopes have reduced the complex battles of the column to scenes of hand-to-hand combat between a Roman soldier and his adversary, in the long tradition of metope design, which can be traced back to such Greek examples as the metopes of the Parthenon. The barbarian adversaries are not only Dacians but also their German and Sarmatian allies. Metope XXXIV (fig. 196) (the numbering system of Florea Bobu Florescu is followed here), for example, depicts a Roman soldier dressed in chain mail attacking an unclothed Dacian archer who is up in a tree. A second naked Dacian, already vanquished and beheaded, lies below the soldier's feet. His now-useless shield is propped up near his head. Through simple but powerful images like these, the message of the trophy is clear: the Romans are all powerful and they are to be admired all the more for their ability to vanquish a strong (the barbarians are equal in size to the Romans) and even heroic people (the Dacian warriors are often depicted in heroic Greek nudity), which is the same message as that of the Column of Trajan. Reference to the beheading of Decebalus, the Dacian king whose suicide occurs near the apex of the column in Rome, has even been seen in Metope V. In this scene, a Roman horseman in scale armor simultaneously tramples a headless Dacian and displays his bearded visage as a trophy. The emperor himself is depicted in some of the metopes, for example, in adlocutio (Metope IX) and marching (Metope XXXVI) scenes. He can be recognized by his position of primacy (he is the central figure in the abbreviated adlocutio scene, with a soldier to left and right) and by his smooth face and cap of hair. Most fascinating of all is the scene in Metope XXVIII (fig. 197). A Roman, in cuirass chain mail but without a helmet, compels his horse to jump from a pedestal in order to attack a Dacian foe wearing the cap of a chieftain. This scene has rightly been compared to

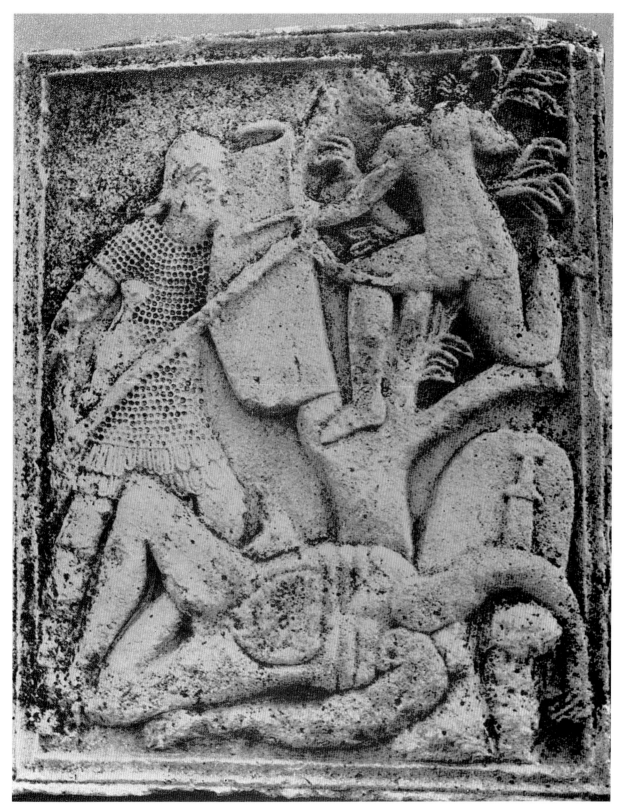

196 Adamklissi, Trophy of Trajan, metope XXXIV with
Roman soldier and Dacian archer, 109. Photo: F. B. Florescu,
Das Siegesdenkmal von Adamklissi: Tropaeum Traiani (Bucharest,
1965), fig. 212

197 Adamklissi, Trophy of Trajan, metope XXVIII with equestrian Roman and Dacian foe, 109. Photo: F. B. Florescu, *Das Siegesdenkmal von Adamklissi* (Bucharest, 1965), fig. 206

figure's ribs are parallel striations, his stomach is indicated by a dot within a circle. His arms are elongated and seem to take on a life of their own. The precise depictions of such details as the Roman armor and the careful adherence to traditional Trajanic subject matter, however, suggest that the artists of the Adamklissi Monument were looking at models from the city of Rome. The discrepancies indicate that the artists were local inhabitants who were not as gifted as their counterparts in Rome. Furthermore, their artistic objectives were different from those of artists working on imperially sponsored reliefs in Rome. They were concerned primarily with getting their message across. The images are simple, bold, and without artifice. The protagonists are few in number and each is a symbol of a greater whole. A Roman soldier stands for his whole legion, a Dacian woman, and the infant wrapped in the fold of her garment, for the Dacian people (Metope LIV). Women and children are, in fact, included in the metopes of the Adamklissi Monument, just as they are in the Column of Trajan. In both cases, these are not women from the imperial court but Dacian women and children. The artist is again interested in humanizing the enemy, in dramatizing his fate, which culminates in the need for whole families (father, mother, and child) to flee the Roman occupation, their belongings strapped to an ox-drawn cart (Metope XLII) (fig. 198). The final scene on the Column of Trajan is a comparably poignant one. It portrays the Dacian survivors of the Trajanic campaigns setting off into exile with all that is left of their belongings and their land – their grazing animals.

the scene of Trajan trampling a Dacian from the Great Trajanic Frieze (see fig. 185) and also frequently depicted on coin reverses of Trajan of 104–107. Although this type of armor would have been considered inappropriate in a triumphal context, Trajan may well have worn it on the northern front for comfort, and the scene may depict Trajan as the superhuman general who goes into the fray without a protective helmet, the scene a symbolic visualization of the concept of the *Virtus Augusti*. This is a very attractive theory, especially because the motif became one of the central images of the Great Trajanic Frieze. Furthermore, it has been suggested that the inclusion of the pedestal makes it possible that the figure of the horseman is based on an equestrian statue of Trajan. The most obvious candidate would be the statue that served as the centerpiece of the forecourt of Trajan's Forum in Rome.

Although the subject matter of the Adamklissi metopes is closely tied to that of the Column of Trajan and Great Trajanic Frieze in Rome, the style of the metopes has little in common with its city of Rome counterparts and is an excellent example of what we refer to today as provincial art in the qualitative as well as geographical sense. The figures in Metope XXXIV (see fig. 196) may depict Dacians in heroic Greek nudity, but the naked bodies are not beautifully modeled or classically conceived. The posture of the figure on the ground, for example, is awkward and even contorted, its proportions clumsy. The

198 Adamklissi, Trophy of Trajan, metope XLII with Dacian family in ox-drawn cart, 109. Photo: DAIR 69.3285

The Monument of Philopappos

A very different kind of Trajanic monument in the provinces is the Monument of Philopappos in Athens. Its Trajanic date is certain because its inscription gives the emperor's titles of Germanicus and Dacicus but not Parthicus, which signifies that it was constructed between 114 and 116. Although the emperor's titles are carved on pilasters on the monument's facade, the monument was erected not in honor of Trajan but to commemorate Gaius Julius Antiochos Epiphanes Philopappos, a man destined to be king of Commagene, a land in eastern Anatolia. The kingdom's hereditary dynasty came to an end when Vespasian made Commagene a Roman province in 72. Philopappos's grandfather, Antiochos IV, was the last king of the realm, and his successors, as well as other family members, emigrated to Rome and to Greece. Philopappos was appointed *suffect consul*, that is, as a replacement for a regular consul, under Trajan in 109 and settled in Athens where he was eventually laid to rest. In fact, the Monument of Philopappos was the man's tomb built near the apex of the Mouseion hill, probably at the instigation of his sister, Balbilla. The placement of a tomb on a lofty site was a rarity in the Graeco-Roman world and is probably due to the inspiration of funerary monuments in Philopappos's homeland, where his ancestors were interred in large-scale, sacred last resting places or *hierothesia* near the tops of hills, as, for example, that of Antiochos I at Nemrud Dagh of the mid-first century B.C.

The tomb's remains (fig. 199) show it to have been a tall, massive structure, almost square in plan, with a plain podium, a low first story, and a lofty upper story. The tomb was probably surmounted by a light story with a simple attic, inscribed, and crowned with attic statuary depicting Philoppapos's distinguished ancestors. The facade is concave in horizontal section above the podium. The first story is divided into a tripartite frieze framed by piers. The frieze (fig. 200) consists of a central panel, which is oriented horizontally, and two side panels of vertical format but of similar height. The frieze depicts what Philopappos probably considered to be the most important moment of his life – his inauguration as consul in Rome in 109. He is accompanied by two attendants and probably originally by twelve lictors (six survive) arranged in two rows to the left and right of the chariot. The upper story of the main facade was also divided into three parts by means of four Corinthian pilasters, only one of which is extant. A large arcuated niche in the center shelters a colossal, seated portrait of Philopappos; in the smaller, square-topped niche on Philopappos's right sits a togate Antiochos IV, his paternal grandfather and last ruling king of Commagene. An inscription, recorded by Cyriacus of Ancona in the fifteenth century, tells us

that the corresponding niche on Philopappos's left would have housed a statue of Seleukos Nikator, a distant relative on Philopappos's mother's side and founder of the Seleucid dynasty. Little survives of the interior and back of the monument – only the inner side of the north wall and the foundations of the other walls. In antiquity, the elaborate facade screened the burial chamber, which was accessible from the rear of the monument. The back wall of the burial chamber was ornamented with a shrine or *naiskos* framing a statue of Philoppapos on a projecting pedestal and possibly crowning his sarcophagus below.

Parallels for the siting of Philopappos's tomb, for its seated statuary, and so forth, can be found in Commagene. Its concave facade was known earlier, or at least contemporaneously, in Campania, but most striking is its analogy with Flavian and Trajanic commemorative arches in Italy – for example, the Arch of Titus in Rome (see fig. 154) and the Arch of Trajan at Benevento (see figs. 188–189). Both the Monument of Philopappos and the Arch of Titus have a tripartite division of the facade as well as the scheme of an arcuated bay flanked by two rectangular niches; most significantly, the chariot scenes on the Athenian tomb and the Roman arch are so similar that it is difficult to imagine that the patron or designer of the tomb, or both, were not familiar with the earlier arch in Rome. Philopappos's own presence in Rome in 109 can be documented. It was in that year that he took part in the consular procession or *processus consularis* commemorating his inauguration as consul. On the tomb, a frieze representing Philopappos in a four-horse chariot is set into the facade of the monument (see fig. 200). The procession moves from right to left and begins with six toga-clad figures with fasces, undoubtedly lictors, five of which fill the left lateral panel. They are followed by the quadriga group. A bearded Philopappos stands in a chariot led by four horses. He is clad in a tunic and toga and carries in his left hand a long scepter. He most likely made a gesture of salute with his right hand. The chariot is followed by an attendant. The right lateral panel is no longer extant, but a fifteenth-century description of the tomb indicates that the panel once included four to six additional lictors. The division of the Philopappos frieze into horizontal and vertical panels inserted into the fabric of the tomb parallels the placement of narrative panels in contemporary Trajanic arches, such as the one at Benevento, and the scene of Philopappos on the day of his consular procession is based on that of Titus's procession into Rome in 70 in celebration of his great victory over Jerusalem (see fig. 156).

As I have tried to demonstrate elsewhere, the Titus-in-triumph panel may not have been selected as the model for the Philopappos frieze solely for formal reasons or because it was a prominent and recent imperial monument

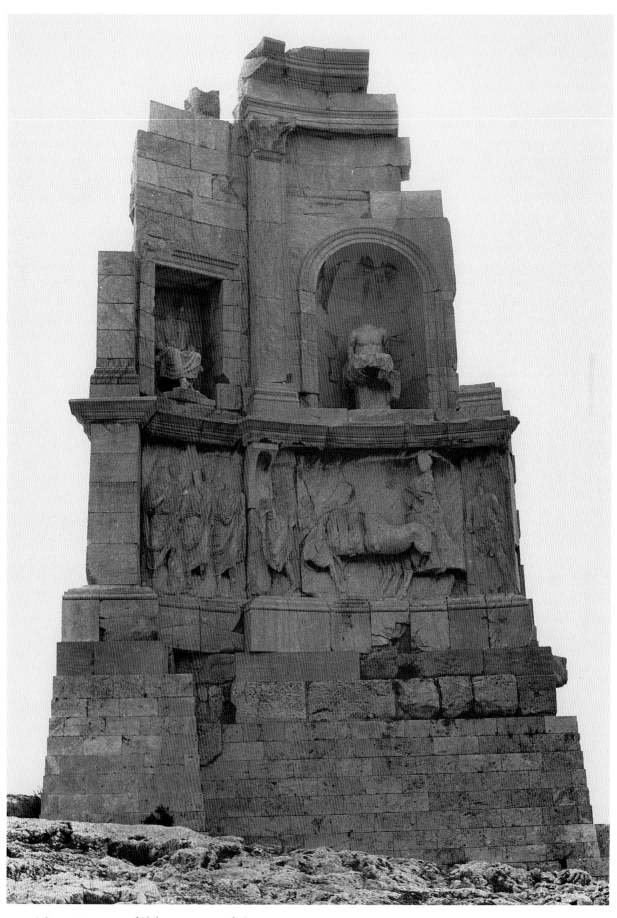

199 Athens, Monument of Philopappos, general view,
114–16. Photo: D. E. E. Kleiner and F. S. Kleiner, 74.20.24

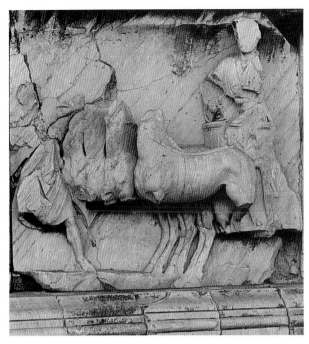

200 Athens, Monument of Philopappos, processus consularis, 114–16. Photo: D. E. E. Kleiner and F. S. Kleiner, 75.25.24

with a chariot scene. Philopappos's father and uncle, Epiphanes and Kallinikos, aided Vespasian and Titus in their campaigns in Judaea and, consequently, the panel representing the Judaean triumph of Titus may have had special significance for Philopappos. Shortly after that triumph, the Commagenian kingdom was disbanded and the royal family brought to Rome. Of all the Roman monuments Philopappos saw during his sojourn in Rome in Trajanic times, the arch commemorating the victory in Judaea must have been one of the most, if not the most, significant for the Commagenian prince.

In the procession on the Athenian tomb, Philoppappos is shown not only at the high point of his life, the day of his investiture as consul, but as a divinity. His head is encircled with a radiate crown; traces of the rays can still be seen above the right ear. Radiate crowns were commonly worn by Philopappos's ancestors, the dynasts of Commagene. Philopappos's chariot is also ornamented with a statue of Hercules holding a club enshrined in a naiskos. It is likely that the image of Hercules was placed beneath that of Philopappos in order to associate him more closely with the mythological figure, who later achieved immortality. The Commagenian dynasts had earlier allied themselves with Hercules. At Nemrud Dagh and other hierothesia in Commagene, Antiochos I with rayed tiara is represented in scenes of a handshake or *dexiosis* with Hercules. The wearing of a rayed crown in a consular procession in Rome was unthinkable. In the

frieze on his tomb, Philopappos is represented at the apex of his Roman career and perhaps at the high point of his life. By donning a rayed crown, however, he indicates that he has not lost sight of his Commagenian origins, of the kingship he claims on his tomb, or of the divinization and worship that were the Commagenian king's due after his death.

The divinization of Philopappos is proclaimed more directly in the upper story of his tomb, where he is seated in heroic nudity between two of his distinguished ancestors. The placement of a representation of a deceased ruler above a scene showing him at the high point of his life is not without precedent. In the arcuated vault of the Arch of Titus in Rome (see fig. 157), the divinized emperor is borne to heaven on the back of an eagle, while below, in the passageway of the arch, the emperor is depicted celebrating a triumph that took place during his lifetime.

Although the Monument of Philopappos was the product of local craftsmen and was built of locally quarried stone, the Athenian masons and sculptors did not create a building that looks Athenian or grows out of an Athenian architectural tradition. Nor may Philopappos's tomb be considered a transplant from the West or East; there are no precise parallels for it anywhere. The unique form of the tomb may, however, be explained as the result of the eclectic tastes of its patron and his diverse background. In this way, the tomb of an heir to the throne of Commagene and a Roman consul, produced in Roman Athens by Athenian artists and artisans, is as fine an example of Roman eclecticism as monuments erected in the capital city.

An important distinction must nevertheless be drawn between the Monument of Philopappos in Athens and the contemporary Trophy of Trajan at Adamklissi (see figs. 196–198). The figural scenes on both were heavily dependent on state reliefs from the city of Rome, but the executor of the processus consularis of Philopappos – an artist trained in the marble workshops of Athens – succeeded in making a fairly close freehand copy of its model. The horses are muscular and foreshortened, and the togati that precede the chariot are depicted convincingly in complicated postures. It is true that the consular procession of Philopappos lacks the vibrant motion of the Titus triumph with its speeding chariot and fasces fluttering in the ensuing breeze, but it is a competent copy of its more famous counterpart. The Adamklissi metopes, however, executed from drawings by local artisans not trained in the Graeco-Roman tradition of stone carving, consist of figural groups drawn from the military repertory of Trajan's column but depict the Roman soldiers and Dacian adversaries in unnaturalistic and contorted postures.

The Art of Freedmen in Trajanic Rome

Roman provincial art, the art of freedmen in the capital, and even state reliefs of early Hadrianic date have much in common, including a disregard for the integrity of time and space, both of which can be found in an extraordinary funerary relief from the Trajanic or early Hadrianic tomb of a freedman in Rome or Ostia. The relief in question is the "Circus Relief" (fig. 201) because it depicts a circus official (*dominus factionis*). At the left of the relief are portrayed, in greatly enlarged scale, a man and woman holding hands. They clasp hands in the dextrarum iunctio meant to symbolize the mutual affection and fidelity of husband and wife; the husband wears a toga. His wife is of smaller stature and hence less important; the relief was probably carved upon the death of her husband and honors him. Although there is no epitaph, that the wife predeceased her husband is expressed pictorially by the extraordinary device of portraying the woman in the form of a statue on a base. The dextrarum iunctio tells the observer that the husband remained faithful to his wife after her death and that the two have now been reunited in perpetuity.

Also fascinating is the circus scene, which occupies most of the relief. The charioteer is depicted twice: first, in his four-horse chariot and again with the palm of victory. This relief, therefore – unlike the reliefs of the Column of Trajan – makes use of continuous narration in which the same protagonist appears more than once in a single scene. Time is conflated here, as it is in the portrait of husband and wife. The scene probably takes place in Rome's main circus – the Circus Maximus. The central spina is portrayed, as are the honorific columns and the dolphin device for keeping score. As in the metopes from the Trophy of Trajan at Adamklissi, the nameless artist has little regard for correct perspective or elegant proportions. He is primarily interested in telling a story, and he does not hesitate to depart from the rules of classical art to achieve his goal. There is extreme disparity in scale. The dominus factionis is enormous, his wife and the charioteer of smaller stature, the horse's attendant and the man on horseback smaller still. The most important figure is depicted largest – in what might be described as a hierarchy of size. The circus scene is also represented from two spatial perspectives, head-on and aerial or bird's-eye view: the chariot, for example, is seen head on, the circus from the air. The perspective has even been called an "earthquake perspective" because the right side of the circus, the entrance gate, and even some of the figures, look

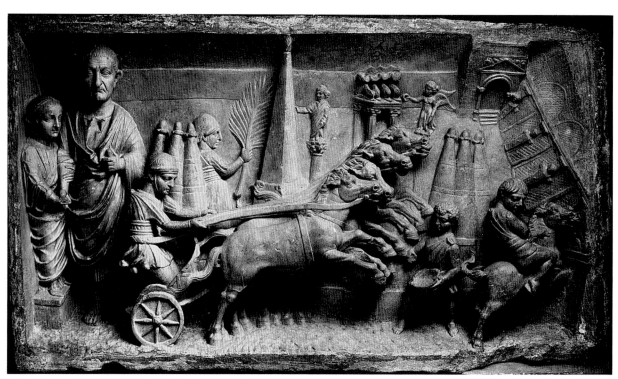

201 Circus relief, perhaps from Ostia, Trajanic or early Hadrianic. Rome, Vatican Museums, Museo Gregoriano Profano. Photo: DAIR 39.557

as if they are about to tumble out of the relief frame. The combination of head-on and aerial perspective, however, can be seen in contemporary state relief, that is, in the Column of Trajan.

Hadrianic Classicism

Publius Aelius Hadrianus, emperor of Rome between 117 and 138, was born in 76. Like Trajan before him, he came not from Rome or even Italy but from Italica in Baetica (part of Spain). Hadrian's mother was Domitia Paulina of Gades and his father was Publius Aelius Hadrianus Afer. Afer died when Hadrian was not yet ten and Hadrian was appointed a ward of Trajan. This was not surprising since a family connection between Hadrian and Trajan had earlier been established by Hadrian's paternal grandfather, a senator who had married Trajan's aunt, Ulpia.

Hadrian was the best-educated and most intellectual of the Roman emperors. He enjoyed music and the arts. Hadrian early on developed a love of Greece and Greek culture, which earned him the nickname Graeculus or "the Greekling" (*Scriptores Historiae Augustae, Hadr.* 2.1). Hadrian actually visited Greece on three occasions, and those visits made a deep impression on him.

He spent much of his long principate traveling to all parts of the Roman world. He not only loved to travel, he was interested in observing the military organization of the empire and its defensive system as well as examining provincial affairs firsthand. Everywhere he went statues and monuments were erected in his name, and for that reason a wide variety of portraits and reliefs honoring him have come down to us.

Hadrian did not have the military ambitions of his immediate predecessor. He was not interested in further expanding the borders but rather in consolidating and protecting that which had already been acquired. It is therefore not surprising that Hadrian built a defensive wall in Britain – Hadrian's Wall. That is not to say that Hadrian had no connection with the military. He had a long and respectable military career and served under Trajan as a staff officer in the first Dacian War and as the commander of a legion in the second Dacian campaign. Hadrian was appointed the governor of Syria in 114, the year that construction began on the Arch of Trajan at Benevento.

The suspicious circumstances surrounding the adoption of Hadrian by Trajan have already been discussed here. Yet, it is likely that Trajan wanted Hadrian to succeed him, and his wife, Plotina, was very much in favor of the adoption. Suspicions nevertheless abounded, and

Hadrian's first order of business was to dispel them. He had been compelled to authorize the execution of some of those who had conspired against him. To counter negative public opinion, he provided the Roman people with a gladiatorial display for a week. He also distributed an especially generous public largess, continued grants to the alimenta, and canceled significant debts to the state.

Hadrian was a great patron of architecture and was himself an amateur architect. He had personal dealings with Apollodorus of Damascus, whom he even approached for a critique of his design for the Temple of Venus and Roma. Apollodorus haughtily chastised Hadrian for designing too low a podium for the building and for cult statues that were too large in scale for their surroundings. Apollodorus, consulting with Trajan on an earlier occasion about his buildings, was interrupted by Hadrian, whom Apollodorus dismissed as a dilettante, by admonishing Hadrian to go away and draw his pumpkins (Cassius Dio LXIX, 4.1–5). The pumpkins referred to drawings Hadrian had been making of vaults shaped like gourds or pumpkins, which were probably based on those constructed by Rabirius for the private wing of Domitian's Palace. Hadrian's designs were eventually actualized at his villa at Tivoli in splendid pumpkin-vaulted structures, which were seemingly built to the emperor's specifications. When Hadrian became emperor, he paid Apollodorus back for his arrogant advice by having the famed architect slain.

Hadrian's Villa at Tivoli is an architectural marvel filled with the emperor's own creations and with those of other highly talented architects of the day. Hadrian also embellished Rome with buildings that are among the finest surviving Roman structures. One of them, a temple to all the gods – the Pantheon – is one of the greatest buildings ever conceived by man. It was not designed by the emperor, who for all his talent was not so gifted, but it does encapsulate his vision of the Roman empire during his principate. Greek and Roman civilization were united and separated from the barbarian world that lay outside the borders of the empire demarcated by Hadrian's Wall. The Pantheon is fronted by a Greek-style portico with columns and a triangular pediment, but its interior is a cylindrical drum surmounted by a vast hemispherical dome and an oculus open to the sky. The oculus allowed mystical communion with the gods, and the natural light provided not only illumination but also drama as it flickered across the gilded coffers and multicolored marbled walls and pavement.

In 100, Hadrian married Vibia Sabina, the daughter of Trajan's sister Marciana. She produced no children but was honored on coinage and on imperially sponsored monuments. Sabina accompanied Hadrian on his

travels, but more of his affection seems to have been lavished on the real love of his life, a beautiful young boy from Bithynia named Antinous. Antinous was born in 110–112 and also accompanied Hadrian on some travels, including a fateful trip up the Nile. Antinous drowned in the Nile in 130, and all sorts of rumors surrounded the event. Some said he committed suicide, others that he gave his own life to save Hadrian's. Whatever the case, he was deeply mourned by Hadrian, who insisted he be deified, and he was – in the eastern part of the empire. The city of Antinoopolis was founded in his memory, and Hadrian commissioned numerous statues to be used in the worship of his cult.

Other cities were founded and still others revitalized under Hadrian. Not surprisingly, Athens, still the cradle of Greek civilization, was developed in an area outside the eastern propylon of the Roman Agora. New structures included the Library of Hadrian, which was based in general form on Vespasian's Templum Pacis in Rome, and the Arch of Hadrian, built to commemorate one of the emperor's visits to the city and demarcating the old Greek and new Roman city. Hadrian also completed the Olympieion, the Temple of Olympian Zeus, which was begun already in the sixth century B.C., continued under Hellenistic dynasts, and planned for completion by Augustus.

Hadrian hoped that he would be succeeded by Lucius Aelius, whom he adopted in 136. Aelius died in 138, and Hadrian adopted Antoninus Pius in his place. In the same year, Hadrian died at Baiae and was divinized by the senate.

The Portraiture of Hadrian

There are more surviving portraits of Hadrian than of any other emperor besides Augustus. This was owing to two factors: because Hadrian was emperor for twenty-one years and because statues of him were erected in cities throughout the empire in anticipation of or in appreciation of his visits.

Hadrian's portraits are interesting in a number of ways. First, they follow the portraits of Trajan by representing the emperor as a never-aging adult. Hadrian became emperor at the age of forty-one and is depicted that age in all his portraits, even those commissioned just before his death. His skin is smooth and wrinkle-free. There are no deep lines in his forehead and no creases mar his cheeks. Second, but even more significant, is that Hadrian wears a full beard. He was the first Roman emperor to do so. In the life of Hadrian, it is rumored that Hadrian wore a beard to hide his poor complexion

(*S.H.A., Hadr.*, 25.1). There may be some truth to this gossip, but even more likely is that Hadrian wore a beard as a Greek affectation. In the second century, Roman men did not wear beards; in second-century Greece, they did. Beards were worn by the Greek poets, philosophers, and statesmen of the past. Hadrian wore a beard in life and in his portraits because he wanted to be "the Greekling." He is even said to have worn the Greek himation rather than the Roman toga in private. Although the wearing of a beard was a private decision, the emperor set a trend – immediately imitated by his contemporaries – and exerted a lasting legacy on his successors. Every Roman emperor since Hadrian, with the exception of boy emperors, wore a beard, a tradition not broken until the fourth century. The introduction of the beard on the face of the emperor had art historical consequences as well because it provided a new facial texture. Artists who fashioned Hadrian's visage and those who captured the physiognomies of his Antonine successors became experts at playing off the texture of the beard and the hair against the softness of the flesh, and the results were often virtuoso performances. Some of the finest Roman portraits date from the Hadrianic and Antonine periods. Another artistic innovation of the Hadrianic period was the drilling of the pupil and iris of the eye. Before this time, the eyes were left blank, the pupil and iris added with paint. The drilling of the eye added still another texture to the face and another area for artistic experimentation.

Hadrian's portraits have been divided into six main types named for the findspot or present location of the finest example. One of the best surviving examples of these, found in 1941 near the Stazione Termini in Rome (fig. 202), is the namepiece of the first type, the Stazione Termini type, created after Hadrian became emperor in 117. It might, therefore, also be thought of as an accession type. There are at present eight known examples of the type: four in Rome, one in Greece and Asia Minor, and one in North Africa. Although the other portraits of the Stazione Termini type exhibit characteristics of Trajanic portraiture, this portrait is of Antonine date, that is, an Antonine replica of a portrait created early in Hadrian's principate. Hadrian is depicted with a full head of curly hair brushed in thick waves from the crown of his head, over his forehead, and arranged in a careful pattern of three primary curls swept delicately across his forehead. It curls down the nape of his neck. Hadrian has a neat moustache and a full but short beard, conforming closely to the shape of his jaw but represented with a plastic fullness. His face is broad and smooth, he has almond-shaped eyes, eyebrows delineated with individual hairs, a straight nose, and full lips. A physical description of Hadrian is given in the *Scriptores* (*Hadr.*, 26.1): "In stature

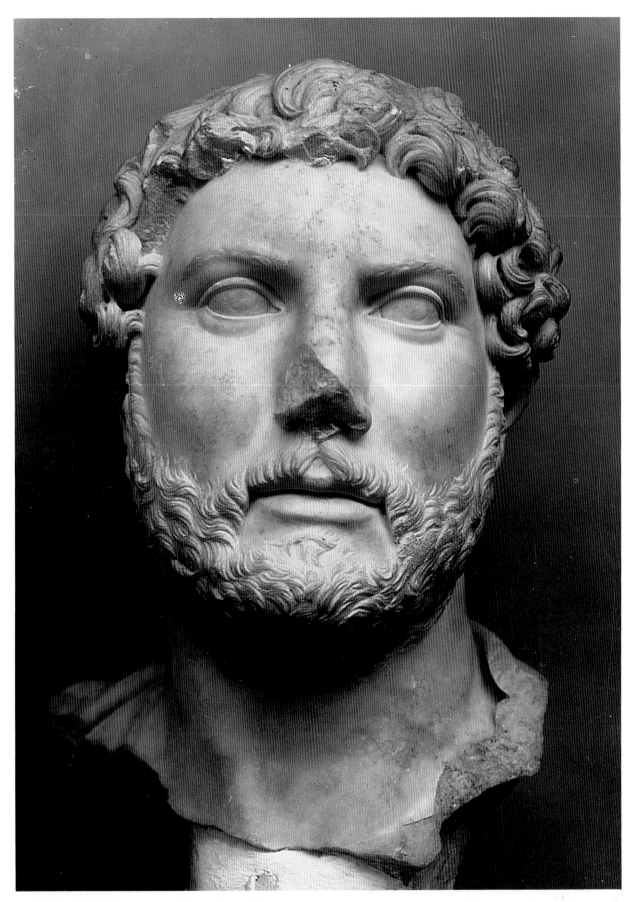

202 Portrait of Hadrian, after 117. Rome, Museo Nazionale delle Terme. Photo: DAIR 54.794

he was tall, in appearance elegant; his hair was curled on a comb and his beard was full, to cover the natural blemishes of his face; his figure was robust."

The portrait is broken off at the collarbone, but the upper folds of the military mantle – the paludamentum – are preserved on the emperor's shoulders. The Stazione Termini portrait is one of the many surviving military portraits of Hadrian.

There are many more examples preserved of Hadrian's later portrait types, distinguished primarily by subtle distinctions in the configuration of the emperor's coiffure. Type 2, the Vatican Chiaramonti 292 type (of which there are twenty-one examples), with its series of hanging locks over the forehead, conforms to numismatic portraits of 118 and may have been created to coincide with the beginning of the emperor's second consulate in the same year. Type 3, or the *Rollockenfrisur* type (having twenty-two examples), has been associated with the Hadrian's third consulate of 119. This curly-haired type is distinguished by the eight broad curls arranged around the forehead. The primary example of this type, which gives it its name, is a portrait of Hadrian in the Museo Nazionale delle Terme (fig. 203).

It was the Vatican Chiaramonti and *Rollockenfrisur* types that predominated between 120–130 and it was only in 127 that a new type (type 4) appears to have been produced, linked with the celebration of Hadrian's decennalia. The only surviving portrait of Hadrian in a toga (fig. 204) is an example of this type, although the primary example is a portrait from Baia, now in the Archaeologi-

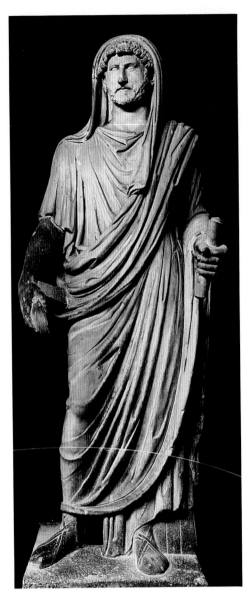

204 Portrait of Hadrian in a toga, 130–40. Rome, Museo Capitolino. Photo: DAIR 55.212

cal Museum in Naples – hence the type's designation as the Cuirass-Paludamentum-Bust Baia type. It is known today in nineteen replicas. In the toga portrait, which dates to 130–140, Hadrian is depicted capite velato as pontifex maximus and probably was in the act of sacrificing at an altar. What separates the type from its predecessors is the emperor's broader and rounder face and the precise configuration of his beard. The eight distinctive curls of the *Rollockenfrisur* type have been replaced with broader clumps of curls over the forehead.

Type 5, the Cuirass-Bust Imperatori 32 type, exemplified by a portrait of Hadrian in the Museo Capitolino of about 130), bears a resemblance to the *Rollockenfrisur* and Baia types in the shape of the face and the arrangement of the curls across the forehead, although

203 Portrait of Hadrian, 119. Rome, Museo Nazionale delle Terme. Photo: DAIR 55.204

there is also a distinctive and elaborate configuration of curls in front of the ears. The type appears to have originated in 128, and twenty-five replicas from all parts of the empire survive.

Hadrian's last type, type 6, known as the Cuirass-Paludamentum-Bust Vatican Busti 283 type and also called the Erbach type, is exemplified by two portraits from Hadrian's Villa at Tivoli, now in the Vatican and Erbach collections, and two others – one in Copenhagen and one in Naples. The type is distinguished by the richer treatment of the hair – in which the play between light and dark is strongly accentuated – the even arrangement of the curls to create an arc over the forehead, and a thinner face with a more pronounced bone structure. Although the type, which exhibits some evidence of the emperor's advancing years, has been designated as Hadrian's latest, the original may have been created earlier and may have been used concurrently with one or more of the others. That the type was devised by an artist with close connections with the court is underscored by the fact that two of the copies were displayed at the emperor's own Tivoli villa.

Still another portrait type of Hadrian has recently been isolated. There are four known replicas, which may belong either to an official type or be a workshop variation of one of the main types. Called the Tarragona type after a portrait now in Tarragona (Spain), it has features in common with the *Rollockenfrisur* and Busti types and, like the Busti and Baia types, seems to be a creation of late Hadrianic times.

The slight distinctions among Hadrian's portrait types are, however, of much less interest than is the enigmatic emphasis on military portraiture under Hadrian. As we have seen, the new emperor was a peace-loving man with no inclination whatsoever to expand the borders of the empire beyond their Trajanic reaches. In fact, the senate criticized Hadrian for terminating Trajan's expansionist policies in the East. Hadrian's military portraits can be explained either as a continuation of Trajanic imagery, for lack of any new initiative in portraiture, but more likely they constituted an attempt to give the impression that the Roman empire continued to be strong militarily and that its borders were secure.

In the same vein were the portraits popular under Hadrian of the emperor triumphing over a vanquished barbarian. Trajan trampled a Dacian on the Great Trajanic Frieze (see fig. 185), a Hadrianic commission; and numismatic portraits of Trajan, minted while he was emperor, show him stepping on a defeated Dacian. A fragmentary statue in the Agora in Athens depicts an emperor in battle gear with a cowering Dacian at his right foot. It could only have been a portrait of Trajan victorious over the Dacians. The type became very popular under Hadrian,

especially in the eastern provinces. A case in point is the over-life-size marble statue of Hadrian (Stazione Termini type) from Hierapytna in Crete (fig. 205), portraying the emperor with his left foot on the back of a fallen barbarian. The emperor wears a wreath with a central decorative medallion and is dressed in breastplate and paludamentum. The figural decoration of the cuirass is of special interest and expresses in a nutshell the political philosophy of Hadrian. An armed statue of Athena (symbolizing Athens), crowned with wreaths by two winged Victories, stands on the back of the she-wolf who suckles Romulus and Remus (Rome). The scene can be interpreted as the triumph of Graeco-Roman civilization over the barbarian world outside Hadrian's Wall. The imagery of this cuirass is so thoroughly identified with Hadrian that even when a headless breastplate with the same scene is discovered, it can with confidence be identified as a portrait of Hadrian. An example is the cuirass from a full-length statue of Hadrian from the Athenian Agora.

The majority of Hadrian's portraits depict him in military costume, but the emperor is also represented in many other guises, and his portraiture is so varied that it provides an excellent picture of Roman role playing. In his portraiture, Hadrian is represented as the Greekling in Greek himation (London, British Museum, Stazione Termini type), as pontifex maximus with the upper edge of his toga drawn up over his head as a veil (Museo Capitolino, Baia type) (see fig. 204), in the guise of Ares Borghese (Museo Capitolino, Vatican Chiaramonti 292), and in heroic nudity (Pergamon Museum, Hadrian as a god).

The Portraiture of Sabina

Hadrian married Trajan's niece, Vibia Sabina, in 100. Since Trajan had no daughter, this is as close as he could come to arranging a dynastic marriage and underscores the likelihood that Trajan wanted Hadrian to succeed him. Coins with Sabina's visage were struck in 128 after she was awarded the title Augusta. She was divinized by Hadrian after her death in 136 or 137, and posthumous coins were minted in her honor. Most of her lifetime portraits in the round, identified by their similarity to her numismatic likenesses, were thus probably produced between 128 and 137. Although the surviving images have been divided into four main types, there is a striking homogeneity among groups. It is still unclear whether these types followed one another chronologically or whether they were created to embody various political aims of Hadrian by assimilating Sabina to Livia, Plotina, and so on.

In any case, Sabina's portraits are of considerable interest because they represent a break with Flavian and

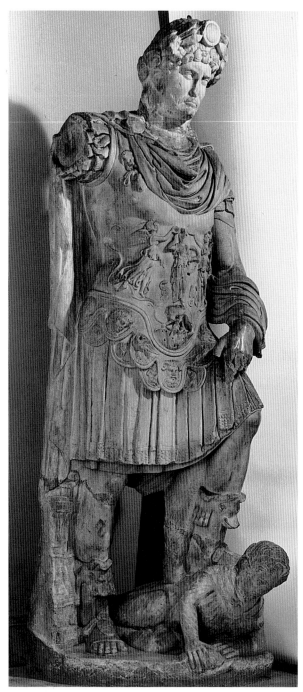

her head. This simple but lovely coiffure is an approximation of the hairstyle worn by Greek goddesses, and it is here that Hadrian's philhellenism reveals itself once again. Nestled in Sabina's hair is a lunate diadem surmounted by a veil. The hairstyle is comparable to those on coins celebrating Sabina as diva Augusta, and it is likely that the portrait dates after the empress's death in 136 and before Hadrian's in 138. The portrait shows the empress to have had an oval face, an aquiline nose, a small, rounded mouth, curved brows with individually delineated brows, almond-shaped eyes with carved pupils and irises. Traces of paint still survive and help to give an idea of the original state of such a portrait statue. The irises of her eyes and her hair were painted brown, her mantle was a purplish red. The head is broken off at the collarbone but originally belonged to a bust or full-length draped statue of the empress.

Other statues of Sabina show her in a variety of guises indicating that Roman role playing was as much the prerogative of empresses as it was of their husbands. One example is a portrait of Sabina from the Palaestra of the Baths of Neptune at Ostia that represents her as Ceres holding the goddess's traditional attribute of poppy and an ear of corn. Although it belongs to the same type as the Terme portrait, it is thought to be a posthumous version.

205 Portrait of Hadrian, from Hierapytna (Crete), ca.120–25. Istanbul, Archaeological Museum. Photo: Forschungsarchiv für römische Plastik Köln, by Gisela Dettloff

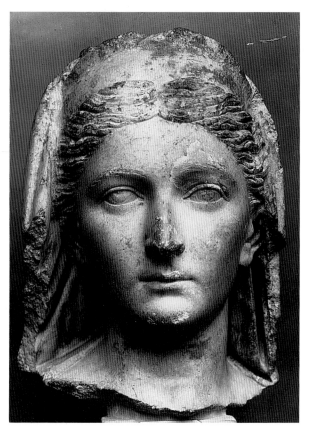

206 Portrait of Sabina, 136–38. Rome, Museo Nazionale delle Terme. Photo: DAIR 54.811

Trajanic tradition. Plotina and other women of the Trajanic court, like Marciana and Matidia, wore their hair in multitiered styles that were less curly but just as elaborate as their Flavian predecessors. As apparent in one of her best-known portraits, now in the Museo Nazionale delle Terme (fig. 206) and belonging to the main type known in twenty-five replicas, Sabina's wavy hair is parted in the center and brushed back over the tops of her ears and fastened in a loose bun at the back of

The Portraiture of Antinous

Hadrian's favorite, Antinous, was immortalized in an impressive series of portraits commissioned after his death in 130 and before Hadrian's in 138. Although numismatic portraits of Antinous were not struck in Rome, a local series was produced in the East between 133 and 134–138 in connection with the cult of Antinous. The portraits in the round show the Bithynian youth in a variety of guises, predominantly those of divinities owing to Antinous's new status as a god. Although arrayed with a multitude of divine attributes, Antinous is always recognizable in his portraits. He is the beautiful youth with round face, deep-set, almond-shaped eyes, straight brows with individually delineated hairs, aquiline nose, and rounded, pouting lips. His hair is full, layered, and tousled. The serpentine curls are carved to stand out from his head in a fluffy mass, their plasticity accentuated by the deep pockets of shadow created by the artist's expertise with the running drill. The portraits of Antinous with their youthful beauty and sensuous surfaces served as important models for the portraits of imperial princes in Antonine times.

The portraits of Antinous have been divided into three types: the Main type, with two variants (A and B distinguished by a slight difference in the arrangement of the locks over the forehead); the Mondragone type; and an Egyptianizing type. In addition, there are surviving portraits that can be identified as Antinous but that are independent of these types. This typology is less significant than the variety of guises assumed by the Bithynian youth, which underscore Hadrian's devotion to the youth's cult and the eclecticism of the emperor's taste.

One of the finest surviving portraits of Antinous, a full-length nude statue found at Delphi (fig. 207), depicts Antinous as Apollo. Laurel leaves may have been added separately to the sculpted wreath, and the statue was probably created between 131 and 132 while Hadrian was on his third journey to Greece. The body type, which is characterized by both feet flat on the ground and a slight tilt of the shoulders and torso, is most similar to the Apollo of the Tiber in the Museo Nazionale Romano.

Another full-length statue of Antinous, draped in a mantle (fig. 208), portrays him as Bacchus – the Roman god of wine. His thick, plastically rendered locks are laced with grapes, and ivy leaves and thick strands of hair fall loosely on his shoulders. The rich texture of the hair is in strong contrast to the soft and sensitive modeling of the face.

Although Antinous was more often than not depicted in the guise of a Roman divinity with a Greek counterpart, as the two already discussed, there are ex-

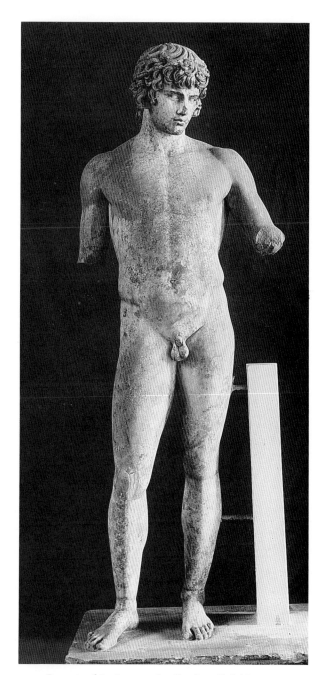

207 Portrait of Antinous as Apollo, from Delphi, 130–38. Delphi, Museum. Photo: École Française d'Archéologie, Athens

ceptions. One is a Pentelic marble relief portrait, found near Lanuvium, of Antinous as the Roman god of the forests – Silvanus (fig. 209). Antinuous wears an olive wreath, the short tunic of the rustic god, and carries his vintager's knife in his right hand. His feet are bare, he is accompanied by a dog, the attribute of Silvanus, and he approaches an altar laden with pinecones, pomegranates, and other fruit, and shaded by an ivy leaf and grape tree. The altar is inscribed with the artist's signature – Antoninianos of Aphrodisias, that is a sculptor from the famous School of Aphrodisias, which thrived in Caria in Asia

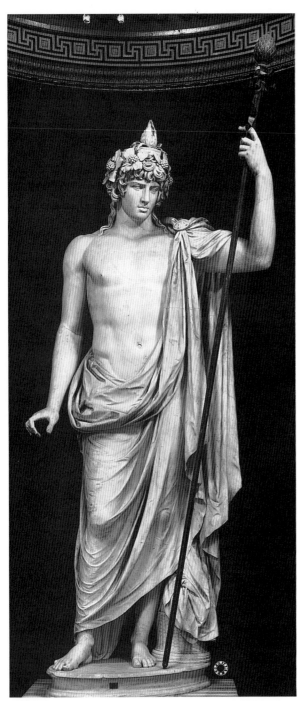

208 Portrait of Antinous as Bacchus, 130–38. Rome, Vatican Museums. Photo: Alinari/Art Resource, New York, 1307

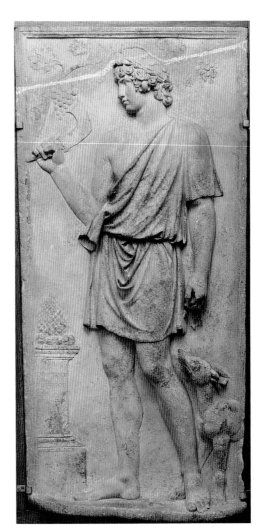

209 Relief with portrait of Antinous as Silvanus, from Lanuvium, 130–138. Private collection. Photo: DAIR 67.72

Minor during the Hadrianic and Antonine periods – one of the small number of artists' names documented from Roman times.

Antinous was also depicted in Egyptian guise in a portrait commissioned by Hadrian for the so-called Poikile of the emperor's magnificent private villa at Tivoli (fig. 210). The choice is a predictable one because Hadrian and Antinous journeyed to Egypt together, and Antinous drowned in the Nile, giving Egypt forever a special significance for Hadrian. The statue portrays Antinous

in an Egyptian kilt and pharaonic headdress without the royal cobra. Antinous clasps in both hands rolled pieces of linen, also carried by Egyptians in their statuary, his arms held stiffly at his sides. Although his tousled hair is completely disguised by the headdress, the facial features, the youthfulness, and the findspot – Hadrian's Villa – make certain the statue's identification as Antinous.

The Sculptural Program of Hadrian's Villa at Tivoli

Hadrian's Villa was the home not only of statues of the deified Antinous but also of an elaborate sculptural program that reflected Hadrian's eclectic taste and documented the extent of his travels. Hadrian's devotion to traveling has already been mentioned. Equally fervent was his desire to recreate his travel experiences at his Tivoli villa by commissioning, or even designing himself, buildings that served as monumental tourist souvenirs.

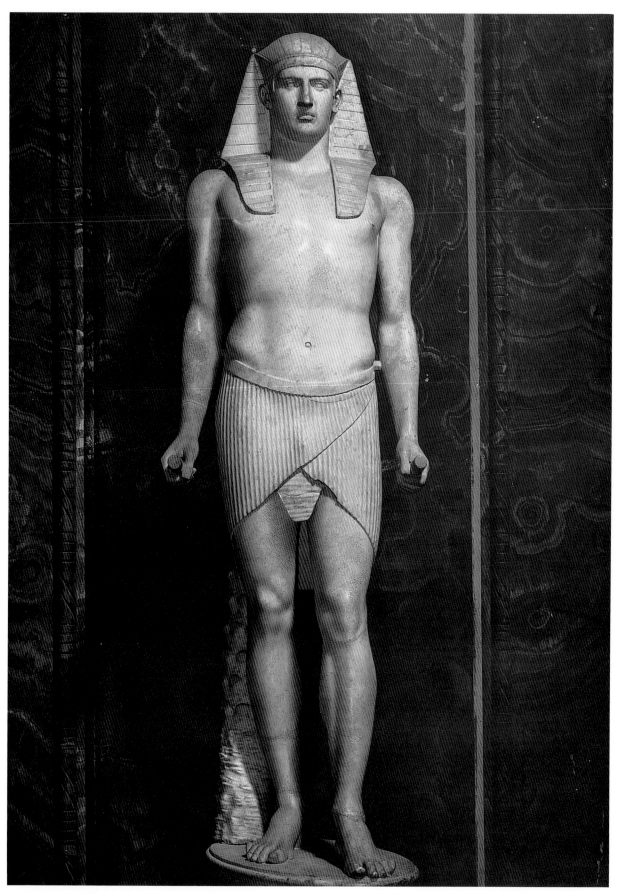

210 Portrait of Antinous as an Egyptian pharaoh, from
the Poikile, Hadrian's Villa, Tivoli, 130–38. Rome, Vatican
Museums. Photo: Alinari/Art Resource, New York, 27022

When Hadrian saw a building he liked on his travels, he brought it back to Tivoli by erecting a replica or a variation of it on the site of his villa. The round Temple of Venus at Hadrian's Villa, for example, is a replica of the fourth-century B.C. Doric Temple of Aphrodite on the island of Knidos. The statue that stood in the center of Hadrian's temple (fig. 211) was a duplicate of the fourth-century B.C. statue of Aphrodite that stood in the Greek temple on Knidos – one of the most famous statues of Aphrodite in Greek antiquity – created by the renowned Greek sculptor Praxiteles.

The Hadrianic copy of the Praxitelean statue still survives and can be viewed in a small museum on the site of Hadrian's Villa. It is one of the few statues still on the grounds of the villa, the emperor's extensive collection of sculpture having been dispersed in later times and now

on display in far-flung museums. The original statuary in Hadrian's Villa includes Roman copies of Greek statues; their prototypes range from the Archaic to the Hellenistic periods. Replicas of famous Greek masterpieces like the Tyrannicides, the Discobolus of Myron, the resting satyr of Praxiteles, and the crouching Aphrodite of Doidalsas, were all prominently displayed in Hadrian's country estate. Especially fine in quality are the old and young satyrs in dark, grayish green marble found in a Corinthian dining room or *oecus* near the so-called Temple of Apollo. These masterworks show both satyrs with hair that is both plastically rendered and energized so that it stands out from their heads. Their inner emotions are mirrored in their expressive faces in a way that diverges from the more serene Hadrianic classicism of contemporary imperial portraiture. The centaurs, in fact, come from a different artistic milieu. They are signed by Aristeas and Papias from Aphrodisias in Caria and thus owe much to the vibrant Hellenistic tradition of Asia Minor. Furthermore, Aphrodisian sculptors frequently worked with different colored marbles, sometimes combining them in the same piece. Their choice of this unusual stone for the satyrs of Hadrian's Villa is explained by this practice.

The greatest of Hadrian's tourist souvenirs and the building with the most complete sculptural decoration still in place is the Canopus (fig. 212), a long pool meant to stand for the canal that led from Alexandria to the city of Canopus, also in the Nile delta, and the location of the Temple of the Egyptian healing god Serapis. Canopus was also the site of an amusement park that Hadrian visited with Antinous. For this reason and also because of Antinous's drowning in the Nile, Hadrian commissioned the construction of the pool and, at one end, a thoroughly modern Roman concrete building, the Serapeum, with a characteristic Hadrianic pumpkin vault undoubtedly designed by the emperor himself to stand for the Temple of Serapis. It probably also stood as a memorial to Antinous and may have housed a statue of the youth. In its context in the villa, it served not as a religious place but as a nymphaeum or fountain. What is of special significance here is that the sculptural program of the Canopus owes only part of its inspiration to Egypt – although not to Egyptian prototypes. The reference to Egypt is apparent in the presence of a marble crocodile that was meant to float in the pool and is now poised on the bank of the canal (fig. 213). Nearby was a statue of a reclining river god holding a cornucopia and resting one arm on a sphinx, certainly a personification of the Nile River. The rest of the sculpture is a testament to Hadrian's eclectic taste and draws on classical Greek and Roman models. The Nile, for example, was paired with the Tiber, identified by the presence of the she-wolf suckling Romulus and

211 Knidian Aphrodite, from Hadrian's Villa, Tivoli, Hadrianic copy. Hadrian's Villa, Museum. Photo: DAIR 79.1778

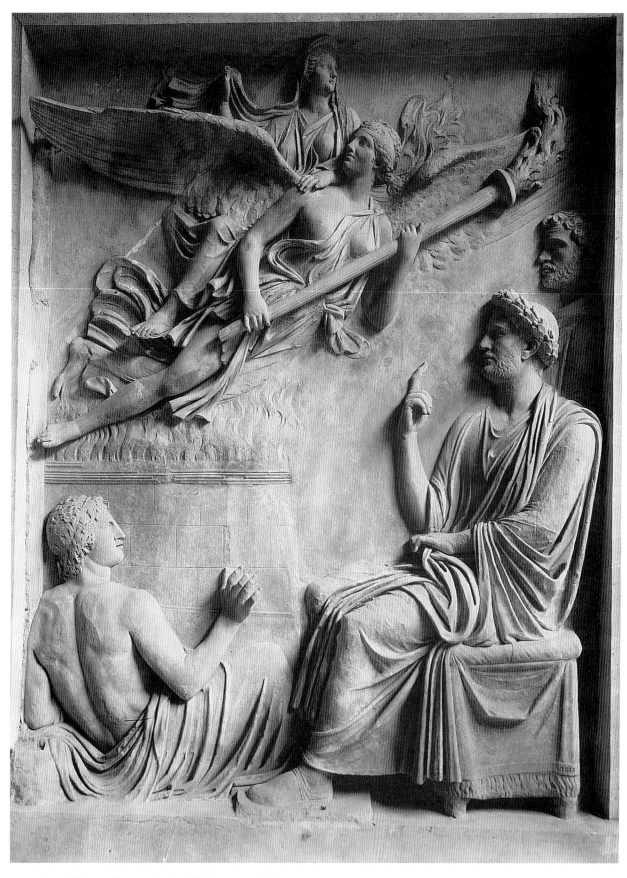

222 Arco di Portogallo, apotheosis of Sabina, 136–38. Rome,
Museo del Palazzo dei Conservatori. Photo: DAIR 1929.283

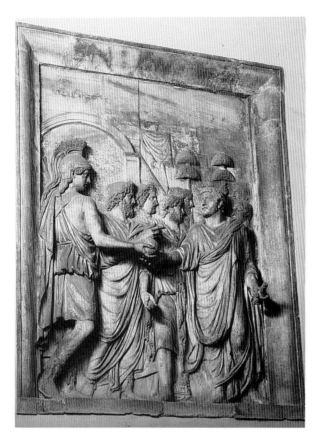

223 Adventus Relief, late Hadrianic/early Antonine. Rome, Museo del Palazzo dei Conservatori. Photo: DAIR 61.1230

the Arco di Portogallo adlocutio and apotheosis on the west facade. This theory has not been widely accepted. The emperor's head is not the original one, and the relief has, therefore, been dated to both the late Hadrianic and the early Antonine period because of its format and style. Another suggestion that the relief decorated an arch on the Via Lata at the entrance to the Antonine Temple of Divine Hadrian has met with wider acceptance. Most scholars now adhere to the theory that the adventus relief, the Torlonia Relief, and the two Arco di Portogallo reliefs came from three different monuments but are all evidence of the late Hadrianic-early Antonine penchant for depicting historical subjects in panels of vertical format.

Private Funerary Art: Sarcophagi

It was during the Hadrianic period that sarcophagi, literally "flesh-eaters," began to be produced in great numbers. They were made not only in Rome but in major cities around the empire. The production of sarcophagi became a veritable industry in the Mediterranean in the second and third centuries, with the most important workshops being in Rome, Athens, and Asia Minor.

Sarcophagi were popular among the Greeks and the Etruscans but were not the chosen form of burial among Romans in the republic and early empire when statuary, funerary reliefs, and altars served as burial markers. That is not to say that there were no stone sarcophagi in early Roman times, but they were the exception rather than the rule. These exceptions include the republican stone sarcophagus, decorated with pulvinars and a Doric frieze, which housed the remains of a member of the family of the Cornelii Scipiones (fig. 224). A late Augustan sarcophagus from Ostia and the well-known Tiberian Caffarelli sarcophagus (fig. 225) are decorated with garlands, bucrania, and paterae, motifs that continued to be popular in the later empire.

It was in the mid-second century that there was a growing interest in sarcophagi. This is due, at least in part, to the change in the Roman burial practice from cremation to inhumation. In Greece and Etruria, cremation and inhumation were practiced side by side according to personal preference or family tradition, and the Romans drew on the heritage of both civilizations for their own burial customs. There are isolated examples of inhumation burial in republican Rome, although such burials seem to have been chosen primarily by members of the upper classes. Nevertheless, it was cremation and not inhumation that was favored in Italy from about 400 B.C. through the early empire. In his description of Poppaea's burial in 65, Tacitus referred to cremation as a Roman custom (*mos Romanus*), and Pliny described the sarcophagus as a foreign wonder.

With the advent of inhumation in the second century, owing both to the increased popularity of Christianity – which professed the resurrection of the soul – and to the desire of the Roman patron and artist for a larger field for decoration, came the concomitant production of stone coffins.

Sarcophagi could be set up both inside or outside mausolea. In the western part of the empire, most were intended for tomb interiors. They were, therefore, carved on only three sides; the plain back side was set up against a wall or in a niche. Western sarcophagi were predominantly rectangular in shape, with flat or slightly sloping lids framed by heads or masks. In later times new shapes evolved in the West, including the round-ended sarcophagus or *lenos*. Eastern sarcophagi, in contrast, were carved on all four sides and were positioned so that the visitor to the tomb or burial ground could encircle the coffin; they also have gabled roofs and in this way resemble temples and tombs or houses of the dead.

Many of the roughly five thousand examples of Roman sarcophagi extant today are decorated with hanging garlands, as the Caffarelli sarcophagus. (see fig. 225). Second to garland sarcophagi in popularity were mythological sarcophagi. This is not surprising since most deco-

224 Sarcophagus of a member of the family of the Cornelii Scipiones, Republican. Rome, Vatican Museums. Photo: DAIR 80.1582

225 Caffarelli Sarcophagus, Tiberian. Berlin, Antikensammlung. Photo: Bildarchiv Foto Marburg/Art Resource, New York, 1.129.967

rated sarcophagi were commissioned by wealthy patrons who were familiar with Greek mythology and had long commissioned statues and mural paintings illustrating Greek myths. An example of late Hadrianic date is the Orestes sarcophagus (fig. 226). It was discovered in 1839 in a tomb near the Porta Viminalis in Rome with brick stamps of 132 and 134 and is thus one of the few securely dated Roman sarcophagi. It is an example of the first of two types of Orestes sarcophagi that focus on differ-

ent parts of the Orestes saga, in this case the murder of Clytaemnestra and her lover Aegisthus. Orestes appears more than once in scenes that move across the front of the sarcophagus in a continuous narration. Also surviving are a considerable number of battle and biographical sarcophagi. The earliest battle sarcophagi do not depict contemporary Roman military history but rather cloak the battles in a veil of myth or ancient history. A sarcophagus, now in the Museo Capitolino (fig. 227), for example, depicts the battle between Greeks and Amazons, even though the tomb was undoubtedly used as the last resting place of a Roman general. Another sarcophagus from the Via Amendola (fig. 228) portrays the battle between Greeks and Pergamene Gauls that took place in the second century B.C. The historical Greek battle was meant to allude, albeit in a very subtle way, to contemporary events and was also certainly used as a coffin for a Roman military commander in about 170. Almost all the surviving battle sarcophagi are Antonine in date and will thus be discussed in detail in the next chapter.

Biographical sarcophagi often include allusions to battle, although actual battle scenes are not described in detail. These sarcophagi depict scenes from both the public and private life of the deceased, usually a Roman general who is portrayed in scenes of clementia, sacrifice, marriage, and similar formal ceremonies. These scenes are spread across the main body of the sarcophagus, and sometimes continue to the lid and are close in subject matter, format, and style to comparable scenes in state relief sculpture. In these sarcophagi, the major events of the deceased's life are highlighted in shorthand vignettes.

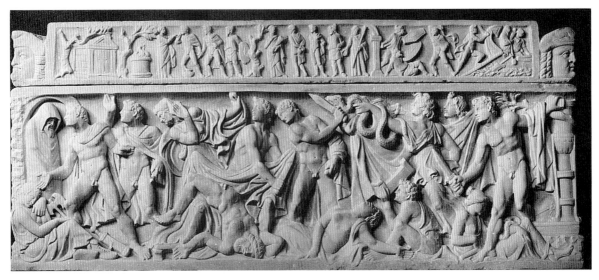

226 Orestes Sarcophagus, from a tomb near the Porta Viminalis, 132–34. Rome, Vatican Museums, Museo Gregoriano Profano. Photo: DAIR 71.1775

227 Sarcophagus with battle between Greeks and Amazons, 140–50. Rome, Museo Capitolino. Photo: DAIR 72.679

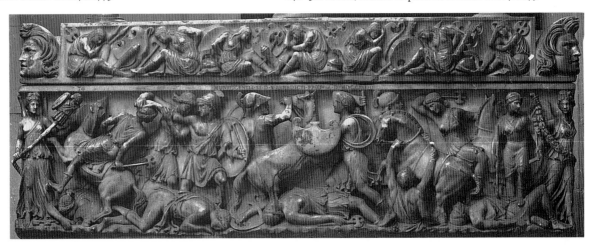

228 Sarcophagus with battle between Greeks and Gauls, from Via Amendola, ca.170. Rome, Museo Capitolino. Photo: DAIR 55.427

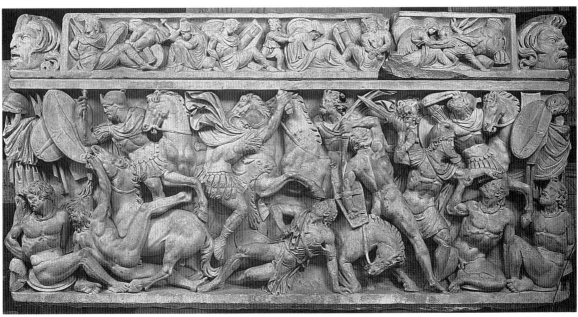

Many are Antonine in date and will also be discussed in the following chapter.

Few Roman sarcophagi have been found in place, and few have surviving epitaphs. It is therefore difficult to establish the patron's position in society, but a few observations can be made. The high cost of the elaborately carved coffins and the taste for mythological subject matter suggest that the patrons were, at the very least, well-to-do. Roman sarcophagi have been characterized as an aristocratic form of art, and there is considerable evidence that they were chosen by wealthy and distinguished families. Yet sarcophagi were not commissioned exclusively by upper-class patrons, as is often implied. Undecorated sarcophagi were, of course, purchased by the less well-off, but even decorated examples of varying quality were used by freedmen of means. Decorated sarcophagi from Rome are preserved that commemorate a shoemaker, a racing-stable owner, and an architect, although such professional scenes appear to be relatively rare on Roman sarcophagi.

Sarcophagi from the first and second centuries with inscriptions identifying the deceased as freedmen and slaves are known from both Rome and North Italy. The Roman examples include the Sarcophagus of Callistus Hagianus, an imperial slave, and that of Tiberius Claudius Pardalus, an imperial freedman and actor. Peducaea Hilara, a freedwoman and her husband were memorialized in an epitaph on a sarcophagus in Modena, and Rafidia Chrysis, also a freedwoman, was buried in a sarcophagus now in Pisa.

Perhaps the best-known and most complex Hadrianic marble coffin is the Velletri sarcophagus (figs. 229–230), so-called because it was found near Velletri and is still on display in the city's museum. The sarcophagus was fashioned out of Greek Parian marble and ultimately housed the remains of seven adults and two children. Although probably produced in a city of Rome workshop, its sloping roof and four-sided decoration were inspired by eastern prototypes. The workmanship of the many scenes is so varied that artists of both western and eastern backgrounds may have carved the figures. Like many Hadrianic works of art, it is thus an eclectic amalgam of eastern and western characteristics. The main body of the sarcophagus is divided into two tiers – it is the earliest extant example of a two-tier sarcophagus – the bottom one punctuated along its length with kneeling atalantes, the top by female caryatids, a favorite motif of the philhellenic Hadrian, which undoubtedly filtered down to the contemporary citizenry. The caryatids support alternating arcuated and triangular lintels, a figure contained within each aedicula, a scheme not unlike that of the Canopus at Hadrian's Villa (see fig. 212). Like so much of Hadrianic art, the figures on the

Velletri sarcophagus owe much to the classical tradition, in this case Greek mythology. The Rape of Persephone is depicted on the lower front register, and the twelve Labors of Hercules are spread across the two short ends and back of the upper relief zone. The deceased patron is also present and portrayed in the act of entering the tomb in the upper middle panel of the short right side. The scenes that have led to the greatest number of scholarly controversies are those in the upper register of the front of the sarcophagus, but all concur that they are mythological. The right scene seems to illustrate the myth of Alcestis, who gave her life to save her husband's and was later brought back from Hades by Hercules. The scene on the left has been identified as another episode from the Alcestis myth in which Mercury leads Alcestis into the Underworld while her husband, Admetus, attempts to follow her. Other scholars suggest that the left-hand scene represents a completely different myth – that of Protesilaus, who died during the Trojan War and was so bitterly mourned by his wife Laodamia that he was returned to her for the duration of three hours. What is of greater consequence than the precise identification of the correct myth is that both stories emphasize earthly death and heavenly reunion. In other words, a married couple parted by death will be reunited in the afterlife. It is the same theme popular in the funerary reliefs of freedmen of bonds formed in life not being broken by death (see, for example, fig. 255).

Hadrianic Art in the Provinces

Hadrian's travels took him to the farthest reaches of the empire. Everywhere he went monuments were commissioned in his name. These were either imperially sponsored or paid for by individual city councils or private patrons. Athens was, not surprisingly, one of those cities that was enhanced in Hadrianic times. Hadrian visited the city on three occasions, and each visit led to additional embellishment of the city. Hadrian finished the Olympieion, which had a long building history commencing in the sixth century B.C. He also built a pantheon, like the one in Rome dedicated to all the gods, but having a different plan. Hadrian also sponsored public works in Athens, including streets and bridges, and built an important new aqueduct that was completed by his successor, Antoninus Pius. It was during Hadrian's third and final visit to the city (131–132) that his major Athenian buildings were dedicated – the Library of Hadrian, the Olympieion, and the Arch of Hadrian.

The arch was erected by the citizens of Athens in honor of Hadrian's benefactions to the city. In fact, the purpose of the arch was to divide the old city of Athens

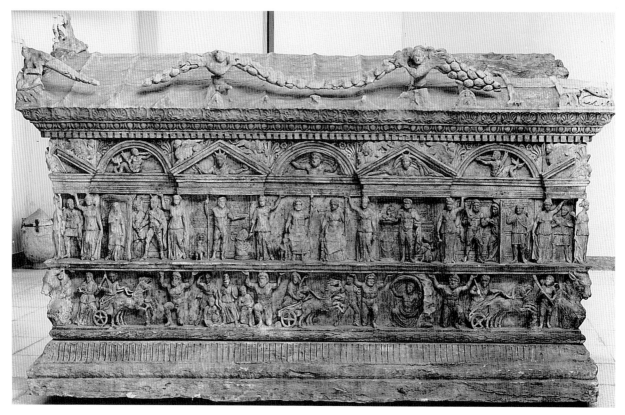

229 Velletri Sarcophagus, from Velletri, long side, Hadrianic.
Velletri, Museum. Photo: DAIR 59.53

230 Velletri Sarcophagus, from Velletri, other long side,
Hadrianic. Velletri, Museum. Photo: DAIR 59.52

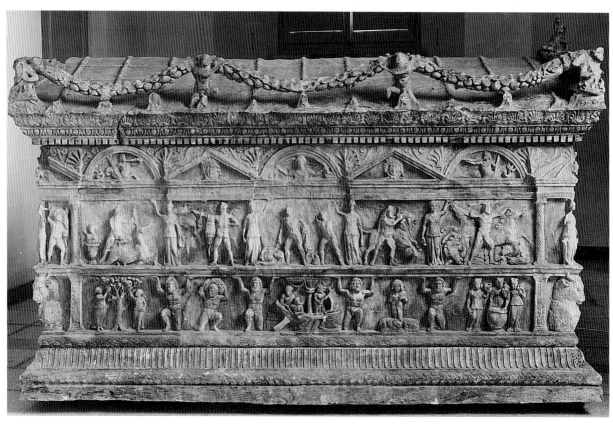

from the new city constructed by Hadrian. The inscription on the arch facing west and the old city says, "This is Athens, the ancient city of Theseus." On the east side of the arch, the inscription reads "This is the city of Hadrian and not of Theseus." The central aperture of a triple opening on the second story of the Arch of Hadrian was screened with a marble slab.

The Arch of Hadrian was located at the northwest precinct of the Olympieion, and it is known that Hadrian passed through the arch in 131–132 on his way to the dedication ceremonies of the Temple of Olympian Zeus. The cella of the temple had a chryselephantine statue of Zeus, and the precinct was filled with statues of Hadrian dedicated by the cities of Greece. The importance of the provinces to Rome under Hadrian is underscored by the first monument commissioned by his successor, Antoninus Pius, in honor of his divine adoptive father – the Temple of Divine Hadrian or the Hadrianeum – which had sculptured reliefs of the provinces that served as column bases or, more symbolically, as the support of the empire (see fig. 251).

The Art of Aphrodisias

Art also flourished in Asia Minor under Hadrian. This is not surprising because the Greek tradition was as strong in Asia Minor as on the Greek mainland. The artistic center in Asia Minor that is best known today is that at Aphrodisias in Caria. It was at Aphrodisias that a school of sculptors about which we know a great deal fashioned art for their own city and also made works of art for export. Works by the Aphrodisian sculptors, Aristeas and Papias, were displayed in Hadrian's Villa at Tivoli, perhaps the highest compliment a sculptor of the mid-second century could receive. Antoninianos of Aphrodisias signed a relief depicting Antinous as Silvanus (see fig. 209), which, along with the works from Hadrian's Villa, would suggest that some Aphrodisian sculptors must have enjoyed imperial patronage. It is likely that some artists from the School of Aphrodisias were members of a traveling workshop that ventured to Italy and elsewhere in the Roman empire in search of lucrative commissions.

The Significance and Legacy of Trajanic and Hadrianic Art

The art commissioned by Trajan and Hadrian is inextricably bound with the political and social history of their time. Since Hadrian was the adoptive "son" of Divus Traianus, he continued many of his predeces-sor's policies and commissioned monuments that not only honored Trajan but that underscored the similarity of their imperial programs. It is for this reason that some early Hadrianic monuments, such as the Great Trajanic Frieze and the Anaglypha Traiani/Hadriani, are almost indistinguishable from their Trajanic prototypes both in subject matter and in style. This is not to say that art commissioned by the two Spanish emperors is identical. Their portraiture is distinctively different and uniquely expresses their different personas. Trajan was the great general, militarily powerful but generously humane; Hadrian was the statesman, cultured world traveler, Grecophile, and amateur architect. Trajan's likenesses portray him in military garb, and his most outstanding monuments, like the Column of Trajan, depict his efficient army, which not only wins battles but also benefits conquered territories by Romanizing them. The inscription of the Arch of Trajan at Benevento lists two of the titles Trajan accumulated in his many military campaigns but also underscores the beneficence of such social programs as the institutio alimentaria. Hadrian is represented in his portraits as the bearded Greek intellectual who continues to display Trajan's military prowess in cuirassed statues that portray him with cowering barbarians at his feet. The latter images nonetheless also celebrate the unification of Greek and Roman civilization, in contrast to the barbarian world that lay outside the borders of the empire extended by Trajan and consolidated by Hadrian.

Trajanic art often shows its indebtedness to the art of the age of Augustus. Trajan is depicted as a neo-Augustus with a neo-Augustan hairstyle, and the Forum of Trajan with its semicircular exedrae is based closely on the Forum of Augustus. Trajan's political and social policies also owe much to those of Rome's first emperor, and under Trajan many new colonies were founded that, like those of Augustan and other times, bore a distinctive Roman stamp.

Trajanic art, however, departs from Augustan art in a number of significant ways. On the Column of Trajan, the emperor is still first among equals or princeps, but on the Arch of Trajan at Benevento, he is the most important figure in the relief scenes, his importance being underscored by his disproportionate size. The figure of the emperor had also become a symbol of imperial power – on the Great Trajanic Frieze (really an early Hadrianic commission), a helmetless Trajan on horseback tramples one Dacian while granting clemency to another. His military exploits and virtues were celebrated at the same time in a scene that preserves for posterity an event that did not actually take place. Although such fictional enactments originated under Augustus, space and time are conflated in the Great Trajanic Frieze in a way that would

have been inconceivable in the imperial art of Augustus. Events that took place at different times and in different parts of the world seem to occur at the same time, as, for example, in the adventus and battle scene from the Great Trajanic Frieze. Figural scenes are depicted from dual vantage points, that is, from head-on and aerial views, as on the Column of Trajan. Figures in different relief panels, such as those of the Capitoline triad and Trajan himself in the attic panels on the city side of the Arch of Trajan at Benevento, are united by gesture and glance across or behind an inscription plaque. The implication is that figures in seemingly different spaces are not confined by that space but can interact freely, another example of the Trajanic and Hadrianic artist's disregard for the rules that had earlier determined the depiction of space in art. Although these techniques were never before employed in imperial monuments, they do appear in earlier relief sculpture commissioned by freedmen in Rome as well as in provincial Roman relief sculpture. It is this adoption of the conventions of the art of freedmen by the imperial circle that ultimately leads to what is called Late Antique art.

The cornerstones of Trajanic art are the emperor's military victories and his social programs celebrated in the Forum and Column of Trajan and in the Arch of Trajan at Benevento. Barbarian women bear the brunt of Trajan's pacification of Dacia, along with their male counterparts and their children, and female personifications, such as the city tyches, abound in the relief panels on the Arch of Trajan at Benevento. Historical women, however, are not included in Trajanic state reliefs, although a poor Italian girl is one of the children who benefits from Trajan's alimentary program in a panel from the top right pier of the country side of the Benevento arch. Trajan's wife, Plotina, was honored in numismatic portraits and likenesses in the round under Trajan, but it was really under Hadrian that she was prominently featured. Plotina's devotion to Hadrian was returned in kind by the new emperor, who apparently owed his adoption and accession to her. She was generously rewarded both during her lifetime and after her death by additional portraits in the round and on coins. Hadrian appears to have placed her statue, along with that of Divus Traianus, on the attic of the Arch of Trajan at Benevento. After her death, Hadrian had her consecrated, and her remains were placed alongside those of her husband in a golden urn at the base of the Column of Trajan. The Temple to Divine Trajan was rededicated as the Temple of Divine Trajan and Divine Plotina. Hadrian's patronage of art depicting women of the imperial court continued during his principate, and it appears to have been Hadrian who commissioned a monument with panels depicting the apotheosis of his wife Sabina. It may have been a funerary monument, but the scene in which Sabina is represented is one that depicts a significant Roman state ceremony: the cremation of the empress on the imperial ustrinum in the Campus Martius. The relief is not only the first extant one in monumental Roman art to depict the apotheosis of a woman, but the first that has a contemporary woman as the focus of the story.

Trajan expanded the frontiers of the empire to their greatest extent and was responsible for founding new Roman colonies built from scratch in the Roman style or rejuvenated with monuments with a distinctive Roman appearance. Some of these structures, like the Trophy of Trajan at Adamklissi, also honored the emperor and his achievements. The Adamklissi Monument, a memorial to Trajan's Dacian victories in the land of that very conquest, attests to the fact that provincial artists under Trajan had access to drawings that duplicated some of the subject matter of the spiral frieze of the Column of Trajan, but that they executed these in a style that best expressed their own view of the war and the consequences for its victims. While the Roman soldiers and their Dacian foes are depicted in the metopes of the Adamklissi Trophy in awkward and contorted postures, the figures in the contemporary consular procession from the Monument of Philopappos are portrayed with a fluid grace that is much closer in format and style to its city of Rome prototype – the chariot scene on the Arch of Titus. Provincial style under Trajan thus varied from region to region, depending on the skill of its artists and their prior experience in executing figures in classical draperies and poses. The tradition for carving Pentelic marble had its roots in the distant past in Athens, but Dacia was an artistic backwater before Roman occupation of the region in Flavian and Trajanic times.

Hadrianic art, like Trajanic art, was also based, at least in part, on the art of the past, especially the Greek past. The philhellene Hadrian commissioned works of art that, like those sponsored by Augustus, drew on classical models. Most of the statues that graced his villa were replicas or variations of famous Greek masterpieces. The portraits of Antinous show Hadrian's favorite in the guise of Greek divinities. Sabina wears the hairstyle of a Greek goddess. The prototypes for Hadrian's portraits were not those of an earlier emperor but those of Greek philosophers and poets, just as Augustus's were images of Greek athletes. The Arco di Portogallo reliefs, with their large elegant figures against a blank background, can only be characterized as classicizing in style.

Hadrianic art also owes much to the art of Trajan. Hadrian's military portraits were based on Trajanic prototypes, and Hadrian – like Trajan – was depicted as the never-aging adult. The Anaglypha Traiani/Hadriani represents a scene of Trajan's alimenta; a successful social

policy that Hadrian continued and that is depicted in one of the reliefs from the Arco di Portogallo. Its style and that of the Hadrianic Hunting Tondi derive from that of the Column of Trajan.

Yet despite its reliance on the distant and the more recent past, Hadrianic art was often innovative. It is perhaps in the field of architecture that Hadrian made his most important contribution. The pumpkin domes of such structures as the Serapeum of the Canopus and the Piazza D'Oro of Hadrian's Tivoli Villa, which may have been based on drawings in the emperor's own hand, were in the tradition of the revolutionary architectural experiments in palace architecture of Severus and Celer and Rabirius. But Hadrian carried that revolution one step further by combining traditional columnar and concrete vaulted architecture in a truly successful synthesis. Hadrian's choice of sculpture for his villa was eclectic. At the Canopus, for example, he placed Egyptian- and Greek-derived and Roman statuary in a picturesque setting of a pumpkin dome and columns surrounding a pool that are meant to conjure up all at once a canal in Egypt, an Egyptian temple, the drowning of Antinous, and the youth's ultimate deification. It might be said that this theatrical display is the private counterpart of Trajan's dramatic public exhibition of architecture, sculpture, and political propaganda in the Forum of Trajan in Rome.

Hadrian's Villa was indeed a private estate, and its art highly personal in nature. Sculpture commissioned by the emperor for the city of Rome was also often personal in its subject matter. The tondi on the Arch of Constantine attest to Hadrian's devotion to the hunt, to his travels, and to Antinous, whose temple-tomb complex they may have decorated. The reliefs from the Arco di Portogallo record the cremation of his wife. Hadrian's earliest commissions, however, honor Trajan's military deeds and social programs, of which the latter received the new emperor's continued support. Furthermore, the Conservatori adventus scene may belong to a public monument of Hadrian, perhaps an arch, and the alimentary distribution from the Arco di Portogallo records Hadrian's public beneficence.

Perhaps it is Hadrian's portraiture that best sums up his contribution to Roman art. While based on Greek prototypes and thus rooted in the classical past and also clearly modeled on the portraiture of his immediate predecessor, the portraiture of Hadrian was completely novel and established a new fashion for bearded imperial portraits and a new image for the emperor of Rome that lasted until the very end of the empire.

Bibliography

Hadrian's biography is preserved in the *Scriptores Historiae Augustae*. Encapsulated biographies of Trajan and Hadrian are in *The Oxford Classical Dictionary*, 2d ed. (Oxford, 1970). General books and articles on the period include: J.M.C. Toynbee, *The Hadrianic School: A Chapter in the History of Greek Art* (Cambridge, 1934). G. Koeppel, "Die historischen Reliefs der römischen Kaiserzeit III: Stadtrömische Denkmäler unbekannter Bauzugehörigkeit aus trajanischer Zeit," *BonnJbb* 185 (1985), 143–213. G. Koeppel, "Die historischen Reliefs der römischen Kaiserzeit IV: Stadtrömische Denkmäler unbekannter Bauzugehörigkeit aus hadrianischer bis konstantinischer Zeit," *BonnJbb* 186 (1986), 1–90. M.T. Boatwright, *Hadrian and the City of Rome* (Princeton, 1987).

The Portraiture of Trajan and Plotina: W.H. Gross, *Bildnisse Traians* (Berlin, 1940). M. Wegner, *Hadrian, Plotina, Marciana, Matidia, Sabina* (Berlin, 1956). R. Calza, *Scavi di Ostia*, vol. 5; *I ritratti*, vol. 1 (Rome, 1964), 59–60, no. 89 (Ostia Trajan). J.C. Balty, *Cahiers de Mariemont* 8–9 (1977–78), 45 ff. (Trajan) K.P. Erhart Mottahedeh, J. Frel, S.K. Morgan, and S. Nodelman, *Roman Portraits: Aspects of Self and Society* (Los Angeles, 1980), 55–57 (S. Nodelman) (Plotina). K. Fittschen and P. Zanker, *Katalog der römischen Porträts in den Capitolinischen Museen und den anderen kommuna-*

len Sammlungen der Stadt Rom, 3 (Mainz, 1983), 7–9 (Plotina). K. Fittschen and P. Zanker, *Katalog der römischen Porträts in den Capitolinischen Museen und den anderen Sammlungen der Stadt Rom*, 1 (Mainz, 1985), 39–44 (Trajan). M.T. Boatwright, *Hadrian and the City of Rome* (Princeton, 1987).

The Forum and Column of Trajan: W. Froehner, *La Colonne Trajane* (Paris, 1861–62). C. Cichorius, *Die Reliefs der Trajanssäule*, 1–2 (Berlin, 1900). K. Lehmann-Hartleben, *Die Trajanssäule: Ein römisches Kunstwerk zu Beginn der Spätantike* (Berlin, 1926). M.E. Bertoldi, *Ricerche sulla decorazione architettonica del Foro Traiano*, *StMisc* 3 (Rome, 1962). F.B. Florescu, *Die Trajanssäule, Grundfragen und Tafeln* (Bucarest, 1969). P. Zanker, "Das Trajansforum in Rom," *AA* (1970), 499–544. L. Rossi, *Trajan's Column and the Dacian Wars* (London, 1971). C. Leon, *Die Bauornamentik des Trajansforum* (Vienna, 1971). A. Malissard, *Études filmiques de la Colonne Trajane* (Tours, 1974). P. MacKendrick, *The Dacian Stones Speak* (Chapel Hill, 1975), 71–94. A. Bonanno, *Portraits and Other Heads on Roman Historical Relief up to the Age of Septimius Severus* (Oxford, 1976), 69–76. L. Richardson, Jr., "The Architecture of the Forum of Trajan," *ArchNews* 6 (1977), 101–7. W. Gauer, *Untersuchungen zur Trajanssäule*, vol. 1, *Darstellungsprogramm und künstlerischer Entwurf* (Berlin, 1977). J. Packer, "Numismatic Evidence for the Southeast (Forum) Facade of the Basilica Ulpia," in L. Casson and M. Price, eds., *Coins, Culture and History in the Ancient World*

(Detroit, 1981), 57–68. C. Amici, *Foro di Traiano: Basilica Ulpia e Biblioteche* (Rome, 1982). G. Becatti, "La Colonna Traiana, espressione somma del rilievo storico romano," *ANRW* II. 12. 1 (1982), 536–78. J. Packer, K. Lee, and R. M. Sheldon, "A New Excavation in Trajan's Forum," *AJA* 87 (1983), 165–72. J. Pinkerneil, *Studien zu den trajanischen Dakerdarstellungen* (Diss., University of Freiburg, 1983). J. C. Anderson, *The Historical Topography of the Imperial Fora* (Brussels, 1984), 141–77. M. Waelkens, "From a Phrygian Quarry: The Provenance of the Statues of the Dacian Prisoners in Trajan's Forum at Rome," *AJA* 89 (1985), 641–53. S. Settis, ed., *La Colonna Traiana* (Turin, 1987). S. S. Frere and F. A. Lepper, *Trajan's Column* (Gloucester, N.H., 1988). P. Pensabene et al., "Foro Traiano: Contributi per una ricostruzione storica e architettonica," *ArchCl* 41 (1989), 27–36. S. Stucchi, "TANTIS VIRIBVS: L'area della colonna nella concezione generale del Foro di Traiano," *ArchCl* 41 (1989), 237–92. J. Packer, "Trajan's Forum in 1989," *AJA* 96 (1992), 151–62.

The Great Trajanic Frieze: F. W. Goethert, "Trajanische Friese," *JdI* 51 (1936), 72–81. M. Pallottino, "Il grande fregio di Traiano," *BullCom* 66 (1938), 17–56. W. Gauer, "Ein Dakerdenkmal Domitians: Die Trajanssäule und das sogenannte grosse trajanische Relief," *JdI* 88 (1973), 318–50. A. Bonanno, *Portraits and Other Heads on Roman Historical Relief up to the Age of Septimius Severus* (Oxford, 1976), 77–81. G. Koeppel, "Die historischen Reliefs der römischen Kaiserzeit III: Stadtrömische Denkmäler unbekannter Bauzugehörigkeit aus trajanischer Zeit," *BonnJbb* 185 (1985), 149–53, 173–95. A. M. Leander Touati, *The Great Trajanic Frieze* (Stockholm, 1987).

Extispicium Relief: G. Koeppel, "Die historischen Reliefs der römischen Kaiserzeit III: Stadtrömische Denkmäler unbekannter Bauzugehörigkeit aus trajanischer Zeit," *BonnJbb* 185 (1985), 154–57, 204–12. A. M. Leander Touati, *The Great Trajanic Frieze* (Stockholm, 1987), 110.

The Arch of Trajan at Benevento: A. von Domaszewski, "Die politische Bedeutung des Traiansbogens in Benevent," *ÖJh* 2 (1899), 173–98. P. G. Hamberg, *Studies in Roman Imperial Art* (Uppsala, 1945), 67–71. C. Pietrangeli, *L'arco di Traiano a Benevento* (Novara, 1947). F. J. Hassel, *Die Trajansbogen in Benevent: Ein Bauwerk des römischen Senates* (Mainz, 1966). M. Rotili, *Il Museo del Sannio nell'Abbazia di S. Sofia e nella Rocca dei Rettori di Benevento* (Rome, 1967), 11, pl. 16 (statues of Trajan and Plotina from the attic). G. Koeppel, "Profectio und Adventus," *BonnJbb* 169 (1969), 130–94. M. Rotili, *L'arco di Traiano a Benevento* (Rome, 1972). K. Fittschen, "Das Bildprogramm des Trajansbogens zu Benevent," *AA* 87 (1972), 742–88. T. Lorenz, *Leben und Regierung Trajans auf dem Bogen von Benevent* (1973). W. Gauer, "Zum Bildprogramm des Trajansbogens von Benevent," *JdI* 89 (1974), 308–35. A. Bonanno, *Portraits and Other Heads on Roman Historical Relief up to the Age of Septimius Severus* (Oxford, 1976), 82–94. K. Stemmer, *Untersuchungen zur Typologie, Chronologie und Ikonographie der Panzerstatuen* (Berlin, 1978), 101, n. 283; 169, no. 66 (cuirassed statue of Trajan from the attic). E. Simon, "Die Götter am Trajansbogen zu Benevent," *TrWPr* 1–2 (1979–80), 3–15. S. De Maria, *Gli archi onorari di Roma e dell'Italia romana* (Rome, 1988), 232–35.

The Pozzuoli Arch: J. Sieveking, "Römisches Soldaten-reliefs," *SBMünch* 6 (1919), 1–10. M. Cagiano de Azevedo, "Un dedica abrasa e i rilievi puteolani dei musei di Filadelfia e Berlino," *BullCom* 67 (1939), 45–56. H. Kähler, "Der Trajansbogen in Puteoli," *Studies Presented to D. M. Robinson*, 1 (St. Louis, 1951), 430–39. K. D. Matthews, "Domitian, the Lost Divinity," *Expedition* 8 (1966), 33–36. D. E. E. Kleiner, *The Monument of Philopappos in Athens* (Rome, 1983), 72–73.

The Arch of Trajan at Ancona: E. Galli, "Per la sistemazione dell'arco di Traiano in Ancona," *BdA* 30 (1936–37), 321–36. S. Stucchi, "Il coronamento dell'arco romano nel porto di Ancona," *RendNap* 32 (1957), 149–64. S. De Maria, *Gli archi onorari di Roma e dell'Italia romana* (Rome, 1988), 227–28.

The Trophy of Trajan at Adamklissi: F. B. Florescu, *Das Siegesdenkmal von Adamklissi* (Bonn, 1965). L. Rossi, "A Historiographic Reassessment of the Metopes of the Tropaeum Traiani at Adamklissi," *Archaeological Journal* 129 (1972), 56–68. P. MacKendrick, *The Dacian Stones Speak* (Chapel Hill, 1975), 95–105.

The Monument of Philopappos: J. Stuart and N. Revett, *The Antiquities of Athens*, 3 (London, 1794). M. Santangelo, "Il monumento di C. Julius Antiochos Philopappos in Atene," *ASAtene* 3–5 (1941–43), 153–253. J. Travlos, *Pictorial Dictionary of Ancient Athens* (New York, 1971). D. E. E. Kleiner, *The Monument of Philopappos in Athens* (Rome, 1983). D. E. E. Kleiner, "Athens under the Romans: The Patronage of Emperors and Kings," in C. B. McClendon, *Rome and the Provinces: Studies in the Transformation of Art and Architecture in the Mediterranean World* (New Haven, 1986), 8–20.

The Circus Relief: O. Benndorf and R. Schöne, *Die antiken Bildwerke des Lateranensischen Musuems* (Leipzig, 1867), 22–24, no. 34. G. Rodenwaldt, "Römische Reliefs: Vorstufen zur Spätantike," *JdI* 55 (1940), 11–22. Helbig, 4th ed., vol. 1 (1963), 724–25, no. 1010. R. Calza, *Scavi di Ostia*, vol. 5; *I ritratti*, vol. 1 (Rome, 1964), 67, no. 103. D. E. E. Kleiner and F. S. Kleiner, "The Apotheosis of Antoninus and Faustina," *RendPontAcc* 51–52 (1978–80), 394–95, fig. 5.

The Portraiture of Hadrian, Sabina, and Antinous: M. Wegner, *Hadrian, Plotina, Marciana, Matidia, Sabina* (Berlin, 1956). R. Calza, *Scavi di Ostia*, vol. 5; *I ritratti*, vol. 1 (Rome, 1964), 79–80, no. 127 (Sabina as Ceres from Ostia). H. G. Niemeyer, *Studien zur statuarischen Darstellung der römischen Kaiser* (Berlin, 1968) (role playing in imperial portraiture). A. Carandini, *Vibia Sabina* (Florence, 1969). C. W. Clairmont, *Die Bildnisse des Antinous* (Bern, 1966). K. Fittschen, *Katalog der antiken Skulpturen in Schloss Erbach* (Berlin, 1977), 72–75 (Hadrian). A. Giuliano, ed., *Museo Nazionale Romano: Le sculture*, I, 1 (Rome, 1979), 280–82, no. 174 (Hadrian) (V. Picciotti Giornetti); 282–83, no. 175 (Sabina) (V. Picciotti Giornetti). C. Pietrangeli, *The Vatican Collections: The Papacy and Art* (New York, 1983), 181–82, no. 98 (C. Sturtewagen and R. S. Bianchi) (Antinous in Egyptian dress). K. Fittschen and P. Zanker, *Katalog der römischen Porträts in den Capitolinischen Museen und den anderen kommunalen Sammlungen der Stadt Rom*, 3 (Mainz, 1983), 10–13 (Sabina). K. Fittschen, "Eine Büste des Kaisers Hadrian aus Milreu in Portugal," *MM* 25 (1984), 197–207 (Tarragona type of Hadrian). K. Fittschen and P. Zanker, *Katalog der*

römischen Porträts in den Capitolinischen Museen und den anderen kommunalen Sammlungen der Stadt Rom, 1 (Mainz, 1985), 44–62 (Hadrian and Antinous).

The Sculptural Program of Hadrian's Villa at Tivoli:
J. Raeder, *Die statuarische Ausstattung der Villa Hadriana bei Tivoli* (Frankfurt, 1983). N. Hannestad, "Über das Grabmal des Antinoos: Topographische und thematische Studien im Canopus-Gebiet der Villa Adriana," *AnalRom* 11 (1983), 69–108. S. Aurigemma, *Villa Adriana*, 2d ed. (Rome, 1984).

The Anaglypha Traiani/Hadriani: E. Petersen, "Hadrians Steuererlass," *RM* 14 (1899), 222–29. W. Seston, "Les 'Anaglypha Traiani' du Forum Romanum et la politique d'Hadrien en 118," *MélRome* 44 (1927), 154–83. M. Hammond, "A Statue of Trajan represented on the 'Anaglypha Traiani,'" *MAAR* 21 (1953), 127–83. U. Rüdiger, "Die Anaglypha Hadriani," *AntP* 12 (1973), 161–74. M. Torelli, *Typology and Structure of Roman Historical Reliefs* (Ann Arbor, 1982), 89–118. G. Koeppel, "Die historischen Reliefs der römischen Kaiserzeit iv: Stadtrömische Denkmäler unbekannter Bauzugehörigkeit aus hadrianischer bis konstantinischer Zeit," *BonnJbb* 186 (1986), 2–4, 11–25. M. T. Boatwright, *Hadrian and the City of Rome* (Princeton, 1987), 182–90.

The Hunting Tondi: J. Sieveking, "Die Medallions am Konstantinsbogen," *RM* 22 (1907), 345–60. S. Reinach, "Les tetes des médallions de l'arc de Constantin à Rome," *RA* (1910), 118–31. H. Bulle, "Ein Jagddenkmal des Kaisers Hadrian," *JdI* 34 (1919), 144–72. E. Buschor, "Die hadrianischen Jagdbilder," *RM* 38–39 (1923–24), 52–54. C. Blümel, "Ein Porträt des Antoninus Pius," *JdI* 47 (1932), 90–96. F. von Lorentz, "Ein Bildnis des Antininus Pius?" *RM* 48 (1933), 308–11. M. Wegner, *Die Herrscherbildnisse in antoninischer Zeit* (Berlin, 1939), 125. H. Kähler, *Hadrian und seine Villa bei Tivoli* (Berlin, 1950). J. Aymard, *Essai sur les chasses romaines des origines à la fin du siècle des Antonins,* BEFAR 171 (Paris, 1951), 523–29. I. Maull, "Hadrians Jagddenkmal," *ÖJh* 42 (1955), 53–67. E. Condurachi, "La genèse des sujets de chasse des 'tondi adrianei' de l'arc de Constantin," *Atti VII Congr. internaz. di archeol. class., Roma-Napoli, sett. 1958,* 2 (Rome, 1961), 451–59. J. Ruysschaert, "Essai d'interprétation synthétique de l'arc de Constantin," *RendPontAcc* 35 (1962–63), 79–100. N. Hannestad, "The Portraits of Aelius Caesar," *AnalRom* 7 (1974), 75–77, 91. H. Kähler, "Zur Herkunft des Antinousobelisken," *ActaAArtHist* 6 (1975), 35–44. A. Bonanno, *Portraits and Other Heads on Roman Historical Reliefs up to the Age of Septimius Severus* (Oxford, 1976), 95–106. G. Koeppel, "Die histo-rischen Reliefs der römischen Kaiserzeit iv: Stadtrömische Denkmäler unbekannter Bauzugehörigkeit aus hadri-nischer bis konstantinischer Zeit," *BonnJbb* 186 (1986), 5, 26–34. J. C. Grenier and F. Coarelli, "La Tombe d'Antinous à Rome," *MEFRA* 98:1 (1986), 217–53. M. T. Boatwright, *Hadrian and the City of Rome* (Princeton, 1987), 190–202.

The Arco di Portogallo: S. Stucchi, "L'arco detto 'di Portogallo' sulla Via Flaminia," *BullCom* 73 (1949–50), 101–22. A. Bonanno, *Portraits and Other Heads on Roman Historical Relief up to the Age of Septimius Severus* (Oxford, 1976), 107–9. G. Koeppel, "Die historischen Reliefs der römischen Kaiserzeit iv: Stadtrömische Denkmäler unbekannter Bauzugehörigkeit aus hadrianischer bis konstantinischer

Zeit," *BonnJbb* 186 (1986), 7–8, 39–43. E. La Rocca, ed., *Rilievi storici Capitolini: Il restauro dei pannelli di Adriano e di Marco Aurelio nel Palazzo dei Conservatori* (Rome, 1986), 21–37. M. T. Boatwright, *Hadrian and the City of Rome* (Princeton, 1987), 226–29, 231–34.

The Adventus Relief: M. Wegner, "Bemerkungen zu den Ehrendenkmälern des Marcus Aurelius," *AA* (1938), 167–68 (dates the Villa Torlonia Relief to the principate of Lucius Verus). F. Castagnoli, "Due archi trionfali della Via Flaminia presso Piazza Sciarra," *BullCom* 70 (1942), 57–82. V. Cianfarani, "Rilievo romana di Villa Torlonia," *BullCom* 73 (1949–50), 235–54 (Villa Torlonia Relief). E. La Rocca, ed., *Rilievi storici Capitolini: Il restauro dei pannelli di Adriano e di Marco Aurelio nel Palazzo dei Conservatori* (Rome, 1986), 12–20. M. T. Boatwright, *Hadrian and the City of Rome* (Princeton, 1987), 231.

Roman Sarcophagi, including the Velletri Sarcophagus: C. Robert et al., *Die antiken Sarkophagreliefs* (Berlin, 1890–66). G. Rodenwaldt, *Der Sarkophag Caffarelli* (Berlin, 1925). F. Cumont, *Recherches sur le symbolisme funéraire des romains* (Paris, 1942). A. D. Nock, "Sarcophagi and Symbolism," *AJA* 50 (1946), 140–70. B. Andreae, *Motivgeschichtliche Untersuchungen zu den römischen Schlachtsarkophagen* (Berlin, 1956). R. Bartoccini, "Il sarcofago di Velletri," *RivIstArch* 7 (1958) 129–214. A. Giuliano, *Il commercio dei sarcofagi attici* (Rome, 1962). B. Andreae, *Studien zur römischen Grabkunst* (Heidelberg, 1963), 11–87 (Velletri Sarcophagus). M. Lawrence. "The Velletri Sarcophagus," *AJA* 69 (1965), 207–22. G. Ferrari, *Il commercio dei sarcofagi asiatici* (Rome, 1966). J. Engemann, *Untersuchungen zur Sepulkralsymbolik der späten römischen Kaiserzeit* (1973). H. Gabelmann, *Die Werkstattgruppen der oberitalischen Sarkophage* (Bonn, 1973). N. Himmelmann-Wildschütz, *Typologische Untersuchungen an römischen Sarkophagreliefs des 3. und 4. Jahrhunderts n. Chr.* (Mainz, 1973). H. Sichtermann and G. Koch, *Griechische Mythen auf römischen Sarkophagen* (Tübingen, 1975). A. Giu-liano and B. Palma, *La maniera ateniese di età romana: I maestri dei sarcofagi attici,* StMisc 24 (Rome, 1975–76). A. M. McCann, *Roman Sarcophagi in the Metropolitan Museum of Art* (New York, 1978). G. Koch and H. Sichtermann, *Römische Sarkophage* (Munich, 1982).

Hadrianic Monuments in Athens: J. Stuart and N. Revett, *The Antiquities of Athens,* 1–3 (London, 1794). P. Graindor, *Athènes sous Hadrien* (Cairo, 1934). A. Benjamin, "The Altars of Hadrian in Athens and Hadrian's Panhellenic Program," *Hesperia* 32 (1963), 57–86. J. Travlos, *Pictorial Dictionary of Ancient Athens* (New York, 1971). D. E. E. Kleiner, "Athens under the Romans: The Patronage of Emperors and Kings," in C. B. McClendon, *Rome and the Provinces: Studies in the Transformation of Art and Architecture in the Mediterranean World* (New Haven, 1986), 10–11. D. Willers, *Hadrians panhelle-nisches Programm: Archäologische Beiträge zur Neugestaltung Athens durch Hadrian,* AntK-BH 16 (1990).

The Art of Aphrodisias under Hadrian: M. Floriani Squarciapino, *La scuola di Aphrodisia* (Rome, 1943). K. Erim, *Aphrodisias: City of Venus Aphrodite* (New York, 1986). For sculpture in colored marbles, see most recently: M. Ander-son and L. Nitsa, eds., *Radiance in Stone: Sculptures in Colored Marble from the Museo Nazionale Romano* (Rome, 1989).

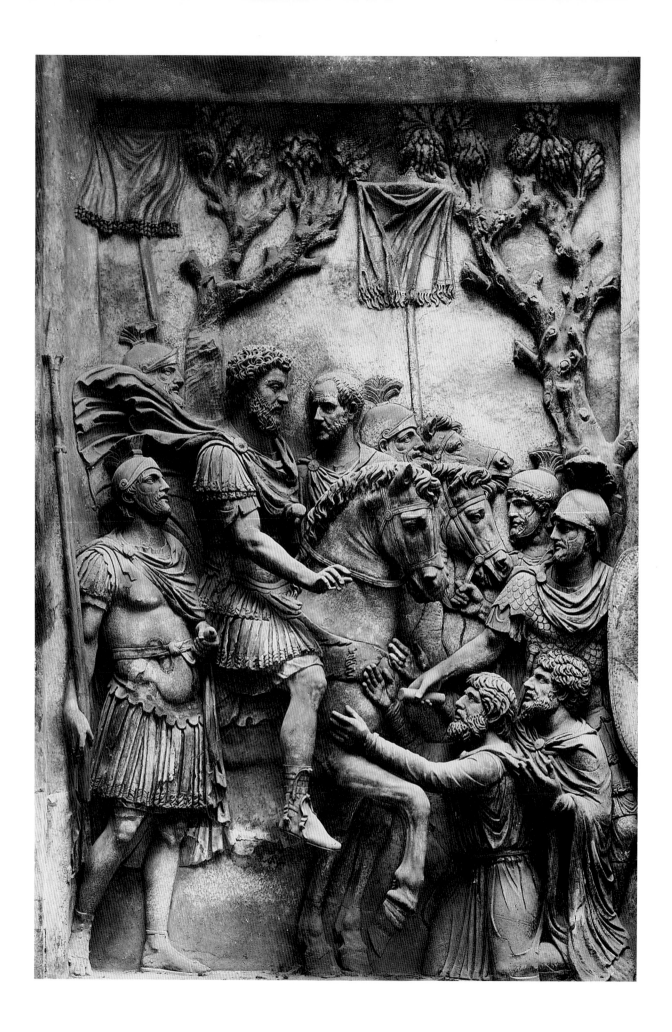

ANTONINE ART
The Beginning of Late Antiquity

CHAPTER VI

The Antonine Dynasty

Titus Aurelius Fulvus Boionius Antoninus, later Antoninus Pius, emperor between 138 and 161, was born in 86 at Lanuvium near Rome. Both his father, Aurelius Fulvus, and his mother, Arria Fadilla, came from the provinces and were members of consular families. Antoninus was appointed quaestor, praetor, and consul in turn, and he served as proconsul in Asia between 133 and 138. After the death of Lucius Aelius in 138, Hadrian adopted Antoninus Pius on the condition that Antoninus adopt as his heirs Marcus Aurelius, nephew of Antoninus's wife Faustina the Elder, whom he married in about 110, and Lucius Verus, son of Aelius.

The transition between Hadrian and Antoninus Pius was a smooth one. Antoninus immediately urged the senate to divinize his predecessor and proceeded to establish a strong working relationship with Rome's governing body. Antoninus's integrity and strong loyalty to the senate, to his adoptive father, to his own family, and to Rome and Italy, earned him the designation *pius* and the title of Augusta was bestowed on Faustina, who bore Antoninus two sons and two daughters. Although Antoninus's principate was marred by uprisings in Britain, Germany, and Dacia, it was on the whole a time of peace and prosperity for Rome, highlighted by the commemoration in 147 of the nine hundredth anniversary of the founding of the city.

From his birth in 121, Marcus Aurelius (first called Marcus Annius Verus) had a close connection with the imperial family. His father, Annius Verus, who was of consular origin and whose relatives came from Spain, was the brother of Faustina the Elder. Verus married Domitia Lucilla, who was from the environs of Rome. Marcus was nicknamed "Verissimus" by Hadrian, who favored the boy from an early age, bestowed titles on him, and paid special attention to his education. The finest teachers of the day exposed the boy to such disciplines as philosophy and law, and it was the tenets of Stoic philosophy that most impressed him. Stoicism imbued his personal life and had a strong impact on the way he governed the Roman empire. His reflections were

Arch of Marcus Aurelius, Conquest and Clemency, 176–80. Rome, Museo del Palazzo dei Conservatori. (See fig. 260.)

recorded in his *Meditations,* a highly self-conscious address to himself. Marcus served in turn as quaestor and consul, the latter office shared with Antoninus Pius himself. The strong relationship between Marcus and Antoninus was further cemented by Marcus's marriage to Antoninus's daughter, Faustina the Younger. Furthermore, in 146, Marcus was granted the tribunician power and a proconsular imperium. Lucius Verus (formerly Lucius Ceionius Commodus), born in 130 and thus ten years younger than Marcus, was granted the same titles at Marcus's request in 161, and in the same year Verus married Marcus's daughter, Lucilla. Marcus Aurelius and Lucius Verus presided over Rome jointly until Verus's death in 169; Marcus continued on alone until his own death in 180.

The well-educated crown prince, versed in the self-sufficiency of Stoicism, found himself emperor at a time when military preoccupations were paramount. There were uprisings in Britain and Parthian and German invasions to contend with, and Marcus was compelled to leave Rome in 170 to wage war against the Marcomanni and Quadi. Revolts in Syria caused him to abandon the Marcomannic campaign in 174, leaving behind local tribesmen, loyal to Rome, to defend the borders. A great triumph was voted him in 176, and he returned to Rome for the celebration. War beckoned again in 177, and Marcus departed once more for battle with the Marcomanni he had defeated in 178. Before leaving the capital, Marcus appointed his son Commodus as Augustus and as holder of tribunician power and proconsular imperium. Marcus Aurelius never returned to Rome. He died, tired and discouraged, on the front, in 180. Rome was now fully in the hands of Commodus, who was to become a despot and bring the Antonine dynasty to its end.

Lucius Aelius Aurelius Commodus was sole emperor of Rome from 180 to 192, although he had already governed Rome in concert with his father from 177. He was born in 161 and, like his father, spent his early years in training to be emperor. Commodus's principate was more peaceful than Marcus's, yet on the domestic front, he made war on the senate and was seemingly deranged by his imperial power. It is rumored that he renamed Rome the *Colonia Commodiana* and viewed himself as a god on earth. He adorned himself with a lion-skin headdress and carried a club, parading through Rome as Hercules incarnate (*Hercules Romanus*). So certain was Commodus of his assimilation to Hercules that he vowed to appear in the Roman amphitheater on 1 January 193 to demonstrate to the populus what a god could do with a sword. Sensing a golden opportunity to rid Rome of a despot, Commodus's closest advisers hired a gladiator named Narcissus to strangle the emperor, who was immediately voted a damnatio memoriae by the senate.

Antonine Portraiture

Hadrian's choice of his successor and the simultaneous naming of Antoninus's heirs established a procedure for dynastic selection that lasted until the end of the second century. Hadrian had no sons to succeed him and therefore set out to create his own nonhereditary dynasty, which is proudly displayed in a panel from the Great Antonine Altar at Ephesus of about 169, depicting Hadrian's adoption of Antoninus Pius and Antoninus's simultaneous adoption of Marcus Aurelius and Lucius Verus in 138 (see fig. 279). The altar itself will be discussed in detail in another context; the panel in question depicts Hadrian and his chosen successors in a group portrait in relief resembling a family photograph. The four male figures in the foreground are frontally positioned. Hadrian, whose face is almost entirely obliterated, is on the right in tunic and toga with the upper edge of the toga drawn over his head as a veil. Antoninus, toward the left, is similarly garbed and draped. His face shows him to be a man of middle age (he became emperor in his early fifties), with a full head of curly hair, a neat moustache, and beard; in other words, his portrait is closely based on that of Hadrian. Their two figures in the Antonine altar panel are, in fact, nearly mirror images of one another. On the far left of the panel is the teenaged Marcus Aurelius, togate, beardless, and with a full head of curly, tousled hair. Between Antoninus and Hadrian is Lucius Verus, also in toga and with curly hair. He is a mere boy of eight, who reaches only to the waists of his sponsors, who are in the process of adopting him as their heir and eventual successor, along with the elder Marcus. The young woman, whose head can be seen behind Hadrian's left shoulder, is probably Antoninus's daughter, Faustina the Younger, Marcus's bride-to-be. It is Faustina who forms the familial link between Antoninus and Marcus. It was their daughter, Lucilla, who would later be betrothed to Lucius Verus.

The portraiture in the round of Antoninus Pius also follows the Hadrianic tradition. Antoninus is depicted as a never-aging adult with the same curly hair and short but plastically rendered beard as Hadrian. The portraits of Antoninus Pius have been divided into three main types: the Formia type from the beginning of his principate, the Vatican Sala a Croce Greca 595 type, created around the time of his decennalia, and a late type, created for the vicennalia.

The Formia type received its name from a fine marble portrait head of the emperor from Formia (fig. 231). It depicts the middle-aged Antoninus with a full, curly coiffure brushed down from the crown of his head with three locks arranged in a distinctive pattern in the cen-

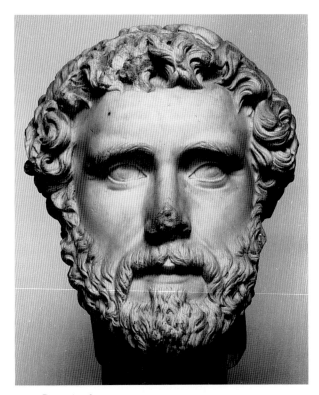

231 Portrait of Antoninus Pius, from Formia, 138–40. Rome, Museo Nazionale delle Terme. Photo: DAIR 65.1113

ter of his forehead. Although the hairstyle closely approximates that of Hadrian, it is tempting to see also a deliberate reference to the central triple forehead locks of Augustus. Antoninus's forehead is relatively smooth, although his cheeks are marred by deeper lines. His eyes are shaded by full eyebrows with individually delineated hairs and framed by lightly etched crow's-feet. The pupils and irises of the eyes are drilled. The emperor's nose is aquiline, and his lips are thin and capped by a neat moustache. Antoninus's beard seems to be a continuation of his hair. It grows naturally from his face and neck and is at once full and yet conforms to the shape of his jaw. The curls of the beard are modulated with drilled pockets of shadow and the texture of hair, beard, and moustache are played off against the softness of the skin by an artist of great skill who has produced a sensitive likeness of the pius Antoninus.

A bust-length portrait from Baia is a version of the same prototype as the Formia head. It depicts Antoninus Pius in cuirass and paludamentum, as do many of his extant portraits, which indicates that the new emperor, although as peace-loving as his predecessor, chose to follow in Hadrian's footsteps by perpetuating the image of a Rome militarily strong and capable of defense, a wise decision in view of the provincial uprisings during his principate.

The Formia type was followed by the Sala a Croce

Greca 595 type, which received its name from a portrait of Antoninus from Ostia now in the Vatican Museums (fig. 232). It has been suggested that the new type was created around 147–149, possibly for the celebration of the emperor's decennalia. It is characterized by a simpler coiffure with only two locks over the center of the forehead and somewhat more mature features than the Formia type. One scholar has recently hypothesized that the Croce Greca type is so close to the Formia type that both must be based on the same prototype and has conflated the first two types to a single type. It is too early to tell whether this new typology will be widely accepted by others. The numismatic portraits of Antoninus Pius, made both during his principate and posthumously, conform only to the Formia type.

The latest type may have been devised to celebrate the emperor's vicennalia, although this hypothesis is controversial. It is known in only four surviving replicas and depicts Antoninus Pius with a coiffure with tighter curls and with some of the signs of advancing age, as apparent in portraits in the Museo Nazionale delle Terme and the Vatican Sala dei Busti (fig. 233). The opposing view is that this type was created, like the Formia type, early in the emperor's principate but never achieved its popularity, and that signs of age were not included. It is differentiated from the Formia type by its different coiffure – with a thicker mass of curls resembling those in the youthful portraits of Marcus Aurelius. Antoninus Pius's posthumous portraits were based on his lifetime images. The portrait of the emperor in the scene of his apotheosis from one of the reliefs of the column base of Antoninus

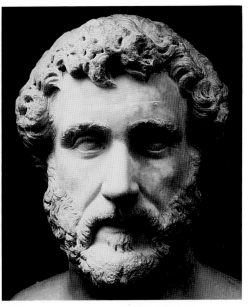

232 Portrait of Antoninus Pius, from Ostia, ca.147–49. Rome, Vatican Museums. Photo: DAIR 33.734

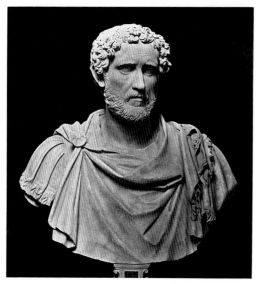

233 Portrait of Antoninus Pius, ca.158. Rome, Vatican Museums, Sala dei Busti. Photo: Alinari/Art Resource, New York, 6500

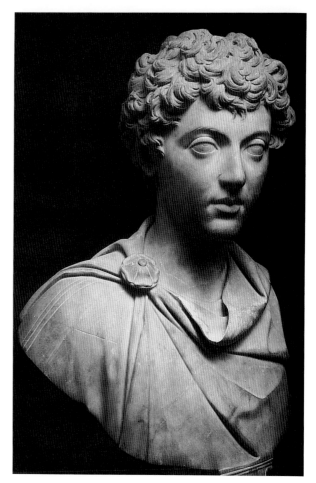

234 Portrait of Marcus Aurelius, ca.140. Rome, Museo Capitolino. Photo: DAIR 2383

Pius (see fig. 253), for example, is based closely on the Croce Greca type.

The portraiture of Marcus Aurelius is of special interest because it reflects the stages of his life and expresses the inner workings of his mind in an unprecedented way. Marcus's extant portraits show him develop from a carefree and handsome crown prince to a militarily strong but merciful world ruler, and ultimately to a tired and disillusioned Stoic philosopher. The portraits of Marcus Aurelius are based both on those of his immediate predecessors and on a premonition of a new direction for Roman portraiture, one in which the emperor's psychological state is as important as his physical appearance. The portraits of Marcus Aurelius have been divided into a series of types roughly corresponding to a chronological development.

The earliest portraits of Marcus Aurelius were manufactured when he was in his late teens. A case in point is the marble bust-length portrait of the young Marcus in paludamentum in the Museo Capitolino (fig. 234 and the frontispiece to the Introduction). It is the finest surviving example of the earliest official portrait type of Marcus, type 1, sometimes referred to as the Capitoline Museum Galleria 28 type after this portrait, and dated to about 140 because of its similarity to coin portraits first struck in about 139. At least twenty-five copies of the type are preserved, and the Capitoline replica illustrates the high quality of Antonine portraiture in which a gifted artist has captured the essence of a handsome and intelligent youth, destined to be emperor. His facial features include oval shaped eyes, a strong nose, highly arched brows, and a beautiful rounded mouth. The soft sensuality of

the young man's skin is masterfully played off against the rough texture of his tousled hair, with its distinctive hanging central locks in a portrait that owes much to the Hadrianic images of Antinous. This is a significant portrait type that was to serve as the primary model for prince portraits of the second and third centuries, not only for portraits of Marcus's own son, Commodus, but also for those of Geta and the infamous Caracalla.

An older but still youthful portrait of Marcus, discovered in the Roman Forum, depicts him in his late twenties (type 2) (fig. 235). In this portrait, made in about 147, possibly on the occasion of the birth of Marcus's first son, Marcus has the same oval face, aristocratic features, and full tousled hair that he had in the Capitoline portrait. A light moustache and beard, however, emerge from his jaw and chin, undoubtedly a symbol of his manhood. The moustache and beard also add an additional texture to the face, of which the artist takes advantage and deliberately contrasts with the smoothness of the skin. The skin is polished to a shine whereas the hair is not, probably because the hair was originally painted while the skin was not. Furthermore, Marcus's upper eyelids

are partially closed, giving the portrait the sleepy sensuous look that was to become a hallmark of Antonine portraiture.

Marcus Aurelius became emperor in 161 at the age of forty. A mature portrait, and indeed the most significant surviving portrait of the emperor, is the gilded bronze equestrian statue that until recently has served since the Renaissance as the centerpiece of Michelangelo's oval piazza on the Campidoglio in Rome (fig. 236). Although literary testimony and extant inscribed statuary bases indicate that bronze equestrian statues of emperors were commonly displayed in Roman fora and basilicas, the statue of Marcus is the only fully preserved imperial example in any medium. Marble equestrian statues of two male members of the Balbus family, wealthy private patrons of Herculaneum, have also come down to us, as have fragments of bronze equestrians of Augustus (see fig. 44) and Domitian/Nerva. The survival of the Campidoglio bronze is due to a happy misconception of the Middle Ages, when the famous statue was thought to be a portrait of Rome's first Christian emperor, Constantine the Great, rather than the pagan emperor Marcus Aurelius, and was piously left unharmed. The Capitoline hill was not the original location of the statue described in its position in the plaza in front of the Church of St. John the Lateran in the tenth century, the site of property belonging to Marcus's grandfather. The statue was transferred to the Campidoglio by Michelangelo in 1528.

The bronze statue depicts Marcus Aurelius in short tunic and paludamentum and with patrician boots, a ref-

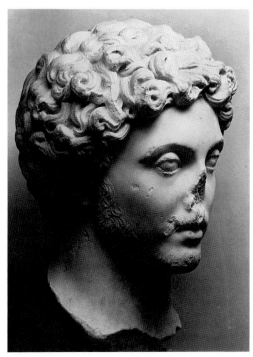

235 Portrait of Marcus Aurelius, from the Roman Forum, ca.147. Rome, Forum Antiquarium. Photo: DAIR 39.244

erence to the civil side of his imperial power. He is seated on a magnificent steed, the front right leg of which is raised with the hoof resting on a fallen barbarian. The barbarian no longer survives but, its original existence is recorded in the twelfth-century *Mirabilia Urbis Romae*. Such a depiction of an emperor on horseback, trampling a barbarian, was confirmed under Domitian, whose equestrian statue was prominently mounted in the Roman Forum. It no longer survives, but a contemporary description by Statius (*Silvae* 1.1.1–37) records the form of the monument dismantled in 96 after the emperor's *damnatio memoriae*. According to Statius, Domitian's gesture with his right hand signaled the end of a military encounter. In his left hand, the emperor held a statue of his patron goddess Minerva, and the hoof of his horse rested on the head of a personification of the vanquished Rhine River, symbol of the German people. In the statue of Marcus, the emperor glances at the fallen figure and reaches toward him with his right hand in a gesture of clemency, perhaps also at the culmination of a military campaign. Marcus Aurelius is thus depicted at once as militarily triumphant over and merciful toward his enemies, in a manner that nearly duplicates his demeanor in the so-called clemency or conquest panel from one of the emperor's lost arches (see fig. 260). In his left hand, he held the horse's reins, now lost, and possibly another object as well.

Marcus's distinctive facial features are accompanied by a tightly curled coiffure, which almost forms an arc over his forehead. It is a close approximation of the hairstyle in fifty or so copies that depend on the same original and has been designated Marcus Aurelius's third type. It is likely that the statue was one of the many monuments erected in honor of Marcus Aurelius's triumph of 176, and should be dated to around that year.

An example of a portrait of Marcus Aurelius corresponding to his fourth and last type, created between 170 and 180, is the marble bust-length portrait of the emperor in cuirass and paludamentum now in the Museo Capitolino (fig. 237). The portrait is the best surviving example of a type that gets its name from this image – the Capitoline Imperatori 38 type. The bust extends to below the breastbone and includes the shoulders and upper arms, a length characteristic of Antonine times. The emperor's physiognomy is the same as in his youthful images – oval face, almond-shaped eyes, aquiline nose, arched brows, semiclosed eyelids, drilled pupils, and irises – but by now he wears a long and full beard that is divided in the center and arranged in individual parallel locks. His hair is still full and tousled, but the mass of hair has been so extensively drilled that there seems to be more shadow than curls.

Portraits made at the end of Marcus's principate are

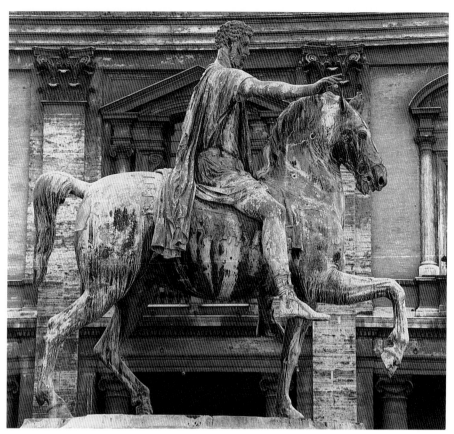

236 Bronze equestrian statue of Marcus Aurelius, 176. Rome,
Museo del Palazzo dei Conservatori. Photo: DAIR 72.25

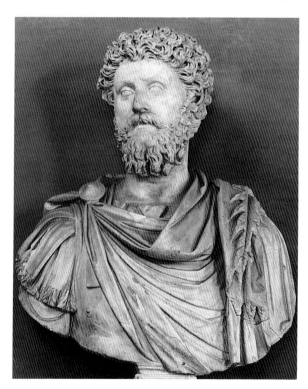

237 Portrait of Marcus Aurelius, 170–80. Rome, Museo
Capitolino. Photo: DAIR 68.3822

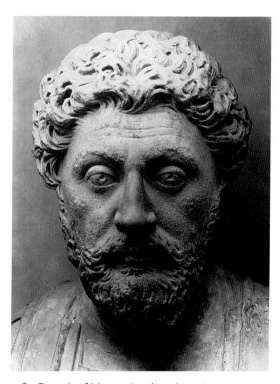

238 Portrait of Marcus Aurelius, from the Roman Forum,
ca.180. Rome, Museo Nazionale delle Terme. Photo: DAIR
38.736

extraordinary human documents because they not only incorporate the aging process but also mirror the state of mind of the philosopher-emperor. It is not surprising that the earliest instance of psychological penetration in Roman portraiture should coincide with the principate of a deep thinker thoroughly imbued with Stoic ideas. An example is the marble portrait of Marcus from the House of the Vestals in the Roman Forum (fig. 238). The bust on which it rests does not belong, and it has been suggested that the original bust showed the emperor with paludamentum. The head, with its upswept coiffure and long beard, corresponds to the Capitoline Imperatori 38 type, discussed above (see fig. 237), that dates to around 170, but there are significant differences between the two portraits that suggest that the Roman Forum portrait was manufactured considerably later, probably at the very end of Marcus's life. The hair and beard are more deeply drilled, with long and crescent-shaped holes. The emperor's forehead is more prominently lined, his eyelids heavier, and his crow's-feet more pronounced. His advanced age is immediately apparent, but that in itself is not new. Vespasian, for example, also grew older in his portraits. What is novel is that the emperor's profound concern for the condition of the empire is captured in his expression. The late portraits of Marcus Aurelius, apparent also in those in relief in the panels of his lost arches (see, for example, fig. 261), were to serve as an inspiration for the famous psychological portraits of the third century.

Lucius Verus, who was born in 130, was already designated a crown prince at his adoption by Antoninus Pius at the instigation of Hadrian in 138. The eight-year-old was depicted in portraits shortly thereafter, as in a portrait of him found on the Esquiline hill and now in the Museo Capitolino. This represents him as a boy with an oval face, narrow, deep-set eyes, straight eyebrows, and a full head of curly hair. It has been suggested that the Capitoline portrait is a variant of Verus's first official type, produced between 140 and 150, and that there were other portrait types created between this one and that of 161.

Lucius Verus rose through the ranks and was appointed quaestor and consul in turn, but Antoninus Pius did not promote him equally with Marcus probably because Verus was not as gifted an administrator nor as strong a personality as Marcus. It was Marcus himself who raised Verus to equal rank, and the two served as Rome's first co-emperors between 161 and 169. Lucius Verus spent the years 163–166 on a major military campaign in the East and also joined Marcus in the Danube area in 168. He died while on his return to Rome in 169, leaving Marcus to govern alone until his own death in 180.

In his mature portraits, Lucius Verus resembles Marcus Aurelius even though there was no familial link between the two. It is not surprising to see the co-emperors of Rome assimilated to one another, and the resemblance was certainly intentional. This is not to say that the two are indistinguishable from one another. In the portrait type of him as emperor created during his principate – the Main type – and exemplified by portraits in Paris (Louvre 1101) (fig. 239) and Rome (Capitoline Imperatori 41), Lucius Verus is portrayed with his own unique physiognomy, which includes an oval face, narrow eyes under relatively straight brows, a long, hooked nose, and rounded lips. His hairstyle closely approximates that of Marcus, although it is not identical. It is a full, curly, and tousled coiffure that is, however, straighter than Marcus's across the forehead and arranged in an egg-shaped mass of curls above and in front of the ears. Verus's beard is as long as Marcus's, and its arrangement in parallel strands is also comparable to that of his elder co-ruler. Verus's moustache is not as thick or as long as Marcus's. Although Lucius Verus is often depicted with an intense expression in his eyes, his portraits lack the psychological penetration of the late portraits of Marcus Aurelius. It is this type that continued to be used during the emperor's lifetime and as a model for posthumous versions.

The silver bust of Lucius Verus in cuirass from the silver treasure of Marengo (fig. 240) is based on the imperial Roman type and exhibits the same features as the portraits in Paris and Rome, except that their interpretation in metal creates a different effect. What makes the Turin bust a significant piece, however, is that it is manufactured out of silver and is one of the few examples, along with the equestrian of Marcus and a gold portrait of Marcus in Switzerland, of a surviving Antonine portrait in precious metal.

Portraits of Marcus's son Commodus are relatively more plentiful than those of other recipients of the damnatio memoriae because of his rehabilitation and divinization under Septimius Severus. The extant portraits of Commodus have been divided into five main types. The first official type depicts Commodus as crown prince and chosen successor of Marcus Aurelius, and not surprisingly, it is based closely on the crown prince portrait type of Marcus. The finest surviving example of this type is the marble portrait of Commodus from the Villa of Antoninus Pius in Lanuvium (fig. 241). The bust of Commodus in paludamentum, which was made between 175 and 177, depicts him at fourteen to sixteen years of age, with a round face, large, broad nose, large, drilled eyes with half-closed lids, delicately arched brows, and a high forehead crowned with a full head of tousled hair. A series of locks are carefully arranged straight across his

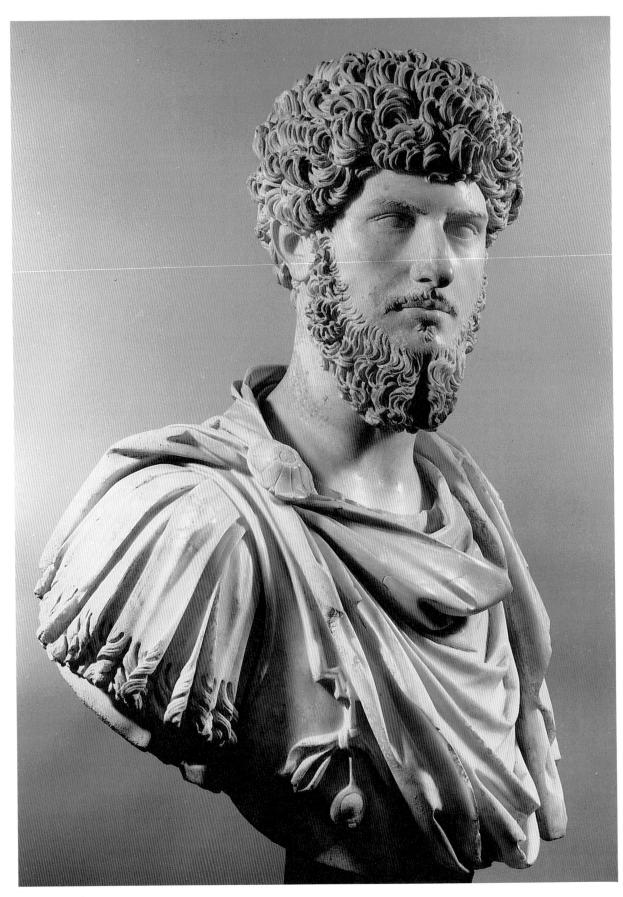

239 Portrait of Lucius Verus, 161–69. Paris, Musée du
Louvre. Cliché des Musées Nationaux

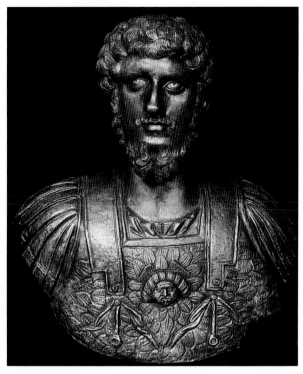

240 Silver portrait of Lucius Verus, from the silver treasure of Marengo, 161–69. Turin, Archaeological Museum. Photo: DAIR 36.629

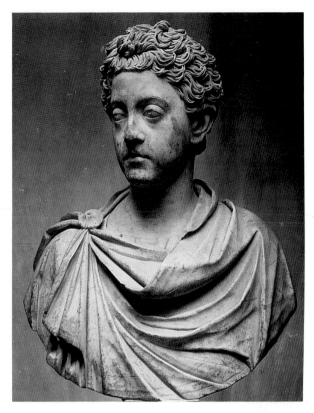

241 Portrait of Commodus, from Lanuvium, 175–77. Rome, Museo Capitolino. Photo: DAIR 4262

forehead, and long crescent-shaped drill holes are used by the artist to create shadows between the locks and to accentuate the lively motion of hair seemingly caught up in a passing breeze. In fact, the depiction of Commodus's hair is a tour de force, as is the rest of the portrait, because the artist also succeeds in capturing the boy's youthful arrogance in his expression. It is clear that the artist responsible for the original portrait of the young Commodus, on which this and other marble replicas were based, attempted not only to describe his physical appearance but also to incorporate the prince's personality into the portrait. In this way, the court artists responsible for the portraits of Commodus, undoubtedly the same as those fashioning the portraits of his father, can be seen to have been as fully committed to depicting the inner as well as the outer essence of their imperial subjects.

A unique example is a fine marble portrait of Commodus, now in the Vatican (fig. 242), in which he is depicted as a somewhat older man, with a moustache and plastically rendered but short beard. His hair is as curly and tousled as in the Capitoline head, but the locks are arranged in a more haphazard manner over his forehead. His facial features are a more mature version of those in the Capitoline portrait, and Commodus's arrogant personality is also captured by this artist.

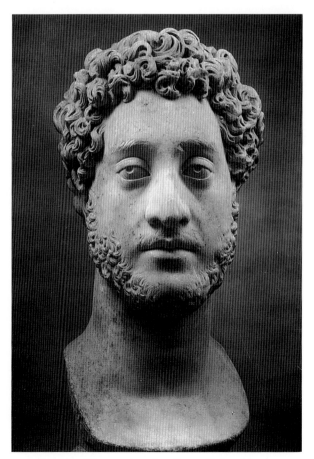

242 Portrait of Commodus, 180s. Rome, Vatican Museums, Sala dei Busti. Photo: DAIR 38.1494

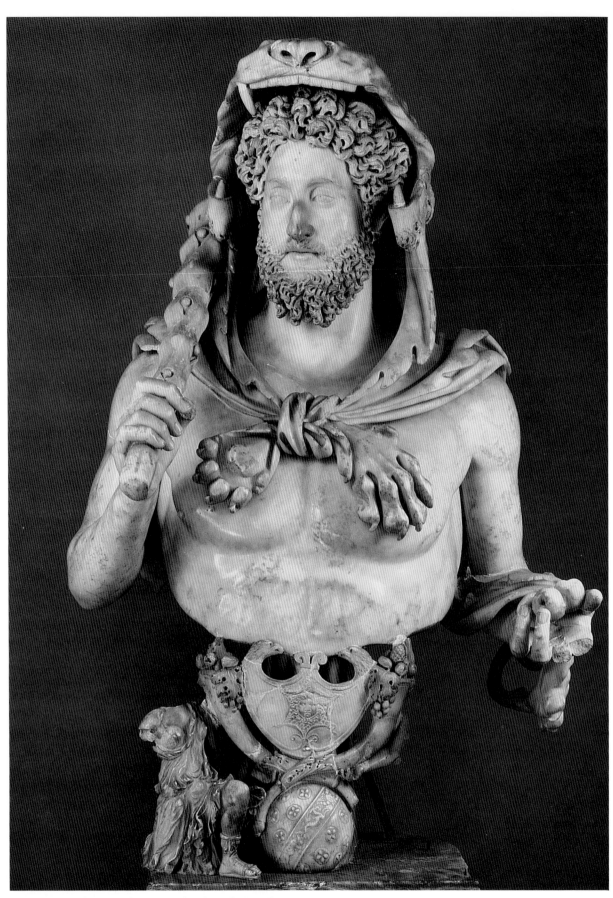

243 Portrait of Commodus as Hercules, from the Esquiline
hill, ca.191–92. Rome, Museo del Palazzo dei Conservatori.
Photo: Gisela Fittschen–Badura

One of the masterpieces of Antonine portraiture is the half-length portrait of Commodus as Hercules, discovered along with two tritons, in the Villa Palombara on the Esquiline in 1874 (in ancient times, a cryptoporticus of the Horti Lamiani) (fig. 243). In this portrait, Commodus is depicted with his long, oval face, arched brows, and half-closed eyes, large nose, small mouth, and arrogant expression. His high forehead is crowned with a halo of tousled hair that is deeply drilled, and he wears a plastically rendered full beard. The portrait head is known in at least a dozen other copies and can be associated with the fifth and final portrait type of Commodus. The piece dates to the very end of Commodus's principate, that is to about 191–192.

Commodus is depicted with a bare chest, and the long bust includes his arms and hands. He holds the club of Hercules in his right hand and the apples of the Hesperides – a reference to one of Hercules's twelve labors – in his left. The emperor is crowned with the lion-skin headdress of Hercules; the paws are tied across his chest. The bust rests on an Amazon pelta above crossed cornucopiae and an orb. At the left is a kneeling Amazon, now headless, and presumably originally balanced by a counterpart on the right.

Commodus is portrayed in the guise of Hercules, and through Hercules's deed of fetching the apples of the Hesperides, has acquired virtus and immortality. The Herculean subject matter is underscored by the three signs of the zodiac – the Bull, the Capricorn, and the Scorpion – carved on the orb. It has been demonstrated that these signs refer to the month of October, which can be associated with a number of important events in the life of the emperor, and that he was renamed after Hercules. The pelta and kneeling Amazon refer to Rome's barbarian enemies, over which Commodus has triumphed and has brought peace and prosperity, symbolized by the cornucopiae, to the empire (seen in the orb). The bust of Commodus was originally flanked by two male tritons who held a *parapetasma* (curtain) above his head (fig. 244), a scheme that is known from contemporary sarcophagi.

The original location of this multifigured theatrical presentation of the emperor masquerading as Hercules is not known, but it is highly likely that it was prominently displayed in a public place. The *Scriptores Historiae Augustae* reports that Commodus was fond of donning the attributes of Hercules in public and that he saw himself as a god on earth (*S.H.A., Comm.*, 14.8). The imperial coinage of 191–92, a widely circulated means of expressing public policy, also depicts Commodus in the guise of Hercules. The Esquiline portrait of Commodus, which depicts him as Hercules at the end of his labors and after the assumption of immortality, suggests that Commodus himself had become immortal. The portrait is another outstanding example of the practice of Roman emperors of combining persona and politics in art.

Female Portraiture under the Antonines – the Faustinas

Female court portraiture under the Antonines both resembles and departs from contemporary male portraiture. The womens' oval faces, drilled eyes with half-closed lids, rounded mouths, delicately arched brows, and smooth, highly polished faces are comparable to those of their husbands and sons, but their hair is not the elaborately drilled halo of their male counterparts, favored also in female portraiture under the Flavians, but a simple, parted coiffure. The womens' hairstyles are carved rather than drilled, and it is the classicizing coiffure of Hadrian's wife, Sabina, that serves as a model. This disparity between male and female imperial portraiture under the Antonines demonstrates that from the point of view of both fashion and workshop technique, the two do not necessarily develop in tandem.

Annia Galeria Faustina or Faustina the Elder was the wife of Antoninus Pius, whom she married in about 110. She produced two sons and two daughters. One of the daughters was Faustina the Younger, future wife of Marcus Aurelius, of whom Faustina the Elder was an aunt. In 138, the title of Augusta was bestowed on Faustina the Elder, who died only a few years later in 141. She seems to have had a very close relationship with her husband, who never remarried even though Faustina predeceased him by twenty years. Upon her death, Antoninus Pius had her consecrated as a diva and established an alimentary charity in her name called the *Puellae Faustinianae*. He also commissioned a temple in the Roman Forum in her honor, which after his own death was rededicated to both Antoninus and Faustina. The loving

244 Reconstruction of group of Commodus as Hercules and two tritons by Klaus Fittschen, ca.191–92. Photo: Courtesy of Klaus Fittschen

pair was depicted together in the apotheosis scene on the base of the Column of Antoninus Pius, a major work of state relief sculpture (see fig. 253).

About fifty portraits in the round of Faustina are also extant. One of the finest is a marble portrait, possibly from a villa in Lanuvium, now in the Museo Capitolino (fig. 245). It depicts Faustina with an oval face, straight brows, almond-shaped eyes with partially closed lids, a relatively large, slightly hooked nose, rounded lips with the upper one protruding somewhat over the lower, and a rounded fleshy chin. Her hair is parted simply in the center, as was Sabina's, and is brushed in waves above and behind her ears. The rest of the hair is plaited in braids and piled on top of her head where it is secured in a flat bun.

The head is the best example of a type seemingly created during the empress's life and designated the Imperatori 36 type after the Capitoline piece. At least two other portrait types of the empress survive, differentiated from one another not by physiognomy but by slight discrepancies in the hairstyle. One of them may well have been

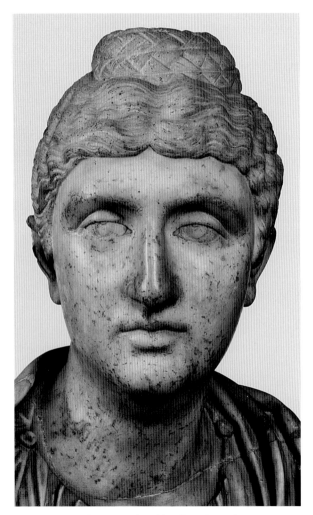

245 Portrait of Faustina the Elder, from Lanuvium, 138–41. Rome, Museo Capitolino. Photo: Gisela Fittschen-Badura

created at the time Faustina was designated as Augusta. Posthumous versions of all three types also survive.

Annia Galeria Faustina or Faustina the Younger, the younger daughter of Faustina the Elder and Antoninus Pius, was born in about 125–130. Formerly engaged to Lucius Verus at the behest of Hadrian, she married, at her father's request, her cousin, Marcus Aurelius, in 145. After the birth of her first child, Domitia Faustina, in 146, she received the title Augusta. Her relationship with Marcus appears to have been a close and loving one. She even accompanied him in 170–74 on his military campaign to the north, and she was designated Mother of the Camps or *Mater Castrorum* for her support. A second campaign took her to the East in 175 where she died. Subsequently, Marcus had her consecrated as a diva and commemorated her by the founding of a second Puellae Faustinianae.

The surviving portraits of Faustina the Younger have been divided into nine main types, commissioned to commemorate significant moments in her life as empress of Rome. Faustina's first portrait type was created in about 147–48 when she was only seventeen and after the birth of her first child and her subsequent designation as Augusta. The finest surviving marble copy of this portrait is preserved in a bust from Hadrian's Villa at Tivoli (fig. 246); several other copies and variants are also known. The Tivoli portrait is a magnificent evocation of a beautiful young empress, wife, and mother. Faustina is depicted with a smooth and polished face shaped like a perfect oval, almost straight and delicate eyebrows over drilled, almond-shaped eyes with partially closed Antonine lids, aquiline nose, and a small, rounded mouth. The drilled pupils of the eyes are formed like hearts, and the shape of the tear ducts is accentuated. The hair is arranged in a distinctive coiffure that is parted in the center and arranged in four overlapping segments on either side of the face, the bottom section covering the tops of the ears. The head is encircled by a narrow braid that begins at the apex of the head where the hair is again divided into individual plaits, all of which are gathered into a circularly shaped bun at the back of Faustina's head. This coiffure, like that of her mother, owes much to the second-century taste for parted coiffures, inspired by those of Greek goddesses and popularized by Sabina. Also influential were the parted and sectioned coiffures worn by female court luminaries under Augustus and eagerly adopted by wealthy freedwomen. It might well be said that the portraits of Faustina the Younger, with their smooth youthfulness and sectioned coiffure, come as close as any portraits of the second century to resuscitating the Augustan ideals of womanhood.

A new type, of which there are at least twenty-two surviving replicas, was created around the time of the

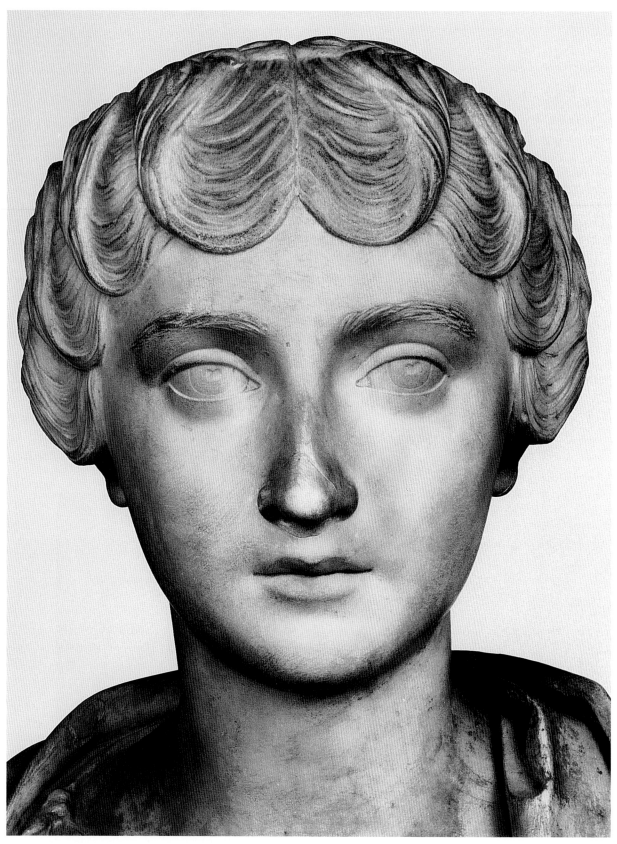

246 Portrait of Faustina the Younger, from Hadrian's Villa at Tivoli, ca.147–48. Rome, Museo Capitolino. Photo: Gisela Fittschen-Badura

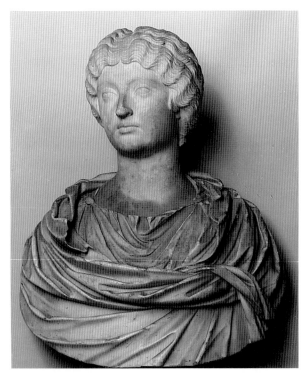

247 Portrait of Faustina the Younger, 161–70. Rome, Museo Capitolino. Photo: DAIR 67.31

birth in 161 of Faustina's twin boys, Commodus and Fulvus Antoninus, and celebrates her as the mother of two male heirs to imperial power and at the high point of her life. An example of this widely disseminated type of about 161–70 is a marble bust-length portrait from Rome and now in the Museo Capitolino (fig. 247), that depicts Faustina in her late thirties. Her features are the same as those in the earlier Capitoline portrait, but her face is imbued with an air of maturity. Her hair continues to be parted in the center, but the sectioned hairstyle has given way to a simpler and more flowing coiffure in which the hair is brushed in waves over her head. The curls practically cover her ears, and the wavy strands are gathered into a loose bun placed low at the back of her neck. The bust extends to below the breasts, and Faustina is draped in a tunic covered by a palla artfully wrapped around her shoulders in an embracing circle.

Private Portraiture under the Antonines

Under the Antonines there was an increased interest in depicting both aristocratic and freed men and women in mythological guise. The models for such statuary groups in the round and in relief were undoubtedly found in the court circle. Even though no extant groups or coins portray an emperor or empress as Mars and Venus, for example, such groups almost certainly existed in antiquity.

We know from Cassius Dio (81.31) that Marcus Aurelius and Faustina the Younger were celebrated as Mars and Venus and that second-century empresses were commonly represented as Venus. Hadrian and other emperors also appeared in statues in the guise of Mars.

Three statuary groups of a man and woman depicted as Mars and Venus in which portrait heads were placed on bodies based on the fifth-century B.C. Greek Ares Borghese type and fourth-century B.C. Greek Venus of Capua type have survived. The earliest of the three extant groups was found in Isola Sacra (fig. 248). The woman is represented according to the Venus of Capua type. She turns toward her husband, puts her left arm around his shoulders, and unlike the Venus of Capua is clothed in a *stola* and palla. The man is nude, wears a helmet, and stands in the Ares Borghese pose. The woman's coiffure, with its series of overlapping locks and its bun at the back of the head, is comparable to that of Faustina the Younger on coins and in portraits in the round of about 147 (see fig. 246). The carving of the coiffure, moustache, sideburns, and face of the man can be compared with numismatic portraits of Marcus Aurelius of about 145 and with the portrait of the young Marcus in the Forum Antiquarium of the same date (see fig. 235). The group must date between about 145 and 150.

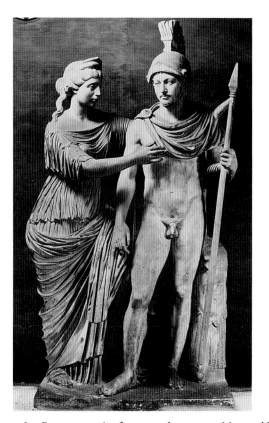

248 Group portrait of a man and woman as Mars and Venus, from Isola Sacra. 145–50. Rome, Museo Capitolino. Photo: DAIR 64.1832

The second group was formerly in the Borghese Collection in Rome and is now in the Louvre. In this group the woman is also represented according to the Venus of Capua type, except that she is clothed. The man is nude, save for a helmet and balteus with parazonium, and stands in the Ares Borghese pose.

The male portrait has often been identified as Hadrian, although the head does not conform to any of the known types of the emperor's portraits. The coiffure and shape of the beard are characteristic of the time of Hadrian and Antoninus Pius, and the use of the drill in the hair and eyes suggests a date during the principate of the latter.

The date of the group can be established on the basis of the female portrait. The head certainly does not portray Hadrian's wife, Sabina. The centrally parted, wavy coiffure drawn into a bun with braids at the back of the head and with a corkscrew curl behind the ears is characteristic of portraits of Faustina the Younger of about 147–60. The Louvre group can thus be dated between around 150 and 160.

The third and latest group was found in the so-called Basilica at Ostia (fig. 249). The portrait group also represents a man and woman according to the Venus of Capua and Ares Borghese statuary types. The group differs from the other two described in that the woman is partially nude. The man is completely nude but wears a helmet and balteus with parazonium.

The group is thought by many to represent an emperor and an empress. Suggestions include Marcus Aurelius and Faustina the Younger and Commodus and Crispina. The basic form of the woman's coiffure is documented during both principates, but the technique of carving the man's face and hair is comparable to that of portraits of the beardless Commodus between about 176 and 180. The Ostia portraits do not, however, conform to any established imperial type and must represent an unknown Roman and his wife. The group should be dated about 175–80.

Although some, but by no means all, scholars have identified the portraits in these three groups as imperial personages, the persons represented are arguable merely wealthy members of Roman society who emulated the conceit of mythological portraiture popular among the members of the imperial circle. Lost imperial Mars and Venus portrait groups or private portrait groups, such as the three just described, served in turn as models for Mars and Venus groups sculptured in relief on second-century sarcophagi. On all such surviving sarcophagi the woman is represented in the Venus of Capua pose and the man as Ares Borghese. The Mars and Venus groups on the sarcophagi are almost always shown on pedestals, which suggests that the relief representations were derived from

freestanding statuary models. The sarcophagi are of special interest because they document the use of Mars and Venus portraits in a funerary context. The statuary group from Isola Sacra may have served as a double funerary marker.

There are also a number of extant funerary portrait reliefs commemorating freedmen and freedwomen that are clearly based on the same prototypes. These include examples in Ostia, the Vatican, and the Palazzo Valentini (fig. 250) and Villa Albani in Rome that date between 140 and 200. They constitute, however, a further modification of the ultimate model or models because the men never appear as Mars. They are represented instead as ordinary citizens or military men dressed in togas, tunics, and cloaks. That the statuary groups were nevertheless the models for the funerary reliefs is confirmed by the use of the Venus of Capua type for the women and the fact that, as in the statuary groups, the men are posed frontally and are embraced by the women. The women in the Ostia and Vatican reliefs clasp their husband's right hands in a dextrarum iunctio. As we have seen in other contexts, the joining of the right hands underscores the affection, devotion, and fidelity that unite the pair and establishes beyond any doubt that the man and woman are husband and wife. The theme of marital fidelity is not stressed in the freestanding groups, and it was obviously of some importance to the Romans who commissioned the funerary reliefs. It is therefore not surprising that although the women are presented as Venus, the men do not appear as Mars. Mars and Venus were not married and were adulterous lovers.

The assimilation of women to Venus was, however, quite widespread in the second century, and it is not surprising to find the conceit in these reliefs. The close association of the empresses of the second century with Venus is well documented; freedwomen, undoubtedly influenced by women of the imperial circle, also had themselves portrayed as Venus, especially as a form of private deification in funerary contexts.

In the statuary groups and on the sarcophagi, Mars is always nude. Venus is sometimes nude and sometimes clothed. This is in keeping with imperial and upper-class practice whereby men were more often than women represented in heroic nudity. In the funerary reliefs, all of the men and almost all of the women are clothed. This rejection of nudity in favor of a more conservative representation suggests that the patrons who commissioned the funerary reliefs had different artistic preferences and may not have shared the desire of their aristocratic counterparts to be depicted without their clothes. This is undoubtedly as true in the second century as it was in the first because those who commissioned the funerary reliefs were drawn exclusively from the freedman class.

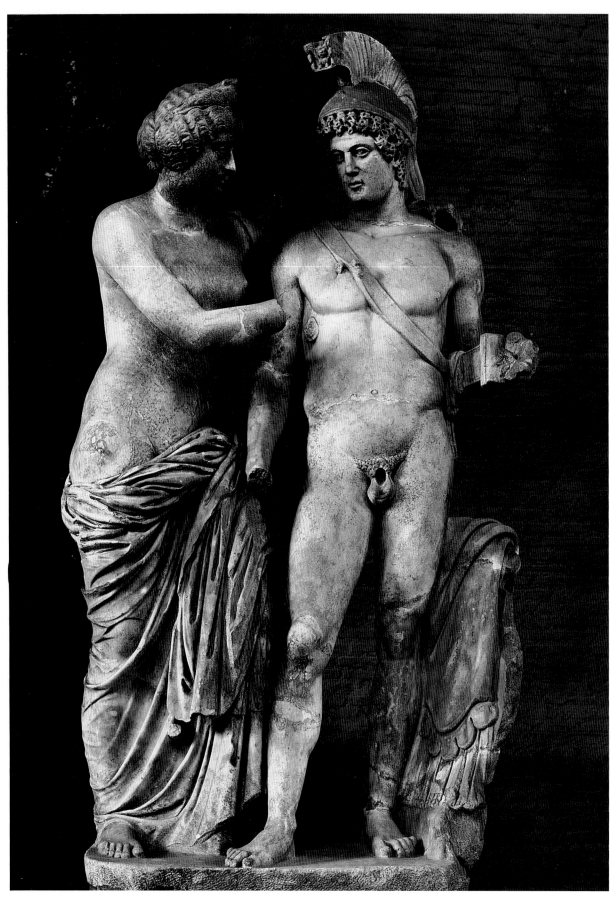

249 Group portrait of a man and woman as Mars and Venus,
from Ostia, 175–80. Rome, Museo Nazionale delle Terme.
Photo: Alinari/Art Resource, New York, 38255

250 Group portrait in relief of a freedman and freedwoman, ca.160–90. Rome, Palazzo Valentini. Photo: DAIR 69.3210

This is another instance of the emulation among freedmen and freedwomen of types used by the aristocracy, which nonetheless bear the distinctive stamp of their patrons.

Antonine State Relief Sculpture

Antoninus Pius's principate was long enough and peaceful enough to allow major building projects at home and abroad. Antoninus Pius, however, probably the most frugal of the Roman emperors, did not construct a forum bearing his name nor did he commission, as far as we know from surviving monuments, great state reliefs with himself as the hero. What characterizes the art of Antoninus Pius is the emperor's pietas. The emperor's only extant commissions were those that demonstrated his devotion toward family members, including his divine

adoptive father Hadrian. One of these undertakings was the Temple of Antoninus and Faustina in the Roman Forum begun at Faustina's death in 141 and at first intended to honor only her. It was, as stated earlier, later rededicated to both emperor and empress by Marcus Aurelius and Lucius Verus.

The Hadrianeum or Temple of Divine Hadrian

Antoninus Pius's only other project of significance was one in the time-honored imperial tradition because it openly commemorated his immediate predecessor Hadrian and more subtly honored himself by association. It consisted of a temple to Divus Hadrian (now the Roman stock market), which included elaborate sculptural embellishment portraying the provinces of the Roman empire united under the aegis of a benevolent and peace-loving emperor (figs. 251–252). That Antoninus commissioned the Hadrianeum and its reliefs was meant to underscore his continued commitment to Hadrian's administration of a provincial system favored by the provincials themselves – who in this monument seem literally, as we shall see, to support Hadrian's policies.

Located between Hadrian's Pantheon and the later columns of Antoninus Pius and Marcus Aurelius, the Temple of Divine Hadrian was constructed in an area of Rome developed by Hadrian and his Antonine successors. The temple is poorly preserved, with only eleven Corinthian columns from the northern peristyle, peperino blocks from the north wall of the cella, part of the vaulting of the cella, and remains of the staircase, surviving. Written and numismatic testimony, as well as the style of the architectural ornament and the names of members of the Antonine imperial family on brick stamps from a nearby conduit, point to a date of about 145 for the Hadrianeum.

The temple proper was surrounded by a precinct with an internal colonnade, two columns of which are still in place. An arch of Hadrian was closely allied with the temple complex, and the adventus relief of Hadrian, now in the Museo del Palazzo dei Conservatori (see fig. 223), may have come from that arch and may record Hadrian's "peaceful" adventus into Rome after his adoption by Trajan in 117. If so, the sculptural decoration of the arch corresponds to that of the temple itself, which was ornamented with a series of reliefs depicting provinces and Roman trophies.

Thirty reliefs from the temple are extant, including twenty-one representing provinces and nine depicting trophies. Most of these are today on display in the courtyard of the Museo del Palazzo dei Conservatori, but

251 Province and trophy reliefs from the Hadrianeum, ca.145. Rome, Museo del Palazzo dei Conservatori. Photo: Fototeca Unione at the American Academy in Rome, 948

252 Relief of the Province of Gaul, from the Hadrianeum, ca.145. Rome, Museo del Palazzo dei Conservatori. Photo: Alinari/Art Resource, New York, 28848

others are part of other museum or private collections. Still others are known only through eighteenth-century drawings.

Scholarly controversy concerning these reliefs has focused on the original location of the reliefs inside or outside the temple and on the identification of the provinces. Most agree that the province plinths alternated with the trophies and that the plinths probably served as architectural supports and as symbols of the provincial system under Hadrian. Depictions of the Roman provinces in the round or in relief were not unprecedented. There were fourteen statues of provinces surrounding that of Pompey the Great in his theater in Rome, and the frieze of the pedestal of the altar of the Ara Pacis Augustae included personifications of provinces and barbarians. In the first instance, the provinces were probably intended to be seen as vanquished captives, much like the Dacian prisoners on the second story of the colonnades of the Forum of Trajan, but those on the Ara Pacis may have been more comparable in intent to those of the Hadrianeum, that is, those provinces united under the pax Romana.

What is less certain is the original location of the reliefs. Three different theories place the reliefs on the outside of the temple: either as the decoration of the balustrade of the temple's podium, with each province relief under a column and a trophy relief in each intercolumniation; a balustrade for the attic of the temple; or as part of an external frieze. Others say that the fine state of preservation and the style point to their location inside the cella of the temple, probably high above the spectator and flanking a statue of Hadrian, the base of a colossal statue having been discovered in the excavations. The identifications of the provinces are based for the most part on their resemblance to the personifications of provinces on coin reverses struck during the principates of Hadrian and Antoninus Pius. Twenty-five provinces of the thirty-six of Hadrianic times were chosen for commemoration on the imperial coinage, and the temple reliefs probably included the same twenty-five provinces.

The style of the province series from the Hadrianeum is consistent with that of other Hadrianic monuments and indicates that artists continued to work in the classicizing Hadrianic style at the beginning of the principate of Antoninus Pius or that, at the very least, Antoninus Pius commissioned a work that honored Hadrian in a style consistent with his predecessor's taste.

The province figures, for example, that of Gaul (see fig. 252), are frontally positioned against a blank background. They are essentially stationary figures depicted in very high relief and are not contained within the square panel incised on the plinth. Rather, they project in front of it with their feet resting on a molded base. The heads,

which are for the most part in three-quarter views, also overlap the frames. Each figure is heavily outlined with the drill, and the drill is also used extensively to create dark shadows in the plastically rendered hair and to delineate drapery folds. Some details, such as locks of hair in the province series and the ribbons of a trophy in a trophy panel, are literally incised on the stone. The outlining of the figures and the drawing in stone are unprecedented in the capital, although the technique was known in the late republic and in the age of Augustus in Roman reliefs manufactured in Gaul (see, for example, figs. 99, 130). The standard explanation for the use of the technique in Gaul is that the reliefs were based on copybook drawings of Hellenistic paintings. In the reliefs from the Hadrianeum, however, the technique probably has more to do with the artist's attempt to highlight figures seen from a distance and from below. In any case, the technique is to be taken up again in Late Antiquity, again for different reasons.

The frontality of the figures should also be remarked upon. Frontally oriented figures appear infrequently in Roman art. Exceptions include the province figures from this monument as well as those from the Julio-Claudian Sebasteion in Aphrodisias, which are presented as single symbolic presences. Frontal figures are also used in state scenes when the figures duplicate those of well-known statuary groups, such as the cult statue in the Temple of Mars Ultor in Rome (Algiers Relief, see fig. 84) and a Julio-Claudian dynastic group (Ravenna Relief, see fig. 121). The appearance of frontal figures in state reliefs with narrative scenes does not occur until the late Antonine period when it became a means for artists to elevate the emperor and transform him into a symbol of imperial power.

The Column of Antoninus Pius

It was not Antoninus Pius but his adoptive sons and successors, Marcus Aurelius and Lucius Verus, who commissioned the most significant monument honoring Antoninus – the Column of Antoninus Pius – erected to honor the new divus and his wife, Faustina the Elder, at Antoninus's death in 161. It consisted of a red-granite column supported by a marble base with an inscription on one side and figural sculpture on the other three. Both Antoninus Pius and Faustina were laid to rest in the Mausoleum of Hadrian, but the column was built to serve as a cenotaph and was erected near Antoninus's ustrinum in the Campus Martius, the site of the funerary pyres of the Antonine emperors. Remains of the column and its pedestal, although not of the portrait statue that crowned the column, were discovered in modern times on Monte Citorio. The pedestal, which was exhibited for many years in the Giardino della Pigna of the Vatican Museums, was moved in recent years to the Cortile delle Corazze.

The inscription on the pedestal states that the column was erected in honor of the new divus by his successors. The side opposite the inscription depicts a scene of imperial apotheosis (fig. 253) that owes much to the earlier apotheosis of Sabina from the Arco di Portogallo (see fig. 222). In the Antonine commission, the figures are set in a horizontal rather than a vertical panel, but the scene again takes place in the Campus Martius, which is personified by the reclining, seminude male figure holding an obelisk in the lower left corner. He is balanced on the right by the figure of Roma, dressed in Amazon costume and wearing a helmet. She sits on a pile of arms and armor and leans with her left arm on a shield depicting Romulus and Remus suckled by the she-wolf. She gestures with her right hand toward the scene of apotheosis above in which a nude, winged male personification, probably the *genius* of the *saeculum aureum* or Golden Age, transports the deceased emperor and empress on his back. The *genius* grasps a globe entwined with a serpent, and his face is framed by deeply drilled serpentine locks. Antoninus Pius carries a scepter crowned by an eagle, the attribute of Jupiter, and the pair is thus assimilated to Jupiter and Juno. They are flanked by two eagles, the symbols of their souls, which stand for those which were actually let loose by a slave after the imperial cremation ceremonies.

The style of the panel is unquestionably classicizing and continues the stylistic tradition of the apotheosis of Sabina. The large, elegantly proportioned figures are placed against a blank background, and the mood is quiet and dignified.

The other two sides of the base (fig. 254) are carved with two nearly identical depictions of the funerary decursio. The decursio in honor of a deceased emperor consisted of a ritual counterclockwise circling of the funerary pyre by – depending on the occasion – priests and magistrates, and by members of the army and the equestrians (*equites*) who performed military maneuvers. On the Antonine column pedestal, the pyre is not represented, and mounted equites and *seviri* circle a contingent of foot soldiers of the Praetorian guard, two of whom are officers with standards (*signiferi*). Since the subject of the two decursio reliefs has been explained long ago, modern scholarship has focused upon the remarkable contrast between the classically inspired apotheosis relief and the nonclassical pictorial composition of the decursiones, in which the background of the reliefs is treated as the actual ground and the horsemen and foot soldiers are disposed on a series of turf segments. The central figures are seen head on and the circling horsemen from above. The

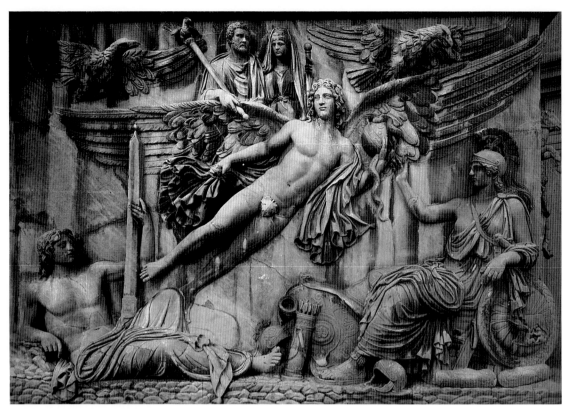

253 Pedestal of the Column of Antoninus Pius, apotheosis,
161. Rome, Vatican Museums, Cortile delle Corazze. Photo:
DAIR 38.1463

254 Pedestal of the Column of Antoninus Pius, decursio,
161. Rome, Vatican Museums, Cortile delle Corazze. Photo:
Fototeca Unione at the American Academy in Rome, 13703

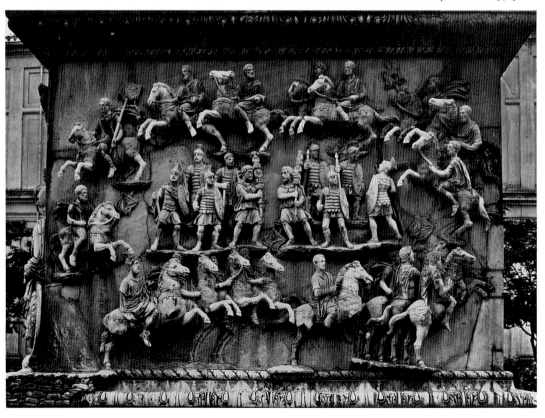

combination of head-on and bird's eye views is already known from the scenes on the Column of Trajan. There is also a precedent for the placement of figures on individual turf segments to suggest depth, but it comes from the art of freedmen and not from the imperial orbit. It is the relief of a funerary procession from Amiternum (see fig. 88) and undoubtedly stands for others of its type.

Despite the attention paid to the major stylistic discrepancies between the scenes of decursio and the apotheosis scene, there has been little recognition of the curious fact that two decursiones are represented. One scholar has suggested that the reason for the duplicate compositions is that a double decursio is represented – one led by Marcus Aurelius, the other by Lucius Verus, co-rulers of equal stature in 161. The pedestal would thus be a document testifying to a calculated imperial propagandistic program in 161 designed to publicize the concordia of the new Augusti. Furthermore, the same scholar identifies the fourth horsemen from the right at the bottom of each relief as the divi filii, Marcus Aurelius and Lucius Verus.

This argument, though ingenious, is not conclusive. One would expect, for example, that the two Augusti would have been given greater prominence. The figures identified as them are not isolated compositionally by the artist. The only figures that are differentiated from the mass significantly are the horsemen midway up the surface of the relief, at the extreme left on each side of the base. Neither they nor the so-called Augusti, however, can be fairly described as leading either decursio. The explanation for the two decusiones must rather be the older one, which this same scholar has rejected but which has recently been taken up again by others: the two decursiones are those in honor of Antoninus Pius and Faustina the Elder, who are seen in the apotheosis on the fourth side of the monument.

It is nevertheless significant that the two decursiones are as identical as free-hand carving could be. Although the deaths of Antoninus Pius and Faustina the Elder – and thus also their funerary honors – occurred twenty years apart, there is no indication whatsoever in the reliefs that the decursiones are not simultaneous. The carving of duplicate decursiones was not a result of a lack of inventiveness on the part of the designer or designers; on the contrary, the composition is a radical departure from earlier imperial designs. The duplicate and apparently simultaneous decursiones must be seen as the necessary complement to the fictional joint apotheosis of the third relief panel.

The representation of two figures being transported heavenward on the wings of only one *genius* is unprecedented in both imperial and private art. One might expect to find such a configuration for the first time on a monument commemorating the simultaneous death of two persons, but its introduction on the pedestal of a cenotaph of a man whose wife had predeceased him by twenty years is extraordinary and cannot be without significance.

The Antonine Column in Rome was part of a consistent program in 161 to emphasize the reunion of Antoninus and Faustina after the death of the emperor. Whether this program was initiated by the emperor's adoptive sons or by the surviving daughter of Antoninus and Faustina, Faustina the Younger, or whether it was carried out according to the express wishes of the deceased emperor, is impossible to determine and is not of great import. What is of the highest significance, however, is that the theme of reunion of husband and wife after the death of the surviving spouse is not new, but is a standard theme in the funerary art of freedmen.

Documentation for the practice of erecting a monument to commemorate the reunion of a husband and wife after the death of the surviving spouse is provided by the late Trajanic Circus Relief in the Vatican Museums. There, the wife, who predeceased her husband, is depicted in the form of a statue (see fig. 201), yet the pair is joined by the gesture of dextrarum iunctio.

The lengths to which sculptors of Roman freedman funerary reliefs would go to proclaim pictorially the unbreakable nature of the marital bond and the expectation of reunion after death are nowhere more apparent than in a curious funerary relief of Apuleius Carpus and Apuleia Rufina found near the Porta San Paolo (fig. 255). The relief was probably originally set into the facade of a tomb on the Via Ostiense. On the basis of the style and coiffures of the portraits, the relief may be dated about 161, that is, exactly contemporary to the monuments erected after the death of Antoninus Pius. The portraits are bust-length and are separated by a large, central, inscribed plaque. Despite the distance between the portraits, the sculptor has insisted upon including the dextrarum iunctio: Carpus's right arm is not represented, but his right hand clasps Rufina's to the left of the epitaph. Since Carpus put up the relief on the occasion of his wife's death, the theme is once again the expectation of reunion after death. In this case, the inscription specifically states that when Carpus himself dies he will be buried beside his wife in the same tomb.

This prior tradition of funerary portraits of spouses who expect to be reunited after death may also explain one of the most unusual features of the representations of the apotheosis of Antoninus and Faustina on the Vatican column pedestal. Unlike the full-length portrayal of Sabina on the late Hadrianic apotheosis relief from the Arco di Portogallo – the obvious model for the Antonine relief and all other imperial apotheoses on coins,

255 Funerary relief of Apuleius Carpus and Apuleia Rufina, probably from the Via Ostiense, ca.161. Rome, Villa Wolkonsky. Photo: D. E. E. Kleiner and F. S. Kleiner, 72.33.21

gems and reliefs – Antoninus and Faustina are depicted in the form of truncated busts. This constitutes a departure from even the separate full-length portrayals on coins and medallions of the apotheoses of Antoninus and Faustina themselves.

The custom of depicting husband and wife together in bust form on a relief with funerary connotations is not documented in an imperial commission before 161. Indeed, the patrons of such reliefs before the death of Antoninus Pius were restricted to a single stratum of Roman society, that of the enfranchised slaves and their freeborn offspring. It is in the art commissioned by these freedmen that many have sought the models for the Antonine decursio reliefs and for the nonclassical style of Late Antiquity in general. The possible derivation of the imperial portraits on the apotheosis relief from the funerary reliefs of freedmen suggests that in 161 even the artists working in the academic style were beginning to enrich their compositions with borrowings from the monuments of freedmen. Thus, not only the decursiones of the column pedestal of Antoninus Pius, but also the apotheosis of Antoninus and Faustina, long believed to epitomize the pompous classicism of Antonine court sculpture, already incorporates compositional devices and themes used earlier in the art of the Roman freedmen and, albeit to a far lesser extent, presages the stylistic revolution in late imperial official art.

The Panel Reliefs of Marcus Aurelius

The Column of Antoninus Pius (see figs. 253–254) was commissioned at the outset of the co-emperorship of Marcus Aurelius and Lucius Verus and serves as an example of a monument that both honors their immediate predecessor, now a divus, and asserts the legitimacy of their right to rule. It is also an innovative work and the very first example of an imperial state monument in which two widely disparate styles coexist. Reliefs made about fifteen years later, in part to celebrate Marcus Aurelius's victory over the Sarmatian and German tribes and his ensuing triumph of 176, are more conservative and are, on the whole, done in a consistent style, although some scholars have divided them into a classicizing and a baroque group.

The reliefs in question are carved on eleven extant panels, eight now part of the fabric of the attic of the north and south sides of the Arch of Constantine in Rome (figs. 256–259) and three now embedded in the walls of the Museo del Palazzo dei Conservatori (figs. 260–262). They seem to have decorated either one or two lost arches of Marcus Aurelius erected in Rome between 176 and 180. Divergent points of view have been taken by those scholars who have discussed the panel reliefs in depth: one argues for two arches and another reconstructs a single monument. In any case, the relief scenes serve both to illustrate specific war episodes from the northern campaign and to exemplify, in a more general way, the virtuous deeds of the emperor. Both sets of panels are vertically oriented, have comparable measurements, and are similarly framed. The Conservatori panels retain the original heads of Marcus Aurelius, whereas those now on the Arch of Constantine were replaced with the heads of Constantine when the reliefs were reused. They were later lost and replaced in the eighteenth century with modern heads of Trajan. The figures occupy slightly over half the height of the relief. The rest of the space is reserved for such edifices as temples and arches silhouetted against a blank background.

The panels on the Arch of Constantine include a profectio, a lustratio, an adlocutio, a clementia, a scene of submission, the Rex Datus, an adventus and a *liberalitas*. The profectio (see fig. 256) is a traditional scene in a long line of leave takings and illustrates Marcus's departure for the north in 169. The emperor is clad in a short tunic and mantle and stands in front of a four-sided arch at the outskirts of the city. The togate and bearded Genius Senatus bids him farewell, and he is urged on by the personification of the Via Flaminia reclining at the right corner. She is seminude, with long, deeply drilled hair,

and she bids Marcus to begin his journey. There is an anecdotal detail at the right where one of the horses, rearing restlessly in its desire to get under way, is quieted by a Roman soldier. Virtus is also present, and it is, in a sense, the emperor's virtue that ensures victory in the coming campaign. The emperor is also accompanied by Tiberius Claudius Pompeianus, Marcus's son-in-law and chief adviser, who assisted him in the northern wars and who is depicted as Marcus's alter ego in most of the panels. Here his profile is outlined on the relief ground behind Marcus as if he were the emperor's shadow.

The lustratio scene depicts the Roman rite celebrating the purification of the army, probably at the beginning of the military campaign. The togate emperor performs the ceremony, which is evidence of his pietas, in front of a small, transportable altar. He is aided by attendants who secure the pig, sheep, and bull – that is, the sacrificial animals of the Roman suovetaurilia. His soldiers, dressed in battle dress and wearing their helmets, gather around with their banners and standards held high. Pompeianus stands behind the emperor, and a musician and a camillus with an incense box are at his side. The scene is crowded

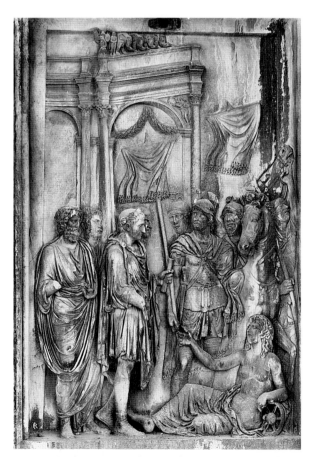

256 Arch of Marcus Aurelius, profectio of Marcus Aurelius, 176–80. Rome, Arch of Constantine. Photo: Alinari/Art Resource, New York, 2534

with figures in a wide variety of positions. Marcus is represented in profile, a soldier at the far right is seen from the rear, and another soldier and the attendants with sheep and pig are essentially frontal.

The adlocutio depicts Marcus Aurelius addressing his troops, probably at the beginning of a military campaign. It is his virtue that ensures their loyalty, as well as his talent as a military commander. Marcus, clad again in tunic and mantle, stands on a tall pedestal with Pompeianus behind his left shoulder. Seven soldiers constitute the group being addressed. Those in the background are depicted in profile and in low relief, while those in the foreground are represented from the rear and are almost sculpted in the round. Their lances and standards are held against a blank background.

In the scene of clementia, a group of soldiers escorts two bearded male prisoners, one in a state of agitation, the other with a decided air of resignation, to Marcus, who, with Pompeianus behind him, stands on a pedestal, probably located on the battlefield. It is the tree at the right that sets the scene. Marcus and Pompeianus are portrayed in the same costume, consisting of a tunic, leggings, and a paludamentum, their chosen attire for military activity short of battle. Once again, the emperor is in profile, but several figures are shown from the rear, a compositional device first exploited on the Column of Trajan.

The scene of Justice (see fig. 257) also focuses on the relation between an emperor and his barbarian foes. Marcus is seated on a tall pedestal and is accompanied by a standing Pompeianus. There is no tree and the site is probably the Roman camp. A contingent of Roman soldiers stands aside as two vanquished barbarians appear before the emperor, who administers justice or grants clemency to his foes – another show of imperial virtue. An elderly male barbarian, who is clothed in a belted tunic and leggings, has flowing locks and beard, and a sorrowful expression. Even though he cannot stand on his own and has to be supported on the shoulder of his son, he valiantly presents himself to Marcus. The boy, dressed in a similar costume, almost collapses under the weight of his father, and his smooth face, framed by a mass of deeply drilled, wavy curls, is one of utter misery. There is a furrow above his nose, his heavily outlined eyes are accentuated by deep drill holes to create the pupils and the tear ducts, and the skin below his eyes and his cheeks is marred by finely etched lines, despite his youth. This dramatic picture of the submission of father and son also underscores the courage and heroism of these barbarians. The artist responsible for carving this panel has knowingly created a very sympathetic picture of Marcus's enemy in order to demonstrate that

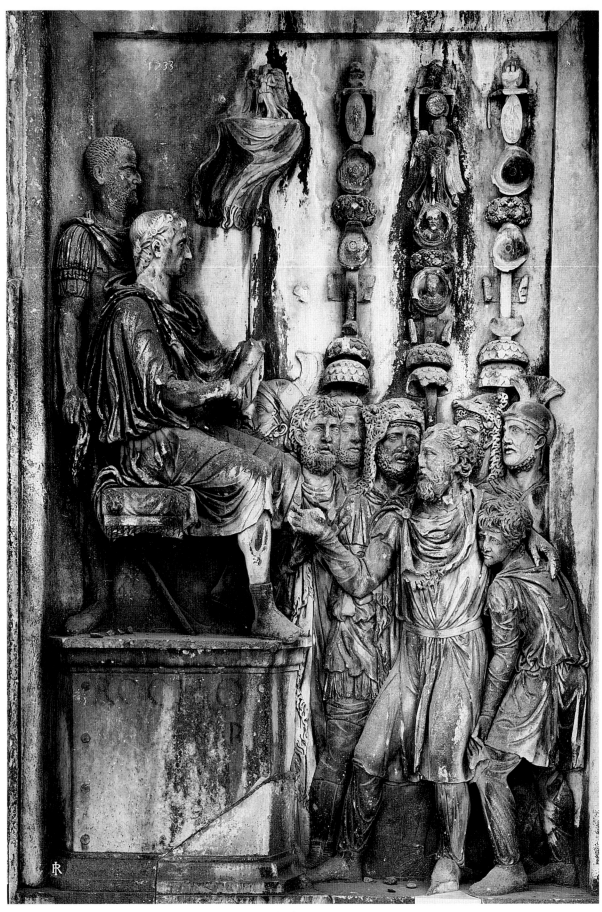

257 Arch of Marcus Aurelius, Justice, 176–80. Rome, Arch of
Constantine. Photo: Alinari/Art Resource, New York, 2538

the emperor was all the more successful in subjugating his foe. One is immediately reminded of the Column of Trajan where this theme was also paramount in such scenes as that of the heroic suicide of the Dacian king Decebalus (see fig. 181).

In the Rex Datus scene, Marcus Aurelius, once again standing on a tall pedestal with Pompeianus, introduces a vassal king to his soldiers. The installation signifies that a peace treaty has been signed heralding the end of war in the region and that Marcus's former enemy is now an ally of Rome. The scene appears to take place in front of the entrance to the Roman camp.

The emperor returned to Rome in 176 after the successful completion of his northern campaign; his adventus is also celebrated in an Arch of Constantine panel. The adventus scene (see fig. 258) represents Marcus's arrival in Rome, a temple and arch of the city (the same arch as in the profectio scene) are prominently displayed in the background, where he is greeted by Roma in her helmet and Amazon costume and by Felicitas with her cornucopia and caduceus. Marcus turns to face Roma and away from Mars, the god of war in full battle gear. That

the emperor's campaign has been successful is signified by the garland held above his head by the flying Victory figure. The identification of the figure behind Marcus's right shoulder is disputed. The most plausible identification is that she is Marcus's wife, Faustina the Younger, Mater Castrorum, hence her proximity to Mars. It is possible that Faustina is also here assimilated to Aeternitas since Faustina died in the East at the end of Marcus's campaign and was formally consecrated as a diva upon Marcus's return to Rome in 176. What is exceptional about this panel is that it is the only one among the eight now on the Arch of Constantine that depicts the emperor exclusively in the company of divinities and personifications. In this way, it continues the tradition begun under the Flavian of the comingling of human and divine in the same scene. Although the Flavian examples pertain to surviving narrative reliefs, however, such combinations appeared earlier on gems and in statuary groups on the attics of arches.

The Liberalitas (see fig. 259) is unquestionably the most controversial scene among the Arch of Constantine panels. It depicts a two-tiered composition with the emperor on a sella curulis in the upper tier surrounded by three togati, one of them Pompeianus, and a male figure in a tunic. The emperor, also togate, is in the process of distributing largess, against a backdrop made up of a colonnade strung with garlands, to the Roman people, who are depicted in the lower tier. Most of the figures have their backs to Marcus; one figure looks directly at the emperor and grasps the ledge of the monumental podium that divides the two tiers. Women and children are included among the figures of the Roman people. One boy stands between two adult males; a second boy rides piggyback on his father's shoulders, a depiction of father and child known from one of the Boscoreale cups and from the institutio alimentaria panel of the Arch of Trajan at Benevento (see figs. 128, 190). The similarity is probably not coincidental, and the motif in all three scenes must have been based on a common prototype.

Scholarly opinion has been divided over which of Marcus's seven acts of largess is portrayed in this panel. It has recently been convincingly argued that the liberalitas is that of 177, but what is significant about the liberalitas of 177 is that it was a joint largess given by Marcus Aurelius and Commodus in celebration of their joint triumph of 176. The later reworking of the right side of the upper tier underscores this supposition. Careful examination of the two togati at the right indicates that the upper part of the figures is depicted in higher relief than the lower and that both parts are not in exact correspondence. There are also stone fragments on the ledge of the pedestal below the feet of the togati. It has been suggested that the stone fragments and the different levels of relief of the togati

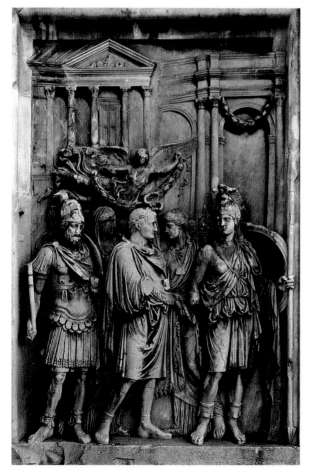

258 Arch of Marcus Aurelius, adventus, 176–80. Rome, Arch of Constantine. Photo: Alinari/Art Resource, New York, 2539

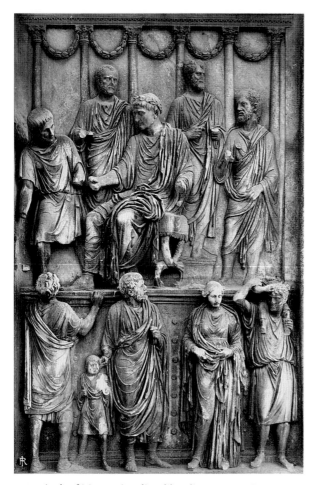

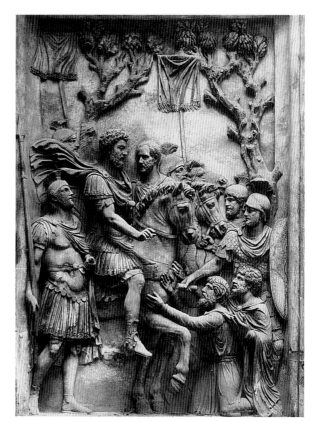

260 Arch of Marcus Aurelius, Conquest and Clemency, 176–80. Rome, Museo del Palazzo dei Conservatori. Photo: Alinari/Art Resource, New York, 6045

259 Arch of Marcus Aurelius, liberalitas, 176–80. Rome, Arch of Constantine. Photo: Alinari/Art Resource, New York, 2541

indicate that a figure originally located to Marcus's left was later removed. Furthermore, the figure was probably that of the seventeen-year-old Commodus, smaller in stature than his father, who sat in a similar posture and on a comparable sella curulis, and that after Commodus's damnatio memoriae, the figure was erased and the figures of the togati extended to fill the gap. As we shall see, the damnatio memoriae also led to the removal of the figure of Commodus in the triumph panel in the Conservatori (see fig. 261).

The three panels from the Museo del Palazzo dei Conservatori depict scenes of conquest or clemency, triumph, and sacrifice. In the first (see fig. 260), Marcus Aurelius, dressed in a cuirass and with his paludamentum billowing out behind him, is represented on horseback, as is his constant companion Pompeianus. The scene, which probably takes place on the battlefield because of the presence of the two trees in the background, is peopled by Roman soldiers, one of whom presents two kneeling barbarians to the emperor, who gestures toward them with his right hand. This gesture has been inter-

preted as one of clemency, indicating that the kneeling barbarians are ambassadors whose supplication presages a formal submission by the enemy. The scene has also been identified as one of conquest with its allusion to the emperor's victory on the battlefield. The formal model for this scene might be something like that of Trajan on horseback trampling a fallen Dacian from the Great Trajanic Frieze (see fig. 185). It is also almost identical with the bronze equestrian statue of Marcus on the Campidoglio (see fig. 236), which portrays the emperor trampling a barbarian while at the same time dispensing clemency. It seems likely that relief panel also has the same dual intention – to show Marcus as both militarily successful over and merciful toward his barbarian enemies.

The triumph panel (see fig. 261) depicts Marcus Aurelius, crowned by Victory, riding in a chariot, decorated with representations of Roma, Minerva, and Neptune, and drawn by four horses. He is accompanied by a single lictor and a lone musician; the latter leads the procession through an archway on the right. There is also a temple in the background. In essence, the scene is a shorthand version of the Triumph of Titus from the Arch of Titus (see fig. 156). The vertical panel format of the Aurelian relief did not allow for the expansive display of twelve lictors

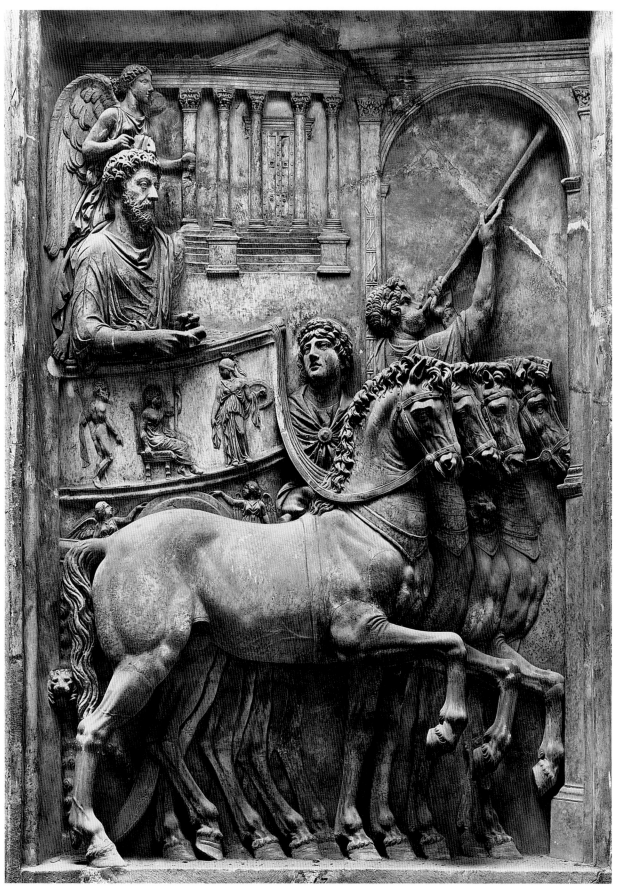

261 Arch of Marcus Aurelius, Triumph, 176–80. Rome,
Museo del Palazzo dei Conservatori. Photo: Alinari/Art
Resource, New York, 6044

and a larger array of divinities and personifications. The Conservatori relief originally had one additional figure, that of Commodus, who rode beside his father in the triumphal chariot. Marcus and Commodus shared a joint triumph in 176, and close examination of the relief makes it clear that the chariot is too large for a single figure. The Victory's hands are also poised to place wreaths over the heads of two figures. The portrait of Commodus was clearly erased after his murder and damnatio memoriae in an attempt to eradicate his memory from history and from monuments of state. It was, at that time, that the steps of the temple in the background were extended to cover the gap, an extension that does not conform to the design of the temple type, which had a frontal and not an encircling staircase.

The sacrifice panel in the Conservatori (see fig. 262) depicts Marcus Aurelius making a sacrifice at an altar located in front of the Temple of Jupiter Optimus Maximus Capitolinus at the apex of the Capitoline hill in Rome. The temple can be identified by its triple doors leading to the three cellas for the cult statues of Jupiter, Juno, and Minerva. Marcus, togate and with the upper edge of his mantle drawn up over his head, sacrifices at a small altar with the help of a camillus and with musical accompaniment provided by a single flute player. Pompeianus is present, as is the Genius Senatus, a flamen, a victimarius with an ax, and the victim itself, a bull that is amusingly depicted by the artist as an active participant in the scene. Attended by the victimarius, the bull is an integral part of the human throng and gazes intently at both the altar and the sacrificant. The sacrifice represented here is either the one to Jupiter at the conclusion of the triumphal procession – and thus the logical counterpart of the triumph relief – or the *vota suscepta,* a votive offering presented by a Roman general in the hope of a successful military campaign.

As we have seen, the Aurelian panels on the Arch of Constantine and in the Conservatori are of approximately the same scale, and the figures are similarly conceived against comparable backgrounds. In both cases, the figures occupy slightly over half the panel, with the remainder allotted to airy space and large temples or arches. The subject matter of both panels is related and seems to refer without question to the Sarmatian and German campaigns and their aftermath – the triumph of 176, the ensuing sacrifice, and the liberalitas of 177. Pompeianus is included in panels from both sets, and the figure of Commodus is removed from one panel in each of the two series. There is some overlapping of subject matter between the two sets, which suggests that the panels came from contemporary but separate arches erected in honor of Marcus Aurelius or of both Marcus and Commodus.

The likelihood of a joint commemoration is underscored by certain historical realities. Although hereditary succession was impossible from the time of Nerva to Antoninus Pius because none of those emperors had sons to succeed them, hereditary succession was still the favored mode, since second-century emperors adopted their chosen heirs as their sons. Commodus was thus destined to be emperor, although at one point it became politically expedient for Marcus Aurelius to proclaim his son's birthright publicly. This public announcement was on the occasion of the revolt against Rome of the governor of Syria, Gaius Avidius Cassius, who had proclaimed himself emperor upon hearing the rumor of Marcus's demise. He persisted in his attempt to wrest power from Marcus, with the support of the eastern provinces, even after hearing that the rumor had no basis in fact. Cassius was killed before Marcus was able to marshal his forces against him, but in Marcus's estimation the revolt had had serious enough consequences to warrant a personal trip through the eastern empire between 175 and 176. Marcus also appears to have learned from this event that his young son's claim to power might well be challenged,

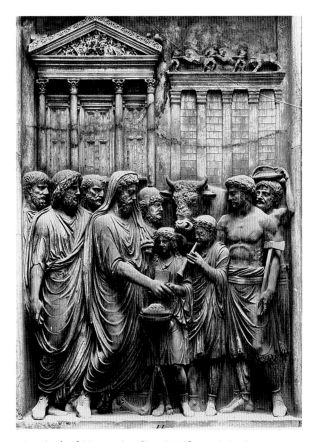

262 Arch of Marcus Aurelius, Sacrifice, 176–80. Rome, Museo del Palazzo dei Conservatori. Photo: Alinari/Art Resource, New York, 6043

and he insisted that Commodus make the tour of the eastern provinces with him. Upon their return to Rome in 176 they were voted the joint triumph, distributed largess together, and in 177 Commodus was granted co-equal status with his father and consequently possessed all titles save that of pontifex maximus.

After Commodus's damnatio memoriae, the figures of Commodus were removed from the reliefs in which he was portrayed jointly with Marcus. In view of the esteem in which Marcus Aurelius was held by his successors, the arches were presumably left standing. It was Constantine the Great, who wished to ally himself politically with Marcus as well as with the other so-called good emperors of the second century, Trajan and Hadrian, who incorporated the panels from one arch into the fabric of the fourth-century Arch of Constantine. Those from the other arch found their way to the Medieval church of S. Martina near the Curia in the Roman Forum.

A number of scholars have attempted to demonstrate that a classicizing style – based on Hadrianic precedents, such as the panels from the Arco di Portogallo (see figs. 221–222) – was employed for the panels now in the Conservatori, and a more baroque style – characterized by a greater interest in motion and emotion – for at least some of the Arch of Constantine panels. The disparity in style supports the suggestion that the panels must have originally belonged to dual arches. It has already been emphasized here that stylistic eclecticism is the hallmark of Roman art and that different styles were readily used at the same time and even in the same monument. Furthermore, if the Aurelian arches of 176 are compared to the earlier base of the Column of Antoninus Pius (see figs. 253–254), where diverse styles also coexist, it is apparent that the panels from the arches of Marcus Aurelius are more conservative and wholly in the mainstream of imperially commissioned Roman relief sculpture. In terms of subject matter, the scenes in the panels are examples of business as usual in the Roman empire, and the styles, whether labeled classicizing or baroque, are consistent with those used in earlier state monuments. It was not until the year 180 and the commission of the last major monument of Aurelian sculpture, the Column of Marcus Aurelius, that we see a significant break with earlier tradition.

The Column of Marcus Aurelius

Marcus Aurelius was proclaimed a god on his death at the front in 180. Immediately following his consecration, Commodus commissioned a column in his father's honor, and its construction took place between the years 180 and Commodus's death in 192. The Luna marble Column of Marcus Aurelius, which is closely modeled on that of Trajan, still stands (fig. 263). Its spiral frieze is severely damaged in sections but is for the most part readable. The bronze statue of the emperor at the column's apex, replaced in the Renaissance with one of St. Paul, has long since disappeared. Its sculpted base also no longer survives; the only preserved record of it is in engravings made in the Renaissance and Baroque periods. Like the Column of Trajan, which served as the centerpiece of the Forum of Trajan, the Column of Marcus Aurelius did not stand in isolation as it does today. It was originally part of an architectural complex facing the Via Flaminia and made up of an open rectangular space with the column in the center and a temple dedicated to the divine Marcus on one end flanked by covered colonnades. It was sited in the Campus Martius, in what is now the Piazza Colonna, and in close proximity to the ustrinum of the Antonine emperors, the Column of Antoninus Pius, the Hadrianeum, and a host of Hadrianic structures. Close by were Augustus's Ara Pacis Augustae and the Solarium Augusti.

The column's historiated frieze is based closely on that of the Column of Trajan (see fig. 179) and purports to represent Marcus's German and Sarmatian campaigns. The spirals are read from bottom to top, and two campaigns are depicted, their division marked in the center of the frieze by the scene of Victory inscribing the deeds of Marcus on a shield. The artists responsible for carving the frieze learned from the mistakes of their Trajanic predecessors, and careful consideration was given from the outset to the placement of the windows to light the spiral staircase. They are carefully integrated into the design, whereas those on the Column of Trajan were an afterthought. In the scene of Victory inscribing the shield on the Column of Marcus Aurelius, for example, the vertically oriented slit window conveniently serves as the pedestal for the shield, whereas on the Column of Trajan a window is paradoxically placed in the middle of a river or next to the chest of a soldier. There are other significant distinctions between the two columns. The Column of Marcus Aurelius has fewer spirals, the figures are depicted in higher relief, and there was an attempt by the master designer to line the key scenes up vertically. All of these adjustments were made to increase the visibility of the scenes from below and to allow a spectator viewing the scenes from a single vantage point to make some sense of the narrative.

The first scenes (I and II) – the numbering system follows that of C. Caprino – at the bottom of the column's shaft are comparable to those at the bottom of the Column of Trajan, indicating that the Column of Marcus Aurelius follows its earlier model in detail as well as in general form. These scenes establish the locale of the

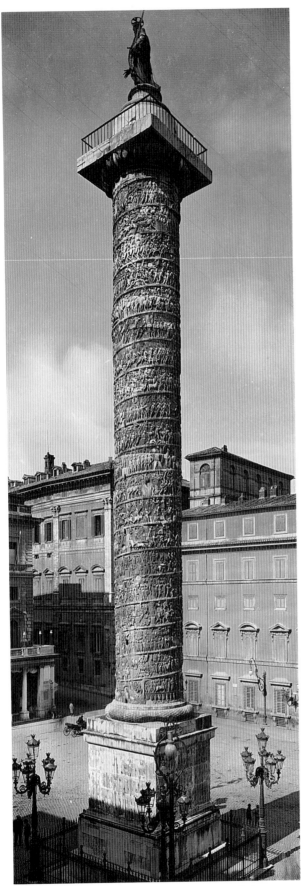

263 Rome, Column of Marcus Aurelius, general view, 180–92. Photo: Alinari/Art Resource, New York, 6697

264 Rome, Column of Marcus Aurelius, adlocutio, 180–92. Photo: C. Caprino et al., *La Colonna di Marco Aurelio* (Rome, 1955), pl. 5, fig. 11

campaigns as the banks of the Danube river and the port of Carnuntum crowded with barges. The Danube River, personified as an old, bearded man seen from the rear, rises up from the waves of the sea and encourages Marcus Aurelius (in cuirass), his generals (probably including Pompeianus), and the Roman troops to cross the bridge over the Danube. Marcus then delivers an adlocutio to his troops, which marks the outset of the campaign. The composition of scene IV (fig. 264) is novel and is the wave of the future in imperially commissioned relief sculpture. The emperor is not depicted in profile as he was in the scenes from his Roman arches of 176, but rather in a frontal view, as are the four signiferi who flank him. He is dressed in paludamentum and carries a lance, and he and the other four figures stand on a special groundline that is distinct from the base of the spiral below. His soldiers, in contrast, have their feet firmly planted on a lower and different groundline which is the undulating turf of the spiral itself. The soldiers in the crowd are either represented in profile or from the rear and serve as a captive audience for their commander.

The use of tiered turf-segments to establish background and foreground space in scene IV owes much to the artistic experimentation of the Antonine artist who carved the decursio scenes on the base of the Column of Antoninus Pius (see fig. 254), and such a device can ultimately be traced back to the freedman milieu where it was first used in late republican and Augustan times in such private reliefs as that of a funerary procession from Amiternum (see fig. 88).

Following the adlocutio, the Romans march against a fortified camp and the *lustratio exercitus,* or the sacrifice marking the beginning of the campaign, is celebrated. The togate Marcus is present, as are the animals of the Roman suovetaurilia. Next, the Roman troops destroy

an abandoned German habitation, and two German soldiers, probably deserters, request the emperor's protection. The emperor and his retinue stand on a rocky promontory, the German riders on a turf segment that is not the same as the ground of the spiral band. In scene IX, Marcus flanked by two men, one of whom may be Pompeianus, reads an order from a rotulus to his troops. The emperor is frontally positioned and with the flanking pair stands on a turf segment above the crowd of figures represented from the rear or in profile. The Germans then defend the crossing of a river while Roman soldiers watch from a castle. The Germans attempt to storm the castle with a siege machine but it is struck down by a thunderbolt and falls back on the barbarian attackers, hurling them to the ground (XI) (fig. 265). Marcus, unarmed and finding himself in difficult straits, prays to the gods for help. Help is supplied in the form of a thunderbolt, and the scene is therefore often referred to as the Miracle of the Thunderbolt. This incident indicates that the army of Marcus is not the efficient and unvanquished war machine of Trajan but needs the help of the gods to secure a victory.

Such a scene does not reflect the business-as-usual-in-the-Roman-empire attitude of the panel reliefs of Marcus Aurelius but rather reveals the soul-searching anxiety of an emperor who was concerned that the Roman empire had gotten out of control. The following scenes depict the Roman attack on a barbarian camp and combat between barbarians and Roman soldiers. Marcus, togate and with his mantle covering his head, sacrifices at a tripod altar and afterward surveys from a seated position the march of his soldiers into hilly terrain. The mountainous region is indicated by a series of individual turf segments on different levels. Scene XVI (fig. 266), which portrays the miracle of the rains, is one of the best-known on the column. The beginning of the narrative is divided into two tiers, with the Roman infantry below and other soldiers with carts and oxen above. One of the Roman soldiers in the upper register gestures toward the sky for help, and his prayers are answered by the rain god. The rain god is an elderly, winged creature with long, straggly hair and beard, and a hairy chest and arms. With his outstretched gesture he brings torrential rains, which reinvigorate an exhausted Roman army but at the same time devastate the barbarians, many of whom are left lying piled high in a heap. The scene is an additional example of the need of Marcus's army for divine intervention, but, in a more positive vein, indicates that the gods are on the side of the Romans.

Scene XVII depicts the submission of barbarians to Marcus, probably on account of the miracle of the rains. Marcus and his retinue stand on a turf segment located halfway up the relief band. A barbarian bends toward the

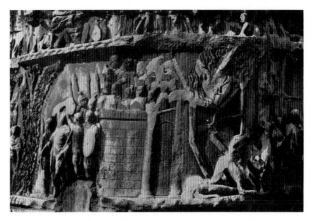

265 Rome, Column of Marcus Aurelius, Miracle of the Thunderbolt, 180–92. Photo: C. Caprino et al., *La Colonna di Marco Aurelio* (Rome, 1955), pl. 8, fig. 17

emperor and kisses his right hand in a gesture of submission. Below, in a lower tier, a crowd of barbarians, including women and children, looks on. A battle between Romans and barbarians around a German house follows, and in the next scene the Romans capture a German princess while a German prince flees. Romans and barbarians are locked in hand-to-hand combat, a village is destroyed, and barbarian prisoners are presented to the emperor. Marcus then addresses the Germans from across the river – the river depicted from a bird's-eye perspective – and the Romans and Germans fight side-by-side against a common enemy.

In scene XXIV, the Romans repel an attack by a new enemy, distinguished by conical caps. The consequence of the battle can be seen in the following scene where two barbarians in conical caps are presented to the emperor. Next, Marcus, with a rotulus in his hand, holds a meeting with his general staff and then proceeds to march with his followers. On their march, the Romans pass a river and Marcus offers a sacrifice. Marcus and two German princes make a pact in a camp, its outlines seen from above. The march starts up again only to be arrested and then to begin again with the emperor at its head. The Roman soldiers cross a river in barges and continue on their march. The emperor reaches the camp, and the Roman army repels an enemy attack. The barbarians request clemency from the emperor and a German prince submits. Afterward, a ceremony in the Roman camp takes place, and an ambassador arrives and then departs. The Romans then attack a German habitation and continue on their march. Marcus consults his general staff about the impending surrender of the Germans, and another village is destroyed. Barbarian fugitives are depicted, and other barbarians are pursued into a marsh. The emperor receives an embassy and meets with a German prince. A battle takes place and more barbarians

submit. A German fortification is attacked, and in scene LV Marcus gives an adlocutio to his troops, which marks the termination of the campaign.

The figure of Victory, inscribing the emperor's deeds and virtues on an oval shield and located between two trophies piled high with captured arms and armor, divides the two campaigns, as did a comparable scene on the Column of Trajan (see fig. 184). The second campaign commences with the emperor receiving barbarians. Others are annihilated in a forest, and the Germans surrender their arms. Germans are led to a river by their countrymen, the river showing three boats depicted as if seen from the air.

Scene LXI (fig. 267), which is one of the best-known on the column, graphically records the decapitation of barbarian rebels who await their fate with their hands tied behind their backs. While on line, they must witness the beheading of their compatriots. A victim who has already been decapitated lies at the feet of another barbarian who is being held in place by one captor while the other readies his sword for the fatal blow. A second executioner, with his back to the one just described, performs a similar task. Next, barbarians appear before the general staff, including Marcus and Pompeianus. A battle between Romans and Germans follows, with the foot soldiers and horsemen depicted in groups on separate turf segments, rather than on a single groundline as in most earlier Roman reliefs. The Romans capture high-ranking Germans in a forest, and a decapitated head of a German prisoner is presented to the seated emperor. The Roman legions march on. In the following scene, barbarians are hurled into an abyss and stabbed with lances by Romans on horseback. It is an especially gory vignette, and one that is a more graphic rendition of the earlier and tamer depictions of Trajan on horseback trampling a Dacian on the Great Trajanic Frieze or Marcus Aurelius crushing a barbarian beneath the hoof of his horse in the Campidoglio bronze (see figs. 185, 236).

Scene LXIX portrays the emigration of barbarians, including men, women, and children, followed by their cattle. Afterward, a battle takes place in the presence of the emperor, and a barbarian village is destroyed. The pursuit of fugitive barbarians is the subject of the next scene and is followed by the capture of women and cattle. Marcus's bodyguards present themselves to him, and Marcus, in paludamentum and with a rotulus, pours a libation on a flaming altar. Next, a battle takes place in the presence of the emperor and high-ranking Germans are captured. The Roman soldiers then depart for a major battle. The march is depicted and Marcus consults with Pompeianus on a bridge.

Across the bridge there is a battle between Romans and barbarians, and Marcus consults with his advisers outside the camp. In this scene (LXXX), as in so many others, Marcus is depicted in a frontal position, as are the two advisers at his left and right. The walls of the camp serve as a backdrop to the figures and isolate them from the crowd. Then the Roman soldiers cross a river in barges; scene LXXXII shows the construction of a camp – a rarity on the Column of Marcus Aurelius, but one of the most common scenes on the Column of Trajan. Marcus's adlocutio is the subject of the next scene, and it is juxtaposed with another depicting the army's passage across a bridge.

Another graphic reminder of the grim consequences of war can be seen in scene LXXXV, where a barbarian woman using her body as a protective shield for her young son is led away by a Roman soldier. Another Roman soldier escorts a carriage drawn by oxen and carrying another barbarian matron, who puts her fingers to her lips in an attempt to quiet her inquisitive young son.

Scene LXXXVI depicts Marcus delivering a speech from a pedestal. He and two of his retinue are depicted in frontal positions, with the spectators at either side of the podium represented in profile or three-quarter views. The crowd is parted to give special emphasis to the isolated frontal figure of the emperor. The emperor and his companions are also slightly larger in scale than the other figures, which indicates that the emperor is the most important figure in the scene. Hierarchy of scale had already been used in the republic – either in the art of freedmen or under the empire in such monuments of state as the Arch of Trajan at Benevento (see fig. 190). It appears in monumental state art of the city of Rome for the first time in the Column of Marcus Aurelius.

In the following scene, riderless horses next to the podium stand ready to take the emperor back on the march. Next, Roman horsemen overwhelm the German resistance in a scene that takes place near a river. Marcus, his retinue and his troops arrive and two German messengers on horseback are escorted in by Roman soldiers. Roman soldiers participate in a fierce battle that leads to the flight of their enemy. The Roman horsemen plunge their spears into their adversaries, some of whom have already toppled from their mounts; other barbarians depart in haste. Scene XCIII represents the emperor and his troops on the march again, their armor and supplies transported in carts pulled by oxen. Two carts move along the ground of the spiral band, another traverses a separate turf segment. The soldiers construct an encampment, and the Roman cavalry continues on the march. Another imperial adlocutio follows; scene XCVII represents the rout of high-ranking barbarians and their capture and murder. Marcus consults with members of his general staff, who incline their heads in his direction. Next, Roman cavalry

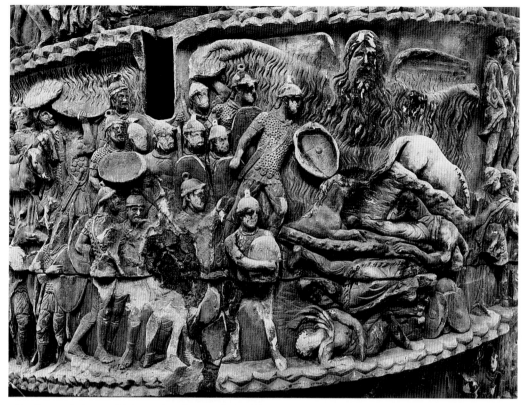

266 Rome, Column of Marcus Aurelius, Miracle of the
Rains, Rome, 180–92. Photo: Alinari/Art Resource, New
York, 4904

267 Rome, Column of Marcus Aurelius, decapitation of
barbarians, 180–92. Photo: DAIR 55.964

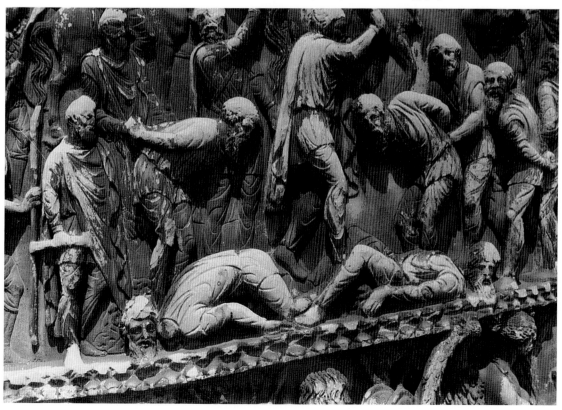

and infantry participate in a successful assault on the enemy, and Marcus gives an adlocutio to his bodyguards.

Scene CI (fig. 268) is justly renowned. It depicts a frontal Marcus Aurelius with rotulus in consultation with two flanking advisers. The scene takes place in a circular camp, the *opus quadratum* (ashlar masonry) blocks of which are carefully designated. The camp has four arcuated doorways and is seen both head on and from an aerial perspective. A messenger, with his back to the spectator, hastily enters the central door. The speed with which he moves is attested by the swirling skirt of his tunic and the billowing motion of his mantle, the entire figure a tour de force by a gifted artist. The messenger's communiqué for the commander-in-chief may have something to do with the two barbarian men of high rank who stand outside the left-hand door.

The next scenes depict the destruction of a village and the capture of barbarians, as well as Marcus Aurelius on the march with the bulk of his army. Barbarians, including women and children, are taken prisoner. The emperor continues on the march, leading the procession across a bridge. The march becomes a battle, and the barbarians are routed and submit. Scene CXV represents the barbarian emigration from the land now secured by Rome. The final scene (CXVI) depicts the capture of barbarian fugitives and cattle.

The subject matter and composition of the scenes on the Column of Marcus Aurelius make it apparent that, despite the obvious similarities between the Columns of Trajan and Marcus Aurelius, there are also significant distinctions that reflect the changing historical circumstances as well as a new view of imperial power. The efficient war machine of Trajan's column, which excelled in battle preparations – including the building of bridges, camps, and so on – is largely gone. It has been replaced by a more insecure army, one that spends more of its time vanquishing its barbarian enemies, shown in sometimes bloody vignettes that depict the Romans plunging their lances into barbarian victims and scenes of decapitation. Women and children are also taken prisoner. Trajan's army is portrayed as optimistic and self-reliant. It counted on the encouraging words of its commander-in-chief, who appears in frequent scenes of adlocutio; and thanks are offered by Trajan to the state gods after significant victories. The army of Marcus and even the emperor himself must appeal to the gods to intervene on their behalf. It was only the miracles of the thunderbolt and the rain god that turned the tide in two Roman encounters.

The emperor is depicted time and again in a frontal position, whereas Trajan was depicted in profile. Trajan was usually elevated on a podium or dais as is Marcus, but in the later monument the artist makes a greater effort to isolate the emperor compositionally from the crowd,

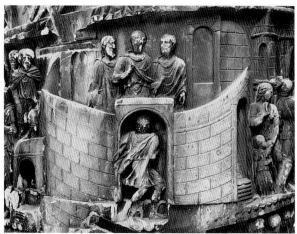

268 Rome, Column of Marcus Aurelius, the emperor receiving a messenger, 180–92. Photo: Alinari/Art Resource, New York, 4903

surrounding him only with the closest members of his staff. Trajan is shown on his column as the commander of his troops, as first among equals. Marcus seems to be more a symbol of imperial power than a Roman general, and the portrayal of him as a hieratically frontal and detached icon documents a major change in the Roman idea of emperorship, a change that is perfectly consistent with Commodus's vision of the office. It was Commodus, who viewed himself as a god on earth, who commissioned the Column of Marcus Aurelius in honor of his divine father.

The frontality of the main protagonist in a relief scene is new to the imperial art of the city of Rome during the late second century, but it had become the hallmark of the art of freedmen since the republic. The same can be said for the new depiction of space. In a state relief such as the Aeneas panel on the Ara Pacis Augustae (see fig. 78), inspired by Hellenistic Greek prototypes, the shrine of the household gods that is meant to be seen in the background is diminutive in size and is placed in the upper left. In the Augustan sepulchral relief of freedmen from Amiternum (see fig. 88), the funerary bier and mourning family members are of the same scale as the figures in procession in the foreground but are placed on individual turf segments to suggest depth. It is this second nonclassical mode that is used in the second century in both the decursio scenes on the base of the Column of Antoninus Pius (see fig. 254) and in the spiral frieze of the Column of Marcus Aurelius.

The base of the Column of Marcus Aurelius no longer survives, but two sides of the rectangular pedestal are recorded in later engravings. One of these depicts four figures of Victory with swags over their shoulders. The two central Victories grasp the sides of a slit window (another indication of the care the artist took to inte-

grate the windows into the design), and with their other hands hold a laurel wreath clasped also by the outer Victories. Another engraving purports to show another side of the base, where the cuirassed emperor appears with other members of his retinue and with a riderless horse. A group of male barbarians, at least two of which kneel at the feet of the emperor in supplication, are brought in by a Roman soldier. The theme is one of conquest and of Marcus's bestowal of clemency on his enemy, and the scene is comparable to others both on the column and in the panel reliefs of Marcus Aurelius.

The base of the Column of Marcus Aurelius, like that of Trajan's column, makes reference to the emperor's military victory and the ensuing subjugation of the enemies of Rome. Although linked thematically, however, the two sides of the base of the Column of Marcus Aurelius give the appearance of two separate works of art combined in a noncohesive whole. This is in strong contrast to the base of the Column of Trajan, with an inscription plaque on the front and where all four sides are covered with piles of captured Dacian arms and armor. The themes of military victory and clementia (see, for example, fig. 270) were also popular on contemporary sarcophagi. It is the horizontal relief panels of such coffins, with their rich repertory of scenes of military victory and victory over death which may have served as the immediate model for the panels of the Aurelian pedestal. The impact of the art of sarcophagi on that of state relief sculpture in Late Antiquity is a profound one, and the beginnings of that trend are apparent in this monument.

Antonine Sarcophagi

In view of the military preoccupations of the principate of Marcus Aurelius and the extensive period of time the emperor spent on the front, it is not surprising that, with one exception, all the surviving Roman battle sarcophagi date to the last three decades of the second century. The majority of these must have been used to house the remains of military commanders or soldiers who had won their reputations in pursuit of the pacification of the northern provinces. Second-century Roman battle sarcophagi also attest to the close relation between sarcophagi and state relief sculpture during this period.

The finest surviving second-century Roman battle sarcophagus is the Portonaccio sarcophagus from Portonaccio on the Via Tiburtina (fig. 269). The sarcophagus is of the western type, carved on three sides and with a flat lid flanked by masks. The main body of the sarcophagus is covered with a frenzied battle scene in which a mélange of Roman soldiers and barbarians are intertwined in a fierce encounter. The main protagonist, a horseman in cuirass

with helmet and lance, appears to emerge from the midst of the fray. He is larger in scale than the surrounding figures, and his face is unworked. The other figures have the elongated proportions, expressive faces, and hair and beards that are accentuated with a drill, like the figures in the spiral frieze of the Column of Marcus Aurelius. The hair and beards, as well as the costumes of the barbarians, indicate that they, similar to their counterparts on Marcus's column, are from the north. Furthermore, the figures emerge from the surface of the sarcophagus as if on separate bases and not a single groundline, a spatial device comparable to that used on the Column of Marcus Aurelius. For these reasons, the Portonaccio sarcophagus is thought to be contemporary to Marcus's column, that is, it probably dates to about 180–90. The sarcophagus may well have been made for one of the leading military men of the day, probably someone who had participated in the German and Sarmatian wars. One scholar has even attempted to associate the sarcophagus with a specific historical personage – the Aurelian general Aulus Iulius Pompilius – although this suggestion is not conclusive. The central battle scene is flanked by two trophies with pairs of subjugated male and female barbarians. The short sides of the sarcophagus are summarily carved with scenes that relate to those on the main body of the sarcophagus. On the left, Roman soldiers escort barbarians across a bridge, and on the right two barbarian men bow in submission to a Roman general.

The lid of the Portonaccio sarcophagus is also covered with figural scenes, although here the figures stand on the groundline formed by the base of the lid. Three contiguous scenes represent vignettes from the life of the deceased general. Interestingly, only one refers to his military career. It is the scene on the far right, and it depicts a clementia with the general in cuirass seated on a curule chair. A male barbarian kneels before him and kisses his hand in a gesture of submission. Behind the general is a Roman soldier attending to a male barbarian with his hands tied behind his back and a female barbarian and her child seated in the shadow of a trophy. The marriage of the general and his wife is celebrated in the scene in the center of the lid where the happy pair is joined in a dextrarum iunctio in the presence of Hymen with a torch. The scene on the far left represents the veiled and seated wife and a nurse giving a bath to the couple's first child. An alternative interpretation of the latter is that it depicts the bath of the deceased himself. In all three scenes on the lid, the faces of the main protagonists are not carved, which suggests either that the sarcophagus was a workshop piece that was never purchased and completed with these portrait heads, or that the coffin was bought in haste for the speedy burial of one of Marcus's generals killed on the front and for some reason never finished.

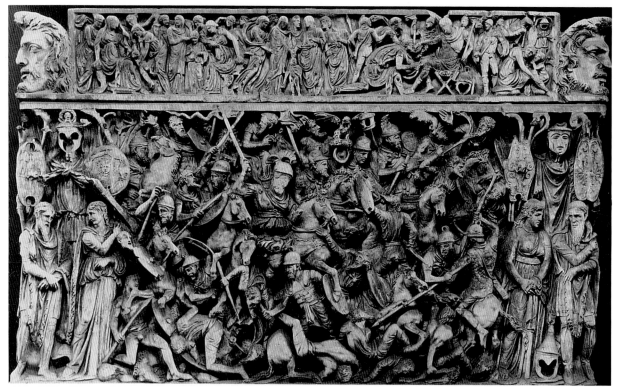

269 Portonaccio Sarcophagus, from Portonaccio, ca.180–90.
Rome, Museo Nazionale delle Terme. Photo: DAIR 61.1399

270 Clementia Sarcophagus, ca.170. Rome, Vatican
Museums. Photo: DAIR 1936.541

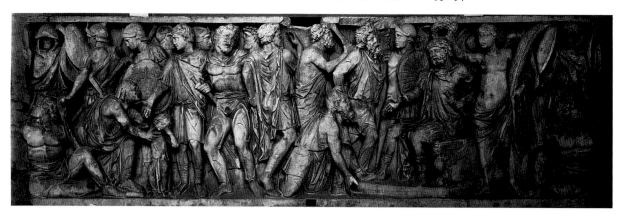

Scenes that decorated the lids on some sarcophagi became the primary subject of the main body of other coffins. A case in point is the so-called Clementia sarcophagus that dates to about 170 (fig. 270). The featured scene is that of a seated general who grants clemency to a kneeling barbarian adversary while he is being crowned with a laurel wreath by Victory. Roman soldiers attend to other barbarians, including a submissive woman and her child; the scene is framed by trophies. In this instance, the general's portrait features are carved, and we are therefore dealing with a finished work of art.

Both the battle and clementia sarcophagi are ex-

amples of what are usually referred to as biographical sarcophagi because their subject is the life of the deceased. Other popular biographical subjects in Antonine times included wedding scenes, the lives of children, sacrifices, and professional vignettes.

As their name suggests, wedding sarcophagi have as their main theme the marriage ceremony between husband and wife, who are usually joined in the traditional dextrarum iunctio that underscores their concordia. Standing between them is Hymen or Hymenaeus, a small boy with a torch who presided over Roman weddings. The wedding scene was often combined with other

subjects, and in Antonine times placing marriage and military scenes side by side was popular. We have already seen that the lid of the Portonaccio sarcophagus had a wedding scene in the center and a scene of the deceased general's clementia at the right. At least seven surviving Antonine sarcophagi combine such scenes on the main body of the coffin. The purpose of this juxtaposition was not only to present both the public and private side of a man's career but to encapsulate the deceased's virtus, clementia, pietas, and concordia in comprehensible visual images.

Although the marriage ceremony was often at the center, as on the Portonaccio lid, it was sometimes relegated to left or right, with center stage occupied by a scene of clemency or sacrifice. An example is a marriage sarcophagus of about 170, now in Mantua (fig. 271), which depicts the wedding at the right, a scene of clemency at the left, and a sacrifice at the center. The wedding ceremony is attended by Hymen with his torch and depicts the modest bride, with her mantle drawn up over her head, in a dextrarum iunctio with her husband, who wears a toga and is depicted with an Antonine coiffure and a full beard. The same man, accompanied by Victory and Virtus, is depicted in cuirass at the left, where he stands on a pedestal and grants clemency to a group of barbarians, including a woman and her child who supplicate before him. At center is a sacrifice scene that takes place in front of a temple, which has been identified as the Temple of Jupiter Capitolinus in Rome because of the oak wreath in the pediment. Furthermore, the same temple is represented in almost all the depictions of such sacrifice scenes on marriage sarcophagi. A beardless youth, dressed in tunic and paludamentum, pours a libation on a tripod altar while a kneeling victimarius restrains a bull about to be slain by the popa with his ax above. That the sacrificant is differentiated from the general and groom is significant. His youth must indicate that he is either the deceased at an earlier phase of his life, the son of the union of the couple at the right, or an unidentifiable sacrificant who is meant merely to illustrate the virtue of pietas and not an historical personage. The scenes of clemency and sacrifice, which signal the deceased's pietas, are near duplicates of comparable scenes on such contemporary state monuments as the Arches of Marcus Aurelius in Rome (see figs. 257, 262), down to the inclusion of a topograhical reference, and further underscore the close association of state and funerary art in the second half of the second century.

A small number of surviving sarcophagi of children (approximately twelve, excluding fragments), also depict events from the life of the deceased, highlighting such significant childhood occasions as the taking of a bath in the presence of mother and nurse, riding in a wagon or chariot pulled by horses, and taking lessons from a pedagogue. The earliest surviving example, which dates to the Trajanic period because of the mother's coiffure, poignantly depicts the child's life as the equivalent of a wagon ride (fig. 272). The wagon at the right shows him as a swaddled infant with his parents and at the left as a toddler seated between father and mother. The left-hand wagon is led by a winged putto and the two wagons are flanked by flaming torches. Between the two wagons are additional scenes from the boy's short life, showing him in a bucolic setting with a wheeled push toy and with a pet goose. This narrative sequence, with the scenes divided at the center by a tree, is the freedman's equivalent of documentary reporting of the Columns of Trajan and Marcus Aurelius.

The other surviving examples appear to be Antonine in date. One sarcophagus (now in Paris) depicts, from left to right, a mother nursing her newborn in the presence of his father, the father lovingly holding his son, the boy as an older child taking a ride in a one-horse chariot, and receiving a lesson from his seated teacher.

Sarcophagi with references to the deceased's profession are also known and seem to be the freedman's equivalent of an aristocratic Roman's battle sarcophagus. The earliest extant example of the small number that survive is the sarcophagus of a shoemaker (fig. 273). It was discovered in Ostia and consists of two scenes divided by an inscription plaque. The epitaph, in Greek, states that the sarcophagus was dedicated by Lucius Atilius Artemas and Claudia Apphias in honor of their friend, Titus Flavius Trophimas, with whom they spent their entire life. Trophimas is designated as a citizen of Ephesus, which, along with his Flavian praenomen and nomen, strongly suggests that he was a freedman of that period. Artemas and Apphias must have also been of Greek origin and were now, like Trophimas, residents of Ostia, a commercial town that was home to many foreigners. It is likely that all three were former slaves who belonged to the same patron and were manumitted, but it is also possible that Trophimas was the patron of the other two, whom he had manumitted and appointed as his heirs.

Trophimas, dressed in tunic and exomis (or chiton), is seated at the left in his shop, which is decorated with a cupboard (armarium) with shoes on top. He is portrayed in the act of making or repairing a shoe and is accompanied by another worker, presumably Artemas, who was a ropemaker, and is likewise occupied with his craft. The right scene also seems to portray the two friends participating in a pantomime appropriate to the Isiac cult, of which they were obviously adherents. Trophimas, again on the left, who is clad only in a loincloth, holds the double flutes, while Artemas, clad in a diaphanous tunic,

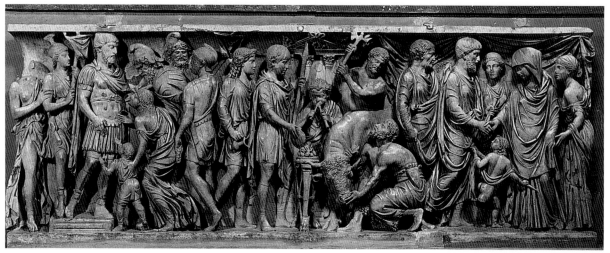

271 Marriage Sarcophagus, ca.170. Mantua, Palazzo Ducale. Photo: DAIR 62.126

272 Sarcophagus of a child, Trajanic. Rome, Museo Nazionale delle Terme. Photo: DAIR 79.3955

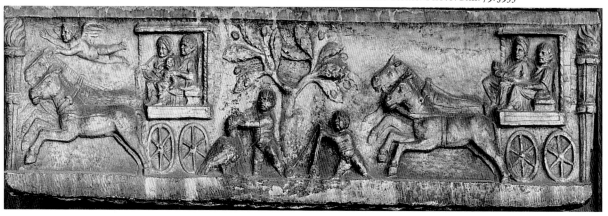

273 Sarcophagus of a shoemaker, from Ostia, Trajanic. Rome, Museo Nazionale delle Terme. Photo: DAIR 1938.1161

claps tambourines together. A long flute rests on the flat table between the two men.

Mythological sarcophagi were also commissioned in large numbers in Antonine times. Favorite subjects included Greek myths featuring Achilles, Adonis, Alcestis, the Amazons, Ares and Aphrodite, Endymion, Herakles, Jason, Medea, Meleager, the Niobids, Orestes, and Persephone. The legendary history of Rome was also a subject for sarcophagi, but scenes depicting Aeneas,

Romulus and Remus, and the Rape of Sabines were rare compared to those of their Greek counterparts.

There are sixty surviving complete or fragmentary Amazon sarcophagi from the city of Rome. Most of the early examples consist solely of a battle between Greeks and Amazons, but later manifestations place the figures of Achilles and Penthesilea in the midst of the fray. The best-known early Antonine example is the Amazon sarcophagus in the Museo Capitolino, which dates to about 140–150 (see fig. 227). The sarcophagus is of the western type with flat lid flanked by masks. The main body of the sarcophagus depicts Greek and Amazon foes locked

in individual encounters. Most of the motifs, for example, an Amazon woman being pulled by her hair from her rearing horse, are taken from well-known Greek prototypes. The lid depicts captive Amazons with their distinctive shields and axes. These recognizable Greek motifs – as well as the friezelike organization of the main scene – underscore the fact that this sarcophagus is highly derivative.

The later sarcophagi include the Achilles and Penthesilea groups, such as an Amazon sarcophagus of the early third century in the Vatican (see fig. 318). They are more innovative in both their rejection of the frieze composition in favor of one in which the groundline is the surface of the relief and in their incorporation of Roman portrait features into the figures of Achilles and Penthesilea. (The Vatican sarcophagus is discussed in depth in the following chapter.)

Sarcophagi representing mythological battles may have been purchased to house the remains of military men in the Antonine period, and their subject may have been meant as a veiled reference to contemporary battles. Later battle sarcophagi, like the one from Portonaccio (see fig. 269), which openly described specific Roman military encounters, must be seen as a later manifestation of the same development.

Sarcophagi depicting the twelve labors of Hercules also began to be very popular in the second half of the second century. Approximately forty city of Rome Hercules sarcophagi survive, thirty-six of which are carved with the twelve labors. The scenes are divided in two ways. About half of the examples have the scenes on the main body and the lid, the other half on the main body and on the two subsidiary sides. In the earliest examples the scenes follow one another in varying order; later, a strict sequence appears to have been followed, with the first ten scenes on the front, from left to right, and the two latest scenes on the subsidiary sides of the sarcophagus. The subject was especially well suited to Asiatic columnar sarcophagi, where individual episodes could be enclosed in an aedicula, such as in a sarcophagus now in the Galleria Borghese (fig. 274).

A fine example of the city-of-Rome type is a lidless sarcophagus, now in Mantua, which depicts a youthful and beardless Hercules at the left and a more mature bearded hero at the center and at the right performing the first ten labors in a continuous narration across the front of the sarcophagus. The Hercules myth was an appropriate choice for sarcophagus decoration in the second half of the second century, and its popularity coincided with the emperor Commodus's assumption of Herculean

274 Sarcophagus with Labors of Hercules, second half of second century. Rome, Galleria Borghese. Photo: Alinari/Art Resource, New York, 1930

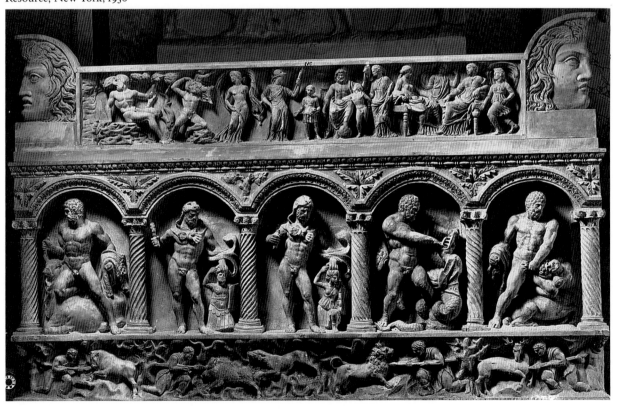

attributes. Like Commodus, the purchaser of the Hercules sarcophagus would have favored the bold alliance of the deceased with the Greek hero who began his illustrious deeds when only a smooth-cheeked youth, continued to triumph in maturity, and upon death, received immortality.

Sarcophagi with the myth of Meleager are among the most numerous preserved; there are close to two hundred city of Rome examples extant. These illustrate different episodes from the Meleager myth, such as the preparation for the hunt, the hunt, the repast after the hunt, and the death of the hero. The hunt was especially favored and appears to have been canonized as a fixed type in the mid-Antonine period. This mid-Antonine configuration consisted of two main scenes set out in a friezelike arrangement with a group of figures at the left and the actual hunt at the right. In other examples, both contemporary and later, the left scene was abbreviated and merged with the right, and the figure of Meleager was placed in the center of the front of the sarcophagus. An example is a sarcophagus, now in the Doria Pamphili Collection (fig. 275). The youthful figure of Meleager, in the center, is nude, save for a mantle over his left shoulder. He is about to plunge his lance into the boar, which is surrounded by other hunt participants, including Atalanta. The Romans were fond of hunt scenes after Hadrian. What made hunt scenes especially appropriate for sarcophagi was that the Romans equated success in the hunt with victory in battle and over death. Furthermore, the emperor Hadrian, who enjoyed hunting, memorialized his favorite hobby in a series of tondi that included not only a scene of the emperor spearing a boar but another that made reference to the immortality gained by the hero Hercules (see figs. 219–220). This cycle of scenes, which may also have had funerary connotations, must partly have inspired the fashion for hunting scenes on the sarcophagi of the well-to-do. Since the Hadrianic period was also characterized by a strong preference for works in the Greek mode, the depiction of the hunt through the vehicle of the Greek Meleager myth must have seemed especially attractive to Antonine patrons. Furthermore, the various versions of the Meleager story indicate that the brave son of Oeneus and Althaea, who saved Calydon from the wild boar, came himself to an untimely death, instigated by his own mother, who held him responsible for the demise of her two brothers. The subjects of heroism, death, immortality through one's brave deeds, and the hunt were all appropriate for the decoration of a coffin, although the traitorous behavior of Meleager's mother must have been ignored by the purchasers of such sarcophagi.

Many Antonine sarcophagi supported lids with reclining figures that had their origins in the similar leaning figures on Etruscan urns and in the kline monuments of freedmen, commissioned in Julio-Claudian times (see, for example, fig. 61). The well-known Melfi sarcophagus, discovered in Melfi in South Italy and now on display in its cathedral (fig. 276), is such an Antonine piece. It dates to about 165–70. On its lid is the portrait of a reclining woman, presumably the deceased, with her wavy hair parted in the center and her facial features delicately carved in the manner of Faustina the Younger (see fig. 247). The sarcophagus is carved on all four sides with individual mythological figures, including Apollo, Aphrodite, Odysseus, and Helen, and all are based on well-known Greek statuary types. These figures are surrounded by an ornate architectural setting composed of spiral columns supporting triangular and segmental pediments. The door to the tomb is located on one short end.

The Melfi sarcophagus is one of the earliest known examples of the Asiatic type of sarcophagus, made in a workshop in Asia Minor, despite its findspot in Italy. Although Asiatic sarcophagi, like Attic sarcophagi, are indebted to such Hellenistic models as the Alexander sarcophagus, they are traditionally larger and more profusely ornamented and deeply carved than their Greek counterparts. The deceased woman, herself as lovely as the goddess Aphrodite, lies in eternal sleep on the luxurious cushions of her funerary bed. She is accompanied by a mourning cupid with a torch, and her pet dog originally lay at her feet. This sarcophagus, made in the East but imported to Italy where the portrait features and coiffure were undoubtedly added, reveals the patron's fondness for Greek works of art. The form and decoration of the coffin is derived from Hellenistic sources. The honorand must have viewed herself as a fashionable Roman woman who was coiffed in nothing less than the latest Antonine court hairstyle.

Since few Roman sarcophagi have been found on their original sites or have surviving inscriptions, the names or social class of their patrons cannot be determined conclusively. The overriding taste for Greek mythology and the high quality of many of the surviving pieces have led most scholars to posit that Roman sarcophagi were an aristocratic phenomenon. Many were commissioned by the nobility, but others must have been purchased by freedmen who had long demonstrated their taste for ostentatious funerary monuments. Sarcophagi of the second century with inscriptions that identify the deceased as freedmen or slaves are known from Rome. These same patrons continued to purchase kline monuments and funerary altars, although the altars were produced in smaller numbers than before, probably because of the increased popularity of sarcophagi.

An example is the Altar of Cattia Faustina, discovered among the remains of Roman tombs in an excavation in

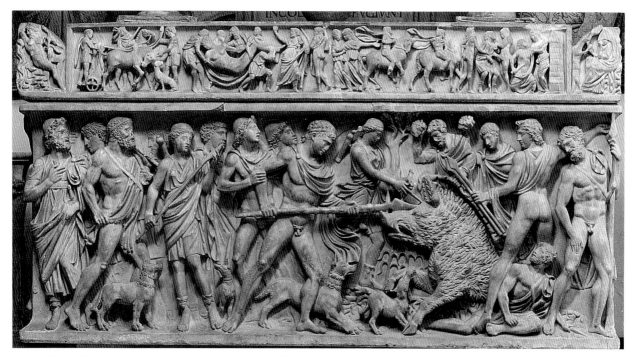

275 Meleager Sarcophagus, ca.180. Rome, Doria Pamphili.
Photo: DAIR 71.1474

276 Melfi Sarcophagus, from Melfi, ca.165–70. Melfi,
Cathedral. Photo: DAIR 76.2954

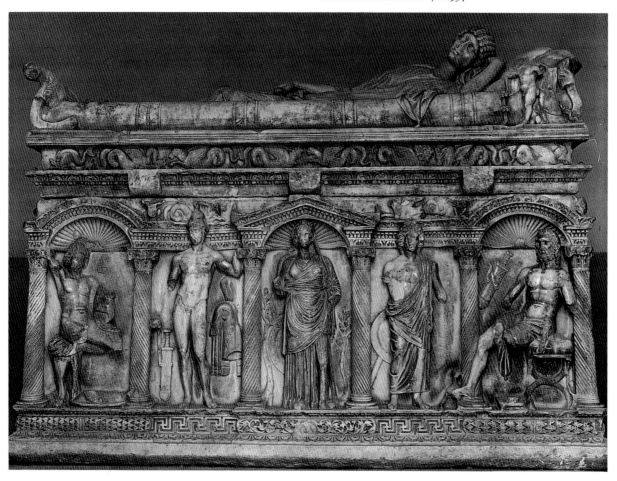

277 Altar of Cattia Faustina, from the Via Appia, ca.150. Rome, Torlonia Museum. Photo: DAIR 34.1965

the area of the sixth milestone of the Via Appia outside Rome and originally part of a funerary precinct belonging to the Cattius family (fig. 277). The altar's spiral columns flanked a tondo with portraits of Faustina and her husband Quintus Cattius Felix. An epitaph plaque above the portraits names the pair and further reports that Felix erected the altar in honor of his wife.

Faustina is represented in a long bust portrait that reaches well below her breasts and is a characteristic Antonine length. She has an oval face and large eyes with drilled pupils. She wears her hair parted in the center and arranged in tiers, the lower one covering the forehead and much of the ears. With this hairstyle, the rest of the hair was undoubtedly fastened in a bun at the back of her head. The hairstyle is a cross between Faustina the Elder's tiered coiffures and the simple parted hairstyle of Faustina the Younger (see figs. 246–247). Felix turns to gaze at his wife. His bust also extends below the breastbone, and he wears a paludamentum fastened on his right shoulder. The military iconography is not surprising at this date, and Felix was undoubtedly the freeborn son of a freedman. Given that they share the same nomen, he must have been her patron. He wears a short but full beard and moustache, and his hair is arranged in a tousled

style. These features parallel those of the preaccession portraits of Marcus Aurelius of about 152–53 (see fig. 236). The style of the two portraits and the lengths of the busts point to a date of about 150 for the altar. That the portraits of this freed couple show their indebtedness to contemporary court portraits indicates that the art of the imperial circle and the aristocracy continued to exert a significant influence on that of freedmen. What is especially significant about Antonine art is that such artistic devices as the hierarchy of scale and distortions of time and space long favored in the relief sculpture of freedmen begin to find their place in imperially sponsored relief in Rome.

Art in Africa under the Antonines

The Arch of Marcus Aurelius and Lucius Verus at Tripoli
Monuments honoring Marcus Aurelius and his co-emperor, Lucius Verus, were erected not only in Rome but in the provinces. The most outstanding example, the Great Antonine Altar at Ephesus (see figs. 279–281), appears to have focused on the military and political career of Lucius Verus, but an arch erected in Tripoli seems to have commemorated both equally.

The arch in question is a quadrifrons that was sited at the crossing of the two main thoroughfares of Tripoli (ancient Oea), in what is now Libya (fig. 278). It is fashioned from local stone and has a stone dome. It is covered with reliefs on the north and south sides and with portraits in niches crowned by male portraits on shields (imagines clipeatae) above on the east and west.

The sculptural program of the Arch of Marcus Aurelius and Lucius Verus in Tripoli is a simple one. The pilasters and frieze are covered with flowering acanthus

278 Tripoli, Arch of Marcus Aurelius and Lucius Verus, general view, 163. Photo: DAIR 58.25

plants and other decorative motifs known from Rome, but there are no frenzied battles, no sacrifices, and no triumphal processions. The east and west side had niches for statues of the co-emperors and two other notables, possibly the two dedicants of the arch, the proconsul of Africa, Servius Cornelius Scipio Salvidienus Orfitus, and his legate, Uttedius Marcellus.

Only one of the four statues has survived: the headless figure of a youthful male who is nude, save for a chlamys over his left shoulder. Traces of the beard can still be discerned, and its configuration has suggested to scholars that the statue depicted Lucius Verus. The draped male busts on shields also defy precise identification because the heads are gone, either weathered or deliberately defaced. The decorative schemes of the north and south sides are almost identical. On both sides, the left and right archivolts are carved with scenes of the tutelary deities of Oea, Apollo and Minerva, in a chariot drawn by two winged griffins and two winged sphinxes, respectively. Below them are trophies, decorated with arms and armor and with prisoners at their base. These captives constitute whole families. In the best preserved group on the northeast pier, the father stands upright and frontal next to the trophy, while the mother sits sideways and comforts her small son, who embraces her and clasps her hand for protection. The touching portrayal of the loving relationship between mother and child is an additional example of the sympathetic portrayal of barbarians in Antonine art both in Rome and in the provinces.

The surviving inscription allows the arch to be dated with certainty. The names of both honorands are given but only that of Lucius Verus is followed by the title *Armeniacus*. This designation was given to Lucius in 163 but bestowed on Marcus only in 164 or at the very end of 163. The arch, therefore, must have been erected in the course of 163 and must commemorate the first victorious stage of the continued Roman battle with Parthia over the fate of Armenia. Furthermore, it has been suggested that the barbarians at the base of the trophies are Parthians. The statue of Lucius Verus is comparable in body type to classicizing statuary in contemporary Rome, and the decorative and figural reliefs of the Arch of Marcus Aurelius and Lucius Verus in Tripoli are, on the whole, expertly carved. The deep shadows between the acanthus leaves are emphasized to a greater extent than they would be in the capital in Antonine times, but the figural types are close to their city of Rome models. Such details as the sensitive rendition of barbarian mother and child on the northeast pier at the same time capture emotion and depict a group of figures in complicated postures and with drapery that delicately molds their bodies. It is likely that the decorative acanthus was made by local artisans but that the overall design and the carving of the figures were entrusted to an artist from Rome or from an Attic or Asiatic workshop.

Art in the Eastern Empire under the Antonines

The Great Antonine Altar at Ephesus

The finest monument erected in the East under the Antonines, indeed one of the greatest known from Roman antiquity, is the Great Antonine Altar at Ephesus (figs. 279–281). It consisted of a monumental U-shaped altar, based on Hellenistic prototypes such as the Great Altar of Zeus at Pergamon. It had two decorated podia, the lower one ornamented with garlands suspended from bucrania, and the upper one encircled by an elaborate figural frieze. The altar originally stood somewhere in the center of ancient Ephesus, probably near the Library of Celsus, in which most of its slabs were reused as fronts for a later fountain basin. These relief slabs are now in Vienna.

The date of the Ephesian altar is highly controversial. Some scholars have proposed that the altar was constructed in about 140 with the purpose of glorifying Hadrian posthumously and his adopted family. Other scholars have attempted to demonstrate that the monument must have been erected after the death in 169 of Lucius Verus and must celebrate the life of Verus from his adoption to his apotheosis. What seems to make the later date conclusive is the mature head of Lucius Verus, published for the first time in 1978, which was part of a full-length portrait of the emperor, crowned by Victory and seated among gods and goddesses.

The slabs of the great frieze are two meters in height, and the frieze was probably about thirty-one meters in length. The order of the slabs cannot be reconstructed with certainty. There are three sets of letters on the slabs, used as guidelines to set them up after Verus's death and probably at two other times in Late Antiquity. The dimensions of some of the panels were altered when they were reused in a new context. Reconstructions based not only on the guide letters but also on the subject matter of the scenes, the chronology of the events, and the style of the reliefs have been suggested.

One of the high points of Lucius Verus's life was his adoption at the age of eight by Antoninus Pius, commemorated in the dynastic scene discussed above (see fig. 279). The occasion for the erection of the Ephesus altar in the eastern part of the empire was, however, not the accomplishment of a boy but that of a mature military commander who took charge of the campaign against Parthia in 163–66. For his efforts, Verus was voted a joint triumph with Marcus Aurelius in 166. Verus's death only three years later in 169 led to his consecration by the

279 Great Antonine Altar, dynastic scene, from Ephesus,
after 169. Vienna, Kunsthistorisches Museum. Photo: Courtesy
of Kunsthistorisches Museum

senate, another major event that needed to be commemorated. It is Verus's adoption, his Parthian victories, and his apotheosis that are celebrated on the Great Antonine Altar at Ephesus.

The adoption scene, with its frontal depiction of the Antonine dynasty, is somber, befitting the seriousness of the event, with figures frontally positioned as if posing for a formal portrait. The priestesses and other figures taking part in the ceremony are also frontally placed and essentially motionless. Except for the frontality, the prototypes for such a scene can be found in earlier imperial processions, such as the one on the north and south friezes of the Ara Pacis Augustae (see figs. 74–77).

Near the adoption scene is the accompanying scene of sacrifice, part of which survives. Two attendants flank the sacrificial bull, and there are musicians in the background. Although the figures are in profile and three-quarter views and the two attendants lean toward the bull, the scene is still essentially devoid of overt activity. Important members of the imperial family, including Sabina and Faustina the Elder, stand in frontal positions to the right of the sacrifice scene and witness the adoption.

The mood changes abruptly as scenes of combat are interspersed with those featuring dying barbarians. In one panel, for example, two heroic Roman legionnaires walk beside three defeated Parthians with shaggy hair and beards. One Parthian kneels and attempts to pull an arrow from his back; another is slumped over the saddle of his horse. A very dramatic scene, as full of motion and emotion as the preceding scenes were not, represents a Roman soldier in tunic, helmet, and sword in hand, raising his right arm across his body (see fig. 280). He is about to use all his force to swing the sword back toward a Parthian who kneels at his feet. Although the crouching Parthian holds weapons in his hands and has a shield strapped to one arm, it is apparent that he is helpless to defend himself against his invincible Roman foe. The rearing horse in the background gives the scene additional drama. Another slab depicts the merciless Roman attack on its enemy, with a Roman horseman charging a barbarian from the back and another barbarian crumpling under the force of the horses' hooves, his sword and the shield he holds protectively over his back unable to withstand the Roman onslaught. As the combat continues, the poignant scene shows one, or maybe two kneeling barbarians plunging their swords into their chests in a last desperate but heroic act of suicide, like that of the Dacian king Decebalus on the Column of Trajan (see fig. 181). Despite the suicide scene, the depiction of the barbarians on the Great Antonine Altar at Ephesus is less sympathetic than the one on the Column of Trajan or on the panel reliefs of Marcus Aurelius. Death and destruction

280 Great Antonine Altar, Roman soldiers and Parthian adversaries, from Ephesus, after 169. Vienna, Kunsthistorisches Museum. Photo: Courtesy of Kunsthistorisches Museum

are given greater emphasis, as they are on the Column of Marcus Aurelius.

Another series of panels depicts personifications of cities of the empire, both east and west, accompanied by river gods. These gods are depicted from the waist up, as on the columns of Trajan and Marcus Aurelius, the cities in full-length. The standing cities, with their frontal bodies and three-quarter positioned heads posed against blank backgrounds, are similar in all but style to the province figures from the Hadrianeum. As in the adoption panels, there is little movement, and the figures stand in quiet poses.

In the apotheosis scene (see fig. 281), Lucius Verus, dressed in cuirass, is not carried to heaven on the back of an eagle or a personification, but instead steps with the aid of Victory into a chariot drawn by two horses and led by Helios and Virtus. Tellus, holding a cornucopia and accompanied by a child with fruit in his cloak (one of the Seasons?), reclines below the horses' hooves. The scene is more similar to that of the apotheosis of Julius Caesar from the Vatican altar of Augustan date (see fig. 86) than it is to second-century scenes of imperial apotheosis. A related scene depicts Selene stepping into a chariot drawn by two stags. Hesperos holds a torch to light the way, and the chariot is led by Nyx while Oceana reclines below.

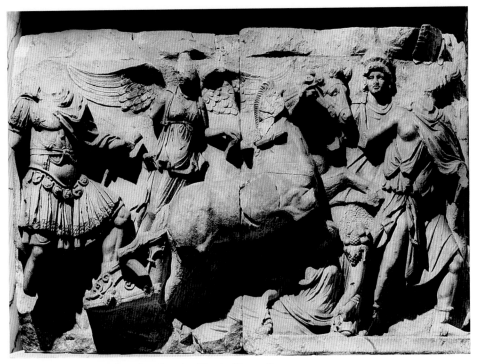

281 Great Antonine altar, Apotheosis of Lucius Verus, from Ephesus, after 169. Vienna, Kunsthistorisches Museum. Photo: Courtesy of Kunsthistorisches Museum

Another series of panels depicts the Olympian gods, including Athena and 'Poseidon. Lucius Verus is also present and is being crowned by Victory.

There are two distinct styles used for the Great Antonine Altar at Ephesus – a subdued rather motionless style with upright figures standing, for the most part, in frontal positions. The other style, which is used appropriately for the battle scenes, is filled with moving figures in a wide variety of postures, their arms and legs diagonally disposed from their bodies. Roman soldiers swing their swords in broad dramatic gestures at cowering barbarians in contorted positions. The deep drillwork in the hair and drapery of the figures in both the quiet and active scenes is consistent with that of Antonine relief sculpture in Rome.

The Contribution and Legacy of Antonine Art

Art under Antoninus Pius was, in large part, a continuation of Hadrianic art. Antoninus's portraits were modeled on those of Hadrian and Antoninus's major extant state commission – the Temple of Divine Hadrian with its panels of supportive provinces – extolled not only the former emperor's interest in seeing the Roman world firsthand but also his expert administration of the provinces, which Antoninus hoped to continue.

The principates of Hadrian and Antoninus Pius were marked by peace and prosperity. With them, an interest in art with themes that reflected this atmosphere flourished. With Marcus Aurelius and Lucius Verus, there was a return to the commission of major monuments of public state art in Rome and the provinces with overtly military subject matter, in part because of the concomitant military preoccupations of the new co-emperors. Wars were conducted on a variety of fronts, and both Marcus and Verus personally participated in the fray. Their first commission was a monument to their divine adoptive father, Antoninus Pius, and his wife, Faustina, and was decorated with peaceful scenes of imperial apotheosis and decursio. Soon, however, state monuments began to be erected in Rome, such as the arches of Marcus Aurelius, and in the provinces, which increasingly focused on the battle between Rome and its barbarian enemies. This new interest, which marked in a sense a return to the militarism of Trajanic art, culminated in the last two decades of the century in graphic descriptions in the spiral relief of the Column of Marcus Aurelius of barbarians decapitated and speared with Roman lances.

The horrors of war were profoundly felt by Marcus Aurelius, an introspective man deeply imbued with the tenets of Stoic philosophy. It is certainly the emperor's bent toward self-examination that led him to commission state portraits of himself that described not only his

physical appearance but also his internal turmoil about the state of the Roman empire. It is under Marcus Aurelius that court artists began to explore the emperor's psyche as well as his outer features in both portraits in the round and in relief sculpture. The sensitivity of Antonine artists to the inner workings of the mind and heart extended to their depictions in state art of their barbarian enemies. An increased desire to portray barbarians as sympathetic and even heroic foes is apparent in scenes from the arches of Marcus Aurelius.

This is not to say that the artists of the day lost their interest in the sensuous surface of skin and its contrast to the plastic texture of hair and beard. The experiments of Hadrianic artists, especially apparent in the portraits of Antoninous, continued under the Antonines and find their finest expression in the highly polished portrait of Commodus as Hercules in the Conservatori Palace. The exaggerated contrast between the soft flesh and deep drillwork of hair and beard is, however, apparent only in male and not in female court portraiture of the day and indicates that the two do not always develop in concert.

With regard to women, under the Antonines the women of the court seemed to have gained in importance. Alimentary funds were created in the names of Faustina the Elder and Faustina the Younger, and both also occupy prominent positions on state reliefs of the period. Faustina the Elder is depicted in a joint apotheosis with her husband on the base of the Column of Antoninus Pius even though she predeceased her husband by twenty years. Faustina the Younger may be represented as Mater Castrorum in the scene of adventus from one of the arches of Marcus Aurelius in Rome and even as far away as Ephesus. She is the only woman depicted in the dynastic Antonine adoption panel. In fact, even though she is represented in the background, Faustina the Younger is a key player in the relief forming the familial link between Marcus Aurelius and Lucius Verus. Children were also considered important as subjects in art under the Antonines, probably because of the prominence of the boy princes, Marcus Aurelius, Lucius Verus, and Commodus, who were liberally displayed in portraits in the round and in relief.

Also apparent in the Antonine period is the profound influence exerted by the art of freedmen on the art of the imperial circle. This is especially apparent in the base of the Column of Antoninus Pius where the two decursiones include small figures with stumpy proportions disposed on different turf segments and seen at the same time from head on and in aerial perspective. Even the classicizing apotheosis scene – with its half-length figures

of deceased husband and wife and its deliberate conflation of time to depict the reunification of the devoted married pair after their death – demonstrates its indebtedness to the art of freedmen. The use of separate turf segments to designate space continues to be employed by the artists who carved the spiral frieze scenes on the Column of Marcus Aurelius. On the column, the artists also elevate the emperor from a man to a symbol of imperial power by isolating him from the mass and representing him in strict frontality. Frontality was used as a device to set the main protagonist apart from subsidiary figures in freedman reliefs from the late republic on.

The coexistence of disparate styles in the panels of the base of the Column of Antoninus Pius, the arches of Marcus Aurelius in Rome, and the Great Antonine Altar at Ephesus indicates that eclecticism was still the hallmark of Roman art.

It is also under the Antonines that there was an increasingly close relation between state relief sculpture and funerary art. The frenzied battle scenes on the Column of Marcus Aurelius are paralleled in contemporary battle sarcophagi, and scenes from state reliefs (such as a general's clementia) become the primary subject of a soldier's biographical sarcophagus. The depiction of Antoninus Pius and Faustina the Elder, united by marriage and reunited twenty years later after death in a magical conflation of time, is unique for an imperial monument but common in the funerary reliefs of freedmen from the time of the late republic. The Great Antonine Altar at Ephesus also has funerary implications in that it includes the apotheosis of Lucius Verus, and the Column of Marcus Aurelius was erected by his son after his death.

Above all, art commissioned under Marcus Aurelius was an art that profoundly reflected the historical situation of the time and the psyche and soul of the ruling emperor. Nowhere was this more apparent than in Marcus's latest portraits. The emperor died on a northern battlefield in 180, the last of the "good" emperors of the second century. It was the beginning of the end for Rome.

At the same time, the art of the Antonine age heralded a new beginning. It was under the Antonines that the emperor was transformed from a man to a godlike symbol, increasingly isolated from the Roman citizenry. Imperial patrons and their artists demonstrated an increased interest in distortions of scale, time, and space, continuing the experiments of imperially sponsored art under Trajan. A greater acceptance of the use of such devices in Antonine art heralded a momentous change and served as a lasting legacy to Late Antiquity and to the Middle Ages.

Bibliography

For ancient biographies of the Antonine emperors, see the *Scriptores Historiae Augustae*. For their modern encapsulated biographies, see *The Oxford Classical Dictionary*, 2d ed. For important general studies of the period, see G. Rodenwaldt, "Über den Stilwandel in der antoninischen Kunst," *AbhBerl* (1938), 1–27. M. Pallottino, "L'orientamento stilistico della scultura aureliana: Studi sull'arte romana," *Le Arti* 1 (1938), 32–36.

Antonine Portraiture: M. Wegner, *Die Herrscherbildnisse in antoninischer Zeit* (Berlin, 1939). E. Calò Levi, *Barbarians in Roman Imperial Art* (New York, 1952). C. Vermeule, *Roman Imperial Art in Greece and Asia Minor* (Cambridge, Mass., 1968). E. R. Knauer, *Das Reiterstand des Kaisers Marc Aurel* (Stuttgart, 1968). K. Fittschen, "Zum angeblichen Bildnis des Lucius Verus in Thermen-Museum," *JdI* 86 (1971), 214–52. C. Saletti, *I ritratti antoniniani di Palazzo Pitti* (Florence, 1974). K. Fittschen, *Katalog der antiken Skulpturen in Schloss Erbach* (Berlin, 1977), 75–78 (Antoninus Pius and Commodus) M. Bergmann, *Marc Aurel: Liebieghaus Monographie,* 2 (Frankfurt a.M., 1978). M. Wegner and R. Unger, "Verzeichnis der Kaiserbildnisse von Antoninus Pius bis Commodus, I," *Boreas* 2 (1979), 87–181; II, *Boreas* 3 (1980), 12–116. R. Invernizzi, "Alcuni ritratti di età antoniniana dalla Grecia," *ASAtene* 57–58 (1979–80), 343–60. F. Albertson, *The Sculptured Portraits of Lucius Verus and Marcus Aurelius (A.D. 161–180): Creation and Dissemination of Portrait Types* (Diss., Bryn Mawr, 1980). *Marco Aurelio – Mostra di Cantiere* (Rome, 1984) (the equestrian statue of Marcus Aurelius). K. Fittschen and P. Zanker, *Katalog der römischen Porträts in den Capitolinischen Museen und den anderen kommunalen Sammlungen der Stadt Rom,* 1 (Mainz, 1985), 63–90. R. Hannah, "The Emperor's Star: The Conservatori Portrait of Commodus," *AJA* 90 (1986), 337–42. M. Cima and E. La Rocca, eds., *Le tranquile dimore degli dei: La residenza imperiale degli horti lamiani* (Rome, 1986), 88–91 (M. Bertoletti), 93–95 (E. La Rocca), 173–77 (C. Häuber), 202 (C. Usai). E. R. Knauer, "MULTA EGIT CUM REGIBUS ET PACEM CONFIRMAVIT: The Date of the Equestrian Statue of Marcus Aurelius," *RM* 97 (1990), 277–306. J. Bergemann, *Römische Reiterstatuen* (Mainz, 1990), 105–8. K. Fittschen, *Die Prinzenbildnisse antoninischer Zeit,* in press.

Female Portraiture under the Antonines: M. Wegner, *Die Herrscherbildnisse in antoninischer Zeit* (Berlin, 1939). K. Fittschen, *Katalog der antiken Skulpturen in Schloss Erbach* (Berlin, 1977), 80–88 (the Faustinas). K. Fittschen, *Die Bildnistypen der Faustina Minor und die Fecunditas Augustae* (Göttingen, 1982). K. Fittschen and P. Zanker, *Katalog der römischen Porträts in den Capitolinischen Museen und den anderen kommunalen Sammlungen der Stadt Rom,* 3 (Mainz, 1983), 13–24.

Private Portraiture under the Antonines: J. Aymard, "Vénus et les impératrices sous les derniers Antonins," *MélRome* 51 (1934), 178–96. M. Wegner, *Hadrian, Plotina, Marciana, Matidia, Sabina* (Berlin, 1956). E. E. Schmidt, "Die Mars-Venus-Gruppe im Museo Capitolino," *AntP* 8 (1968), 85–94. D. E. E. Kleiner, "Second-Century Mythological Portraiture: Mars and Venus," *Latomus* 40 (1981), 512–44. K. Fittschen and P. Zanker, *Katalog der römischen Porträts in den Capitolinischen Museen und den anderen kommunalen Sammlungen der Stadt Rom,* 1 (Mainz, 1985), 69–70. H. Wrede, *Consecratio in Formam Deorum* (Mainz, 1981).

The Hadrianeum (Temple of Divine Hadrian): F. Castagnoli, "Due archi trionfali della via Flaminia presso Piazza Sciarra," *BullCom* 70 (1942), 57–82. J. M. C. Toynbee, *The Hadrianic School* (Cambridge, 1934). A. M. Pais, *Il "podium" del tempio del Divo Adriano a Piazza di Pietra in Roma* (Rome, 1979). L. Cozza, ed., *Tempio di Adriano: Lavori e studi di archeologia pubblicati dalla soprintendenza archeologica di Roma* 1 (Rome, 1982).

The Column of Antoninus Pius: L. Vogel, *The Column of Antoninus Pius* (Cambridge, Mass., 1973). A. Bonanno, *Portraits and Other Heads on Roman Historical Relief up to the Age of Septimius Severus* (Oxford, 1976), 110–13. D. E. E. Kleiner and F. S. Kleiner, "The Apotheosis of Antoninus and Faustina," *RendPontAcc* 51–52 (1978–80), 389–400. D. E. E. Kleiner, "A Portrait Relief of D. Apuleius Carpus and Apuleia Rufina in the Villa Wolkonsky," *ArchCl* 30 (1978), 246–51. R. Hannah, "*Praevolente nescio ingenti humana specie* . . . A Reassessment of the Winged Genius on the Base of the Antonine Column," *BSR* 57 (1989), 90–105.

The Panel Reliefs of Marcus Aurelius: I. S. Ryberg, *The Panel Reliefs of Marcus Aurelius* (New York, 1957). H. von Heintze, "Zum Relief mit der *Liberalitas* des Marc Aurel," *Hommages à Marcel Renard,* 3 (1969), 662–74. G. Koeppel, "Profectio und Adventus," *BonnJbb* 169 (1969), 136–38, 148–56. A. Bonanno, *Portraits and Other Heads on Roman Historical Reliefs up to the Age of Septimius Severus* (Oxford, 1976), 117–36. E. Angelicoussis, "The Panel Reliefs of Marcus Aurelius," *RM* 91 (1984), 141–205. R. R. Holloway, *NAC* 14 (1985), 267–68. G. Koeppel, "Die historischen Reliefs der römischen Kaiserzeit IV: Stadtrömische Denkmäler unbekannter Bauzugehörigkeit aus hadrianischer bis konstantinischer Zeit," *BonnJbb* 186 (1986), 47–75. E. La Rocca, ed., *Rilievi storici Capitolini: Il restauro dei pannelli di Adriano e di Marco Aurelio nel Palazzo dei Conservatori* (Rome, 1986), 38–52.

The Column of Marcus Aurelius: E. Petersen et al., *Die Marcus-Säule auf Piazza Colonna in Rom* (Munich, 1896). J. Morris, "The Dating of the Column of Marcus Aurelius," *JWarb* 15 (1952), 33–43. W. Zwikker, *Studien zur Marcussäule* (Amsterdam, 1941). C. Caprino et al., *La Colonna di Marco Aurelio* (Rome, 1955). G. Becatti, *La colonna di Marco Aurelio* (Milan, 1957). G. Koeppel, "Profectio und Adventus," *BonnJbb* 169 (1969), 175–79. A. Bonanno, *Portraits and Other Heads on Roman Historical Relief up to the Age of Septimius Severus* (Oxford, 1976), 137–42. H. W. Boehme, "Archäologische Zeugnisse zur Geschichte der Markomannenkriege (166–80 n. Chr.)," *JRGZM* 22 (1975), 153–217.

Antonine Sarcophagi and Funerary Altars: P. G. Hamberg, *Studies in Roman Imperial Art* (Copenhagen, 1945), 173–89. B. Andreae, *Motivgeschichtliche Untersuchungen zu den römischen Schlachtsarkophagen* (Berlin, 1956). H. Sichtermann and G. Koch, *Griechische Mythen auf römischen Sarkophagen* (Tübingen, 1975). B. Andreae, *The Art of Rome* (New York,

1977), 246. A. Giuliano, ed., *Museo Nazionale Romano: Le sculture,* I, 2 (Rome, 1981), 148–50, no. 44 (L. Musso and P. Lombardi) (sarcophagus of T. Flavius Trophimas, the shoemaker). G. Koch and H. Sichtermann, *Römische Sarkophage* (Munich, 1982). G. Zimmer, *Römische Beruf-darstellungen* (Berlin, 1982), 132–33, no. 47 (sarcophagus of T. Flavius Trophimas). A. Giuliano, ed., *Museo Nazionale Romano: Le sculture,* I, 8 (Rome, 1985), 177–88 (L. Musso) (Portonaccio sarcophagus). Fuhrmann in unpublished study mentioned by P. G. Hamberg in *Studies in Roman Imperial Art* (Portonaccio sarcophagus). D. E. E. Kleiner, *Roman Imperial Funerary Altars with Portraits,* Rome, 1987 (the Altar of Cattia Faustina).

Art in Africa under the Antonines: The Arch of Marcus Aurelius and Lucius Verus at Tripoli: S. Aurigemma, *L'arco quadrifronte di Marco Aurelio e di Lucio Vero in Tripoli, Libya Antiqua,* supp. 3 (Rome, 1970).

Art in the Eastern Empire under the Antonines: The Great Antonine Altar at Ephesus: F. Eichler, "Das sogenannte Partherdenkmal von Ephesos," *VI International Kongress für Archäologie* (Berlin, 1939), 488–94. C. C. Vermeule, *Roman Imperial Art in Greece and Asia Minor* (Cambridge, Mass., 1968), 95–123. F. Eichler, "Zum Partherdenkmal von Ephesos," *ÖJh* Beihefte 2 (1971), 102–36. A. Bonanno, *Portraits and Other Heads on Roman Historical Relief up to the Age of Septimius Severus* (Oxford, 1976), 114–16. W. Oberleitner, "Das Partherdenkmal," *Funde aus Ephesos und Samothrake, Katalog der Antikensammlung* II (Vienna, 1978), 66–94. T. Ganschow, " Überlegungen zum Partherdenkmal von Ephesos," *AA* (1986), 209–21.

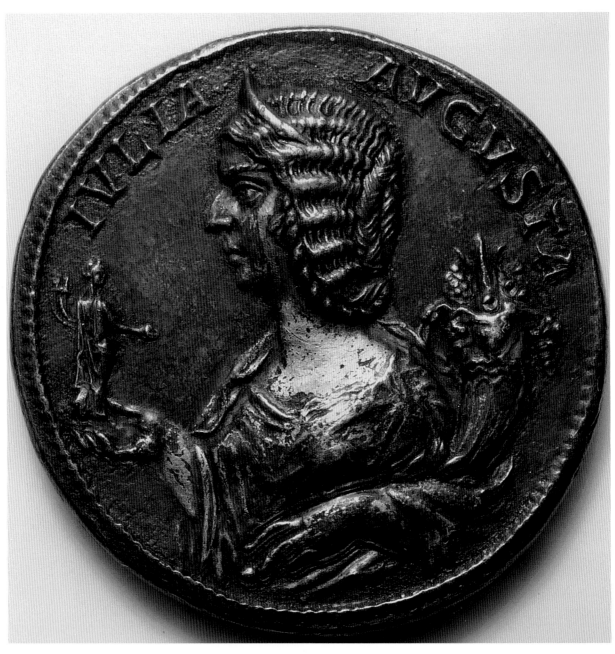

Medallion with portrait of Julia Domna as Abundance, from
Rome, 207. (See fig. 292.)

THE SEVERAN DYNASTY

CHAPTER VII

After the murder and damnatio memoriae of Commodus in 193, the Praetorian guard selected Publius Helvius Pertinax as the next emperor of Rome. Pertinax was an obvious choice because he had distinguished himself both under Marcus Aurelius and Commodus. During Marcus's principate, he was adlected into the senate and served under the emperor in a military campaign in Raetia; he later accompanied Commodus to Britain. Pertinax had great respect for Marcus; his primary goal was to reinstate his policies, but the Praetorians soon regretted their decision, and Pertinax was killed after only three months in office. The Praetorians selected the wealthy senator, Marcus Didius Julianus, in Pertinax's stead, but he too was an unpopular choice.

Within a few weeks Lucius Septimius Severus and Pescennius Niger were declared emperors by their troops in Carnuntum and the East, respectively. Clodius Albinus also appears to have been declared emperor by his legions in Britain. Septimius Severus proceeded to Rome where his appointment was acclaimed by the senate; Clodius Albinus agreed to become his Caesar. Severus, viewed as the avenger of Pertinax, held an elaborate funeral in Pertinax's honor and arranged for his divinization. In order to associate himself even more closely with Pertinax, Septimius Severus adopted his predecessor's name as his own between 193 and 198. Severus then departed for the East to do battle with his only remaining rival.

In 194 and 195, he celebrated a series of successive victories at Cyzicus, Nicaea, Issus, and elsewhere, and led a number of forays against Parthian vassals who had sided with Niger. These led to a full-scale war with Parthia that resulted in the fall of Ctesiphon in 198. When the war ended in 199, Septimius Severus had already annexed Osroene and Mesopotamia and had been granted the title Parthicus. The years following the Parthian invasion were largely spent in Rome. In 211, however, Septimius Severus died at York, after an unsuccessful invasion of Scotland, although he did receive the title *Britannicus* for his repair of Hadrian's Wall. At the instigation of his sons and successors, he was deified by the senate.

The imperial coffers were significantly depleted during the principate of Septimius Severus, not only because

his many military campaigns were exceedingly expensive, but also because he increased the pay of his soldiers, reinstated the alimentary program instituted by Trajan, and offered liberalitas six times to the Roman populace. Further expenditures were incurred in the emperor's ambitious building program in Rome, which saw monumental additions to the imperial palace on the Palatine hill – including a three-story ornamental facade in the form of a columnar screen named the Septizodium because of its association with the seven planets – and the construction of a grandiose arch in the Roman Forum in honor of the emperor's Parthian victories.

Septimius Severus also planned the revitalization of his hometown of Leptis Magna in North Africa where he returned for a visit in 199–200. The city had enjoyed some favor under Augustus and was, before the Severan rebuilding, still largely embellished with monuments built in the late first century B.C. and early first century A.D. Septimius Severus was the first emperor since Trajan and Hadrian to be born in the provinces, either in 145 or 146. It was his birth in North Africa, perhaps more than anything else in his life, that determined his general outlook and his artistic predilections. That is not to say that his bonds with Rome were not strong. His father, Geta, was of equestrian rank and had senatorial connections in Rome.

Septimius Severus was well versed in Greek and Latin, studied in Rome and Athens, and was respectful of Roman traditions. He received senatorial status under Marcus Aurelius and had an illustrious military career. He was appointed consul in 190 and became governor of Upper Pannonia. Severus's first wife, Marciana, produced two daughters but no male heirs. His second and better-known wife, Julia Domna, whom he married in 186, was the mother of his two sons, Caracalla (Septimius Bassianus and later Marcus Aurelius Antoninus), born in 188, and Geta (Lucius Septimius Geta), born in 189. Julia Domna, daughter of the priest Bassianus, was herself born in Syria. The authors of the *Scriptores Historiae Augustae* report that Septimius Severus sought her because it was foretold that she would marry a king (*S.H.A., Sev.,* 3.5). Senators of provincial origin also enjoyed favor and influence under Septimius Severus, even though the senate as a body had lost much of its authority. Furthermore, new Roman colonies, especially in Africa and Syria, were founded during his principate. Severus and his wife also favored eastern cults, and literary sources refer to the emperor's strong reliance on astrological signs. Julia Domna gathered around her a coterie of the leading philosophers of the day, including Philostratus, who was a proponent of an orientalizing mysticism.

Also of great significance was Septimius Severus's desire to establish a new dynasty on the model of that of the Antonines. In 196, he had himself adopted retroactively into the Antonine family, many of whose members were, of course, now divi. He even had Commodus, whom he viewed as a brother, divinized. To ensure the succession, he made his elder son, Caracalla, a Caesar in 196, Augustus in 198, and a joint-consul in 202. He also ordered special anniversary issues of coins and medallions to honor Antonine predecessors. We shall see that Severus's dynastic ambitions were the cornerstone of much of his art.

Septimius Severus's counsel to his sons expresses his philosophy succinctly. According to Cassius Dio (LXXV, 2.2–3), while on his deathbed Severus told his boys to live in peace, to enrich the soldiers, and to despise the rest of the world. It is true that the army enjoyed increased prestige and higher salaries during the principate of Septimius Severus and that the first emperor of the third century relied more than any before him on the strength of his army.

Caracalla heeded at least some of his father's advice. He was very popular with the army, and his portraiture reflects his military mien and aggressive personality. His important Edict of 212 (*Constitutio Antoniniana*) – the most significant legislation of his principate – bestowed Roman citizenship on all of the free inhabitants who lived inside the boundaries of the empire. His real motive was, however, not altruistic but was designed to extract additional revenue from inheritance taxes. In other ways, he did not follow Severus's exhortations. He did not, for example, share his father's overriding commitment to the Severan dynasty. His feud with his younger brother, Geta, caused a serious rift between the two, and Julia Domna became concerned that the empire would be divided in two parts. This never came to pass, not because of a reconciliation between Severus's two sons but because of the death of Geta, ordered in 212 by his vengeful brother after a co-emperorship that lasted about a year. Caracalla also convinced the senate to issue a damnatio memoriae of Geta. Caracalla had earlier procured the murders of Plautianus, Severus's powerful Praetorian prefect and fellow native of Leptis (A.D. 205), and Plautianus's daughter, Plautilla, who had married Caracalla in 202 and with whom he had been unhappy (A.D. 211). Caracalla was emperor alone from 212 to 217. He participated in several military campaigns, including those in Germany and the East, where he hoped to duplicate the conquests of his idol, Alexander the Great. He was, however, assassinated near Carrhae in 217 before participating in a full-fledged Parthian war.

Caracalla was born in Lyons in 188, was made an Augustus in 198, assumed the toga virilis in 201, and was appointed to a joint consulship with his father in 202. Caracalla – or more correctly Caracallus – was a nickname

for Septimius Bassianus, changed in 196 to Marcus Aurelius Antoninus at the time of his designation as Caesar by his father, who thus demonstrated his reverence for the Antonine family and his desire to have his new dynasty perceived as a continuation of that of his predecessors.

Like his father before him, Caracalla was interested in architecture, and it was he who willed to posterity the great imperial baths in Rome that bear his name – the *Thermae Antoninianae,* better known as the Baths of Caracalla and dedicated in 216. These brick-faced concrete baths comprise a series of grandiose rooms surmounted by towering domed and barrel-vaulted ceilings revetted with marble and mosaic. Many of the black-and-white and multicolored tessellated pavements still survive, as does some of the bath's sculptural decor. The sculptural remains make it clear that they were originally part of a carefully orchestrated artistic program. A column capital interlaced with a representation of Hercules was located near a large-scale replica of the so-called Hercules Farnese originally created by the Greek sculptor Lysippos. On the floor of another room was a magnificent mosaic with portraits of the famed athletes and gladiators of the day. Their heads are blocklike, they wear short-cropped hair, and they possess intense expressions that, as we shall see, are not unlike Caracalla's own.

Literary accounts indicate that Caracalla was well educated, but he displayed little reverence for members of the senatorial class, preferring to present himself to the public as an uncultivated military man, an image he also affected in his portraiture. His capricious governing of the empire and his hatred of the senators were returned in kind, and literary accounts attest to his personal cruelty and to the violence of his times. He was, however, highly regarded by his troops and popular with the Roman people. He was, in fact, consecrated by Macrinus, the very Praetorian prefect who plotted his assassination, and two third-century successors, Elagabalus and Alexander Severus, claimed to be his sons in order to establish their own legitimacy.

Severan Portraiture

The Portraiture of Septimius Severus

The portraits of Lucius Septimius Severus in the main follow the tradition of Antonine portraiture. This is not surprising since Severus wanted to link his new Severan dynasty with the Antonines. Stylistically, the primary models for the portraits of Severus were those of Marcus Aurelius, although Severus's portraits lack the psychological penetration of Marcus's likenesses, and portraits of Severus from about 200 on also demonstrate their indebtedness to the traditions of North Africa.

Septimius Severus was about forty-eight or forty-nine when he became emperor of Rome. Cassius Dio describes him as being "physically small but strong," and in the *Scriptores Historiae Augustae* (S.H.A., Sev., 76.16.1) he was said to have had a long beard and curly white hair. Furthermore, "his face inspired reverence, his voice was resonant but with a trace of an African accent right up to his old age" (S.H.A., Sev., 19.8). Septimius Severus's portraits have been collected and studied by several scholars who have divided them into a series of types that range from four to ten in number; the division into four has been more widely accepted by scholars and will be followed here. The four main types, which are closely allied with portraits of the emperor on the imperial coinage – the Accession type, the Adoption type, the Serapis type, and the Decennial type – appear to correspond to important events in the emperor's career.

Since Septimius Severus was not a crown prince, there are no surviving preaccession portraits, but portraits of the Accession type began to be produced while he was battling his rivals for imperial supremacy, that is, between 193 and 196. The coins of 193 show nearly identical portraits of Septimius Severus, Didius Julianus, and Clodius Albinus, probably because the mints had not yet received an official portrait of Severus. The only individualistic numismatic portrait of this date, which continued to be used on coins until 196, shows the new emperor in a realistic soldier-portrait type, with a square fleshy face, furrowed brow, large eyes, straight nose, jutting chin, curly hair that is straight across the forehead, long moustache, and a short, parted beard with corkscrew locks. These numismatic portraits are comparable to those of the Accession type in the round; it has been suggested that there is already a reference to Commodus in these early images.

Some of the numismatic portraits of 194 show Severus with a longer beard that more closely resembles that of Pertinax, a correspondence that might well have been intentional or might indicate that the mint was using a portrait of Pertinax in the absence of one of Septimius Severus. This coin image accords with the Accession type. An example of this type in the round is the nude, full-length bronze statue of Septimius Severus assimilated to Mars-Victor, from Nicosia (fig. 282). The emperor probably originally held a spear in his right hand and a small trophy in his left. The statue may have been commissioned to honor Severus's victory in 197 over Clodius Albinus, signifying that the new emperor had exerted power over the eastern and western parts of the empire. The portrait head accords well with the coins of the first official type because the emperor is depicted with a square, fleshy face, curly hair arranged in a fairly straight pattern across his forehead, and a short, parted

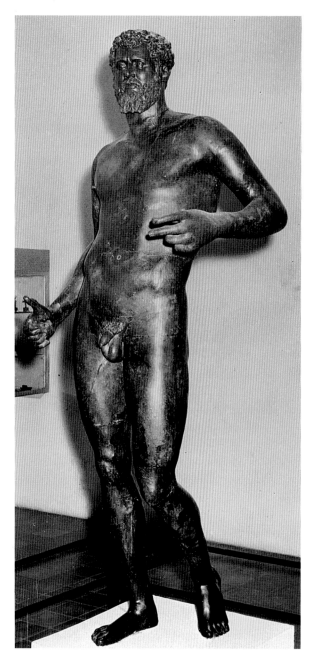

282 Bronze portrait of Septimius Severus, from Nicosia, ca.197. Cyprus, Museum. Photo: Courtesy of A. M. McCann, 63.7

domly arranged curls. The facial features are generally the same but more idealized. These changes were undoubtedly introduced to underscore Septimius's alliance with his Antonine predecessors, especially Marcus Aurelius, by stressing a fictional family resemblance. The portraits in the round of this type, however, have very bland expressions. The exploration of the emperor's psyche, apparent in the latest portraits of Marcus Aurelius, is absent in those of Septimius Severus.

It was in 200 that another new portrait of Septimius Severus was introduced on the Roman coinage. In it, Severus was associated with the African god Serapis. Serapis was both a personal symbol of Severus's origins and a general symbol of death and renewal, which reflected the demise of civil war and the rise of a new dynasty and a new golden age. Its creation also followed the designation of Severus's heir, Caracalla, as Caesar in 196 and Augustus in 198 – the year in which Geta was also appointed Caesar – but was probably especially inspired by the visit of the imperial family to Egypt, specifically to the Sanctuary of Serapis in Memphis, in 199–200. The Serapis portrait type also possesses idealized features and a divided beard but introduces corkscrew locks on the forehead. The type is used in the relief of Severus and Julia Domna from the privately commissioned Arch of the Argentarii in Rome of 204 (see fig. 302), and numerous portraits in the round of this type have been identified. This constitutes the largest single type (one scholar lists seventy-four examples), which suggests that it became the canonical portrait of the African emperor.

These portraits show three or four corkscrew locks on the forehead and a long, parted beard and are thought to be a reflection of a famous cult statue of Serapis by the Greek sculptor Bryaxis that stood in the god's temple in Alexandria. Because of the popularity of the Serapis type, which was produced over a long period and in many locations, there is much diversity among the Serapis-Severus portraits, although they all adhere to the same general type. In some, for example, the emperor is represented with large, uplifted eyes. An example is the slightly under life-size marble portrait of Severus found either at Ostia or at Portus (fig. 283). In every other way it is a canonical example of the Serapis type, with its four Serapis locks across the emperor's forehead and with a divided beard.

A medallion of 202 depicts Severus in the guise of Hercules, probably a dual reference to Hercules as one of the patron gods of Leptis Magna and as the patron god of Commodus, who chose to be depicted with attributes of Hercules both in portraits in the round and on medallions. It was Severus who decided to divinize Commodus – whom he viewed as his brother – and thus to cement further his fictional familial ties to the Antonine dynasty.

beard. Other coins of 193–94 show a marked similarity between Severus and Clodius Albinus, whose title of Caesar ensured coin commemorations.

A new type, the Adoption type, emerged after 196, the year in which Severus had himself retroactively adopted into the Antonine dynasty. Coins of 196–97 accentuate the resemblance between Severus and the Antonines by emphasizing the division of Severus's longer beard into three parts and by the replacement of the straight hair across his forehead with looser, more ran-

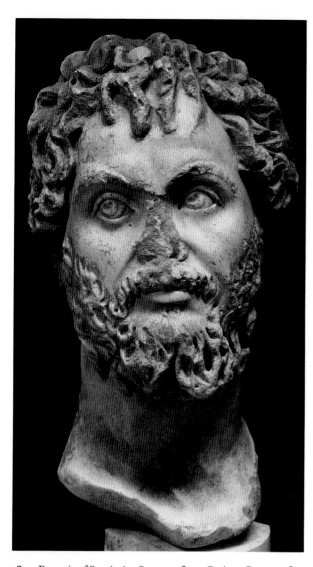

283 Portrait of Septimius Severus, from Ostia or Portus, after 200. Boston, Museum of Fine Arts, Harriet Otis Cruft Fund. Photo: Courtesy of the Museum of Fine Arts

The fourth and last portrait type of Septimius Severus appears to have been created at the time of the celebration of his decennalia in 202 and can be seen on coins beginning in that year. The portraits of this type combine the features from all of the earlier types but exhibit a new classicizing treatment of the facial features. The corkscrew curls have been replaced with flatter locks brushed back over the forehead. This type continues to be favored in coins struck between 209 and 211, when Severus was in Britain, and was used on the Arch of Septimius Severus at Leptis Magna (see fig. 310). The flatter hair straight across the forehead and the somewhat greater geometry of the emperor's features may presage the military portraits of Caracalla after his accession or may suggest that some of these were fashioned posthumously. It has been pointed out that the coin emissions of Septimius Severus as a divus depict the emperor with a Severan beard but with the facial features of Caracalla.

Severan Dynastic Group Portraiture

Septimius Severus's dynastic ambitions led to the commissioning of significant numbers of prince portraits of his sons and heirs, Caracalla and Geta. Their visages were displayed on coins, medallions, cameos, in paintings, on reliefs, and in portraits in the round – sometimes alone, sometimes together, and sometimes in a family group portrait with their parents. Aurei of 202 depict on the reverse a frontal bust portrait of Julia Domna flanked by profile portraits of Caracalla and Geta, at the left and right, respectively. The portraits are accompanied by the legend "felicitas saeculi," the modern equivalent of "happy days are here again." The implication was that the new Severan dynasty ensured continuity and a new era of peace and prosperity.

The best-known group portrait of the entire family is preserved on a painted tondo from Egypt (fig. 284). It is done in tempera on wood and is the only surviving painted portrait portraying personages of imperial status, even though such paintings were common in antiquity. It was probably made about 200, that is, at about the time of Severus's visit to Africa. Although the tondo was not executed by one of the master painters of the day but by a local Egyptian artist, he captures the imperial family in a lifelike manner, showing Severus, for example, with the full head of gray hair described in the *Scriptores Historiae Augustae* and the curly gray beard parted in the center. The flesh color of his face and those of the others is built up by a network of impressionistic strokes. Severus wears an elaborate crown, made of gilded laurel leaves and jeweled medallions, and a toga lined with gold stripes. He is accompanied by Julia Domna, who is decked out in a jeweled tiara and gilt-edged costume; she also wears a large pearl necklace and triple pearl earrings. She has the round face and long, wavy brown hair that were also the hallmarks of her sculpted portraits (see fig. 290). In front of the empress and emperor are their two sons, Geta and Caracalla. Caracalla, as the elder son and primary heir, is positioned in front of Septimius Severus and is dressed in a similar costume of white toga with gold borders and a gilded crown of laurel leaves and precious stones.

Caracalla has the curly hair also apparent in his early prince portraits (fig. 285). Geta is posed in front of Julia Domna; he is garbed like his brother, and he, Caracalla, and Severus all carry gold-tipped scepters. Geta's face is erased, the victim of the far-reaching and powerful effects of the Roman damnatio memoriae. The tondo's fortuitous preservation is due to the dry climate of Egypt, which has also protected numerous painted portraits of private individuals of Roman date in the Fayum that are stylistically comparable to the Severan work. Also noteworthy is the frontal position of the imperial subjects, which in itself is not new to imperial art. We have

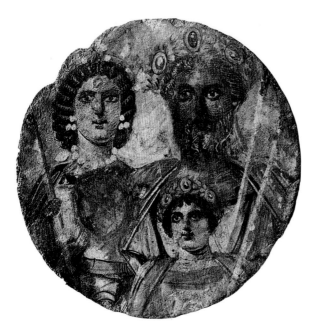

284 Painted tondo with group portrait of the Severan family, from Egypt, ca. 200. Berlin, Staatliche Museen, Antikensammlung. Photo: DAIR 69.159

already seen the imperial family posed frontally as if for a formal portrait in the dynastic panel from the Great Antonine Altar at Ephesus (see fig. 279). Frontal presentations of the emperor became standard with the Column of Marcus Aurelius (see fig. 268). This tondo indicates that the tradition was continued under the Severans in the provinces. Frontal depictions of the emperor or other imperial personages are characteristic of Severan art in general and can be found in many monumental works of Roman sculpture in both the provinces and the capital. In the Berlin tondo, the eyes of Severus and Caracalla are not only wide and staring but also slightly uplifted, a characteristic seen in some of Severus's portraits of the Serapis type and almost universally adopted in Roman imperial portraiture of the third century.

The Portraiture of Caracalla

The portraits of Caracalla have been divided into five types that range from portraits of a young prince in the Antonine mode to likenesses of a mature military commander done in what can be characterized as an innovative style. The precise chronological development of the portrait series remains controversial with scholars divided over the specific events in the emperor's career that led to the commissioning of a new type. The general development, however, can be determined with some certainty.

Type 1 appears to have been created in 198 when Caracalla was raised to the rank of Augustus. It corresponds to numismatic portraits of 198–204 and is sometimes called the Arch of the Argentarii type because the best-known example of the type is the portrait of the young Caracalla on the Argentarii Arch in Rome (see fig. 303). It depicts the young Caracalla with a full head of deeply drilled curly locks and a distinctive arrangement of thick curls over the forehead, a round face with chubby cheeks, and a short, upturned nose. A fine example is the portrait of the young Caracalla, now in the Vatican, with its full cheeks, deeply drilled halo of curls and distinctive forelocks, the straight eyebrows with individually delineated hairs, the drilled almond-shaped eyes, the short, upturned nose, and curved lips. Of greatest significance are the curly locks modeled on those of the Antonine crown princes, Marcus Aurelius and Commodus (see fig. 234 and the frontispiece to the Introduction and fig. 241, respectively). They certify that Caracalla is worthy of his newly chosen name – Marcus Aurelius Antoninus – and that the court artists, undoubtedly the same as those carving the contemporary imperial images of Septimius Severus, are depicting an heir not only to his father but to the Antonine legacy.

Another example of type 1 is the unique portrait of Caracalla as the infant Hercules strangling snakes in the Museo Capitolino (see fig. 285). It was probably made in the 190s and may have been intended as a private commission. The statue depicts a seated pudgy child who holds a snake in each of his hands. The round face and chubby cheeks, as well as the upturned nose, identify him as Caracalla, whose face is framed with a full cap of drilled and tousled locks. This significant work depicts him as an Antonine prince, heir to the Antonine dynasty's legacy (the highly polished surface of the stone is another hallmark of Antonine art) and also in the guise of a Greek hero. We know that such mythological conceits were popular in Antonine court circles. The taste for such artificial but symbolically charged portraiture continued to be the vogue under the Severans.

There is a similar portrait of a kneeling Antonine prince grasping two snakes in the Boston Museum of Fine Arts. Originally from the Tivoli region, it dates to about 165–70 and probably depicts either Commodus or his brother Annius Verus. If the statue represents Annius Verus, it may have been a posthumous heroization of a boy prince who died at the age of seven in 170. If it depicts Commodus, it underscores the close association of the Severan dynasty with Commodus. If Septimius Severus was the brother of Commodus, it follows that Caracalla was his nephew. In any case, the taste for such mythological imagery, based on Hellenistic Greek precedents, appears to have filtered down to freedmen during the Severan period.

Types 2 to 4 depict a still-young but maturing prince.

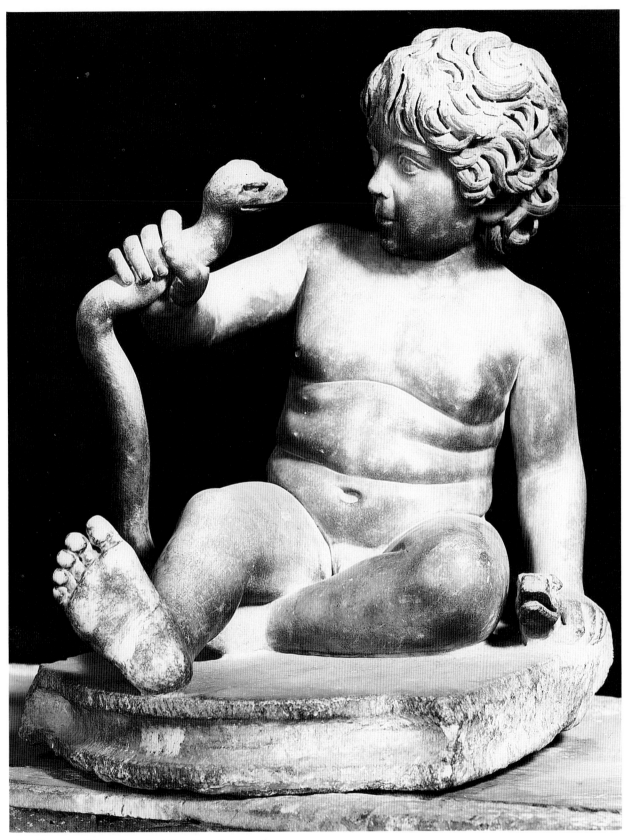

285 Portrait of Caracalla as the infant Hercules strangling
serpents, 190s. Rome, Museo Capitolino. Photo: Alinari/Art
Resource, New York, 5990

Type 2 (the Gabii type) began to be manufactured in 204, although the date of the inception of type 3 (the House of the Vestals type) has been disputed, with suggestions ranging from 205–9. Type 3 depicts an older youth than type 2 (he was seventeen in 205), with a closely cropped coiffure and a more serious expression, and in some replicas, the facial growth of a first beard. The chronology of type 4 (the Tivoli type), is also disputed, with its introduction being dated as early as 206 and as late as 211. An example is a portrait now in the Metropolitan Museum (fig. 286) that portrays Caracalla as an adult (he was now over eighteen), with square face and cleft chin, lined forehead, closely cropped hair that recedes somewhat at the temples and forms a slight wedge shape over the forehead. There is a V-shaped crease between his eyes and across his forehead, and deep lines run from his nostrils to his mouth, forming an inverted V. Both sets of V-shaped creases create an X across the center of the face. Caracalla wears a short beard (although the earliest numismatic portraits of this type are beardless) that adheres to his jaw and is stippled in with the chisel to create what might be called a negative carving effect. The geometry of the face is accompanied by a severe expression, which reflects both the sitter's military bearing and his cruel disposition. It is in the adult portraits of Caracalla that we see the resuscitation of an image that records not only the outer appearance but the inner psyche of its subject by an expert sculptor whom one scholar calls the "Caracalla Master." It is once again Antonine portraiture, especially that of Marcus Aurelius, that continues to exert a profound impact on the portraiture of its Severan followers.

Type 4 was replaced in 212 or somewhat later by type 5 (the Sole Emperor type), the best-known and most widely disseminated type, exemplified by a fine bust now in Berlin (fig. 287). The type 5 portraits of Caracalla are closely based on those of type 4, although the head is more massive and blocklike, the X across the center of the face is more deeply incised, and the serious expression has become more fiercely intense. The hair remains closely cropped, although individual, tightly wound curls are more apparent and the beard adheres to the shape of the cheeks and jaw. Most significant, perhaps, is the sharp turn of the head to one side, usually the left, which gives the impression that the artist has captured his sitter in a momentary action. The spontaneous twist of the head accentuates the power and energy of its subject, but the transitory pose also captures the essence of a cruel and suspicious man who glances over his shoulder as if to catch would-be-assassins off guard. The sharp turn of the head was also characteristic of the portraiture of the great Hellenistic general and ruler, Alexander the Great, with whom Caracalla liked to associate himself, especially after his visit to Egypt. Alexander's tomb was

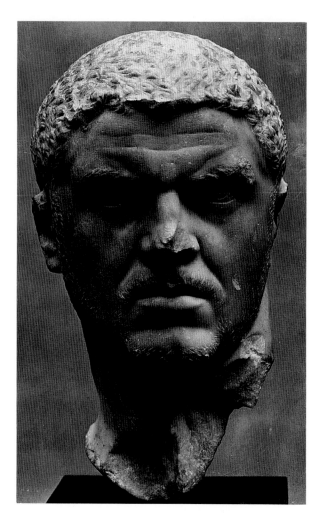

286 Portrait of Caracalla, 206–11. New York, Metropolitan Museum of Art, Samuel D. Lee Fund, 1940. Photo: Courtesy of the Metropolitan Museum of Art, 40.11.1A

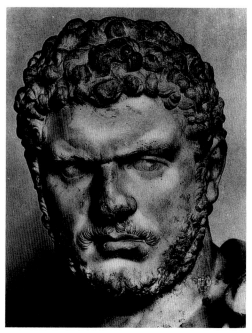

287 Portrait of Caracalla, ca. 212. Berlin, Staatliche Museen, Antikensammlung. Photo: Bildarchiv Foto Marburg/Art Resource, New York, 1.082.064

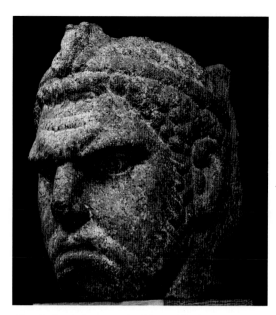

288 Red-granite portrait of Caracalla, from Koptos, ca. 212–17. Philadelphia, University of Pennsylvania Museum. Photo: Courtesy of the University Museum

in Alexandria. Caracalla's desire for significant military conquests in the East appears to have been inspired by his hero-worship of Alexander. The Berlin portrait depicts Caracalla wearing a paludamentum over his left shoulder and a balteus across his chest, references – along with the short military haircut, beard, and fierce expression – to Caracalla as a soldier-emperor.

Another example of Caracalla's type 5 portraits is a colossal, red-granite head of Caracalla wearing the head-dress of an Isiac priest (fig. 288). The portrait comes from the steps of the Temple of Isis at Koptos. The geometric shape of the face, short, tightly curled coiffure, short beard, X-shaped creases, and intense expression are all present. The rounded, sneering lips of the type 5 portraits from the city of Rome have here been transformed into a frowning slit. There is no meaner surviving portrait of Caracalla anywhere. The head is almost a caricature of its subject, but the exaggeration of its features is not due to the talent of a master of sculptural satire but rather to the fact that the Koptos head is a provincial work clearly based on metropolitan models but executed by a local Egyptian artist. It is nevertheless a highly effective work of art and one that underscores the unification of physical description and psychological penetration in the portraits of Caracalla, whether they were manufactured in the capital or in outlying artistic centers.

The Portraiture of Geta

Lucius Septimius Geta was born in Rome in 189. He went with Septimius Severus on the emperor's second Parthian campaign in 197 and was elevated to the rank of Caesar in 198. Upon his return to Rome in 202, he assumed the toga virilis. He shared the consulate with Caracalla in 205 and 208 and was appointed Augustus in 209. After the death of Severus in 211, they governed jointly until Geta was assassinated at the instigation of his brother. Caracalla's claim that he had his brother murdered in self-defense led to the damnatio memoriae of Geta and to the concomitant destruction of his statues and reliefs and the erasure of his name from public inscriptions. His visage thus disappeared from the tondo from Egypt, the Arch of the Argentarii relief, and the Palazzo Sacchetti Relief (see figs. 284, 299, 302), but a reasonable number of portraits have survived and have been divided into a series of three types and distinguished from those of his brother because of their thinner face and parted coiffure.

Type 1 (the First Caesar Portrait), which was initiated on coinage in 198 at the time of Geta's elevation to Caesar and continued to appear until 204, is exemplified by a fine portrait now in Munich, which depicts Geta with a wavy but flatter coiffure than his brother, and it also has a central part (fig. 289). His face is more oval than round, the eyes almond-shaped with brows that are relatively straight and have individually delineated hairs, the lips rounded, and the nose turned up like Caracalla's. Type 2 (the Second Caesar Portrait) replaced type 1 in 205, the year in which Geta shared his first consulship with Caracalla. It is the type used in a relief portrait of Geta from the Arch of Septimius Severus at Leptis Magna (see fig. 310) and shows an older and more mature boy who has lost his baby fat and has acquired more angular features. The coiffure is closely cropped, adheres more to the skull, recedes somewhat at the temples, and is sketched in with short chisel marks.

Geta's assumption of the title Augustus in 209 appears to have been the occasion for the creation of a new portrait type, the Augustus portrait type or type 3. Type 3 portraits of Geta are based on those of type 2 but with a longer and heavier face, a downward sloping nose, and deep facial lines. A portrait of Geta in the Louvre, for example, shows a contraction of the musculature of the face that gives the portraits an intensity missing in the more placid portrayals of Geta as a boy and that show a marked resemblance to the expressive mature portraits of Caracalla. The coiffure resembles that of type 2 without the recession of the hair at the temples.

Female Portraiture under the Severans: Julia Domna

Julia Domna met her future husband when he was on command in Syria; they were married in about 185. Like the Antonine Faustinas, she was appointed Mater Cas-

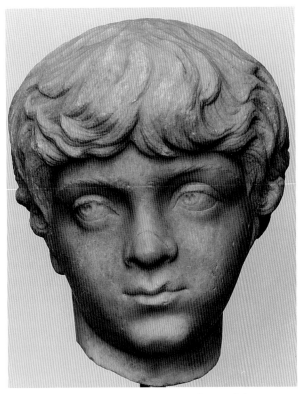

289 Portrait of Geta, ca.198–204. Munich, Staatliche Antikensammlungen und Glyptothek. Photo: Courtesy of Staatliche Antikensammlungen und Glyptothek, Munich, G1352

trorum because she had accompanied Severus on some of his campaigns. Her status was raised still further when she was given the title *Mater Augusti et Caesaris* on the elevation of Caracalla and Geta to Augustus and Caesar, respectively. She appears to have been the first empress since Livia to wield significant imperial power. Her most formidable rival was the Praetorian prefect Plautianus, Severus's compatriot, who augmented his own influence over the emperor after the marriage of his daughter, Plautilla, to Caracalla in 202. It was Caracalla, probably encouraged by his mother, who caused the demise of Plautianus in 205. Julia Domna was as distressed as her husband over the seeming irreconcilability of their two sons and personally witnessed the death of one son at the hands of the henchmen of the other. During the principate of her elder son, she further consolidated her power and appears to have taken full charge of the state in Caracalla's absence. After Caracalla's death, she lost much of her influence and died soon after. She was deified under the last of the Severan emperors, Alexander Severus.

The surviving portraits of Julia Domna have been divided into six official types, named after the present location of their best examples: the Gabii, Vienna, Leptis, Berlin, Munich, and Vatican types. The chronology is based on numismatic evidence and on the major events of the empress's life. The first portraits on coins and in

the round appear to have been made in 193 and depict Julia Domna with an oval face and fleshy cheeks, widely spaced eyes, long nose, and prominent chin. Her face is framed by a coiffure that is parted in the center and falls in deep waves that cover her ears. The remainder of the hair is gathered in a broad bun at the back of her head. The coiffure was certainly a wig, which was given a naturalistic touch by the introduction of curls of real hair on her cheeks that escape from the peruke. The empress is depicted in this type on the relief from the Arch of the Argentarii in Rome (see fig. 302), which indicates that it was still being used in 204, and also in a well-known head from Gabii (fig. 290), from which type 1 gets its name. In the latter portrait, she is shown with an oval face, delicately arched brows, and rounded lips with dimples at the corners.

In Julia Domna's later portrait types, the wig is so rigid that the coiffure has been called the helmet hairstyle. The hair is still parted in the center and falls in deep waves on either side of the face, almost to the bottom of the neck where it is further embellished with thick coils of hair twisted from bottom to top and fastened at the level of the temples. The wig encloses the head like a confining helmet and covers the ears and cheeks, although a few tendrils of real hair escape onto the cheeks. The Leptis type can be seen in the reliefs of the Arch of Septimius Severus in Leptis Magna and in a portrait of the empress as Ceres from Ostia (fig. 291). The latter is also an example of the continued interest of the imperial patrons of the Severan dynasty in having themselves depicted in the guises of divinities and heroes. A silver medallion struck in Rome (fig. 292) also represents Julia Domna in a similar portrait and in the guise of the personification of Abundance. The empress, whose distinctive physiognomy is immediately recognizable, cradles a cornucopia in her left arm and carries a statuette of Abundance, also with a cornucopia, in her right hand. The implication is that Julia, who is designated in the accompanying legend as Julia Augusta, is thus doubly abundant. In fact, it is her fertility that has provided the empire with the two male heirs who will fulfill the Severan destiny. A tiara emerges from her wig, which is of the close-fitting helmet type with a central part, long, deep waves with braided coils at the front edges, and a large bun at the back of the head.

The Caracalla Master

It has been suggested that the first official portraits of Septimius Severus and his family were executed by an artist whose name and personal history are not recorded but who has been called the Caracalla Master. He appears to have been active in Rome between 193 and 220 and was the executor of the great portraits of the day, such as

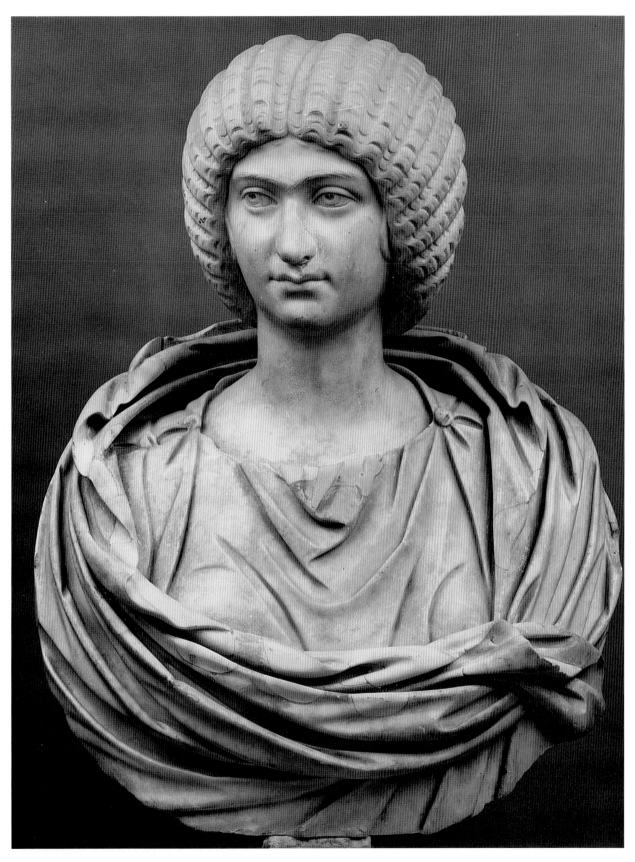

290 Portrait of Julia Domna, from Gabii, ca.193–94. Paris,
Musée du Louvre. Photo: Cliché des Musées Nationaux

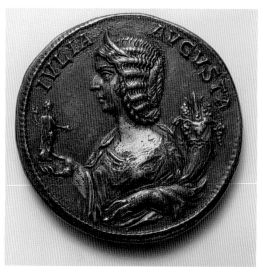

292 Medallion with portrait of Julia Domna as Abundance, from Rome, 207. Berlin, Staatliche Museen, Antikensammlung. Photo: Hirmer Verlag München, 21.0083

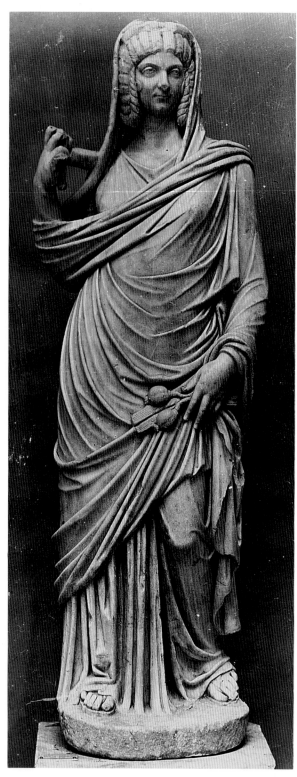

291 Portrait of Julia Domna as Ceres, from Ostia, ca. 203. Ostia, Museum. Photo: Istituto Centrale per il catalogo e la documentazione, F 5708

the representation of the boy prince Caracalla as Hercules strangling snakes (see fig. 285), which may be an original by the Caracalla Master's own hand and which was executed for a private context. These first works were done in an overtly Antonine style and were heavily influenced by another artist, sometimes called the Commodus Master, working in Rome in the 170s and 180s. The later portraits of Septimius Severus were created by another court artist, but the Caracalla Master continued to produce portraits of Julia Domna and her two sons, causing modern speculation that it was the empress who recognized the talent of the young genius and encouraged his work with imperial commissions. After all, it was Julia Domna who was the vital force behind the intellectual life of Rome in the early third century and who gathered around her the greatest writers, philosophers, and artists of the day. It has been convincingly demonstrated that the Caracalla Master was profoundly affected by the style and message of the great work of state relief of Commodus's principate – the Column of Marcus Aurelius (see figs. 263–268) – and by Pergamene art, which had been recreated in Rome in Antonine times in expert Roman copies, like the Gaul killing himself and his wife in the Ludovisi Collection, and the Dying Gaul in the Museo Capitolino. He was also imbued with the almost spiritual introspection of his day, earlier apparent in the Stoic philosophy of Marcus Aurelius and the psychological examination of his portraits, and continuing in the oriental mysticism – popularized by Philostratus and followed by Julia Domna and other contemporary imperial luminaries. It was the Caracalla Master who was able to unite the organic geometry of the natural world, an understanding of the artistic traditions of the Graeco-Roman past, and a

sensitivity to the expressionistic concerns of the present in a cohesive and indeed inspired whole. It was his entire oeuvre, and especially the adult portraits of Caracalla, that served as a catalyst for the masterful psychological portraits of the third century.

State Relief in Rome under the Severans

The Arch of Septimius Severus in the Roman Forum

An arch celebrating Septimius Severus's Parthian victory and the legitimacy of the new Severan dynasty was erected in 203 in the Roman Forum (figs. 293–294). Severus had come to power after a civil war. His triumph over a foreign enemy sanctioned him and his successors, just as it had Augustus. The Arch of Septimius Severus was situated in the northeast corner of the forum, diagonally across from the Parthian Arch of Augustus of 19 B.C. and on the same side of the forum as an Arch of Tiberius, which was constructed in 16 to commemorate the emperor's avenging of Varus's defeat in Germany. Yet, Tiberius's connection with Parthia was also well known, since it was he who had received the Roman standards earlier lost by Crassus to Parthia, an event memorialized on the breastplate of the statue of Augustus from Primaporta (see fig. 42). The location of the Arch of Septimius Severus was carefully selected and demonstrates Severus's desire to underscore his link with the first emperor of Rome, as he did elsewhere with his Antonine predecessors, despite his North African origins. The hereditary dynasty of Augustus, who was succeeded by his adoptive son Tiberius, would continue to flourish under the Severans with the ascension to power of Severus's two natural sons, Caracalla and Geta. Both the Parthian victory and the foundation of the dynasty are alluded to in the long inscription that is located on the attic of the arch and refers to Septimius as Parthicus and Caracalla and Geta as Augustus and Caesar, respectively. Geta's name was erased after his damnatio memoriae. This elevation of Severus's sons coincided with the taking of Ctesiphon in 198, which marked the end of the Parthian War. Military victory and dynastic continuity are purposely intertwined in the attic inscription and in the overall sculptural program of the arch.

The Arch of Septimius Severus is the first surviving three-bayed arch in Rome, although arches with three arcuated bays, a larger one in the center flanked by two smaller ones, had already been constructed in the provinces in Julio-Claudian times and in Rome under the Flavians. The primary provincial example is the Arch of Tiberius at Orange (see fig. 130), which is traditionally dated to the Tiberian period, although some scholars have attempted to reassign it to Severan times because of

its striking similarity to the Arch of Septimius Severus in Rome. An even earlier three-bayed arch, which no longer survives, was erected in Avignon in Augustan times. Furthermore, extant Flavian and Trajanic coins with reverse depictions of the three-bayed arches of Domitian and Trajan in Rome suggest that by the early second century three bays were already traditional in the capital for large, important arches that had to support substantial attic statuary decoration. Note that the Parthian Arch of Augustus in Rome (see fig. 67) had three openings: a central arcuated bay flanked by pedimented wings with trabeated spaces, a fact that may not have been lost on the creators of Severus's arch, who almost certainly had little or no knowledge of Augustan and Julio-Claudian arch design in southern France but must have been drawing instead on prototypes in Rome.

The Arch of Septimius Severus in Rome is traditional in design. Its two long sides are punctuated among the bays by free-standing columns with composite capitals resting on tall, decorated pedestals resembling those of still another Parthian arch in Rome, that of the emperor Nero (see fig. 131). The pedestals (fig. 295) are carved on the sides with one pair, and on the fronts with two pairs, of captured Parthian prisoners in traditional costume being escorted by Roman soldiers. The only additional figure is the child cradled in the arms of a Parthian in one of the panels, a small but significant reference to the high regard in which children were held under Severus, who not only had dynastic ambitions for his own sons but who reinstated the alimentary program of Trajan, which benefited poor children in Italy.

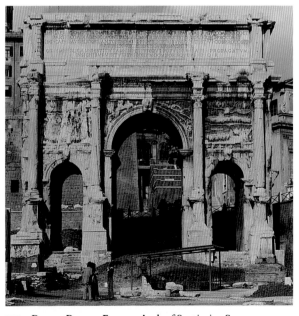

293 Rome, Roman Forum, Arch of Septimius Severus, forum side, general view, 203. Photo: DAIR 74.1138

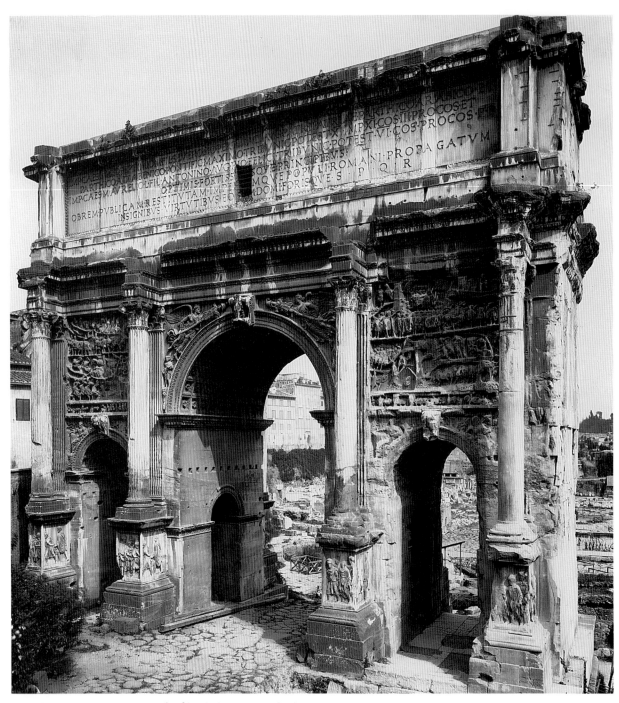

294 Rome, Roman Forum, Arch of Septimius Severus, Capitoline side, general view, 203. Photo: Alinari/Art Resource, New York, 5835

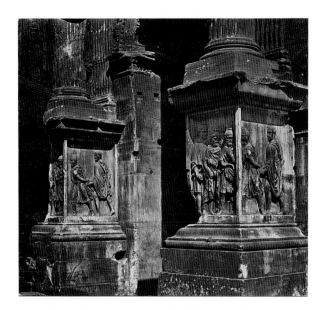

295 Rome, Roman Forum, Arch of Septimius Severus, pedestal relief with Roman soldiers and Parthian prisoners, 203. Photo: Alinari/Art Resource, New York, 32037

The entire arch is encircled by a small frieze depicting Severus's Parthian triumph of 202 and is based on similar friezes on the arches of Titus in Rome and Trajan at Benevento (see figs. 154, 188–189). The two-part parade consists of spoil-laden wagons escorted by Roman soldiers toward an oversized, seated female figure – probably the personification of the defeated Parthia – followed by other Roman soldiers and Parthian captives who approach a seated Roma. The Roman soldiers and Parthian prisoners occupy the full height of the register, although both Parthia and Roma are depicted in larger scale to emphasize their significance. The central bay is articulated with spandrels with Victories carrying trophies and with personifications of the four seasons below; the two smaller bays are decorated with reclining river gods like those on the Arch of Trajan at Benevento. The message is the same as that on the earlier arches. The emperor is victorious in all seasons and in all parts of the world, and Rome will continue to flourish under his heirs. The arch's attic was surmounted by a dynastic statuary group that consisted of a portrait of Severus in a bronze quadriga with equestrians of his sons to left and right.

The Arch of Septimius Severus in Rome, however, differs from earlier Roman arches in several important ways. The dedicatory inscription, for example, occupies not just a central plaque, as on the arches of Titus in Rome and Trajan at Benevento, but expands to fill the entire attic. Above all, it is the relief panels which are unlike any that were inserted into earlier arches. As noted, panel design had become the norm for the outer faces of arches by the time of Trajan (Benevento), and although horizontal panels were employed at Benevento, vertical

ones, which had been used in Nero's Parthian Arch, became especially popular in the second century (as in the Benevento attic, the Arco di Portogallo [see figs. 221–222], and the lost arches of Marcus Aurelius [see figs. 256–262]).

The master responsible for the Arch of Septimius Severus in Rome returned to the horizontal format favored in the early second century, but the Severan panels do not in any other way resemble their Trajanic prototypes. The large-scale figures on a single groundline, which is also the lower edge of the frame in the Trajanic relief, are replaced by numerous small figures dispersed on a series of individual sloping turf segments. Scenes are envisaged not from a single vantage point, but from simultaneous head-on and aerial perspective. Events that took place at different times and in different locales appear to be happening simultaneously. There are four panels in all, two on each long side of the arch, and all four depict Parthian War episodes. The identification of the individual vignettes is still controversial, but it has been established that the scenes probably all come from the second Parthian campaign and follow one another sequentially from bottom to top. Although the panel format of earlier arches continued to be used in the Severan arch, it is apparent that the third-century panels were also closely based on the spiral reliefs of the columns of two of the so-called good emperors of the second century – Trajan and Marcus Aurelius (see figs. 179, 263). In those, the helical bands are populated with small figures, and the scenes can be read from bottom to top. In effect, what has been done here is to excerpt a selection of scenes from the columns and enclose them in a panel format.

This was a progressive idea on the part of the master artist but, at the same time, a totally unsatisfactory solution to arch design. The complex historical scenes on the columns, which provide a wealth of anecdotal detail, are necessarily abbreviated on the panels and are thus rendered less intelligible. The easy flow of the winding narrative of the column is arrested on the arch, where the scenes can only be read from bottom to top and not in a circling rotation. Of course, the visual circling of the column had already been deemphasized in the Column of Marcus Aurelius, where there was a greater attempt by the artist to align the scenes vertically. It is for these reasons that the experimental treatment of the panels of the Arch of Septimius Severus appears never to have been repeated. The bold attempt to apply the principles of design of one genus of monument to another was in tune with its time and is another example of the Late Antique adoption in state-sponsored monuments of some of the conventions and motifs of the earlier art of freedmen. Multiple groundlines, crowds of small figures, and the conflation of time and space were characteristics of freed-

men reliefs such as the Augustan funerary procession from Amiternum or the Trajanic Circus Relief (see figs. 88, 201). This is not to say that Severus's state artists deliberately borrowed from their counterparts who worked for freed patrons but rather that Severan art adopted the artistic conventions of freedmen from mainstream, imperially sponsored art, such as the Great Trajanic Frieze, the Column of Trajan, the base of the Column of Antoninus Pius, and the Column of Marcus Aurelius (see figs. 179, 185–186, 254, 263).

The individual panels are severely weathered. Careful examination of their scenes necessitates reliance on the expert engravings of A. Bartoli, which were produced when the reliefs were in better condition. Panel 1 depicts in the bottom register Roman soldiers departing their camp (at Carrhae?) through three arcuated doorways. The middle register represents a battle between Romans and Parthians, with the Parthian king fleeing on horseback at the right. In the uppermost tier, Severus, who is frontal and accompanied by his general staff and possibly by his two sons, addresses his troops (adlocutio). The group of soldiers is parted in the center to emphasize further the elevated position of the emperor; individual figures are depicted in profile or from the rear. At the top right is a walled city with a Roman officer waiting in the arcuated gateway. The open door and relaxed mien of the soldier suggests the willing surrender of the city, possibly Nisibis, to the Romans. Scenes in all four panels focus on the sieges of cities – also characteristic of triumphal paintings – such as Ctesiphon, the capital of Parthia, also the site of the elevations of Caracalla and Geta.

In panel 2 (fig. 296), there is an attack of a walled city, possibly Edessa, with a Roman siege machine in the lowest tier. However, the city does not resist, and its Parthian inhabitants, their banners high in the air, can be seen willingly greeting the troops. In the center register

at the right is a scene of the submission of barbarians to a frontal Septimius Severus (Caracalla may be present), and at the left the emperor addresses his troops and the Parthian soldiers, who have willingly joined his army. On the upper right Severus, again frontal, holds a war council in a camp, and on the left the emperor directs the rest of the campaign.

Panel 3 (fig. 297) focuses on the simultaneous taking of Babylon and Seleucia depicted in the two lowest registers. Some of the inhabitants of the first city flee, but those of the second submit to Severus and Caracalla.

Panel 4 (fig. 298) is concerned with the siege of Ctesiphon, the capital of Parthia and thus the most important city strategically and symbolically. Its fall in 198 signified the end of the Parthian war and occurred simultaneously with the elevation of Caracalla and Geta to Augustus and Caesar, respectively. Once again, the foreign military successes of the Severans and the inevitability of their dynastic continuity are interwoven. The scene in the lowest tier depicts the siege machine needed to take the city; its fleeing king is seen at the right. In the middle register the emperor, accompanied by both Caracalla and Geta, addresses his troops at the culmination of the campaign, and at the upper right a Roman soldier with a riderless horse awaits Severus's triumphant departure. The walled city at the upper right is probably Ctesiphon itself.

Septimius Severus personally participated in the campaigns against Parthia, and he is therefore included in the scenes in the four panels on his Roman arch. Like Marcus on the Commodan column in Rome, Severus is represented in frontal positions and as somewhat isolated from his troops, a figure to be treated with respect and awe, rather than as first among equals.

The Palazzo Sacchetti Relief

The Palazzo Sacchetti Relief (fig. 299) also celebrates the legitimacy of the Severan dynasty. The relief, from Rome and now in the Palazzo Sacchetti, depicts on the right a seated, togate, and headless Septimius Severus on a dais. He is surrounded by four male togati, two of whom are his sons and heirs, Caracalla and Geta. Geta, on the emperor's left, is smaller than his brother in stature, headless, and frontally positioned to face the spectator. Caracalla, at his father's right, is depicted as a curly haired, round-faced youth with traces of his first beard on his cheeks, a portrait that is closest to Caracalla's type 2 portrait, which dates to 204. The relief also may date to 204, but more likely to 205 because it has been associated with Caracalla's and Geta's appointment as joint consuls on 1 January of that year.

Even if the precise date of the month and exact occasion cannot be pinpointed, the Palazzo Sacchetti Relief

296 Rome, Roman Forum, Arch of Septimius Severus, panel 2 (northeast), 203. Photo: DAIR 33.52

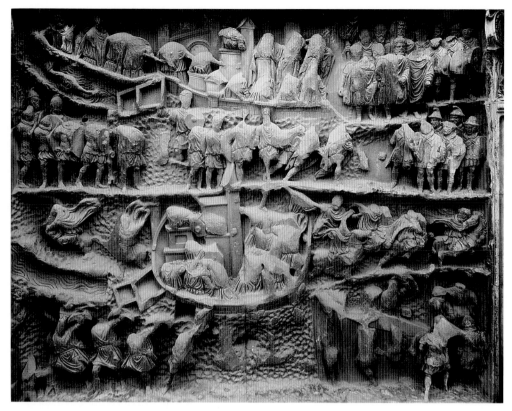

297 Rome, Roman Forum, Arch of Septimius Severus,
panel 3 (northwest), 203. Photo: DAIR 33.49

298 Rome, Roman Forum, Arch of Septimius Severus,
panel 4 (southwest). 203. Photo: DAIR 33.51

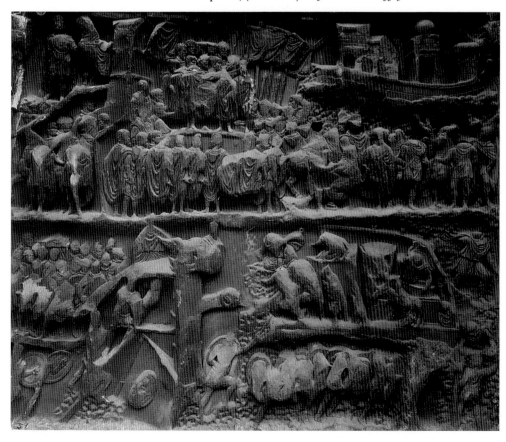

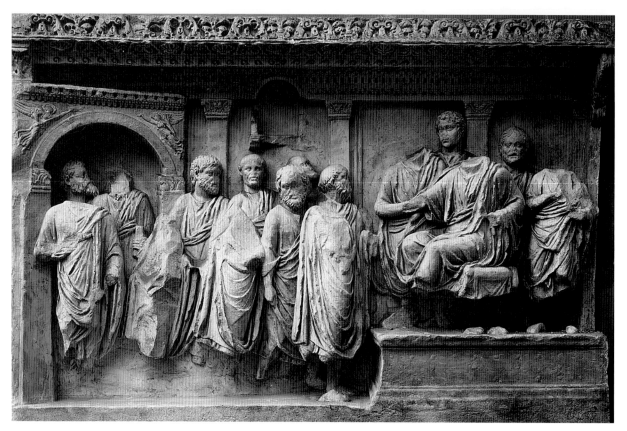

299 Dynastic relief of Septimius Severus, Caracalla, and
Geta, from Rome, 204 or 205. Rome, Palazzo Sacchetti. Photo:
Alinari/Art Resource, New York, 47136

and its message are completely consistent with that of
other Severan state reliefs. Septimius Severus is presented
as the founder of a new dynasty, which is a continua-
tion of that of his predecessors, the Antonines, and as the
father of the two sons who will carry on that tradition.
This message is underscored by the composition, style,
and architectural setting of the reliefs, which are in a sense
closer to second-century precedents than they are to the
Arch of Septimius Severus in the Roman Forum. When
viewed against the backdrop of the second century and
the artistic conventions used in the state reliefs of Trajan,
Hadrian, and the Antonines, the Palazzo Sacchetti Relief
is a very conventional work of art.

The members of the senate to whom Caracalla, and
perhaps also Geta, are being introduced approach from
the left. The scene is set by the single bayed arch with
Victory spandrels and the pilasters supporting an entab-
lature behind them and the imperial group. The Ana-
glypha Traiani/Hadriani, for example (see fig. 216), with
its dais scene and architectural setting, is very similar. It
is only the deeply drilled, curly coiffures and beards and
the frontal postures of some of the figures that suggest a
third- rather than a second-century date.

Private Monuments with Imperial Subject Matter

The Porta Argentariorum or the Arch of the Argentarii

The Arch of the Argentarii in Rome (fig. 300) also
celebrates the military success and dynastic ambitions of
the Severan family and was put up contemporaneously
to the Parthian arch, but it is not located in the Roman
Forum nor was it an imperial commission. It was erected
in 204 in the Forum Boarium, the market of the cattle
dealers in ancient Rome. Its patrons were a trade guild
of either silversmiths or, more likely, banking auction-
eers who collaborated with the cattle dealers (hence the
modern designation of the monument as the Arch of the
Argentarii or Silversmiths) – either in gratitude for an
imperial favor, possibly legislation governing the meat
supply of Rome, or in the hopes of receiving one. It is a
small trabeated gate with a single opening and may have
served as an entranceway to a building or *schola* in which
the guild or college conducted its business. The gate is
not fully preserved today; the east side was inserted into
the fabric of the church of S. Giorgio in Velabro.

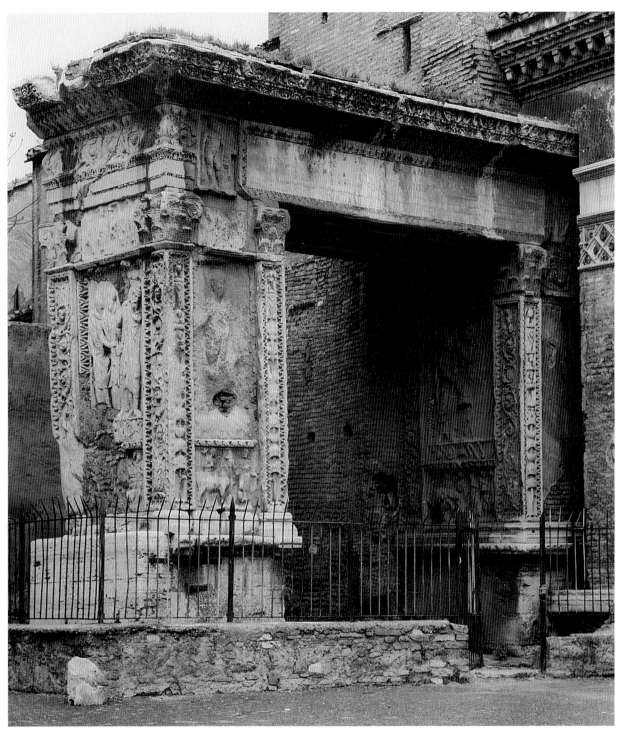

300 Rome, Forum Boarium, Arch of the Argentarii, 204.
Photo: DAIR 59.746

The gate consists of two travertine pedestals supporting piers faced with marble and articulated at the corners with pilasters with composite capitals and decorated on the front or south with Roman standards and on the west side with spiraling acanthus plants; the north side is not ornamented. Between the pilasters are recessed panels – a large vertical one between two horizontal ones – indicating that the designer followed the panel format of arch design popular since the late Julio-Claudian period. The same scheme is used on the west side and in the inner faces of the gate where the panels are again framed by pilasters with acanthus. There are two additional vertical panels, of smaller scale than those below, in the attic. These frame an extensive inscription giving the names and titles of the gate's honorands – Septimius Severus, Julia Domna, and Caracalla – as well as the identification of the dedicants – *argentari* and *negotiantes*. It has been convincingly demonstrated that the lines contain many alterations and substitutions and that the inscription originally included the names of Geta, Plautilla, and Plautianus, removed after their damnatio memoriae.

Panel D (following the scheme of Haynes and Hirst) (fig. 301) on the west side depicts two Roman soldiers and two barbarian captives, probably Parthians. The panel may well have been inspired by those of the pedestals of the Parthian arch (see fig. 295) and, along with the standards and a frieze of captured arms and armor (frieze R), refers to the emperor's military victories, probably not just over Parthia, but in general. The standards are Praetorian standards or *signa* and include the imagines of Septimius Severus and Caracalla and probably also Geta. Above panel D is a horizontally oriented panel (relief L) representing four camilli, the center two carrying a censer for burning incense. The vertical panel on the southwest pier (panel C) depicts a full-length frontal togate male figure whose features are too obliterated to aid in his identification. A plausible suggestion is that this figure depicted one of the patrons of the colleges of the Argentarii and the Boarii and that another patron was presented in a matching panel on the southeast pier. The small, horizontally oriented panels (reliefs G and H) below those of the patrons are both preserved and depict, in mirror image, a sacrificial bull escorted by a victimarius and a popa with an ax. The figures in the vertical panels to the left and right of the attic inscription are Hercules with his club and lion skin (relief J) – a favorite with the members of the Forum Boarium *collegia* – and the Genius Populi Romani with a cornucopia, high boots, and ivy leaves in his hair (relief K).

Of greatest interest are the two vertical panels located at either inner face of the gate's trabeated bay. These depict religious sacrifices made by members of the imperial family and also attest to the power of the Roman dam-

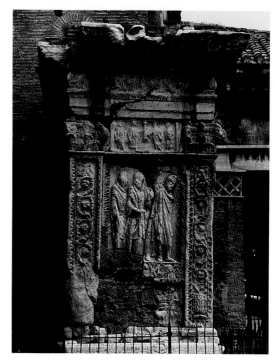

301 Rome, Forum Boarium, Arch of the Argentarii, panel D, 204. Photo: DAIR 59.749

natio memoriae. The panel on the east pier (panel A) (fig. 302) portrays Septimius Severus as pontifex maximus, dressed in a toga and with the upper edge of his mantle drawn up over his head like a veil, sacrificing to the penates at a small, portable tripod altar. He probably held a patera in his right hand, his hair is arranged across his forehead in a series of Serapis locks, and his beard is divided. He is accompanied by Julia Domna, veiled and wearing a crescent-shaped tiara. She is also distinctively coiffed in her centrally parted hairstyle with long deep waves covering her ears. Both figures are essentially frontal. A floating caduceus and a blank space can be seen to the spectator's right, the space originally occupied by a nearly frontal figure of Geta, holding a patera and, like his father, making a sacrifice at the altar. It was Julia Domna, as Mater Castrorum, who held the caduceus, her arm and hand clumsily reworked in an attempt by the artist to cover the erasure of Geta.

Panel B (fig. 303) depicts, on the right side of the slab, a togate Caracalla holding a patera in his right hand and pouring a libation on a tripod altar. The center and left side of the panel are blank; they were certainly filled in earlier with the portraits of Caracalla's young wife, Plautilla, on the left, and her father, Plautianus, at the center, as if posed for a formal wedding portrait. Reliefs E and F, located below panels A and B, depict the same scene

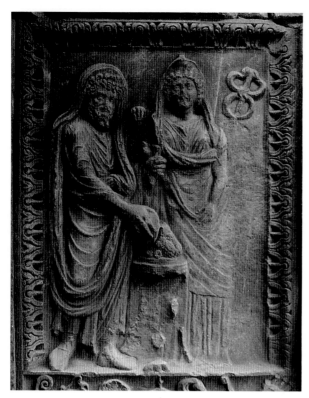

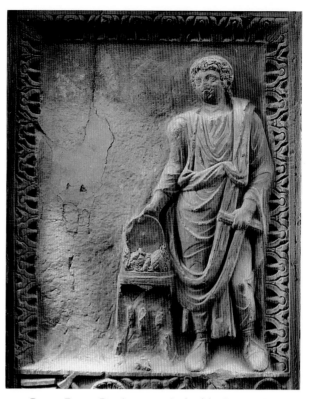

302 Rome, Forum Boarium, Arch of the Argentarii, panel A, 204. Photo: DAIR 70.993

303 Rome, Forum Boarium, 204. Arch of the Argentarii, panel B, 204. Photo: DAIR 70.1000

in reverse order. The head of a bull is held down by a kneeling victimarius, while a second one stands behind the animal. Present also are three camilli, one with an incense box and another with a pitcher, and the popa, who raises his ax to deliver the fatal blow.

Above the panels of imperial group portraits are those with a pair of Victories supporting garlands (reliefs M and N), another reference to the emperor's Parthian victories and to imperial military triumphs in general. The feet of the imperial personages rest on the lower border of the frame, which is decorated with sacrificial implements arranged across a blank backdrop as if a kind of religious still life. Frieze P depicts a lituus, an *urceus* (pitcher), a patera, a flamen's cap with apex, a fly fan, a *simpulum* (ladle) for libations, and a sheath with three knives. Frieze Q (beneath the portrait of Caracalla) represents an *acerra* or incense box, a *sacerna* or sacrificial ax, a patera, a bucranium, an urceus, a *malleus* to stun the animal victims, and a round vessel – possibly an incense censer.

Below the panel that depicts the two Roman soldiers and their Parthian prisoners (panel D) is a small fragmentary scene that is both unique and more significant than its size would suggest. It depicts a bearded herdsman driving his bulls, some of which are seen head on and others from a bird's-eye perspective. He strides purposefully

from right to left, and his expressive activity contrasts sharply with the hieratic solemnity of the frontal imperial figures. The scene is probably set on a farm that provides bulls to the cattle dealers of the Forum Boarium, which they in turn sold to the Roman populace for both ritual sacrifice and personal consumption. The rustic subject matter of the scene, as well as the artist's disregard for the naturalistic depiction of scale – the bulls are much too small – places this scene in the orbit of freedman rather than imperially sponsored art, but its presence here is not surprising because the patrons of the monument were themselves freedmen.

Although the Arch of the Argentarii was commissioned by freedmen and the Arch of Septimius Severus in the Roman Forum was a state commission, the two Severan monuments have much in common and are equally characteristic of their time. Most striking perhaps is the partiality, apparent in both commissions, for frontal portraits, the combination of head-on and aerial perspective, symbolic scale, and the casual combination in one monument of a variety of disparate styles. It might even be said that their similarity attests to the fact that the artists executing imperial commissions and those of freedmen in Severan times shared goals, subject matter, and artistic conventions in an unprecedented way.

Decorative Sculpture in Rome
The Baths of Caracalla

The Severan emperors favored personal aggrandizement in their art. They celebrated their military victories, especially the Parthian triumph, with great fanfare and a multitude of monuments and suggested in inscribed word and visual image that the establishment of the new dynasty heralded a new golden age. As noted, Septimius Severus extended the imperial palace on the Palatine hill and added a grandiose facade called the Septizodium after the seven planets and possibly honoring himself as cosmocrator. Both Severus and Caracalla commissioned great bathing establishments based on the baths of second-century emperors like Trajan. These served both as personal memorials and as great public works that benefited the Roman populace as a whole.

The *Thermae Septimianae* no longer survive but the Thermae Antoninianae (the Baths of Caracalla) preserve both the main bathing block and the surrounding enclosure with its lecture halls, seminar rooms, and Greek and Latin libraries. The bath building consisted of such architectural tour de forces as a three-bay, groin-vaulted frigidarium and a circular caldarium with a dome and having a span not much smaller than that of the Pantheon. The architect, whose name is not recorded, was a master of shaping spaces, establishing dramatic vistas and dissolving the massive concrete walls and vaults by the skilled application of marble veneers and tessellated mosaics. He also manipulated natural light so that it was reflected off the shimmering walls, patterned floors, swimming pools, and miscellaneous water basins scattered around the complex.

The majestically vaulted rooms were also the perfect setting for the display of sculpture. The sculptural decoration of public baths in Rome and the provinces has been comprehensively studied. It has been determined that the most popular statues for such establishments were those of water deities like Neptune, divinities associated with health like Aesculapius, muscular athletes, and powerful heroes like Hercules. These were interspersed with portraits of the patrons of the baths and members of the imperial family. It has also been demonstrated that these sculptures were most often set up in the frigidarium, which was generally not only the largest but also the most central room in the baths. Evidence comes from the findspots of surviving pieces and also from the location of statuary niches in preserved walls.

The Baths of Caracalla were one of the Roman thermae embellished with statues of healing gods, athletes, and heroes. Forty-one statues have come to light in modern excavations (the earliest took place in the 1540s) in and around the bath's remains. These include a head of Aesculapius, replicas of the head and torso of Polykleitos's Doryphoros, and full-length statues of Venus, Flora, and other goddesses. Also originally displayed in the baths was what is known today as the Farnese Bull group (fig. 304), a colossal Antonine or Severan replica of a Hellenistic original with the mythological theme of the Punishment of Dirke of about 150 B.C. by the sculptors Apollonios and Tauriskos from Tralles. It was accompanied by a twice-life-size copy of an even more renowned work – the muscular but weary Hercules leaning on his club – created by Lysippos in about 320 B.C. and copied and signed by Glykon of Athens in the late second or early third centuries – also in the Farnese Collection in Naples and thus referred to as the Farnese Hercules (fig. 305). It was discovered in the mid-sixteenth century in the frigidarium of the Baths of Caracalla, along with a second statue of Hercules that is a variation of the Farnese type but with the club resting on a bull's head. The second, heavily reworked statue is now in the Bourbon Palace at Caserta.

Most of the statues in the Baths of Caracalla were inserted in niches and could be viewed only from one side, but the two statues of Hercules were set up between two columns so that they were visible both from the front and the back. Without such a placement, the message of the statues would have been lost because Hercules grasps the apples of the Hesperides, a reference to the last of his twelve labors, in his right hand, hidden behind his back. A version of Polykleitos's Hercules was also on display in the frigidarium as was a statue of Achilles with the body of Troilos, although some scholars identify the latter as Hercules killing his son.

A composite capital, also from the Baths of Caracalla, includes among its leaves a miniature figure of the Greek hero in the same weary Hercules Farnese pose (fig. 306). Hercules was a popular subject for bath sculpture in Rome and the provinces but the decision to decorate the frigidarium of the Baths of Caracalla with more than one statue of him and to intertwine his figure in the architectural decor indicates that he was important not just as a god with therapeutic powers but as a god of the state and as the personal protector of Caracalla.

There are ten known surviving colossal statues from the complex. Those that can be dated are contemporary with the baths, whereas all but one of the extant life-size statues were made earlier and set up in the baths. The colossal statues are rare in baths, and the Baths of Caracalla constitute the only bath structure to have more than two surviving examples. This indicates that the choice of colossal statuary for the baths was a conscious decision on the part of Caracalla, the patron of the complex, or his planner. Furthermore, these colossi might have been

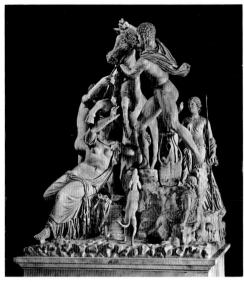

304 Farnese Bull Group, from Baths of Caracalla, Antonine or Severan copy of a Hellenistic original of ca.150 B.C. Naples, Museo Nazionale. Photo: Alinari/Art Resource, New York, 23201

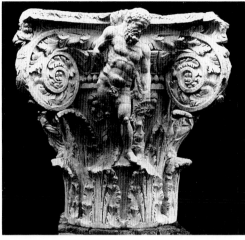

306 Rome, Baths of Carcacalla, composite capital with miniature figure of Hercules Farnese, ca.216. Photo: Alinari/Art Resource, New York, 6757

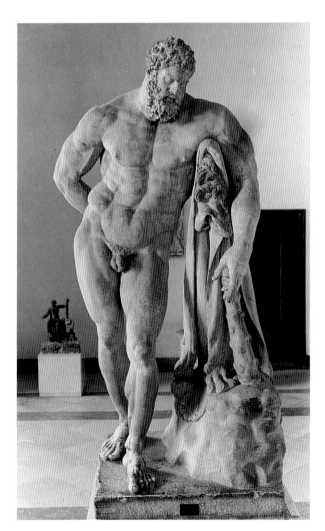

305 Weary Hercules, from Baths of Caracalla, late second or early third century copy of a statue of Lysippos of ca.320 B.C. Naples, Museo Nazionale. Photo: DAIR 80.2908

made for specific locations in the baths, which would also have been unusual for bath design, and their manufacture would have been extremely costly, which explains why the remainder of the bath's sculptural decoration consisted of reused earlier statuary. It has been posited that the mythological groups of the Punishment of Dirke and Achilles with the body of Troilos were manufactured by the same workshop. Their common denominators include not only their style and technique but their unusual and indeed horrific subject matter. The Hercules Farnese, although based on a popular prototype, is also exaggerated and provokes a strong response from the spectator in the same way as the theatrical portraits of Caracalla seething with cruel intensity.

It is apparent that the patron and the master artist of the Baths of Caracalla were concerned above all with the integration of freestanding and architectural sculpture in a carefully orchestrated whole in which the person of the emperor and that of the Greek hero were intertwined. As noted, the portraits of famous athletes and gladiators of the day depicted in a floor mosaic from the baths bear a striking similarity to those of the emperor himself. Caracalla's desire to accentuate his brute strength and military and athletic prowess is also demonstrated through this depiction. The choice of unusual and even shocking subject matter, executed in a dramatic and even exaggerated style, offers additional insight into the personality and artistic goals of the patron of the Thermae Antoninianae.

Provincial Art under the Severans:
The Embellishment of Leptis Magna

Septimius Severus returned to visit the city of his birth, Leptis Magna in Tripolitania, North Africa, upon becoming emperor of Rome. One of his greatest dreams was to give his city a distinctive Severan stamp, and his imperial status made that hope a reality. During his principate he transformed what was essentially an Augustan city with some Hadrianic and Antonine additions into a showplace for the Severan dynasty. Although Severus's architectural accomplishments in Rome were themselves significant, it is in Leptis that we get a real sense of what Severus envisioned a true Severan city to be. It is there that the emperor constructed a new harbor, colonnaded street, forum, basilica, temples, arches, and nymphaeum, some of which were profusely decorated with sculpture, which not only glorified the Severan dynasty but also made reference to the Parthian victories that legitimized Severus and his sons. Any evaluation of either the architecture or its sculptural embellishment in Leptis Magna must take into consideration its obvious ties with what was being built contemporaneously in Rome as well as the local traditions of Leptis Magna.

Leptis Magna and indeed all of Tripolitania did not come under the spell or influence of Greece. It was Carthage that held sway in the area, and the language was Berber and Punic before it became Latin. Public monuments built in Leptis Magna under Augustus demonstrate a respect for local Carthaginian tradition. The Augustan marketplace, for example, has an inscription in Latin and a neo-Punic translation, a nod to the Punic side of the population. The central space of the Augustan forum has one oblique side, its irregularity governed by preexisting Punic shrines on the site. In fact, the city of Leptis Magna began as a Carthaginian trading post, and Punic structures were certainly built on the site even though it is only the Roman remains – made of local limestone and imported marble – that are visible today. Leptis Magna is a city of ruins, but they are remains untouched by later habitation or rebuilding because Leptis Magna was abandoned in antiquity. In time, the city disappeared under sand and mud and was rediscovered in modern excavations by Italian archaeologists.

The Arch of Septimius Severus at Leptis Magna
The major sculptural commission in early third-century Leptis Magna was the Arch of Septimius Severus (figs. 307–310), the North African equivalent of the Parthian Arch in Rome (see figs. 293–294). Most scholars date the arch to the year 203, and it is, therefore,

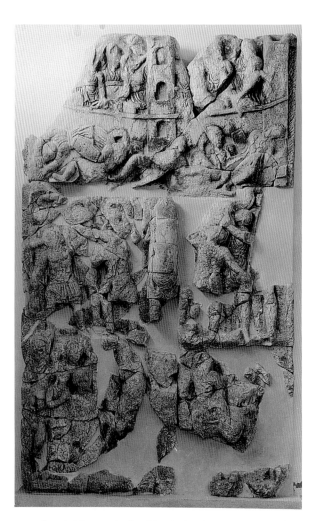

307 Leptis Magna, Arch of Septimius Severus, pier relief with siege scene, 203. Photo: DAIR 61.1710

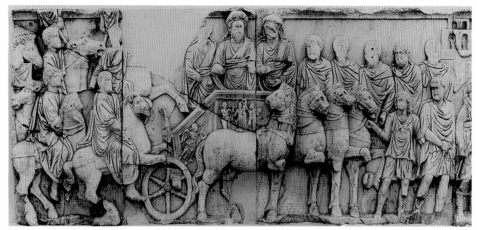

308 Leptis Magna, Arch of Septimius Severus, attic triumph
panel, 203. Photo: DAIR 651.1695

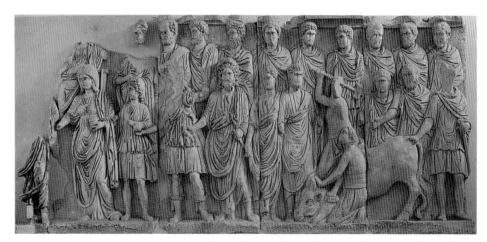

309 Leptis Magna, Arch of Septimius Severus, attic sacrifice
panel, 203. Photo: DAIR 61.1699

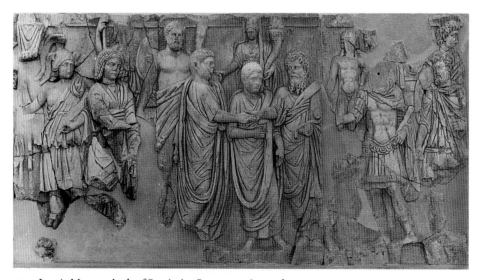

310 Leptis Magna, Arch of Septimius Severus, attic panel
with concordia augustorum, 203. Photo: DAIR 61.1701

contemporary with the Arch in the Roman Forum. The similarity and differences between the two key Severan monuments elucidate our understanding of their patron and his military and dynastic ambitions as well as of the distinctions between the contemporary city of Rome and provincial, state-sponsored art.

We have already seen that the Parthian arch, which faced its Augustan counterpart diagonally across the space of the Roman Forum, had a significant topographical context. The Arch of Septimius Severus at Leptis Magna was also closely allied with its urban setting because it was situated at the crossing of the city's two main thoroughfares, the *cardo* and the *decumanus,* and was thus a quadrifrons arch.

The arch first came to light in excavations of the 1930s and was restored and repaired in a painstaking process that took many years. The diligent work of excavators and restorers revealed that the arch's limestone core was faced with marble panels and a shallow dome crowned the four solid piers upon which the superstructure of the arch rested. The dome was supported by brackets in the form of eagles, and the interior face of the arch was elaborated with figural panels. The four arcuations of the four sides of the arch were framed with eight Corinthian columns, the pair on each side supporting a broken pediment. The corners are articulated with Corinthian pilasters with a vine scroll decoration laced with serpents, birds, and so on. The area between column and pilaster is decorated with trophies to which are affixed captive barbarians, and there is a Victory, with wreath and palm branch, in all eight spandrels. Above the columns is a frieze of spiraling acanthus, and between the sides of the broken pediment a second frieze depicting erotes supporting a garland.

The arch is surmounted by a four-sided attic, each face ornamented with a frieze depicting the emperor and his family in scenes of triumph, procession, sacrifice, and *Concordia Augustorum.* These are now on display in the Tripoli Museum. There is no surviving inscription, which makes the determination of a precise date difficult and also makes less certain the event that led to the arch's construction. It is probable, however, that references to the emperor's Parthian victories and his triumph over one of the eastern cities are intended.

The interior pier reliefs, which include the fragmentary scene of the siege of a city, and the triumphal and sacrificial imagery of the attic reliefs are in keeping with the subject matter of city of Rome state reliefs. Yet the overall design of the arch – with its four-sided shape, broken pediments, and horizontal attic panels with historical and religious scenes – is strikingly different from the more conventional arches of the capital. The groups of fighting figures in the inner face of the pier (see fig.

307) are dispersed on the relief ground in a series of tiers reminiscent of those in the four great historical panels on the Parthian arch in Rome (see figs. 296–298). The pier reliefs also include reliefs of Septimius Severus and Julia Domna enthroned as Jupiter and Juno, a sacrifice in the presence of the imperial family, and the tyche of Leptis Magna with a cornucopia.

The attic triumph panel (panel A) (see fig. 308) is of special interest because it can be compared with earlier imperial representations of the same subject, such as those on the Arch of Titus and lost Arch of Marcus Aurelius (see figs. 156, 261). The Severan triumph retains the horizontal field of Titus's triumph and some of its vivid movement: the galloping horses and togate riders at the left and right of the chariot and togate men on foot transporting a litter with a captive woman of high rank. The equestrian figures and togati and their prisoners are arranged in tiers, which reveal their indebtedness to the artistic experiments of artists like the master of the Antonine Column base (see fig. 254). Furthermore, the movement of the procession is arrested by the chariot scene, which more closely resembles that of Marcus Aurelius in the panel now in the Conservatori (see fig. 261).

In the Severan version, four horses in profile pull a chariot containing the three frontal figures of Septimius Severus, Caracalla, and Geta. The heads of both boys are obliterated. The imperial protagonists are not accompanied by a crowning figure of Victory or a state slave, as in earlier scenes of triumph, but Victory figures ornament the chariot, which also has representations of Cybele and regional variants of Hercules and Venus. The juxtaposition of active narrative events and static emblematic ones in the same relief is not new but was already apparent in precocious imperial reliefs such as the Great Trajanic Frieze (see fig. 186) and ultimately derives from Roman eclecticism. Its appearance here and in other examples of Late Antique art demonstrates, however, that such a combination offered artists the opportunity to tell a story and present a synoptic image of imperial might and dynastic continuity simultaneously. Although the majority of the figures, other than the imperial triad, are varied in posture, gesture, physiognomy, and hairstyle, the treatment of the folds of the tunic, togas, and barbarian costumes are overridingly decorative. The preoccupation of the artists in the deep undercutting of the garments' creases has led to an interest in the pattern of lines across the surface regardless of the shape of the body below.

Panel B, which is very fragmentary, depicts Julia Domna, an imperial male in the guise of Hercules, a group of equestrian male figures, and captive women on litters.

Panel C (see fig. 309) represents the sacrifice of two

bulls in the presence of the imperial family and other dignitaries. One victim is escorted in from the left, whereas the other is already being restrained for the fatal blow. The positioning of the animals and the postures and gestures of the victimarii are nearly identical to those on earlier imperial state reliefs. In the center of the Seve11an panel are the almost fully frontal figures of Roma or Virtus, flanked by Julia Domna and Caracalla on the left and Septimius Severus and Geta on the right. Geta's face was not obliterated, and his features and characteristic curly hair are still visible. As in the triumph panel, the figures are disposed on two levels. The imperial retinue and the sacrifice vignettes are located in the first register, and the second tier is made up of male dignitaries. Again, the artist has paid attention to the unique physiognomies and characteristic hairstyles of the imperial protagonists and the accompanying dignitaries, and also to representing a wide variety of postures and gestures and – although many of the bodies are frontal – none of the faces is frontal. The special interest in the pattern of deeply carved drapery folds is as apparent here as in Panel A.

Panel D (see fig. 310) portrays the Concordia Augustorum with Septimius Severus, holding a lituus in his left hand, clasping right hands with Caracalla. Geta stands between them, and Julia Domna is depicted off to the side of the solemn ceremony, which takes place in the presence of the tutelary deities of the imperial family and of Leptis Magna. These are depicted to the left and right of the imperial figures and behind them on a second register. The message of the relief is clear. It purports to underscore the concord between the emperor, who enjoys the sanction of Roman and African gods alike, and both of his male heirs, especially his eldest son, who is next in the line of succession.

The Severan Forum and Basilica at Leptis Magna

The Severan Forum covered a traditional rectangular space dominated by a temple honoring the Severan family. The red-granite columns of the octastyle structure rested on tall, figural pedestals with scenes of a Gigantomachy, and the surrounding arcuated colonnades were punctuated above the columns with sculpted Medusa heads. An ingeniously designed wedge-shaped row of shops masked the passage from forum into the two-storied basilica, which, along with the forum, was dedicated in 216. The basilica had double apses that were in turn enhanced by two rows of columns with crowning brackets. At the end of the colonnades on either side of the basilica were four decorated pilasters covered with a delicate acanthus interlace enclosing animals. Two additional ornamented pilasters flank the central apse on either end of the basilica. The animals of the other pilas-

ters are here replaced with the figures of the two patron gods of Leptis Magna, Dionysus in one pair of pilasters and Hercules in the other. The figures are deeply undercut from the natural growth so that they appear almost in the round, and the branches, vines, and leaves themselves are also meticulously carved so that each leaf is distinct from the other and emerges as a sinuous shape against a shadowed ground.

In the Dionysus cycle, vines emerge from wine-mixing bowls, and the leaves enclose Dionysus himself and panthers, centaurs, and other figures. The cycle of Hercules (fig. 311) depicts the hero, sometimes clean-shaven, sometimes bearded, participating amid twisting branches and leaves in his various exploits and with his patron goddess, Minerva. The expert carving of these pilasters and the similarity of their general format and style to pilasters from the entrance to the Hadrianic Baths at Aphrodisias has led to the hypothesis that they were fashioned by artists from the School of Aphrodisias, which, if true, attests to the continuing popularity of traveling workshops in Severan Asia Minor.

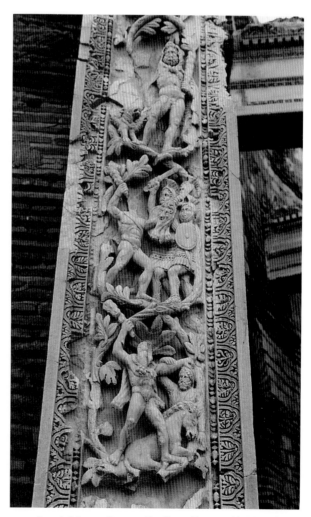

311 Leptis Magna, Severan Basilica, pilaster with Hercules cycle, 203. Photo: DAIR 58.62

The Pulpitum of the Theater of Sabratha

The city of Sabratha was, like Leptis Magna, a part of Tripolitania. In fact, it was the three cities of Sabratha, Leptis, and Oea that gave the area its name. Like Leptis, Sabratha had Punic origins and was a trading outpost in pre-Roman times. Carthage held sway in Sabratha as it did in Leptis, and also like Leptis, it began to take on a Roman shape under Julius Caesar and Augustus when its forum was laid out and temples were built, both from local sandstone. Construction continued there under the Julio-Claudians and Flavians, and under Antoninus Pius, Sabratha became a Roman colony and was revitalized architecturally. New temples were built and others were refurbished and elaborated with columns, pediments, and staircases of imported marble.

The tour de force of Roman architecture in Antonine and Severan Sabratha was the new theater constructed in the last quarter of the second century to accommodate five thousand spectators. Built of local sandstone, the three-storied stage front or *scaenae frons* had columns with composite capitals and served as a magnificent backdrop for the stage sets. It was fronted by the stage platform (fig. 312) that was scalloped with rectangular and semicircular niches ornamented with figural reliefs of theatrical and mythological scenes and scenes of local significance. The individual figures and those in groups are placed on projecting bases, which gives them the appearance of statues. Most are frontal, compact, and relatively squat. Dancing figures, muses, and a scene depicting students rehearsing in an acting school are included, as are depictions of the three Graces, Paris and Venus, and Hercules with his lion skin and club.

Of greatest interest and significance is the central scene that depicts personifications of Rome and Sabratha joining hands in concordia. Roma can be identified by her Amazonian costume and helmet; the tyche of Sabratha wears a long robe, a turreted crown, and carries a cornucopia. Helmeted military men with daggers and upraised right hands flank the central group. These soldiers are in turn framed by two parts of a sacrifice scene. At the left, a bearded emperor, who has been identified as Septimius Severus, is flanked by another bearded man of comparable stature and by a youth, possibly Plautianus and Caracalla, respectively. The sacrificant holds a patera into which a camillus pours a libation. The sacrifice at the right, perhaps in honor of the Genius Augusti, depicts a bull led in procession by two victimarii to an altar laden with fruit, cakes, and a pinecone. The soldiers, who have their hands upraised, may be in the process of taking an oath. For this reason, the unique scene has been identified as the swearing of allegiance to Rome by local members of the army. It has been suggested, however, that such an event would have taken place when Sabratha became a Roman colony under the Antonines and not under Septimius Severus. Since the reliefs of the Sabratha Theater Pulpitum are linked to the reliefs from the Arch of Septimius Severus at Leptis Magna by the presence of the emperor and his elder son, by the division of the sacrifice

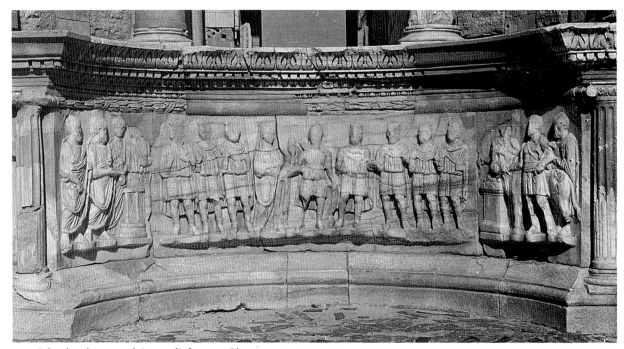

312 Sabratha, theater, pulpitum relief, ca.203. Photo: DAIR 58.459

into two parts, the taste for Hercules imagery, and by the frontal and hieratic style of the figures, the scene should probably not be recognized as a specific historical event but rather as a more general reference to the romanization of Sabratha and to the fidelity of the African members of the Praetorian cohorts to Rome. Furthermore, its manufacture may be associated with Severus's visit to Tripolitania before 204. Both the Sabratha reliefs and those from the Arch of Septimius Severus at Leptis Magna thus attest to there having been a distinctive North African provincial style and iconography in Tripolitania during the period of the Severan dynasty.

Private Funerary Art under the Severans

The Tomb of the Secundinii at Igel near Trier

The Tomb of the Secundinii in the village of Igel near Trier (fig. 313), which dates to the first half of the third century (some scholars place it as late as about 250) is in the form of a square sandstone tower with stepped base, podium, vertical story with pilaster frame, frieze, attic, pediment, and pyramidal roof. With the exception of the stepped base and pyramidal roof, all the other surfaces are carved with a combination of mythological and professional scenes. The habit of completely covering a stone surface with relief scenes is characteristic of earlier provincial art, such as the Arch of Tiberius at Orange (see fig. 130), but also of Severan art in Rome and the provinces, such as in the arches of Septimius Severus in Rome and Leptis Magna and in the basilica piers at Leptis (see figs. 293–294, 307–311).

The daily life scenes focus on the making of cloth, which was the primary business of the Secundinius family. It was their success in this endeavor that provided them with the funds to erect the Igel Monument. The fragmentary inscription, located on the front of the south side of the tomb, indicates that the brothers, Lucius Secundinius Aventinus and Lucius Secundinius Securus, commissioned the tomb in honor of their deceased ancestors and themselves, although they were still living at the time of the tomb's erection ("parentibus defunctis et sibi vivi"). The tall vertical panel above the inscription and between two pilasters decorated with erotes depicts the two patrons and one of their sons between them with three bust-length portraits of their relatives in the three medallions above their heads. Father and son clasp hands in a scene of leave taking. The myth of Perseus and Andromeda is represented in the main west panel and that of Achilles in the east; the rear panel portrays the apotheosis of Hercules in a four-horse chariot surrounded by the signs of the zodiac and the heads of the four winds (fig. 314).

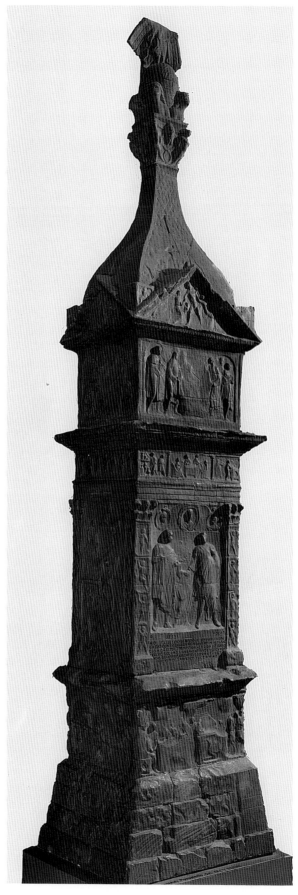

313 Igel, Tomb of the Secundinii, general view, first half of third century. Photo: Alinari/Art Resource, New York, 47228

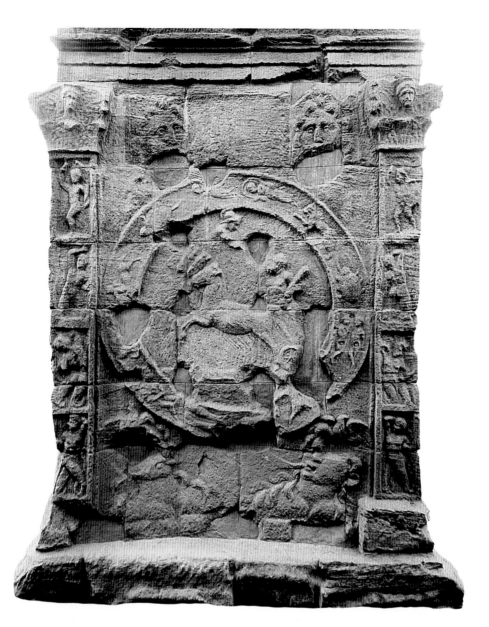

314 Igel, Tomb of the Secundinii, nortn side, apotheosis of
Hercules, first half of third century. Photo: Bildarchiv Foto
Marburg/Art Resource, New York, 1.073.133

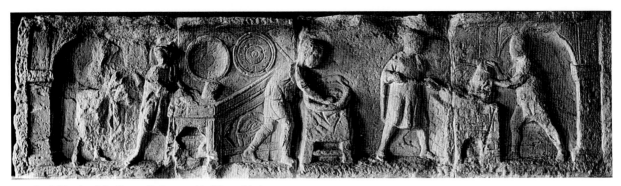

315 Igel, Tomb of the Secundinii, east side frieze, kitchen scene, first half of third century. Photo: Bildarchiv Foto Marburg/Art Resource, New York, 1.195.617

The three mythological scenes honor celebrated Greek heroes and the triumph of immortality over death. Perseus rescued Andromeda from the monster who chained her to a rock; Achilles opted for a short but heroic life filled with glorious deeds; Hercules was one of the most acclaimed heroes of Graeco-Roman antiquity and was ultimately granted immortality. The Secundinius family's hope for everlasting bliss is apparent in the patrons' choice of such mythological scenes for the monument and for the pairing of the scene of Hercules on the back of the monument with that of the Secundinii and their ancestors on the front of the tomb.

It is also clear that they wished to preserve for posterity a record of their own accomplishments, which they hoped would be remembered as were the deeds of famous Greek heroes. Consequently, the socle of the tomb is carved with professional scenes (fig. 315): on the front, a chest for cloth; on the east, a workshop; on the back, a warehouse; and on the west, the transporting of the cloth in a wagon. The frieze above the tall vertical panels portrays scenes from the daily life of the Secundinius family: the taking of a meal in a columned dining hall (front); the kitchen (east); tenants paying rent at an office (west); and beasts of burden laden with manufactured goods (rear). The crowning attic is carved with additional professional scenes: the exhibition of cloth (south); an office scene (east); the journey of the brothers on a wagon, including a specific topographical reference to the milestone that marks the distance from Igel to Trier (west); and Eros between two griffins (rear).

Mythological scenes and figures and cosmological signs are also enclosed in the four pediments that crown the tomb's attic: the myth of Hylas, friend of Hercules for whom Hercules searched long and far (south); Rhea-Silvia, mother by Mars of Romulus and Remus (west); and busts of the sun and moon (north and east). These are

in turn surmounted by a figural capital with giants at the corners, which supports a pinecone topped with a statue of an eagle carrying the beautiful Ganymede to heaven, where he is to serve as Jupiter's cupbearer.

The mythological scenes thus serve both as the tomb's foundation (the carved podium) and as its crowning element (pediments and finial). Their major theme is of loss and recovery, death and rebirth, and immortality achieved through apotheosis. The full implication of the sculptural program of the Igel Monument, with its juxtaposition of family scenes and mythological subjects, is that the family's professional accomplishments on earth were the vehicle by which they acquired immortality in the afterlife.

Also noteworthy is the use of Hercules iconography, favored by Septimius Severus and Caracalla, in a contemporary private funerary setting. Hercules imagery was also employed in sarcophagi produced in Rome in the third century and underscores the close association not only of public and private art but also of art in Rome and the provinces. The style of the professional reliefs is consistent with that of earlier freedman commissions. The emphasis is on storytelling and not on proportion, perspective, or individualized portraiture. Small, active figures in tunics perform a variety of activities against a backdrop filled with the accoutrements of daily life such as tables and stoves. One interesting feature is the artist's inclusion of architectural components such as archways, curtains, and columns to set the scene, which perhaps suggests some reliance on the topographical references of contemporary historical reliefs.

The figures in the portrait relief of the Secundinii are attenuated and posed in quiet frontality with their heads turned toward one another. They wear the togas characteristic of the more formal freedman group portrait and pose for posterity surrounded by ancestral portraits in

316 Funerary altar of a boy as the infant Hercules strangling
serpents, from Ostia, ca.160–220. Ostia, in front of museum
storerooms. Photo: D.E.E. Kleiner and F.S. Kleiner 79.8.11A

medallions. It could certainly be argued that the models for the main portrait panel were the city of Rome freedman group portraits (see figs. 58–60) widely imitated in provincial versions from the late republic on and that the professional scenes find their prototypes in the journalistic genre scenes, which also began to be made in the late republic (see figs. 93–95). The scenes involving divinities and heroes were in turn based on the appropriate mythological cycles. Severan art commissioned by freedmen and their descendants in the western provinces appears to have had the same eschatological intentions and artistic predilections as it did in Rome in late republican and Augustan times, with a greater reliance on the mythological allusions that began to become increasingly popular with freedmen in the second and third centuries.

Funerary Altars and Reliefs of Freedmen

Mythological allusions and Hercules imagery were also popular among freedmen in Severan Rome and environs. An example is the altar of a boy from Ostia, which dates to around 160–220 (fig. 316). The portrait of a boy with a compact chubby body is contained in a niche with an inscription below identifying the deceased honorand as a *verna* or slave born in his master's house and the dedicant as an imperial slave named Quartus. The boy, whose facial features are unfortunately obliterated, is frontally positioned with his weight on both legs, and he grasps two snakes in his clenched fists. In other words, the nameless boy is portrayed as is the infant Hercules strangling serpents. The portrait is undoubtedly based on imperial counterparts such as the portraits of Annius Verus or Commodus and Caracalla as the infant Hercules strangling serpents, in Boston and Rome, respectively (see fig. 285). This is not surprising because the boy is an imperial slave like his father and thus adopts his own master's iconography. The depiction of the young boy on the Ostia altar, however, differs from its imperial models because the boy is standing rather than kneeling or sitting. The Ostia altar clearly indicates that the imitation of imperial conceits in the portraiture of freedmen in Rome continued in the Severan period.

Severan Man and Woman as Mars and Venus

Another example of the adoption of mythological imagery, favored by members of the imperial circle and the aristocracy, in the portraiture of Severan freedmen is a relief of a man and woman portrayed as Mars and Venus, now in the Villa Albani (fig. 317). The woman, who is almost entirely nude and whose left arm is draped across her husband's shoulders, stands in a pose based

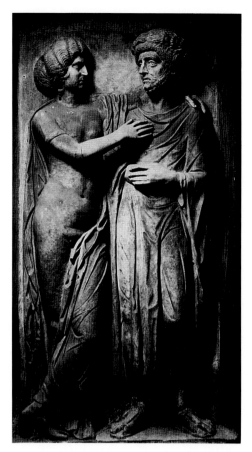

317 Relief portrait of a man and woman as Mars and Venus, ca.190–200. Rome, Villa Albani. Photo: DAIR EA 4337

closely on the fourth-century B.C. Venus of Capua statuary type. Her hair is parted in the center and brushed in loose waves covering her ears. The rest of the hair is swept into a large bun that fully covers the back of her head. A corkscrew curl falls from the mass of hair onto her neck behind her ear. The closest parallels can be found in the portraiture of Didia Clara, daughter of the emperor Didius Julianus and his wife, Manlia Scantilla, of about 193–200. The woman's husband is clothed in a tunic without a toga and wears sandals on his feet. The left side of his face is restored and the rest may have been reworked in modern times. Consequently, the character of the man's head is no help in dating the relief. The woman's coiffure suggests a date of about 190–200 for the work.

The Villa Albani Relief attests to the continuance of the Antonine taste for depicting both aristocrats and freedmen in the guise of Venus and Mars into the Severan period. Although the woman in the Albani relief is almost entirely nude, her husband is not, this relative modesty is a hallmark of the art of freedmen. Note that second-century freedwomen, influenced undoubtedly by the women of the imperial circle, increasingly had

themselves depicted as nude Venuses, especially as a form of private deification in funerary contexts.

Mythological Sarcophagi under the Severans

The taste for mythological sarcophagi continued unabated under the Severans. Sometimes mythological and military themes were intertwined, which is not surprising given the fondness for military iconography in the state monuments of Septimius Severus and the public portraiture of Caracalla. A primary example is a sarcophagus, now in the Vatican Museums, which dates to the second quarter of the third century (Alexander Severus, the last of the Severans, was emperor between 222 and 235) and depicts the age-old battle between Greeks and Amazons (fig. 318).

The origin of motifs like that of a naked Greek warrior pulling an Amazon from a horse by her hair can be traced back to architectural sculpture of fifth-century Greece and was used in the earliest Roman Amazon sarcophagi of Hadrianic times. These groups here, however, are not arranged in the friezelike composition favored earlier but in a multitiered scheme that is clearly based on Antonine battle sarcophagi and on the artistic experiments of such state monuments as the Column of Marcus Aurelius in Rome (see fig. 263). Striding Amazons, which are mirror images of one another, are sym-

metrically disposed at the front corners of the main body of the sarcophagus; the center is reserved for the two main protagonists: Achilles and Penthesilea.

Penthesilea was the daughter of Ares and the queen of the Amazons. She was killed by the Greek hero Achilles, who at the time he was slaying her was touched by her courage and beauty. Achilles, naked save for his tall helmet, grasps Penthesilea around her waist. She has her right arm flung around his shoulder, but otherwise her body is limp and lifeless. The model for the relief group is the Pergamene barbarian groups in the round of Hellenistic date, such as the Gaul killing himself and his wife (in the Museo Nazionale delle Terme). Like the Gaul, Achilles turns his head from his victim at the last moment rather than confront her gaze as he does in the myth.

This constitutes a surprising discrepancy since the pair in the guise of Achilles and Penthesilea are probably man and wife. In fact, the whole idea of depicting a husband in the act of killing his wife on a commemorative sarcophagus is a bit bizarre and may indicate that some of these coffins were purchased because of the Hellenic connotations of their subjects, especially those that depicted a tragic death, with little regard for the particular myth narrated. The woman is coiffed in a Severan hairstyle with a central part and deeply waved curls covering her ears popularized by Julia Domna. Achilles' hair beneath his helmet is cropped short and hatched in with the chisel in the manner of the adult portraits of Caracalla

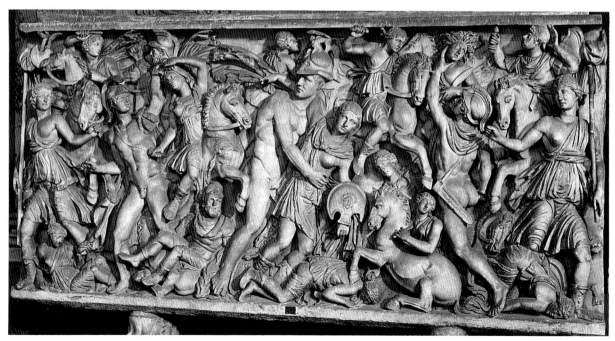

318 Sarcophagus with Achilles and Penthesilea, second quarter third century. Rome, Vatican Museums. Photo: Alinari/Art Resource, New York, 6653

(see figs. 286–287). The Severan hairstyles and the main protagonists' individuated features indicate that portraits were intended and that they were certainly added by a special portrait artist commissioned to complete a work that was almost certainly carved somewhat earlier.

Severan Art
Antonine Origins and New Directions

Severan art, like the art of other periods, has one foot in the past and one in the future. Tradition was important to Septimius Severus who, in his portraiture, state relief sculpture, and architectural commissions frequently allied himself with earlier emperors like Augustus, Tiberius, Pertinax, and with the Antonines, especially Marcus Aurelius and Commodus. His Parthian arch made reference to the Parthian Arch of Augustus and an arch of Tiberius, another hero of Rome's conflict with Parthia. It also followed the overall triple-opening design of the Augustan arch and was embellished with the freestanding columns and decorated pedestals of the arches of Julio-Claudian emperors like Nero (the Arch of Nero was also a Parthian arch). Its four great panels were deliberate excerpts from the columns of Trajan and Marcus Aurelius with contemporary subject matter.

Septimius Severus directed his court portraitist to create images of him that revealed his familial resemblance to Marcus Aurelius and commissioned both public and private portraits of his sons, like that of the curly-haired infant Caracalla strangling serpents, that were based on the prince portraits of Marcus Aurelius and Commodus. Julia Domna, who like the Faustinas was given the title Mater Castrorum, shared their unlined oval faces and feathery brows and also wore her hair parted in the center with deep waves and gathered in a large bun at the back of her head.

Severan state reliefs and portraits were not slavish copies of their imperial predecessors. It is true that in his earliest portraits Severus modeled himself on Pertinax, Marcus Aurelius, and Commodus, but these same portraits were devoid of the psychological penetration of Marcus Aurelius's images. Before long Severus's likenesses began to reveal the impact of the art and religious beliefs of Leptis Magna.

That Septimius Severus was born in North Africa and his wife in Syria obviously had a significant bearing on his artistic predilections and on the appearance of his portraits and state monuments. In portraits of about 200 Severus had already begun to be represented with the corkscrew curls over his forehead that referred to those of the Egyptian god Serapis and to the emperor's North African origins. Severus's decision to have him-self depicted in the guise of Serapis may also have been prompted by his great victory over the Parthians at Ctesiphon in 198 and the simultaneous elevation of his sons and heirs, Caracalla and Geta, to the ranks of Augustus and Caesar, respectively. Septimius Severus, like Augustus and others, had come to power after victory in a civil war and needed a foreign conquest to legitimize his principate and his dynasty. Serapis was not only a healing god but the god of death and renewal. Severus's adoption of his coiffure made reference to the emperor's personal origins and to the end of civil and foreign strife and to the beginning of a new golden age that would be continued under his sons and heirs. In fact, the double themes of the victory over Parthia and the foundation of a legitimate dynasty are the cornerstones of Severan art.

These ideas were glorified in both city of Rome and provincial state commissions such as the Arch of Septimius Severus in the Roman Forum, the Palazzo Sacchetti Relief, the Arch of the Argentarii, and the Arch of Septimius Severus at Leptis Magna. The inscription on the Parthian Arch in Rome states that it was put up to celebrate the victory over the Parthians and to declare the legitimacy of the Severan dynasty. In scenes from the arch's panels, Severus is accompanied by Caracalla and Geta both at the outset of the second Parthian campaign and at Ctesiphon. The Palazzo Sacchetti Relief depicts the conferral of power by Severus on both his sons, as does the Concordia Augustorum panel from the attic of the Leptis arch. In the reliefs in the central bay of the Arch of the Argentarii, Severus, in the presence of Julia Domna and Geta, sacrifices to the penates at an altar. His son, Caracalla, formally posed in a facing panel with his bride and father-in-law, is almost his father's alter ego as he pours a libation on a second altar.

Septimius Severus was proud of his military victories, and military iconography consequently became one of the main subjects of his state commissions. Severus depleted the imperial treasury because of his many campaigns and augmented the pay of his soldiers. It was Severus who exhorted his sons on his deathbed to reward the army and despise everyone else. This emphasis on the military translated into an emphasis on military imagery both in the specific and generic sense. It is not surprising to see that many of the motifs and compositional devices in Severan state relief show their indebtedness to those of the art of other emperors, namely Trajan and Marcus Aurelius, who favored art with military subject matter.

Iconographic and stylistic borrowings by artists from such monuments as the Column of Trajan, the Arch of Trajan at Benevento, the Great Trajanic Frieze, the Anaglypha Traiani/Hadriani, the panels from the lost arches of Marcus Aurelius, and the Column of Marcus Aurelius were prevalent in Severan times. Septimius Severus

is depicted in the midst of the fray in siege scenes from the Parthian arch in Rome, which was also carved with depictions of Parthian prisoners and Roman soldiers and personifications of Victory; a city is also taken in a panel on the pier of the Leptis arch. These siege scenes have small, active figures dispersed over the relief ground in a series of registers that approximate the spiral bands of the columns of Trajan and Marcus Aurelius. Even the private Argentarii gate is covered with military imagery such as trophies, standards, and the taking of Parthian prisoners by Roman soldiers. The interest in military subject matter also appears in private art of the period. An example is the Vatican sarcophagus of Penthesilea in which the theme of the age-old battle between Greeks and Amazons is interwoven with the mythological story of Penthesilea and Achilles, who bear the facial features of an anonymous Severan couple.

Military imagery continued to be popular under Caracalla, who allied himself in actuality and in his portraiture with the uncultivated soldiery of Rome rather than with the aristocratic members of the senate. He hoped to follow in the footsteps of the greatest general of all times – Alexander the Great – and to celebrate important victories in the East. For the most part, these military triumphs eluded him, but he accentuated his alliance with Alexander by having himself portrayed in an unmistakable military portrait that emphasized his closely cropped military hairstyle, his short chiseled beard, and his serious expression. The sharp turn of the head to the left was adopted in his latest images as a reference to the portraiture of Alexander. It also stressed the immediacy of the portrait in which the Caracalla Master captured not only the emperor's physical characteristics but also the essence of his personality.

Caracalla's portraits projected the image of a physically powerful and psychologically intense soldier who was most at home among his men. Unlike his father, Caracalla was not interested in stressing the familial bond in art and did not commission felicitous group portraits of the happy Severan family. This is not surprising. Caracalla was, after all, a man who was credited with the deaths of his brother, wife, and father-in-law. Instead, he authorized mosaic likenesses of the most famous athletes and gladiators of the day to grace the pavement of his monumental baths in Rome. For that same complex, he ordered an unprecedented number of colossal marble statues and group compositions that stressed horrific subject matter and depicted its subjects with exaggerated musculature.

Among these were two statues of Hercules, one a copy and the other a variation of the well-known Farnese type. These were displayed between two columns in the frigidarium of the baths not far from a composite capital with a miniature version of the same weary Hercules depicted amid the acanthus leaves. The overriding significance of Hercules in the sculptural program of Caracalla's frigidarium is not coincidental and must have reflected the emperor's own wishes. The powerful Greek hero who gained renown through his labors and was eventually granted immortality was earlier favored by Septimius Severus because Hercules was both a patron god (along with Dionysus) of Leptis Magna and because he was the special favorite of one of Severus's Antonine predecessors, Commodus. In a medallion of 202, Severus is shown with the attributes of Hercules in order to emphasize his relationship with Commodus and to refer to his North African origins. When Severus had himself adopted, after the death of Commodus, into the Antonine family, he also divinized Commodus, whom he now viewed as his brother.

Commodus saw himself as an incarnation of Hercules and frequently masqueraded as the god in life and in portraiture. The greatest example of the latter is the marble portrait of Commodus wearing the lion skin of Hercules and carrying his club, as well as the apples of the Hesperides, attributes of the hero's final labor. The apples are also held by the Hercules Farnese in the frigidarium of the Baths of Caracalla. Hercules is one of the tutelary deities in the scene of the Concordia Augustorum on the Leptis arch and is also depicted on the chariot of Septimius Severus and his sons in the triumph panel, also from the attic. His deeds are adumbrated in a series of scenes that emerge from the swirling acanthus leaves of a pier in the Basilica of Leptis. Hercules with his lion skin and club is represented in a relief from the pulpitum of the Theater at Sabratha and in a panel from the Arch of the Argentarii, where he was honored as a patron of Leptis Magna and as a personal favorite of the private collegium that commissioned the monument honoring the imperial family.

Hercules imagery was even popular among freedmen in the Severan period, and it is likely that its adoption by these patrons signals their continued desire to take over as their own the mythological conceits favored by the imperial circle and aristocracy. One example is the portrait of an imperial slave in the guise of the infant Hercules that appears on the front of a private funerary altar from Ostia. Another is the panel representing the apotheosis of Hercules on the back of the Igel Tomb. The hero is portrayed with the attributes of club and lion skin, and he rises in a chariot to heaven where he is greeted by his patron goddess, Minerva. The scene takes place in a cosmic setting indicated by the signs of the zodiac and the four winds. It is deliberately paired with the front panel,

which represents the Secundinius brothers and is meant to liken their accomplishments and future immortality to those of Hercules.

As noted, the cornerstones of Septimius Severus's political and artistic programs were his Parthian victory and his foundation of a new dynasty. Consequently, Severus favored not only military subject matter but also commissioned myriad monuments that celebrated his sons and heirs, Caracalla and Geta, as his inevitable successors, and his wife, Julia Domna, as Mater Augusti et Caesaris. Individual and group portraits appeared on coins and medallions, in paintings and in relief sculpture, and in portraits in the round. Dynastic portraiture had not had such a heyday since the time of Augustus and the Julio-Claudians. The emperor, empress, and their two sons are depicted together in the attic panels of the Leptis Arch, in the relief panels from the bay of the Arch of the Argentarii, and in the tondo from Egypt. Severus, Caracalla, and Geta share a dais in the Palazzo Sacchetti Relief. In the Arch of Septimius Severus in the Roman Forum, Severus and his sons are depicted in key scenes from the second Pathian campaign; Caracalla and Geta are also mentioned in the arch's lengthy inscription, and their statues were next to the chariot group that crowned the attic. Caracalla is at his father's side when he sacrifices at a small tripod altar in the center relief on the pulpitum of the Theater at Sabratha. Julia Domna was the most powerful empress since Livia; she wielded her influence not only in the political arena but also in the artistic realm since she served as the head of a celebrated salon of the intellectual elite of the day. It may well have been she who recognized the talent of the Caracalla Master and continued to offer him important commissions.

The artists who designed and carved the state reliefs of the Severan period in Rome and the provinces continued to employ the stylistic and formal devices of city of Rome Antonine reliefs like those of the Column of Marcus Aurelius. These included an emphasis on the frontality of the main protagonists; the isolation of the emperor as a figure of awe and reverence and no longer as first among equals; the placement of small figures in two or more registers; the conflation of time and space;

and the interest in the surface pattern of drapery folds rather than in the way a garment molds the body beneath it. What is of special interest is that these very motifs and artistic devices were those employed since the late republic in the art of freedmen.

Their appearance in Severan art does not indicate that Severan artists were looking at and imitating the monuments of freedmen, but rather that these characteristics were already integrated into imperially sponsored art under the Antonines. What is striking in the Severan period, however, is that both state-sponsored and private monuments of freedmen are more similar to one another than ever before. Caracalla and an imperial slave, for example, are both depicted as the infant Hercules strangling serpents; and the Arch of the Argentarii – commissioned by a private collegium – combines in a single work Roman soldiers and Parthian prisoners, hieratic group portraits of the first family, and a rustic genre scene in a lively narrative style that makes reference to the provision of bulls, tended by country herdsmen, to the Roman populace.

Some scholars have suggested that the Severan emphasis on frontality and on the almost iconic image of the emperor is a result of the profound influence of the East brought to Rome not only by a North African emperor who consulted astrological signs but by his Syrian-born wife, who favored oriental mysticism. There is no question that Severus's North African origins and his wife's Syrian background shaped their artistic predilections, but Septimius Severus was also deeply impressed with Roman traditions.

All the features of Severan art that have been termed eastern, with the exception of the Serapis motif in imperial portraiture, were already present in city of Rome art under the Antonines. In fact, Severan art might well be considered a final chapter of Antonine art, with the possible exception of the adult portraits of Caracalla, which although deeply indebted to the psychologically penetrating images of Marcus Aurelius, possess a revolutionary character which was to prove highly influential in the third century.

Bibliography

For the ancient biographies of the Severan emperors, see the *Scriptores Historiae Augustae.* Useful modern encapsulated biographies can be found in *The Oxford Classical Dictionary*, 2d ed. (Oxford, 1970).

General books and articles on Severan art include: L. Franchi, *Ricerche sull'arte di età severiana in Roma, StMisc* 4 (Rome, 1964), 20–32. G.C. Picard, "Problèmes de l'art sévérien," *Hommages à Marcel Renard*, 3, *CollLatomus* 103 (Brussels, 1969), 485–96.

The Portraiture of Septimius Severus, Caracalla, and Geta: K.A. Neugebauer, "Die Familie des Septimius Severus," *Die Antike* 12 (1936), 155–72. L. Budde, *Jugendbildnisse des Caracalla und Geta* (Münster, 1951). H.P. L'Orange, "Severus-Sarapis," *Bericht über den VI: Internationalen Kongress für Archäologie, Berlin 21–26 August 1939* (Berlin, 1940), 495–96. F.W. Goethert, "Die Söhne des Septimius Severus auf dem Berliner Familienbild," *Neue Beiträge zur klassischen Altertumswissenschaft: Festschrift zum 60. Geburtstag von Bernhard Schweitzer* (Stuttgart, 1954), 361–63. C. Vermeule, review of *OpRom* 1 (1954) in *AJA* 59 (1955), 351 (Bronze portrait of Septimius Severus from Nicosia). S. Nodelman, *Severan Imperial Portraiture A.D. 193–217* (Diss., Yale University, 1965). A.M McCann, *The Portraits of Septimius Severus A.D. 193–211, MAAR* 30 (Rome, 1968). C.C. Vermeule, *Roman Imperial Art in Greece and Asia Minor* (Cambridge, Mass., 1968), 399, n. 10 (Nicosia bronze). H.B. Wiggers and M. Wegner, *Caracalla, Geta, Plautilla, Macrinus bis Balbinus* (Berlin, 1971). W. Hornbostel, "Severiana: Bemerkungen zum Porträt des Septimius Severus," *JdI* 87 (1972), 348–87. D. Soechting, *Die Porträts des Septimius Severus* (Bonn, 1972). V. Poulsen, *Les portraits romains*, 2 (Copenhagen, 1974). M.B. Comstock and C.C. Vermeule, *Sculpture in Stone: The Greek, Roman and Etruscan Collections of the Museum of Fine Arts Boston* (Boston, 1976), 232–34 (Commodus or Annius Verus as infant Hercules strangling serpents); 235 (Septimius Severus). K. Fittschen, *Katalog der antiken Skulpturen in Schloss Erbach* (Berlin, 1977), 91–92 (Caracalla). K. Fittschen and P. Zanker, *Katalog der römischen Porträts in den Capitolinischen Museen und den anderen kommunalen Sammlungen der Stadt Rom*, 1 (Mainz, 1985). G. Daltrop, "Lucio Settimio Severo e i cinque tipi del suo ritratto," in N. Bonacasa and G. Rizza, eds., *Ritratto ufficiale e ritratto privato* (Rome, 1988), 67–74.

The Portraiture of Julia Domna: V. Scrinari, "Le donne dei Severi nella monetazione dell'epoca," *BullCom* 75 (1953–55), 117–35. J. Meischner, *Das Frauenporträt der Severerzeit* (Diss., University of Berlin, 1964). S. Nodelman, *Severan Imperial Portraiture A.D. 193–217* (Diss., Yale University, 1965), 110–36. R. Schlüter, *Die Bildnisse der Kaiserin Iulia Domna* (Diss., University of Münster, 1977). K. Fittschen and P. Zanker, *Katalog der römischen Porträts in den Capitolinischen Museen und den anderen kommunalen Sammlungen der Stadt Rom*, 3 (Mainz, 1983).

The Arch of Septimius Severus in the Roman Forum: R. Brilliant, *The Arch of Septimius Severus in the Roman Forum,*

MAAR 29 (Rome, 1967). A. Bonanno, *Portraits and Other Heads on Roman Historical Relief up to the Age of Septimius Severus* (Oxford, 1976), 143–46.

The Palazzo Sacchetti Relief: A.J.B. Wace, "Studies in Roman Historical Reliefs," *BSR* 4 (1907), 263–70. L. Budde, *Severisches Relief in Palazzo Sacchetti, JdI-EH* (Berlin, 1955). S. Nodelman, *Severan Imperial Portraiture, A.D. 193–217* (Diss., Yale University, 1965). W. Hornbostel, "Severiana," *JdI* 87 (1972), 358–67. G. Koeppel, "Die historischen Reliefs der römischen Kaiserzeit IV: Stadtrömische Denkmäler unbekannter Bauzugehörigkeit aus hadrianischer bis konstantinischer Zeit," *BonnJbb* 186 (1986), 15, 82–84.

The Arch of the Argentarii: D.E.L. Haynes and P.E.D. Hirst, *Porta Argentariorum* (London, 1939). M. Pallottino, *L'Arco degli Argentarii* (Rome, 1946). A. Bonanno, *Portraits and Other Heads on Roman Historical Relief up to the Age of Septimius Severus* (Oxford, 1976), 147–49.

The Sculpture of the Baths of Caracalla: C.C. Vermeule, *Greek Sculpture and Roman Taste* (Ann Arbor, 1977), 58–63. H. Manderscheid, *Die Skulpturenausstattung der kaiserzeitlichen Thermenanlagen* (Berlin, 1981). M. Marvin, "Freestanding Sculptures from the Baths of Caracalla," *AJA* 87 (1983), 347–84.

The Severan City of Leptis Magna, including the Arch of Septimius Severus, and the Severan Forum and Basilica: R. Bartoccini, "L'arco quadrifronte dei Severi a Leptis Magna," *AfrIt* 4 (1931), 32–152. P. Bober, *The Sculptures of the Arch of Septimius Severus at Leptis Magna* (Diss., New York University, 1943). J.B. Ward-Perkins, "Severan Art and Architecture at Lepcis Magna," *JRS* 38 (1948), 59–80. J.M.C. Toynbee and J.B. Ward-Perkins, "Peopled Scrolls: A Hellenistic Motif in Imperial Art," *BSR* 18, n.s. 5 (1950), 1–43. J.B. Ward-Perkins, "The Art of the Severan Age in the Light of Tripolitanian Discoveries," *ProBritAc* 37 (1951), 269–304. R. Bianchi Bandinelli, V. Caffarelli, and G. Caputo, *Leptis Magna* (Rome, 1963). M.F. Squarciapino, *Leptis Magna* (Basel, 1966). V. Strocka, "Beobachtungen an den Attikareliefs des severischen Quadrifrons von Leptis Magna," *AntAfr* 6 (1972), 147–72. A. Bonanno, *Portraits and Other Heads on Roman Historical Relief up to the Age of Septimius Severus* (Oxford, 1976), 150–55.

The Pulpitum of the Theater of Sabratha: G. Guidi, "La scena del teatro romano di Sabratha," *Atti IV Congresso Nazionale di Studi Romani* (1935) (Rome, 1938), 198–202. I.S. Ryberg, *Rites of the State Religion in Roman Art, MAAR* (1955), 136–37. G. Caputo, *Il teatro di Sabratha e l'architettura teatrale africana* (Rome, 1959).

The Tomb of the Secundinii at Igel: H. Dragendorff and E. Krüger, *Das Grabmal von Igel* (Trier, 1924). H. Kähler, "Die rheinischen Pfeilergrabmäler, *BonnJbb* 134 (1934), 145–72. H. Eichler, "Zwei unbekannte Bilder des Grabmals von Igel," *TrZ* 18 (1949), 235 ff. F. Oelmann, "Die Igeler Säule und die Eigelsteine als Probleme der Nameskunde," *BonnJbb* 154 (1954), 162–81. E. Zahn, *Die Igeler Säule bei Trier, Rheinische Kunststätten* 6–7 (1968); (1970). E. Zahn, "Die neue Rekonstruktionszeichnung der Igeler Säule," *TrZ* 31 (1968), 227–34.

Funerary Altars and Reliefs of Freedmen: D. E. E. Kleiner, "Second-Century Mythological Portraiture: Mars and Venus," *Latomus* 40 (1981), 527–29. D. E. E. Kleiner, *Roman Imperial Funerary Altars with Portraits* (Rome, 1987).

Mythological Sarcophagi under the Severans: R. Redlich, *Die Amazonensarkophage des 2. und 3. Jahrhunderts n. Chr.* (Berlin, 1942). P. G. Hamberg, *Studies in Roman Imperial Art* (Uppsala, 1945). G. Koch and H. Sichtermann, *Griechische Mythen auf römischen Sarkophagen* (Tübingen, 1975). G. Koch and H. Sichtermann, *Römische Sarkophage* (Munich, 1982).

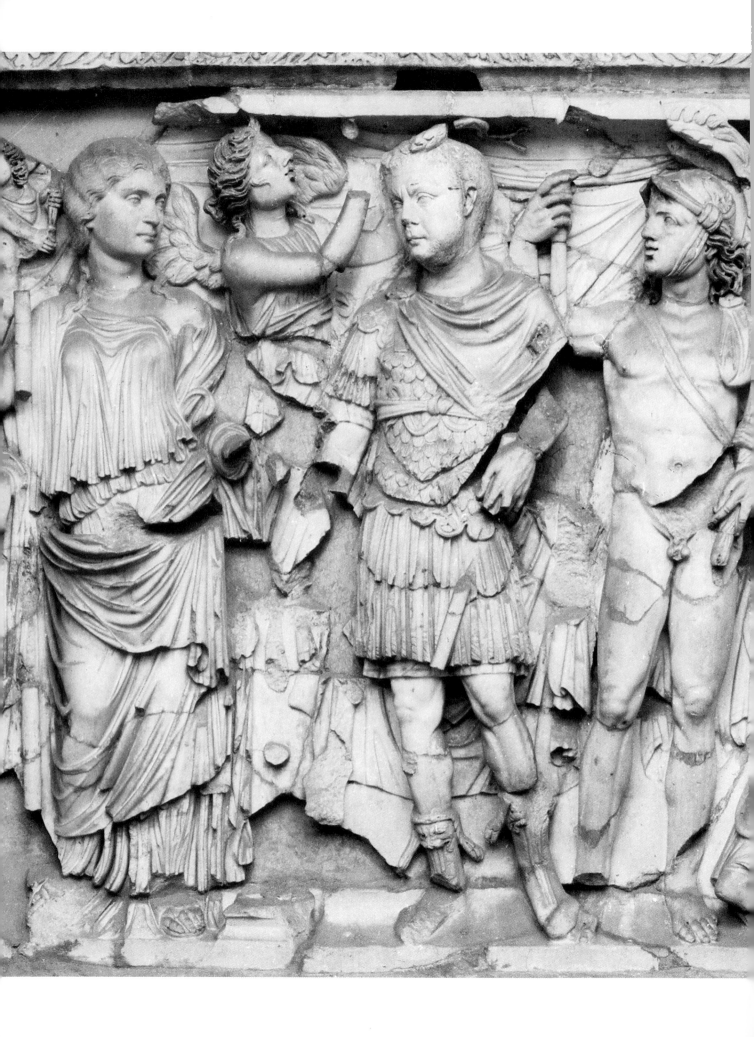

THE THIRD CENTURY

A Century of Civil War

CHAPTER VIII

The legacy of the personality and portraiture of Caracalla continued in the first half of the third century and beyond. Macrinus, who plotted Caracalla's assassination, succeeded him; Macrinus was followed in 218 by Elagabalus, who claimed to be Caracalla's natural son. Like Septimius Severus, Macrinus came from Africa and became Praetorian prefect under Caracalla. He ruled as co-emperor with his ten-year-old son, Diadumenianus, and reversed the Severan policy of richly rewarding the army by lowering legionary pay in the East and ending Caracalla's Parthian War. Both acts made him less popular with the army than Caracalla had been and paved the way for the ascendancy of Caracalla's "son," who was saluted emperor by one of the legions. Macrinus was murdered after his defeat in a decisive battle near Antioch.

Elagabalus, who was emperor of Rome from 218–22, was the grandson of Julia Domna's sister, Julia Maesa. In fact, it was Julia Maesa who maintained that Varius Avitus Bassianus, the son of her daughter, Julia Soaemias, was the son of Caracalla, thus bolstering his claim to be emperor. When he was fifteen years old, he was saluted emperor at Emesa in Syria and renamed Marcus Aurelius Antoninus, a designation that underscored his connection to his alleged father and his descent from an unbroken line of dynasts beginning with the Antonines. The fiction of the Severan dynasty as a continuation of that of the Antonines was alive and well in the first half of the third century. He was, however, called Elagabalus, a name that betrays his Syrian origins because it comes from the name of the sun god of Emesa, Elah-Gabal.

Elagabalus was the hereditary priest of his namesake, and his major undertaking as emperor of Rome was the furtherance and indeed the glorification of his religion. In fact, the greatest architectural accomplishment of Elagabalus's principate was the construction of the splendid Temple of Sol Invictus Elagabalus on the Palatine hill in Rome. The elaborate religious rituals that took place there were sanctioned by the emperor himself, who thus bestowed imperial acceptance on the practice of eastern religions in Rome. The temple and its rites, however, were so intimately bound with the current emperor that after Elagabalus's death the temple was rededicated to a traditional Roman state god, Jupiter Ultor.

Detail. Balbinus Sarcophagus, 238. Rome, Catacomb of Praetextatus. Photo: DAIR 72.482

Julia Maesa and Julia Soaemias continued in the tradition of Julia Domna by wielding considerable power during Elagabalus's principate. To ensure the continuance of the Severan line, Maesa compelled Elagabalus to adopt his cousin Alexander Severus as Caesar, and Soaemias participated in senate debates and oversaw a group of prominent women who determined contemporary rules of etiquette. It was still another woman, Julia Mamaea, sister of Soaemias and mother of Alexander Severus, who plotted against Elagabalus and in 222 convinced the Praetorians to murder both Elagabalus and her influential sister. Mamaea continued to exert considerable power over her son, who was emperor of Rome from 222–35.

Marcus Aurelius Severus Alexander received his new name when he was thirteen on the occasion of his adoption by Elagabalus. He was born Alexianus in 208 or 209 and was also alleged to be a "son" of Caracalla. Although Alexander Severus and Mamaea established good relations with the senate, his military efforts were not as successful. He celebrated a triumph in 233 after his invasion of Mesopotamia, but the young emperor alienated the army when he attempted to buy peace rather than fight in a military encounter on the Rhine. The legions decided they needed a man rather than a boy to lead them and chose a physically powerful Thracian called Maximinus as their next emperor, which soon after resulted in the deaths of Alexander Severus and his mother.

Gaius Julius Maximinus, called Maximinus Thrax because of his Thracian origins, was from peasant stock. His great physical strength led to his appointment as a centurion by Septimius Severus and to his elevation to imperial status when the Roman legions in Mainz recognized that they needed a courageous man to lead them rather than a cowardly boy. Maximinus spent much of his brief principate, which lasted from 235–38, in campaigns in Germany and on the Danube but was himself deposed when the elderly Gordian I and his son were proclaimed co-emperors in 238. The senate recognized the legitimacy of Gordian, but others remained loyal to Maximinus. The son was killed in an attempt to find a military solution to the rivalry. Gordian I committed suicide after he heard the unfortunate news and after serving as Rome's emperor for only twenty-two days. Maximinus was killed at Aquileia.

At the double deaths of the two Gordians, two new co-emperors, Decius Caelius Calvinus Balbinus and Marcus Clodius Pupienus Maximus, were chosen by the senate. The establishment of this dyarchy may have indicated that one man was no longer capable of governing an empire out of control and presaged the creation of the tetrarchy in the late third century. Balbinus and Pupienus were favored because both had had long senatorial

careers, and although they were equal in power, they divided their responsibilities. Balbinus took charge of the administration of the government and Pupienus oversaw the army. Gordian III, son of the daughter of Gordian I, was appointed Caesar. Although the new appointments pleased the senate, the Praetorians were completely dissatisfied, and after only three months in office the joint emperors were taken by force from the imperial palace and murdered.

The Praetorians chose instead the thirteen-year-old Caesar, Gordian III, as the new emperor. In true third-century tradition, the governance of the empire fell at first to Gordian's mother, Maecia Faustina, but Timesitheus, the Praetorian prefect, took control in 241. After Timesitheus's death in 244, he was replaced by Philippus. Gordian celebrated some military success in a campaign against the Persians, but once again the boy was no match for the man and Philippus became emperor after the murder of Gordian in 244.

Julius Verus Philippus came originally from Arabia and is consequently referred to as Philip the Arab. He wielded significant power in Rome as Praetorian prefect during the principate of Gordian III and took advantage of a grain shortage in the city to convince the populace they needed a new emperor. He concluded Gordian's war with Persia and put a high premium on good relations with the senate. He also celebrated an important victory over the Carpi in 247. Finally, it seemed as if Rome again had an emperor who combined military stature with senatorial support, and Philip attempted to found a dynasty by the elevation of his son to the rank of Augustus, also in 247. It was in the next year that Philip was fortuitously able to preside over the thousandth birthday of Rome. Philip's principate, which lasted from 244 to 249, and his dynastic ambitions came to an end after new pretenders to imperial power surfaced and the Goths invaded Moesia. Trajan Decius became leader of the troops in the Danube region. His great popularity with the soldiers led to an imperial acclamation. Both Philip and his son were killed by Philip's men in 249 at a battle at Verona.

Gaius Messius Quintus Decius was born in Pannonia but had Italian connections on his mother's side. The latter may have led him to be a strong supporter of Roman traditions. He even adopted the name Trajan to underscore the association between himself and his second-century predecessor and to signal his support of the senate. It was Philip who appointed Trajan Decius the commander of the Danubian forces, an act that ultimately led to Philip's own demise, because it was Decius's popularity with his troops that compelled them to acclaim him emperor. Decius was emperor of Rome from 249 to 251, and his principate is remembered primarily for the emperor's persecution of the Christians. He rationalized

this by stating that the cults of the old state gods needed to be strengthened in order to ensure the continuation of the empire. Invasions in 250 of both the Carpi and the Goths led to a devastating military defeat for Decius, and the man who had come to power through the military came to a similar end. As Decius and his son, Herennius Etruscus, were trying to make their way back to Rome, they were killed in a battle at Abrittus against the Goths.

Decius was succeeded by Gaius Vibius Trebonianus Gallus, who came from Perusia and was also appointed by the army. Trebonianus's principate was marred by further attacks by the Goths and Persians and by a serious plague that devastated the empire. Trebonianus was murdered in 253 and was succeeded by Marcus Aemilius Aemilianus from Djerba, who was emperor for only three months before he was killed by his own troops after the announcement that Valerian had been proclaimed emperor.

Publius Licinius Valerianus was able to hold onto power for seven years, serving as emperor of Rome from 253 to 260. He was both a senator and a distinguished military commander who had headed a legion in Raetia during the principate of Trebonianus Gallus. Upon the death of Aemilianus, Valerian and his son, Publius Licinius Egnatius Gallienus, both became Augusti of Rome, establishing another dyarchy. Valerian was responsible for the East and Gallienus for the western part of the empire. The dyarchy of the two co-emperors was marred by attacks from the Borani in Pontus, the Goths in Bithynia and along the Ionian Coast. Valerian himself had spent time in the East on the front and was, in fact, captured by the Persians at Edessa in 260.

Prior to 260, while Valerian was occupied in the East, Gallienus participated in military campaigns in the western part of the empire. He led commands against German tribes and the Alemanni in North Italy. Valerian's death left a leadership void in the East filled by military commanders in the area; Gallienus continued on alone as emperor of Rome. Uprisings seemed to spread across the empire with revolts surfacing in Gaul, Africa, the Balkans, Asia Minor, and Greece, but somehow Gallienus managed to keep the empire essentially intact. He reversed Valerian's policy of religious persecution against the Christians but may have alienated the senate by favoring professional military men over senators for command posts.

The senate rejoiced when better relations were established with Gallienus's successor, Marcus Aurelius Claudius Gothicus II, who became emperor after Gallienus's assassination in 268. Claudius came from Illyria and rose through the military ranks, eventually becoming one of Gallienus's leading officers. Marcus Aurelius Claudius Gothicus, whose name signifies his desire to link himself both to the Julio-Claudian and Antonine traditions, received the title *Gothicus* after he celebrated a major defeat over the Goths. He was one of the few emperors of the third century to die a natural death, of the plague at Sirmium in Yugoslavia in 270. His later reputation rested on his victory over the Goths, and even the illustrious Constantine claimed to be descended from Claudius – even though this claim had no basis in fact.

In view of the significance of Claudius's victory over the Goths, which may have restored the faith of the senate and the people of Rome in the emperor and the empire, it is not surprising that Claudius's successor had also distinguished himself in the war against the Goths. The man in question was Lucius Domitius Aurelianus, who served as military commander under Claudius Gothicus and who also may have participated in the assassination plots against Gallienus. Aurelian was of humble birth and came originally from Dacia Ripensis. His principate, which lasted for the five years between 270 and 275, was marked by additional military triumphs, including victories over the Vandals, the Juthungi, the Goths, and Carpi, and especially over Palmyra, which at that time was ruled by the famous Queen Zenobia. As a prisoner, she later participated in the great triumphal procession in Rome in honor of all of Aurelian's victories. Aurelian was the victim of an assassination plot, encouraged by his personal secretary, Eros, that took place before Aurelian could fulfill a last ambitious military campaign against Persia.

It was Aurelian, more than any of his third-century predecessors, who was credited with restoring a modicum of stability to the empire. For this accomplishment, he was called restorer of the world or *Restitutor Orbis*. He was regarded as a brilliant military tactician and controlled the army through strict disciplinary action. He also reformed the Roman coinage and in 274 instituted the cult of Sol Invictus in Rome. It was his hope that the worship of Sol Invictus as the primary god would unify the empire. He was on the verge of renewing the persecution of the Christians when this objective was canceled by his death.

Neither the senate nor the army had a successor waiting in the wings at the death of Aurelian in 275. Finally, an elderly senator, Marcus Claudius Tacitus, was chosen with the hope that his appointment would further cement close relations between the emperor and the senate. Despite his age, Tacitus was the decisive victor in a battle with the Goths. By 276, however, Tacitus was murdered by his troops.

Marcus Aurelius Probus, born at Sirmium, succeeded Tacitus in 276. His major objective was to follow Aurelian's policy of a strong military presence in the provinces and good working relations with the senate. He put down revolts of the Alemanni and other tribes in Gaul and the

Vandals on the Danube, and there were also victories in Pisidia and in Egypt. These successful campaigns led to Probus's celebration of a splendid triumph in Rome in 281. Once again, however, a Praetorian prefect – in this case, Carus – gained enough power to be saluted as emperor by the troops in Raetia, and Probus was killed by his own troops. Despite Probus's considerable military successes, there was a growing discontent among the soldiers, and Probus continued Gallienus's earlier policy of excluding senators from military commands.

Marcus Aurelius Carus succeeded Probus in 282 after serving as his Praetorian prefect. He too had military ambitions and immediately upon becoming emperor left Rome for campaigns against the Quadi and Sarmatians in the Danube region and to wage war against Persia. The second venture led to the capture of Ctesiphon, but Carus was killed in a latter foray in 283, possibly at the instigation of Aper, another scheming Praetorian prefect.

While Carus was on campaign, his elder son, Marcus Aurelius Carinus was Caesar in the West; his brother, Marcus Aurelius Numerianus, also Caesar, had accompanied Carus on his campaign. Carinus, with Numerian at his side, succeeded Carus at his death. Numerian died of mysterious causes in 284, possibly on the order of Aper. It was also in 284 that Diocletian was chosen by the army to succeed Numerian, and he defeated Carinus in 285. It was Diocletian who finally ushered in a period of relative stability and peace and who introduced a new form of government to the empire.

In the hundred or so years between the principates of Trajan and Caracalla, Rome had seven emperors – nine if one counts joint emperors like Lucius Verus and Geta. But in the roughly seventy-year-period between 217 and 284, Rome had twenty full-fledged emperors and many more pretenders. None was able to hold onto power for more than a few years, and only a small number were able to found dynasties and be succeeded by their sons, whose own principates were also short-lived. The uprisings that began in the provinces under the Antonines intensified, and it is therefore no coincidence that most of the third-century emperors were soldiers and that they spent most of their time on the front. Few died at the hand of their foes, however. Most were literally stabbed in the back by their own troops, all too often at the order of their trusted Praetorian prefect.

Relations between the senate and the army were strained. Although some of the third-century emperors were senators and were selected by the senate because of this affiliation, most were professional soldiers from the provinces who had risen through the ranks and were chosen by the troops because of their military prowess or their popularity among their cohorts. The military preoccupation of the third century is also reflected in the names of its emperors. Most adopted the praenomen Marcus, and nomen, Aurelius and retained their own cognomen. This choice attests not only to the continued respect for the Antonine dynasty but also to the affinity these third-century commanders felt for Marcus Aurelius, who had spent most of his principate on the front and who commissioned monumental works that concentrated on military themes.

The brief principates of the emperors of the third century were marked by the kind of political instability that necessitated constant vigilance. Most were themselves occupied on the northern and eastern fronts relegating governmental matters in Rome and the West to a designated Caesar or a Praetorian prefect. Major monuments such as fora, temples, commemorative arches, and columns could not be planned and constructed in such an atmosphere, and the third century might well be termed an artistic wasteland, at least with regard to monumental works of art.

But the third century is not a wasteland when it comes to the works that were produced, that is, coins, portraits, and sarcophagi. The greatest artists concentrated their talents on such works, because these were the major commissions of the day. In fact, the portraits of the third century are among the finest portraits surviving from antiquity, and some of the masterpieces of Roman funerary art were also produced at this time. Even in troubled times, the need for coins was obvious. The military emperors of the third century needed to pay their troops, and they wanted coins with their own portrait and not of a rival. The necessity for portraits in the round was equally obvious. Portraits with the features of the new emperor needed to be set up in Rome and distributed throughout the empire. Sarcophagi were essential to bury the increasing number of military casualties, including the emperors themselves, since in the third century even the emperors were buried in sarcophagi.

The only major architectural projects of the third century, subsequent to the principates of Septimius Severus and Caracalla and before the ascendancy of the tetrarchs in the 280s, were commissioned by Aurelian, whose few years of relatively stable governance allowed him to build both a temple of the Sun and a system of defensive walls. The temple was noteworthy because it was large in scale, incorporated western and eastern features, and was dedicated to a single deity, signaling the increased interest in monotheism in Late Antiquity. Elagabalus had also earlier constructed a temple to Sol Invictus Elagabalus on the Palatine. In a long-established Roman tradition, the funds for Aurelian's temple were provided from the war spoils from Aurelian's victory over Queen Zenobia in Palmyra.

The Aurelian Wall, named for Aurelian and begun in

270 or 271, was also a profound reflection of the sentiment of its time and of the emperor's fervent desire to fortify the capital city after the infiltration of German tribes into the Po Valley. Rome had long ago outgrown the Servian Walls, and the new system enclosed a much larger city in a brick-faced concrete circuit. The building of a defensive wall system in Rome brought military frontier architecture from the provinces to the capital and demonstrated not only Aurelian's concern for the safety of the capital city and its citizens but sent the message to the populace that the enemies who had long threatened faraway lands were now within distance of Rome itself. What was meant to shore up confidence probably dissipated it and may have served to make the public more receptive to the anxious and introspective messages of contemporary art.

Imperial Portraiture

It is actually anxiety and introspection that are the hallmarks of third-century portraiture. Third-century portraits of a series of short-lived emperors may lack the classical composure and unwavering confidence of imperial portraiture of the first and second centuries, but those that have survived are moving human documents which capture the brooding intensity of their subjects and the reflective mood of the times. It is not surprising that the adult portraiture of Caracalla, with its simultaneous emphasis on the solid physical features of a military man and its exploration of his fearsome personality, served as the primary model for third-century emperor portraits. It has been suggested that the third-century emperors who came to power through military election tended to favor a Caracallan style, whereas those chosen by the senate or through hereditary adoption were depicted in a style that owes more to the Augustan ideal. In view of the reverence in which Marcus Aurelius was held in the third century, it is not surprising to see that his portraits, with their smooth, sensuous surfaces played off against deeply drilled hair and beard, sometimes also served as inspiration. As we have seen, the artists responsible for Marcus's portraits portrayed him as a man deeply concerned about the fate of the empire. This latter characteristic also continued to be incorporated into third-century portraiture.

The portraiture of the emperors of the third-century has been well studied, but as in earlier periods there is considerable controversy over the identity of certain heads and over the number of and reason for creating individual portrait types. The situation is further complicated by the brevity of the emperors' principates. Although portraits of all the third-century emperors will be discussed here, individual portrait types will only be considered when there are a large enough number of surviving examples or some other reason to warrant it.

The Portraiture of Macrinus

Surviving numismatic evidence has allowed scholars to isolate two portrait types for Macrinus. What is of special interest about Macrinus's numismatic portraits is that he is depicted on coins in likenesses with a long curly beard and also with a short-cropped military beard, thus alternately associating himself with the Antonine dynasty (especially Marcus Aurelius) and with Caracalla. A bronze portrait in Belgrade has been identified as Macrinus, as have marble heads in the Museo del Palazzo dei Conservatori, the Museo Capitolino, and the Sackler Museum at Harvard. The Conservatori head (fig. 319) represents Macrinus with a creased brow, the bulging forehead musculature and X-shaped naso-labial

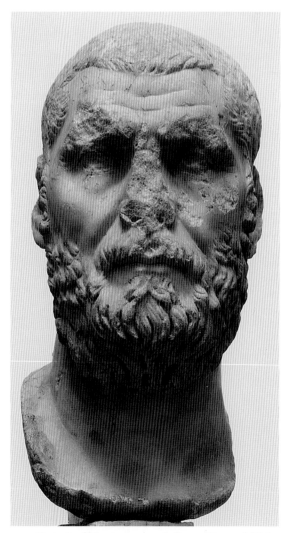

319 Portrait of Macrinus, 217–18. Rome, Museo del Palazzo dei Conservatori. Photo: DAIR 69.2168

pattern of Caracalla's portraits, a short cap of hair that recedes at the temples and resembles Caracalla's military coiffure, and a full moustache and curly beard, plastically rendered with the drill and based on Antonine prototypes. The Conservatori portrait of Macrinus attests to the confluence of Antonine and Caracallan features in the years immediately following Caracalla's demise and also to the fact that contemporary workshops continued to be equally versatile in both an Antonine and a late Severan style.

The Portraiture of Elagabalus

Both Elagabalus and Alexander Severus claimed to be the natural sons of Caracalla. Since the legitimacy of their right to power was based on these assertions, it is not surprising to see them accentuating their familial resemblance to their "father" in their portraiture. Creating a likeness of a thirteen or fourteen-year-old boy was a different artistic problem from portraying a fully formed adult, and artists had to rely on diverse prototypes – namely the prince portraits of the Antonines and Severans, including those of Caracalla himself. A marble head in the Museo Capitolino (fig. 320) has been accepted by most, but not all, scholars as a portrait of Elagabalus. As in the portraits of Caracalla (see fig. 286), the head is round, relatively geometric and blocklike, and the hair conforms to the shape of the head. More Antonine are the individual locks that are longer and more plastically rendered, the feathery eyebrows, and the

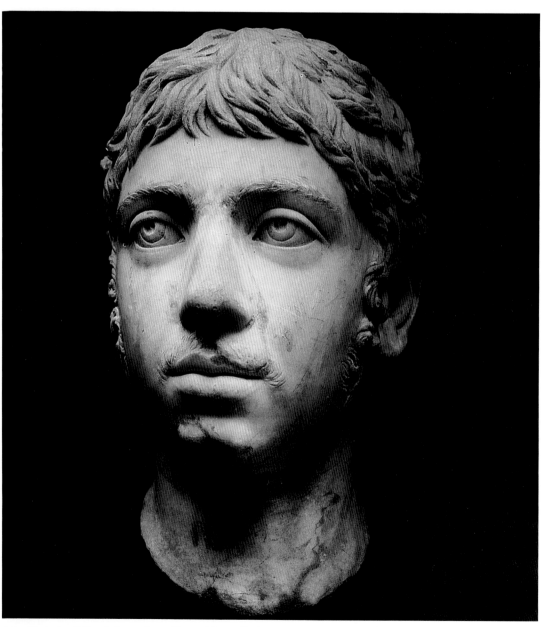

320 Portrait of Elagabalus, 218–22. Rome, Museo Capitolino. Photo: DAIR 4256

long, thick sideburns. Upon becoming emperor, Elaga-
balus was renamed Marcus Aurelius Antoninus, accen-
tuating his connection not only with Caracalla but with
the Antonine dynasty. In the Capitoline portrait, Elaga-
balus also has the slightest hint of a moustache and large,
rounded eyes.

The Portraiture of Alexander Severus

The portraits of Marcus Aurelius Severus Alexander,
"son" of Caracalla, also predictably demonstrate their in-
debtedness to both Antonine and Caracallan portraiture,
but in a somewhat different way. In a securely identi-
fied portrait of the boy emperor, now in the Louvre (fig.
321), for example, the cubic face has been transformed
into a classical oval that, along with the fluid, even sensu-
ous, modeling of the face, recalls Antonine precedents.
The lips are delicately rendered, oval rather than round
eyes are surmounted by straight feathery brows, and
the expression in his eyes has been described as dreamy
and detached, a mood reminiscent of that of Antonine
portraiture. The hair forms an almost even arc over the
forehead in a manner similar to Trajan's coiffure (see fig.
171), but what sets this portrait apart from its second-
century prototypes is that the hair is barely raised above
the scalp and is etched into the surface with a chisel. The
shape of the coiffure is the shape of the skull, and the
technique might be called negative rather than positive
carving. Such a depiction of hair would have been im-
possible without the experiments of such artists as the
Caracalla Master, and the portraits of Alexander Severus
presuppose those of Caracalla.

A portrait of Alexander Severus in the Museo Capi-
tolino appears to be an example of his first official type
and depicts him as younger than in the Paris portrait and
with chubbier cheeks. The Louvre portrait depicts him in
the more mature image that constitutes his second type.
Other surviving portraits, such as one in Florence (fig.
322) and another in Naples (fig. 323), reworked from a
portrait of Elagabalus, show him, respectively, in a toga
with a *contabulatio*, or a flat taut band across the left shoul-
der, which was favored in the third century, and in heroic
nudity assuming a Polykleitan pose. In the statue, he may
have been assimilated to a divinity whose attributes have
long since disappeared, but what is most significant is that
both the Florence and Naples portraits indicate that role
playing continued to be an imperial prerogative in the
third century. Alexander Severus is alternately depicted
as a man with administrative and senatorial powers and
as a superhuman being.

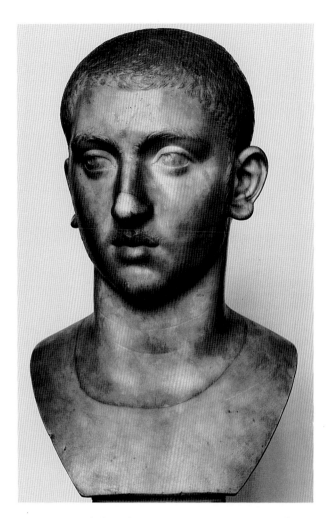

321 Portrait of Alexander Severus, 222–35. Paris, Musée du
Louvre. Photo: Cliché des Musées Nationaux

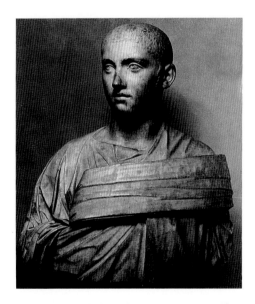

322 Portrait of Alexander Severus, 222–35. Florence, Galleria
degli Uffizi. Photo: DAIR 62.1844

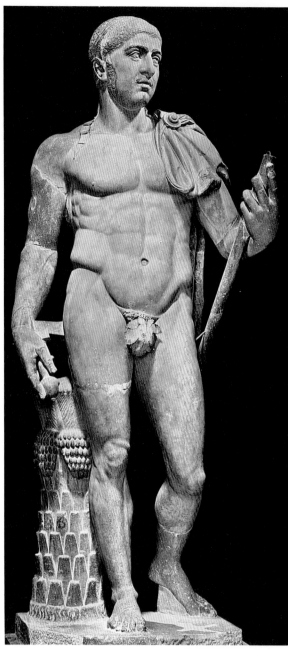

323 Portrait of Alexander Severus, 222–35. Naples, Museo Nazionale. Photo: Alinari/Art Resource, New York, 23010

The Portraiture of Maximinus Thrax

The ascendancy to power of Maximinus Thrax, an adult male who wanted to accentuate his maturity in contrast to the boyishness of his youthful predecessors, brought with it a renewed interest in the adult portraiture of Caracalla that served as the primary model for the new emperor's image. One of the best-preserved portraits of Maximinus Thrax, now in Copenhagen (fig. 324), depicts

a powerful man whose strength is expressed through artistic devices learned from the Caracalla Master. The face, which is rectangular in shape, has an underlying geometry. A subtle X-pattern formed by the furrows between the nose and the creases beside the mouth and the protruding musculature of the brow contribute to the concentrated intensity of the expression. Maximinus's military power is underlined by his short cropped military hairstyle, which recedes at the temples and peaks downward in the center, and the long sideburns and short beard that adhere closely to the shape of his jaw and continue down his neck. The hair over the forehead is only slightly raised and that on the back of the head and of the beard appears to be chiseled out of the stone. The

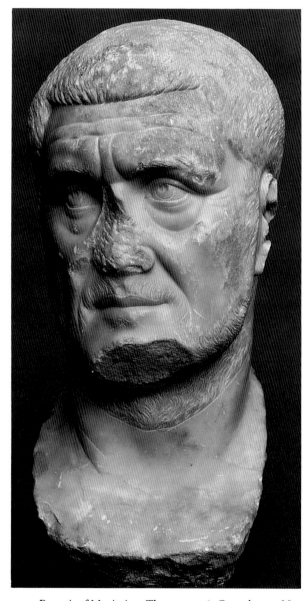

324 Portrait of Maximinus Thrax, 235–38. Copenhagen, Ny Carlsberg Glyptotek. Photo: Courtesy of the Ny Carlsberg Glyptotek, Copenhagen

head is turned to the right and the eyes, with sagging flesh above and heavy bags below, glance in the same direction, suggesting that Maximinus is pondering some unknown fate. The nose, now missing, was broad, and the lips are full and curved.

The Portraiture of the Co-emperors Pupienus and Balbinus

The identification of portraits of Gordian I, who succeeded Maximinus Thrax and ruled for only twenty-two days, and his son, Gordian II, remains too controversial to allow a meaningful discussion. Portraits of the co-emperors Pupienus and Balbinus, who followed the Gordians and themselves remained in power for only three months, have, however, been securely identified and are each preserved in several high-quality examples.

The portrait of Pupienus, now in the Vatican Museums (fig. 325), is a case in point. The marble bust-length portrait, which is finished well below the breastbone and depicts the emperor in a toga with contabulatio, is a fascinating example of the confluence of features of Antonine and Caracallan portraiture, and is evidence that even in 238 artists working in Rome were still fully conversant with both an Antonine and late Severan style.

The Caracallan features include the hair, which adheres to the skull and is chiseled from it. The strands barely emerge from the scalp and are etched in short, negative strokes. The forehead is deeply furrowed, the lines forming an undulating pattern. The lowest forehead wrinkles and the creases at the corners of the mouth form a subtle X-pattern across his face and attest to the profound influence of the underlying facial structure devised by the Caracalla Master. Antonine in origin are the half-

closed sensuous eyes – which, however, also have the faraway glance characteristic of third-century portraits – and the long plastically rendered beard, which is parted in the center and along with the sideburns and beard seems to grow organically from the face. Pupienus was both a senator and a senatorial selection and also the co-emperor who supervised the army. By having himself depicted with an Antonine beard, he emphasized his senatorial side and his descent from such "good" emperors of the past as Marcus Aurelius. Likewise, with his adoption of a short, chiseled military cap of hair, he declared his alliance with the Roman army. The latter effort was to no avail since it was the Praetorians who engineered his downfall.

Balbinus, co-emperor with Pupienus in 238, was also a senator and a senatorial appointment. He was, however, responsible for civil administration while Pupienus supervised the army. The finest surviving portrait of Balbinus (fig. 326) is an original work of art fashioned by a leading artist of the day for the lid of the emperor's sarcophagus, now in the Catacomb of Praetextatus in Rome. The portrait head surmounts a togate figure of the emperor who, along with his wife, is depicted as reclining on the top of a sarcophagus that is in the form of a funerary bed (see fig. 356).

The origins of such a kline group portrait, as well as the subject matter and style of the scenes on the main body of the sarcophagus, will be discussed later in this chapter. What is of significance here is the portrait head, which shows Balbinus with an oval face, full cheeks,

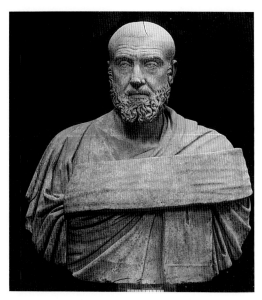

325 Portrait of Pupienus, 238. Rome, Vatican Museums. Photo: DAIR 686

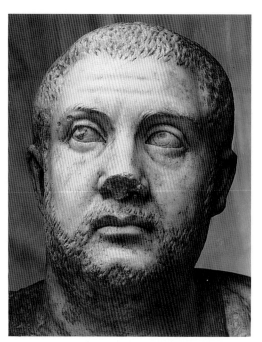

326 Portrait of Balbinus, from the lid of the Balbinus Sarcophagus, 238. Rome, Catacomb of Praetextatus. Photo: DAIR 38.667

broad nose, full, curved lips, large eyes with a faraway glance, and relatively straight brows with individually delineated hairs. Fleshy pouches below his eyes suggest impending age, but the forehead, bridge of the nose, and cheeks are not as deeply creased as in the portraits of Maximinus Thrax or Pupienus. That this is a posthumous portrait of a deceased emperor may have something to do with the wrinkles having been somewhat smoothed over. Balbinus wears his hair in a military crewcut that recedes at his temples. The cap of hair is barely raised over the scalp, and the individual strands of hair are chiseled into the skull. This shorthand, even impressionistic, technique is used also for the sideburns, moustache, and short beard. The beard adheres so closely to the jaw that it seems as if it is the jaw itself that has been gouged with short chisel marks to create what looks more like a slight growth than a full-fledged beard.

The portrait of the deceased emperor does not depict him in heroic nudity or as a god but rather as a civil magistrate. This does not mean that such statues of Balbinus and other third-century emperors were not produced. Examples include the nude statue of Alexander Severus in Naples (see fig. 323) and a full-length marble statue of Balbinus as Jupiter from the Piraeus in Greece (fig. 327). In its general type, the Piraeus statue is based on such early imperial masterworks as the statues of Claudius as Jupiter with an eagle with outstretched wings from Lanuvium and Olympia (see figs. 106–107); that the latter statue of Claudius was manufactured in Greece demonstrates a liking for such depictions in the eastern part of the empire.

The subtle contrapposto of the Claudian statuary type, with the weight on the right leg and the left leg relaxed and drawn back, is missing in the third-century version, in which Balbinus stands with both feet next to one another and flat on the ground. The sinuous S-curve of the earlier statue has been replaced with a less fluid and more solid image in which the full torso is not as fully revealed but covered in part by a large triangular fold. Claudius's powerful musculature is replaced by a more flaccid body and is accompanied by a face with bloated cheeks and chin. Balbinus's veristic facial features owe much to the realistic portrait of Claudius, but the statue as a whole has lost the majesty and grace of its first-century predecessor. The third-century artist's disposition toward an underlying geometric structure and a striving for inner essence over outer beauty of form is apparent in this portrait.

The Portraiture of Gordian III

Gordian III, heir to Gordian I and Caesar under Pupienus and Balbinus, became emperor after their assassina-

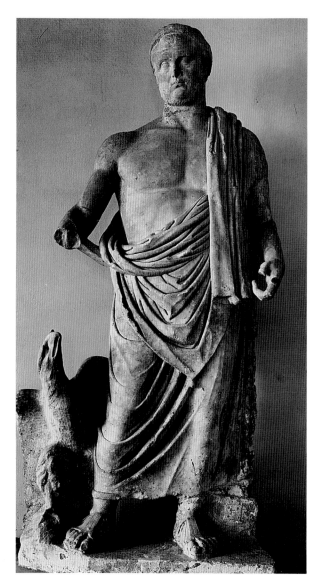

327 Portrait of Balbinus as Jupiter, from Piraeus, 238. Piraeus, Museum. Photo: Deutsches Archäologisches Institut Athen

tion when he was only thirteen years of age. Even though he was dominated at first by his mother and then by the Praetorian prefect – also his father-in-law, Timesitheus – numerous portraits of at least two types were commissioned of him during his six-year principate.

Type I, a childhood portrait, was produced between 238 and 241. It is exemplified by a fine portrait in Berlin (fig. 328), representing the boy in a finished togate bust with contabulatio. Characteristic of Gordian is the pronounced triangularity of his face, with broad cranium and narrow chin, the long nose, rounded lips, almond-shaped eyes, and slightly arched, thick brows with individually delineated hairs, which grow together at the bridge of his nose. The eyebrows thus create a triangular configuration that matches the sharp triangle of the chin and is reiterated still again in the triangular peak of the hair in

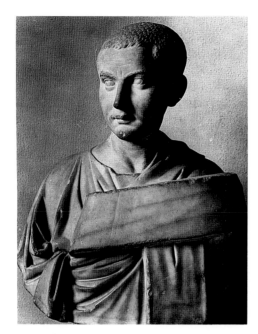

328 Portrait of Gordian III, 238–41. Berlin, Staatliche Museen, Antikensammlung. Photo: Bildarchiv Foto Marburg/Art Resource, New York, 1.132.362

the center of the forehead. This reiteration of triangular shapes, which create a crescendo across the face, gives it an underlying geometry. The resulting structure is quite different from the X-shaped facial organization of Caracalla's portraits but is, nonetheless, the result of the same quest for organic systematization that characterizes third-century portraiture in general and is based on the artistic experiments of the Caracalla Master.

Gordian III's second portrait type, usually referred to as the adolescent type and datable to 242–44, represents a boy whose imperial responsibilities have matured him beyond his youth. The best example of the type is a colossal marble head from Ostia (fig. 329) that purports to depict a young but powerful presence. It is an image meant to impress the spectator into believing that Gordian could govern Rome without the help of his mother or Timesitheus. The peaked cap of hair, knitted brows, and triangular chin still give the head its fundamental structure. Although the smooth brow and cheeks continue to accentuate Gordian's youthfulness, two deep vertical lines above his nose, the cleft in his chin, and the intensity expressed in the large staring eyes imbue the portrait with a new maturity, underscored by the longer sideburns and the delicately etched moustache. The cap of hair is slightly raised above the skull and is hatched in with short chisel strokes that delineate the thick eyebrows. The geometric structure of the head with its repeating triangles is accentuated to such a degree that it has become an end in itself, and the face has been frozen

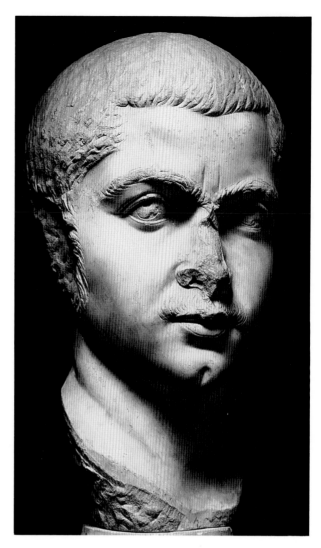

329 Portrait of Gordian III, from Ostia, 242–44. Rome, Museo Nazionale delle Terme. Photo: Alinari/Art Resource, New York, 17373

or abstracted into a kind of symbol – or what one scholar calls an ideogram – and may reflect the style of a specific artistic personality who created portraits not just of Gordian but also of his wife Tranquillina.

Though still a boy, Gordian had some success in military campaigns against the Persians. Although he was not a renowned commander, he commissioned portraits of himself in military dress and even as a great victor. An over-life-size marble portrait of Gordian in cuirass and paludamentum (fig. 330), for example, is of special interest because it is a half-portrait cut off at the waist and because of the culmination of artistic experimentation with the extension of the bust, which began at the collarbone in Augustan times.

It has recently been suggested, however, that the bust was possibly recut from a full statue. Furthermore, the military subject matter of the portrait has been associated with the ascendancy of Timesitheus. A medallion made

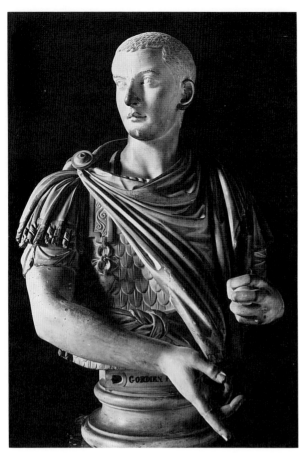

330 Portrait of Gordian III, from Gabii, ca. 243. Paris, Musée du Louvre. Photo: Giraudon/Art Resource, New York, 1346

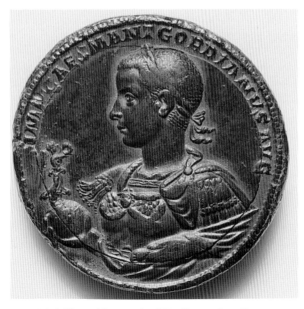

331 Medallion with portrait of Gordian III, from Rome, 238. Berlin, Staatliche Museen. Photo: Hirmer Verlag München, E2030 916V

in 243 (fig. 331) would seem to underscore this assertion. Gordian is represented on the obverse in a profile half-length portrait wearing the cuirass and paludamentum. He cradles a scepter(?) in his left arm and holds an orb with a figure of a winged Victory presenting him with a laurel wreath in his right hand. The youth, with his smooth cheeks and short military coiffure, is thus portrayed as a world ruler, decked out with a panoply of the symbols of his administrative and military roles. On the reverse, Gordian is depicted in a scene of adlocutio to his troops.

The Portraiture of Philip the Arab

Philip the Arab was the man to replace the boy. His maturity is therefore emphasized in portraits that owe much to the adult portraiture of Caracalla. Although only two portraits in the round of Philip appear to have survived, one of them, a togate bust with contabulatio in the Vatican Museums (fig. 332), is a masterpiece of third-century art. In the Vatican bust, Philip's head is turned sharply to the right. His rectangular face is structured by the imposition in the center of an X-shape of forehead bulges and mouth creases. His forehead is deeply lined, his nose prominent, and his lips rounded. His eyes are narrow slits, but they possess the distant glance characteristic of third-century portraits. The eyebrows are relatively straight and are accentuated at the inner corners by deep diagonal wrinkles. Philip wears his hair closely cropped in a military cap that recedes at the temples and peaks downward in the center. The cap is raised somewhat from the skull and the individual strands hatched in. The beard is very slight, although it covers much of the neck as well as the jaw. The effect is more of an unshaven man than of a man with a beard because the hairs have been stippled into the chin and neck with a chisel. In the Vatican portrait, the short coiffure and beard of the soldier are combined with the civilian costume of a constitutional leader. This is not surprising because Philip prided himself on his simultaneous success on the battlefield and with the senate.

After a significant campaign against the Carpi in 247, Philip the Arab elevated his son, Philip II, to the rank of Augustus and attempted to found a dynasty based on those of the Antonines and Severans. Coins and medallions commemorated the foundation of the new partnership and, at the same time, glorified the imperial family in a manner inspired by Severan dynastic art. An example is a medallion, made in 247, that depicts profile portraits of Philip the Arab, his wife, Otacilia, and Philip II. Philip the Arab is on the left with Otacilia silhouetted behind him, and their son faces them on the right. Both Philips are portrayed with the paludamentum, and the

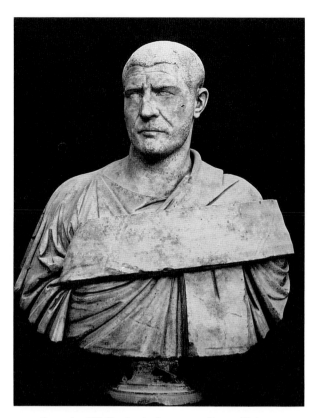

332 Portrait of Philip the Arab, 244–49. Rome, Vatican Museums. Photo: DAIR 651

it appears to have been made of a more malleable material like clay. The undulating planes of the face have been molded by an anonymous artist who has captured the physical reality of a soldier-emperor whose visage also mirrors the instability of troubled times. Although Decius's face is essentially oval, the sinuous curves of its outline convincingly reflect the shifting surfaces of real flesh. In characteristic third-century fashion, however, a strict geometric order is imposed even on this head by the deeply etched and repetitive pattern of forehead lines and the ubiquitous X-shaped creases between the eyes and next to the mouth.

Decius resembles other third-century emperors in yet another way. He wears the cropped military hairstyle and short beard in vogue since Caracalla. The coiffure is again a slightly raised cap, although the recession at the temples is very pronounced. Moreover, the strands of hair above the ears are relatively long and are brushed toward the face in a manner reminiscent of Trajan (see fig. 172). The beard conforms closely to the shape of the jaw and is, in fact, chiseled from it. The eyes are shadowed by thick undulating eyebrows, and the eyes themselves are large and curve downward at the corner, giving Decius a mournful expression. The pupils are large and heart-shaped, and there are sagging pouches beneath the eyes. The lips are rounded, and there are subtle indentations in the flesh at the corners. The neck is lined and sunken, suggesting the advancing age of the emperor.

The Capitoline portrait of Trajan Decius could be viewed as a paradigm for the third century. A master artist has described in minute detail the peculiar characteristics of the face of Decius and has also captured Decius's concern for both the state of the empire and for his own and his family's fate. At the same time, the artist has made the shifting facial planes and anxious expression of a specific historical personage a visual symbol of unstable times and human apprehension of the unknown. The anonymous creator of the Capitoline portrait of Decius had to express in a single image what the designer of the Column of Marcus Aurelius could in a winding narrative. The master of the Decius portrait knew only too well that in the political and social chaos of the third century, there was no time for more.

A second noteworthy portrait of Trajan Decius is the full-length marble statue of the emperor in the Museo del Palazzo dei Conservatori (figs. 334–335). It is not of high artistic merit and was certainly not done by the talented artist of the Capitoline head. Its interest lies rather in the fact that the emperor is represented in the guise of Mars. He is nude save for a mantle draped across the top of his chest; he also wears a helmet. Decius carries a sword in his right hand and rests his weight on his left leg; his right leg is bent and turned to the side. The statue is

younger Philip wears the same short military hairstyle as his father. In fact, the numismatic portrait of Philip II, with his military costume and coiffure and his smooth-cheeked youthfulness, is clearly based on the childhood and adolescent portraits of Gordian III (see figs. 328–331).

The Portraiture of Trajan Decius

Decius became emperor of Rome because of his popularity with the army, but like Philip the Arab he also courted the support of the senate. It was for this reason, as well as because of his mother's Italian connections, that he added the name Trajan to his own, thus associating himself with the "good" emperor of the second century as well as with senatorial tradition. Five surviving portraits, of which the finest is a marble head in the Museo Capitolino (fig. 333), have been securely identified as Decius.

The Capitoline head is one of the masterworks of third-century portraiture and must have been made by one of the leading artists of the day. Even though it is fashioned from marble, it is so sensitively rendered that

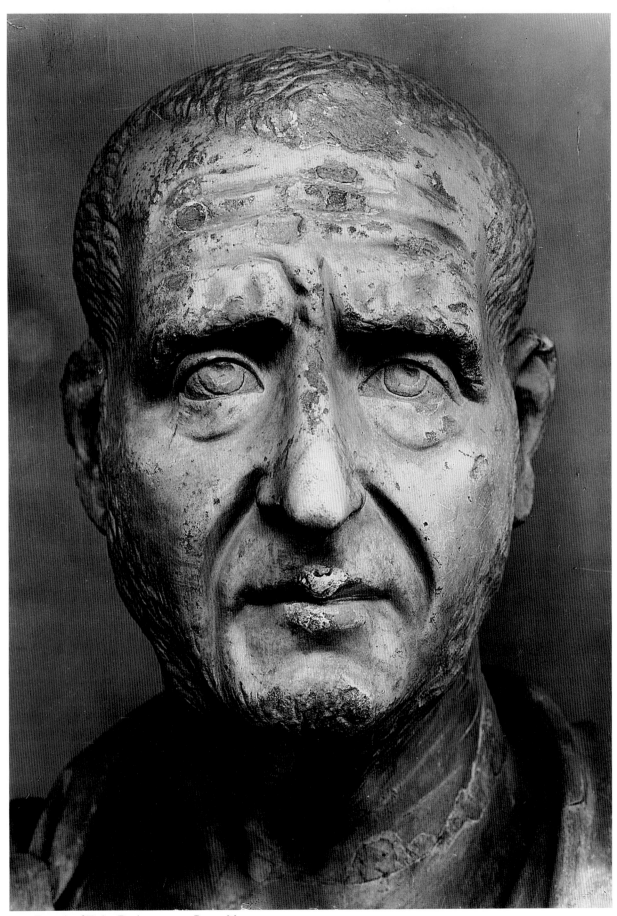

333 Portrait of Trajan Decius, 249–51. Rome, Museo
Capitolino. Photo: DAIR 55.13

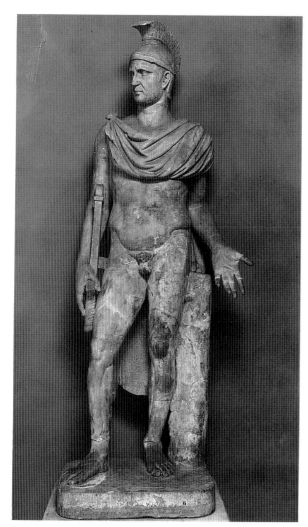

334 Portrait of Trajan Decius, 249–51. Rome, Museo del Palazzo dei Conservatori. Photo: DAIR 57.356

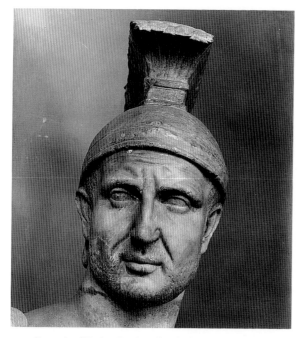

335 Portrait of Trajan Decius, detail of head, 249–51. Rome, Museo del Palazzo dei Conservatori. Photo: DAIR 57.357

probably based on the fifth-century B.C. Ares Borghese of Alkamenes, which was favored as a statuary type by emperors like Hadrian in the second century. The sharp turn of the head to the right, the outward turn of the right leg, and the outstretched left hand are, however, variations on both the Greek type and its second-century interpretations. The result is a statue that is expressive both in body and face, because the portrait head shares the emotionality of its third-century counterparts but is unintentionally awkward and lacking in the grace of its statuary prototypes.

The Portraiture of Trebonianus Gallus

Another graceless but emotionally powerful third-century statue is the colossal bronze of Trebonianus Gallus discovered in Rome near the Church of S. Giovanni in Laterano (fig. 336). Its association with Trebonianus is not universally accepted by scholars. Nonetheless, its towering stature identifies it as an imperial personage, and its physiognomy and ferocious intensity suggest Trebonianus.

The statue, which is the only extant full-length bronze from the third century, depicts a nude Trebonianus in a pose that is loosely based on the Hellenistic Alexander with a lance type by Lysippos. The upraised right hand originally grasped a long lance and the emperor's weight is on his right leg; his left leg is bent and placed somewhat behind the other with the heel raised. The musculature of the torso is barely articulated, and a mantle is draped over his left shoulder and wound around his left arm. The size of the head is too small for the colossal proportions of the body. Perhaps paradoxically, it is in the head rather than the body that the expressive intensity of the portrait lies. The oval face is turned slightly to the left and rests on a powerful neck. The lined forehead has a bulging profile, and there are also vertical creases above the bridge of the nose and at the corners of the mouth. In fact, an X-pattern across the center of the face, derived from other third-century portraits but ultimately based on Caracallan models, serves as its underlying structure. The nose is broad, the lips slightly curved, and the almond-shaped upraised eyes shadowed beneath protruding brows. The face has an almost animalistic ferocity, and the models for both the face and massive nude body seem to be those of athletes and gladiators, like those in the mosaic pavement from the Baths of Caracalla, rather than imperial statues.

The shape of the hair and the beard of Trebonianus Gallus is the shape of the skull and the jaw, the individual hairs etched into the surface and barely raised from it. Here the negative carving technique invented for stone portraiture has been successfully transferred to metal.

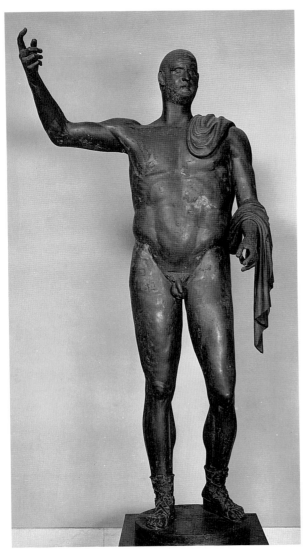

336 Bronze portrait of Trebonianus Gallus, from Rome, 251–53. New York, Metropolitan Museum of Art, Rogers Fund, 1905. Photo: Courtesy of the Metropolitan Museum of Art, 05.30

a few days' growth than of a man with an ample head of hair and a full beard. Such a rendition of hair and beard contributes to the military nature of the portrait – that is, of a soldier too busy on the front to cut his hair or shave his beard and is a far cry from the patrician portraits of the Antonine emperors, including Marcus Aurelius, with their flowing locks and corkscrew beards.

At mid-century, the artistic language created decades earlier by the Caracalla Master continued to be the one that best captured the physical characteristics and inner essence of the typical third-century emperor. It was under the successors of Trebonianus Gallus, Valerian, and Gallienus, that a new style began to come into being.

The Portraiture of Aemilianus

The principate of Aemilianus lasted only three months. He was appointed by the troops that opposed Trebonianus Gallus and was murdered by his own army. There is no extant, securely identified portrait of Aemilianus, but numismatic portraits struck in Rome during his principate depict an emperor who resembles Trebonianus Gallus. He has a high, bulging forehead, a strong hooked nose, creased forehead and cheeks, and a short, military hairstyle and beard. The hair of both is indicated by small, impressionistic strokes.

The Portraiture of Valerian

The new style was characterized in part by a retrospective attitude on the part of its patrons, who, in staunch Roman tradition, wanted to associate themselves – for political reasons – with great emperors of the past. Valerian, a senator, was able to stay in power for seven years, a long time in third-century terms, and – with a son to carry on the tradition – even established a dynasty. Despite his seven years as emperor, there is only one surviving portrait that has been universally accepted as a portrait of Valerian, although there are Sassanian rock-cut reliefs in Iran with likenesses of Valerian that were produced by local artists with a different cultural background and have no bearing on the development of Roman imperial portraiture.

The portrait in question is a marble head that is probably from Asia Minor (fig. 337). The portrait shows Valerian with a square face and pointed chin, high forehead, broad nose, curved lips, almond-shaped eyes that gaze into the distance, and arched brows. The forehead lines are not pronounced, but there are two vertical lines at the bridge of the nose and deep naso-labial creases. The pronounced arch of the brows and the cheek creases do form an X-pattern across the center of the face, a last vestige of Carcallan facial structure. Valerian is depicted with a slight, stippled moustache and beard, but what is distinctive and sets this portrait apart from its third-century predecessors is the length and arrangement of the hair.

The slightly raised, chiseled military cap is rejected in favor of a fuller coiffure with short, comma-shaped locks. These are parted in the center with one group brushed left and the other right. There is recession at the temples, but additional locks are carefully combed forward over each ear. The prototype for such a hairstyle is found in the portraiture of Augustus and the Julio-Claudians; it was also resuscitated under Trajan. Valerian's decision to have himself portrayed with such a coiffure was a momentous one and represents a significant break with what by now was the tradition of third-century portraiture. It could, of course, be argued that the Copenhagen head

quotations are, however, combined with an increased taste for formal abstraction, which was a later but parallel development to the greater use of frontality, isolation of the main protagonist, hierarchy of scale, and so forth, in the state reliefs of late Antonine and Severan times. Gallienus himself did not commission any major monuments during his principate, but a contemporary of his, a Roman equestrian, rededicated an arch in Rome in honor of Gallienus and his wife, Salonina, which dates to about 260–68. The arch was not a new structure but a reused Augustan gate, the Porta Esquilina, which was transformed into the "Arch of Gallienus" by the addition of a double inscription naming Gallienus and Salonina. One scholar has recently attempted to demonstrate that the Gallienic patron deliberately chose an Augustan monument for rededication to the third-century emperor. If so, Gallienus's desire to associate himself with Rome's first emperor must have been widely known and in this instance capitalized on by someone hoping to win the emperor's favor.

The Portraiture of Claudius Gothicus

Claudius Gothicus, like Gallienus, favored allusions to earlier emperors in his portraiture. His full name, Marcus Aurelius Claudius Gothicus, demonstrates his allegiance to both the Julio-Claudians and the Antonines, and the title Gothicus refers to his military victory over the ever-threatening Goths. On the basis of its similarity to heads of Gothicus on coins, a marble portrait now in Worcester (fig. 341) has been identified as a portrait of Claudius Gothicus. He has retained Gallienus's Julio-Claudian cap of hair, which is arranged in comma-shaped locks over the forehead and parted in the center in a manner approximating Claudius himself. He wears a short but curly beard which like Gallienus's resembles that of Hadrian, the founder of the Antonine dynasty. His face is oval, he has a high, slightly lined forehead, an aquiline nose, and rounded lips, and the portrait may be said to continue not only the historical allusions but also the abstract tendencies of Gallienus's portraiture. Since this identification remains controversial, it is important to note that the same characteristics can be seen in extant numismatic portraits.

The Portraiture of Aurelian

Aurelian, like Claudius Gothicus, celebrated a victory over the Goths, but his main claims to fame were his triumph over the famous Zenobia in Palmyra, the construction of the Aurelian Walls in Rome, and the bestowal of the imperial stamp of approval on the cult of Sol Invictus in Rome and the empire. Numismatic portraits,

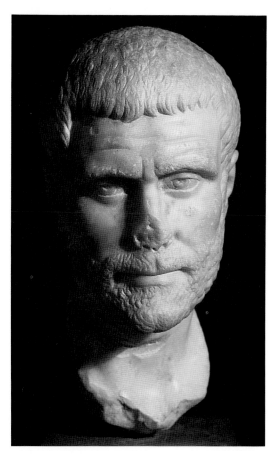

341 Portrait of Claudius Gothicus, 268–70. Worcester Art Museum. Photo: Courtesy of the Worcester Art Museum, Worcester, Massachusetts

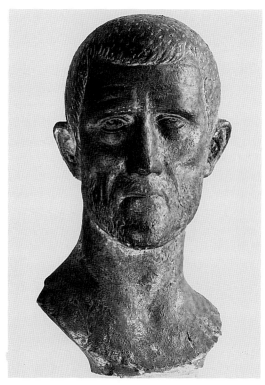

342 Bronze portrait of Aurelian, 270–75. Brescia, Civici Musei d'Arte e di Storia. Photo: Courtesy of the Civici Musei d'Arte e Storia di Brescia

as well as a bronze head of Aurelian, now in Brescia (fig. 342), demonstrate that the new emperor continued to commission portraits in the Gallienic abstract style but combined it with a resuscitation of the military hairstyle of the first half of the third century. The military reference is not surprising in view of the emperor's emphasis on major campaigns in the provinces and the erection of a defensive wall system in the capital.

The Brescia portrait depicts Aurelian with a slightly raised cap of hair that recedes at the temples and is hatched in with stippled strokes. There is just a hint of looser, more individual locks across the forehead and in front of the ears, a vestige of the Gallienic classical revival. The beard is short and individual curls are indicated; these are flatter than those in Gallienus's portraits but clearly derived from them. Aurelian's face is almost an immobile abstract mask, the forehead has both horizontal and vertical creases, and there are also naso-labial lines. The eyes are narrow, the eyebrows straight, the nose aquiline, and the mouth tightly closed and slitlike.

The Portraiture of Tacitus

Aurelian was succeeded by Tacitus, an elderly senator who, although also victorious over the Goths, was killed before too long by his own troops. No extant portrait of Tacitus has been identified with certainty. Numismatic likenesses depict him with the same military cap and beard with individual curls as Aurelian and in a similar abstract style.

The Portraiture of Probus

Tacitus was followed by Probus, who hoped to continue Aurelian's objectives of a strong provincial policy and a positive alliance with the senate. Like Aurelian, he had successful military campaigns and celebrated a major triumph in Rome in 281. It is therefore not surprising that Probus's portraiture is based on that of Aurelian. Such continuity of style is due in part to the succeeding emperors' shared objectives and also to the continuity of artists whose association with an imperial workshop outlasted their patron's tenure as emperor. An over-life-size marble head of Probus, now in the Museo Capitolino (fig. 343), shows its indebtedness to its Aurelian prototype.

Probus's head is rectangular in shape with a high forehead, narrow eyes beneath straight brows, an aquiline nose, and narrow lips. His glance is more frontal than is customary for the third century. He wears a short beard, which like Aurelian's adheres to the shape of the chin and consists of individual flat locks. Also in the manner of Aurelian, Probus wears a short military coiffure, which recedes at the temples and which in the severity of its shape accentuates the geometric quality of the head. Close examination of the back of the head indicates that the hair is impressionistically rendered with short chisel marks, but the hair directly over the forehead and in front of the ears is divided into individual commalike locks. In the portraiture of Probus there is a fascinating confluence of Gallienic classicism, Caracallan military imagery, and Gallienic abstraction, which demonstrates that Roman eclecticism continued to flourish in the second half of the third century. This is a significant head that prefigures both the portraiture of the Tetrarchs and of Constantine the Great.

The Portraiture of Carus, Numerian, and Carinus

Carus and his two sons, Carinus and Numerian, were emperors of Rome between the death of Probus in 282 and the rise to power in 284 of Diocletian. No portraits of Carus and Numerian have been securely identified, although there are surviving numismatic likenesses of both. Carus's portraits continue to be executed in an abstract style, and the emperor is shown with a military hairstyle and short beard. Numerian, a youth, is depicted with a fuller coiffure with comma-shaped locks and long sideburns.

A marble head in the Conservatori Palace (fig. 344) has been associated with Carinus. Carinus is depicted with the smooth cheeks and triangular face of Gallienus, and he also adopts Gallienus's curly beard, which is rendered in a full plastic style owing much to the portraits of Hadrian. His hair adheres closely to his head like a cap and recedes at the temples, as was customary in the portraits of soldier-emperors, but the individual locks are rendered in a somewhat fuller manner than traditional military images, and there are looser locks over the forehead.

Third-Century Portraits of Imperial Women

Third-century imperial male portraiture has been called veristic by some scholars who have suggested that the creased and furrowed faces of the soldier-emperors were ultimately based on those of elderly and wizened republican patricians. The hallmark of female portraiture during the republic was also its descriptive nature. Aristocratic women of a certain age were favored as subjects for portraiture and were depicted with the same wrinkles and blemishes as their husbands. Third-century portraits of women are also largely characterized by the maturity and even homeliness of their subjects, who are represented in a matter-of-fact and even unflattering manner. The Antonine beauties, like Faustina the Younger, with their oval faces and even features, luminous eyes, and

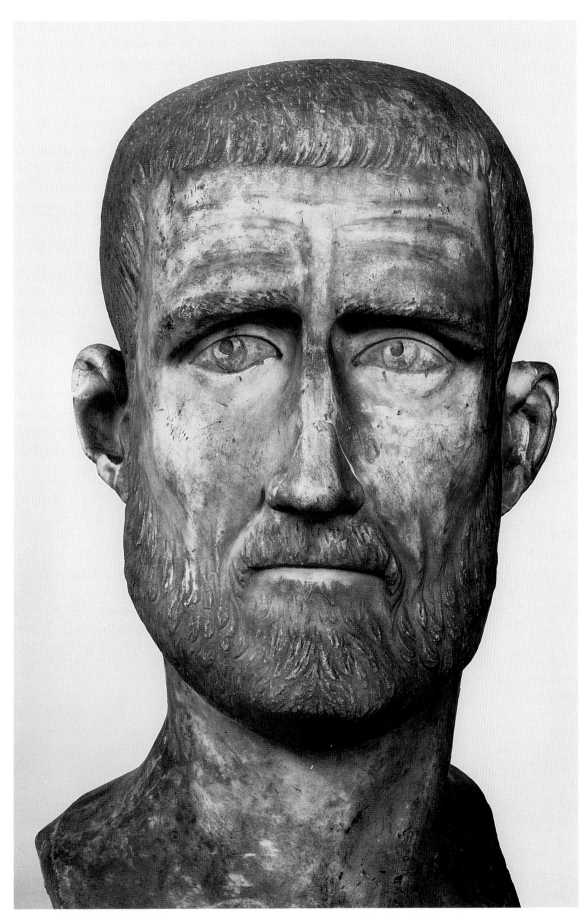

343 Portrait of Probus, 276–82. Rome, Museo Capitolino.
Photo: Gisela Fittschen-Badura

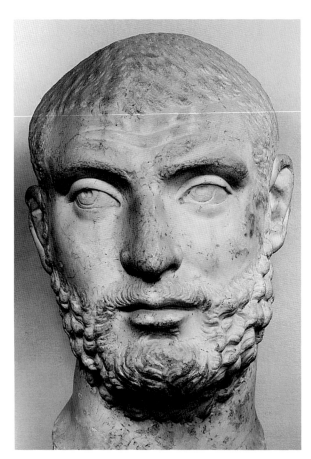

344 Portrait of Carinus, 283–84. Rome, Museo del Palazzo dei Conservatori. Photo: Gisela Fittschen-Badura

and these are surmounted by feathery brows that nearly meet over her nose. She has a large broad nose, sagging cheeks, and curved lips that are tightly shut to hide her projecting teeth.

Balbinus's wife, whose name is not known, is represented with him in a group portrait on the lid of his sarcophagus in the Catacomb of Praetextatus in Rome (see fig. 356). Her likeness (fig. 346) shows her with a round, fleshy face with heavy chin. Her upraised eyes are framed by arched brows that meet over the bridge of her nose. Her hair is parted in the center and is brushed in loose waves that almost entirely cover her ears and more closely approximates Julia Domna's coiffure rather than Julia Mamaea's.

A private portrait of an anonymous woman, now in the Museo Capitolino (fig. 347), is a fine example of the taste for realism in the portraits of third-century females. The marble head depicts an aging woman with a hairstyle that is a simplified version of the coiffure of Julia Mamaea. It is parted in the center and brushed in limp waves behind her ears. The face is geometrically organized. Its overall shape is that of a rectangle, the eyes are rounded, and the eyebrows form simple arches. The nose is large and long and the lips tightly closed. Most noteworthy is the artist's expert rendition of the sagging flesh of the cheeks, chin, and neck.

The wife of Philip the Arab, Otacilia Severa, is known not only through the dynastic family portraits on Philip's coins and medallions but in a number of surviving marble heads. One portrait type, preserved in three replicas, is exemplified by a head from the Via dei Fori Imperiali in Rome (fig. 348). Otacilia is depicted with the round, fleshy face of Balbinus's wife and a simple parted and waved coiffure that is severe and brushed behind the ears like that of Julia Mamaea. Otacilia's forehead and cheeks are unlined, as are those of other third-century imperial women, indicating that even though they are depicted as aging matrons, they are not portrayed with the deep lines of concern that etch the faces of their husbands, who bear the burden of their office. Her almond-shaped, upraised eyes are surmounted by straight, narrow brows.

The portraits of Furia Sabina Tranquillina, wife of Gordian III, are different in a number of significant ways from their immediate predecessors and seem to herald the adoption of the new abstract style in female portraiture of the third century that was to blossom under Gallienus. The marble head of Tranquillina in London (fig. 349) embodies all of the characteristics of the new style. The empress's youth is incorporated into her portrait, and she is depicted with soft, unlined skin. Her face is a perfect oval, although her sharply pointed chin transforms the oval into a triangle and makes the overall shape of her head more comparable to Gordian's. Her hair is

hairstyles resembling those of classical Greek goddesses, are gone, replaced by stern, even dour, Roman matrons whose unpleasing visages suggest that the third century was as trying for them as for their beleaguered husbands.

The primary model for third-century female portraits was the portraiture of Julia Domna (see figs. 290–292). It is her wiglike hairstyle, parted in the center and brushed in deep waves covering her ears, that is adopted by her third-century successors, who, however, rejected her somewhat idealized features in favor of a more practical realism.

The portraits of Julia Mamaea, mother of Alexander Severus and – at the beginning of his principate at least – the one who wielded imperial power, is a case in point. A marble bust-length portrait in the Museo Capitolino (fig. 345) depicts her with a smooth, oval face. Her hair is a more naturalistic and severe version of a Julia Domna coiffure, in which the hair is parted in the center and brushed in rippling waves behind her ears where it falls straight but short of her shoulders and ends with a slight curl at the bottom. The rest of the hair is coiled in a bun at the back of the head. Mamaea is given the same almond-shaped eyes with a faraway glance as her son,

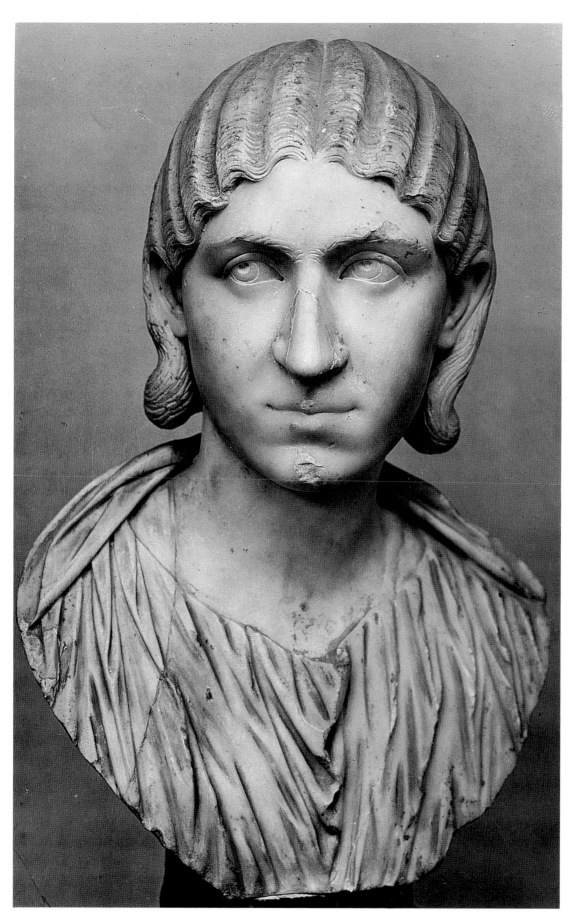

345 Portrait of Julia Mamaea, 220s. Rome, Museo
Capitolino. Photo: DAIR 57.743

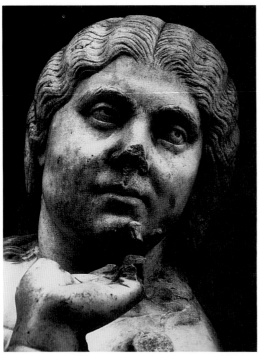

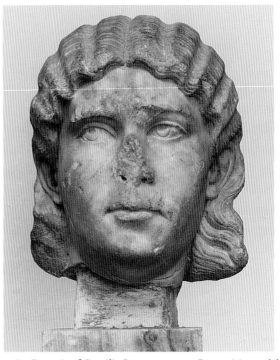

346 Portrait of Balbinus's wife, from the lid of the Balbinus Sarcophagus, 238. Rome, Catacomb of Praetextatus. Photo: DAIR 38.668

348 Portrait of Otacilia Severa, 244–49. Rome, Museo del Palazzo dei Conservatori. Photo: DAIR 69.2161

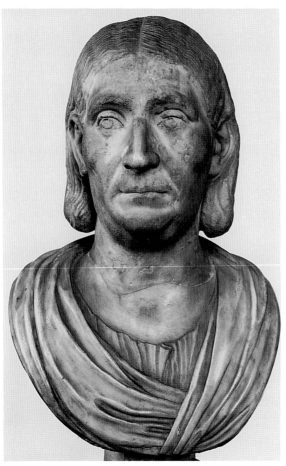

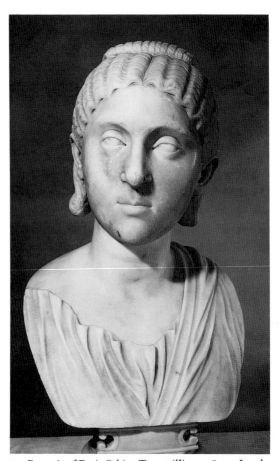

347 Portrait of an anonymous woman, 220s. Rome, Museo Capitolino. Photo: Gisela Fittschen-Badura

349 Portrait of Furia Sabina Tranquillina, 238–44. London, British Museum. Photo: Courtesy of the Trustees of the British Museum

arranged in a style that can be traced back to the style of Julia Mamaea's. It is parted in the center and is brushed in relatively tight waves behind the ears. The rest of the hair is gathered into a braided chignon placed high on the top of her head. Her features are regular with round eyes, arched brows, an aquiline nose, and a small, delicate mouth. Most striking perhaps are the eyes, which are imbued with a dreamy, sensuous expression because of the partially closed lids – the hallmark of Antonine portraiture – clearly based on Antonine precedents. The portraiture of Tranquillina, like that of Gallienus somewhat later, clearly drew on earlier imperial styles.

The new abstraction, which under Gordian and Gallienus was coupled with a reverence for historical references, culminated in the late portraits of Gallienus, which were masklike and iconic. The same features can be seen in female portraiture in the 260s. An example is the marble portrait of an anonymous woman, identified as Gallienus's wife, Salonina, and now in Copenhagen (fig. 350). The young woman has a smooth, oval face, upraised eyes, straight brows, and rounded lips. The artist has emphasized the flat planes of her face, and her coiffure is rendered in an equally simple manner. It is parted in the center, combed in straight strands behind her ears, and gathered in an unadorned chignon.

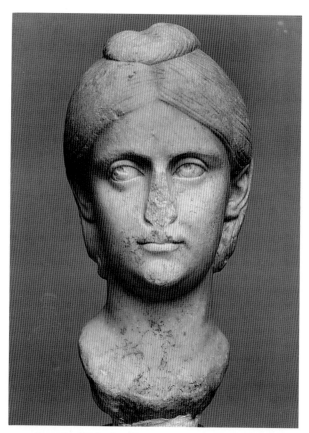

350 Portrait of Salonina (?), 260s. Copenhagen, Ny Carlsberg Glyptotek. Photo: Courtesy of the Ny Carlsberg Glyptotek, Copenhagen

Private Portraiture in the Third Century

Private portraits of aristocrats and freedmen continued to be produced in the third century; both were profoundly influenced by trends in imperial portraiture even though they often revealed the personal predilections of the patron and sometimes his position in Roman society.

An interesting example is a group of three marble male statues in the round that were discovered in the remains of the same structure, which are now in the Villa Doria Pamphili in Rome (figs. 351–353). The group consists of a man in a toga with contabulatio and two others in heroic nudity save for their mantles, which are wrapped around their left shoulders and strategically across their genitals in a show of relative modesty. One carries a sword in his left hand; the other is accompanied by a hunting dog. The dog and sword suggest that the two nude men were depicted as hunters.

The drapery of the togate man reveals little of the shape of his body below but documents the artist's overriding interest in the pattern of the drapery folds. The nude statues instead demonstrate that third-century artists could still depict a nude figure in subtle contrapposto. This particular artist's reliance on classical prototypes is so great that the figure of the man with dog is a replica of Polykleitos's Doryphoros, although the musculature is not as pronounced and the parts of the body are beginning to be represented in a flatter and more abstract manner.

The contabulatio of the togatus and the cubic faces with upraised eyes of all three figures suggest a third-century date for the group. All three have a short cap of hair, but the scalp is not chiseled. Rather the hair is raised over the skull, and individual locks are arranged in a pattern across the forehead, suggesting to a number of scholars that the portraits must have been produced during the Gallienic period; they are usually assigned to the 250s. It has even been posited that the resemblance of these heads to the portraits of Gallienus is so striking that they must represent the young emperor in a variety of roles, including statesman and hunter. None of the three heads, however, duplicates a known portrait of Gallienus, and a more likely solution is that the three figures depict a father and two sons in a family group portrait. Such a pair owes much to the dynastic groups of the Antonine and Severan periods and also attests to the continued use of Greek masterpieces as models for statues in contemporary contexts.

Funerary portraits of freedmen or their descendants also show their indebtedness to contemporary imperial portraits, especially to their military iconography. Extant funerary altars with portraits commissioned in the 220s until the 250s are exclusively of military men, some

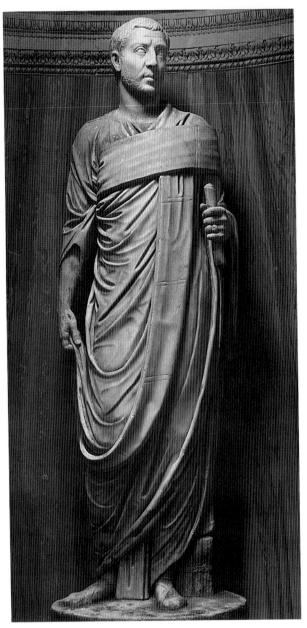

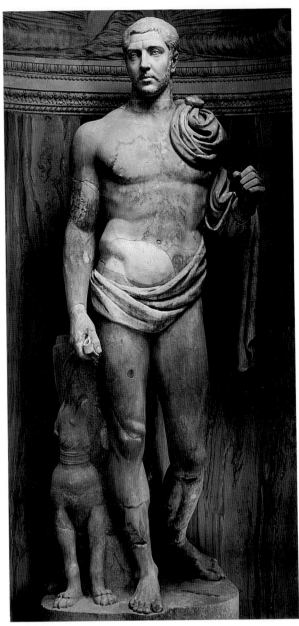

351 Portrait of a man, from a tripartite group, 260s. Rome, Villa Doria Pamphili. Photo: DAIR 8158

352 Portrait of a man, from a tripartite group, 260s. Rome, Villa Doria Pamphili. Photo: DAIR 8153A

of which proudly display the former positions of these men. The portrait of Marcus Aurelius Vitalis, for example, a Praetorian cohort for thirteen years, is shown on a funerary altar – now in the Museo Capitolino (fig. 354) – with a sword in a sheath, a military belt, and a military mantle. He wears his hair in a closely cropped military coiffure that adheres to his head like a close-fitting cap. His hair, close-shaved beard, and moustache are delineated with short drill strokes, giving them a textured appearance. The treatment of the hair and beard can be

paralleled in the portrait of Balbinus on the sarcophagus in the Catacomb of Praetextatus of 238 (see fig. 326), and the altar can be dated to the decades between 230 and 250.

Aurelius Pyrrhus, who was honored in an altar erected between 225 and 250 by his children and now in the courtyard of the Palazzo Massimo alle Colonne in Rome (fig. 355), was born in Pautalia in Western Bulgaria, served in the eighth Praetorian cohort, received an honorary discharge, and lived just over forty-five years. Although his military status is announced with pride on his funerary

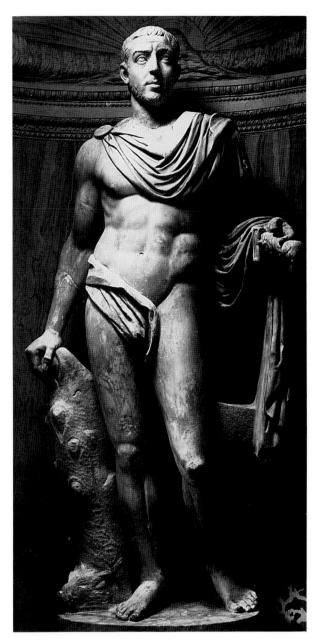

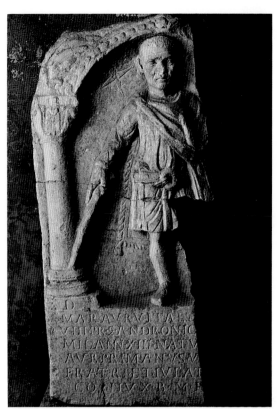

354 Funerary altar of Marcus Aurelius Vitalis, 230–50. Rome, Museo Capitolino. Photo: Courtesy of the Musei Capitolini, by Barbara Malter

353 Portrait of a man, from a tripartite group, 260s. Rome, Villa Doria Pamphili. Photo: DAIR 8162A

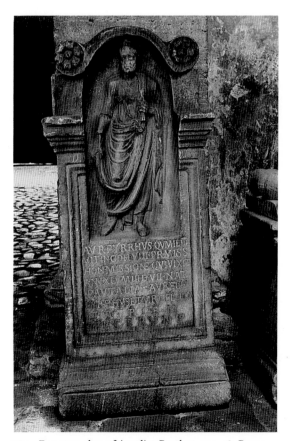

355 Funerary altar of Aurelius Pyrrhus, 235–38. Rome, Palazzo Massimo alle Colonne. Photo: DAIR 60.343

altar, Pyrrhus is not represented in his portrait as a military man but instead as a Roman citizen wearing a tunic and toga and holding a scroll in his left hand. Apparently, Pyrrhus wished to be remembered by posterity more as a literate Roman citizen than as a veteran. The man wears a short beard that conforms to the shape of his jaw and a short coiffure that recedes somewhat at the temples. Both the hair and beard were accentuated by the drill and parallels can be found in the portraits of Maximinus Thrax of 235–38 (see, for example, fig. 324).

Third-Century Sarcophagi

The Balbinus Sarcophagus

The third century was almost entirely devoid of the monumental sculptural projects that had characterized the early and high empire. Third-century sculptors were not called upon to execute extensive narrative cycles for historiated columns, nor to carve figural relief panels for grandiose arches. They had to be content with fashioning imperial and private portraits and with repeating a repertory of stock scenes on sarcophagi. For that reason, the large marble sarcophagus of the emperor Balbinus (fig. 356), with its imperial group portrait and its public and private scenes, must have been one of the greatest commissions of its day. Although the sarcophagus lacks an extant inscription, the male protagonist carries the imperial attribute of eagle-tipped scepter and has the facial features and coiffure of Balbinus.

Emperors and empresses continued to be cremated in the second century despite the growing popularity of inhumation among the Roman populace. Evidence for this comes not only from the multistoried funerary pyres that are frequently depicted on Antonine coins, but from monumental reliefs that depict scenes of imperial cremation in the Campus Martius, like those on the Arco di Portogallo and the pedestal of the Column of Antoninus Pius and Faustina the Elder (see figs. 222, 253). It was not until the third century that Roman emperors were

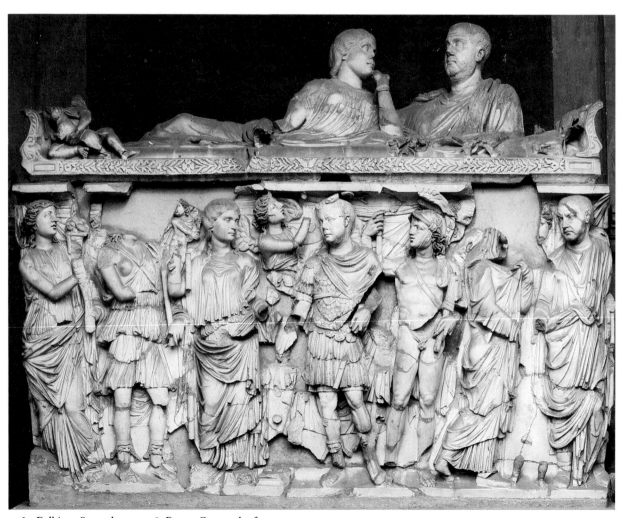

356 Balbinus Sarcophagus, 238. Rome, Catacomb of Praetextatus. Photo: DAIR 72.482

buried, as opposed to cremated, with any regularity. The Balbinus sarcophagus is one of the three surviving third-century Roman sarcophagi that may have honored an emperor or a member of his family. Its importance for our understanding of imperially commissioned funerary art, therefore, cannot be overestimated. Although the great imperial Mausolea of Augustus and Hadrian, which housed the remains of the Julio-Claudian, Flavian, and Antonine emperors, still stand, their sculptural decoration, probably statuary in the round, has long since disappeared.

The lid of the Balbinus sarcophagus depicts a group portrait of the emperor and his wife reclining on a funerary bed. This type of lid is not special to this imperial commission but had already become popular by the second and third centuries. It was based on kline funerary monuments commissioned by Roman freedmen in the first and second centuries (see, for example, fig. 61), which were in turn indebted to reclining figures on Etruscan urns and sarcophagi. Balbinus, in tunic and toga, is accompanied by his wife, who wears a tunic and palla. The private nature of the monument – inasmuch as any imperial funerary monument could ever truly be termed private – is underscored because the imperial pair is accompanied by erotes who hold a hare and a cithara. The portraits, described in detail above (see figs. 326, 346), were undoubtedly carved by a special portrait artist who fashioned contemporary portraits in the round.

The heads of the main protagonists in the scenes on the main body of the sarcophagus, however, appear to have been carved by a different artist. There were originally two relief portraits of Balbinus and two of his wife. One of Balbinus is intact, the other is now in Cleveland. Only one of Balbinus's wife survives. The marriage of the imperial couple is depicted at the far right where they are joined in a dextrarum iunctio. The emperor's wife is portrayed as a modest bride with a veil over her head, and her husband is clad in a tunic and toga. His head is preserved, and he is represented with the same round, fleshy face and impressionistic hair and beard as in the portrait on the lid.

Hymenaeus, with a torch, who originally united the happy pair, no longer survives, although his feet are preserved between the couple. Another scene, which must have been considered more significant by the master designer because it occupies over two-thirds of the front of the coffin, depicts the emperor, in breastplate and paludamentum, making a sacrifice at a small portable altar (now missing). The ceremony takes place in the presence not only of his beloved wife but also before Mars, Victory, Virtus, and Fortuna. Victory crowns Balbinus with a wreath, and Mars stands at his side. These gods, the personifications, and the emperor's military attire suggest that Balbinus wished to be remembered, above all, as a triumphant military commander. In a more general sense, however, it is the emperor's virtues that were celebrated on the front of the sarcophagus. Virtus herself is a witness to the sacrifice, concordia is celebrated in the taking of the marriage vows, and pietas in the making of a sacrifice.

The prominent frontal figure of Balbinus's wife in the sacrifice scene is of special interest. She is no longer veiled, and her hair is parted in the center and brushed in deep waves covering her ears – a hairstyle that resembles that of her portrait on the lid and ultimately derived from the wiglike coiffure of Julia Domna. The empress's features are more idealized in the relief than in the kline portrait. Her body, molded by a clinging drapery that falls sensuously off her left shoulder, relies ultimately on the Venus Genetrix type of the fifth century B.C. but is probably based on more recent imperial adaptations, such as the statue of the empress Sabina in the Venus Genetrix pose, now in Ostia. The decision to present Balbinus's wife in the guise of Venus is either a form of private deification or an attempt to elevate her to the status of the surrounding divinities and personifications. Neither the name of the empress nor the year of her death are known. If she predeceased her husband, he would have had an additional reason to commission a sarcophagus in which she was portrayed in divine guise. The short sides of the sarcophagus are carved with the Three Graces on the left and dancing figures on the right, imagery more appropriate to the empress than to Balbinus himself. The Three Graces, companions of Venus, were goddesses of beauty, grace, and mirth, and celebrate the empress's virtues.

That Balbinus and his wife are celebrated as equals on the Praetextatus sarcophagus attests not only to the increased status of imperial women from Antonine times on but also suggests that the sarcophagus was commissioned to hold her remains as well as his. The joint commemoration of an imperial husband and wife in a funerary context is prefigured by the apotheosis scene on the base of the Column of Antoninus Pius (see fig. 253).

The figures of emperor and empress occupy the full height of the sarcophagus. The bodies are frontally positioned, although all the heads are turned toward the center and thus seen by the spectator in three-quarter views. The draped figure of Balbinus's wife as Venus demonstrates that the artist who carved this imperial commission was still concerned not only with classical prototypes but with the way drapery can conform to the shape of the human body and even enhance it.

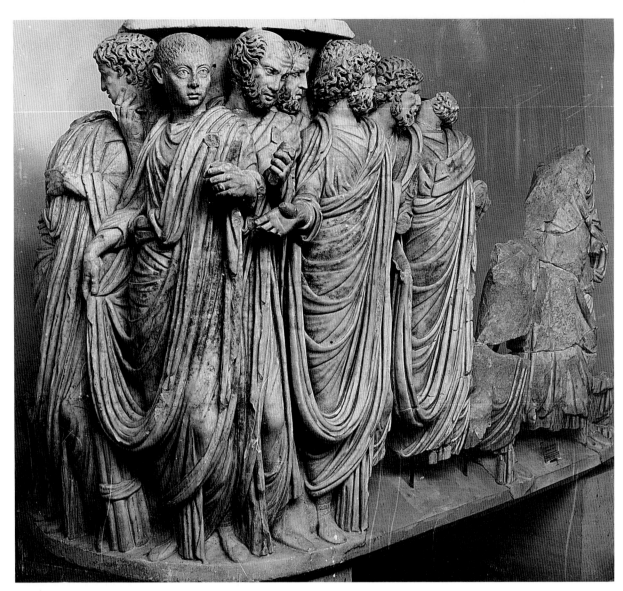

357 Acilia Sarcophagus, from Acilia, 238. Rome, Museo
Nazionale delle Terme. Photo: DAIR 59.20

The Acilia Sarcophagus

The Acilia sarcophagus (fig. 357) was discovered in Acilia, south of Rome near Ostia. It is a lenos or "bathtub type" of sarcophagus with rounded corners and is only partially preserved. The side in good condition is carved with a group of mature men and one young boy in strict frontality, with their heads turned in three-quarter positions. They are executed in very high relief and clad in voluminous togas. The artist deftly depicts the broad curvature of the toga's sinus and delights in repeating its pattern in a series of recurrent curves that demonstrates that he is more interested in pattern than in the shape of the bodies beneath the robes. The folds are plastically rendered, and the spaces beneath them deeply shadowed. The decorative draperies are played off against the rough texture of the mens' deeply drilled hair and beards. The long side of the sarcophagus has a group portrait of a bearded man, also in toga, and his wife, now headless, who is accompanied on her left by three additional female figures, of which only the feet and the lower edge of the drapery are preserved. Numerous other fragments, which include a female head, miscellaneous hands, knees, drapery, and parts of the now-missing lid with a scene of vintaging erotes, are preserved in the storerooms of the museum.

The Acilia sarcophagus is an outstanding work of art and one that has provoked a great deal of controversy, focusing on the identification of the young man whose head is so carefully differentiated from the others that a recognizable portrait is clearly intended. Some scholars have argued that the youth is one of the boy emperors or princes of the third century; others that the sarcophagus honors a Roman consul at the high point of his career. This distinction is, of course, of great significance because if an imperial personage is depicted, the sarcophagus is one of a very small number of surviving examples that can be associated with the imperial family. Furthermore, if the sarcophagus represents an important event in the life of that emperor, it is, despite its private nature, one of the most significant sculptural documents of the third century.

The boy is clad in a tunic and toga but is beardless and depicted with a short military coiffure that is barely raised over his skull and is chiseled to suggest hair. His head is triangularly shaped with a tapering chin. He has large staring eyes and arched brows. It is his striking resemblance to Gordian III (see figs. 328–331) that has caused some scholars to purport that the portrait is of the boy emperor. If so, the sarcophagus may have belonged to Gordian's father, the consul Julius Balbus, and portraits of both him and his wife, Maecia Faustina, may have been carved on one of the long sides.

Faustina might have been the frontal headless female figure toward the center of the front of the sarcophagus. She probably faced the bearded male togatus with contabulatio on the left. To the woman's left, at the curvature of the right side of the sarcophagus, are the feet and lower edge of the drapery of three additional female figures. The sarcophagus would have been carved at the death of Balbus in 238, which coincided with the appointment of his son as Caesar first and then Augustus at the age of thirteen, a designation that pleased the senate and may account for the presence of the Genius Senatus, who has been identified as one of the bearded togate males. A date of 238 or somewhat later is consistent with coin portraits of Gordian of that year. The deeply drilled plastic hair and beards of the Genius Senatus and other figures are also treated comparably to that of the beard of Pupienus in the Vatican head of 238 (see fig. 325), which represents the emperor with the same contabulatio worn by the main male protagonist of the sarcophagus's long side.

Even those scholars who have agreed upon the imperial nature of this sarcophagus have disagreed on the identity of the main protagonist. One scholar, who dates the sarcophagus to 270–80 and identifies the boy as Nigrianus, son of Carinus and Magna Urbica, who died and was consecrated before his father, points to the similarity of the style of Carinus's portrait in the Museo del Palazzo dei Conservatori (see fig. 344) to some of the male heads on the Acilia sarcophagus. Other scholars see Hostilianus and his parents, Trajan Decius and Etruscilla, in the imperial threesome. Still others doubt that the sarcophagus is an imperial commission, in part because a sarcophagus depicting a significant historical event involving an imperial personage would have been made under special order.

It is apparent, however, upon close examination, that "Gordian's" massive hands with protruding veins were designed for the figure of an adult male, not a teenaged boy. This detail suggests that the sarcophagus was not an original commission or at the very least that it was not finished in the manner originally intended.

Nonimperial suggestions for the sarcophagus's subject matter include a marriage scene or a more general scene of family life. Of the nonimperial theories perhaps the most compelling and the one that has received the widest acceptance is that which identifies the scene on the Acilia sarcophagus as a consular procession (or processus consularis), the most important event in the life of a Roman consul. The consular procession would have included not only friends of the consul's and those of his wife (the surrounding male and female figures on the sarcophagus), but also contemporary senators (signified by the Genius Senatus). Consular virtues might also be referred to in both the value placed on friendship and in the concordia of the marriage scene, possibly of the

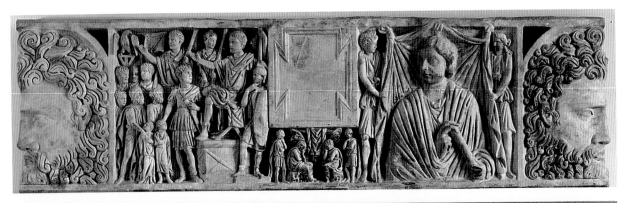

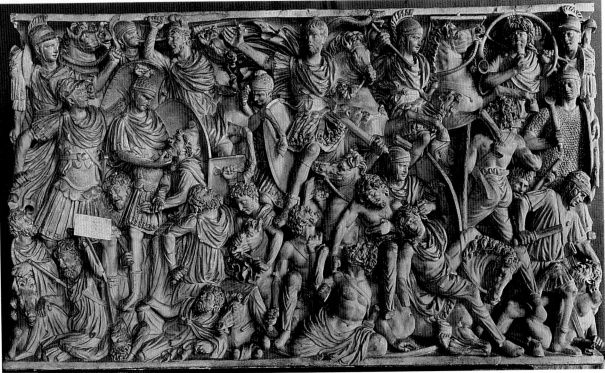

358 Ludovisi Sarcophagus, lid, ca.260. Mainz, Römisch-Germanisches Zentralmuseum. Photo: Courtesy of the Römisch-Germanisches Zentralmuseum, Mainz (*top*)

359 Ludovisi Sarcophagus, ca.260. Rome, Museo Nazionale delle Terme. Photo: DAIR 58.2011 (*bottom*)

consul's parents. Even if the sarcophagus is not an imperial commission, a date of 268 for the sarcophagus seems too late and that of 238 more consistent with the style of the portraits and the drapery.

These controversies may never be resolved, but the Acilia sarcophagus probably does depict the consular procession of Julius Balbus and the concordia of Balbus and his wife, Maecia Faustina, who as the daughter of Gordian I was a member of the imperial family. The togate figure with massive hands was originally carved with Balbus's portrait, but upon his death and the designation of his son, Gordian III, as the new Augustus, the

decision was made to redesign the sarcophagus to include a portrait of the family's greatest claim to fame – their illustrious son, an emperor of Rome at only thirteen years of age. Maecia Faustina was a very ambitious woman, and it was she who orchestrated her son's imperial career until Timesitheus came to power. It would be completely in Maecia Faustina's character to commission a master artist to recarve her husband's sarcophagus to celebrate her now-famous son and to solidify her family's claim to imperial power in what would have been one of the major sculptural commissions of the day.

The Ludovisi Sarcophagus

The so-called Ludovisi sarcophagus (figs. 358–359) was discovered in 1621 in the Vigna Bernusconi outside the Porta S. Lorenzo in Rome. It was acquired by Cardinal Ludovisi for his private collection, hence its modern designation as the Ludovisi sarcophagus, and later became part of the Ludovisi Collection, which came into the possession of the Museo Nazionale delle Terme in 1901.

The high quality of its carving has made the Ludovisi sarcophagus justly famous. It is also highly controversial. Dispute has centered on the main protagonist, a male figure on horseback who is frontally positioned and dominates the action with a dramatic outward gesture of his right hand, and whom some scholars have identified as a member of one of the third-century imperial families.

The Ludovisi sarcophagus is one of a small number of surviving battle sarcophagi, most of which were made during the principate of Marcus Aurelius. It was under Marcus that there was a vogue for such coffins, which were based closely in style and subject matter on the frenzied battle scenes on the Column of Marcus Aurelius. The Portonaccio sarcophagus (see fig. 269) is an outstanding example.

The front of the Ludovisi sarcophagus, fashioned of Italian marble, is completely covered with a melee of intertwined figures of Roman soldiers and barbarian adversaries. The Romans wear helmets, breastplates, and military mantles and brandish heavy swords and sharp spears with which they gain the upper hand over their enemies. The barbarians wear leggings, and some have tunics while others are barechested. They have deeply drilled long hair and full beards, and their facial expressions are emotional and filled with an anguish noticeably lacking in the faces of their Roman opponents. Their suffering is sympathetically captured by the artist, who was undoubtedly profoundly influenced by the compassionate view of barbarians that suffused the Antonine period and that was well expressed in such scenes as that of Justice from one of the lost arches of Marcus Aurelius (see fig. 257). The figures on the sarcophagus are not depicted on a single groundline but seem to emerge from a kind of interlocking tapestry of arms and legs, which covers the surface of the relief. In this way, it again betrays its indebtedness to such second-century predecessors as the Column of Marcus Aurelius (see fig. 263) and the Portonaccio sarcophagus.

What sets the Ludovisi sarcophagus apart from the Portonaccio sarcophagus, however, is that its main protagonist may be an identifiable historical personage, but which one is a matter of considerable controversy. The young man has a triangular face with broad cranium and

narrow chin, smooth skin, even features, slightly upraised eyes shaded by thick, straight eyebrows with individually delineated hairs, a moustache, and short beard that grows organically from his cheeks and chin and, most importantly, a plastic cap of hair that is arranged in comma-shaped locks across his forehead. The hairstyle, with its obvious reference to Augustus, the Julio-Claudians, and Trajan, finds its closest parallels in the milieu of the Gallienic revival.

Since the portrait is not a replica of any of those of Gallienus himself, it may depict an important military commander of the day. For some time, scholarly inquiry focused on the two sons of Trajan Decius, Hostilianus and Herennius Etruscus, who both died in 251. Hostilianus, although involved in military exploits, died not in the midst of battle but in a plague. His portrait appears on coins where he is sometimes depicted with a *sphragis* or seal in the shape of a cross carved on his forehead, seen also in the Ludovisi sarcophagus portrait. The seal is thought to make reference to Mithraic beliefs and to mark Hostilianus as the savior of humanity, the bringer of light to a world of tumult, and the guarantor of eternity. In such an interpretation, the precise identity of the barbarians is not significant. They may be the Goths, who were threatening Rome in the mid- and late third century, or they may be intended as a more generic representation of the barbarian world.

Also on the basis of numismatic evidence, some scholars have identified the young commander as Herennius Etruscus, the older brother of Hostilianus, who was actually killed in a battle against the Goths in 251.

More recent scholarship, however, favors a date not of 251 but of 260, that is, in the midst of the Gallienic revival. The structure and spatial organization of the Ludovisi sarcophagus are thought to be comparable to other reliefs of that date. It has been pointed out that neither Hostilianus nor Herennius Etruscus were ever depicted with beards in official portraits. At present, it seems impossible to connect the commander with certainty with an emperor or imperial prince of the 250s or 260s, or with a specific general whose name is recorded. The head is heavily influenced by the retrospective likenesses of Gallienus of about 260. The exquisite quality of the piece makes it one of the finest surviving works of its time, which certainly suggests that its patron was at least from the upper echelons of Roman society. Emperors alternated as quickly as the changing seasons in some years and their heirs were often murdered along with them. For this reason, it is still not impossible that the young man represented in the Ludovisi sarcophagus was, at one time, someone of historical consequence.

What also differentiates the Ludovisi general from the commander on the Portonaccio sarcophagus is that while

the Portonaccio equestrian wears a helmet and carries a spear, the Ludovisi general is bareheaded and holds no weapon. The implication is that he is insuperable and will be victorious without protection or weaponry. The commander is thus depicted in the image of the invincible general personified by Alexander the Great, who plunges bareheaded into battle against Darius of Persia in the famous House of the Faun mosaic copy of a lost Hellenistic painting by Philoxenos of Eretria.

The lid of the sarcophagus (see fig. 358) is now in Mainz. It was flanked by large masks and contained an inscription plaque in the center. It is now empty but was perhaps once painted. Beneath the epitaph plaque is a small scene of captive barbarians. On the left is a larger scene of a Roman soldier presenting barbarians, including children, to the general for clemency, a popular subject in earlier state monuments and also on second-century biographical sarcophagi like that of a commander in the Vatican Museums (see fig. 270). On the right is a half-length portrait of a woman in a tunic and palla and holding a scroll, who is positioned in front of a curtain. Her head is turned sharply to her right, as is that of the military commander on the main body of the sarcophagus below. The woman must be the wife or mother of the main protagonist. She wears her hair in a parted and waved coiffure that covers her ears and is a close approximation of the one popularized by Julia Domna and worn in the third century by the wife of Balbinus and others.

Biographical Sarcophagi

The Balbinus, Acilia, and Ludovisi sarcophagi all belong to a category of coffins with scenes from the life of the deceased, designated in German scholarship as *Menschenleben* or biographical sarcophagi. Battle sarcophagi – like the one in the Ludovisi collection, of which there are only twenty surviving examples – began to be manufactured in the 160s, undoubtedly under the influence of the military themes in Antonine art and by Marcus Aurelius's own presence on the front. Clashes with northern barbarians also must have left a number of commanders dead, and they needed to be buried in a manner befitting a military hero.

The majority of sarcophagi were produced between 160 and 200; the sole exception is the Ludovisi sarcophagus of about 260. The earliest examples depict the battle scene as a frieze, whereas the latest, like the Portonaccio and Ludovisi sarcophagi, represent the battle on a variety of levels and cover the entire relief ground, an approach to the depiction of space based on that of the Column of Marcus Aurelius.

The Balbinus sarcophagus is probably best categorized under marriage sarcophagi. There are ninety extant examples, which were produced from the second to the fourth century. What they have in common is their emphasis on the close relationship between husband and wife, who, in the case of the Balbinus sarcophagus, are depicted not only taking part in the actual marriage ceremony but participating in a sacrifice and reclining together on the lid of the coffin. Unlike battle sarcophagi, which owe a considerable debt to Greek models (for example, the Hellenistic battle friezes and the Pergamene Gaul groups), the scenes on Roman marriage sarcophagi are based on Etruscan and republican Roman prototypes with their private scenes emphasizing marital bonds through the depiction of one spouse embracing the other.

Greek mythology could, however, sometimes impinge on Roman ritual, and husband and wife were sometimes depicted in the guise of male and female divinities whose virtues they shared. In fact, there is considerable overlap among categories, even among examples from the Menschenleben group. The Ludovisi sarcophagus has a portrait of the commander's wife (or mother) on the lid, and the Acilia sarcophagus represents the main protagonist's father and mother side by side on the front of the sarcophagus, both references to the Roman marriage bond.

Even fewer examples of sarcophagi with scenes of processus consularis survive than those with battle scenes, but all are of very high quality and all date to around 250 or the surrounding decades.

Hunt Sarcophagi

Hunt sarcophagi, the surviving examples of which number 250, also belong to the Menschenleben type. They began to be manufactured in about 220 or 230 and continued until Constantinian times. They can be divided into four groups, the largest and most important of which constitutes lion-hunt sarcophagi, which were produced between 220 and 280. In their fully developed form, such as in a sarcophagus now in Paris of 230–40 (fig. 360), these lion-hunt sarcophagi depict the departure for the hunt and the hunt itself. In the former scene, the hunter, located on the left side of the front of the sarcophagus, receives the reins of his horse from a groom. The rest (nearly three-quarters) of the scene, represents the hunter on horseback. He is accompanied by Virtus, at whose urging he draws back his right arm and gets ready to plunge a spear into a pouncing lion. Since these scenes are found in a funerary context, the lion is meant to

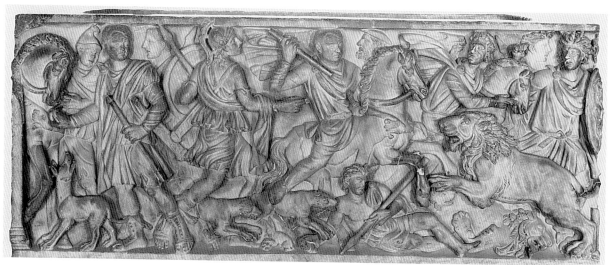

360 Lion Hunt Sarcophagus, 230–40. Paris, Musée du
Louvre. Photo: Cliché des Musées Nationaux

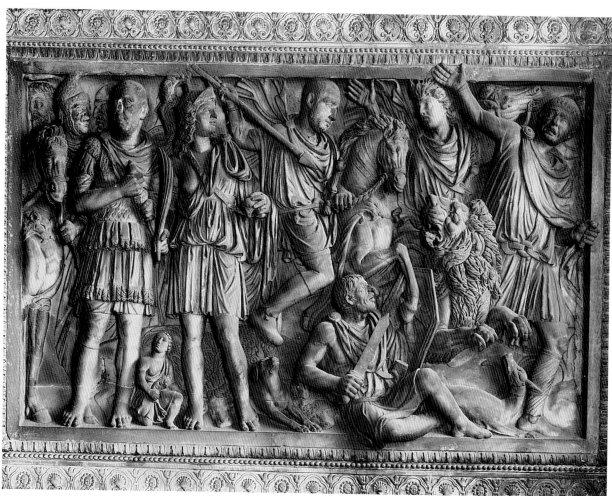

361 Mattei Lion Hunt Sarcophagus, 250. Rome, Mattei
Collection. Photo: DAIR 80.935

symbolize the death over which the hunter (the deceased) can triumph by vanquishing the beast.

It has been suggested that the models for these scenes can be found in those of hunters in Greek mythology, such as Hippolytus, Meleager, and Adonis, and that in a complex process of transformation, the boar became a lion. It is unquestionably true that some of these mythological sarcophagi depict a similar sequence with comparable protagonists. Scenes of the hunt, themselves possibly also derived from mythological models, had already been popular in imperial reliefs, even those with possible funerary connotations. A case in point is the hunting tondi from a lost monument of Hadrian (see figs. 219–220), which depict in different roundels the departure for the hunt, the hunt itself with the emperor brandishing a spear against a bear and a boar, and the emperor standing triumphant over a dead lion. Although the tondi, now part of the Arch of Constantine, may originally have been part of a funerary monument commemorating Antinous or someone else in the imperial circle, victory in the hunt, over death, and even victory in battle were intended to be synonymous.

The hunt and funerary symbolism of the lion-hunt sarcophagi are immediately apparent, but even in these military connotations are also common. The hunter, like the triumphant general, is accompanied by Virtus. In some of the sarcophagi, for example, the so-called Mattei sarcophagus of 250 (fig. 361), the departing hunter is depicted in cuirass rather than tunic and has a captive barbarian at his feet. The so-called Rospigliosi sarcophagus of about 240–50 portrays both the departing hunter and the horseman in battle dress, further accentuating the close relation between private and military art in the third century.

Dionysiac Sarcophagi

Despite the increased interest in sarcophagi depicting scenes from the life of the deceased, which probably also served to enumerate the virtues of the honorand in the third century, mythological sarcophagi continued to be produced in large numbers. Dionysiac sarcophagi were among the most popular. Although they were already produced in early imperial times, they flourished in the third century with three hundred of the four hundred surviving examples dating from the decades around 200.

One of the finest surviving examples, now in the Metropolitan Museum in New York, is of the bathtub or lenos type and represents the triumph of Dionysus amid the Four Seasons flanked by Earth and Ocean (fig. 362). The sarcophagus is of high quality and may be one of the first, if not the first, season sarcophagus –

although male Seasons had been included in state monuments since the Trajanic period. Dionysus, seated on a panther, is depicted at the center in the front. He holds his ivy-and-vine-ornamented wand or *thyrsus* in his left hand and pours wine from one vessel into another held by Pan. Reference to the god's mystery rites can be found in the basket with snake and liknon with phallus below his feet. The Seasons have been interpreted as symbols of apotheosis, and it is very likely that the individual buried in the sarcophagus was intentionally associated with the god whose image it bears. The implication was that the deceased, a member of the Dionysiac mystery cult, would find renewed life in the hereafter.

The figures of the Seasons and that of Dionysus occupy the full height of the sarcophagus, but the smaller subsidiary figures and animals fill the spaces between them, creating an overall tapestry of figures comparable to that of the Ludovisi sarcophagus (see fig. 359). Although the artist has paid careful attention to the sinuous curves of the bodies of the Seasons and the shape of Dionysus's legs beneath his mantle and was clearly inspired by classical prototypes, the figures are almost frontally positioned, attenuated, and the torsos and limbs do not have a defined musculature but seem to serve as abstract shapes set against a decorative pattern of angular arms and limbs.

Third-Century Art
The Caracallan Tradition and Beyond

The approximately seventy years between the death of Caracalla and the rise to power of Diocletian were marked by political instability both within Rome and along the frontiers of the empire. The barbarian uprisings that came to the fore under Marcus Aurelius intensified in the third century with special problems on the eastern and northern borders. More often than not, the presence of the emperor himself was required at the front, and Rome was governed by a series of boy Caesars (who later became emperors), their scheming mothers, and ambitious Praetorian prefects.

In view of the military requirements of the emperorship, most of the third-century contenders were drawn directly from the army and elevated to office by the troops themselves. Such appointments alternated with those made by the senate, which tended to choose members of its own body, who were often elderly. Some third-century emperors wisely attempted to appeal to the army and to establish good relations with the senate. A few did so with some success and, like Valerian, were able to remain emperor for up to seven years and even to

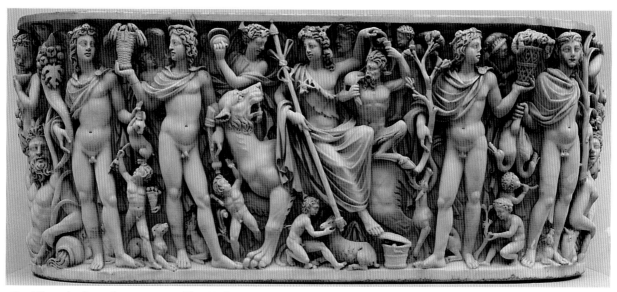

362 Dionysiac Sarcophagus, 220–35. New York, Metropolitan Museum of Art, Purchase, Joseph Pulitzer Bequest, 1955. Photo: Courtesy of the Metropolitan Museum of Art, 55.1.5

found a short-lived dynasty. These were the exceptions. Most emperors were not able to hold onto power for more than a few years, and many were deposed after only a few months in office. Few third-century emperors died a natural death. Most were betrayed by the very armies that had originally elevated them to power.

The third-century emperors, even those with senatorial appointments, were thus first and foremost military men, and it is for this reason that the third century is often referred to as the century of the soldier-emperors, and it was as soldiers that they most wished to be portrayed in their portraits. The model par excellence for such military images was the portraiture of Caracalla, which at first seems paradoxical since Caracalla was assassinated and branded a tyrant by the senate. Though unpopular with the senate, he had a strong following among the troops, and it was he who granted Roman citizenship to all those who lived within the empire's boundaries, including parts of the empire from which many of his successors came. Furthermore, Caracalla appears to have been deified by Macrinus, and both Elagabalus and Alexander Severus claimed to be his sons. Above all, it was the brute strength of a powerful military man with a cubic face, short soldier's hair and beard, and the intense psychological drama of the features of his face, captured in his adult portraits by the Caracalla Master, that appealed to subsequent rulers and their court artists. Almost without exception, the portraits of the mature emperors of the third century, including those of Macrinus, Maxi-

minus Thrax, Balbinus, Philip the Arab, Trajan Decius, Trebonianus Gallus, Aurelian, Tacitus, and Probus, were based on the Caracallan creations of the Caracalla Master. These share the creased brow, the bulging forehead musculature, the underlying X-structure of the face, the closely cropped military cap of hair, short beard, and intense expression.

The popularity of military imagery in the third century is also attested by the Ludovisi sarcophagus, which was undoubtedly one of the major commissions of its day. The battle between intertwined Roman and barbarian adversaries was based on Antonine battle sarcophagi. Its main protagonist is either one of the sons of Trajan Decius or a Gallienic military commander. Possibly inspired by Mithras, whose sign is carved on his forehead and who was long favored by soldiers, he charges into the fray without helmet or weapon. The god's protection has made him invincible against his enemies and against death. As the god of light, Mithras was closely identified with the sun, and Sol and Mithras were often depicted together in art. It was during the third century that Sol was increasingly worshipped as the primary god, demonstrating a greater Roman interest in a kind of monotheism. Elagabalus and Aurelian both dedicated monumental temples to Sol Invictus during their principates.

Another major third-century relief commission, that of the Sarcophagus of Balbinus and his wife, depicts the emperor in military as well as administrative garb. On

the front of the sarcophagus, the emperor is represented in cuirass sacrificing at an altar in the presence of gods and personifications, one of whom is his wife in the guise of Venus. The scene is the most important one on the sarcophagus, and it is therefore apparent that it was above all as a military commander that Balbinus wished to be remembered for posterity.

Even the third-century boys who came to power in Rome as teenagers had military pretensions. Gordian III, for example, is represented in battle dress as a world conqueror in a portrait on a medallion struck while he was emperor. Freedmen (or their descendants) also favored military imagery for their funerary monuments. The Altar of Marcus Aurelius Vitalis, for example, celebrates a Praetorian cohort who is decked out in full military dress.

While the adult portraiture of Caracalla served as the primary model for the portraits of mature third-century emperors, the person of the same emperor was the inspiration for his youthful successors. Both Elagabalus and Alexander Severus claimed imperial power by asserting they were sons of the infamous Severan dynast; and the portraits of Elagabalus were based on the childhood portraits of Caracalla as a prince, which were executed in a more dramatic Antonine style. The prince portraits of Caracalla were themselves based on those of his Antonine predecessors, such as Marcus Aurelius and Commodus, the connection underscored by Caracalla's adoption of the name Marcus Aurelius Antoninus. Elagabalus was also renamed Marcus Aurelius Antoninus, and Alexander Severus's original name was Alexianus; he took the Severus from Lucius Septimius Severus. Alexander Severus is not depicted with the plastic Antonine hair of Elagabalus, but his portraits do possess the dreamy classical mood of those of the Antonines.

It was with the portraiture of Alexander Severus, the last of the Severan emperors, that there was an abrupt and significant change in style. Despite his classically shaped oval face and sensuous Antonine expression, the hair of Alexander Severus, while based in general shape on that of Caracalla, is barely raised from the scalp, and the skull is etched with impressionistic strokes. This negative rather than positive carving became the norm for third-century portraiture, although it is clear from some portraits – such as that in the Vatican of the emperor Pupienus, who is depicted with a long, curly beard – that third-century sculptors continued to be versed in the Antonine style and to employ it when needed. When Valerian and Gallienus decided to commission portraits in a new retrospective mode based on Alexandrian, Augustan, and Hadrianic models, they were able to employ artists who had already executed works in an Antonine style and who were readily able to carve serpen-

tine plastic locks and beards with tight curls. The retrospective style was accompanied by an increased interest in geometric abstraction, which became so pronounced in the late portraits of Gallienus and those of Aurelian and Probus that some scholars have referred to it as the abstract style. It was this latter style that presaged the iconic style favored by the tetrarchs. The same abstraction, combined with retrospection, culminated in the art of the Constantinian period.

The portraits of Alexander Severus served as the model for the likenesses of such other third-century boy emperors and heirs to power as Gordian III and Philip II. Private portraits of young men were also understandably popular in the third century, a period that also witnessed the continuing impact of imperial women. Antonine and Severan women of imperial rank were depicted frequently in portraiture and were often included in scenes on state monuments. Antoninus Pius and Faustina the Elder are represented together in the apotheosis scene from Antoninus's column base; Marcus Aurelius appears with his bride to be, Faustina the Younger, in the dynastic scene from the Great Antonine Altar at Ephesus; Faustina the Younger is also included in the adventus panel from a lost Arch of Marcus Aurelius in Rome. Julia Domna appears with her husband in scenes on the public arch of the emperor at Leptis Magna as well as on the private Arch of the Argentarii in Rome.

No major monuments with state reliefs survive from the period of the emperors from Macrinus to Carinus, and, given the brevity and military preoccupations of their principates, it is unlikely that any were ever commissioned. Sarcophagi associated with patrons from the imperial circle, however, give considerable prominence to women. Balbinus's wife is honored equally with her husband on the sarcophagus from the Catacomb of Praetextatus. They recline together on the top of the lid and are both included in the two scenes carved on the front of the sarcophagus: the dextrarum iunctio and the sacrifice in which the empress is depicted as the modest bride and in the guise of Venus, respectively. Her feminine virtues are also referred to in the scenes on the short subsidiary sides of the sarcophagus. The Acilia sarcophagus also seems to include a portrait of a woman from the imperial court circle: Maecia Faustina, daughter of Gordian I and mother of Gordian III. Faustina was married to the consul, Julius Balbus, whose portrait appears at her side and whose consular procession may be represented on the sarcophagus. Faustina is accompanied by other women, who are probably friends of the couple participating in the ceremony. The portrait of a woman, the wife or mother of the main male protagonist, is also included on the lid of the Ludovisi sarcophagus, which may also have been commissioned by an imperial patron.

Women of the court wielded significant power in the third century. Julia Maesa saw to it that Elagabalus became emperor of Rome by claiming his kinship with Caracalla. The boy's mother, Julia Soaemias, dominated her son at the beginning of his principate, attended senate discussions, and headed a women's group that was responsible for establishing contemporary rules of etiquette. Julia Mamaea ordered the murder of Soaemias and Elagabalus, clearing the way for the succession of her son, Alexander Severus, another of Caracalla's "sons." Maecia Faustina also appears to have governed Rome for her son, Gordian III, at the very beginning of his principate. The portraits of imperial women like Julia Mamaea, Balbinus's wife, Tranquillina, and Salonina, follow essentially the same sequence of veristic, retrospective, and abstract styles as those of their husbands, although their hair was never treated with negative carving but was represented as a relatively full, parted pageboy with a high chignon based on the parted wiglike coiffure of Julia Domna.

Third-century imperial women were depicted for the most part in realistic and even uncomplimentary portraits, but the factual heads were sometimes combined with bodies based on famous Greek masterworks. The best example is perhaps that of Balbinus's wife, who is portrayed with her own facial features but with the body of Alkamenes's Venus Genetrix of the fifth century B.C., popular among the Julio-Claudians for portraits of Livia and others.

Role playing was not only the prerogative of imperial women. The portraits of third-century emperors continued to represent them in classical postures and in the guises of gods. Alexander Severus (probably originally Elagabalus) is depicted in heroic nudity and in a Polykleitan pose in a full-length statue in Naples; Balbinus appears as Jupiter in the statue from Piraeus; Decius is portrayed in the guise of Mars in a statue in Rome based on the Ares Borghese type of Alkamenes; Trebonianus Gallus appears in a colossal bronze based on the Alexander with a lance by Lysippos. Such mythological pretensions were also adopted in the private portraiture of the times. One of the most interesting examples is the statue of a hunter in the pose of Polykleitos's Doryphoros that is part of a three-figure group, now in the Villa Doria Pamphili. Although such statues betray their debt to their more famous prototypes, the bodies of such statues are, on the whole, lacking in the subtle contrapposto and classical grace of their models. The musculature of the bodies is often barely indicated, the S-curve is less pronounced, and although the bodies are often accompanied by heads that display an overt emotionalism, the bodies are often flat, geometric, and abstract. It was this abstraction, drained of its emotional content, that was adopted by the tetrarchs for their portraiture and even for state monuments, which, with the return of a strong central government, began to be commissioned again in great numbers.

Bibliography

The *Scriptores Historiae Augustae* contains biographies of Macrinus, Diadumenus, and Elagabalus. *The Oxford Classical Dictionary*, 2d ed. (Oxford, 1970) provides modern encapsulated biographies of all the third-century emperors.

The Aurelian Walls: J. B. Ward-Perkin, *Roman Imperial Architecture* (Harmondsworth, 1981),

Third-Century Imperial Male Portraiture: R. West [A. Gräfin von Schlieffen], "Eine römische Kaiserstatue im Piraeus Museum," *ÖJh* 29 (1935), 97–108. R. Delbrueck, *Die Münzbildnisse von Maximinus bis Carinus* (Berlin, 1940). G. Bovini, "Gallieno, le sua iconografia e i riflessi in essa delle vicende storiche e culturali del tempo," *MemLinc*, 7th ser., 2 (1941), 115–62. G. Bovini, "Osservazioni sulla ritrattistica romana da Treboniano Gallo a Probo," *MonAnt* 39 (1943), 179–366. G. Mathew, "The Character of the Gallienic Renaissance," *JRS* 33 (1943), 65–70. G. B. Dusenbery, "Sources and Development of Style in Portraits of Gallienus," *Marsyas* 4 (1945–47), 1ff. H. von Heintze, "Studien zu den Porträts des 3. Jhs. n. Chr. 1. Gordianus III," *RM* 62 (1955), 174–84. H. von Heintze, "Studien zu den Porträts des. 3. Jhs. n. Chr. 2. Trebonianus Gallus-Traianus Decius. 3. Gordianus I–Gordianus II," *RM* 63 (1956), 56–65. B. M. Felletti Maj, *Iconografia romana imperiale da Severo Alessandro a M. Aurelio Carino (222–285 d.C.)* (Rome, 1958). G. Zinserling, "Altrömische Traditionselemente in Porträtkunst und Historienmalerei der ersten Hälfte des 3. Jahrhunderts u. z.," *Klio* 41 (1963), 196–220. J. Bracker, *Bestimmung der Bildnisse Gordians III nach einer neuen ikonographischen Methode* (Diss., Westfälische Wilhelms Universität zu Münster, 1966). H. von Heintze, "Studien zu den Porträts des 3. Jhs. n. Chr. 7. Caracalla, Geta, Elagabal und Severus Alexander," *RM* 73–74 (1966–67), 190–231. J. Meischner, "Zwei Stilrichtungen in der Porträtkunst des 3. Jahrhunderts n. Chr.," *AA* 82 (1967), 34–46. K. Fittschen, "Bemerkungen zu den Porträts des 3. Jahrhunderts nach Christus," *JdI* 84 (1969), 197–236. K. Fittschen and P. Zanker, "Die Kolossalstatue in Neapel – eine wiederverwendete Statue des Elagabal," *AA* 85 (1970), 248–53. H. Wiggers and M. Wegner, *Caracalla bis Balbinus* (Berlin, 1971). V. Poulsen, *Les portraits romains*, 2 (Copenhagen, 1974). B. Haarlov, *New Identifications of Third-Century Roman Portraits* (Odense, 1975). M. Bergmann, *Studien zum römischen Porträt des 3. Jahrhunderts n. Chr.* (Bonn, 1977). H. von Heintze, "Studien zu den Porträts des 3. Jahrhunderts n. Chr. 8. Die vier Kaiser der Krisenjahre 193–197," *RM* 84 (1977), 159–80. M. Wegner, J. Bracker, and W. Real, *Gordian III bis Carinus* (Berlin, 1979). A. M. McCann, "Beyond the Classical in Third Century Portraiture," *ANRW* II.12.2 (1981), 623–45. D. Salzmann, "Die Bildnisse des Macrinus," *JdI* 98 (1983), 353–60. S. Wood, *Roman Portrait Sculpture, 217–260 A.D.* (Leiden, 1986). K. Fittschen and P. Zanker, *Katalog der römischen Porträts in den Capitolinischen Museen und den anderen kommunalen Sammlungen der Stadt Rom,* 1 (Mainz, 1985).

The Arch of Gallienus: G. Lugli, "L'arco di Gallieno sull'Esquilino," *L'Urbe* II, 4 (1937), 16–26. L. La Follette,

"The 'Arch of Gallienus': Evidence for Changing Architectural Standards in Third-Century Rome," *AJA* 91 (1987), 284 (abstract).

Third-Century Portraiture of Imperial Women: K. Wessel, "Römische Frauenfrisuren von der severischen bis zur konstantinischen Zeit," *AA* 61 (1946–47), 62–76. V. Poulsen, *Les portraits romains*, 2 (Copenhagen, 1974). M. Bergmann, *Studien zum römischen Porträt des 3. Jahrhunderts n. Chr.* (Bonn, 1977). S. Wood, *Roman Portrait Sculpture, 217–260 A.D.* (Leiden, 1986). K. Fittschen and P. Zanker, *Katalog der römischen Porträts in den Capitolinischen Museen und den anderen kommunalen Sammlungen der Stadt Rom, 3* (Mainz, 1983).

Private Portraiture in the Third-Century: H. von Heintze, "Drei antike Porträtstatuen," *AntP* I (1962), 7–31. R. Calza, ed., *Antichità della Villa Doria Pamfili* (Rome, 1977), 299–301, nos. 372–74 (R. Calza). M. Bergmann, *Studien zum römischen Porträt des 3. Jahrhunderts n. Chr.* (Bonn, 1977), 65. S. Wood, *Roman Portrait Sculpture, 217–260 A.D.* (Leiden, 1986), 108–10. D. E. E. Kleiner, *Roman Imperial Funerary Altars with Portraits* (Rome, 1987).

Third-Century Sarcophagi: E. Reschke, "Römische Sarkophagkunst zwischen Gallienus und Konstantin dem Grossen," in F. Altheim and R. Stiehl, *Die Araber in der alten Welt* 3 (Berlin, 1966), 307–416. B. Andreae, "Zur Sarkophagchronologie im 3. Jahrhundert nach Christus," *JAC* 13 (1970), 83–88. N. Himmelmann-Wildschütz, *Typologische Untersuchungen an römischen Sarkophagreliefs des 3 und 4 Jahrhunderts n. Chr.* (Mainz, 1973).

The Balbinus Sarcophagus: M. Gütschow, "Das Museum der Praetextatus Katakombe," *MemPontAcc,* ser. 3, 4, pt. 2 (1938), 77–106. H. Jucker, "Die Behauptung des Balbinus," *AA* 81 (1966), 501–14. H. Jucker, "A Portrait Head of the Emperor Balbinus," *Cleveland Museum of Art Bulletin* 54 (1967), 15–16. H. Wiggers and M. Wegner, *Caracalla bis Balbinus* (Berlin, 1971), 248. G. Koch and H. Sichtermann, *Römische Sarkophage* (Munich, 1982).

The Acilia Sarcophagus: R. Bianchi Bandinelli, "Sarcofago di Acilia con la designazione di Gordiano III," *BdA* 39 (1954), 200–220. H. von Heintze, "Studien zu den Porträts des 3. Jahrhunderts n. Chr. 5. Der Knabe des Acilia-Sarkophags," *RM* 66 (1959), 175–91. G. Gullini, *Maestri e botteghe in Roma da Gallieno alla tetrarchia* (Turin, 1960), 4–15. C. C. Vermeule, "A Graeco-Roman Portrait Head of the Third Century A.D.," *DOP* 15 (1961), 16–17. G. Traversari, *Aspetti formali della scultura neoclassica a Roma dal I al III d.C.* (Rome, 1968), 103–4. B. Andreae, "Processus Consularis: Zur Deutung des Sarkophags von Acilia," *Opus Nobile: Festschrift für Ulf Jantzen* (Wiesbaden, 1969), 1–13. A. Giuliano, ed., *Museo Nazionale Romano: Le sculture* I, 1 (Rome, 1979), 298–304 (M. Sapelli). G. Koch and H. Sichtermann, *Römische Sarkophage* (Munich, 1982). M. R. Di Mino and M. Bertinetti, eds., *Archeologia a Roma: La materia e la tecnica nell'arte antica* (Rome, 1990), 145–46, no. 120 (M. Sapelli).

The Ludovisi Sarcophagus: G. Rodenwaldt, "Der Grosse Schlachtsarkophag Ludovisi," *Antike Denkmäler* 4 (1929), 61–68. B. Andreae, *Motivgeschichtliche Untersuchungen zu den römischen Schlachtsarkophagen* (Berlin, 1956). H. von

Heintze, "Studien zu den Porträts des 3. Jahrhunderts n. Chr. 4: Der Feldherr des grossen Ludovisischen Schlacht-sarkophag," *RM* 64 (1957), 69–91. G. Gullini, *Maestri e botteghe in Roma da Gallieno alla tetrarchia* (Turin, 1960), 12–20. N. Himmelmann-Wildschütz, "Sarkophag eines gallienischen Konsuls," *Festschrift für Friedrich Matz* (Mainz, 1962), 110–24. B. Andreae, "Die Komposition des Grossen Ludovisischen Schlachtsarkophags," *Festschrift für G. von Lücken* (Rostock, 1970), 151–66. M. Bergmann, *Studien zum römischen Porträt des 3 Jhr. nach Chr.* (Bonn, 1977), 44, n. 138; 63, 134. K. Fittschen, "Sarkophage römischer Kaiser oder vom Nutzen der Porträtforschung," *JdI* 94 (1979), 578–93. A. M. McCann, *Roman Sarcophagi in the Metropolitan Museum of Art* (New York, 1978), 110. G. Koch and H. Sichtermann, *Römische Sarkophage* (Munich, 1982). A. Giuliano, ed., *Museo Nazionale Romano: Le sculture* I, 5 (Rome, 1983), 56–67, no. 25 (L. de Lachenal).

Marriage Sarcophagi: A. Rossbach, *Römische Hochzeits und Ehrendenkmäler* (Leipzig, 1871). S. Wood, "Alcestis on Roman Sarcophagi," *AJA* 82 (1978) 499–510. G. Koch and H. Sichtermann, *Römische Sarkophage* (Munich, 1982).

Hunt Sarcophagi: B. Andreae, *The Art of Rome* (New York, 1977), 450. B. Andreae, *Die antiken Sarkophag Reliefs* I, 2 (1980). G. Koch and H. Sichtermann, *Römische Sarkophage* (Munich, 1982).

Dionysiac Sarcophagi: K. Lehmann-Hartleben and E. C. Olsen, *Dionysiac Sarcophagi in Baltimore* (Baltimore, 1942). R. Turcan, *Les sarcophages romains à représentations diony-siaques* (Paris, 1966). F. Matz, *Die dionysischen Sarkophage* (Berlin, 1968–69). A. M. McCann, *Roman Sarcophagi in the Metropolitan Museum of Art* (New York, 1978). G. Koch and H. Sichtermann, *Römische Sarkophage* (Munich, 1982).

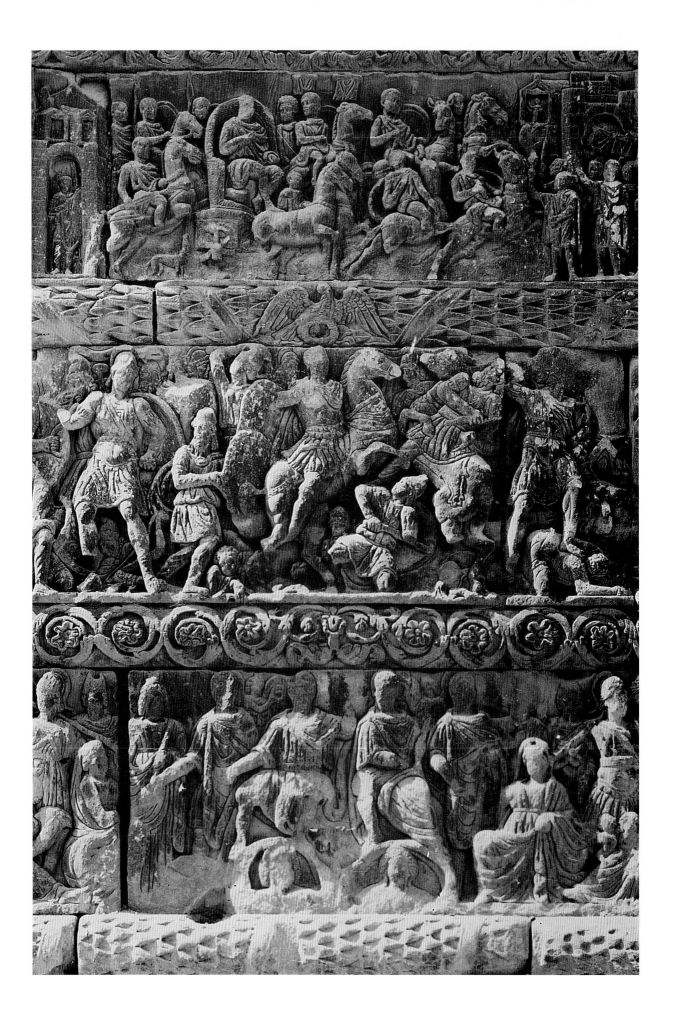

THE TETRARCHY

Gaius Aurelius Valerius Diocletianus was a Dalmatian of low birth who served as an imperial bodyguard to Numerian and eventually rose to great heights by becoming emperor of Rome. Diocletian was chosen in 284 by the army for the critical task of avenging Numerian, who had been murdered at the instigation of Aper, his Praetorian prefect. After successfully achieving the army's charge, Diocletian did battle against Numerian's brother, Carinus, defeating him in 285 and thereafter appointing an old friend, Maximian, as his Caesar. Maximian was dispatched to Gaul to crush local insurgencies, and the favorable result of his campaign led to his elevation to the rank of Augustus in 286.

Diocletian's rise to power did not automatically bring peace to the empire. Uprisings continued to be commonplace on the borders, and after becoming Augustus, the emperor did battle in Egypt and against the Alamanni, Sarmatians, and Saracens. Diocletian quickly recognized that the empire could not be governed by a single individual, and in 293 he instigated a new form of government known as the tetrarchy, which means four-man rule. This new governmental system, the brainchild of Diocletian, was the first of its kind and heralded the transition from principate to dominate. The empire had earlier been governed by co-emperors who had sometimes been responsible for different imperial duties, but this was the first time that the empire had been divided into distinct parts, each with a different capital. This division into four parts led to the decreased importance of Rome and the ascendancy of other cities in both the West and East. Some cities served as capitals and others were the sites of splendid imperial residences. Diocletian was the Augustus in the East; his palace was constructed at Split (Spalato) in Yugoslavia. Galerius was his Caesar, and he built his residence, which included a hippodrome, in Salonica. Maximian was Augustus in the West; his residence may have been the Villa at Piazza Armerina in Sicily. His Caesar was Constantius Chlorus, whose base was Trier, where he built a palace and basilica.

To enhance further the bonds among the four men, the Caesars were linked to the Augusti by marriage with their daughters, although Diocletian's stated objective was, nonetheless, to do away with hereditary succession.

Detail. Salonica, Arch of Galerius, southwest pillar, four tetrarchs enthroned, ca. 298–303. Photo: DAIR 79.464

The foursome embarked on separate military missions that had the common goal of bringing the stability to the empire that had been missing since the mid-second century. Their individual campaigns led to the recapture of Britain, the suppression of revolt in Egypt, a victory over the Carpi (which led to the unification of Mesopotamia), and the addition of several satrapies to the Roman empire.

It was in 303 that Diocletian celebrated twenty years of imperial power, the vicennalia, and the tenth year of his tetrarchy, the decennalia, by a visit to Rome. Due to ill health, he abdicated on 1 May in 305. Maximian followed his lead, and the two Caesars, Galerius and Constantius Chlorus, were elevated to the rank of Augusti. Two new Caesars, Severus in the West and Maximinus Daia in the East, were chosen. But without the strong presence and organizational ability of Diocletian, the tetrarchy fell apart. It left, however, a significant legacy.

Most of the emperors of the fourth century governed jointly, and many continued to practice a somewhat rigid and hierarchical court ceremony based on oriental models that Diocletian had earlier adopted in order to bring increased nobility to the imperial position. This included an association of the person of the emperor with a Roman state god. Diocletian, for example, was allied with Jupiter and Maximian with Hercules. Diocletian's choice of a Roman state god as his special patron represents a distinct break with the third-century emperors who favored Sol Invictus and foreign deities. Diocletian was a staunch supporter of old Roman traditions and religious customs, and he openly upheld them to strengthen the unity of the empire. The dark underside of these policies, however, was the increased persecution of the Christians. Diocletian was also forced to raise taxes to fund the larger army necessary to maintain an enduring peace.

Whatever his flaws, Diocletian was able to stabilize the empire enough to allow the four rulers to embark on ambitious building programs that were impossible under their third-century imperial predecessors. The multiplication of capitals that needed enhancement provided major public and private projects for architects who had earlier executed only defensive walls and religious structures. Sculptors, who had carved only sarcophagi and portraits, were once again called upon to design and carry out narrative reliefs with imperial protagonists and traditional themes.

Imperial Portraiture under the Tetrarchs

Imperial portraits on coins and in the round continued to be produced in the late third and early fourth centuries. Both those in miniature and in monumental scale were fashioned in a geometric and starkly abstract style that was already apparent in incipient form in the late cubic portraits of Gallienus, Probus, and others (see figs. 340, 343). This abstraction was attractive to tetrarchic artists, who were faced with the challenge of presenting the emperor not as an individual with a distinctive physiognomy but as an awe-inspiring symbol of collective imperial power. The pronounced geometry of the new tetrarchic style was also a visual reflection of the solid stability of Diocletian's new form of government.

Since the most outstanding feature of imperial portraiture under the tetrarchs was the deliberate suppression of distinctiveness in favor of a communal image, it has been difficult for scholars to identify individual portraits and organize them in chronological sequence. The general stylistic trends of the period have nevertheless been agreed upon, and in recent years scholars have greatly augmented our understanding of both imperial and private likenesses of the late third and early fourth centuries.

The abstract style favored under the tetrarchs was already apparent in the coin and medallion portraits of the 280s. An example is a gold medallion of 287 (fig. 363) celebrating the joint consulship of Diocletian and Maximian, who are represented on the front in facing profile portraits and carrying the insignia of their office. They wear a short military coiffure that recedes at the temples and is impressionistically stippled, as is the short beard that follows the contour of the jaw. The beard grows down the neck and is artfully waved at the bottom edge. A comparable depiction of hair and beard can be seen in Probus's coin portraits of the earlier 280s. Probus's portraits also share with those of Diocletian and Maximian a cubic organization of the planes of the face and neck. The reverse of the medallion depicts the co-emperors, crowned by Victory, in a biga drawn by elephants.

These numismatic portraits belong to what has been designated type 1, which depicts Diocletian as a soldier-emperor. It was popular in the 280s and early 290s before the formation of the tetrarchy. Other medallions and aurei of the 280s and 290s depict Diocletian, Maximian, Galerius, and Constantius Chlorus alone, but in all cases their faces and attributes are essentially interchangeable. All of their portraits are distinguished by the same features as those in the medallion of 287, although the portraits do demonstrate an increasing abstraction that seems to signal the creation of a new type, usually referred to as type 2. An example is a numismatic portrait of Diocletian on a gold medallion of 294 (fig. 364), where the hair is shorter on the nape of the neck and the beard is a strip of hair along the curvature of the jaw. The face and neck are more blocklike; the eyes larger and stare straight ahead.

Frontal portraits on coins also became popular under the tetrarchs. These had appeared before only on occasion

363 Five-aureus coin with facing profile portraits of Diocletian and Maximian, from Rome, 287. Berlin, Staatliche Museen. Photo: Hirmer Verlag München, 2062/63.933 V

364 Ten-aureus coin with portrait of Diocletian, 294. London, British Museum. Photo: Courtesy of the Trustees of the British Museum

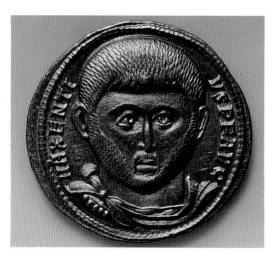

365 Aureus with frontal portrait of Maxentius, 308. Private collection. Photo: Hirmer Verlag München, S27 0126 V

but now seemed appropriate to express an increasingly iconic image of the emperor, who was more a symbol of his power than an individual, and to parallel the increased taste for frontality in state relief that began under the Antonines. These frontal portraits, such as one of Maxentius, a later tetrarch, of 308 (fig. 365), are also characterized by a blocklike geometry, a frozen, masklike expression, and a military hairstyle and beard that seem to encase the head like a metal helmet.

Although marble portraits in Cairo, Florence, Leiden, Milan, and Munich have been associated with the soldier-emperor type of Diocletian, what is most striking and indeed unprecedented in the portraiture of the tetrarchs is that the emperors are truly indistinguishable from one another. They wear the same coiffures and costumes, carry identical attributes, and their physiognomies are alike in every way. This is, of course, deliberate on the part of the patrons and artists and is, in fact, a significant part of the message of the portraits. The tetrarchs, both Augusti and Caesars, are as equal in status as they are in appearance. This is not to say that similitude (*similitudo*) in portraiture was not used earlier to underscore familial and political ties. The Julio-Claudian emperors are depicted in the same bland classizicing style as Augustus; and later emperors, like Trajan, who wished to associate themselves with Rome's first emperor, deliberately adopted a comparable hairstyle.

Both the Julio-Claudians and Trajan are individual and recognizable personages who could never be mistaken for Augustus. The goal in tetrarchic portraiture is to depict the foursome as forming an indivisible unit and to subsume personal quirks in a homogenous whole that symbolizes the cohesiveness not only of the co-emperors but of the entire empire. It is also for this reason that the tetrarchs were often depicted in group portraits that ornamented the niches of arches – such as that of Galerius at Salonica – or were placed atop columns like those of Diocletian's Decennial or Five-Column Monument in Rome (see figs. 382–385). Furthermore, at least two surviving examples depict a group configuration of the four tetrarchs that formed the decoration of porphyry columns and that was fashioned of the same hard material. The provenance of both must have been Egypt, where porphyry was quarried and favored for imperial statuary because of the royal connotations of the reddish-purplish color. The hardness of porphyry was also especially appropriate for carving the sharp geometric shapes and creating the abstract quality favored under the tetrarchs. In fact, it has been demonstrated that such works (and extant fragments of similar groups have been found elsewhere in the Roman world) were manufactured in imperial workshops at Mons Claudianus in Egypt and exported.

One of the well-preserved porphyry groups, which

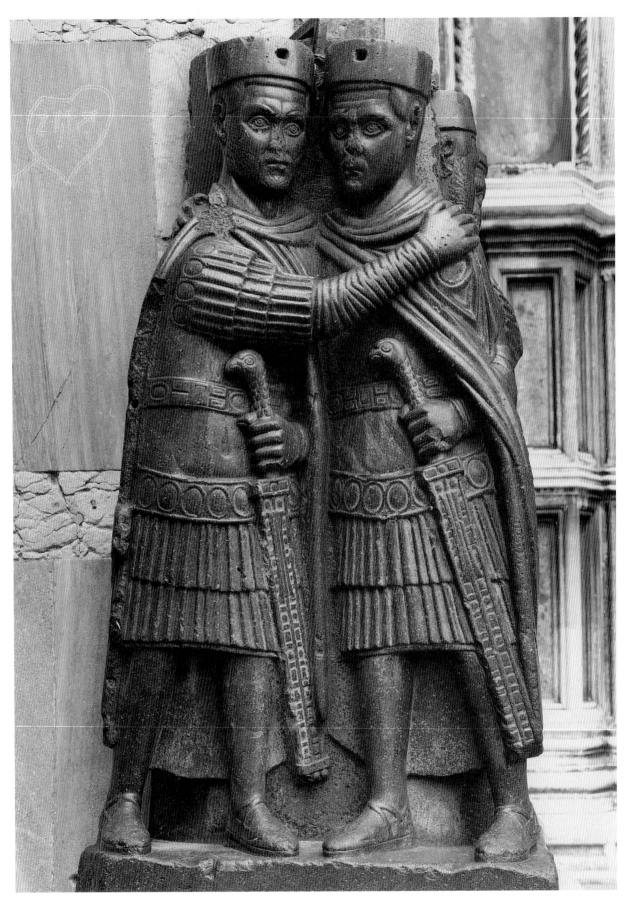

366 Two tetrarchs from porphyry group portrait of the four
tetrarchs, from Constantinople, ca.300. Venice, southwest
corner of Basilica of S. Marco. Photo: DAIR 68.5152

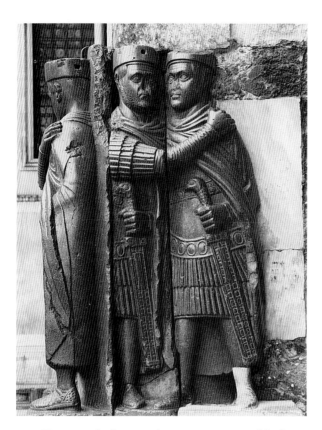

367 Two tetrarchs from porphyry group portrait of the four tetrarchs, from Constantinople, ca.300. Venice, southwest corner of Basilica S. Marco. Photo: DAIR 68.5154

comes from the imperial palace in Constantinople, is now embedded in the southwest corner of the Basilica of San Marco in the Piazza of S. Marco in Venice (figs. 366–367). The original location of the group was recently confirmed by the discovery in the palace of a porphyry foot of the exact dimensions as the marble replacement now affixed to the Venice group. The group is traditionally dated to about 300 and portrays two pairs of tetrarchs with each twosome standing on a bracket that presumably extended from the porphyry column. Such a display of statuary on columns with projecting brackets is known from the eastern provinces, such as on the main colonnaded street at Palmyra.

The figures are frontally positioned with both legs placed firmly on the ground. Gone is the subtle contrapposto of classical times. The figures are not sinuously curved but rectangular in shape. Although they wear the cuirass, the musculature of the chest is not defined. The breastplate is cinched at the waist with a military belt, and each tetrarch wears a long paludamentum draped over the left shoulder that was originally fastened on the right with a brooch, probably added in a different stone. The artist plays the rigid pattern of the vertical folds of the skirt of the cuirass and of the upper sleeves of the tunic against the scheme of concentric circles around the

lower sleeve and the uppermost edge of the paludamentum, further complemented in the disks that ornament the upper band of the skirt.

While the left tetrarch in each pair embraces the other with his right arm, each holds an identical bird-headed sword in an elaborately ornamented sheath in his left hand. Although the bodies are frontal, the two figures in each pair turn toward each other in a display of mutual admiration and unity.

Their faces, which are as similar to one another as free-hand carving allows, are geometrically ordered and conform to Diocletian's type 2 portrait. The face itself is an oval, the eyes almond shaped, heavily lined, and surmounted by dramatically arched brows. The forehead has deep creases that cross it horizontally and, along with vertical furrows above the bridge of the nose, are part of a network of wrinkles that demonstrate the artist's overriding interest in pattern. The hair, which is carved in a straight line across the forehead, recedes at the temples, and curves in front of the ears, is more a geometric shape than a coiffure since individual strands of hair are not delineated. The short beard, worn by the left tetrarch of each pair and conforming to the shape of the cheeks and chin, was created by short, carved strokes. The beards are the only differentiating characteristic, and it is likely that the bearded member of the pair is the Augustus and the cleanshaven emperor his Caesar, the pairing of a slightly older and a younger emperor perhaps intended to underscore a father-son relationship. Each tetrarch wears a rounded but severe Pannonian cap, which, according to the fourth-century historian Eutropius, was introduced into the imperial regalia by Diocletian. These hats were originally ornamented with a stone or jewel affixed to the center of the front.

While in the S. Marco tetrarchs each Augustus appears to be joined with his Caesar, scholars have suggested that the two Augusti and two Caesars are paired in another well-preserved porphyry group on two porphyry columns now in the Vatican Library in Rome (figs. 368–369). The frowning duo with the deeply furrowed foreheads, possibly connoting their more advanced age or at least their experience, have been identified as the two Augusti, Diocletian and Maximian, whereas those with smoother faces and straight lips seem to be the somewhat younger and more junior Caesars, Galerius and Constantius Chlorus. Their physiognomies are nearly identical in other respects. The faces are oval, the large, staring eyes almond shaped and prominently outlined. The geometric cap of hair, which recedes at the temples and is cut straight across the forehead, has the barest indication of individual locks, as do the beards. As in the S. Marco group, the pairs are depicted in an embrace of unity, the bodies are frontally positioned, and the artist demon-

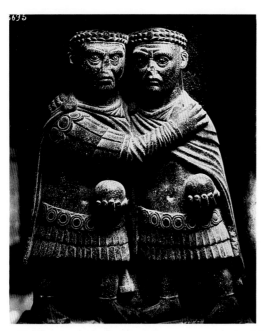

368 Two tetrarchs from porphyry group portrait of four tetrarchs, ca.300. Rome, Vatican Library. Photo: DAIR 5695

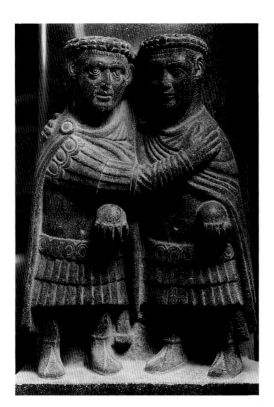

369 Two tetrarchs from porphyry group portrait of four tetrarchs, ca.300. Rome, Vatican Library. Photo: DAIR 5694

strates little regard for the shape of the body beneath the emperors' breastplates. The figures are squat in proportion and cubic in shape. They wear laurel wreaths with stones or jewels at the center above the forehead, and each tetrarch holds an orb in his left hand.

Although all the porphyry portraits of the tetrarchs seem to be fashioned in this style, the style was also used for portraits made from local stone or marble. Examples of the former include the emperor's relief medallion portrait in his mausoleum at Split (see fig. 386) and a portrait herm, discovered near the imperial palace and now in Salona; the latter is represented by a marble portrait herm, known as the Jerichau herm, formerly in Rome and now in the Ny Carlsberg Glyptotek in Copenhagen.

The portraits of Maximian, Augustus in the West, have also been divided into two types: a soldier-emperor type of the 280s and early 290s, and a more cubic abstract portrait type of the 290s. There is evidence of both on surviving coins, but the only certain monumental versions are those that belong to the porphyry groups and to the portrait herms of the tetrarchs in Salona. The figure of the tetrarch in the so-called Great Hunt mosaic in the Villa at Piazza Armerina, which has been linked to Maximian, probably also represents the emperor.

The similitudo of the four emperors is so great that such individual portraits are difficult to identify. A case in point is a powerful porphyry bust from Athribis in Egypt and now in Cairo (fig. 370), which is identified as Galerius because of its similarity to extant portraits of the emperor on his two arches in Salonica. A porphyry replica of the Athribis head, now lost but at one time in the Museum at Antioch, can also be associated with the Cairo portrait, as can the heads of the Caesars in the Venice and Vatican porphyry groups.

Specific identification does not really matter because the artist's goal was to create the image of a tetrarch rather than to capture the specific features of one member of the foursome. The Cairo portrait shows its subject with a cubic face, deep horizontal forehead furrows, vertical creases above the bridge of the nose, and nasolabial lines. The eyebrows are dramatically arched. The almond-shaped eyes are heavily outlined and contain large, staring pupils. The geometry of the face is underscored by the severity of the hair and beard, which finds its origins ultimately in the portraiture of Caracalla. The emperor is depicted with a short military haircut that is combed straight across the forehead and recedes at the temples. The individual strands of hair are carved into the hard stone with short strokes and are meticulously arranged in parallel rows. The same technique was used to indicate the hairs of the beard, which is short and conforms closely to the shape of the cheeks and jaw. The sharp line that demarcates the smooth skin from the

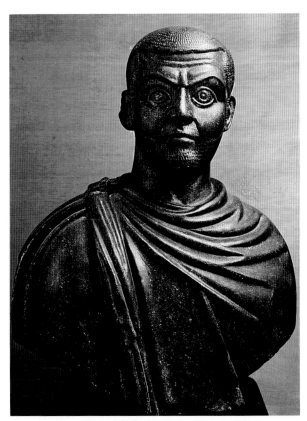

370 Porphyry portrait of Galerius (?), from Athribis, ca.300. Cairo, Cairo Museum. Photo: Alinari/Art Resource, New York, 47129

textured beard and dividing the forehead strands from the horizontal furrows below are so pronounced that they set the beard and hair off from the face as geometric shapes. A profound predilection for geometry and abstraction is apparent in the carving of the entire head, in which the artist creates a masklike countenance by exaggerating the curves of the forehead furrows and the arched eyebrows and the heavy outlines of the prominent staring eyes. Even the ears seem to be sinuous shapes rather than an organic part of the head.

Both the Cairo portrait and the S. Marco and Vatican groups were produced in Egypt, and the groups were clearly exported. Many of the coins discussed above were manufactured in mints like those in Antioch, Cyzicus, and Nicomedia, which were in the eastern part of the empire and under the direct control of Diocletian. The majority of the heads in marble or local stone associated with Diocletian's type 2 portrait also have an eastern provenance. It is for these reasons that this abstract style suggests a provincial rather than a city-of-Rome phenomenon, although such a distinction is less meaningful in the tetrarchic period when Rome was no longer the sole capital of the empire.

An additional example is the gold medallion with a

portrait of Diocletian (see fig. 364), struck in about 294 at Nicomedia, depicting the emperor with a severe, blocklike head and neck and large, heavily outlined and staring eyes. The military cap of hair and short beard are geometrically ordered and conform closely to the shape of the skull and jaw. It is fair to ask whether the same abstract and iconic style was used contemporaneously in portraits made in Rome. An abstract style, seen in the late portraits of Gallienus, Probus, and others, was already firmly entrenched in Rome (see figs. 340, 343), and aurei and medallions from the city of Rome of the 280s – for example, the gold medallion with portraits of Diocletian and Maximian struck at the Rome mint in 287 (see fig. 363) – include portraits conceived in this manner. The city-of-Rome style retains some naturalistic effects and is not the immobilized mask of the eastern examples. Although a stylized abstraction probably characterized all the portraits of the tetrarchs produced in the Mediterranean in the late third and early fourth centuries, subtle distinctions, due to regional preferences, are clearly apparent.

Examples of tetrarchic portraits in a softer, more naturalistic style are the two marble masterworks now in Copenhagen. One was purchased in Rome, the other is of unknown provenance. In both cases, the identity of the subject is disputed, but all scholars who have discussed them agree that they were made in the late third or early fourth century. One of the heads, worked for insertion into a full-length statue, is usually associated with Diocletian, although at least one scholar identifies it as a private portrait of the late third century (fig. 371). It depicts an animated emperor with his head turned sharply to his left and his face carefully modulated with shifting planes. He is caught by the artist in a melancholy mood, his heavy-lidded eyes glance to the left, and his lips are tightly set. He has deep furrows in his forehead and expressive, arched eyebrows, and he wears a short military coiffure that forms a widow's peak in the center and recedes at the temples. The strands of hair are delicately etched into the cap, which is only slightly raised above the skull. The very light beard is made up merely of scattered chisel marks. This highly sensitive portrait of Diocletian depicts him in a style that closely approximates that of his third-century predecessors.

The second Copenhagen head, from Rome and also worked for insertion into a full-length statue (fig. 372), is traditionally associated with Diocletian's fellow tetrarch, Galerius, but may have been made upon his elevation to Augustus after Diocletian's abdication, that is, between 305 and 311. Many scholars, however, have questioned this identification. Stylistically it is closer to the porphyry portraits than to third-century models; there are even features that presage those that emerge under Constantine.

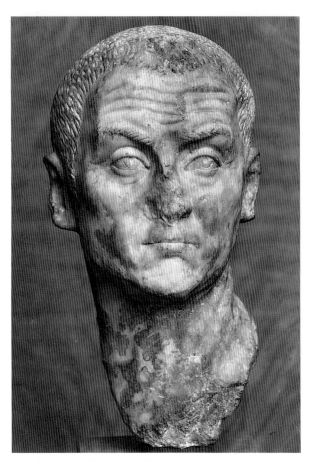

371 Portrait of Diocletian (?), late third or early fourth century. Copenhagen, Ny Carlsberg Glyptotek. Photo: Courtesy of the Ny Carlsberg Glyptotek, Copenhagen

The face is solid and cubic, with the features arranged roughly symmetrically. The slightly hooked nose serves as the center, and the sharply arched brows flare out from it. Large and heavily outlined eyes are shadowed below. As in the head of Diocletian, the beard is barely hatched into the cheeks and jaw, and this impressionistic rendering contrasts with the full cap of hair worn by the emperor. What is most striking is that the hair is not a military cap but a full head of hair with comma-shaped locks arranged across the forehead, in a manner associated with Augustus and the Julio-Claudians, and with Trajan. It is this hairstyle that was adopted roughly contemporaneously by Constantine the Great, the son of Galerius's fellow Augustus, Constantius Chlorus, in an attempt to present his principate as a continuation of the principate of the "good" emperors of the past. It may well be that Galerius and some of the other emperors recognized a good idea when they saw one and in the tetrarchic spirit of *similitudo* adopted it as their own.

In sum, a more naturalistic, but still abstract, style appears to have been adopted for portraits manufactured in Rome in the late third and early fourth centuries. The controversy surrounding the identities of those depicted in this manner makes it all but impossible to ascertain whether it was favored by the court or only by private individuals of the day. Since imperial personages were customarily the trendsetters, the former explanation is more likely.

The tetrarchic style of the 290s, which one scholar attributes to the impact of the portraiture of Galerius, is least apparent in the numismatic and monumental portraits of Constantius Chlorus. Coins struck in the West depict the emperor with an individualistic face and prominent nose, strong jaw, a fuller head of hair with the locks delineated, and a naturalistic beard. Two surviving marble portraits of Constantius Chlorus from Rome, both replicas of the same prototype of about 300, are now in Berlin and Copenhagen (fig. 373). They are powerful evocations of the father of Constantine the Great, with his long, oval face, hooked nose, prominent chin, deeply set, wide eyes under arched brows, and wide but heart-shaped mouth. Although the coiffure resembles a military cap, the individual hairs are carefully delineated and arranged in small comma-shaped locks across the forehead. A light beard is hatched into the cheeks and chin and grows in a subtle wave across the junction of jaw and neck. Although the features express the subject's individuality, they are somewhat subsumed in an underlying abstraction that betrays the portrait's tetrarchic date. The effective synthesis in the Berlin and Copenhagen heads of individuality and abstraction and the return to a fuller coiffure with comma-shaped locks presages the portraiture of Constantius's son, Constantine the Great.

When Diocletian and Maximian retired on 1 May 305, their Caesars became Augusti, and two new Caesars, Flavius Valerius Severus and Gaius Galerius Valerius Maximinus Daia, were chosen. Valerius Severus was killed in 308 by Maxentius and in his place, Licinius was made Augustus in the West, although he oversaw only Illyria since Constantine, first Caesar to Severus, had already assumed the title of Augustus in Gaul. Daia was the son of Galerius's sister and was thus promoted by his uncle and eventually made Caesar in the East. In 310, he assumed the rank of Augustus. Constantine and Licinius allied themselves against Daia, who sided with Maxentius. Maxentius was, however, defeated by Constantine and Daia by Licinius, leaving the former allies to contest one another for imperial power. It was apparent that Diocletian's new order was in disarray and could not successfully outlast its founder.

Daia, emperor from 305 to 313, was depicted on coins in an abstract cubic style resembling that favored by the first set of tetrarchs (save Constantius Chlorus) in numismatic portraits of the 290s. The blocklike character of the

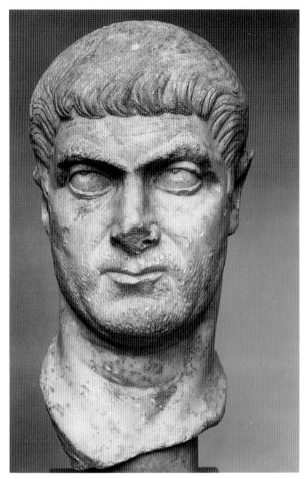

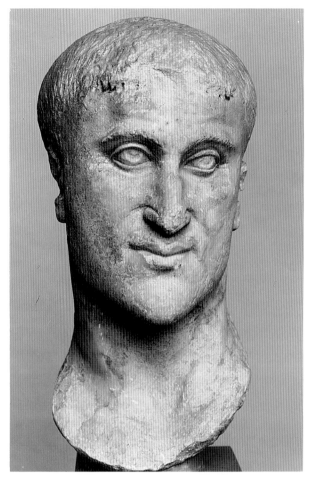

372 Portrait of Galerius (?), from Rome, late third or early fourth century. Copenhagen, Ny Carlsberg Glyptotek. Photo: Courtesy of the Ny Carlsberg Glyptotek, Copenhagen

373 Portrait of Constantius Chlorus, from Rome, ca.300. Copenhagen, Ny Carlsberg Glyptotek. Photo: Courtesy of the Ny Carlsberg Glyptotek, Copenhagen

head and thick neck is even more accentuated, and the military coiffure and the thin strip of short beard separate his head and face into a pair of geometric shapes. The facial features are added with a minimal amount of detail and consist of large eyes, arched brows, sharp nose, and small mouth. Portraits in the round of Maximinus Daia also demonstrate that the tetrarchic style in the East, epitomized by the Venice and Vatican porphyry groups, was perpetuated under the later tetrarchs.

The numismatic portraits of Valerius Severus are, however, more individualistic and therefore more in the tradition of Constantius Chlorus than the other original tetrarchs. His distinctive profile with prominent nose and pointed chin are combined with a pronounced emphasis on stereometric form in the blocklike rendition of the face, neck, and military hairstyle. Secure portraits of Valerius Severus in the round have not been identified.

The numismatic portraits of Maxentius, emperor from 306 to 312, are even more idiosyncratic than those of Valerius Severus. Like Constantius Chlorus, Maxentius

is depicted in aurei of 307–12 with a distinctive profile and relatively naturalistic features. The eyes, nose, mouth, and chin are carefully modeled, and the hair and beard appear to grow organically from the head and face. The hair is a military cap, but it is fuller, raised from the scalp, and most important, arranged in comma-shaped locks across the forehead. Three similar portraits in Rome, Dresden, and Stockholm have been identified as likenesses of Maxentius because of their similarity to the numismatic portraits. They are not replicas of a common prototype but nonetheless exhibit a striking resemblance.

The portrait in Rome (fig. 374), is the finest of the three and depicts Maxentius in a naturalistic manner with eyes deeply set beneath relatively straight brows. His distinctive profile matches one on contemporary coins, and he is portrayed with a slight, stippled beard and a coiffure brushed down from the crown of his head and arranged in comma-shaped locks across his forehead and in front of his ears.

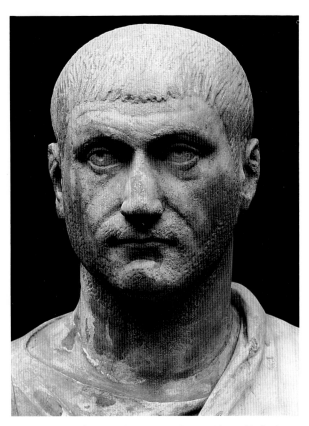

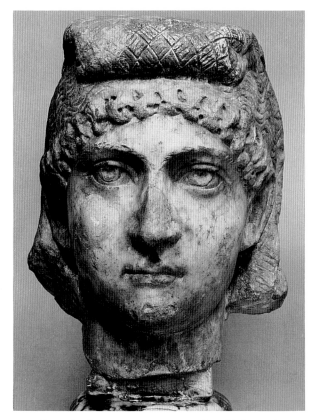

374 Portrait of Maxentius, 307–12. Rome, Museo Torlonia.
Photo: DAIR 33.1782

375 Portrait of an anonymous woman, late third or early
fourth century. Rome, Museo Capitolino. Photo: Gisela
Fittschen-Badura

Female Portraiture under the Tetrarchs

Female portraiture in Rome under the tetrarchs fol-
lows, for the most part, the tradition of third-century
female portraiture. Court and aristocratic women are
represented in straightforward likenesses that realistically
capture their physiognomic peculiarities and depict them
with coiffures that are waved across the forehead, fall
loose behind the ears, are swept into a flat bun covering
the back of the head, and are rolled at the top of the head
to add height. An example is the portrait of a woman,
now in the storerooms of the Museo Capitolino (fig.
375), whose identity is uncertain, although she has been
associated with Helena, the wife of Constantius Chlorus,
or Fausta, the daughter of Maximian.

Comparable coiffures can be found in numismatic
portraits of women from the late third and early fourth
centuries, as well as in marble heads in Boston and
Adolphseck. What sets the treatment of this coiffure apart
from its third-century prototypes, however, is the artist's
increased interest in symmetrical pattern, which is also
apparent in contemporary male portraiture. Although
the hair over the forehead is bunched in drilled, cork-
screw curls, and the hair immediately behind it is gently
waved, the strands that are arranged in the wide bun at

the rear of the head and the roll above are disguised be-
neath what seems to be a hairnet. The net is made up
of crisscrossed lines that create a pattern of diagonally
dispersed diamonds. Moreover, the head is more stereo-
metric than those of third-century females. The face is a
perfect oval, and the features are symmetrically disposed,
with the look of the eyes straight ahead. The faraway
glance and shifting facial planes of third-century female
portraiture are no longer in evidence.

State Relief under the Tetrarchs

It was Diocletian's formation of the tetrarchy and
the initial success of this new form of government that
brought renewed stability to Rome and indeed to the
entire empire. As noted, Diocletian celebrated his vicen-
nalia in 303, a year that also marked the decennalia of the
tetrarchy. Such a commemoration attested to the seeming
permanence of the tetrarchy. No single emperor or co-
emperors had held onto power for twenty or ten years,
respectively, since the end of the second century. With
renewed stability came the opportunity to build the kind
of large-scale monuments that had been largely missing

from the skyline of Rome and the provincial cities in the third century. Although Diocletian was Augustus in the East, he erected major monuments in Rome, which attest to Rome's continued prestige and to the fact that the tetrarchs were in power everywhere, even though they were individually responsible for different regions.

Major monuments in Rome included the spectacular Baths of Diocletian on the Viminal and the Arcus Novus. It was while Diocletian was emperor, specifically in 284, that a great conflagration in Rome destroyed the part of the Roman Forum closest to the Capitoline hill and demolished one of the city's most important buildings, the Curia, begun by Julius Caesar and completed by Augustus. It was Diocletian who was responsible for restoring this structure essentially along its republican lines, although the taste for severe abstract forms apparent in the choice of unadorned expanses of brickfaced cement walls was a hallmark of the tetrarchic architectural style in Rome. The new pavement was decorated with multicolored marble blocks, including those in porphyry, a tetrarchic favorite. By choosing to restore this structure, Diocletian paid homage to the beginnings of Roman *imperium* in the same way that his choice of Jupiter, the chief god of the Roman state, as his personal patron demonstrated his reverence for traditional Roman religious customs. While piously restoring revered buildings of the past, Diocletian also commissioned new structures that bore his own name, such as the Baths of Diocletian. Others, like the Decennial or Five-Column Monument in the Roman Forum (see figs. 382–385), commemorated the success of the tetrarchy, Diocletian's personal triumphs, and alluded to the special relationship the emperor had with his patron god Jupiter.

The Arcus Novus

The Arcus Novus was erected on the Via Lata in Rome in honor of Diocletian's decennalia of 293 and in anticipation of his vicennalia of 303. The reason for its erection and its date are suggested by a relief with female personifications and shield inscribed with "VOTIS.X.ET.XX" that appears to have belonged to the monument (fig. 376). The year of the arch's construction coincides with that of the formation of the tetrarchy; it is likely that the arch commemorates that as well as Diocletian's personal achievement.

Whether the arch was single or three-bayed is controversial because the structure no longer survives. It was dismantled in 1491 at the order of Pope Innocent VIII, but surviving sculptural fragments found their way into the Della Valle-Capranica Collection in 1535 and in 1584 came into the possession of Cardinal de' Medici. The relief with the female personifications and shield was one of those incorporated into the wall on the garden side of the Villa Medici on the Pincian hill in Rome, and two pedestals (figs. 377–381) were transported to Florence in 1785 where they were set up in the Boboli Gardens. The pedestals supported freestanding columns, like those from the earlier Arch of Septimius Severus in the Roman Forum (see fig. 295), and are decorated on three sides with panels of vertical format carved with figures of the Dioscuri with their horses, a Victory with a palm tree and a palm branch, another Victory with a trophy and a barbarian, and captured barbarian prisoners with accompanying Roman soldiers.

The two socles, of Diocletianic date, probably flanked the central bay. The outer faces of the pedestals were carved with the Victories facing forward, with the one on the right socle turning left toward the central bay and the one on the left turning right, also in the direction of the central opening. The Dioscuri were on the inner faces of the pedestals closest to the facade and were also both turned to face the central bay. Each outer face has a male captive with his hands tied behind his back and paired with a Roman soldier. The groups move away from the arch and in the direction of the Victory.

The Dioscurus on the right pedestal (see fig. 377) faces left and is nude save for a mantle and a helmet with a star at the apex. He cradles a sword in a sheath in his left arm and holds the reins of his horse in his right. The face of the horse is cut off, indicating that the relief was truncated when it was inserted into its modern frame. The body of the Dioscurus is frontally positioned, but the head is turned right in the direction of the horse and the central bay of the arch. The musculature of the torso is more carefully defined than that of Mars in the sacrifice scene on the tetrarchic Decennial Monument in the Roman Forum (see fig. 385), but the modeling of the forms is not as fluid as in state reliefs of the High Empire. The mantle that swirls around the back of the figure is highly patterned and attests to the artist's expertise in the use of the drill to create decorative effects that seem to have a life of their own. The posture of the horse is quite stiff, and the mane seems more a decorative motif than a depiction of real hair growing from an animal's head. The wrinkles on the horse's neck are also treated as a pattern rather than as the natural creases of the animal's skin.

The Victory on the same pedestal (see fig. 378) is also frontally positioned with her head turned sharply left toward the arch's central bay. Her weight rests on her right leg, and her muscular body is molded beneath the drapery. The folds seem to have an independent existence as they swirl around her breasts and abdomen, and across her thighs. She carries a palm branch in her left hand and a wreath in her right. The arm with the wreath is raised as if she were about to crown someone with her

376 Rome, Arcus Novus, Villa Medici fragments, Claudian or Antonine. Rome, Villa Medici. Photo: DAIR 74.763

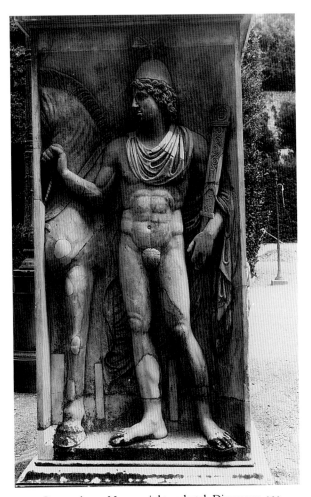

377 Rome, Arcus Novus, right pedestal, Dioscurus, 293. Florence, Boboli Gardens. Photo: DAIR 7759

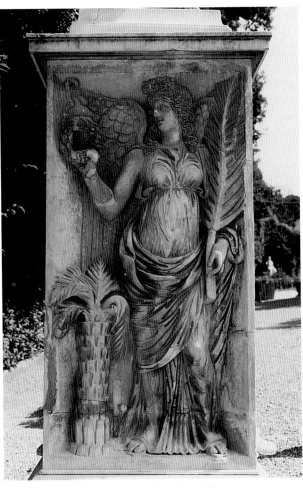

378 Rome, Arcus Novus, right pedestal, Victory, 293. Florence, Boboli Gardens. Photo: DAIR 65.2127

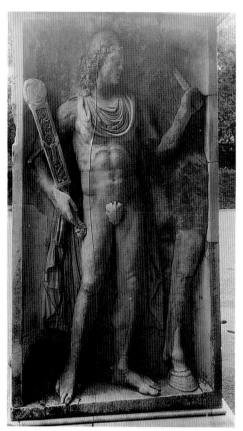

379 Rome, Arcus Novus, left pedestal, Dioscurus, 293. Florence, Boboli Gardens. Photo: DAIR 7762

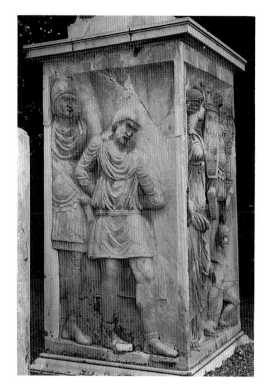

381 Arcus Novus, Rome, left pedestal, Roman soldier and captive, 293. Florence, Boboli Gardens. Photo: DAIR 65.2126

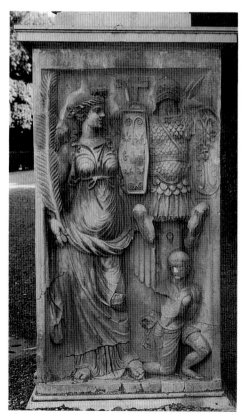

380 Rome, Arcus Novus, left pedestal, Victory, 293. Florence, Boboli Gardens. Photo: DAIR 65.2124

attribute. There is a palm tree to her right. Her wings are artfully conceived so that both can be seen behind her body and the individual leaves are meticulously delineated. Her hair is parted at the center and gathered in a high topknot at the apex. The remainder is brushed in deep waves that cover her ears, and thick curly strands fall on each shoulder.

The male captive on the outer face of the right pedestal is frontally positioned with his head facing away from the Victory. He is, however, accompanied by a Roman soldier who was removed when the relief was recut. His right shoulder, epaulet, and right elbow are still preserved, and the position and musculature of the arm indicate that he was pushing the captive toward the left and thus in the direction of the Victory. The barbarian has a bare chest partially covered with a long fur mantle and wears leggings fastened at the waist with a belt. His feet, covered with soft shoes, project beyond the frame. He has a long scraggly beard but wears his hair in a neat coiffure brushed from the crown of his head over his forehead and partially over his ears like a cap.

The Dioscurus on the left pedestal (see fig. 379) faces right. He is depicted in the same pose and with the same cap, mantle, and attributes as the Dioscurus on the right socle. He is also represented with his horse, of which only one of the rear legs is preserved. The Victory on the front

face of the left socle (see fig. 380) stands frontally with her weight on her right leg. Her left leg is slightly bent and her left heel raised. Her garment molds her curvaceous form, but the artist's interest in drapery is not just as a complement for the body but as subject in its own right. He therefore explores the drapery patterns around and in between the breasts and across the abdomen and thighs. The Victory holds a palm branch in her right hand, but the wreath of her counterpart is here replaced with a trophy, which she embraces with her left arm. It is made up of a helmet, breastplate, two shields, and greaves, and below it is represented a kneeling male captive with his arms chained behind his back. He wears leggings but is nude from the waist up.

The male captive on the left face of the left pedestal (see fig. 381) wears his hair in similar fashion to his counterpart on the other socle, but his beard is short and he wears a belted tunic and mantle rather than leggings and a fur robe. The accompanying Roman soldier in cuirass and helmet urges his companion to proceed from left to right toward the Victory.

The progression from captive to Victory to Dioscurus that moves in a crescendo from the outer edges of the arch toward the center is deliberately orchestrated by the designer of the arch not only to provide a central focus but to narrate a story in synoptic form. The soldiers and captives refer to Roman military victories over their enemies by Diocletian (and probably also by Maximian, his co-Augustus), and the Victories with their palm branches, trophy, and kneeling captive, to the celebration of these same military conquests. The twin Dioscuri with their steeds may be an additional reference to Roman military supremacy since they were favored for worship by the army, but they may also have been chosen for depiction here because they are the divine twins. On the Arch of Galerius at Salonica, Diocletian and Maximian and their two Caesars are accompanied by divinities and personifications, including the Dioscuri and their horses (see fig. 388). The Dioscuri on the Boboli Gardens bases are not only guardians of the gate but also may serve as counterparts for the twin Augusti themselves. The two were worshipped as divine twins, their concordia mirrored in their similitudo.

Although some scholars have dated the bases to the period of the emperor Aurelian, suggesting that they came from the entrance to that emperor's Temple of the Sun, others have convincingly connected the pedestals to the Arcus Novus, listed in the regional catalogue of the Constantinian period and by a chronographer of 354. Furthermore, it has been demonstrated that the Late Antique socles were combined with spolia in the design of the Diocletianic arch. These spolia included architectural members and figural reliefs that were joined to make up

both the fabric and sculptural decoration of the structure.

Although the sculptural fragments seem to have come from monuments in the immediate vicinity of the Arcus Novus, they were not chosen haphazardly. Rather, their selection demonstrates that the designer of the Diocletianic arch had a specific program in mind for the arch that glorified Diocletian and celebrated the formation of the tetrarchy that in turn anticipated a successful future. The architectural spolia included undecorated marble blocks, a Corinthian half-capital, a keystone, two fragments of the cornice, and a wing of a Victory, probably from one of the spandrels. The architectural fragments and the Victory can be dated to the Claudian period and were originally part of the single-bayed Arch of Claudius erected in 51–52 in honor of the emperor's victories in Britain in 43 and the ensuing triumph of 44. The Claudian arch was erected over the Via Lata about 150 meters north of the Arcus Novus.

The sculptural fragments include the female figure writing on the shield with a stylus, now in the Villa Medici (see fig. 376), which was discovered along with the Boboli Gardens bases. The fragment incorporates another female personification with a walled city as a crown who kneels at the other's feet. The vota fragment, so-called because of its inscription, is one of four that were separated but originally belonged to the same panel. The additional fragments depict a small flying Eros with a perfume jar or *alabastrum* and a full-length figure of Virtus wearing an Amazonian costume, a balteus across her chest, and a helmet. She carries a sword in her left hand and a Roman standard with an eagle and thunderbolt in her right. She is accompanied by a male figure with a long scepter or lance in his left hand who is seen from the rear. He has a furrowed forehead and wears a short cap of hair articulated by a drill – a coiffure that is comparable in shape and style to those of the late third or early fourth century, which suggests that the head was reworked when the fragment was incorporated into the Arcus Novus.

Still another fragment depicts an additional female figure that is almost frontal, although she turns her head sharply to her left. She wears a long-sleeved tunic, leggings, and a long mantle fastened on her left shoulder. In her right hand, she holds a duck-headed bow. She wears a broad band across her forehead. Another figure wearing what is possibly the same costume (all that survives is her right arm with a long-sleeved tunic and long mantle) lays her right hand on the better-preserved woman's left shoulder. The date of these fragments is very controversial. Most scholars recognize a Hadrianic or Antonine style. A smaller number favor a Claudian date for the Medici fragments, based on stylistic analysis as well as on their fragmentary state, suggesting that

they were separated for easier insertion into a later monument. Furthermore, they too were part of the Della Valle-Capranica Collection, and one fragment has a recarved tetrarchic head. The vota inscription with reference to both a ten- and twenty-year rule is consistent with Diocletian's situation. Similar vota reliefs appear, as we shall see, on the Five-Column Monument and on the Arch of Galerius in Salonica.

Several fragments and panels from the Ara Pietatis Augustae may also have been reused in the tetrarchic arch. These fragments were either found in excavations of 1923 and 1933 near the Church of Sta. Maria in Via Lata or consist of fragments embedded in the walls of the Villa Medici, which – like the Boboli Gardens socles and the vota relief – originally came from the Della Valle-Capranica Collection. It has been suggested that the Ara Pietatis relief, representing the Temple of Cybele (see fig. 119), was reused in the Arcus Novus not only because it came into the Della Valle-Capranica Collection but also because the head of the togatus on the right side of the relief has been recarved. His short military coiffure and short beard, indicated in an illusionistic way by the dots of a drill, is inconceivable in the Claudian period and must have been reworked in the tetrarchic period for reuse in a monument of that time. The figure has even been identified as one of the tetrarchs, and a reconstruction of four similar scenes of four equal emperors sacrificing in front of four temples has been posited for the arch. Fragments of three temples have already been found, but only this one includes a recarved portrait. The reliefs from the Ara Pietatis also date to the Claudian period. Although already vowed by Tiberius, the altar was constructed by Claudius and dedicated in 43. It may have been erected on or near the Via Lata and if so would have been a convenient source of reused material for the Diocletianic Arcus Novus.

The Arcus Novus was undoubtedly erected not only in honor of Diocletian but of the tetrarchy in general. As we have seen, it seems to celebrate the formation of the tetrarchy and the decennalia of Diocletian and includes a reference to the future vicennalia (similar to the Vota x.xx on the Arch of Constantine) or to Diocletian's vicennalia and the decennalia of the other three tetrarchs. In the former and more likely case, the monument must have been erected in 293; in the latter, in 303. All of the major state monuments of the tetrarchic period appear to have been dedicated to all four emperors, even if one was honored above the others. The Arch of Galerius at Salonica, although part of the palace and tomb complex of Galerius, seems to have had statues of all four tetrarchs in niches; of the five columns of the Decennial Monument in the Roman Forum, four had statues of the tetrarchs, one with that of Jupiter.

As mentioned above, it has been suggested that all four tetrarchs were depicted in scenes on the Arcus Novus, although that hypothesis remains controversial. One of the tetrarchs, Constantius Chlorus, even celebrated a major military victory in Britain, an event possibly alluded to in the scene of the tetrarchs enthroned on the Arch of Galerius at Salonica (see fig. 390). The importance of a British victory to the iconography of tetrarchic art makes the expropriation of panels from Claudius's British arch for that of the tetrarchs not only more probable but also more understandable. The tetrarchs were legitimizing their link to the popular emperors of the first century, much in the way that Constantine later connects himself on his arch in Rome with the "good" emperors of the second century. It was supporters of Constantine the Great who invented a distinguished genealogy for the family by asserting that Constantius Chlorus was descended from Claudius Gothicus, who chose his name in an attempt to link himself with the original Claudius.

The Five-Column Monument or the Decennial Monument
The Five-Column Monument is also referred to as the Decennial Monument or the Tetrarchic Monument. Its three names describe its major characteristics. It consisted of five columns and celebrated the decennalia of the tetrarchy in 303 and must have been erected in approximately the same year. It also commemorated the vicennalia of Diocletian and Maximian (even though Maximian was actually appointed Augustus a few years later), which marked the first and only time Diocletian was in Rome as emperor, as well as Diocletian's Persian triumph. It was erected in one of the most prominent locations in Rome, at the northeast corner of the Roman Forum behind the Rostra and next to the Arch of Septimius Severus. It was the first major structure to be erected in the Forum since Severan times, which in itself is of great significance.

All that survives of the monument today is one of the decorated bases, which was discovered in 1547 and originally supported one of the five columns (figs. 382–385). A representation of the tetrarchic decennial monument in the frieze of Constantine's oration from the Arch of Constantine (see fig. 412), however, records the monument's form and indicates that four of the original columns were aligned in a row: the fifth was taller and stood alone behind the others. Foundation blocks excavated behind the Rostra in 1959 revealed that the columns were arranged in a hemicycle that followed the curvature of a low niched wall built contemporaneously with the Decennial Monument.

Results of this excavation, along with a reconstruction of the monument, were published in 1964. The wall

niches were surmounted by soffits carved with Eros figures with crowns, perhaps for the portraits of the four empresses that may have graced the niches. The shafts of all five columns were smooth rose granite, and the columns supported white marble capitals carved with female and Medusa heads. Four of these were in turn surmounted by togate porphyry statues of the *genii* of the tetrarchs. One over-life-size statue still survives, as do fragments of others. The statues of the Augusti were taller than their corresponding Caesars. That the statues represented the *genii* of the emperors, and not the tetrarchs themselves, is indicated by the paterae and cornucopiae that they carry in the Constantinian oration relief. The fifth and taller column supported a statue of Jupiter, the patron god of Diocletian and the chief god of the traditional Roman pantheon, whose temple crowned the nearby Capitoline hill. Jupiter's base was inscribed with the words "VICENNALIA IMPERATORVM." His column was closest to those of the two Augusti, with those of the two Caesars at the outermost sides. The surviving base was the northernmost of the five.

Diocletian's choice of a columnar monument to celebrate the tetrarchy is also indicative of his respect for old Roman traditions. The column had been used as a pedestal for honorific statuary since the republic, and the Roman Forum was one of the earliest sites of such commemorations. The columns of Trajan and Marcus Aurelius (see figs. 179, 263) were themselves elaborate statuary bases. The shaft of the Column of Antoninus Pius was fashioned from red granite and stood on a decorated Luna marble base with a statue of the emperor at the apex (see figs. 253–254).

Although only one of the decorated bases of the Decennial Monument survives, all five columns must have rested on carved bases. Only the top of the monument is visible behind the Rostra in the Constantinian relief, so such a hypothesis cannot be documented with certainty. The front of the extant relief (see fig. 382) depicts a scene with heraldic Victories holding a shield on which is carved "CAESARVM DECENNALIA FELICITER," roughly translated as "on the happy occasion of the decennalia of the Caesars," suggesting that this base supported the statue of one of the two Caesars, either Galerius or Constantius Chlorus. Although the emperor in question is himself depicted in the scene of sacrifice that is carved on one side of the base, his facial features are obliterated. He is accompanied by an array of divinities, who may give clues to his identification (discussed below).

Personal qualities are subsumed in the collective identity of the tetrarchy, and the emphasis in this base is on the traditional scenes favored in earlier imperial state relief sculpture. The reliefs are horizontal in format, linking them with such panels as those on the base of the Column

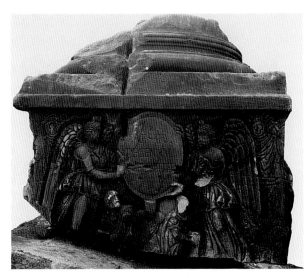

382 Rome, Roman Forum, Five-Column Monument, Victories with a shield, 303. Photo: DAIR 35.734

of Antoninus Pius (see figs. 253–254) but also with Roman sarcophagi. It is likely that the artists responsible for carving this imperial commission were trained in a third-century sarcophagus workshop. Two inscriptions, now lost and originally belonging to the monument, were also discovered in the sixteenth century. They proclaimed "AVGVSTORVM VICENNALIA FELICITER" and "VICENNALIA IMPERATORVM" and undoubtedly belonged to two more of the original five column bases. Since petitions or vota for the continuation of power for an additional ten years were undertaken at the celebration of the decennalia of the tetrarchy and the vicennalia of Diocletian and Maximian, the remaining bases were probably inscribed with the words "CAESARVM VICENNALIA FELICITER" and "AVGVSTORVM TRICENNALIA FELICITER."

The right Victory holds the shield with two hands as the left Victory carves the letters of the inscription with a stylus held in her right hand. The latter motif can be traced to the columns of Trajan and Marcus Aurelius where a Victory inscribing the emperors' deeds on a shield divides the military campaigns described in the encircling spiral frieze (see fig. 184), although heraldic Victories flanking a shield were known in the first century B.C., such as in the relief from the Piazza della Consolazione (see fig. 34). Like the second-century Victories, the tetrarchic Victory wears her hair fastened high on the top of her head, and her drapery slips off her right shoulder in the manner of the fourth-century B.C. Greek Aphrodite of Capua type. Significant stylistic changes can be seen in the Late Antique work. The artist is less interested in using drapery to mold the body beneath the garment and focuses instead on the repeating patterns of the folds. Both the bodies and wings are emphasized

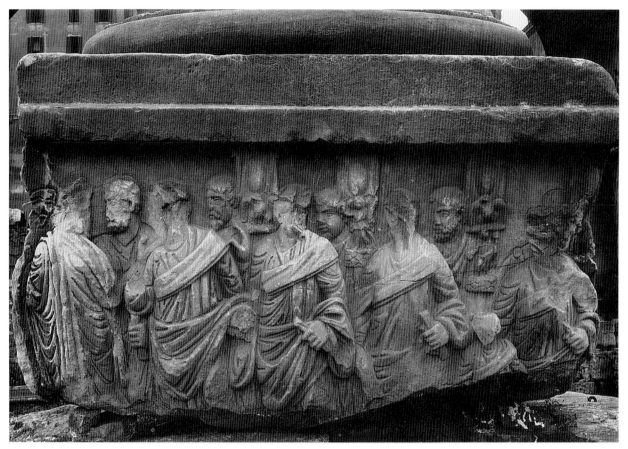

383 Rome, Roman Forum, Five-Column Monument,
procession, 303. Photo: DAIR 35.356

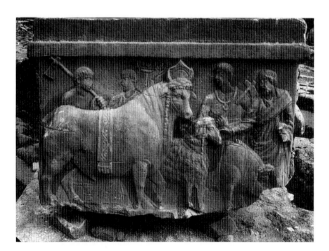

384 Rome, Roman Forum, Five-Column Monument,
suovetaurilia, 303. Photo: DAIR 35.358

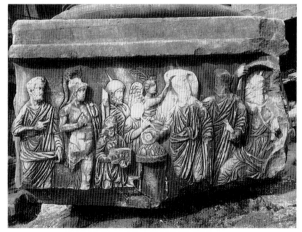

385 Rome, Roman Forum, Five-Column Monument,
sacrifice, 303. Photo: DAIR 35.357

with a bold, deeply carved outline, and the trophies and accompanying arms and armor at the left and right sides of the relief are not elevated but merely drawn on the stone. Beneath the shield are crossed greaves flanked by two seated male barbarians, one with a smooth face and a Phrygian cap and the other bearded but with shorter hair – a possible reference to eastern and northern tribes and to either a specific military victory of one of the tetrarchs or the generic victories of all of them.

On the left side of the base is a scene with a procession of male figures moving from right to left (see fig. 383). The heads of the four frontal figures in the foreground, who wear togas with the contabulatio, are unfortunately obliterated, although a beard can be discerned on at least one of the figures. The lack of facial features makes them unidentifiable, yet it is tempting to associate the four with the tetrarchs themselves. They are traditionally identified as senators. They all carry scrolls in their left hands and between the third and last togatus there is a small boy, also togate and with contabulatio, who seems to be intended as the companion of the fourth togatus. It is logical to think of him as the man's son and intended heir.

These foreground figures are in frontal positions, although their heads are turned in different directions. The two central togati face one another and seem to converse. The foursome is preceded by another togatus with his back to the spectator who appears to lead the group around the corner to the culminating sacrifice scene, which is on the opposite side of the base from the inscribed shield. A second row of soldiers moving from right to left are represented in the background. Their heads are depicted in three-quarter views, and all but one of the military men wear beards and have long, wavy hair. They wear the paludamentum, and at least three carry Roman standards decorated with eagles, divinities, and personifications – including Victory with a wreath and a *genius* with cornucopia and patera.

This *genius* has variously been identified as the Genius Populi Romani and the Genius Augusti. At least one scholar has suggested the latter and has identified the four soldiers in the background as the four tetrarchs. It seems highly unlikely, however, that the artist would have relegated the illustrious foursome to the second relief tier. It is more likely that the tetrarchs are the togati in the foreground, accompanied in procession by their soldiers and by the Victory, who offers a wreath to the tetrarch in the middle (Diocletian?). Also present is the Genius Augusti and the eagle of the tetrarchs' divine patron, Jupiter. The two central conversing tetrarchs would be the Augusti flanked by their Caesars, a similar arrangement to that of the columns of the monument itself and to the scene of the tetrarchs enthroned on one of the piers of the Arch of Galerius at Salonica (see fig. 390). The male child was

thus probably the son of either Constantius Chlorus or Galerius. The most prominent son was Constantine, son of Constantius Chlorus and Helena. He lived at Diocletian's court and served under Galerius in the Persian Wars. After the construction of the Decennial Monument, he became Galerius's Caesar and eventually an Augustus. He was born in 285 which means that he was eighteen at the time the relief was carved.

This processional scene is based closely on first- and second-century imperial prototypes, even though it was updated with contemporary costumes and undoubtedly portrays a recent event. The figures occupy two relief planes, and although the bodies are essentially frontal, the artist has varied the position of the heads in the foreground. The inclusion of a child in the scene is of utmost significance since, as we have seen, children are rarely included in monuments of state. Most of the exceptions are found in Augustan and Trajanic times and can be explained by the emperors' dynastic and social policies. Children were important again under the Antonines and the Severans and reflect dynastic ambitions. A male child is included here for the same reason. Diocletian had brought stability back to Rome through the vehicle of the tetrarchy. The Caesars were linked to the Augusti through marriage with their daughters. The obvious expectation was, despite the publicly stated objections to hereditary succession, that the sons of such unions could be raised to carry on the imperial tradition.

The scene on the right side of the monument represents the traditional Roman suovetaurilia (see fig. 384). The pig, sheep, and bull, decked out in festive regalia, are accompanied by the popa with an ax, a camillus with a dish of fruit, and a victimarius wearing a *bulla* or metal boss suspended from the neck and also carrying an ax. A single togatus with contabulatio and a knobbed staff, the attribute of a high official, directs the way. The figures move from right to left and thus toward the main sacrifice scene. The choice of a suovetaurilia for this base is significant because such scenes traditionally referred to the purification or lustration of the Roman army before or after a major military confrontation during which the victims were at first paraded and then sacrificed to Mars. Since the anniversary celebrations necessitated the sacrifice of only an ox, the inclusion of the pig and sheep indicates that this is not only the sacrifice in honor of the decennalia and vicennalia but probably also celebrates Diocletian's Persian triumph and the generic military triumphs of the entire tetrarchy.

The final and most significant scene is that of the sacrifice (see fig. 385), which must have been made to celebrate the decennial and vicennial anniversaries of the tetrarchs and at the same time offer prayers for the continuity of their governance for an additional ten years.

One of the tetrarchs, whose face is obliterated, wears a toga capite velato and pours a libation from a patera on a flaming tripod altar. At the same time, he is crowned by the Genius Senatus with his scepter at the right and by Victory at the left. There is no precedent in state relief sculpture for the joint coronation of an emperor by Victory and the Genius Senatus. It was chosen here undoubtedly to underscore the concomitant celebration of military victory and the vota (and also alludes to the idea of total senatorial support). A young camillus, with an incense box, and a flute player also participate in the ceremony, which is witnessed by a flamen with his spiked cap, Mars, the god to whom the suovetaurilia was offered, a togate male at the left, and by Roma and a radiate Sol Invictus at the right. The joint appearance of Roma and Sol celebrates the eternity of Rome, and Roma also serves to localize the scene that took place in the capital city.

The identity of the tetrarch is uncertain although he must be either Galerius or Constantius Chlorus since, as mentioned above, the inscription indicates that the column honored one of the two Caesars. The presence of Roma might suggest Constantius Chlorus since he was Caesar in the West, but this is inconclusive since the anniversary celebration actually took place in Rome. Mars was often associated with Galerius but as the god of war, he was also the divinity to whom the suovetaurilia was offered. Sol has been linked with both Galerius and Constantius Chlorus.

The identification of the sacrificant must be linked with the identification of the youth in the procession scene, who may be the son of the Caesar honored in the surviving pedestal reliefs. The inclusion of children in scenes of state must be seen as having been carefully calculated by a patron or artist. Since the Five-Column Monument celebrated not only the stability of Diocletian's new government and its illustrious military triumphs but also asserted the expectation that the tetrarchy would be in power in concert for at least another ten years, it is likely that the male child was a symbol of that continuity. Diocletian's organization of the tetrarchy ensured that at the abdication of the Augusti, the future of the tetrarchy was, nonetheless, certain, since they were to be succeeded by their Caesars. Furthermore, the marriage of the Caesars to the daughters of the Augusti would serve to provide future heirs who would be the blood progeny of the tetrarchy's founding fathers.

Portraits of the heir-producing empresses crowned by erotes appear to have been displayed in the niches of the wall next to the monument's hemicycle. If the youth is the blood heir of one of the Caesars, he is probably Constantine, the son of Constantius Chlorus by his concubine, Helena. Constantius Chlorus's marriage to Theodora, the step-daughter of Maximian, did not pro-

duce a male heir. Galerius married Valeria, the daughter of Diocletian, but there was no son. Galerius pinned his hopes for succession instead on Maximinus Daia, his nephew, who was the son of his sister. He was given the rank of Caesar in 305. Constantine also received appointment as Caesar under Galerius. The socle must therefore have belonged to the column honoring Constantius Chlorus.

The stylistic characteristics apparent in the scene of Victories with a shield can be seen in varying degress in the other three reliefs. While the procession and suovetaurilia scenes are done in somewhat higher relief, the figures continue to be surrounded by heavy, dark contours, and in the sacrifice scene the Victory's wing and part of her topknot are drawn directly on the relief ground. The designer of the reliefs displays a partiality for the frontality of the figures, although not the heads. At least one of the artists who carved the reliefs demonstrates in his rendition of Mars that he can still model a nude figure, but the artists manifest a greater interest in the pattern of the drapery folds of the garments than in the bodies they envelop.

Even though each scene is contained within its individual rectangular field, the artist has made some effort to establish narrative continuity. The two key scenes are those of the vota and the sacrifice to Mars, and they are depicted on opposite sides of the socle. The procession and suovetaurilia proceed toward the sacrifice to Mars, their common goal.

Diocletianic Monuments in the East

We know that Diocletian visited Rome only once while emperor. He was present in 303 at the celebration of his vicennalia and the decennalia of the tetrarchy. He was Augustus of the East, and he made the city of Nicomedia the capital of his quarter of the empire. It is therefore not surprising that monuments honoring him were erected in the East as well as in Rome. It was in the city of Split on the Dalmatian Coast in Yugoslavia that Diocletian built the palace that was to serve as his residence after his abdication. The fascination of the imperial residence lies, in large part, in its being in essence a city in itself based on the plan of a military castrum, complete with fortified walls with square and octagonal towers, two main colonnaded thoroughfares, and living and ceremonial quarters.

The residential wing was located in the south side facing the sea. It included not only sleeping and living rooms and a bathing block, but also a temple dedicated to Jupiter and the emperor's mausoleum. The inclusion of the emperor's tomb in his palace complex was an innova-

tion of the tetrarchic period and is paralleled in Galerius's palace at Salonica and Maxentius's residence on the Via Appia in Rome. Diocletian's tomb, in the form of a roofed octagonal drum, is elaborately embellished inside with a double row of columns with projecting ressauts. The upper row of columns are smaller than the bottom, and there is a sculptured frieze (fig. 386) encircling the building beneath the entablature of the second story. It is deeply carved with a profusion of erotes, who alternately hunt or support tondi or garlands with masks. Two of the roundels enclose individual portraits of Diocletian and his wife, Prisca. The erotes must make reference to the Elysian fields to which the departed emperor and empress have been transported. Such imagery owes much to the earlier apotheosis scenes of Titus, Sabina, and Antoninus Pius and Faustina the Elder (see figs. 157, 222, 253). This is the only surviving depiction of an imperial consecration since the late second century, and it is interesting that the emperor and empress are portrayed together in their mausoleum.

In contemporary official art, Diocletian was insepa- rable from the other tetrarchs. The foursome appear to have been depicted on occasion with their wives to underscore the hope for the continuation of the tetrarchy. Also interesting is the juxtaposition of hunting scenes with those with funerary connotations. Remembering that in the minds of the Romans, victory over death and victory in the hunt were symbolically related, we find both alluded to in such private monuments of the High Empire as the hunting tondi from a lost monument of Hadrian (see fig. 220). The persistence of this theme, which was also popular on late Roman hunt sarcophagi (see figs. 360–361), and its appearance in a Diocletianic structure at Split attests to the founder of the tetrarchy having been a staunch supporter of Roman tradition. This is further underscored by the juxtaposition of the mauso- leum and the Temple of Jupiter directly across the colon- naded street. Although its subject matter owes much to earlier tradition, the relief frieze from the Mausoleum of Diocletian at Split is contemporary in style and appears to have been crafted by undistinguished local artisans. The erotes are barely blocked out, and the animals and trees appear like static shapes against a blank background. The frontal portrait of Prisca in a wreathed tondo depicts the empress with large eyes in a smooth, round face that is framed by a parted coiffure. The portrait of Diocletian also represents the emperor with a round, wrinkle-free face and large eyes surmounted by arched brows. His coiffure, although weathered, seems a corona of full curls in contrast to the severe military hairstyle in most of his portraits.

386 Split, Diocletian's palace, mausoleum, frieze with portraits of Diocletian and Prisca, 300–306. Photo: H. Kähler, *Rom und Seine Welt* (Munich, 1958), pl. 247

The Two Arches of Galerius at Salonica

Gaius Galerius Valerius Maximianus was born in about 250 at Serdica and died in 311. Although he was of peasant origin and completely uneducated, he was, like so many of the third-century provincials who later attained imperial status, a tough military man who was able to rise through the ranks in the army. He was selected as Caesar in the East by Diocletian in 293 and served his Augustus with great devotion. For the sake of the political unity of the tetrarchy, he left his wife to marry Diocletian's daughter, Valeria. After becoming Caesar, he undertook military campaigns against the Carpi, the Sarmatians, and against Narses of Persia. The last was the most significant and led, after an initial defeat at Car- rhae in 297, to a major military victory in the same year in Armenia with the Romans, aided by Armenian allies, and an ensuing peace in 298. The victory over Narses, which led to the taking of the king's harem as well as a significant cache of war spoils, was considered so spec- tacular that Galerius was heralded by later panegyrists as a new Alexander the Great. After Diocletian abdicated

on 1 May 305, Galerius took his place as Augustus in the East with Constantius Chlorus occupying the same position in the West. At the death of Constantius in 306, Galerius resigned himself to accepting Constantius's son, Constantine, as Caesar in the West but refused to acknowledge Maxentius.

At first, it seemed likely that Galerius would choose Sirmium in Pannonia as his capital, but he later selected Salonica as his seat of government. In the early years of the fourth century, he constructed a palatial residence there that included a hippodrome, mausoleum, and commemorative arch, inspired by Diocletian's Palace at Split. Despite his lack of education, Galerius showed himself to be a superb patron of architecture because the Salonica complex included not only a number of splendid edifices but – notwithstanding its late date – demonstrated its indebtedness to the tradition of Roman imperial architecture. Like Diocletian's Palace at Split, the complex resembled a small city and, with its two major crossing thoroughfares, was based in its general plan on the military castrum design. It was fortified and had four gates. The residential block included a courtyard with porticoes, living and sleeping rooms with mosaic floors, and an octagonal structure resembling Diocletian's mausoleum at Split, the function of which is uncertain. It appears not to have been Galerius's tomb, which was a circular structure – today the Church of Hagios Georgios – connected with the four-sided triumphal arch by a porticoed processional way.

The Arch of Galerius at Salonica (fig. 387) is an octopylon with a central quadrifrons surmounted by a dome and supported by four great piers spanning two intersecting colonnaded streets. One was a city thoroughfare, the other connected the arch to the emperor's mausoleum. Additional piers were added to the tetrapylon during construction so that the structure would conform more closely to the shape of the surrounding palace. The secondary pillars supported cupolas and provided subsidiary passageways. Although the arch was begun in 298–99, dedicated at the time of Galerius's decennalia in 303, and erected to commemorate Galerius's victory over Narses in Persia, it was also intended as a monument to the tetrarchs as four equal rulers who upheld the empire like the arch's supporting piers. Portraits of Diocletian and Galerius (now lost) were probably displayed in niches on the southeast side, which was the facade that faced the East, Thrace, and the Danube, which they governed. Niches on the northwest side probably housed statues of Maximian and Constantius Chlorus (also now lost) who looked toward the provinces under their aegis – Italy, Gaul, Spain, Britain, and Africa. Decorative roundels completed the ornamental scheme.

Only two of the original four piers of the arch survive; one subsidiary pier is also extant. Although the core of these pillars is reused material, they are faced with contemporary marble blocks carved with figural scenes. Each scene is contained within a rectangular horizontal

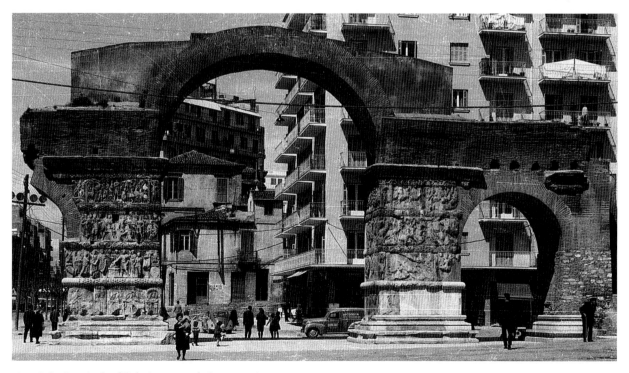

387 Salonica, Arch of Galerius, general view, ca. 298–303.
Photo: DAIR 63.891

frame, although the scenes are vertically stacked and divided from one another by elaborate decorative moldings. The renewed interest in the state reliefs of Late Antiquity in scenes in horizontally oriented frames, apparent in the Arch of Galerius and seen also in the surviving socle from the Five-Column Monument in Rome (see figs. 382–385), is undoubtedly because this was the same shaped field as that of the sarcophagus. Third-century artists working in relief received only sarcophagus commissions.

Scholarly study of the arch has centered on the identification of the surviving scenes and hypothetical reconstruction of those that have vanished. In these same studies, attention has also been paid to the narrative sequence of the reliefs within each pier and from pier to pier. Were they supposed to be read from bottom to top, as on the columns of Trajan and Marcus Aurelius and in the great relief panels from the Arch of Septimius Severus in Rome, or from top to bottom? Are the events of individual campaigns confined to a single pillar or are there cross references from one pier to another? Is there any correlation between the location of the individual scenes and the siting of edifices in Galerius's palace-complex in Salonica?

The seminal study of the arch was published in 1890, and in it the author suggested that the reliefs of the surviving south pier refer to events in Galerius's war against King Narses in Armenia, a satrapy of the Persian empire, and that the scenes on the north pier retell events from the emperor's contest with the enemy in Adiabene. He posited that the missing piers originally depicted scenes of campaigns in Media and Adiabene and that the artists were not especially concerned with chronological sequence but with establishing a scheme in which the scenes could be read from top to bottom, with the most significant scenes at eye-level.

The idea that the scenes on each pier did not refer to different campaigns and that those on the two surviving pillars described events from the war against Narses was first put forward in 1937. Furthermore, it was posited that actual scenes of battle were interspersed with others that focused on court ceremonies or were symbolic presentations of the entire tetrarchy. More recent scholarship has adhered, in the main, to the theory that the surviving reliefs center on Galerius's campaign against Narses, although there have been disagreements over the identification of the individual scenes and their sequential arrangement. Scholars have also begun to take into consideration the positions that the reliefs occupied on the arch in relation to the palace complex.

The specific subject matter of the missing piers will never be known, and it is impossible to ascertain the associations among piers without the complete set of scenes,

but what can be determined from the two surviving pillars is that the narrative tradition of the columns of Trajan and Marcus Aurelius was alive and well in the late third and early fourth century. Some scenes on the Arch of Galerius were narrative explications of the events of Galerius's Persian campaign, and others celebrated the institution of the tetrarchy, that is, they underscored the meaning of the arch as a whole. Scenes describing specific battles and even such anecdotal details as the taking of King Narses's harem are juxtaposed with those depicting court ceremonies and honoring the concordia of the tetrarchs. All of these scenes are based closely on established prototypes from the High Empire, although they are executed in a style that clearly betrays their Late Antique date.

The subject matter of the scene in the top register of the southwestern side of the northeast pillar (Pier AII – the numbering system follows that of Hans Laubscher) has been disputed. It appears to depict a battle between Romans and Persians, probably belonging to the campaign of 298. The emperor, with his mantle billowing behind him, is on horseback, and the hooves of his steed crush dying foes. The scene is reminiscent of that of Trajan on horseback trampling the Dacian enemy in the Great Trajanic Frieze (see fig. 185). At the far right there is a chariot drawn by four elephants that contains Victory or the personification of Persia already announcing, in traditional Roman fashion, the successful outcome of the emperor's foray.

The scene just below represents Galerius at the left (only his left foot is preserved) granting clemency to three kneeling male barbarians. They appear to have just exited from a town, possibly Satala, a gate and two towers of which can be seen on the far right. In front of the gate is a camel carrying two diminutive females. A second camel with a mother and child is represented in the center rear. They must be participants in a procession of captives.

The next scene down depicts the peaceful adventus of the emperor in enemy territory, either Satala or Nisibis. A group of women, one with flowers, awaits the emperor at the right. He is represented in civilian garb and in a four-horse chariot proceeding from left to right and led by two children, probably slaves. The bottom register, which is very weathered, depicts a procession of animals, probably oxen, moving from left to right and guided by Roman soldiers.

The southeast side of the northeast pillar (Pier AI) depicts, in the uppermost tier, a battle between Romans and their foes. A Roman soldier, possibly in concert with the emperor himself, exits from a gate, possibly Satala's. Before him is the Roman cavalry in pursuit of the enemy, which has approached the gate but is now retreating.

The Roman cavalry attacks the enemy in the dramatic

scene below, and male and female victims of the battle lie at the center on the ground beneath the hooves of the horses. Some of the men try to protect their female companions, and one Persian man plunges his sword into his own neck rather than be taken by the Romans. The latter motif has a long history in Greek and Roman art and was used in the Hellenistic context for the Attalid group of the Gaul killing himself and his wife in the Museo Nazionale delle Terme of about 230–20 B.C., and in Roman times on the Column of Trajan to portray the heroism of the Dacian king Decebalus, who committed suicide rather than submit to Roman domination (see fig. 181). Both Galerius and the Persian queen Arsane are included in this tumultuous scene, which has been variously identified as the capture of Narses's harem or the battle before Ctesiphon, the Sassanid capital.

In the next register is a severely weathered scene of Persians, pursued by the cavalry and attempting to flee across a river, identified as the Tigris by an accompanying Greek inscription and personified by a reclining bare-chested male figure. All that survives of the bottom register is the personification of Victory wearing a long, flowing gown and leading a horse.

The northwestern side of the northeast pillar (Pier AIII) depicts the emperor, seated on the left, in his camp on a sella castrensis and surrounded by attendants, granting clemency to a group of barbarians who are gathered in front of him. Two kneel in submission before Galerius, and a woman and her child are also present. Scenes like this one have a long history in Roman art. A comparable tableau can be seen as early as the Tiberian period on one side of the cup of Augustus from the Boscoreale treasure, which also incorporated children (see fig. 128).

Curiously enough, the scene directly below is practically a mirror image of the one in the top register. It also represents a clementia Caesaris, but the emperor is located on the right rather than on the left. The display of duplicate scenes suggests that one honors Galerius and the other a different tetrarch, probably Diocletian. Such a replication of identical scenes is not unprecedented. An earlier example is the double decursio on the base of the Column of Antoninus Pius (see fig. 254).

In the next tier is a fragmentary scene originally thought to represent a group of female prisoners of noble rank. One carries a bouquet of flowers and another holds a long scepter. High-ranking captives were also prominently depicted in the scenes from the Column of Marcus Aurelius. Recent scholarship favors the identification of Galerius surrounded by personifications. A procession of animals, heavily damaged, was depicted just below. Pier AIV is carved with four camels, laden with war booty and moving in procession from right to left, and below that a parade of animals.

Some of the arch's best-known and most significant scenes belong to the southwest pillar. The uppermost register of the northeastern side (Pier BII) (fig. 388) of the southwest pillar depicts either the adventus of Galerius in a foreign city or more likely the transfer of Galerius's residence from Sirmium to Salonica in 304. He is under heavy escort and is depicted in a chariot drawn by two horses. He receives a tumultuous welcome from the inhabitants of the city who wait at the gate with banners and flowers. The emperor's goal was the city's temple, represented in the background to the left of the city gate. The doors are opened to reveal the cult statue, probably Sol since Salonica possessed a sanctuary to Sol Invictus. The scene is framed by two heraldic female personifications, probably Victoria-Felicitas, carrying pitchers. They are separated from the main event by pilasters and appear to be contained in niches that underscore their function as framing elements rather than as participants in the main scene.

These female figures are larger in scale than any of those in the main scene, including the emperor, and Galerius and members of his escort dwarf the inhabitants of the city. Such discrepancies in size were used by the artist to denote status, a convention occasionally used in monumental imperial state relief since its first appearance on the Arch of Trajan at Benevento (and earlier on coins) (see fig. 190), and ultimately derived from the private monuments of freedmen (see, for example, fig. 95). Figures of the Dioscuri frame part of the frieze from the Augustan arch at Susa, but they are of the same scale as the human protagonists. The use of large female framing figures thus also shows the indebtedness of the Arch of Galerius at Salonica to private prototypes. Large figures that flank the primary relief scene but also complement its subject matter are known from second- and third-century sarcophagi such as the Portonaccio sarcophagus where the battle scene is framed by tall trophies with barbarian captives (see fig. 269). This resemblance further underscores the reliance of fourth-century state reliefs on third-century funerary commemorations, largely because state monuments with relief decoration were rarely produced in the third century.

The figures in the transfer scene on the Arch of Galerius, like most of the others on the monument, are accentuated by deeply carved outlines and some details including faces and the plumes of helmets, or individual attributes are drawn directly onto the background of the stone in a manner similar to that used on the surviving reliefs of the Five-Column Monument in Rome, which is roughly contemporaneous (see fig. 382).

The scene just below (fig. 389) depicts a battle with Galerius as the main protagonist. He is represented on horseback in the center of the scene, wearing a cuirass

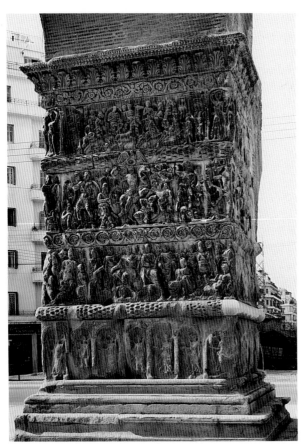

388 Salonica, Arch of Galerius, southwest pillar, adventus of Galerius, ca. 298–303. Photo: Hirmer Verlag München, 582.1385

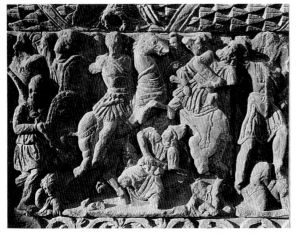

389 Salonica, Arch of Galerius, southwest pillar, Galerius on horseback crushing his Persian enemy, ca. 298–303. Photo: DAIR 61.3190

decorated with the motif of Romulus and Remus suckled by the she-wolf. The emperor is doubly victorious. As the hooves of his horse trample a kneeling foe, he has plunged his spear into the chest of the Persian king, Narses, who, wounded, is attempting to draw it out of his chest with his right hand. Galerius's triumph over his enemy is underscored by the wreath held over his head by an eagle with outstretched wings.

A scene like this one is fully in the tradition of Roman triumphal imagery and can readily be compared with such reliefs of the High Empire as that of an equestrian Trajan triumphing over the Dacians in the Great Trajanic Frieze (see fig. 185). An earlier source is the famous battle between Alexander the Great and Darius, the Persian satrap, a Hellenistic tableau known through the Alexander Mosaic from the House of the Faun in Pompeii. The reliance of this scene on its earlier prototypes is all the more striking since its portrayal here is a fiction. In actuality, Galerius and Narses never met face to face on the battlefield. The anticipatory announcement by the presence of a Victory with a wreath or, in this case, by the eagle with a wreath, also has a long history in Roman state relief sculpture. Galerius is flanked by two Roman soldiers in the thick of battle, who are larger in scale than any other figures in the scene, including the emperor himself. They stand on dying and dead Persians, and have been identified as Licinius and Constantine, who took part in Galerius's campaign. The scene is framed by traditional figures of Victory at the left and perhaps Diana at the right.

All scholars who discuss the monument agree that the scene in the third register of the northeastern side of the southwest pillar (fig. 390) depicts the four tetrarchs enthroned, with the Augusti in the center flanked by their two Caesars. The figures kneeling at the emperors' feet are disputed, however, variously being identified as Mesopotamia and Armenia or Syria and Britain. The Augusti have their feet on two personifications sometimes associated with the Tigris and Euphrates Rivers and sometimes with the sky god, Caelus, and a female counterpart. The former identifications associate the scene with Galerius's Persian campaign, whereas the latter place the scene in a cosmic setting rather than in a specific eastern locale. Between the head of each Caesar and each Augustus is a flying Victory with a wreath who faces and crowns the Augustus. The tetrarchic group, frontally posed as if for a formal portrait, is surrounded by a host of divinities and personifications that elevates further the status of the foursome: Jupiter, Mars, Virtus, Tellus, Isis, Oceanus, the Dioscuri, Serapis, Honos, and Fortuna.

In the lowest tier are seven figures of Victory in identical poses. Each holds a branch in her left hand and a

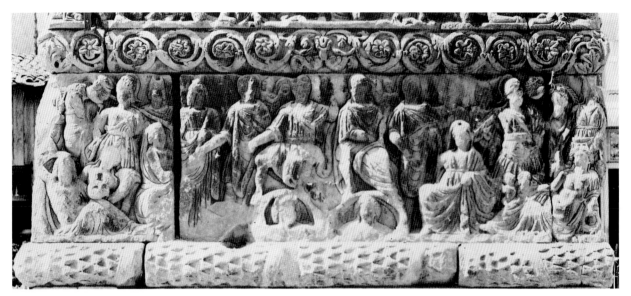

390 Salonica, Arch of Galerius, southwest pillar, four
tetrarchs enthroned, ca. 298–303. Photo: DAIR 79.464

statuette in her right. They may be intended as the seven
planetary deities. Each is contained in a niche supported
by columns and with a shell motif in the vault. There was
a taste for such nichelike enclosures with figures arranged
in a horizontal register in sarcophagus design, especially
in the eastern provinces, which again underscores the re-
liance of tetrarchic state relief on the composition and
motifs of late second- and third-century sarcophagi.

The southeastern side of the southwest pillar (Pier BI)
begins at the top with a traditional scene (see fig. 387):
the address of the emperor, in this case Galerius, to his
troops, possibly in front of Nisibis. The adlocutio is seen
time and again on the columns of Trajan and Marcus
Aurelius and in the panels from the lost arches of Marcus
Aurelius and other arch reliefs. In all of these, the em-
peror stands on a tall pedestal, usually on the left side of
the relief, and addresses his soldiers, who stand in front
of him in a variety of poses that show them in profile and
from the rear. Although the emperor is depicted in an ele-
vated position, his scale is the same as that of his troops.
In the Arch of Galerius at Salonica, the emperor stands on
a wide but relatively flat podium, which is necessary to
make room for the gigantic figure of the emperor whose
head reaches to the top of the relief. He is at the center of
the relief and is the focal point of the scene as he addresses
soldiers in a variety of postures and at various levels to
his left and right. A reclining female figure sets the scene
at the left and a large Victoria-Felicitas in a niche balances
her at the right.

In the scene below, Galerius, at the left, in battledress
and surrounded by his guards (one soldier carries a shield
with the figure of Hercules), receives a delegation sent

by Narses and led by his friend Apharban, attempting
to arrange for the release of the king's harem or surren-
dering on behalf of the Sassanids. The Persians kneel in
supplication at the emperor's feet and and behind them is
Roma or Virtus, who balances the figure of the emperor.
She is, in turn, followed by female figures thought to
personify major Roman cities. It is from this scene that
a head of Galerius in relief, originally in Berlin and now
lost, may have come. It depicts the tetrarch with a square
face, large eyes, and arched brows, a furrowed forehead,
and military cap of hair and is thus consistent with other
known heads produced in the eastern part of the empire.

The scene in the next register depicts a sacrifice by
Galerius and Diocletian who are depicted flanking a cen-
tral altar. Scholarly disagreement centers on whether
the scene represents a specific historical event – possibly
Galerius's sacrifice at Antioch in 296 at the beginning of
his military campaign against the Persians, or – as in the
scene of the emperors enthroned – a more generic refer-
ence to tetrarchic piety. Galerius, clad in military garb,
stands to the right of an altar ornamented with figures
of Jupiter and Hercules. The flaming altar is the site of a
number of offerings, one of which is held by the majestic
figure on the left, which compositionally balances that of
Galerius. It is Galerius's Augustus, Diocletian. Although
two traditional camilli are included at left, the victim of
the sacrifice (a bull) is at right, and the event takes place
in front of an arcaded structure, the rest of the scene is
unusual in its inclusion of divinities and personifications.
Aion stands near Diocletian, and the two female figures
between Diocletian and Galerius have been identified
as Oikoumene (Earth) and Omonoia (Harmony). The

personifications of Eirene (Peace) and another female attendant are to the right of Galerius. The scene is framed by Victories above shields ornamented with eagles grasping thunderbolts in their claws.

The lowest scene represents the Persians presenting gifts, probably the spoils of war, to the emperor. Included in the procession are attendants with two lionesses and a file of riders on the backs of elephants.

The northwestern side of the southwest pillar (Pier BIII) depicts in the uppermost tier the homage paid to Galerius on account of his eastern triumphs. Victory is depicted twice, once in the niche at the left where she also serves as a framing element for the scene, and in front of the seated emperor (with scepter and orb), whom she crowns with a wreath. To the right is a female figure, dressed in a long garment and with a shield and spear. She has been identified as Valor and leads a carriage pulled by four elephants, which may refer to Galerius's military victories in the East.

The scene below, which is heavily damaged, depicts a battle between Romans and Persians. It shows, once again, Galerius, who is the hero of the story and is depicted at the center on horseback and with an eagle above his head. He is surrounded by Roman foot soldiers, and there are dead and wounded Persians at their feet.

In the next tier is a scene, also poorly preserved, that is highly controversial. It has been identified as the capture of King Narses's harem, which seems unlikely since the key scene appears on the other pier. Instead, it may depict the triumphal procession or *pompa triumphalis,* with Roman soldiers accompanying animals leading a cart with prisoners, including women and a child. Persians with war spoils are also represented.

The scene below is difficult to discern because of severe weathering, but it seems to represent a series of figures in niches, with Roma with orb and cycle of the zodiac seated at the center and flanked by Victories like those on the northeastern side of the southwest pillar.

One last relief, which decorates the south face of the southwest pier (Pier BIV), represents an altar supporting a shield in the center, with two flanking Victories. It probably refers to Galerius's decennalia celebration and should be compared to a similar scene on the socle from the Five-Column Monument in Rome (see fig. 382). Framing trees are laden with spoils and to the side of each tree are Mars and Virtus. The scene is bordered at left and right by trophies. There is still another scene with the procession of animals below.

Although recent scholarship tends to support the idea that the extant scenes on the Arch of Galerius are divided into historical and panegyrical ones, some individual scholars believe that there is an underlying chronological sequence that can be traced from top to bottom and

from pier to pier, with the lowest reliefs serving as supporting socles. It has been suggested, for example, that the lowest processional scenes of Victories, animals, and so forth are arranged in such a way as to lead the eye of the spectator toward the inner faces of the piers and in the direction of the palace complex. This is underscored by the fact that many eastern arches were tetrapylons with extensive internal decoration. Such directionality has numerous earlier imperial precedents, including examples from the West: the triumphal procession on the Arch of Titus (see figs. 155–156) moves along the Via Sacra toward the Temple of Jupiter on the Capitoline hill just as it would have in actuality; and the pedestal reliefs of the Arch of Septimius Severus in Rome depict Roman soldiers escorting barbarian captives in a procession around the faces of the pedestals (see fig. 295).

Furthermore, it has been asserted that the relief scenes on the outer sides of the Arch of Galerius are not arranged chronologically or conceptually in a single pier or from one to another but that the interior scenes are carefully arranged in a well-thought-out program. Events are related in chronological order along the eastern face of the north pier and continuing down the south face, and those on the south pier focus on the ceremonial activities of Galerius and also of the entire tetrarchy, the legitimacy of which is underlined by this glorious eastern victory. It is possible that the missing piers included scenes from additional eastern victories of Galerius or Diocletian, or even made reference to the empirewide invincibility of the tetrarchic system by relating western triumphs.

The spectator standing beneath the four great decorated piers of the Arch of Galerius in Salonica was made aware first and foremost of the equality of the four emperors whose presence as a group was alluded to in the scenes of the south pier. It was, after all, all four who were honored in the niche portraits on the arch's two main facades. The military victories of each individual tetrarch also brought glory to the foursome, just as Titus's victory over Jerusalem was exploited by all of the Flavian emperors as the cornerstone of their dynastic claims. Galerius's eastern triumph, which caused him later to be acclaimed Alexander the Great reincarnate, was a showcase for the tetrarchy. It was also an opportunity to advertise in his capital city (also his place of residence) the very virtues that made him worthy of his elevated status: virtus, pietas, clementia, and above all, concordia with his fellow emperors.

The Arch of Galerius in Salonica, with its narrative and ceremonial scenes that emphasize the emperor's virtues and the legitimacy of his form of government, is closely bound to Roman state monuments of the High Empire, such as the columns of Trajan and Marcus Aurelius, and with the the arches of Septimius Severus in

Rome and Leptis Magna (see figs. 179, 263, 293–294, 307–310). It is also clear that the Arch of Galerius is a product of its time. The organization of its scenes into vertically stacked, horizontal fields with decorative bands owes much to third-century sarcophagus production and such stylistic features as the deep outlining of figures and the emphasis on drapery pattern, as well as a preference for the frontal and hierarchical presentation of some of the main protagonists, also apparent in such contemporary reliefs as those from the Decennial Monument in Rome (see figs. 382–385).

The niches with portraits of the four tetrarchs on the Arch of Galerius at Salonica were accompanied by roundels whose sculptural decoration is not known. Although Galerius is depicted in almost all of the surviving scenes from the arch, the heads were obliterated, possibly by the Christians whose persecution he ordered. Only one fragment of a head, possibly of Galerius, formerly in Berlin and now lost, has been associated with the arch. A roundel with a portrait of Galerius, however, ornaments a small arch of 293–305.

The arch (fig. 391), which stood in Salonica and is now in the Archaeological Museum in that city, gives us an idea of the appearance of the portraits on the roughly contemporary but larger arch. All that survives of the single bay structure is the arch and the spandrels, which are elaborately ornamented with a profusion of architectural sculpture. The archivolt has a bust of Dionysus at the apex and vines growing from a cantharus at either side. Large roundels in the spandrels are supported by flying Attis figures in Phrygian costume assimilated to Winter and Autumn. Erotes as Spring and Summer grasp opposite ends of a wreath. Attis, a vegetation god, was

associated with a spring festival of death and resurrection that originated in Phrygia and must be alluded to here. Representations of Pan and a nymph are carved on the sides of the arch. The right tondo contains a portrait of Galerius depicting the emperor in a paludamentum and with a severe military coiffure. His forehead is lined, his eyebrows highly arched, his eyes large, his lips small and rounded, and his chin cleft. Just as on the larger arch, Galerius is paired with a personification. The left roundel contains an image of the tyche of the city, who is depicted with her identifying attribute of turreted crown in the form of a cityscape. She is depicted with wavy hair parted in the center, which frames a round, idealized visage. Winged erotes rest on the upper edges of the roundels.

The Tetrarchic Revival of Roman Tradition
A New Order and A New Art

Tetrarchic art is characterized by the simultaneous adherence to Roman traditions and religious customs and the creation of a new style. This innovative style, which is marked by the artists' preference for stereometric form and extreme abstraction, also has roots in the past. In portraiture, it was based ultimately on the artistic experiments of the Caracalla Master, which resulted in the blocklike and abstract portraits of not only Caracalla himself but also of such third-century emperors as Probus. The new style was enthusiastically adopted by the tetrarchs and their artists because it effectively expressed the solid stability and traditional values of Diocletian's tetrarchy, with its division of the empire into four equal parts.

Although portraits manufactured in the western and eastern halves of the empire have these features in common, there is some distinction, due to regional preferences, in the portraits produced in Rome and elsewhere. The Roman heads are more naturalistic and conceived in a softer style, with subtle nuances in the plastic modeling of the face and a more sensitive rendition of hair, beard, and facial expression. Concurrently, there developed in the East a strikingly iconic and even masklike representation of the emperors in which their personal characteristics were subsumed in a collective identity. Many of the tetrarchic portraits of this type were made of porphyry, a hard reddish-purplish stone that connotes royalty and was especially conducive, because of its hardness, to creating the kind of solid and geometric images that expressed the new order. All seemingly produced by the same workshop in Egypt, they portrayed individual tetrarchs, but more often groups that were attached to architectural members, specifically columns, also of

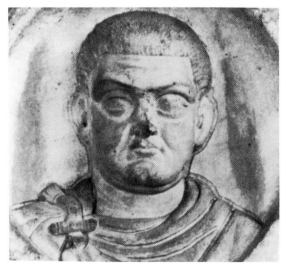

391 Salonica, Small Arch of Galerius, roundel with portrait of Galerius, 293–305. Photo: J. Meischner, *AA* (1986), fig. 1

porphyry. The best-known groups are those now in Rome and Venice, but there are other surviving fragments that indicate that these were not the only examples and that the workshop at Mons Claudianus exported such works to numerous locations around the empire.

The most striking characteristic of the official portraits of the tetrarchs is that the four are essentially indistinguishable. Their *similitudo* is intentional on the part of their patrons and artists, and even when they are represented alone, it is difficult to tell them apart. In numismatic portraits, for example, they can be differentiated only because of the accompanying legends giving their names and titles. To underscore their equality in numismatic portraits and in portraits in the round, the tetrarchs are depicted with the same hairstyle, the same costume, the same attributes, and even the same physiognomy. Even this deliberate similitude has its sources in the past. Beginning in the Augustan period, Roman emperors often adopted in their portraiture the facial features and coiffures of their imperial predecessors in order to establish a real or fictional familial tie or an ideological link.

Before the tetrarchy, these portraits continued to be recognizable likenesses. In contrast, the portraits of the tetrarchs, especially those in the East, depict equal rulers whose visages have been drained of all personal idiosyncracies in favor of a collective tetrarchic image. Numismatic likenesses and portraits in the round produced in the West under the tetrarchs – especially those of Constantius Chlorus and Maxentius – are more individualistic and are fashioned in a softer style. Both emperors were represented with a military coiffure that resembled in its general shape those of the other tetrarchs but had comma-shaped locks arranged across the forehead, suggesting an intentional link with Augustus and the Julio-Claudians or with Trajanic portraiture.

Portraits of women of the period draw on third-century prototypes and depict their subjects in a matter-of-fact style. They are geometrically conceived, and the artists who fashioned them display an overriding interest in the symmetry of the features and the patterns of the elaborate coiffures. Although identifiable women were not included in the relief scenes on the major state monuments of the day, for example, the Arch of Galerius and the Arcus Novus, female divinities and personifications such as Roma, Virtus, and Victory abound. Tyche is featured along with Galerius in the twin roundels on the small Arch of Galerius in Salonica. Empresses were politically significant under the tetrarchs. It was through them that the Augusti and their Caesars were dynastically united. It is even possible that the portraits of the empresses were displayed in the niches in the low wall against which stood the columns of the Decennial Monument in the Roman Forum. Furthermore, the dynastic message of the Decennial Monument was underscored by the inclusion of portraits of the four tetrarchs and one of their heirs, probably Constantine, in the procession scene in relief on the surviving socle. Foreign women were also the subject of tetrarchic state relief sculpture, and both the chosen members of Narses's harem and other Persian women and children are included in many of the pier scenes on the Arch of Galerius at Salonica. In the private context, Prisca is honored, along with her husband Diocletian, in tondo portraits from the frieze of the emperor's mausoleum in Split, where they are displayed amid hunting erotes.

Diocletian, fervently committed to the Roman state religion, which was rejected in favor of eastern cults by many of his third-century predecessors, chose Jupiter as his patron god and adopted the epithet *Jovius*. Maximian became *Herculius* with Hercules as his divine supporter. The works Diocletian commissioned in Rome and in the East also heralded a return to Roman art of the first and second centuries in part because of their monumentality and in part because of their subject matter, which emphasized traditional themes. Diocletian was the first emperor since the Severans to initiate major commissions in Rome, including a splendid bathing establishment that could rival Caracalla's in size and opulence. His Decennial Monument celebrated the emperor's Persian victories as well as the foundation and inevitable continuation of the tetrarchy. It stood near the Arch of Septimius Severus, which similarly honored the emperor's triumph over a foreign foe (Parthia) and the creation of a new dynasty. The Diocletianic arch over the Via Lata, supported by newly carved socles and also incorporating into its main fabric reliefs expropriated from earlier monuments of the emperor Claudius, suggested that Diocletian and his tetrarchs, who based their legitimacy on their many foreign victories (including one over Britain) were not usurpers but legitimate dynasts in the tradition of the Julio-Claudians.

Diocletian's co-emperors also undertook major projects, the monumentality of which attested to the power of the tetrarchy in the provinces as well as in Rome. Galerius, like Diocletian, favored traditional themes that linked the new government in its eastern capitals to that of the city of Rome in earlier times. The Arch of Galerius in Salonica is the most grandiose of the tetrarchic arches and rivals the arches of Marcus Aurelius and Septimius Severus in Rome in its scale and in the complexity of its sculptural program.

The new tetrarchic monuments in East and West could not fail to impress the contemporary spectator with their scale, unprecedented since Severan times, and their familiar subject matter. Recognizable scenes rep-

resenting adventus, adlocutio, clementia, sacrifice, procession, suovetaurilia, the emperor in battle, and so on – which had appeared earlier on the columns of Trajan and Marcus Aurelius and on the arches of Marcus Aurelius and Septimius Severus – surfaced again in tetrarchic commissions. Furthermore, the tetrarchs were depicted in the midst of such traditional gods and personifications as Jupiter, Mars, Roma, Virtus, the Genius Senatus, The artists responsible for these same commissions demonstrated their awareness of artistic conventions employed earlier in state relief sculpture in Rome in the second century and employed by some of the designers of private sarcophagi in the third century: fictional storytelling, the use of frontality, scale discrepancies to denote status, the vertical stacking of scenes, the outlining of figures for increased emphasis and readability, and the fascination with the complex patterns of drapery folds, which can be explored independent of the shape of the body below.

Tetrarchic state monuments in the East and West are linked by their emphasis on one or two of the following key events: the formation of the tetrarchy, the celebration of the decennalia of Diocletian, the decennalia of the tetrarchy, and the vicennalia of Diocletian. The Arcus Novus was built in honor of Diocletian's decennalia and the formation of the tetrarchy; the Five-Column Monument commemorates Diocletian's vicennalia and the decennalia of the tetrarchy. These events are alluded to in the vota reliefs of each monument, which depict Victory inscribing a shield. A vota scene also appears in a relief from one of the surviving piers of the Arch of Galerius in Salonica, which also honors Galerius's decennalia. At the same time, these state monuments commemorate tetrarchic military victories. The Arcus Novus refers to Constantius Chlorus's triumph over Britain, which may also be referred to in one of the pier scenes on the Arch of Galerius. The Salonica arch, however, memorializes, above all, Galerius's Persian victory. The Five-Column Monument was erected to honor Diocletian's Persian triumph as well as his anniversary and that of his co-emperors.

Diocletian and his co-emperors came from backgrounds that were similar to their third-century predecessors. Hailing from such provincial centers as Dalmatia and Illyria, they too rose through the ranks in the army to exalted imperial positions. They cemented their power by individual victories in the East and West, the most noteworthy being those over the Persians. It was the Persian triumphs of Diocletian and Galerius that not only established the legitimacy of the tetrarchy but also provided one of the most significant subjects of their state relief sculpture. And it was that the tetrarchs were able to document their military triumphs in monumental works of art that separated them from the emperors of the third century. It was the continuity of the dominate and the new form of government that provided the stable political environment in which large-scale monuments with elaborate sculptural programs could be erected. The detailed depiction of the Persian conquest on the Arch of Galerius is matched in importance only by the other main theme of tetrarchic art: the celebration of the concordia of the tetrarchs, apparent not only in the popular vota reliefs, which commemorated ten- and twenty-year anniversaries, but also in the scenes depicting the emperors enthroned and in the statuary groups of the foursome that graced the niches of arches and the brackets and apexes of porphyry columns. The tetrarchs' propensity for building major monuments, especially arches; their taste for narrative reliefs and those symbolizing the concordia of the tetrarchy; their liking for a naturalistic portraiture with ties to that of Augustus and Trajan and for an iconic abstract style; and above all their reverence for Roman tradition and their proclivity toward innovation were all inherited by Constantine the Great – himself a son of a tetrarch and a tetrarch in his own right. It was Constantine – who may have been included in scenes on both the Decennial Monument and the Arch of Galerius in Salonica – who capitalized on these dichotomies and created an art that was the last chapter of tetrarchic art and, at the same time, the wave of the future.

Bibliography

Encapsulated biographies of the tetrarchs can be found in *The Oxford Classical Dictionary*, 2d ed. (Oxford, 1970). For a general book on the period, see: H.P. L'Orange, *Art Forms and Civic Life* (Princeton, 1965).

Imperial Portraiture under the Tetrarchs: J. Sieveking, "Constantius Chlorus," *MüJb* 11 (1919–20), 44–55. R. Delbrueck, *Spätantike Kaiserporträts* (Berlin, 1933). H.P. L'Orange, *Studien zur Geschichte des spätantiken Porträts* (Oslo, 1933). A. Ragona, *I tetrarchi dei gruppi porfirei di S. Marco in Venezia* (Caltagirone, 1963). W. von Sydow, *Zur Kunstgeschichte des spätantiken Porträts im 4. Jahrhundert n. Chr.* (Bonn, 1969). R. Calza, *Iconografia romana imperiale da Carausio a Giuliano (287–363 d.C.)* (Rome, 1972). V. Poulsen, *Les portraits romains* II (Copenhagen, 1974). M. Bergmann, *Studien zum römischen Porträt des 3. Jahrhundert n. Chr.* (Bonn, 1977), 138–79. C.C. Vermeule, "Commodus, Caracalla and the Tetrarchs: Roman Emperors as Hercules," *Festschrift für F. Brommer* (Mainz, 1977), 289–94. B. Andreae, *The Art of Rome* (New York, 1977), 327 (porphyry groups). H.P. L'Orange, *Das spätantike Herrscherbild von Diokletian bis zu den Konstantin-Söhnen 284–361 n. Chr.* (Berlin, 1984). K. Fittschen and P. Zanker, *Katalog der römischen Porträts in den Capitolinischen Museen und den anderen kommunalen Sammlungen der Stadt Rom,* 1 (Mainz, 1985). J. Meischner, "Die Porträtkunst der ersten und zweiten Tetrarchie bis zur Alleinherrschaft Konstantins: 293 bis 324 n. Chr.," *AA* (1986), 223–50.

Female Portraiture under the Tetrarchs: M.B. Comstock and C.C. Vermeule, *Sculpture in Stone: The Greek, Roman and Etruscan Collections of the Museum of Fine Arts Boston* (Boston, 1976), 242–43, no. 380. M. Bergmann, *Studien zum römischen Porträt des 3. Jahrhunderts n. Chr.* (Bonn, 1977), 190–91, pls. 55.1, 56.1. K. Fittschen and P. Zanker, *Katalog der römischen Porträts in den Capitolinischen Museen und den anderen kommunalen Sammlungen der Stadt Rom,* 3 (Mainz, 1983) (esp. p. 115, no. 173). H.P. L'Orange, *Das spätantike Herrscherbild von Diokletian bis zu den Konstantin-Söhnen 284–361 n. Chr.* (Berlin, 1984).

The Arcus Novus: H. Kähler, *Zwei Sockel eines Triumphbogens im Boboligarten zu Florenz, BWPr* 96 (Berlin, 1936). J. Sieveking, "Zu den beiden Triumphbogen-Sockeln im Boboligarten," *RM* 52 (1937), 74–82. H. Laubscher, *Arcus Novus und Arcus Claudii, Zwei Triumphbögen an der Via Lata in Rom* (Göttingen, 1976). S. De Maria, *Gli archi onorari di Roma dell'Italia romana* (Rome, 1988), 197–203, 312–14.

The Five-Column Monument: A.L. Frothingham, "Diocletian and Mithras in the Roman Forum," *AJA* 18 (1914), 146–55. H.P. L'Orange, "Ein tetrarchisches Ehrendenkmal auf dem Forum Romanum," *RM* 53 (1938), 1–34. I.S. Ryberg, *Rites of the State Religion in Roman Art, MAAR* 22 (Rome, 1955), 117–19. H. Kähler, *Das Fünfsaulendenkmal für die Tetrarchen auf dem Forum Romanum* (Cologne, 1964). H. Wrede, "Der Genius Populi Romani und das Fünfsaulendenkmal der Tetrarchen auf dem Forum Romanum," *BonnJbb* 181 (1981), 121–42.

The Palace of Diocletian at Split and the Frieze of Diocletian's Mausoleum: J. Marasovic and T. Marasovic, *Diocletian Palace* (Zagreb, 1970) (English ed.).

The Arch of Galerius at Salonica: K.F. Kinch, *L'arc de triomphe de Salonique* (Paris, 1890). H. von Schönebeck, "Die zyklische Ordnung der Triumphalreliefs am Galeriusbogen in Saloniki," *BZ* 37 (1937), 361–71. H. von Schönebeck, *JbBerlMus* 58 (1937), 54ff., figs. 2–3 (head of Galerius in relief in Berlin, now lost). C.C. Vermeule, *Roman Imperial Art in Greece and Asia Minor* (Cambridge, Mass., 1968), 336–50. C.J. Makaronas, *The Arch of Galerius at Thessaolniki* (Salonica, 1970). H.P. Laubscher, *Der Reliefschmuck des Galeriusbogens in Thessaloniki* (Berlin, 1975). M.S. Pond Rothman, "The Panel of the Emperors Enthroned on the Arch of Galerius," *Byzantine Studies/Etudes Byzantines* 2:1 (1975), 19–40. M.S. Pond Rothman, "The Thematic Organization of the Panel Reliefs on the Arch of Galerius," *AJA* 81 (1977), 427–54. J. Engemann, "Akklamationsrichtung, Sieger- und Besiegtenrichtung auf dem Galeriusbogen in Saloniki," *JAC* 22 (1979), 150–60. H. Meyer, "Die Frieszyklen am sogenannten Triumphbogen des Galerius in Thessaloniki," *JdI* 95 (1980), 374–444.

The Small Arch of Galerius at Salonica: G. Daux, "Chronique des Fouilles en 1957," *BCH* 82 (1958), 756–830, figs. 4–5. C.C. Vermeule, *Roman Imperial Art in Greece and Asia Minor* (Cambridge, Mass., 1968), 417–18. C.J. Makaronas, *The Arch of Galerius at Thessaloniki* (Salonica, 1970), 50, figs. 47–48. J. Meischner, "Die Porträtkunst der ersten und zweiten Tetrarchie bis zur Alleinherrschaft Konstantins: 293 bis 324 n. Chr.," *AA* (1986), 223–24, fig. 1.

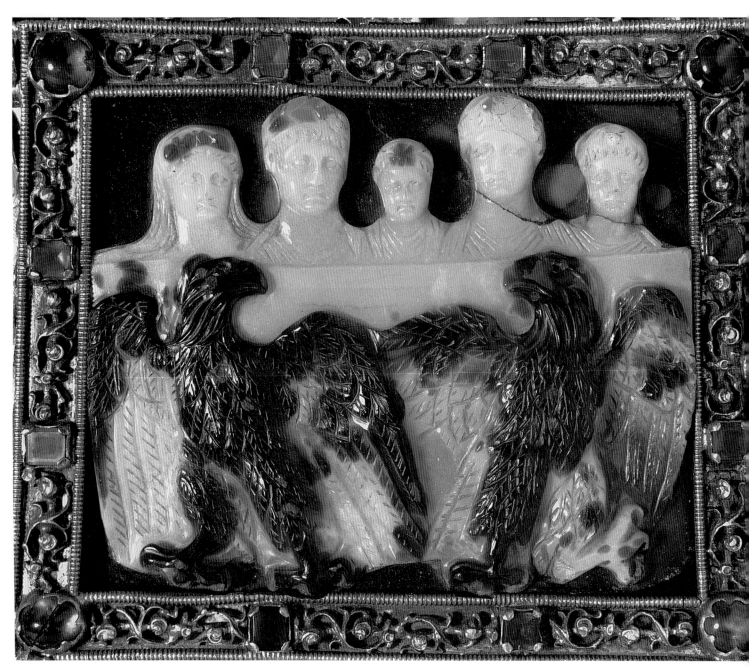

Ada Cameo, 318–23. Trier, Stadtbibliothek. (See fig. 403.)

THE CONSTANTINIAN PERIOD

CHAPTER X

Flavius Valerius Constantinus, better known as Constantine the Great, was born at Naïssus in Moesia, probably in 285. It was a significant year not only because it saw the birth of the last pagan and first Christian emperor of Rome, but because it was also the year in which Diocletian defeated Carinus and the year that preceded his taking Maximian as his co-emperor, which led to the founding of the tetrarchy. In fact, it was Constantine's father, Constantius Chlorus, who was chosen by Diocletian in 293 to serve as tetrarch in the West. Constantine's mother, Helena, was Constantius's concubine, but, for reasons of political expediency, the tetrarch married Valeria, the stepdaughter of Maximian. It was Helena, however, who was honored with court portraits and an imperial mausoleum when her son became emperor of Rome.

Constantine was only eight when Constantius was appointed Caesar; his father's new position allowed the boy access to Diocletian, at whose court he resided. Given his background, it is not surprising that Constantine early on demonstrated talent as a military officer, and he served under Galerius in his important campaign against Persia. It has already been established that the Persian victories of Galerius and Diocletian gave legitimacy to the first tetrarchy. It is possible that a portrait of Constantine, along with one of Licinius, who also participated in Galerius's eastern campaign, was included in one of the scenes on the northeastern side of Pier BII of the Arch of Galerius at Salonica (see fig. 388). Furthermore, Constantine accompanied Constantius on his British campaign, which led to another significant victory for the tetrarchy, a success that the tetrarchs shared with the Julio-Claudian emperor Claudius. Reference to the association of the tetrarchs' British victory with that of Claudius was made by incorporating fragments from Claudius's British Arch in Rome into Diocletian's Arcus Novus (see figs. 119, 376).

While father and son were on the front in Britain in 306, Constantius – who had in the meantime been appointed Augustus in the West on the occasion of Diocletian's abdication in 305 – died. The troops, loyal to him and to Constantine, saluted the son as Augustus. Such a designation was unacceptable to Galerius, who appointed

Severus Augustus in his stead, grudgingly proclaiming Constantine his Caesar. At the same time as Constantine's salute as Augustus by the troops, Maxentius, son of Maximian, was proclaimed Augustus in Rome. Maxentius was attacked by Severus, who waged an unsuccessful attempt and was forced to surrender. Maximian, who had forfeited his retirement to aid his son, defeated Constantine in Gaul. Galerius joined the fray in an attempt to take Italy, but like Severus, he was forced into retirement. Subsequently, Maximian switched his allegiance and attempted to depose his son. His failure to do so led him to turn to Constantine for protection.

Since the tetrarchs favored marriages that complemented their political goals, Constantine was affianced to Fausta, the daughter of Maximian, in 293. Since Maximian now supported Constantine over his own son, he insisted that Constantine marry Fausta in Gaul in 306 and concurrently bestowed on his new son-in-law the title of Augustus. The Conference of Carnuntum of 308 directed Constantine to relinquish the title of Augustus and to become a Caesar under Licinius. Constantine and Maximinus Daia, who was given a similar directive, both refused. While the tetrarchs and their descendants battled for imperial supremacy, some of them faced insurgencies in the lands under their purview. Constantine successfully defended the Rhine, which was threatened by numerous tribes. At the same time, he moved against Maximian, who had taken Marseilles, and forced him to commit suicide. Since Constantine's defeat of Maximian seriously discredited the Herculian branch of the tetrarchy (Maximian's patron god was Hercules), he immediately claimed kinship with Claudius Gothicus, a staunch supporter of the senate and rumored to be the ancestor of Constantine and his father, Constantius. Constantine's rival, Maxentius, was all that remained of Maximian's side of the tetrarchy. In early 312, Constantine invaded Italy. His campaign began with decisive victories near the northern Italian cities of Turin and Verona. Buoyed by these successes, Constantine marched on Rome and clashed with Maxentius at the famous Battle of the Milvian Bridge, bringing defeat and death to Maxentius and victory to Constantine, who ascribed his triumph to the sign of the cross.

These battles for imperial supremacy left only two survivors: Constantine, favored by the senate, was appointed Augustus in the West, and Licinius, who was allied with Constantine by marriage to his sister, Constantia, became emperor in the East. Jointly Constantine and Licinius issued an epoch-making decree in 313, the Edict of Milan, which granted religious freedom to the Christians. Crispus and Constantine II, the sons of Constantine, and Licinius II, Licinius's son, became Caesars in 317. Relations between Constantine and Licinius be-

came strained, and they battled in 314 (or 316) and then again in 323. Constantine demonstrated military and naval supremacy over his foe, and Licinius was executed in 324.

The elimination of his last rival left Constantine sole emperor of the Roman world with power to restructure the army, restore stature to the senate, and return prestige to the empire. The latter part of the Constantinian period was marked by peace, marred only by a small incursion of the Goths. Constantine, unlike Diocletian, favored hereditary succession, and his wife Fausta produced sons for him to groom for an imperial position. Although a court scandal shrouded in mysterious circumstances caused Constantine to authorize the execution of Fausta and his eldest son by Minervina, Crispus, his three remaining heirs were appointed Caesars: Constantine II in 317, Constantius II in 323, and Constans in 333.

The Constantinian period was also noteworthy for its architectural accomplishments, some of which were begun by Constantine's rival, Maxentius, who was a great builder in the tradition of the tetrarchs. During the six years he was emperor (306–12), Maxentius commissioned several major works in Rome. He added offices to the Curia, renovated by Diocletian, and was responsible for the complete restoration of Hadrian's Temple of Venus and Roma on the Velia near the Arch of Titus. A fire in 307 had destroyed much of the northeast corner of the Roman Forum. Veneration for Hadrian and the fact that the outer walls and colonnades of the structure were still standing led to the temple's revitalization, including the fashioning of the double apses back to back, the sculptured cella walls with their aediculae flanked by small porphyry columns, and the lozenge-shaped coffering in the half-domes of the apses. The structure's magnificent pavement was made of multicolored marble, including porphyry, which continued to be favored by the tetrarchs' successors.

The fire had also cleared an area that became the site of the grandiose Basilica of Maxentius, slightly redesigned and dedicated by Constantine after his victory over Maxentius at the Milvian Bridge. The Basilica of Maxentius-Constantine (or the Basilica Nova) is among the greatest structures of Late Antiquity and one of the finest Roman buildings ever erected. It has soaring vaults with elaborate coffers and the colossal marble-seated portrait of Constantine (see figs. 399–401) – parts of which still survive – may have been designed specifically for one of the apses.

Maxentius also ordered the construction of a villa on the Via Appia on the outskirts of Rome. The residential and public sections of the palace were accompanied by a great circus, resembling Galerius's in Salonica, which is reported to have been able to accommodate fifteen thou-

sand spectators and had as its centerpiece the same Egyptian obelisk that originally embellished the Domitianic Temple of Isis in the Campus Martius in Rome. Near the racecourse was Maxentius's mausoleum, a round structure which was a copy, in reduced scale, of Hadrian's Pantheon. The inclusion of a circus and mausoleum in the villa's plan, as well as the villa's resemblance to a small city, betrays the fact that Maxentius's palace in Rome was built on the model of those of the tetrarchs in the provincial capitals.

Constantine followed the lead of Maxentius by completing his rival's major building projects, such as the Basilica Nova, and by instituting many of his own. These included basilican churches for the public celebration of the Christian faith as well as centralized structures that served as martyria. Both were the results of the practical needs of the Christian liturgy, but each building type reveals its indebtedness to the Roman past: the longitudinal churches based on Roman basilicas and the martyria on round mausolea.

Other Constantinian constructions are even more closely linked with the pagan past, for example, the *Thermae Constantinianae* (Baths of Constantine) on the Quirinal hill, which were modeled on the imperial Baths of Caracalla and Diocletian. The Arch of Constantine (see figs. 406–407) demonstrates its indebtedness to the Arch of Septimius Severus in the Roman Forum (see figs. 293–294); and the two imperial tombs of Tor Pignattara and S. Costanza, like the Christian martyria, were based on the Mausolea of Augustus and Hadrian. The former tomb is located near the Via Praenestina in Rome and was originally designed to house the remains of the emperor himself. His mother, Helena, was eventually laid to rest in the round structure resembling the earlier Mausoleum of Maxentius. The other Constantinian mausoleum was also circular but was surrounded by a barrel-vaulted ambulatory with magnificent mosaics depicting erotes harvesting grapes. It served as the burial place of Constantine's daughter, Constantina. The two tombs attest to the fact that separate burial places were constructed in Constantinian times for individual members of the same family, in contrast to earlier imperial practice whereby not only entire families but one or two dynasties were buried in the same mausoleum.

Constantine's vision of the cross at the Battle of the Milvian Bridge led to his staunch support for Christianity, underscored as early as 313 in the Edict of Milan and attested by the public support he gave to the new religion. Some of the third-century emperors demonstrated an interest in monotheism, favoring such gods as Sol Invictus. Constantine also associated himself with Sol but seems to have come to believe that the God of the Christians would best protect Rome and that the des-

tiny of the empire was closely interwoven with that of its new patron. It was for this reason that Constantine supported the Church and encouraged the construction of churches in Rome and elsewhere. He appointed Christians to official posts and personally rejected paganism. Constantine's devotion to Christianity ultimately led to his baptism on his deathbed, and it is Rome's first Christian emperor who should be credited with transforming Christianity from a minority religion practiced in secret to an empirewide religion publicly celebrated in imperially sponsored edifices.

Despite Constantine's monumental building program in Rome, still capital in the West, he was cognizant that Rome's traditional prominence had been called into question by Diocletian and the first tetrarchs, who had established four distinct places of government. In fact, it was Diocletian who recognized the strategic importance of an eastern capital and who chose Nicomedia as his base. Constantine chose Constantinople in its stead and dedicated it in 330 as the "New Rome." Celebrations in honor of this momentous event were accompanied by a great deal of fanfare, and the city was rapidly embellished with buildings that bore a distinctive Roman stamp.

Imperial Portraiture

The earliest surviving portraits of Constantine may be those in relief on the socle of the Decennial Monument in Rome (see fig. 383) and on Pier BII of the Arch of Galerius in Salonica (see fig. 388). The former depicts Constantine in toga as heir apparent to his father and also in conjunction with the other three tetrarchs with whom he also had significant connections. He was the son of Constantius Chlorus, who was married to the stepdaughter of Maximian. He lived in Diocletian's palace and served under Galerius in the Persian Wars. It was in the last capacity that he was represented, along with Licinius and Maximian, on the Arch of Galerius, where he appears in battledress trampling Persian foes. He is represented near Galerius in what might be called the most important scene on the arch because it is the one in which Galerius, in cuirass and on horseback, encounters the Persian king, Narses. It is the culminating moment of the Persian Wars and is carefully staged, with Galerius, already crowned with the wreath of victory, at the center and Narses on the right. The scene is arranged, therefore, like a symbolic tableau with a pseudohistorical scene as its focus. Although the identities of the officers have been challenged, their inclusion would add another level of meaning to a scene in which the artist has distorted truth to impart the desired message: Galerius's preordained victory over Narses is celebrated by him and

by all of the tetrarchs; the future of their form of government is assured by their heirs who have also triumphed over the Persians.

Neither the togate youth on the socle of the Decennial Monument nor the officer on Pier BII of the Arch of Galerius at Salonica has an extant head. For that reason their identities may never be certain. If they did depict Constantine, they are the only surviving images of him in his late teens, because there appear to be no extant heir-apparent portraits of Constantine in the round, even though his father was emperor in the West.

Even those portraits of Constantine that can be definitively identified with him are no less controversial. The best-known portrait of the emperor, and indeed one of the most renowned surviving Roman portraits – the marble colossus from the Basilica of Maxentius-Constantine, which is now on display, along with fragments of the statue's arms, hands, and feet, in the courtyard of the Museo del Palazzo dei Conservatori – is alternatively dated to the time of the dyarchy or to the period of Constantine's sole emperorship. Several over-life-size cuirass statues (see figs. 396–397), which must represent members of the Constantinian family, are variously identified as Constantine and/or one of his sons. Another colossus, in bronze and also in the Museo del Palazzo dei Conservatori (see fig. 402), is sometimes associated with Constantine the Great and sometimes with his son Constantius II.

These disputes may never be satisfactorily resolved, but their very existence is instructive. The basic message of tetrarchic portraiture was the similitude of the four equal emperors; it is conceivable that Constantine, son of a tetrarch, continued to believe that the close visual association of himself and his hereditary heirs was desirable. Since in this case we are dealing with a father and his real sons, the family resemblance would, of course, be expected. Constantine favored dynastic portraiture, and the two groups that still survive appear to have depicted Constantine and three of his four sons, thus continuing to underscore the significant number four.

Furthermore, Constantine's earliest securely identifiable likenesses, which appear on coins of about 306–7, demonstrate their profound indebtedness to tetrarchic models. That coins with Constantine's portrait began to be struck in 306 is not surprising since it was in that year that Constantius Chlorus died and Constantine was saluted as Augustus by the troops in Britain. An argenteus of 306–7 (fig. 392) depicts Constantine as a tetrarch, that is, as a bearded blockhead. He has a military coiffure, short beard, thick neck, and sharply defined features that associate him with his father and other members of the tetrarchy. To resemble the tetrarchs more closely, he is depicted as much older than his twenty-one years. A

similar portrait, but without the beard, also appears on contemporary coins; the beardless version has been designated as the first official portrait type of Constantine. Despite his appointment as Augustus in 306, Constantine was, at that time, still battling his rivals for imperial supremacy. The Battle of the Milvian Bridge was six years in the future. It was the coins and medallions struck by Constantine after 312, specifically in 313, that document the most extraordinary transformation of an emperor in the history of Roman portraiture. In these coin portraits of 313 (see, for example, fig. 393), Constantine has lost twenty years of age and has shaved his beard. He has become a neo-Augustus with a neo-Trajanic hairstyle in which comma-shaped locks are arranged in an arc across his forehead.

It has been suggested, however, that this new hairstyle appears on *solidi* from Trier as early as 311 and were struck to honor Constantine's *quinquennalia* as Augustus. In one gold solidus of 313, struck at Ticinum (Pavia) (fig. 394), Constantine wears a cuirass and carries a spear and a shield decorated with the solar chariot. An image of Sol with his rayed crown is silhouetted below Constantine's profile portrait, and the accompanying legend refers to *Invictus Constantinus*. Constantine is depicted with a smooth face and a hooked nose and strong jaw. His wide eyes look straight ahead and are surmounted by arched brows. He wears a wreath in his cap of hair, which is arranged in a pattern of comma-shaped locks across his forehead.

In a famous silver miliarensis of about 315, possibly from Rome (fig. 395), Constantine, continuing the tetrarchic tradition, is depicted in a frontal portrait. His face is oval, smooth, and youthful, and he has large staring eyes and a coiffure with comma-shaped locks forming an arc over his forehead. He is clad in a cuirass and holds the reins of his steed in his right hand. In his left hand, he grasps a scepter and a shield ornamented with a traditional Roman symbol – the she-wolf suckling Romulus and Remus. Constantine is portrayed in this medallion portrait as a Roman officer with his horse and protective arms and armor. His shield is emblazoned with the very symbol of Rome, and his youthful and smooth countenance and cap of hair with comma-shaped locks associate him with Trajan. The scene on the reverse, which depicts the adlocutio of Constantine, who is elevated above his troops, which encircle him, underscores the military imagery of the medallion. Although Constantine is bareheaded in the scene of the address to his troops, he is depicted with an elaborate jeweled and feathered helmet in the obverse portrait. Nestled amidst the feathers is a decorative medallion that is embossed with the chi-rho – the emblem of Christianity – which identifies Constantine as a supporter of the Christian cause. He is thus, at

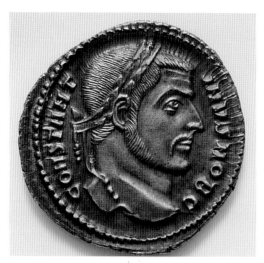

392 Argenteus with portrait of Constantine, 306–7. Milan, Castello Sforzesco. Photo: Hirmer Verlag München 2077.756

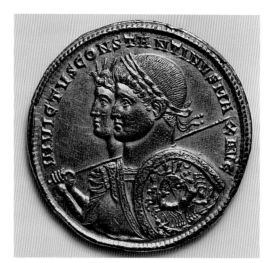

394 Gold nine-solidus coin with portraits of Constantine and Sol, from Ticinum, 313. Paris, Bibliothèque Nationale. Photo: Hirmer Verlag München, 2076.968V

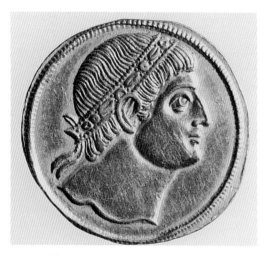

393 Gold one-and-a-half solidus coin with portrait of Constantine, 313. London, British Museum. Photo: Courtesy of the Trustees of the British Museum

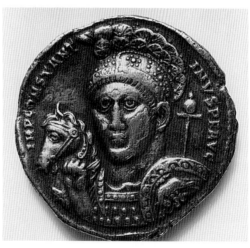

395 Miliarensis with portrait of Constantine, possibly from Rome, ca.315. Munich, Staatliche Münzsammlung. Photo: Hirmer Verlag München, 2076.589V

the same time a Roman soldier and leader in the tradition of such soldier-emperors as Trajan and also the first Christian crusader.

Roughly contemporary with these miniature medallion portraits are the relief portraits of Constantine from the Arch of Constantine in Rome. The arch, which was erected between 312 and 315 in honor of Constantine's victory over Maxentius at the Battle of the Milvian Bridge and the dyarchy of Constantine and Licinius, is a pastiche of fourth-century reliefs and reused second-century reliefs. In the latter, the heads of the main protagonists have been recarved with the features of Constantine and Licinius. It has been pointed out that the Arch of Constantine is to the dyarchy what the Arch of Galerius at Salonica was to the tetrarchy. It simulta-

neously commemorated the military victories of one of its members and the concordia of the regime.

The heads of Marcus Aurelius in the eight panels that decorate the attic (see figs. 256–259) were originally replaced with those of Constantine, but those now on the arch are modern renditions of Trajan. Heads of Trajan in the two fragments of the Great Trajanic Frieze, which face one another across the central bay of the arch (see figs. 185–186), were replaced with those of Constantine. It is only the cycle of eight medallions from a lost monument of Hadrian (see figs. 219–220) that include portraits of both members of the dyarchy – Constantine and Licinius. Those of Constantine depict him when he was twenty-seven to thirty years old. The best-preserved and most revealing of his appearance at this age is the recut

head in the boar hunt (see fig. 220). Hadrian's coiffure has been retained for the most part; apparent are the deep waves that are brushed from the crown of the head on the neck, in front of the ears, and down on the forehead. The thick curls that once framed the forehead, however, have been cut away to form an arc that is more in keeping with the shape of Constantine's coiffure on contemporary coins. Hadrian's beard and moustache have, however, been removed, and the face of Constantine is not only cleanshaven, but thin and oval with pronounced cheekbones and an angular facial construction. The nose is now missing, but the lips are small and relatively straight, with slight dimples at the corners. The eyes are large but not staring, and the lids are accentuated at top and bottom.

The head of Trajan in the scene of the emperor crowned by Victory was also recarved as Constantine (see fig. 186). Again, the original coiffure has been retained, but in this case it is more comparable – with its caplike appearance and comma-shaped locks – to the one actually worn by Constantine. Trajan was also cleanshaven. All that needed to be accentuated were the cheekbones and the eyes, which are large and lined by heavy upper and lower lids. The pupil and iris are carved, which would have not been the case in the original head.

A youthful portrait type of Constantine, sometimes referred to as type 2, which depicts him during the time of the dyarchy (312–24) when he was twenty-seven to thirty-nine years old has been identified by scholars. It includes the coin and medallion portraits of 312–24, the relief portraits from the Arch of Constantine, and marble portraits in the round in Grottaferrata, Copenhagen, Madrid, Rome, and Tunis.

Constantine's elimination of Licinius, his final rival for sole power, was an event momentous enough to necessitate the creation of a new portrait type. In his youthful or type 2 portrait, Constantine had already demonstrated his desire to disassociate himself from the tetrarchic dynasty and to emphasize his descent from Claudius Gothicus and his alliance with Trajan. Constantine was the first sole emperor in approximately forty years, and his idea of universal monarchy included a belief in hereditary succession. His two wives, Minervina and Fausta, provided him with four sons, and he and his heirs were celebrated in dynastic groups. One such group, possibly from the Baths of Constantine on the Quirinal hill in Rome, appears to have been erected after the death of Crispus and may have commemorated Constantine and his three remaining sons. It comprised marble statues of all four clad in cuirasses and wearing the corona civica. Three of the four statues survive; two are displayed on the balustrade of the Capitoline hill (fig. 397), the other is in S. Giovanni in Laterano (fig. 396).

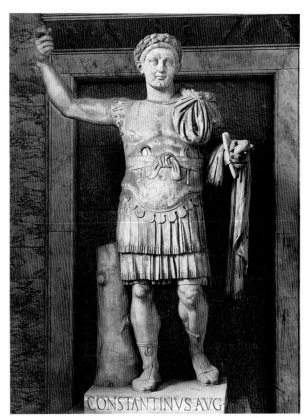

396 Portrait of Constantine the Great, from a dynastic group, 312–24. Rome, S. Giovanni in Laterano. Photo: Alinari/Art Resource, New York, 98

The latter, of colossal proportions, appears to have been the central figure and certainly depicts Constantine the Great. The Campidoglio statues probably represented Constantine II and Constantius II; the lost one would then have represented Constans. Such a group not only had first- and second-century precedents but also probably derives from the tetrarchic practice of portraying the Augusti and their Caesars as a foursome. Constantine's intended message was that he was continuing Diocletian's practice of joint rule while at the same time championing hereditary succession.

The S. Giovanni statue depicts Constantine in a portrait that is a more mature version of the youthful type. He continues to be depicted with a narrow face and prominent cheekbones, small, rounded lips, and large eyes that look straight ahead; the nose is restored. The eyebrows are arched and the individual hairs are delineated. Constantine is cleanshaven, and he is depicted with a cap of hair that is short on the nape of the neck but arranged in comma-shaped locks across the forehead. The strands on either side of the head are brushed toward the center and meet over the nose. Although the type is similar to the youthful type, it is likely that the group was commissioned after Constantine eliminated Licinius in 324. The flaps of the cuirasses are decorated with crosses

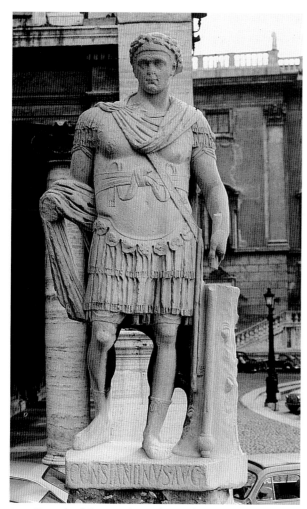

397 Portrait of Constantine II, from a dynastic group, 312–24. Rome, Campidoglio. Photo: DAIR 67.1751

associated with earlier imperial imagery. The head, however, is turned to the left and somewhat upraised, which is at odds with the self-contained tetrarchic icons of the East and betrays its origins in a past more heavily influenced by Hellenistic portraiture. The base of the statue of Constantine in S. Giovanni in Laterano is inscribed with the name *Constantinus Augustus*.

One of the over-life-size statues on the Campidoglio (see fig. 397) is similarly inscribed (although these inscribed bases may not belong to the statues), which has led most scholars to associate it with Constantine. There are others, however, who believe that it depicted Constantine II instead and belonged to a four-figure dynastic group with the S. Giovanni in Laterano statue of Constantine as its focal point. The figure is similarly garbed in cuirass and paludamentum and also wears a corona civica. His facial features and coiffure resemble closely those of his father, and, although his proportions are more attenuated, his breastplate is depicted in the same blocky manner. His left arm rests at his side and his right arm is bent but not upraised like Constantine's.

Constantine II's over-life-size companion on the balustrade is often also associated with Constantine II since his pedestal is inscribed *Constantius Caesar*. He has also been identified as Constantius II, younger brother of Constantine II, designated a Caesar in 323 (Constantine II became one in 317). He is also in military garb and wears a corona civica on his head. The shape of his face, features, and coiffure resemble those of his father and brother, although in a somewhat more youthful version.

Another dynastic group, made out of porphyry instead of marble, has also been associated with Constantine and three of his sons and was set up between 333 and 337, by which time all three boys had been raised to the rank of Caesar. The group appears to have been set up in Alexandria rather than Rome, and the statue of a headless seated togatus, probably originally Constantine himself, was found there and is now in the Alexandria Museum. Three other large headless porphyry statues depicting two young men in the chlamys and another in a cuirass were also found in Egypt and are now in Berlin, Vienna, and Turin, respectively. The commission of such a group in the 330s in Alexandria demonstrates the continued impact of the tetrarchic ideal of constitutional unity and attests that in the East porphyry continued to be the favored stone for fourth-century imperial statuary. Also significant is the shift from the military imagery of the dynastic group from the Baths of Constantine to one with a focus on the civil administration of the empire. This is not surprising. The group from Rome was erected right after Constantine's victory over Licinius, whereas the Alexandria group was put up approximately ten years after Constantine became sole emperor.

(perhaps only rosettes) – possibly referring to the open acceptance of Christianity inside the pomerium after that date. It has been suggested that the group was put up in 326 in honor of Constantine's vicennalia. Constantine stands with his weight on his right leg; his left leg is bent and his left foot is raised. He holds the hilt of a sword in his left hand, and his right arm is upraised and probably grasped a long lance or scepter in a statuary type that is probably derived from the emperor as Jupiter popularized by Claudius and others (see, for example, fig. 106). Constantine, however, is not depicted in the guise of Jupiter but as a military man with cuirass and paludamentum. He wears the corona civica not only because it was customary for Roman emperors to do so but as a reference to to the fact that he had saved Roman lives by putting an end to civil war in Italy. Although the head, already described, is more naturalistic and is thus in the western rather than the eastern tetrarchic tradition, the cuirass is treated as a rectangular shape with little definition of the musculature beneath the breastplate. The proportions of the figure are also stocky, and there is little of the grace

The surviving portraits of Constantine that were made between his assumption of sole power in 324 and his death in 337 have been grouped together by scholars. None of these is part of a replica series, but they all show Constantine with a comparable hairstyle, which in some is ornamented by the diadem he adopted after 324. The cap of hair is thicker and is arranged in a smaller number of fuller comma-shaped locks across his forehead. They are brushed inward from either side and meet in the center of the face above the nose. Such an arrangement is distinctive and special to Constantine even though the general shape of the coiffure and the forehead locks are reminiscent of the hairstyles of Augustus and Trajan. The individual portraits of Constantine made between 324 and 337 include marble heads in Istanbul, New York, Schloss Fasanerie, Rome, and a bronze one with a diadem in Belgrade. The New York head (fig. 398) depicts Constantine with the same narrow face and pronounced cheekbones as in his youthful likenesses. His face is smooth and his large eyes, with carved pupils and irises, are surmounted by arched brows with individually delineated hairs that add texture to the face. The nose is prominent and the mouth curved. The hair is a full cap with thick comma-shaped locks brushed toward the center of the face. The heads in Belgrade and Schloss Fasanerie show the same facial features and hair, but the large eyes are more uplifted – as in many of the coin portraits of the 320s and later – and the shape of the face is more rectangular.

The best-known portrait of Constantine the Great – the colossal marble head – now in the courtyard of the Museo del Palazzo dei Conservatori (fig. 399) – is usually associated with this group. The head, along with surviving fragments of the arms, hands, and legs (figs. 400–401), belonged to a thirty-foot, seated statue of the emperor that occupied the west apse of the Basilica of Maxentius-Constantine in Rome and was found in the building's ruins in 1486. In 1951, the left breast of the statue in the basilica's west apse was discovered – an exceedingly important find because it indicated that the figure was not clad in a toga or a cuirass but had a bare chest. Constantine was almost certainly depicted in the traditional Jupiter pose with his mantle draped across his legs. Furthermore, the statue was an acrolith with the head, chest, arms, and legs fashioned from three different white marbles, with the drapery probably of bronze. Constantine would have carried a scepter, possibly the cross-scepter described by Eusebius. Since two right hands have been associated with the statue, it has been suggested that the second hand, with the cross-scepter, replaced the first, with a regular scepter, in order to imbue the statue with the new Christian iconography.

Maxentius intended his basilica to have an east-west

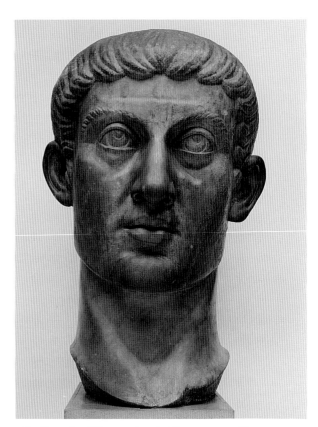

398 Portrait of Constantine the Great, 324–37. New York, Metropolitan Museum of Art, bequest of Mrs. F. F. Thompson, 1926. Photo: Courtesy of the Metropolitan Museum of Art, 26.229

axis and for the west apse to house his own colossus, but Constantine changed the orientation by adding an apse on the north side and a columned-porch opening onto the Via Sacra, on the south. He also personalized the structure and underscored his civil war victory over his arch rival by replacing Maxentius's portrait in the west apse with his own. The expropriation of a foe's monument and the replacement of his portrait with that of his conqueror is part of a long Roman tradition and can be traced to the republic when Aemilius Paullus transformed Perseus's victory pillar in Delphi into a monument celebrating his own triumph over his rival (see fig. 5).

The Basilica Nova was rededicated by Constantine in 313. For that reason and because of the close stylistic similarity of the colossal marble head with the portrait of Constantine on a silver miliarensis – possibly from Rome – of about 315 (see fig. 395), many scholars date the seated statue to about 315. Furthermore, these scholars see close stylistic and typological similarities between the Conservatori portrait and others of early Constantinian date. Other scholars assign the head to the time of Constantine's sole emperorship because its features are thought to be close to those of the late portraits and because it seems

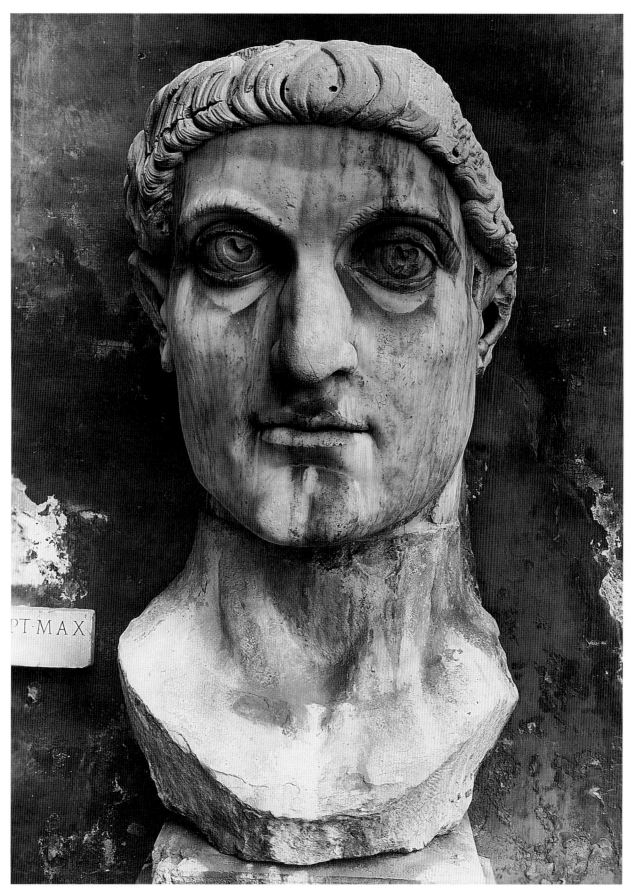

399 Portrait of Constantine the Great, from the Basilica
Nova, ca.315–30. Rome, Museo del Palazzo dei Conservatori.
Photo: DAIR 57.998

400 Portrait of Constantine the Great, fragment of arm, from the Basilica Nova, ca.315–30. Rome, Museo del Palazzo dei Conservatori. Photo: DAIR 6381

401 Portrait of Constantine the Great, fragment of foot, from the Basilica Nova, ca.315–30. Rome, Museo del Palazzo dei Conservatori. Photo: DAIR 6726

likely that a diadem was fastened to the head (attachment holes are preserved), an attribute that Constantine did not adopt until after 324. Of course, the latter might have been added at a date later than the portrait head was fashioned, perhaps at the same time that the hand with scepter was replaced by another with a cross-scepter.

The head does exhibit features characteristic of the portraits of Constantine fashioned when he was the sole emperor of Rome: the blocklike rectangular head, the immense eyes under arched brows with individually delineated hairs, and the caplike coiffure with comma-shaped locks brushed from either side toward the center of the forehead. The smooth face with prominent cheekbones, hooked nose, and rounded lips, are seen in the early and late portraits.

There is a significant contrast between the starkly abstract and geometric head and the more naturalistic body. The joints of the hands are meticulously indicated, as are the prominent veins on the inner side of the upper arm and forearm. Such details have led to the suggestion that the body was carved in Trajanic times and combined in the fourth century with a new head of Constantine. This is an interesting theory and is bolstered by the Constantinian taste for creating pastiches from second- and fourth-century works. It is also possible, however, to demonstrate that there was a classical revival in Constantinian times that surfaced not only in the portraits of a beardless emperor who resembled Trajan, but in more naturalistic renditions of the nude body; the seated colossus may be an illustration of that trend.

The controversy over the dates for both the head and the body of the Conservatori statue may never be solved conclusively. It may be wisest, at present, to date the entire portrait to the fifteen-year period from 315 to 330. In any case, its precise date is less important than that it is the most significant surviving imperial image of the first half of the fourth-century. It demonstrates as well as any portrait of that time that Constantinian art was rooted in both the immediate tetrarchic past and in the more distant second century and, at the same time, was expressive of its own age. The strict geometry of the tetrarchic image was adhered to, and the beardless face and comma-shaped hair of Trajan was adopted. The emperor is posed like Jupiter, the head of the Roman pantheon, but he carries the attribute of the new Christian god. In this way, the portrait of Constantine from the Basilica Nova, which served as a Roman law court and not as a place for Christian worship, is the equivalent of Constantine's greatest state monument – the Arch of Constantine in Rome – which combines second- and fourth-century reliefs in an eclectic mélange that conveys the emperor's reverence for the past and his hopes for the future.

The identity of the emperor depicted in a bronze

head, now in the Sala dei Bronzi of the Museo del Palazzo dei Conservatori (fig. 402), is also highly controversial. Its colossal scale indicates that it portrays an emperor. Scholars have suggested Constantine in old age or one of his sons, probably Constantius II. The statue to which it originally belonged was probably about five times life-size, and the figure may have held an orb. A bronze hand and a globe and a right foot have been associated with it, but even if they did belong to the figure, there is no indication as to whether the original work was a seated or standing statue. Although it was recorded in 1200 in front of the Lateran Palace in Rome, its location in antiquity is not attested.

The head has in common with the marble colossus from the Basilica Nova the rectangular face, large heavily lidded eyes, dilated pupils, arched brows with individually delineated hairs, hooked and assymmetrical nose, rounded lips, prominent chin, and thick neck. The major differences between the two are in the ages of the subjects (the man in the bronze looks older) and in the configuration of the coiffure. The high forehead and the arcuated pattern of the forehead locks of the marble Constantine is gone in the bronze portrait where the hair, which is brushed from the crown of the head, ends in thick curls that are arranged straight across the forehead. There are corkscrew locks in front of the ears, and the hair falls long on the neck in serpentine strands.

Such divergent features are seen in the latest lifetime portraits of Constantine on coins, such as a gold solidus of 336–37 from Constantinople, which depicts the aging emperor with longer and straighter forehead hair having slight waves at the ends, curls brushed in front of his ears, and long locks curling on the back of his neck. The numismatic portraits of Constantine II and Constantius II of the 330s and Constans of the 340s represent the sons with a similar coiffure but with a more youthful countenance. The bronze portrait has recently been tentatively identified as Constantine the Great at the end of his life or in a posthumous image. In view of the portrait's closeness to numismatic likenesses of the late 330s and the advancing age of its subject, this seems a convincing suggestion. Other scholars have identified him as Constantius II. It is true that Constantius is depicted on coins with a comparable coiffure, but he died at the age of forty-five and the bronze portrait seems to be of an older subject.

The controversy that surrounds the Conservatori bronze head underscores the successful assimilation of Constantine's sons with their father by the court artists of the day. By 333, Constantine II, Constantius II, and Constans had all become Caesars, and dynastic groups (discussed above, see figs. 396–397) of the foursome had already been commissioned in the second half of the 320s. Influenced by the powerful image of the tetrarchy

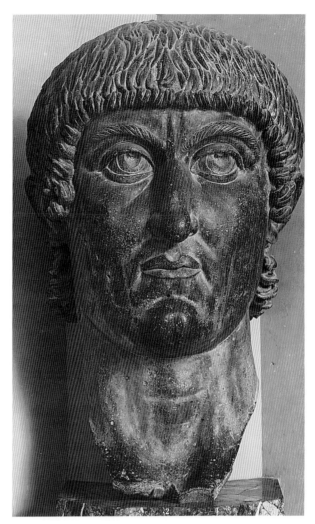

402 Bronze portrait of Constantine the Great, 336–337. Rome, Museo del Palazzo dei Conservatori. Photo: DAIR 59.1723

as an indivisible unit and inspired by the bland classicism of Augustan times which also subsumed individuality, these groups depict imperial male personages who are essentially interchangeable.

Female Portraiture in the Constantinian Period

Emperors who commissioned dynastic groups honoring themselves and their male progeny also tended to demonstrate a profound interest in the portraiture of female court luminaries, who are sometimes depicted with their children. The monumental Constantinian statuary groups from Rome and Alexandria seem to have excluded women, but small-scale cameos and medallions from the period incorporate them. One example is the so-called Ada Cameo, now in the Stadtbibliothek in Trier

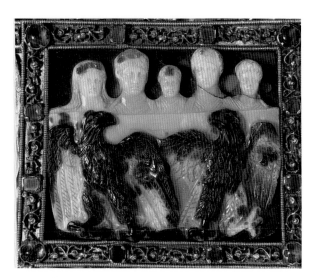

403 Ada Cameo, 318–23. Trier, Stadtbibliothek. Photo: Courtesy of the Stadtbibliothek, Trier

(fig. 403), which appears to be Constantinian, although Claudian and Theodosian dates have also been suggested by scholars. The cameo appears to date between 318 and 323 and depicts Helena, who in 318 was honored with the title *nobilissima femina,* Constantine, Constantius II, Fausta, and Constantine II. The imperial family is displayed behind two eagles with outstretched wings, signs of their sovereign status. The young princes are miniature versions of their father, with round faces and caplike coiffures with comma-shaped locks. Helena is veiled as befitted her new position, and Fausta is flanked by her two sons. Both women also have round faces and hair parted in the center and brushed back in waves.

A bronze medallion, found in 1922 in the Loire and now in the Musée Debrée in Nantes, was probably produced after the deaths of Fausta and Crispus and appears to depict Constantine and Helena in large facing-profile portraits with Constantine II and Constans, also in profile, flanking a frontal Constantius II below. The boys are again diminutive renditions of their father, and Helena wears an elaborate coiffure with waved and plaited locks. Individual portraits on coins and in the round of Helena and Fausta were also made in Constantinian times, and the numismatic versions, with their accompanying legends, allow the identification of monumental works in marble and bronze.

Flavia Iulia Helena was born sometime between 250 and 257 in Bithynia. She came from a humble background but fulfilled a great destiny by becoming the concubine of Constantius Chlorus and giving birth to the future Constantine the Great at Naïssus in about 285. Constantius Chlorus was later coerced into an arranged marriage to cement the political unity of the tetrarchy, and Helena

was relegated to obscurity until the ascension to power of her gifted son. She lived at Constantine's court from 306 on. Numismatic portraits of Helena were manufactured in almost all of the known mints of the day, and twenty surviving portraits in the round have been associated with her, although the identification of many are disputed. She received the title of nobilissima femina in 318 and in 326, the year of Constantine's vicennalia, became an Augusta and was thenceforth allowed to wear the diadem. It was these appointments that afforded the opportunity for the creation of new portrait types. A coin of 318–19 from Salonica depicts her with a fairly severe coiffure reminiscent of that of Faustina the Younger (see fig. 247). It is parted in the center and brushed back so that it covers the upper part of her ears. It is gathered into a bun, which is secured at the nape of the neck and is twisted with a braid. Her wide, open eyes, large nose, and strong jaw accentuate her resemblance to her son. A coin from Ticinum of 324–25, which depicts her just before her appointment as Augusta, shows her with the same facial configuration but with a more ornate and stately coiffure. The hair is parted in the center and arranged in a series of deep waves across the side of her face. The remainder of the hair is brushed back, leaving free the lower part of her ear, and is intertwined with a jeweled diadem.

The best-known marble portrait of Helena is the head inserted into a seated statue – to which it does not belong – in the Museo Capitolino (fig. 404). It depicts Helena with a broad, smooth face, uplifted eyes under delicately arched brows, a hooked nose, and small mouth. Her hair is parted in the center and brushed in waves that do not cover her ears. The remainder is wrapped in a succession of braided rolls in a coiffure close to that of the Augusta on coins and medallions made after 326.

Constantine encouraged in his mother a devotion to Christianity that is reflected in Helena's pilgrimage to the Holy Land in about 326, where she visited sacred Christian sites and had churches built on the Mount of Olives and at Bethlehem. By the early fifth century Helena's pious journey and good Christian deeds were so renowned that she was credited, without foundation, with the discovery of the True Cross. The date of her death is as uncertain as that of her birth. The location is also disputed. She appears to have died at Constantinople or Rome between 329 and 337. Contemporary and later texts make contradictory assertions, the most compelling of which is that Helena's porphyry sarcophagus with sculpted figures was placed in a mausoleum located at the third mile of the Via Labicana in Rome on imperial property in her possession. That the remains of a circular tomb of Constantinian date still stands on this very site has convinced scholars that Constantine erected an im-

404 Portrait of Helena, after 326. Rome, Museo Capitolino. Photo: Gisela Fittschen-Badura

round have been associated with her. Medallions and coins made at around the time she was appointed Augusta in 324 depict her with two different coiffures, one parted in the center with deep waves, a central braid, and a bun at the nape of the neck (the Faustina variant), and another more elaborate hairstyle with thicker curls and plait, and a diadem, which are variants of those of Helena. It is the similarity of the numismatic portraits of Helena and Fausta that has led to the confusion over their identities in monumental portraits. In view of the assimilation of Constantine's sons to the emperor, the close visual association of Helena and Fausta and other female members of the court may have been intended. The over-life-size bronze bust in Arles (fig. 405) has been identified as Fausta because of the similarity of the coiffure and the facial features to Fausta's coin portraits of 324–25, as well as to the presence of a diadem.

Constantine's eldest daughter, Constantina or Constantia, married Hannibalianus in 335; after his death in 337, she married Gallus. Like Helena and Fausta, she was granted the title Augusta. When she died in 354 she was buried in a porphyry sarcophagus – decorated with erotes harvesting grapes – in a second Constantinian

perial mausoleum on the spot prior to the foundation of Constantinople. When Helena died in 329, she was buried there because a family tomb had yet to be constructed in Constantinople. The porphyry sarcophagus is now in the Vatican Museums and is discussed in detail below (see fig. 418).

Flavia Maxima Fausta was born in 297. As the daughter of Maximian, one of the first tetrarchs, she was promised in marriage to Constantine, son of another tetrarch, to cement further the political unity of the four rulers. Fausta and Constantine were married in 307 when Fausta was ten. When Fausta reached childbearing age, she produced three sons, Constantine II (born 316), Constantius II (born 317), and Constans (born 320), and two daughters, Constantina (or Constantia) and Helena III. She was commemorated with the same titles during her life as Helena – nobilissima femina and Augusta – but a serious scandal later dishonored her and she received a damnatio memoriae at her death.

Coins with the portrait of Fausta were struck in western and eastern mints, and a handful of portraits in the

405 Bronze portrait of Fausta, 324–25. Arles, Musées d'Arles. Photo: Photographies Michel Lacanaud, Musées d'Arles

mausoleum in Rome, this one on the Via Nomentana (see fig. 419). No coins with her portraits are recorded, and there are no securely identified portraits in the round. A few possible contenders have been suggested by scholars; her sarcophagus still survives and is discussed below.

State Relief Sculpture under Constantine

The Arch of Constantine in Rome

The triple-bay Arch of Constantine (figs. 406–408) was erected at the beginning of the Via Triumphalis in Rome between 312 and 315 in honor of the emperor's decennalia (25 July 315) and Constantine's military victory over Maxentius at the Battle of the Milvian Bridge (28 October 312). It also honored the dyarchy of Constantine and Licinius. The text of the inscription, which is duplicated on the north and south sides of the attic of the arch, refers not only to a tyrant, undoubtedly Maxentius, but also to the sign of the divinity, thought to be an allusion to the sign of the cross seen by Constantine at the Milvian Bridge.

Other inscriptions are carved on the north and south sides above the Hadrianic tondi: "VOTIS X" (north left) and "VOTIS XX" (north right). On the south in the same positions are "SIC X" at the left and "SIC XX" at the right. Votis X undoubtedly refers to Constantine's decennalia, which would have been celebrated in 315. The Votis or Sic XX seems to allude to Constantine's vicennalia, which would have been celebrated in 325–26. The tradition of making reference to the present and future anniversary was already apparent in tetrarchic times when the decennalia, vicennalia, and *tricennalia* were all referred to in the inscriptions of the Five-Column Monument in the Roman Forum (see fig. 382). In the central bay on the eastern side above the scene of Trajan's adventus on the Arch of Constantine are the words "FVNDATOR QVIETVS," and on the west above Trajan on horseback, "LIBERATOR VRBIS." These were added to the scenes in Constantinian times.

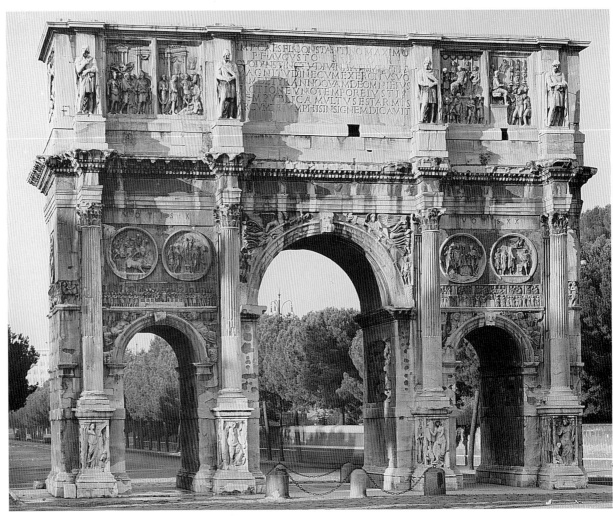

406 Rome, Arch of Constantine, general view of north side, 312–15. Photo: DAIR 61.2297

Although the Arch of Constantine was erected in the fourth century to commemorate a contemporary historical event, only part of the arch is actually of fourth-century manufacture. Much of the relief sculpture and even some of the architectural members – entablature, capitals, columns, and bases – come from earlier monuments. These were either deliberately despoiled in the fourth century, came from earlier monuments destroyed in fires of 287 and 307, or (less likely) were selected from among unused parts of monuments still stored in imperial workshops.

The Arch of Constantine was not the first Roman monument to make use of spolia. Rather, the incorporation of earlier architectural members and figural reliefs into a new monument seems to have been the norm for arch design in Late Antiquity. An earlier example is Diocletian's Arcus Novus (see figs. 376–381) and two post-Constantinian manifestations are the Arch of Janus quadrifrons of the first half of the fourth century and the Arco di Portogallo, probably erected in the fifth century.

The combination of reliefs with stylistic discrepancies in one monument, in this case the more classically conceived reliefs of second-century manufacture and those of Constantinian date, is not unusual in the context of Roman art. Roman art was eclectic from its beginnings, and the Arch of Constantine is merely a late example of the co-existence of diverse styles in Roman art.

The reused material includes four sections (two in the central bay and one each on the east and west sides of the attic) of the Great Trajanic Frieze. In the central bay, Trajan is represented in a scene of adventus (*fundator quietus*) and on horseback trampling a fallen Dacian (*liberator urbis*) (see figs. 185–186); both have heads of Trajan recarved as Constantine. The attic reliefs depict a scene or scenes of battle between Roman soldiers and Dacians (see fig. 408). Eight figures of Dacian prisoners, perhaps also from the Forum of Trajan, surmount the eight projecting columns of the arch (see figs. 406–407).

On the north and south sides of the arch are eight tondi, probably from a lost private monument of Hadrian

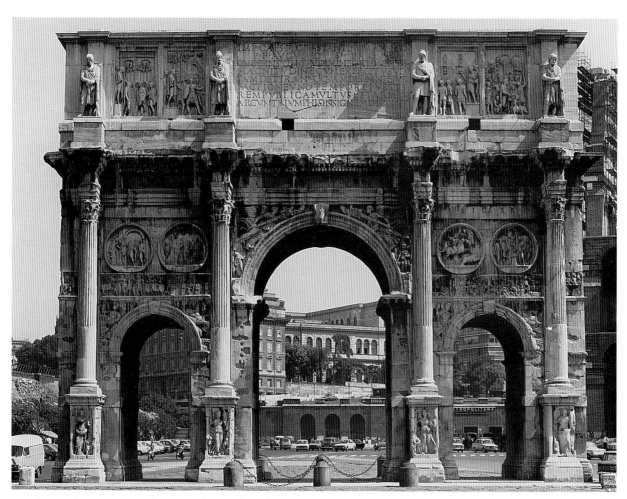

407 Rome, Arch of Constantine, general view of south side, 312–15. Photo: DAIR 77.1641

(see figs. 219–220). They represent scenes of the hunt and sacrifice and include a number of recut heads of Constantine and Licinius. The scenes on the south are the departure for the hunt, the sacrifice to Silvanus (over the west bay), the bear hunt, and a sacrifice to Diana (above the east bay); those on the north side are the boar hunt and sacrifice to Apollo (above the east bay), and the lion hunt and sacrifice to Hercules (over the west bay). The head of the main protagonist survives in five of the eight medallions, and four of the five belong to a set of pairs on the north side of the arch: Constantine hunts the boar and Licinius sacrifices to Apollo above the east bay, and Constantine triumphs over the lion and Licinius sacrifices to Hercules over the west bay. On the south side, it is Constantine who sacrifices to Diana, and – if the scheme was consistent – Licinius must have participated in the bear hunt and in the departure scene and Constantine in the sacrifice to Silvanus. It has been convincingly suggested that the equal prominence of the two emperors in the medallion cycle indicates that the concordia of the dyarchy was one of the messages of the Arch of Constantine. The imperial message was further underscored by the fact that each roundel was set into a porphyry slab. The reddish-purplish stone was the imperial color and was also the favored stone of the tetrarchs. The heads of Constantine and Licinius are each surrounded by a halo in the scenes of the boar hunt, lion hunt, and sacrifices to Apollo and Hercules. These were presumably added when the heads were reworked in the early fourth century. Since Constantine and Licinius are aureolate, the halos may refer to the sanctity of both members of the dyarchy or to the sign of the divinity that made the victory over Maxentius possible.

Eight relief panels from a lost Arch of Marcus Aurelius are embedded in the north and south sides of the attic of the Arch of Constantine (see figs. 256–259). The eight reliefs, of vertical format, depict scenes of adventus and profectio (northeast), liberalitas and submission (northwest), adlocutio and lustratio (southeast), and *rex datus* and prisoners (southwest). The heads of Marcus were replaced in the fourth century with those of Constantine, in modern times themselves replaced with heads of Trajan.

Constantinian in date are the spandrels with Victories accompanied by *genii* of the seasons in the central bay on the north and south sides (see figs. 406–407); River Gods above the smaller bays; and the keystone figures, including, on the south side of the arch: Mercury (west), *Quies* or *Securitas rei publicae* (center), Genius Populi Romani (east); and on the north side: Mars (west) and Roma Aeterna (center); the east figure is missing. Also of fourth-century date are the socles decorated with Victories and Roman soldiers or trophies with captive barbarians; tondi on the east (Sol Invictus) and the west (Luna); and most important, a frieze that begins at the northwest corner of the arch and encircles the monument. It depicts Constantine's departure from Milan, the Siege of Verona, the Battle of the Milvian Bridge, the emperor's entrance into Rome, his address from the Rostra to the Roman people (*oratio*), and a congiarium, probably of 1 January 313. These scenes are linked to one another by smaller vignettes representing, for the most part, Roman soldiers on foot or horseback. Although most scholars agree on these identifications of scenes, at least one has suggested that they exemplify the emperor's virtues as well as immortalize key historical events.

The encircling figural frieze on an imperial commemorative arch was usually located above the engaged columns, such as on the arches of Titus in Rome and Trajan at Benevento (see figs. 154, 188–189). It traditionally depicted the emperor's triumphal procession. The architectural scheme of later arches, such as those of Septimius Severus (see figs. 293–294) and Constantine in Rome, with their freestanding columns on tall pedestals and projecting entablatures, negated the practicality of placing elaborate figural friezes in this position where they would be difficult to read. The frieze is instead divided into four framed horizontal panels surmounting the smaller bays; the undulating frieze above the columns is left blank. There are four such panels on the Severan arch, and this scheme is adopted by Constantine's artists. They have adjusted it by adding panels on the two short sides of the arch beneath the tondi of Sol and Luna. On the long sides, small horsemen panels are appended to the main four to create the visual impression that the frieze is continuous and expands behind the columns.

The emperor's triumphal procession is the subject of these horizontal panels on the Arch of Septimius Severus, but it is divided into separate vignettes instead of unfolding as a continuous narration. The nameless master designer of the Arch of Constantine took advantage of the new panel format and discarded the continuous triumphal theme in favor of the representation of discrete historical episodes, such as the Siege of Verona, and ceremonial scenes, such as the congiarium. He was a man who must have received his training in the third-century sarcophagus workshops and was thus naturally drawn to the horizontal panel as a field of decoration. Although it is highly unlikely that the Master of the Constantinian Frieze would have had any firsthand knowledge of the Arch of Galerius at Salonica, historical and ceremonial scenes were also combined and enclosed in horizontal frames on the earlier tetrarchic monument (see figs. 387–390).

The triumphal procession was probably also discarded as a subject because the victory celebrated by the

arch is not a foreign but a domestic one, and Constantine consequently did not claim a triumph at its denouement. The Arch of Constantine is therefore set apart from most, if not all, of its predecessors by its commemoration of a civil war between two countrymen and not a foreign victory. The only related monument is Augustus's Actian arch in the Roman Forum, which celebrated his momentous victory over Mark Antony for which the young Octavian was granted a triumph. For political reasons, however, the conquest was presented to the Roman populace as one over a foreign queen (Cleopatra), and in any case the Actian arch was soon torn down to make way for another arch commemorating Augustus's Parthian victory (see fig. 67).

The striking similarity of the Constantinian panels to their tetrarchic predecessors was already recognized in 1907. In 1989 it was suggested that four of the six – or even all six – fourth-century relief panels originally belonged to a Maxentian monument and were reworked for insertion into the Constantinian arch. This hypothesis, which is based on such observations as the awkwardly cut holes for the replacement of imperial heads, the truncated feet of the figures in the crowds of the oration, and largess scenes is plausible, but scholarly consensus on the issue must await further publication. For iconographical reasons, a Constantinian date for the frieze seems most valid.

The Constantinian frieze unfolds chronologically from left to right beginning with the departure of Constantine's army from Milan (see fig. 408). The procession, which exits a gate at the far left, consists of two officials on a carriage drawn by four horses, Constantine's soldiers leading a horse and a camel, defectors from Maxentius's army, signiferi carrying aloft the signs of Victory and Sol Invictus, and musicians. The artist is primarily interested in presenting his story. The figures fill the entire frame, and there is little attention paid to varying the postures or physiognomies of the soldiers. Most are depicted in a similar striding gait, although the head positions are differentiated; some look to the front and others to the rear of the procession. They are clad in tunics, leggings, and mantles that are arbitrarily striated to create the effect of drapery folds. Some of the soldiers wear helmets; the veterans sport the Pannonian cap popularized by Diocletian and the tetrarchs. Some of these veterans wear the short beard and closely cropped hair of the tetrarchs, and their faces are articulated by blocky geometric forms that show their indebtedness to tetrarchic portraiture.

The next panel depicts the Siege of Verona (fig. 409). It is an enigmatic version of this famous battle because it is filled with action and is at the same time curiously static. Constantine was able to take the city owing to the skill of several of his soldiers who attacked the city's walls – depicted at the far right of the panel. The five towers of the fortified wall of Verona, with their crenelated battlements, are carefully articulated. The city's protectors throw rocks at their attackers, who are three soldiers with lances and round shields, depicted in identical positions as if they were stamped from a cookie cutter. They hold back their lances and their action appears to be frozen. One of these attackers has wounded his foe, who falls head first from the battlement. A fourth member of Constantine's contingent bravely forges ahead alone and storms the wall. The battle is surveyed by the emperor, now headless, who is depicted in battledress and leaning on a large oval shield. He is accompanied by two bodyguards and by his horse. Constantine takes up the full height of the relief, whereas the other figures are depicted in two tiers. His larger size establishes that he is the most important figure in the scene, hierarchy of scale having been a device of increasing importance in the imperial art of Late Antiquity. Also larger than the other protagonists is the figure of Victory, who flies behind the emperor to crown him. The simultaneous portrayal of the crowning of an emperor as victor and a Roman military conquest has a long history in Roman state relief. An earlier illustration of it can be found elsewhere on the Arch of Constantine. In the Fundator Quietus scene, Trajan (now Constantine) is crowned by Victory and welcomed home by Virtus, while the Roman troops defeat their Dacian foes (see fig. 186).

After his victory at Verona, Constantine departed for Rome where the key battle between him and his rival Maxentius took place (fig. 410). Constantine's and Maxentius's troops are depicted in two tiers. Maxentius's men, in scaled armor, are in the lowest register, engulfed in the waves of the Tiber River, personified by the River God at the left. Constantine's soldiers, some on foot and some on horseback, attack from above. While the battle was being waged, Constantine was crossing the Tiber in a boat. Part of the latter is still preserved above the River God at the left, but the figure of the emperor is obliterated. He was flanked by striding figures of Roma and Victory; the former signified the location of the battle, whereas the latter ensured the emperor's military success. Constantine's triumph was heralded by Victory at the left and celebrated by musicians at the right while the battle progressed between them. The frenzied melee of the interwoven opponents owes much to Antonine battle sarcophagi and to the military clashes on the Column of Marcus Aurelius (see figs. 263, 269).

On the day following his victory over Maxentius, Constantine entered Rome through the Porta Flaminia, which is depicted on the far left of the succeeding relief (fig. 411). The emperor, whose head is now missing, is

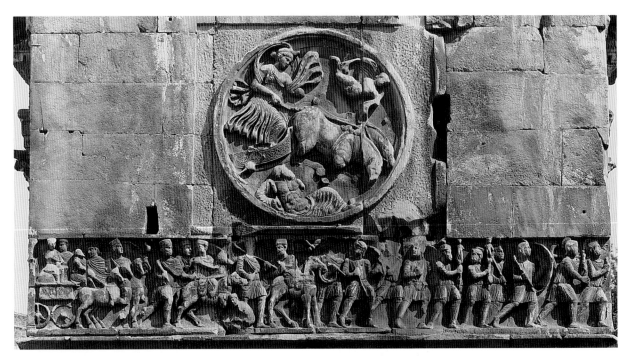

408 Rome, Arch of Constantine, general view of west side with departure from Milan, 312–15. Photo: Alinari/Art Resource, New York, 17323

409 Rome, Arch of Constantine, south side with siege of Verona, 312–15. Photo: Alinari/Art Resource, New York, 17328

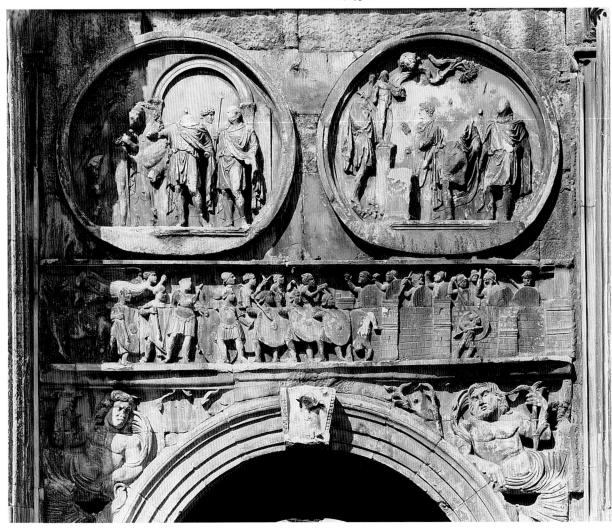

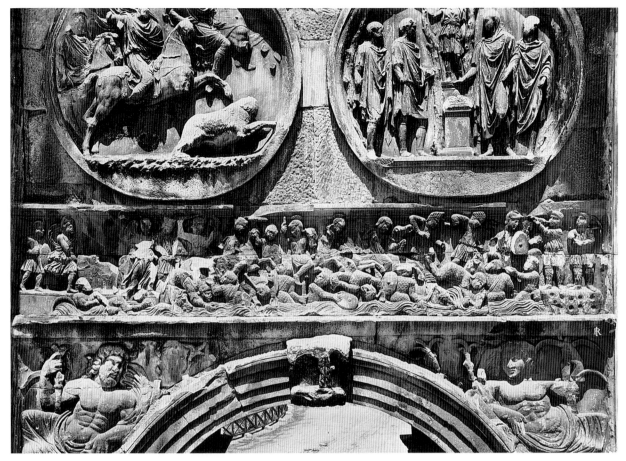

410 Rome, Arch of Constantine, south side with Battle of
the Milvian Bridge, 312–15. Photo: Alinari/Art Resource,
New York, 2534

411 Rome, Arch of Constantine, east side with entry into
Rome, 312–15. Photo: Alinari/Art Resource, New York, 17324

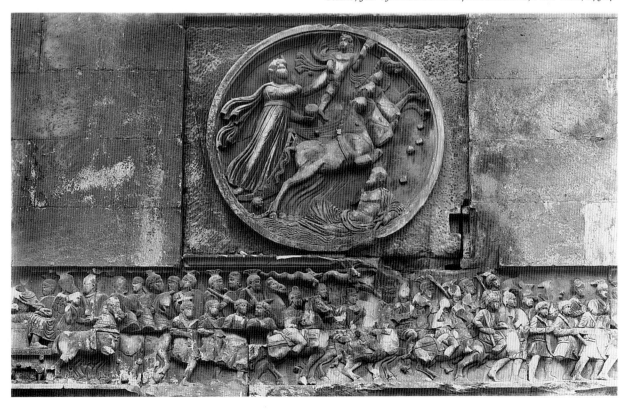

clad in a belted tunic and mantle and holds a scroll in his left hand. He sits on *cathedra* decorated with ivy leaves that is part of a chariot pulled by four elaborately embellished horses whose reins are guided by Victory. The emperor's chariot is preceded by his helmeted troops arranged in three tiers; some soldiers are on horseback, others on foot. Those leading the procession pass through the same Domitianic quadrifrons surmounted by an elephant quadriga that is represented in the Aurelian profectio panel now in the attic of the Arch of Constantine (see fig. 256). The scale of the seated emperor is greater than that of most of the soldiers, with the exception of one or two that are tall enough to occupy more than one register. The soldiers march from left to right, and the artist has made little effort to vary the postures, costumes, or facial expressions of the figures.

The following scene is without doubt the most interesting and significant on the arch because it is through its details that the arch's political program can be deciphered. The scene (fig. 412) portrays Constantine's address (oratio) to the Roman people from the Rostra in the Roman Forum. The location is established not only by the detailed depiction of the Rostra itself but by the attention paid to its topographic setting. To the left of the Rostra are the arcades of the Basilica Julia, the single bay Arch of Tiberius, and to the right the triple bay Arch of Septimius Severus. In their precise location immediately behind the Rostra are the five columns of the Decennial Monument with their statues of Jupiter and the *genii* of the four tetrarchs. The standing frontal figure of Constantine, whose head is obliterated, is situated in front of the statue of Jupiter. He is clad in military, not civic, dress, which consists of a short, belted tunic and voluminous mantle. He is, however, surrounded by senators in togas who are also frontal, although they turn their heads to gaze at the emperor. The people, consisting entirely of tunicate men and a few boys, flank the Rostra to the left and right. They are arranged in two registers with only the heads of those in the second tier visible behind the full figures of those in the front.

Close examination of the figures indicates that the artist made some effort to differentiate them. Although the emperor is the center of attention, only some of the members of the civilian audience face him. Others turn in the opposite direction and toward their nearest companion as if engaged in conversation. Some gesture with their hands, adding variety to the scene. Their heads are also not identical. Some of the men are cleanshaven, others are bearded; some have wavy hair, others sport corkscrew curls, and still others are depicted with balding pates. The inclusion of three male children, one on the left and two on the right, is of special significance

since, as we know, children (and women as well) were rarely included in relief scenes on state monuments.

Constantine wanted to reinstate hereditary succession and had four sons, three of whom were appointed to the rank of Caesar. He commissioned group portraits of himself with his heirs that appear to have excluded the female members of the family – in contrast to the dynastic groups of the Julio-Claudians or the Severans where women were a significant part of the family configuration. The Constantinian groups may have been based on the Diocletianic idea of the four tetrarchs as a kind of pseudo-family. That the emperor's concept of the Roman people was confined to adult men and their male progeny may reflect his concept of the imperial family. It is notable that the procession scene on the socle of the column of Constantius Chlorus from the Diocletianic Decennial Monument portrayed the four tetrarchs and their heir Constantine as a discrete group (see fig. 383).

The Rostra was carefully described by the artist who carved the oratio panel on the Arch of Constantine. Its small pilasters, which punctuate the surrounding screen, are surmounted by the heads of amorini, and the dais is ornamented at left and right with seated statues on pedestals. There may have been such statues on the Rostra in Constantinian times, although it is unlikely that they were of the personages depicted here. Careful examination of the portrait features and coiffures of the two adult males indicates that they are Constantinian versions of portraits of Marcus Aurelius at the viewer's left and Hadrian at the right. Their inclusion here is a deliberate fiction on the part of Constantine and his master designer. We have already established that Constantine's political program included disassociating himself from the tetrarchs and allying himself instead with the emperors of the second century: Trajan, Hadrian, and Marcus Aurelius. Constantine's head is obliterated, but he was undoubtedly represented as a neo-Trajan with a smooth face and a cap of hair with comma-shaped locks surrounded by recognizable images of Hadrian and Marcus Aurelius. Marcus is depicted with his narrow face, curly coiffure, and long beard; and Hadrian with his distinctive wavy coiffure and short beard. It is this scene of Constantine, who presents himself as one in a line of good emperors, which makes it likely that the fragments from monuments of Trajan, Hadrian, and Marcus Aurelius were not haphazardly incorporated into the Arch of Constantine. They were carefully selected because their inclusion underscored the new emperor's attempt to associate himself not with his immediate predecessors but instead with those whose vision he believed he shared. Such retrospective references are an integral part of Roman imperial art. Their appearance here demonstrates that the Arch of

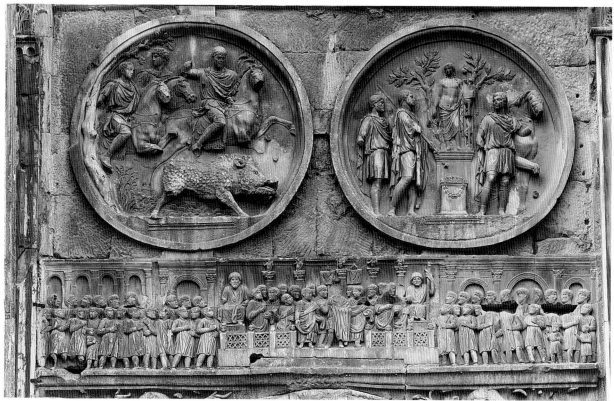

412 Rome, Arch of Constantine, north side with oratio,
312–15. Photo: Alinari/Art Resource, New York, 17326

413 Rome, Arch of Constantine, north side with congiarium,
312–15. Photo: Alinari/Art Resource, New York, 17325

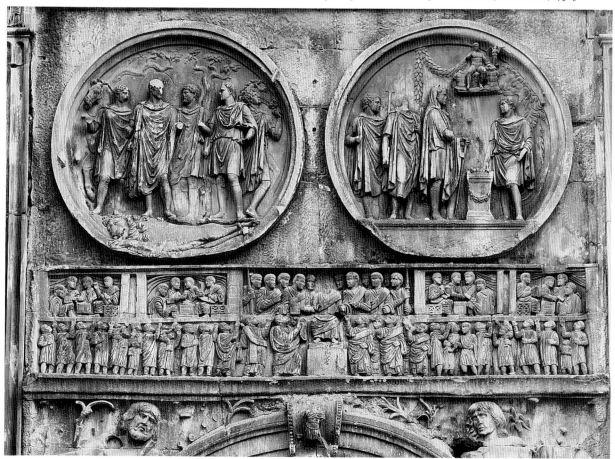

Constantine, made at the moment of the conversion of a pagan empire into a Christian one, is a monument in the mainstream of Roman art.

The last scene depicts Constantine's distribution of public largess to members of the Roman senate and to the Roman people, which took place on 1 January 313 (fig. 413). As in the oratio relief, the emperor – whose head is now missing and was probably carved separately – is situated in the center. He is frontal, seated on a podium, and clad in a toga with contabulatio. He holds in his right hand a small tablet with twelve round indentations designed to hold coins. Some have already fallen from the tablet and are caught by a senator in the folds of his toga. This senator is one among a handful of togate officials with contabulatio who stand at the base of his pedestal and raise their hands to gather their share of the distribution. The emperor is surrounded above by other senators who observe the event. They are flanked at the extreme left and right by two attendants carrying candles, which according to eastern practice attests to the sanctity of the enthroned emperor.

The Roman people, consisting, as in the oratio scene, of adult men and male children, are arranged in single file in the lowest tier. They are distinguished from the senators by their tunics. The second register also has a series of galleries, each containing four togate officials who aid in the distribution of money by dispensing it from the same tablets with circular indentations as the emperor's and who record the transactions on wax tablets and scrolls. The tunicate figures on the left side of the bottom tier are less varied than their counterparts on the right as well as comparable figures in the oratio relief. All of the adult males on the left face toward the emperor and gesture upward with their left or right hand. They too appear to be stamped with a cookie cutter. The only differentiation is in the heads. Some are cleanshaven and some wear beards; some have wavy hair, others corkscrew curls. Their garments are accentuated by a series of deep striations that are essentially ornamental and have little to do with the shape of the body below. Male children are included among the crowd as in the oratio relief, although their presence here is somewhat more anecdotal. Two on the left side of the relief ride piggyback on their fathers' shoulders. This is a motif seen earlier in the institutio alimentaria relief on the Arch of Trajan at Benevento (see fig. 190). There was, therefore, apparently a tradition for including such a theme in scenes celebrating the emperor's distribution of money to the citizenry. The inclusion of children in this scene, as well as in the oratio, signifies once again that Constantine thought male children were important and worthy subjects for state monuments. There is somewhat more diversity among the tunicate figures on the right. Some face away from

the emperor and not all are represented in the same posture. One man carries his progeny on his back, and two other fathers are accompanied by their sons.

While the Constantinian frieze appears to have been designed specifically for this arch and should be viewed as a novel work that incorporated earlier devices, many of the column pedestals are near replicas of those of the Arch of Septimius Severus in the Roman Forum and Diocletian's Arcus Novus, also in Rome (see figs. 295, 377–381). There are, however, noteworthy stylistic distinctions between the models and their copies, and these document the difference between Constantinian art and that which went before. There are also some iconographic anomalies that impart a specifically Constantinian message.

The Constantinian pedestals are carved with three main themes that are systematically arranged around the three visible faces of each socle. These reliefs represent Victories and kneeling barbarians, Roman soldiers with their foreign prisoners, and trophies with captive families. The Victory figures are on the front of the pedestals framing the arcuated bays. On the south side, the central duo (pedestal reliefs 5 and 8 – the numbering scheme used by Hans Peter L'Orange and Armin von Gerkan in their monograph on the arch is adopted here) carry trophies and are flanked by chained barbarians. The outer pair (pedestal reliefs 2 and 11) are accompanied by mourning eastern captives. Reference to military victory is also made on the north side of the arch where the outer Victories stand next to prisoners from the North (pedestal reliefs 14 and 23). Those in the center inscribe the decennial and vicennial vota on shields while they rest their feet on crouching northern barbarians (pedestal reliefs 17 and 20). The four outermost faces of the pedestals represent one eastern and three northern captive families, made up of a father, mother, and child who surround a trophy (pedestal reliefs 1, 12, 13, and 24). The presence of children again underscores the political significance of children, domestic and foreign, in Constantinian times. The remainder of the secondary faces of the pedestals depict Roman soldiers. Those flanking the two smaller bays depict two Roman soldiers leading two chained male captives, some from the East (pedestal reliefs 4, 9), but most from the North (pedestal reliefs 3, 10, 15, 16, 21, and 22). The reliefs flanking the central bay on the south represent marching signiferi (pedestal reliefs 6 and 7), while those on the north depict Roman soldiers with statuettes of the gods favored by the troops, Sol Invictus and Victory (pedestal reliefs 18 and 19). Their presence also implies that, with his military victory over Maxentius, the emperor has inaugurated a new age under the protection of Sol Invictus. It is worth remembering that the sign of the divinity who inspired Constantine's success is referred to

in the dedicatory inscription of the arch. Furthermore, the socle reliefs seem to refer synoptically to a procession in honor of the emperor's foreign victories narrated in detail in the encircling friezes on the arches of Titus in Rome and Trajan at Benevento (see figs. 154, 188–189).

The iconographic details that set these pedestals apart from their formal models are the inclusion of children in the trophy panels, the presence of Sol Invictus and Victory, and the inclusion of eastern and northern captives. The children sit or stand between their parents, gaze at them, and pull on their garments in an anecdotal way that is reminiscent of the family groups in the great friezes of the Ara Pacis Augustae (see figs. 75, 77). Those few Roman state reliefs that incorporate children demonstrate such striking correspondences that they must all rely on common prototypes.

The formal similarities and stylistic differences among the socles from Diocletian's Arcus Novus and those from the Arch of Constantine are apparent in all the pedestal reliefs, but two examples will suffice. A socle relief with Victory and a kneeling male barbarian from the north side of the arch (fig. 414) can be compared – for example – to the Victory with a palm tree from the Arcus Novus (see fig. 379). The frontal position and head turned sharply to the right of the Victory from the Arch of Constantine are identical to those of the Diocletianic personification. The former likewise cradles a palm branch in her left arm and originally held a wreath in her left. Both are similarly draped with a garment tied just below the breasts and with a mantle draped below the rounded belly and across the thighs; both have their weight resting primarily on their right foot with their left slightly bent; both wear a classicizing coiffure with a high topknot over the forehead. In fact, the similarities are so striking that a common prototype can be posited.

The differences between the two are also instructive. The wings of the Diocletianic Victory are artfully rendered, with the left bent and behind the right to suggest depth and the slight rotation of the personification's body. The feathers of the wings overlap and face in different directions underscoring the artist's interest in variation and texture. The wings of the Constantinian Victory are placed to the left and right of the figure with no overlap and no suggestion of movement. The leaves are arranged in fairly regular rows with the artist's goal being merely a repetitive pattern. The rendition of the garment is also an excuse to play straight and swirling lines off one another with little regard for the human form below, while the tetrarchic Victory's garment molds and accentuates the curves of her body.

Another apt comparison is that of a Constantinian socle from the same pedestal, which depicts two Roman soldiers and their two male captives (fig. 415), and the

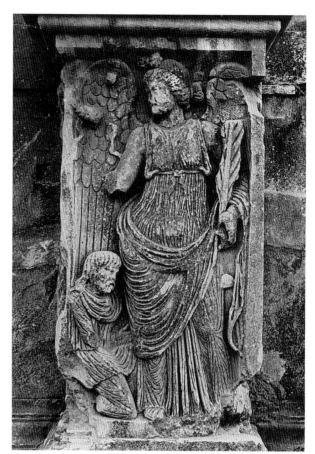

414 Rome, Arch of Constantine, pedestal with Victory and barbarian, 312–15. Photo: DAIR 1543

Boboli Gardens pedestal, which depicts a Roman legionary and his prisoner (see fig. 381). The soldier and captive in the front plane of the Constantinian panel are near duplicates of the Diocletianic pair. Each captive is clad in a short, belted tunic and mantle, have their hands tied behind their backs, and wear a long, caplike coiffure. The soldiers, helmeted and in cuirass, guide their prisoners from left to right. In the Constantinian relief, the head of the second prisoner is depicted between those of the soldier and the other captive, and there is an additional soldier behind the first. His head and body are literally drawn on the stone, a convention already used in tetrarchic times on the socle of the surviving column from the Decennial Monument and earlier in Augustan Gaul (see figs. 99, 382). Although the Constantinian and Diocletianic schemes each derive from a common source, the Constantinian group is rendered in a flatter, more schematic way, and the artist displays his fondness for decorative effects and abstraction.

The short east and west sides of the arch are decorated not only with fragments of the Great Trajanic Frieze and two sections of the Constantinian frieze but also with two tondi. These were produced in the fourth

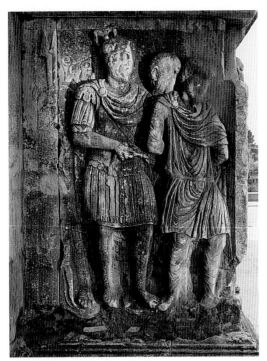

415 Rome, Arch of Constantine, pedestal with Roman soldiers and captives, 312–15. Photo: DAIR 35.602

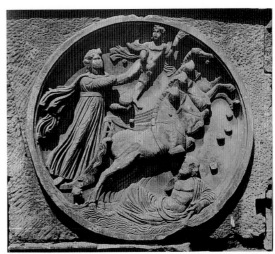

416 Rome, Arch of Constantine, east side, roundel with Sol, 312–15. Photo: DAIR 32.70

417 Rome, Arch of Constantine, west side, roundel with Luna, 312–15. Photo: DAIR 32.69

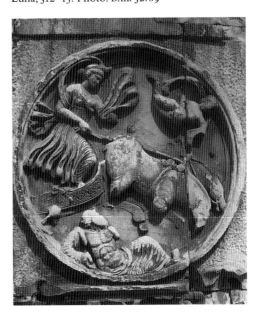

century but were meant to complement the eight Hadrianic roundels incorporated into the north and south sides of the arch. They are of the same scale and are framed by porphyry slabs. In subject matter, however, they do not continue the hunting or victory theme, nor do they celebrate the dyarchy of Constantine and Licinius. Rather they impart a message that is thoroughly Constantinian. Furthermore, their stylistic features are those of the Constantinian frieze and socles and not of the Hadrianic period.

The roundel on the east side of the arch (fig. 416) depicts the sun god Sol dressed in a long, belted garment, who steps from the sea (personified as Oceanus) into the solar chariot drawn upward by four horses. Sol holds the globe of the sun in his left hand and a flying Amor leads the way with his lighted torch.

The corresponding medallion on the west side (fig. 417) depicts Luna, also in a long garment and with her mantle billowing up behind her, descending in a chariot decorated with an acanthus scroll and led by two horses whose reins are guided by an Amor. Their destination is the sea as personified by the elderly, bare-chested Oceanus below.

It is, of course, conceivable that the presence of Sol was dictated by Constantine's close association at the time of the construction of the arch with Sol Invictus, whose statuettes are held aloft in two of the scenes on the column pedestals and in the scene of Constantine's entry

into Rome on the frieze. The god may also be referred to in the arch's inscription, and contemporary medallions depict Sol as Constantine's alter ego (see fig. 394). Roman historical scenes took place in cosmic settings as early as the Augustan period, and it is possible that the Constantinian tondi depicting the rising of the Sun and the setting of the Moon are simply in that tradition. Furthermore, since the Sun rises in the east and the Moon sets in the west, this arrangement is a standard one. The Rising Sun and Setting Moon had already appeared, for example, in the Parthenon pediment of the fifth century B.C.

The reuse of earlier reliefs beside new ones on the Arch of Constantine has been a subject of controversy since the Renaissance. The differences are so jarring to

modern eyes that they have led to derogatory comments by scholars, including Bernard Berenson, who describes the scenes from the lost second-century monuments as charming, dignified, more gracious, and more spirited than those of Constantinian manufacture. The Constantinian reliefs are "inferior," with ill-proportioned figures, unfunctional draperies, and examples of figures "as helplessly chiselled as ever European art sank to in the darkest ages." Berenson's comments are exaggerated, but what is described as an unusual stylistic diversity is noted by other scholars. In characterizing the reused reliefs, Donald Strong comments: "The contrast between these earlier works and the Constantinian contribution is very marked," and he notes that "the monument is full of the strange contradictions that characterize the period." Stylistic diversity, indeed a deliberate eclecticism, is apparent in Roman art from its beginnings. It is unlikely that the coexistence of diverse styles in a single monument was in any way troubling to the ancient observer.

We have seen that Roman eclecticism and the coexistence of different styles, even within the same monument, were apparent in the republic. In the Domitius Ahenobarbus Monument, for example (see figs. 30–31), a Hellenistic style is fittingly chosen by the artist for the Greek myth of the marriage of Poseidon and Amphitrite, whereas a more straightforward narrative style in the contemporary Roman mode is used for the Roman scene of census and sacrifice. In Flavian times, a classicizing style is employed for the adventus and profectio of Domitian's Cancelleria Reliefs, but the Domitianic Arch of Titus is executed in what has been called an illusionistic style (see figs. 155, 158–159). The apotheosis of Antoninus and Faustina on the base of the Column of Antoninus Pius is dutifully rendered in a cold but beautiful classicizing style with large elegant figures against a blank background, but the double decursio has miniature equestrians on what look like toy horses that prance around in a circle, viewed at the same time from head on and from above (see figs. 253–254). These examples indicate that the co-existence of two or more styles in a given historical period or even within the same monument is present from the outset in Roman art and that the Late Antique preference for spolia was simply the natural outcome of a long Roman experimentation with eclecticism.

What might be called the Late Antique spolia phenomenon must also be attributed to the decline of the number of artists working in Rome at monumental scale. Major commissions in the East must have drawn talent away from Rome, and it was probably no coincidence that while the fourth-century reliefs on the Arch of Constantine were relatively small in scale, those of second-century manufacture were larger and more ambitious.

Constantinian Sarcophagi

Sarcophagi continued to be manufactured in great numbers in workshops around the empire in the Constantinian period, and the production of sepulchral altars is also attested. Some of the sarcophagi can even be associated with members of the imperial circle.

Imperial porphyry Sarcophagi
Porphyry, the favored stone of the tetrarchs, continued to be employed for imperial commissions under Constantine. Monumental porphyry sarcophagi were produced to house the remains of members of Constantine's court, and it has even been suggested that an extant fragment with scrolls and erotes found in Constantinople belongs to the emperor's own coffin. Two fully preserved sarcophagi, found in Rome, housed the remains of Constantine's mother and daughter. These sarcophagi attest that fourth-century imperial personages continued to be buried in sarcophagi and that in the fourth century these coffins were fashioned from the material that connoted imperial status.

The Sarcophagus of Helena
The porphyry Sarcophagus of Helena (fig. 418) was discovered in the Mausoleum of Helena on the Via Labicana in Rome. Although the sarcophagus housed the remains of a woman, it is enigmatically carved on its two long and two short subsidiary sides with a military scene depicting a battle between Romans and barbarians. The episodes on all four sides are divided into two registers, with Roman soldiers with drawn lances and on horseback in the upper tier and fallen barbarians below. On the two long sides there are additional male and female busts in the upper left and right corners. Garlands, held by erotes, are draped across the lid on which recumbent female figures and a lion rest. Although the sarcophagus is carved on all four sides in the manner of sarcophagi of eastern manufacture, it appears to have been placed in the tomb according to western tradition. The sarcophagus was flush with the wall of a niche facing the entrance to the mausoleum.

The Sarcophagus of Helena has engendered heated scholarly controversy since the early twentieth century. These disputes have arisen in part because the entire sarcophagus is so heavily restored and polished that only one figure still retains its antique head. Some figures are entirely modern, and none of the original surface survives. Damage was wrought to the sarcophagus by tomb pillagers, fire, and its numerous moves within the

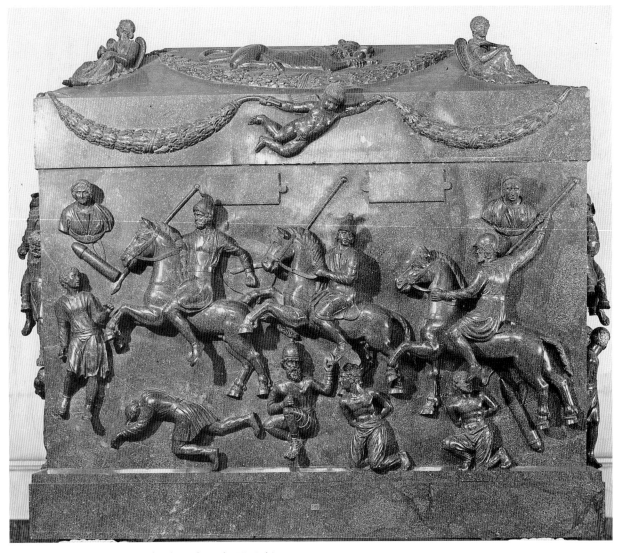

418 Porphyry Sarcophagus of Helena, from the Via Labicana, Constantinian. Rome, Vatican Museums. Photo: DAIR 63.2339A

Lateran. It is reported that it took the nine years between 1778 and 1787 for twenty-five sculptors to restore it to its present pristine condition. Engravings made by Bosio and Piranesi before the restoration have enabled scholars to make an assessment of these repairs, but these important engravings also differ in many of their most significant details.

The date of the sarcophagus's manufacture is also debated. Some scholars have dated it to the second century in part on the basis of its striking similarity to the style, composition, and subject matter of the decursio scenes on the pedestal of the Column of Antoninus Pius (see fig. 254). One has gone so far as to identify it as the cinerary urn of Marcus Aurelius, with the emperor's decursio on the main body of the coffin and his astrological sign, Leo, on the lid. Other scholars have favored a fourth-century

date and have suggested that, because of its military subject, the sarcophagus was commissioned for Constantius Chlorus or Constantine, and subsequently inappropriately used for Helena at her death. Scholars reach consensus only on the provenance of the piece, associating it with an Alexandrian workshop largely because it was fashioned from a stone customarily carved in Egypt.

It is clear from the presence of the barbarians in the encircling reliefs (the scene on the front moves from right to left, that on the rear from left to right, and those on the sides from back to front) that the subject is not a decursio but rather a depiction of the triumph of Roman soldiers against their barbarian foes. Some effort has been made to identify the nationalities of the enemies, but this has been largely unsuccessful owing to the heavy restoration of the costumes. The subject remained popular under

Constantine and is apparent in the reused reliefs from the Great Trajanic Frieze and the Arch of Marcus Aurelius incorporated into the Arch of Constantine (see figs. 185, 261), as well as in the fourth-century pedestals depicting Roman soldiers and their northern and eastern captives (see figs. 415).

The fondness for two-tier composition is also characteristic of the Constantinian period and can be seen in the scenes of the Battle of the Milvian Bridge, the oratio, and the congiarium from the frieze of the Arch of Constantine (see figs. 410, 412–413). The decursio reliefs from the pedestal of the Column of Antoninus Pius represent instead a circling motion seen from head on and from above; the individual figures are placed on individual turf segments. Here the horsemen and barbarians inhabit the space that is the ground of the relief, with the horsemen behind the barbarians. The proportions of the figures and horses are more attenuated and elegant than the stumpy characters on the Antonine pedestal. For these reasons, and also because of its findspot and material, the porphyry Sarcophagus of Helena must be seen as a Constantinian work executed in the second quarter of the fourth century and done in a classicizing style. This mode was used concurrently with an abstract style; both, however, had some features in common, such as the two-register composition.

The military subject matter of the Sarcophagus of Helena does make it more likely that it was initially manufactured for a male member of the imperial family, possibly Constantine himself, who was the commissioner of the tomb in which it was placed. That Constantine celebrated his greatest triumph over an internal and not a foreign enemy is a stumbling block, yet foreign captives are also depicted on the arch's column pedestals, and Constantine did have early victories in Persia with Galerius, in Britain with his father, alone on the Rhine, and after he became sole emperor, he put down some incursions from the Goths. His eastern and northern victories are both alluded to in the pedestal reliefs of the Arch of Constantine. The male and female bust portraits on the sarcophagus, which may once have provided a clue to the identification of the person for whom the sarcophagus was made, are too heavily restored to provide conclusive evidence. This sarcophagus has no overt Christian symbolism, whereas one of those found in Constantinople, along with the fragment from Constantine's sarcophagus, has a chi-rho on the lid.

The Sarcophagus of Constantina

A porphyry sarcophagus made to house the remains of a female member of the Constantinian family was originally placed in the ambulatory or in a deep niche opposite the entrance to a fourth-century mausoleum on the Via Nomentana adjacent to the Church of S. Agnese (fig. 419). Unlike the Sarcophagus of Helena, it has not been extensively restored. Its subject of erotes harvesting grapes and garlands would be appropriate for either a man or woman. A date in the fourth century for the sarcophagus has not been contested. All that is uncertain is the precise identity of the woman interred in it, probably either Constantia or Constantina. Surviving texts refer to the sickly virgin daughter of Constantine, Constantia, who witnessed the vision of St. Agnes and subsequently requested that her father build a basilica on the site of the miracle where she hoped to be buried; and to Constantina, daughter of Constantine, who was interred in a building on the Via Nomentana – the same Constantina who was twice married, first to Hannibalianus and then to Gallus. Some historians believe that Constantina was the elder daughter of Constantine and Constantia the younger one; others conflate the two into a single historical personage. It is Constantia who is referred to in the name of the circular edifice, received in the thirteenth century, S. Costanza. The sarcophagus remained in that edifice until the eighteenth century, when it was transferred to the Vatican. Association with one or the other of these women suggests a date for the sarcophagus of between 330 and 360.

Like the Sarcophagus of Helena, that of Constantina is carved on all four sides, even though the fourth side would not have been visible. The articulation of the sarcophagus in the round suggests an eastern provenance for the piece, and it is likely that it too was made in an Alexandrian workshop expert in the working of the hard Egyptian porphyry.

The two long sides of the sarcophagus are ornamented with winged erotes wearing bullae who are harvesting the grapes while contained within sinuous acanthus scrolls; the two short sides depict them producing the wine. Peacocks, rams, and doves are also included in the tableau. Although such scenes were associated in a pagan context with the cult of Dionysus, they were equally amenable to a Christian interpretation. The Bacchic Elysium becomes the Christian Paradise, and the gathering and pressing of the grapes refer as readily to the Eucharist as to the wine that was part of Dionysiac rites. The lid is decorated with garlands suspended from two male and two female heads that have been identified as the masks of bacchants. Erotes harvesting grapes are also depicted in the splendid mosaics that decorate the ambulatory vaults of S. Costanza, and it is clear that the designer of the sarcophagus intended its decoration to complement that of the vaults above.

The Sarcophagus of Constantina is a work of high quality that demonstrates its designer's interest in

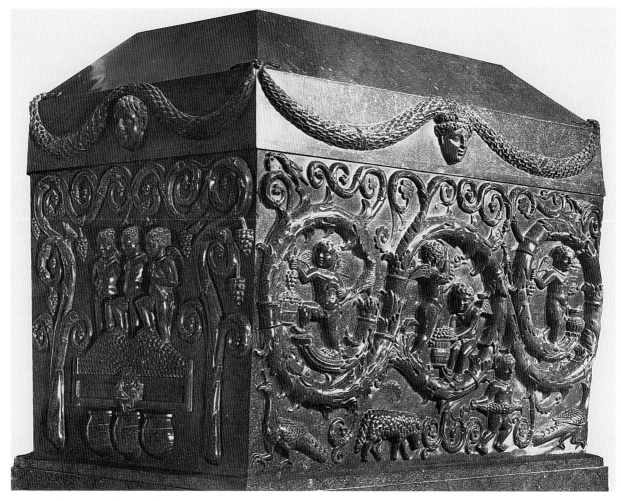

419 Porphyry Sarcophagus of Constantina, from the Via
Nomentana, 330–60. Rome, Vatican Museums. Photo: Alinari/
Art Resource, New York, 6651

classical subject matter but also betrays his interest in the
symmetry and abstraction favored in Constantinian re-
lief sculpture, such as on the Arch of Constantine. The
sarcophagi of Constantina and Helena are outstanding
examples of the eclecticism that was as much a part of the
Late Antique as the republican or imperial milieu.

Season Sarcophagi

The erotes and garlands on the porphyry Sarcopha-
gus of Constantina can be associated with another subject
that also featured boys and youths and was popular on late
Roman coffins – that of the Seasons. Seasons appeared in
private calendars, and male Seasons are attested in monu-
mental funerary sculpture in the late first or early second
century. Small decorative panels flanking the doors of the
mausoleum on the tomb relief from the Monument of the
Haterii depict the Seasons with their attributes (see fig.

166). Although the theme on Constantinian sarcophagi
is probably based on those in the private milieu, Sea-
sons became an important theme in state art under Trajan
when they began to be depicted below Victories in the
spandrels of arches (see figs. 188–189).

They were customarily young boys who, depending
on the season they symbolized, were swaddled in heavy
clothing or depicted seminaked. They were depicted with
attributes that underscored their identity. In the Arch
of Trajan at Benevento, they were included to signify
that the emperor was militarily victorious (the Victories)
not once, but in all seasons. They were included in the
sculptural program of the Arch of Septimius Severus in
the Roman Forum for the same reason (see figs. 293–
294), and it was also in Severan times that they began
to appear on sarcophagi. It has been demonstrated that
such sarcophagi were manufactured in Rome since the
majority of the surviving examples were found in that

city or environs or in Italy. The few examples that found their way to the provinces were probably made in Rome and exported. Local renditions were rare, and the city of Rome type seems not to have exerted a significant impact elsewhere.

The earliest Season sarcophagi show the Seasons in conjunction with Dionysus, who was depicted at the center; examples of the first half of the third century replace the god with a portrait medallion and give increased emphasis to the figures of the Seasons. The Seasons are represented in a variety of poses, but most are standing, walking, running, jumping, or dancing.

One of the finest examples of the type is the Season Sarcophagus, formerly in the Palazzo Barberini in Rome (fig. 420). The large marble coffin is carved on the front with four winged youths who represent from left to right Winter, Spring, Summer, and Autumn. The two central Seasons, Spring and Summer, support a medallion, ornamented with the signs of the zodiac, which contains the unfinished portraits of husband and wife. The roundel is supported by erotes harvesting grapes, and there are additional small figures interspersed among the feet of the Seasons. These figures include a shepherd milking a goat and a harvester in scenes that focus on events that would take place in different seasons, typical of calendar decoration. The sides of the sarcophagus are also unfinished.

The Palazzo Barberini sarcophagus is an example of what many scholars have referred to as Constantinian classicism. Although the youths are essentially in frontal positions, their postures are deliberately varied, their proportions elegantly elongated, and the artist who carved them demonstrates his ability to model a nude male figure. The musculature of the chest, arms, pelvis, and legs is carefully delineated. The round faces with straight brows, almond-shaped eyes, aquiline noses, and small delicate mouths, are not differentiated, and all but that of Autumn are framed with a heavily drilled coiffure that falls in a series of three corkscrew curls on each shoulder. Autumn has a shorter, tousled hairstyle that covers his ears. The figures are carved almost in the round and the wings stand out from the background. A comparison of these Seasons with those below the Victories in the spandrels of the Arch of Constantine is instructive. Those on the arch (see figs. 406–407) are squatter and squarer, and their musculature is less well defined. Their pudgier bodies are accompanied by round faces with features that are more simply conceived. The coiffures are also not complex, with the hair parted in the center and brushed in loose waves covering the ears. The similarity rests in the frontal positions of the figures, with their weight resting equally on left and right feet.

Constantinian Funerary Altars and Reliefs

Boys were also memorialized in freedmen funerary altars and reliefs in Constantinian times. An example is a marble altar from the Abbazia delle Tre Fontane in Rome, which depicts on the front a medallion portrait

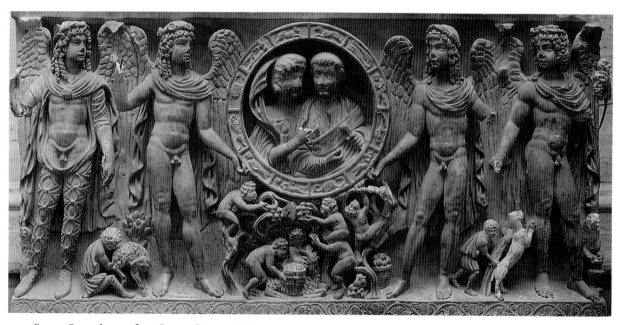

420 Season Sarcophagus, from Rome, Constantinian. Washington, Dumbarton Oaks Collection. Photo: Byzantine Visual Resources, Dumbarton Oaks, Washington, D.C.

421 Funerary altar of Florus, ca. 280–320. Rome, Museo Nazionale delle Terme. Photo: DAIR 65. 12

of Florus (fig. 421). The accompanying inscription states that Florus lived precisely two years, ten months, and twenty-four days, and that his parents were Bassaeus and Servea. That the father and mother are designated only by single names suggests that they were of servile origin. Their son is represented with a bare chest with a mantle draped across his left shoulder and fastened with a circular brooch at the right. He has a round face, broad nose, full lips, and large eyes that are deeply shadowed and heavily lidded at top and bottom. The pupils are deeply incised. This treatment of the eyes is comparable to that of early fourth-century portraiture, the most striking example of which is the colossal portrait of Constantine from the Basilica Nova (see fig. 399). Florus does not wear Constantine's neo-Trajanic cap, however, but rather the severe military cap of the tetrarchs. Above the right ear the hair is longer and gathered into a long braid that falls on the right shoulder. This is the so-called Horus lock, which in Egypt was a sign of high birth and is associated in both Egyptian and Roman contexts with the cult of Horus/Harpocrates. Florus is thus portrayed in this altar as a "son of Isis." If he had lived longer, he would undoubtedly have led a life of service to the Isiac cult.

Stylistic features such as the coiffure and the carving of the eyes suggest a date in the late third or early fourth centuries for the Altar of Florus. The likelihood of a date between 280 and 320 is underscored by the fact that the cult of Horus/Harpocrates reached its greatest popularity in Late Antiquity. This is further attested by the portraits of other sons of Isis on funerary reliefs of Constantinian date, for example, the relief of a boy from Ostia that depicts him with a coiffure that includes the Horus lock.

The New Rome

Constantine, aware that Diocletian had earlier demonstrated the strategic importance of an eastern capital, dedicated Constantinople as the "New Rome" on 11 May 330. The new city also provided Constantine with an opportunity to begin anew by commissioning buildings that were free of pagan associations and expressed the new Christian ideology. At the same time, he was free to draw on pagan prototypes for inspiration. Although almost nothing of Constantinian Constantinople survives, it appears to have resembled Rome quite closely. It too was divided into fourteen regions and had seven hills, and its skyline included traditional Roman structures like a Capitolium, senate house, and a forum, which stood side by side with Christian churches. The new edifices were decorated with statues brought to Constantinople from Rome and elsewhere. Renowned monuments from

elsewhere in the Graeco-Roman world were transported to Constantinople in a reversal of the policy of expropriating eastern works for Rome in late republican and Augustan times. A fifth-century B.C. bronze monument from Delphi stood on the spina of the hippodrome. Also decorating the race course was a bronze quadriga with horses attributed to Lysippos. The heads of Roman state gods were replaced with portraits of the emperor with his upward gaze accentuating his communion with the god of the Christians. Constantine's association with the sun god was not lost even in Constantinople where his portrait atop a statue of Apollo adorned a porphyry column at the center of his new forum. At the same time, he commissioned images of Christ and the Apostles and had his palace (complete with hippodrome) decorated with a mosaic of the Cross. The New Rome was, simultaneously, a repository of the past and a laboratory for the artistic experiments that were to be the wave of the future in the eastern part of the empire.

The Constantinian Achievement and Its Legacy

Most students of Late Antiquity consider the monuments commissioned by Constantine and his immediate predecessors to be markedly different from those of the Early and High Empire and to herald a break with the past. The geometric abstraction and cold aloofness of imperial portraits under Constantine and the poor quality of the carving of the emperor's most prominent state reliefs, such as those on the Arch of Constantine, are often cited as the symbols of a society that had degenerated to the point of artistic exhaustion.

This is far from the truth. Careful examination of the monuments shows the opposite to be the case. The Constantinian period is notable for its construction of architectural marvels to rival the greatest ever constructed in the heyday of imperial Rome. These include the majestic Basilica Nova in the Roman Forum, the monumental Baths of Constantine on the Quirinal hill, the massive Arch of Constantine, and the round mausolea on the Via Flaminia and the Via Nomentana. The Constantinian period also saw the construction, almost from scratch, of the New Rome on the Bosphorus admired for its profusion of magnificent structures – such as its vast forum and splendid hippodrome based on models in Rome and decorated with Graeco-Roman masterpieces. The Constantinian building program continued that begun by the tetrarchs, not only in Rome, but in all of the capitals of the empire, and the vast organizational ability and artistic talent needed to complete such major undertakings should not be underestimated.

The portrait sculpture of the Constantinian period may be considered a further development of the extreme abstraction that had come into vogue under Probus. It too is characterized by the desire of its patrons and artists for colossal scale (just to manufacture portraits of the size of the thirty-foot, seated colossus of Constantine from the Basilica Nova was a feat in itself) and for the grouping of several figures into monumental displays of dynastic unity.

The Arch of Constantine was one of the most ambitious state monuments ever built. Its surfaces were almost entirely covered with reliefs that recount the deeds and extol the virtues of Rome's emperor and that celebrate his concordia with his fellow dyarch, Licinius. The fabric of the Arch of Constantine combines architectural and sculptural material from the second and fourth centuries in what has been disparagingly called a pastiche. To denigrate the synthesis of earlier and contemporary reliefs in a new creation, however, is to miss the point.

Roman art is marked from its beginnings by its eclecticism, by its taste for recombining Greek masterpieces from disparate dates, by a taste for portraits of Roman emperors on the bodies of Greek divinities, by its fascination with what we have called the interchangeability of parts, and by its interest in spolia. The Arch of Constantine is not only in the mainstream of Roman art, it is probably the finest surviving example of Roman eclecticism.

The Arch of Constantine, however, was not designed as a textbook example of Roman eclecticism. Its individual parts were combined in a unified program that is one of the most carefully thought out in the history of Roman art. The spolia were not haphazardly chosen but deliberately selected to add richness and nuance to the overall program of the arch. Although it is uncertain whether the reused material came from monuments that had been destroyed in recent fires (which is most likely) or from edifices that were deliberately despoiled or never used, the reliefs chosen were only those that belonged to the monuments of the good emperors of the second century, with whom Constantine wanted to associate himself.

To underscore this point, Constantine had himself portrayed as a neo-Trajan with a neo-Trajanic coiffure in his many portraits on the arch. In the scene of the oratio, unquestionably the most significant on the arch, this neo-Trajan is depicted on the Rostra in the Roman Forum, flanked at left and right by statues of Marcus Aurelius and Hadrian. Furthermore, Constantine was not the first Roman emperor to use spolia in his arch. Diocletian also incorporated fragments from earlier structures in his Arcus Novus, and his choice of spolia was also a deliberate one. Some of the reused reliefs came from Claudius's

nearby British arch, since Claudius's conquest of Britain was repeated in tetrarchic times.

Roman art is distinguished from its beginnings by its selective retrospection. Republican generals like Pompey and Roman emperors like Augustus were already associating themselves with great generals of the past, Greek athletes, or divinities in their choice of coiffure and body type for their portraits, or style for their state reliefs. Constantine demonstrates in his portraiture and state monuments that he is fully in this tradition. Constantinian art, like the art of all Roman periods, is indebted to the past and expressive of the present; it is rooted in the tetrarchic past. It also makes deliberate reference to imperial art of the first and second centuries. Further, it articulates the concerns of its times.

Constantine's first portraits depict him with the blocklike face, military coiffure, and short beard of a tetrarch. His arch, like Diocletian's Arcus Novus, is a deliberate pastiche; the style of its frieze, with its squat figures with geometric faces, Pannonian caps and patterned drapery, owes much to the reliefs on the base of the tetrarchic Decennial Monument or the Arch of Galerius. Constantine's later portraiture is characterized by its classicizing angular, smooth face and comma-shaped locks reminiscent of Trajan, but such portraits of the emperor were often combined with those of his three sons and Caesars in dynastic groups that extolled their indivisible unity as well as their physical interchangeability, a configuration undoubtedly inspired by that of the close-knit tetrarchic foursome.

Male children were important to Constantine for obvious reasons. He believed in hereditary succession, and his strong position as the first sole emperor of Rome in approximately forty years enabled him to establish a dynasty by appointing three of his sons to the rank of Caesar. It is for this reason that dynastic groups depicting him and his heirs were produced during his own time. Surviving examples depict all four in military garb and in an array of civil and military dress; all were made in Rome and in a provincial workshop in Alexandria. The political import of male children under Constantine also led to their inclusion in state relief sculpture.

Although there are no surviving public reliefs of Constantinian date that incorporate his sons, the male progeny of average male citizens are represented in the oratio and congiarium reliefs on the Arch of Constantine. Even barbarian children were depicted in Constantinian state monuments. The sons of barbarian families are depicted with their parents in the four outer panels of the pedestals of the Arch of Constantine. In the private sphere, male children of freedmen were honored by individual funerary dedications in the form of altars and reliefs. One of the most popular funerary dedications for

men and women of all ages was the Season sarcophagus, which had as its subject four boys with the attributes of Fall, Winter, Spring, and Summer.

Women are also included in state relief sculpture of the Constantinian period. These women are, however, not members of the imperial court nor of the Roman citizenry, but instead they are barbarian women, female divinities, and personifications such as Roma and Victory. There is earlier precedent for the exclusion of identifiable women from the imperial circle from state relief sculpture. The Ara Pacis Augustae with its family groups including men, women, and children from the court is a noticeable exception to the rule, as are a few examples from Antonine times. Women of the court were not, however, completely forgotten under Constantine. Although they seem not to have been included in the major dynastic groups, such as those in Rome and Alexandria, they appear as part of the family in the Ada Cameo and on bronze medallions. Statues in the round of women like Helena and Fausta were also manufactured in Constantinian times, and Helena and Constantina were provided with individual mausolea, whereas earlier empresses were buried with their husbands in family tombs. The remains of both women were placed in elaborate porphyry sarcophagi. The battle scene that decorated one of these sarcophagi was more appropriate for a man and may indicate that the coffin was originally designed for Constantine himself. In any case, it is an important example of the continued impact in a funerary context of subjects first explored in the political sphere. Constantine and his sons are joined with their respective mothers, Helena and Fausta, in the Ada Cameo and in family groups on bronze medallions, and not with Constantine's father, Constantius Chlorus.

Constantius Chlorus is noticeably absent in these family groups for one obvious reason: Constantine's decision to disassociate himself from the tetrarchs and thus from his father. Although Constantine is depicted alongside Constantius Chlorus and the other three members of the first tetrarchy in Constantius's socle from the Decennial Monument, he never incorporated portraits of his immediate predecessors, the tetrarchs – including Constantius Chlorus – in any public or private commission, choosing instead to link himself to fictional fathers whose ideology was closer to his own.

Constantine – who issued the Edict of Milan giving religious freedom to the Christians, who publicly supported Christianity, who sponsored the construction of Christian churches in Rome, and who was himself baptized on his deathbed – is considered the first Christian emperor of Rome. He attributed his victory over Maxentius at the Milvian Bridge to the sign of the Cross, and the inscription on the Arch of Constantine refers to the

sign of the divinity. In 315, Constantine was depicted on a medallion with the emblem of the chi-rho on his helmet, and the second version of the colossal marble statue of the emperor in the apse of the Basilica Nova may have depicted him holding the cross scepter. Constantine's profound interest in Christianity seems to have been assimilated by his mother Helena, who embarked on a pilgrimage to the Holy Land where she built churches and performed pious acts.

Constantine was also the last pagan emperor of Rome, with strong ties to the pagan past. His colossal statue in the Basilica Nova may have been transformed by the addition of a cross scepter, but it depicted the emperor in the pose of Jupiter. In the medallion of 315, the emperor may have the chi-rho on his helmet, but he also carries a shield decorated with the very symbol of pagan Rome – the she-wolf suckling Romulus and Remus. Constantine founded Constantinople as a Christian Rome in 330. His forum in Constantinople, undoubtedly based on ancient prototypes, had as its centerpiece a porphyry column shaft supporting a statue of Constantine with the attributes of Apollo. This statue attests that at the time Constantine was embellishing his new Christian city, he still commissioned statues of himself in the guise of pagan divinities. That it was Apollo is even more significant. Apollo or Helios, syncretized with the Syrian sun god Sol Invictus, figures prominently in Constantinian iconography from the start. Sol Invictus was introduced to Rome by Elagabalus and his worship entrenched under Aurelian.

From the late third century until the triumph of Christianity in the early fourth century, the cult of Sol Invictus received imperial favor and official recognition, paralleling that of Jupiter. Under Constantine, Sol Invictus continued to be associated closely with the person of the emperor and to figure prominently in state commissions. A medallion of 313, for example, shows Sol silhouetted behind Constantine, who himself holds a shield decorated with a solar chariot. Statuettes of Sol Invictus are carried by Roman soldiers in the Constantinian

frieze and on the column socles of the Arch of Constantine. The Constantinian tondi on the arch depict Sol and Luna. It is clear from the Constantinopolitan statue of Constantine as Apollo that Constantine's long personal association with the sun god was still strong toward the end of his life, and there may have been some assimilation between Apollo-Sol and the god of the Christians in the mind of Constantine. The distinction, therefore, between the emperor's pagan past and his hopes for a Christian future is not completely clear. He was at the same time the pagan emperor and the Christian crusader who stood with one foot in Rome and the other in the twin city of Constantinople.

Paganism, solar symbolism, and the new Christian religion were interwoven in a seamless whole in Constantinian times. Two disparate styles, one classicizing and one abstract, were also combined to create a unified Constantinian vision. The rigid and hierarchical reliefs of Constantinian date and the more naturalistic sculptures from lost monuments of the second-century were masterfully arranged on the Arch of Constantine to celebrate the emperor's domestic and foreign military victories, his virtues, and his dyarchy with Licinius. Stylistic discrepancies enhanced the political message of the arch; indeed, they were an integral part of it. The immobilized and geometric features of the marble colossus of Constantine are softened by the Trajanic cap of hair and the lifelike appearance of the body with its modulated musculature and prominent veins. The contrast was a deliberate one – presenting Constantine with the supple body of the pagan god Jupiter but with the awesome face of a superhuman being who had been inspired by the rays of the sun or by the sign of the cross. The classical style was transferred from Rome to Constantinople where it was exploited by the emperor Theodosius and his successors. The abstract style was also occasionally used in Constantinople, such in the base of Theodosius's obelisk in the hippodrome, but it found a more hospitable home in the West where it became the overriding choice of patrons and artists of Medieval times.

Bibliography

The Oxford Classical Dictionary, 2d ed. (Oxford, 1970) provides encapsulated biographies of Constantine and his sons.

Imperial Portraiture: R. Delbrueck, *Antike Porphyrwerke* (Berlin, 1932). R. Delbrueck, *Spätantike Kaiserporträts* (Berlin, 1933). H.P. L'Orange, *Studien zur Geschichte des spätantiken Porträts* (Oslo, 1933). S. Stucchi, "Ritratti della famiglia imperiale constantiniana: Crispo e Constantino II," *ArchCl* 2 (1950), 204–8. H. Kähler, "Konstantin 313," *JdI* 67 (1952), 1–30. R. Calza, "Un problema di iconografia imperiale sull'arco di Costantino," *RendPontAcc* 32 (1959–60), 133–61 (Portraits of Constantius Chlorus in the Hadrianic tondi). J. Bracker, "Zur Ikonographie Konstantins und seiner Söhne," *KölnJb* 8 (1965–66), 12–23. E. Harrison, "The Constantinian Portrait," *DOP* 21 (1967), 81–96. W. von Sydow, *Zur Kunstgeschichte des spätantiken Porträts im 4. Jh. n. Chr.* (Bonn, 1969). P. Brunn, "Constantine's *dies imperii,* and *quinquennalia* in the Light of the Early Solidi of Trier," *NC* (1969), 177–205. R. Calza, *Iconografia romana imperiale da Carausio a Giuliano (287–363 d. C.)* (Rome, 1972). P. Brunn, "Portrait of a Conspirator: Constantine's Break with the Tetrarchy," *Arctos* 10 (1976), 5–25. H. von Heintze, "Statuae quattuor marmoreae pedestres, quarum basibus Constantini nomen inscriptum est," *RM* 86 (1979), 399–437. H.P. L'Orange, *Das spätantike Herrscherbild von Diokletian bis zu den Konstantin-Söhnen 284–361 n. Chr.* (Berlin, 1984). K. Fittschen and P. Zanker, *Katalog der römischen Porträts in den Capitolinischen Museen und den anderen kommunalen Sammlungen der Stadt Rom, 1* (Mainz, 1985). D. Wright, "The True Face of Constantine the Great," *DOP* 41 (1987), 493–507.

Female Portraiture in the Constantinian Period: K. Fittschen and P. Zanker, *Katalog der römischen Porträts in den Capitolinischen Museen und den anderen kommunalen Sammlungen der Stadt Rom, 3* (Mainz, 1983). M. Wegner, "Die Bildnisse der Frauen und des Julian," in H.P. L'Orange, *Das spätantike Herrscherbild von Diokletian bis zu den Konstantin-Söhne 284–361 n. Chr.* (Berlin, 1984) (for the Ada Cameo, see p. 127, pl. 174a).

The Arch of Constantine: A.J.B. Wace, "Studies in Roman Historical Reliefs," *BSR* 4 (1907), 270–76. H.P. L'Orange and A. von Gerkan, *Der spätantike Bildschmuck des Konstantinsbogens* (Berlin, 1939). B. Berenson, *The Arch of Constantine or the Decline of Form* (New York, 1954). A. Giuliano, *L'arco di Costantino* (Milan, 1955). F. Magi, "Il coronamento dell'Arco di Costantino," *RendPontAcc* 29 (1956–57), 83–100. J. Ruysschaert, "Essai d'interprétation synthétique de l'arc de Constantin," *RendPontAcc* 35 (1962–63), 79–100. L. Richardson, jr., "The Date and Program of the Arch of Constantine," *ArchCl* 27 (1975), 72–78. D. Strong, *Roman Art* (Harmondsworth, 1976), 276–78. I. Iacopi, *L'arco di Costantino* (Rome, 1977). H.P. L'Orange, *Das spätantike Herrscherbild von Diokletian bis zu den Konstantin-Söhnen 284–361 n. Chr.* (Berlin, 1984), 44–49 (recarved portraits of Constantine and Licinius). S. E. Knudsen, "Spolia: The So-called Historical Frieze on the Arch of Constantine," *AJA* 93 (1989), 267–68 (abstract); "Spolia: The Pedestal Reliefs on the Arch of Constantine," *AJA* 94 (1990) (abstract), 313–14. S. De Maria, *Gli archi onorari di Roma dell'Italia romana* (Rome, 1988), 203–11, 316–19. D.E.E. Kleiner, "The Arch of Constantine," in N. T. de Grummond, ed., *The Historical Dictionary of Classical Archaeology* (Westport, Conn., 1993).

The Porphyry Sarcophagus of Helena: A.L. Frothingham, "Discovery of the Sarcophagus of M. Aurelius," *AJA* 13 (1909), 59–60. P. Franchi de' Cavalieri, "Il sarcofago di S. Elena prima dei restauri del secolo XVIII," *NuovB* 27 (1921), 15–38. A. Riegl, *Die spätrömische Kunstindustrie* (Vienna, 1927). R. Delbrueck, *Antike Porphyrwerke* (Berlin, 1932). G. Rodenwaldt, "Zum Sarkophag der Helena," *Scritti in onore di B. Nogara* (Rome, 1937), 389–93. F. W. Deichmann and A. Tschira, "Das Mausoleum der Kaiserin Helena und die Basilika der heiligen Marcellinus und Petrus an der via Labicana vor Rom," *JdI* 72 (1957), 44–110. G. Koch and H. Sichtermann, *Römische Sarkophage* (Munich, 1982), 578–79.

The Porphyry Sarcophagus of Constantina: C. Gradara, "I sarcofagi vaticani di S. Elena e di S. Costanza," *NuovB* 20 (1914), 43–49. K. Michalowski, "Zum Sarkophag aus S. Costanza," *RM* 43 (1928), 131–46. R. Delbrueck, *Antike Porphyrwerke* (Berlin, 1932). E. Sjoqvist and A. Westholm, "Zur Zeitbestimmung der Helena- und Constantia- sarkophage," *OpArch* 1 (1935) 1–46. A.A. Vasiliev, "Imperial Porphyry Sarcophagi in Constantinople," *DOP* 4 (1948) 1–26. G. Koch and H. Sichtermann, *Römische Sarkophage* (Munich, 1982), 578–79.

Season Sarcophagi: G.M.A. Hanfmann, *The Season Sarcophagus in Dumbarton Oaks,* 1–2 (Cambridge, Mass., 1951). G. Koch and H. Sichtermann, *Römische Sarkophage* (Munich, 1982), 217–23.

Funerary Altars and Reliefs: D.E.E. Kleiner, *Roman Imperial Funerary Altars with Portraits* (Rome, 1987), 37–38, 46, 65–66, 272–74, no. 126 (Altar of Florus).

The "New Rome": D. Strong, *Roman Art* (Harmondsworth, 1976), 296–97. J.B. Ward-Perkins, *Roman Imperial Architecture* (Harmondsworth, 1981), 465–66.

Glossary of Latin and Greek Terms

Translations are from *Cassell's New Latin Dictionary,* the *Dictionary of Greek and Roman Antiquities* (Smith), J.B. Ward-Perkins, Roman Imperial Architecture (Harmondsworth, 1981); and *Webster's Ninth New Collegiate Dictionary*.

acerra: incense box used in sacrifices

adlocutio: a public address

adventus: an arrival, especially of an emperor or general into Rome

aedilis: an aedile, one of a group of elected officials at Rome who had charge of the streets, traffic, markets, and public games

ala, -ae: in a Roman house, wings extending to right and left at the far end of the traditional atrium, in front of the tablinum

anastole: the hair standing up over the center of the forehead; characteristic hairstyle of Alexander the Great

alabastrum: a pear-shaped perfume casket

alimenta: distributions of food among the poor

apparitores: attendants on magistrates

argentarius, -i: a moneychanger, banker

armarium: a cupboard

augur: an augur, soothsayer, seer; member of a special college at Rome

Augustus: a name granted to Octavian in 27 B.C. as first emperor and later to all subsequent Roman emperors

aula regia: audience hall

aurea aetas: golden age

aureus, -ei: a gold coin of ancient Rome

balteus: a girdle or belt serving to hold a weapon

bisellium, -a: a seat of honor large enough to accommodate two distinguished persons

bozzetto: a preliminary model

bucranium, -ia: a bull's skull

bulla, -ae: a circular boss of metal worn suspended from the neck by children, especially by sons of the nobility and the wealthy

bustuarius, -ii: a gladiator who fought at a funeral pyre in honor of the dead

calceii patricii: high shoes worn by priests

camillus, -ii: boy employed in the religious rites and ceremonies of the Romans

capite velato: with veiled head

cardo: one of the two main streets of a Roman camp or city, usually running north-south

castrum: a Roman military or fortified camp rectangular in plan with two main streets intersecting at the center

cathedra: a chair, usually with a back

cingulum: a girdle or swordbelt

cithara: an ancient Greek stringed instrument similar to but larger than the lyre

clementia: mercy, clemency

clipeus virtutis: shield of bravery or valor

cognomen: the third name of a Roman citizen following the name of the *gens* (family)

collegium, -ia: a group of persons united in an office or for any common purpose

coma in gradus formata: hair arranged in terraces; used by Suetonius to describe one of Nero's hairstyles

concordia, -ae: agreement, union, harmony, concord

congiarium, -i: a distribution of money to the people

conlibertus, -i: a fellow-freedman

consul, -sulis: consul, one of the two chief magistrates of the Roman state

contabulatio: flat drapery fold across the chest of the Roman toga

corona civica: civic crown consisting of oak leaves

damnatio memoriae: official condemnation

decennalia: a festival celebrated with games every ten years by the Roman emperors; anniversary of the tenth year of rule

decumanus: one of the two main streets of a Roman camp or city, usually running east-west

decursio, -iones: ritual circling of the funerary pyre

denarius, -i: a Roman silver coin, originally equivalent to ten asses but afterward to eighteen

designator: (*dissignator*) an undertaker who directed funeral processions

dexiosis: a handshake

dextrarum iunctio: a joining of the right hands in marriage

diva, -us: goddess, god; divine or deified

divi filius: son of a god

dominus factionis: an owner of a circus faction

dominus et deus: lord and god

dorsuale, -alia: broad band wrapped around the body of an animal victim

duovir (or duumvir): one of a pair of magistrates, one of a commission of two

dyarchy: rule by two

equites: the knights, a distinct order in the Roman commonwealth, between the senate and the plebs

erotes: cupids

exomis: a dress that had only a sleeve for the left arm, leaving the right arm with the shoulder and part of the breast free

ex testamento: from the will of

extispicium: an inspection of entrails

fasces: bundle of sticks with an ax projecting, carried by lictors before the chief Roman magistrates

fasti consulares: a list of consuls

fasti triumphales: a list of triumphant generals

felicitas saeculi: a fortunate age

ferculum: litter, bier, platform

filius: son

flamen: priest responsible for a cult of a particular god in Rome; the Collegium Pontificum comprised a total of fifteen flamines

frigidarium: cold room of a Roman bath

fundator quietis: a founder of peace

galli: priests of Cybele

genius, -i: the guardian spirit of a man or place

gens, gentes: a clan, a number of families connected by a common descent, and the use of the same gentile name

haruspex: a soothsayer, one who foretold the future from the inspection of entrails

hasta: a spear

hierothesion, -ia: sacred last resting place

imago clipeata / imagines clipeatae: portrait(s) on shields

imperator: a commander, leader; the commander in chief of an army

imperium: the highest political power, authority

in hoc panario: in this breadbasket

institutio alimentaria: system of distribution of food among the poor

kline: bed, couch; funeral couch

lar, lares: tutelary household deities among the Romans

laudatio: funeral oration

lenos: sarcophagus in the shape of a bathtub

liberalitas: courtesy, generosity; a grant

libertus, -i; liberta, -ae: a freedman; a freedwoman in relation to the former owner

libertinus, -i: freedman

liberator urbis: liberator of the city

liknon: winnowing basket that held the phallus in the cult of Dionysus

limus: an apron trimmed with purple, worn by a priest when offering sacrifice

lituus: the curved staff or wand of an augur

lustratio: a purification by sacrifice

lustrum: an expiatory sacrifice, especially that offered every five years by the censors at the close of the census on behalf of the Roman people, at which an ox, sheep, and pig (suovetaurilia) were sacrificed

malleus: a hammer, mallet, especially the ax used for slaying animals offered in sacrifice

medicus: a physician

naiskos: a small shrine

negotiantes: businessmen

nobiles: distinguished, of noble birth; especially belonging to a family that had held curule magistracies

nobilissima femina: the noblest woman; a title granted to some of the Roman empresses

nobilitas: noble birth, nobility; the aristocrats, the nobility

nodus: a roll of hair; a hairstyle in which the hair is arranged in a roll over the forehead

nomen: the gentile or family name of a Roman

oecus: dining room in a Roman house

opus quadratum: ashlar masonry of large squared stones laid in horizontal courses

oratio: a speech

paludamentum: a military cloak, a soldier's cloak, especially a general's cloak

parapetasma: a curtain

parazonium: a short sword in a scabbard

pater: father

patera: a shallow dish or saucer from which a libation was poured

pater patriae: father of his country

patricius: patrician, noble; the Roman patricians or nobility

penates: Latin deities of the household and family

pharos: a lighthouse

pietas: dutifulness, dutiful conduct toward the gods, one's country, one's relatives

pistor: a miller, a baker

pius: acting dutifully toward the gods, one's country, one's relatives

plebs: the plebeians, the common people, the lower orders

pomerium: a space left free from buildings on each side of the walls of a town, bounded by stones

pompa triumphalis: a triumphal procession

pontifex maximus: chief priest of the Roman state religion

popa, -ae: a junior priest or temple servant who slew the animal victims

praefectus urbi: governor of the city (Rome)

praenomen: the first name, usually that standing before the gentile name

praetor: a leader, chief; one of the group of Roman magistrates who helped the consuls by administering justice and by commanding armies

princeps: first, foremost; as a title of the Roman emperor

princeps iuventutis: a leader among the youth

processus consularis: consular procession

proconsul: a proconsul, one who serves as a consul in command of an army, or as a governor of a province

profectio: a departure, especially of an emperor or general from Rome

propraetor: a Roman who, after having been praetor at Rome, was sent abroad as governor to a province or given a military command

pudicitia: modesty, chastity, feminine virtue

quaestor: a quaestor, one of a group of junior magistrates in Rome

quinquennalia: a festival celebrated at the end of every four years. Although instituted in honor of Julius Caesar and Augustus, usually associated with Nero and also called the Neronia. It consisted of musical, gymnastic, and equestrian contests

quiquennium: a period of five years

redemptor: a contractor

rex datus: the assigned king

sacerdos Vestae: a priest of Vesta

sacerna: a sacrificial ax

saeculum aureum: golden age

scaenae frons: the permanent stage facade in a Roman theater

schola: a school or place where learned disputations were carried on

sella castrensis: a chair in a military camp

sella curulis: a magistrate's seat

sestertius, -i: a Roman silver coin equal to one quarter of a denarius

sevir, seviri: one of a group of six young men of senatorial birth who participated with the equestrians in a parade or transvectio in Rome; members of a college of six who were part of the Augustales, a priesthood in the municipalities

signum, -i: a standard

signifer, -i: a standard-bearer

similitudo: likeness, resemblance

simpulum: a ladle

sinus: the hanging fold of the Roman toga

situla: a jar for water

sodalis: a member of an association, especially a college of priests

solidus, -i: Roman gold coin, lighter than the aureus, and first struck under Constantine the Great

sphragis: seal in the shape of a cross

spolia: any booty or plunder taken from an enemy, spoils

stola: a long outer garment, especially as worn by Roman matrons

suffect consul (*consul suffect*): a substitute consul

suovetaurilia: a sacrifice of a pig, a sheep, and a bull

tabula census: the census register

thermae: baths

thiasos: a religious procession

thyrsus: a wand, twined around with ivy and vine leaves, carried by Dionysus and his attendants

toga picta: a toga worn by generals in triumphs

toga praetexta: a toga with a broad purple stripe worn by magistrates and freeborn children

togatus: wearing the toga, that is as a Roman citizen, as opposed to a foreigner or a soldier

toga virilis: toga worn by young men on coming of age

tricennalia: a festival celebrated every thirty years; a celebration of thirty years in office

triumphator: triumphant general

triumvir, triumviri: a triumvir, usually plural, a board or commission of three

tubicen: a trumpeter

tufa: the principal building stone of Latium and Campania, a concreted volcanic dust

urceus: a jug, a pitcher

ustrinum: base for a funeral pyre

uxor: wife

verna: a slave born in the master's house

vexillum, -a: a standard, a flag

vicennalia: a festival celebrated every twenty years; celebration of twenty years in office

vicomagistri: street superintendents

victimarius, -i: an assistant at a sacrifice who slaughtered the animal victim

virtus: manliness, manly and moral excellence; worth, goodness, virtue, valor, courage

vivit: he or she lives; used in Latin epitaphs to denote that one of the honorands is still alive

vota suscepta: a votive offering presented by a Roman general in hope of a successful military campaign

votum: a solemn promise or vow to the gods

Index

Numbers in bold refer to illustrations.

Abundance, Julia Domna as, 326, **292**

Achates, 93

Achilles, 304, 305, 345, 338, 339, 347, 350, 352; and Penthesilea, 158, 161, 304, 305, 350, 352; sarcophagus of Achilles and Penthesilea, 350–51, 352, **318**

Acilia, sarcophagus, 387–88, 390, 394, **357**

Actium, battle of, 47, 59, 62, 63, 65, 65, 81, 82, 83, 84, 86, 87, 99, 102, 112, 114, 116, 125

Ada Cameo, 441–42, 462, **403**

Adamklissi, Trophy of Trajan, 4, 208, 217, 230–32, 235, 236, 262, **196–98**

Adiatorix, 93

Admetus, 259

Adonis, 253, 304, 392

Aegisthus, 257

Aelia Paetina, 129

Aelius, Lucius, 238, 252, 253, 267

Aemilia, 42

Aemilianus (Marcus Aemilius), 359; portraits of, 372

Aeneas, 7, 23, 51, 63, 67, 88, 93, 98, 102, 103, 104, 109, 114, 115, 116, 158, 161, 304

Aesculapius, 338

Aeternitas, 291, 254

Afer, Publius Aelius Hadrianus, 237

Agrippa, Marcus, 59, 60, 72, 78, 98, 115, 123, 124; portraits of, 75, 92, 93, **52**

Agrippa Postumus, 78, 123, 124

Agrippina (daughter of Julia), 78

Agrippina the Elder, 135, 151

Agrippina the Younger, 129, 131, 133, 136, 140, 156, 158, 161, 171, **116**

Ahenobarbus, Domitius, 49, 51; altar of (Paris-Munich reliefs), 10, 49–51, 54, 86, 455, **30–31**

Ahenobarbus, Gnaeus Domitius, 135, 147

Aion, 151, 423

Alcestis, 259, 304

Alexander (son of Cleopatra), 93

Alexander the Great, 26, 34, 42, 44, 47, 55, 100, 113, 127, 151, 181, 318, 324, 352, 373, 374, 390, 395, 418, 422, 424

Alexander Sarcophagus, 306

Alexandria, Caesarium, 45

Algiers, Relief of Mars, Venus, and Divus Julius, 13, 100–102, **84**

Alimenta. See Institutio alimentaria

Alkamenes, Ares Borghese, 371, 395

Amazon Sarcophagus: Museo Capitolino, 257, 304, **227;** from Via Amendola, 257, **228;** Vatican Museums, 305, **318**

Amiternum: relief with funerary procession, 103–5, 196, 287, 296, 300, 332, **88–89;** relief with gladiatorial combat, 103–5, **87**

Amulius, 23

Anaglypha Traiani/Hadriani, 248–50, 251, 253, 261, 262–63, 334, 351, **216–17**

Ancestral practice and portraiture, 6, 8, 11, 36–38, 54; man with busts of ancestors, 36–37, **13;** terracotta head of man from Rome, 37, **14**

Anchises, 93, 158

Ancona, Arch of Trajan, 229

Andromeda, 345, 347

Ankara, Temple of Roma and Augustus, 60

Annius Verus, 267; portraits of, 322, 349

Antinous, 16, 31, 161, 238, 243–44, 252, 253, 261, 262, 263, 392, **207–10**

Antiochos IV, 233

Antius Restio, Gaius, 42

Antonia (wife of Mark Antony), 46

Antonia the Elder, 92

Antonia the Younger, 13, 92, 93, 129, 130, 139, 146, 150, 156, **114**

Antoninianus of Aphrodisias, 161, 243, 261

Antoninus Pius (Titus Aurelius Fulvus Boionius Antoninus), 267, 268, 273, 283, 284, 287, 309, 312, 313, 344; portraits of, 252, 253, 254, 261, 268–70, 281, 287–88, 312, **231–33**

Antony, Mark (Marcus Antonius), 39, 54, 59, 62, 67, 77, 78, 81, 82, 83, 84, 87, 99, 102, 114, 115, 116, 125, 139, 447; portraits of, 39, 46–47, **29**

Antony, Mark (grandfather of Mark Antony), 49, 50

Aper, 360, 399

Apharban, 423

Aphrodisias, 7; Sebasteion, 16, 158–61, 285, **133–34;** School of, 16, 243–44, 261; Hadrianic Baths, 343

Aphrodite, 158, 161, 304, 306, 414. See also Venus

Apollo, 65, 67, 84, 135, 158, 227, 446, 461, 463; as patron god of Augustus, 59, 62, 71, 81, 82, 83, 84, 88, 92, 99, 103, 114, 243, 252, 306, 309

Apollodorus of Damascus, 4, 15, 16, 162, 213, 214, 215, 219, 237

Apollonius, 338

Apuleius Carpus and Apuleia Rufina, funerary relief of, 228, 259, 287, **255**

Arachne, 194

Ares, 304. See also Mars

Aristeas and Papias of Aphrodisias, 246, 261

Arkesilaos, 4, 11

Arles: Arc du Rhône, 13

"Arringatore," statue of, 5, 10, 33–34, **10**

Arsane, 421

Arsinoe, Amphitheater, 124

Ascanius, 23, 93, 96

Asinius Pollio, 11

Athena, 86, 114, 241, 312. See also Minerva

Athens: Monument of Philopappos, 4, 233–37, 262, **199–200;** Mount Pentelicon, 5; conquest of by Sulla, 26; Odeion of Agrippa, 75; Altar of Pity (Altar of the Twelve Gods), 90; Parthenon, 92, 93, 114, 454; Erechtheion, 100, 114; Pinakotheke, 179; Propylaia, 179; Library of Hadrian, 181, 238, 259; Temple of Athena Nike, 209; Roman Agora, 238; Arch of Hadrian, 238, 259, 261; Temple of Olympian Zeus (Olympieion), 238, 259, 261; Pantheon, 259

Atistia. See Rome, Tomb of Eurysaces, Marcus Vergilius

Attis, 425

Augustus (Gaius Octavius), 3, 4, 7, 9, 12, 31, 44, 46, 59–60, 61, 69, 75, 98, 102, 110, 113, 114, 116, 117, 123, 129, 130, 135, 144, 145, 152–53, 161, 168, 171, 172, 181, 192, 207, 208, 217, 224, 329, 238, 254, 261, 262, 340, 344, 351, 353, 361, 367, 409, 447; portraits of, 8, 9, 13, 42, 61–69, 72, 74, 114, 124, 127, 131, 136, 158, 161, 176, 201, 208, 250, 261, 262, 271, 372, 373, 374, 389, 401, 406, 426, 427, 434, 438,

Augustus (Gaius Octavius) (*continued*)
462, **37–46, 49, 133;** Primaporta statue, 10, 31, 63–67, 74, 92, 100, 114, 115, 123, 142, 209, 329, **42;** as divus, 123, 134, 145, 149–51, 158

Aurelia, 44

Aurelian (Lucius Domitius Aurelianus), 359, 360, 361, 376, 412, 463; portraits of, 375–76, 393, 394, **342**

Aurelius Pyrrhus, funerary altar of, 382–84, **355**

Aurora, 65

Avellino, Actian Apollo relief, 84

Avidius Cassius, Gaius, 294

Bacchus, 243

Balbilla, 4, 233

Balbinus (Decius Caelius Calvinus Balbinus), 358; sarcophagus of, 365, 378, 382, 384–85, 390, 393–94, **326, 346, 356;** portraits of, 365–66, 393, 395, **326–27**

Balbus, Julius, 387, 388, 394

Belvedere Altar, 102–3, 115, 311, **85–86**

Benevento, Arch of Trajan, 12, 105, 134, 153, 156, 185, 208, 209, 224–29, 230, 233, 237, 248, 249, 250, 254, 261, 262, 291, 298, 331, 351, 421, 446, 452, 453, 458, **188–93**

Berenice, 171

Berenson, Bernard, 455

Bernini, Gian Lorenzo, 220

Bianchi Bandinelli, Ranuccio, 12, 14, 17

Borcoreale, cups from, 152–54, 291, 421, **128–29**

Bosio, 456

Brendel, Otto, 17

Britain, invasion of, 129, 130, 161, 171, 412, 413, 427, 431, 462; Hadrian's Wall, 237, 241, 317

Britannia, 154

Britannicus, 129, 133, 135, 151, 156, 158

"Brutus," portrait of, 5, 24, 25, 33, **2**

Brutus, Marcus, 44, 46, 59, 99, 114

Bryaxis, 320

Burrus, 135

Caelus, 65, 102, 422

Caenis, 171, 177

Caesar, Gaius (father of Julius Caesar), 44

Caesar, Gaius, 13, 60, 62, 65, 67, 69, 70, 72, 75, 78, 79, 80, 81, 90, 92, 98, 102, 103, 112, 114, 115, 123; portraits of, 72–75, 93, 158, 161, **50–51**

Caesar, Julius (Gaius Julius Caesar), 5, 42, 44, 59, 61, 82, 110, 113, 114, 116, 344, 409; Divus Julius, 7, 13, 61, 63, 100, 102, 103, 114; portraits of, 8, 26, 42, 44–46, 55, 79, **25–28**

Caesar, Lucius, 60, 62, 70, 72, 75, 78, 79, 80, 81, 90, 92, 98, 102, 103, 112, 114, 115, 123, **48**

Caesarion, 46

Caesernius Statianus, Titus, 252, 253

Caesernius Macedo Quinctianus, Titus, 252, 253

Caffarelli Sarcophagus, 256, **225**

Caligula (Gaius Julius Caesar Germanicus), 76, 124, 126, 129, 130, 134, 140, 141, 142, 146, 151, 161, 169, 172; portraits of, 126–27, 133, 162, 176, 250, **102–4**

Callistus Hagianus, sarcophagus of, 259

Calpurnia, 44

Canopus, Temple of Serapis, 246

Capri, Villa Jovis, 124

Caracalla (Septimius Bassianus/Marcus Aurelius Antoninus), 318–19, 320, 326, 329, 332, 334, 336, 338, 339, 342, 343, 344, 347, 351, 352, 353, 357, 360, 376, 395; portraits of, 8, 270, 321, 322–25, 329, 332, 336, 339, 349, 350, 351, 352, 361, 362, 363, 364, 365, 367, 368, 369, 371, 372, 392, 393, 394, 404, 425, **285–88**

"Caracalla Master," 16, 324, 326, 328–29, 352, 353, 363, 364, 365, 367, 372, 373, 393, 425

Carrara. *See* Luna (Carrara)

Carinus (Marcus Aurelius Carinus), 360, 376, 387, 399, 431; portraits of, 376, 397, **344**

Carus (Marcus Aurelius Carus), 360, 376; portraits of, 376

Caryatids: Agrippa's Pantheon, 4, 11, 109; Forum of Augustus, 7, 31, 100, 114, 213, 247, **83;** Erechtheion, 100, 114, 247; Hadrian's Villa, 247, 259, **214–15;** Velletri sarcophagus, 259

Cassius, Gaius, 44, 46, 59, 99, 114

Cassius Dio, 69, 82, 161, 217, 237, 280, 318, 319

Castor and Pollux, 31

Cattia Faustina, altar of, 306–8, **277**

Celer. *See* Severus and Celer

Cephisodotus, 83, 114

Ceres, 24, 158, 197; Roman women with attributes of, 7, 151, 242, 326, **291**

Chatsworth Relief, 251, **218**

Chieti, Monument of Lusius Storax, 148–49, 161–62, **123–25**

Children, sarcophagi of, 303, **272**

Cicero, 29

Cinna, 44

Circus Relief, 236–37, 250, 287, 332, **201**

Città Castellana, base from Falerii, 51, **32–33**

Claudia (daughter of Claudius), 129

Claudia Antonia (daughter of Claudius), 129

Claudia Augusta (daughter of Nero), 135

Claudius Nero, Tiberius, 76

Claudius (Tiberius Claudius Nero Germanicus), 3, 69, 76, 129–30, 135, 136, 139, 140, 142, 168, 169, 192; portraits of, 5, 130–35, 138, 141, 144, 145, 146, 154, 158, 161, 162, 168, 208, 366, **105–8, 134;** as divus, 130, 135, 141

Claudius Gothicus II (Marcus Aurelius Claudius Gothicus II), 359, 413, 432, 436; portraits of, 375, **341**

Clementia sarcophagus, 302, **270**

Cleomenes, 109

Cleopatra VII, 44, 45, 46, 47, 59, 78, 83, 84, 87, 93, 98, 99, 102, 114, 115, 116, 117, 125, 447

Cleopatra (daughter of Cleopatra VII), 93

Clodius Albinus, 317, 319–20

Clytaemnestra, 257

Coelius Caldus, Gaius, 42

Commagene, 233

Commodus (Lucius Aelius Aurelius Commodus), 268, 280, 294–95, 300, 305, 313, 317, 318, 320, 352; portraits of, 270, 273–77, 281, 291–92, 294, 313, 319, 322, 349, 351, 394, **241–44**

"Commodus Master," 328

Concordia, 70, 90, 98, 342, 343, 351, 352, 385, 387, 412, 424, 427, 446, 461

Constans, 443; portraits of, 436, 441, 442

Constantia, 432

Constantina, 433, 443–44; sarcophagus of, 443–44, 457–58, 462, **419;** portraits of, 444, 462

Constantine the Great (Flavius Valerius Constantinus), 2, 16, 163, 253, 295, 406, 413, 416, 417, 419, 427, 431–33, 442, 443, 444, 454, 455, 456, 457, 460, 463; portraits of, 5, 9, 13, 221, 251, 271, 288, 376, 406, 426, 427, 431, 433–41, 442, 445, 446, 460, 461, 462, 463, **392–96, 398–402**

Constantine II, 432, 443; portraits of, 436, 437, 441, 442, **397**

Constantinople, 433, 460–61, 463

Constantius Chlorus (Flavius Valerius Constantius Chlorus), 9, 399, 400, 406, 408, 413, 416, 417, 419, 422, 431, 433, 434, 442, 450, 456, 462; portraits of, 251, 403, 406, 407, 414, 419, 426, 462, **373**

Constantius II (Flavius Julius Constantius), 432, 443; portraits of, 434, 436, 437, 441, 442

Constitutio Antoniniana, 318

Coponius, 42

Corinth: canal, 135; Julian Basilica, 72

Cornelia, 42

Cornelia (wife of Julius Caesar), 44

Cornelii Scipiones, sarcophagus of, 256, **224**

Corona civica, 127, 131, 133, 436

Cottius, Marcus, 4, 110, 115

Crassus, 44, 67, 123, 329

Creticus, Marcus, 46

Crispus, 432, 436, 442

Cumae, portrait of man from, 37–38, **15**

Cupid. *See* Eros

Cybele, 88, 144

Cyriacus of Ancona, 233

Dacia, campaigns of Trajan in, 207, 208, 213, 214, 216–20, 221, 227, 237, 262

Damnatio memoriae, 10, 13, 78, 136, 156, 157, 172, 176, 185, 192, 193, 229, 268, 271, 273, 292, 294, 295, 317, 318, 321, 325, 329, 336

Darius of Persia, 390, 422

Decebalus, 216, 217, 219, 230, 421

Decius, Trajan (Gaius Messius Quintus Decius), 358–59, 387, 389; portraits of, 369–71, 393, 395, **333–35**

Decursio, 285, 287, 288, 296, 300, 312, 313, 421, 455, 456

Delos: portraits from, 5, 34–35; Pergamene Gaul from, 216

Delphi, Monument of Aemilius Paullus, 9, 26–27, 47, 48, 51, 54, 86, 438, **5;** Sanctuary of Apollo, 26

Demetrius, 48

Diadumenianus, 357

Diana, 65, 67, 84, 88, 158, 252, 422, 446

Didia Clara, 349

Didius Julianus, 317, 319, 349

Diocletian (Gaius Aurelius Valerius Diocletianus), 360, 376, 392, 399, 400, 403, 405, 406, 408, 409, 412, 413, 414, 416, 417, 418, 421, 423, 424, 426, 427, 431, 432, 433, 436, 447, 460, 461; portraits of, 400, 401, 403, 404, 405, 406, 418, 419, 426, **363–64, 371**

Diogenes, 4, 11, 60, 109

Dioysiac sarcophagus, 392, **362**

Dionysios of Halikarnassos, 93

Dionysus, 158, 181, 183, 343, 352, 392

Dioscuri, 157–58, 409, 411, 412, 421, 422, 425, 457, 459

Dioscurides, 4, 11, 60, 69, 109

Doidalsas, 181, 246

Domitia, 172, 177, 178–79, 195, **148**

Domitia Lucilla, 267

Domitia Paulina of Gades, 237

Domitian (Titus Flavius Domitianus), 10, 171, 172, 183, 185, 188, 191, 199, 200, 201, 207, 213, 217, 221, 229, 230; portraits of, 13, 174, 176–77, 187, 192, 202, 208, 214, 271, **144–45**

Domitilla, Flavia, 171, 177

Drusilla, 140

Drusus the Elder (Nero Claudius Drusus), 76, 92, 93, 98, 123, 129, 130, 135, 146, 153

Drusus the Younger (Julius Caesar Drusus), 70, 124, 135, 142, 151, 156, 161

Drusus, Julius (brother of Caligula), 126

Drusus (son of Claudius), 129

Eclecticism, Roman, 2, 9–11, 33, 183, 191, 194, 202–3, 244–47, 295, 313, 342, 376, 461

Eirene, 424

Elagabalus (Varius Avitus Bassianus/Marcus Aurelius Antoninus), 319, 357, 358, 360, 393, 394, 395; portraits of, 362–63, 394, 395, 463, **320**

Eleusis, Lesser Propylaia, 100

Endymion, 304

Epaminondas, 27

Ephesus: Great Antonine Altar, 268, 308, 309–12, 313, 322, 394, **279–81;** Library of Celsus, 309

Epiphanes, 234

Eros, 65, 74, 88, 100, 146, 153, 154, 158, 178, 196, 347, 412, 414, 454

Eros (secretary to Aurelian), 359

Esquiline hill, tomb with historical scene, 48

Etruscans: control of the city of Rome, 2; impact on Roman art, 2, 24, 33; materials for sculpture, 5; sarcophagi, 5; bronze-casting technique, 24, 33; Roman subjugation of, 25

Etruscilla, 387

Eubilides of Piraeus, 5

Euripides, 29

Eurysaces, Marcus Vergilius. *See* Rome, Tomb of Eurysaces, Marcus Vergilius

Eusebius, 438

Eutropius, 208, 403

Extispicium Relief, 5, 223–24, **187**

Fabius Maximus, 27, 29

Fabius, Quintus, 48

Fabullus, 4, 136

Fadia, 46

Fannius, Marcus, 48

Fausta (Flavia Maxima Fausta), 408, 432, 436, 442, 443; portraits of, 408, 442, 443, 462, **375, 405**

Faustina the Elder (Annia Galeria Faustina), 267, 277, 285, 287, 312, 313, 325; portraits of, 278, 288, 308, 311, **245**

Faustina the Younger (Annia Galeria Faustina), 268, 280, 287, 313, 325, 376; portraits of, 13, 277–80, 281, 291, 306, 308, 442, 443, **246–47**

Felicitas, 291

Flamininus, Titus Quinctius, 26, 27, **4**

Flora, 338

Florescu, Florea Bobu, 230

Florus, altar of, 459–60, **421**

Fortuna, 100, 144, 157, 385, 422

Freedmen, 1, 2, 3, 4, 7, 17; portraits of, 14, 16, 40–42, 78–81, 194–95, 287–88, 349–50, 381–84, 385, 459–60, **19–22, 58–61, 162–63, 167–68, 255, 316, 317, 354–55, 421;** sarcophagi of, 15, 306; art of, 116, 196–99, 221, 236, 421, **164–66, 236**

Fulvia, 46, 78; portraits of, 39

Fulvus Antoninus, 280

Furia Sabina Tranquillina, 378–81, **349**

Furnilla, Marcia, 171, 177, 178, 179, **146**

Galba, Gaius Sulpicius (father), 68

Galba (Servius Sulpicius Galba), 136, 167–68, 169; portraits of 8, 167, 168, 172, 200, 202, **135**

Galerius (Gaius Galerius Valerius Maximianus), 9, 399, 400, 406, 416, 417, 418–19, 420, 421, 422, 423, 424, 425, 427, 431, 432, 433, 457; portraits of, 403, 404, 405, 406, 414, 418, 419, 423, 425, 426, **370, 372, 391**

Gallienus (Publius Licinius Egnatius Gallienus), 359, 360, 372, 376; portraits of, 373–75, 376, 381, 389, 394, 400, 405, **338–40**

Gallus, 443, 457

Ganymede, 347

Gemma Augustea, 69–72, 96, 116, 149, 161, **47**

Genius Populi Romani, 153, 183, 188, 191, 192, 227, 254, 336, 416, 446

Genius Senatus, 70, 183, 188, 191, 192, 227, 254, 288, 294, 387, 417, 427

Gerkan, Armin von, 452

Germanicus, 69, 70, 71, 84, 92, 93, 124, 126, 129, 135, 139, 146, 151, 153, 156

Geta (Lucius Septimius Geta), 318, 320, 326, 329, 332, 334, 336, 342, 343, 351, 353, 360; portraits of, 270, 321, 325, 332, 336, **289**

"Glanum Master", 113

Glyce, Cornelia, altar of, 194–95, **162**

Glykon of Athens, 338

Gordian I (Marcus Antonius Gordianus), 358, 388, 394; portraits of, 365

Gordian II (Marcus Antonius Gordianus), 358, 394; portraits of, 365

Gordian III (Marcus Antonius Gordianus), 358, 378; portraits of, 366–68, 369, 373, 381, 387, 388, 394, **328–31**

"Gordian Master", 16

Graces, 344, 385

Grand Camée de France, 149–52, **126**

Great Trajanic Frieze, 12, 214, 220–23, 224, 232, 241, 248, 250, 253, 261, 262, 292, 298, 342, 351, 420, 422, 435, 444, 445, 447, 453, 457, **185–86**. *See also* Extispicium Relief

Greece: impact on Rome, 2, 4, 26, 33; Greek art in Roman triumphs, 4, 25, 26, 27–29; imported marble from, 5, 6

Hadrian (Publius Aelius Hadrianus), 6, 12, 16, 31, 163, 212, 213, 214, 220, 221, 229, 237–38, 242, 243, 246, 248, 249, 250, 251, 252, 253, 254, 259, 261, 262, 263, 267, 268, 283, 284, 295, 306, 309, 312, 318, 334, 432, 450; portraits of, 13, 221, 228, 238–41, 261, 262, 268, 281, 284, 371, 373, 374, 375, 376, 436, 450, 461, **202–5**; adventus relief of, 254–56, 263, 283, **223**

Hannibalianus, 443, 457

Haterius, Quintus. *See* Rome, Tomb of the Haterii

Hegias, 5, 131

Helen, 306

Helena (Flavia Iulia Helena), 408, 416, 417, 431, 433, 442–43, 456–57, 463; portraits of, 408, 431, 442–43, 462, **375, 404;** sarcophagus of, 442–43, 455–57, 458, 462, **418**

Helena III, 443

Helenus, 102

Helios, 311

Helius, 167

Herculaneum: Villa of the Papyri, 6; destruction of, 171; equestrian statues of the Balbus family, 271

Hercules, 6, 7, 83, 86, 114, 157, 158, 183, 201, 227, 235, 252, 259, 304, 305, 306, 319, 336, 338, 342, 343, 344, 345, 347, 349, 352, 400, 423, 426, 432, 446; Roman men with the attributes of, 268, 277, 305–6, 313, 320, 322, 328, 342, 349, 351, 352, 353; sarcophagus with twelve labors of, 305, **274**; from Baths of Caracalla, 338, 339, 352

Herennius Etruscus, 359, 389

Hersilia, 102

Hesperos, 311

Hippolytus, 392

Honos, 98, 153, 158, 188, 221, 227, 422

Horace, 60, 82

Horus/Harpocrates, 460

Hostilianus, 387, 389

Hylas, 347

Hymen (Hymenaeus), 301, 302, 303, 385

Iaia of Kyzikos, 11

Ianuaria, Volumnia, 195

Igel, Tomb of the Secundii, 345–49, 352, **313–15**

Ilia, 96

Institutio alimentaria, 153, 199, 207, 224, 227, 237, 248, 249, 250, 253, 254, 261, 262, 263, 452

Io, 84

Isis, 46, 126, 303, 422, 460

Isola Sacra, group portrait from, 280, 281, **248**

Italia, 70, 96, 248

Italiae Tellus, 70, 71, 96, 98

Jason, 304

Jerusalem, temple, 6, 171, 181, 187, 188

Jewish Wars, 7, 171, 183, 185, 190, 194, 202, 233, 424

Josephus, Flavius, 185, 188

Julia (daughter of Augustus), 59, 60, 72, 80, 90, 98, 102, 115, 124; portraits of, 75, 78, 93, **77**

Julia (daughter of Julius Caesar), 42, 44

Julia Domna, 318, 336, 342, 343, 350, 353, 358; portraits of, 321, 325–26, 336, 351, 378, 385, 390, 395, **290–92**

Julia Drusilla, 126

Julia Maesa, 357, 358, 395

Julia Mamaea, 358; portraits of, 378, 381, **345**

Julia Soaemias, 357, 358, 395

Julia Titi, 171, 172, 177, 178, 195, **147**

Julia the Younger, 60; portraits of, 93

Juno, 158, 223, 227, 294; empresses with attributes of, 285, 342

Jupiter, 24, 27, 69, 71, 83, 92, 157, 158, 197, 215, 217, 223, 227, 228, 294, 347, 400, 409, 413, 414, 416, 417, 418, 422, 423, 426, 427, 437, 438, 440, 450, 463; emperors with attributes of, 131, 133–35, 138–39, 151, 162, 187, 285, 342, 366, 395

Kallinikos, 235

Kline monuments, 14, 81, 365, 385, **61**

Knidos, Temple of Aphrodite, 246

Laodamia, 259

Laubscher, Hans, 420

Leda, 158

Lehmann-Hartleben, Karl, 216

Lepida, Aemilia, 168

Lepidus, Marcus, 46, 59, 60

Leptis Magna: Arch of Septimius Severus, 320, 326, 340–43, 344, 345, 351, 352, 353, 394, 425, **307–10;** Augustan forum, 340; Augustan market, 340; Severan forum, 343; Severan basilica, 343, 345, 352, **311**

Leto, 88

Libertini. See Freedmen

Licinius (Valerius Licinianus), 251, 406, 422, 431, 432, 433, 435, 436, 437, 444, 454, 461, 463; portraits of, 435, 446

Licinius II, 432

Lion hunt sarcophagus: Paris, 390, 391, 418, **360;** Rospigliosi, 392; Mattei, 392, 418, **361**

Livia Drusilla, 59, 60, 67, 71, 76, 90, 98, 102, 103, 107, 114, 116–17, 123, 125, 130, 142, 144, 145, 241; portraits of, 13, 75, 76–78, 79, 80, 92, 114, 124, 139–40, 146, 151, 158, 326, 353, 395, **53–56, 75, 115**

Livilla, 140

Livy, 27, 60, 129

L'Orange, Hans Peter, 452

Lucan, 136

Lucius Verus (Lucius Ceionius Commodus), 254, 267–68, 273,

283, 285, 287, 288, 309, 311, 312, 313, 360; portraits of, 8, 254, 273, 309, **239–40**
Lucilla, 268
Ludovisi Sarcophagus, 10, 389–90, 393, 394, **358–59**
Luna, 158, 223, 446, 454, 463
Luna (Carrara), 5, 6, 60, 99, 113, 116
Lysippos, 4, 29, 47, 319, 338, 371, 395, 461

Macer, Clodius, 167
Macrinus (Marcus Opellius Macrinus), 319, 357, 393; portraits of, 361–62, **319**
Macro, 126
Maecia Faustina, 358, 387, 388, 394
Magna Mater. *See* Cybele
Magna Urbica, 387
Mainz, Jupiter Column, 157–58, 162, 214–15; **132**
Manlia Scantilla, 349
Mantegna, 215
Mantua: battle relief, 86, 114, **66;** marriage sarcophagus, 303, **371**
Marcellus, Gaius, 77
Marcellus, Marcus, 60, 78, 115, 123
Marcellus, Marcus Claudius, 26, 27–29
Marciana, 229, 237, 242, 318
Marcius, Ancus, 24
Marcus Aurelius (Marcus Annius Verus), 254, 267–68, 273, 280, 283, 285, 287, 288, 294–301, 309, 312–13, 317, 328, 331, 351, 365, 390, 392, 450, 456; portraits of, 8, 268, 270–73, 280, 288–94, 300, 308, 319, 320, 322, 351, 353, 361, 372, 389, 394, 435, 446, 450, 461, **235–38;** equestrian statue, 11, 271, 292, 298, **236**
Mars, 7, 23, 49–51, 54, 67, 74, 82, 86, 88, 96, 98, 102, 114, 115, 116, 153, 156, 158, 192, 227, 247, 291, 347, 385, 409, 416, 417, 422, 424, 427, 446; Mars Ultor, 9, 13, 81, 100, 115, 144, 181, 217, 230, **150;** men in the guise of, 145–46, 280–83, 319, 349–50, 369, 395
Marysas, 248, 249, 250
Matidia, Vibia, 179, 199, 242, **149**
Maxentius (Marcus Aurelius Valerius Maxentius), 406, 419, 432, 433, 444, 446, 447, 452; portraits of, 400, 407, 426, **365, 374**
Maximian (Marcus Aurelius Valerius Maximianus), 399, 400, 403, 406, 408, 412, 413, 414, 417, 426, 431, 432, 433, 443; portraits of, 400, 404, 405, 419, **363**
Maximinus Daia (Gaius Galerius Valerius Maximinus Daia), 400, 406, 417, 432; portraits of, 406–7
Maximinus Thrax (Gaius Julius Maximinus), 358; portraits of, 364–65, 366, 384, 393, **324**
Medea, 304
Meleager, 113, 158, 304, 306, 392
Melfi: sarcophagus, 306, **276**
Memphis, Sanctuary of Serapis, 320
Menelaos, 4
Menelaos: Ludovisi group, 31, **9**
Mercury, 157, 197, 259, 446
Messalina, Statilia, 135
Messalina, Valeria, 129, 135
Metellus, Aulus. *See* "Arringatore," statue of
Metellus, Quintus, 29
Mettius, Marcus, 45
Michelangelo, 271
Mid-Italic art, 24–25, 33; relief from Lucera, 25, **3**
Milan, Edict of, 432, 433, 462
Milonia Caesonia, 126
Milvian Bridge, battle of, 432, 433, 434, 435, 444, 446, 462
Minerva, 157, 181, 187, 192, 194, 202, 223, 227, 271, 292, 294, 309, 343, 352

Minervina, 432, 436
Misenum: Shrine of the Augustales, 201
Mithras, 393
Mithridates VI of Pontus, 34, 42
Mucia, 42
Mummia Achaica, 168
Mummius, Lucius, 26
Musicus, Quintus Gavius: altar of, 195, **163**
Mussidius Longus, Lucius, 39
Mussolini, Benito, 90
Myron, 6, 181, 246

Narcissus, 3, 129, 268
Narses of Persia, 9, 418, 419, 420, 421, 422, 423, 424, 426, 433
Nemrud Dagh, Hierothesion of Antichos I, 233, 235
Neptune, 6, 71, 82, 158, 292, 312, 338; Neptune and Amphitrite, marriage of, 49, 54, 455
Nero (Nero Claudius Caesar), 6, 13, 129, 135–36, 140, 151, 157, 158, 167, 169, 171, 172, 190, 192, 215; colossus of, 4, 11; portraits of, 8, 13, 126, 135, 136–39, 156, 158, 161, 162, 168, 172, 176, 177, 202, **110–13**
Nerva, Marcus Cocceius, 10, 172, 207, 208, 213, 294; portraits of, 192, 199–201, 202, 271, **169–70;** as divus, 209
Nigrianus, 387
Nile, 6, 181, 238, 244, 246
Nikopolis, Actium Monument, 82
Nîmes, Pont-du-Gard, 75
Niobe, 84; Niobids, 113, 304
Nobilior, Marcus Fulvius, 29
Nodus coiffure, 39–40, 76, 77, 78, 79, 80, 124, 139
Numerian (Marcus Aurelius Numerianus), 360, 376, 399; portraits of, 376
Numitor, 23
Numa Pompilius, 24
Numonius Vaala, Gaius, 39
Nyx, 217, 311

Oceana, 311
Oceanus, 71, 422, 454
Octavia, 46, 77, 80, 98, 139, 181; portraits of, 39, 78, 93, **17, 57**
Octavia (daughter of Claudius), 129
Octavia (wife of Nero), 135, 151, 156
Octavius, Gaius (Octavian). *See* Augustus
Octavius, Gaius (father of Augustus), 59, 82, 113
Odysseus, 306
Oea, 309
Oeneus, 306
Ofellius Ferus, Gaius, 5
Oikoumene, 71, 423
Omonoia, 423
Orange, Arch of Tiberius, 113, 154, 329, 345, **130**
Orestes sarcophagus, 257, 304, **226**
Osiris, 46, 253
Ostia, 2, 5, 25, 212, 227; theater, 209; Baths of Neptune, 212, 242; group portrait from, 281, **249;** shoemaker sarcophagus, 303, **273;** relief of boy as infant Hercules, 349, 352, **316**
Otacilia Severa, 368, 378, **348**
Otho (Marcus Salvius Otho), 135, 136, 167, 168–69; portraits of, 167, 169, 176, **136**
Otricoli, portrait of man, 38, **16**

Palestrina, Nile mosaic, 48
Pallas, 129

Palombara Sabina, portrait of woman, 40, **18**

Pan, 196, 392, 425

Pardalus, Tiberius Claudius, sarcophagus of, 259

Paris, Louvre: Suovetaurilia relief, 141, 145, 162, 183, **117**

Pasiteles, 1, 4, 5, 6, 29, 30–31, 54, **7–8**

Pausanias, 15

Pax, 90, 96, 98, 156, 158

Peducaea Hilara, sarcophagus of, 259

Penthesilea. *See* Achilles

Pergamon: Great Altar of Zeus, 49, 216, 309; Sanctuary of Athena, 52, 67, 90

Pericles, 62

Persephone, 259, 304

Perseus, 345, 347

Perseus of Macedon, 26, 27, 438

Pertinax (Publius Helvius Pertinax), 317, 351; portraits of, 319

Pescennius Niger, 317

Pharsalus, battle of, 42, 59, 81, 86, 99, 102, 103, 114, 116, 217

Pheidias, 4, 29, 247

Philip the Arab (Julius Verus Philippus), 368, 369; portraits of, 368–69, 393, **332**

Philip II, 368; portraits of, 368–69, 394

Philathenaeus, 5, 131

Philetairos of Pergamon, 6

Philip V of Macedon, 26

Philiscus of Rhodes, 5

Philopappos, Gaius Julius Antiochus. *See* Athens, Monument of Philopappos

Philostratus, 328

Philexenos of Eretria, 390

Phraates IV, 67

Piazza Armerina, Villa, 399, 404

Pietas, 144, 146

Pindar, 27

Piranesi, 456

Piso, Gaius Calpurnius, 136

Ploteia, 44

Plotina, Pompeia, 207, 214, 228, 229, 237, 241, 242, 262; portraits of, 178, 212, 229, 248, 262, **176**

Plautia Urgulanilla, 129

Plautianus, 318, 326, 336, 344

Plautilla, 318, 326, 336

Pliny the Elder, 4, 5, 11, 15, 29, 36, 82, 84, 109, 256

Pliny the Younger, 224

Plutarch, 4, 27, 42

Pola, Arch of the Sergii, 111–12, 116, **98**

Pollaiuolo, Antonio, 23

Polybios, 36

Polycharmus, 5

Polycles, 5, 181

Polykleitos, 338, 363; Doryphoros, 4, 6, 9, 15, 31, 63, 65, 115, 338, 381, 395; Westmacott Athlete, 31; Diadoumenos, 34–35

Pompeianus, Tiberius Claudius: portraits of, 289, 291, 292, 294, 298

Pompeii: tombs, 4, 14; mural paintings, 15; mills, 107; gladiatorial cycles, 148; destruction of, 171; House of the Faun, Alexander Mosaic, 390, 422

Pompeius, Sextus, 82, 83

Pompeius Rufus, Quintus, 42

Pompey the Great (Gnaeus Pompeius), 29, 44, 98, 113; portraits of, 42–44, 54, 462, **23–24**

Poppaea Sabina, 135, 168, 256; portraits of, 140–41

Portonaccio: Etruscan temple, 24; sarcophagus, 301, 303, 305, 389, 390, 421, **269**

Postumius Albinus, Aulus, 42

Pozzuoli, arch, 229–30, **194–95**

Praxiteles, 4, 31, 181, 246, **211**

Primaporta, Villa of Livia, 63, 67

Prisca: portraits of, 418, 426

Probus (Marcus Aurelius Probus), 359–60; portraits of, 376, 393, 394, 400, 405, 425, 461, **343**

Processus consularis, 387

Proculus, Julius, 102

Prometheus, 158

Propertius, 83, 84

Proserpina, 158, 195, 197

Protesilaus, 259

"Pseudo-Athlete" from Delos, 35, 36, 115, 162, **11**

Ptolemy XIII, 44

Pupienus (Marcus Clodius Pupienus Maximus), 358; portraits of, 365, 366, 382, 394, **325**

Pydna, battle of, 25, 26–27, 36

Rabirius, 4, 237, 263

Rafidia Chrysis, sarcophagus of, 259

Ravenna Relief, 145–47, 161, 162, **121**

Remus, 23, 88, 96, 98, 158, 161, 241, 247, 285, 304, 347, 422, 434, 463

Res Gestae Divi Augusti (Monumentum Ancyranum), 60, 90, 93, 107, 116, 117

Rhea Silvia, 23, 347

Riegl, Alois, 11

Rimini, Arch of Augustus, 251

Roma, 52, 70, 71, 96–98, 100, 183, 188, 191, 192, 202, 227, 254, 285, 291, 292, 331, 343, 344, 417, 423, 424, 426, 427, 446, 447, 462

Rome

 Aqua Anio Novus, 130

 Aqua Claudia, 130

 Aqua Julia, 75

 Aqua Traiana, 208

 Aqua Virgo, 75, 154

 Ara Pacis Augustae, 10, 12, 16, 51, 60, 70, 71, 74, 75, 78, 79, 86, 89, 90–99, 104, 107, 109, 111, 112, 114, 115, 116, 141, 144, 145, 147, 148, 152–53, 161, 162, 181, 202, 223, 224, 254, 284, 295, 300, 311, 453, 462, **71–81**

 "Ara Pietatis Augustae," 77, 100, 141–45, 149, 161, 162, 183, 413, **118–20**

 Arch of the Argentarii, 320, 322, 325, 326, 334–37, 351, 352, 353, 394, **300–303**

 Arch of Claudius, 13, 154–56, 161, 162, 163, 412, 413, 426, 431, 461–62

 Arch of Constantine, 10, 12, 154, 221, 253, 288, 291, 295, 413, 414, 433, 435, 436, 440, 444–55, 457, 458, 459, 461, 463, **406–17**

 Arch of Domitian, 329

 Arch of Gallienus, 375

 Arch of Hadrian, 283

 Arch of Janus Quadrifrons, 445

 Arch of Nero, 13, 88, 156, 158, 161, 162, 163, 227, 230, 329, 331, 351, **131**

 Arch of Octavius, Gaius, 65, 82, 114

 Arch of Septimius Severus, 12, 86, 88, 154, 156, 329–32, 334, 336, 337, 370, 342, 351, 352, 409, 413, 420, 424, 426, 427, 433, 446, 450, 452, 458, **293–98**

 Arch of Tiberius, 154, 329, 351, 450

 Arch of Titus, 6, 11, 12, 16, 86, 171, 176, 183–91, 194, 196, 197,

202, 203, 224, 227, 233, 235, 254, 262, 292, 331, 342, 418, 424, 432, 446, 453, 455, **154–57**

Arches of Augustus, Actian, 2, 161, 447; Parthian, 86–88, 112, 115, 161, 329, 342, 351, 447, **67**

Arches of Marcus Aurelius, 13, 273, 288–95, 303, 311, 312, 313, 331, 342, 351, 389, 394, 423, 426, 427, 446, 450, 457, **230, 256–62**

"Arco di Portogallo," 11, 202, 253–54, 256, 262, 263, 285, 287, 295, 331, 384, 418, 445, **221–22**

Arcus ad Isis, 197

Arcus Novus, 409–13, 426, 427, 431, 445, 452, 453, 461, 462, **376–81**

Basilica Aemilia, frieze, 88–89, 93, 115, 116, **69–70**

Basilica Julia, 248, 249, 450

Basilica of Maxentius-Constantine (Basilica Nova), 432, 433, 440, 461, 463

Baths of Agrippa, 60, 75

Baths of Caracalla, 6, 7, 319, 338–39, 352, 371, 426, 433, **304–6**

Baths of Constantine, 7, 433, 436, 437

Baths of Diocletian, 409, 426, 433

Baths of Nero, 135

Baths of Septimius Severus, 338

Baths of Titus, 171, 183, 202

Baths of Trajan, 208, 212

Caelian hill, pediment from Via S. Gregorio, 52, 54, **36**

Camp for Praetorian Guard, 124

Campus Martius, 24, 113, 135, 254, 285, 384

Capitoline hill, 409, 414

Circus Maximus, 236

Colosseum (Flavian Amphitheater), 171, 183, 197, 202

Column of Antoninus Pius and Faustina, 9, 11, 17, 269–70, 283, 285–88, 295, 296, 300, 313, 332, 342, 384, 385, 394, 414, 418, 421, 455, 456, 457, **253–54**

Column of Marcus Aurelius, 11, 12, 16, 157, 162, 283, 295–301, 303, 311, 312, 313, 322, 328, 331, 332, 350, 351, 352, 353, 369, 389, 390, 414, 420, 421, 423, 424, 427, 447, **263–68**

Curia, 59, 227, 248, 409, 432

Decennial Monument (Five-Column Monument), 401, 409, 413–17, 420, 421, 424, 425, 426, 427, 433, 434, 444, 450, 453, 462, **382–85**

Domus Aurea, 4, 15, 16, 135–36, 169, 171, 181, 183, 202

Domus Transitoria, 135, 183, 202

Forum of Augustus, 6, 7, 31, 60, 99–102, 116, 158, 181, 193, 213, 219, 230, 251, 261, **82–84;** Temple of Mars Ultor, 7, 9, 59, 81, 99, 100, 102, 103, 114, 115, 145, 156, 181, 285

Forum of Julius Caesar, 4, 44, 99, 100, 158, 181, 193; Temple of Venus Genetrix, 11, 44, 100

Forum of Nerva (Forum Transitorium), 172, 181, 192–94, 200, 202, 213, **160–61;** Temple of Minerva, 181, 193

Forum of Trajan, 4, 6, 7, 15, 207, 208, 212–14, 219, 250, 251, 261, 262, 263, 284, **177;** Column of Trajan, 4, 6, 7, 11, 12, 16, 153, 157, 162, 207, 208, 209, 212–20, 221, 223, 230, 232, 236, 237, 248, 250, 253, 261, 262, 263, 287, 289, 291, 295, 298, 300, 301, 303, 311, 332, 351, 352, 414, 420, 421, 423, 424, 427, **179–84;** Basilica Ulpia, 6, 209, 214, 219, 221, **178;** Dacian prisoners, 6, 219, 445; Markets of Trajan, 207; Temple of Divus Traianus, 214, 220–21, 248, 249, 250, 262. *See also* Great Trajanic Frieze

Hunting Tondi of Hadrian, 113, 251–53, 263, 392, 418, 435, 445–46, 454, **219–20**

Mausoleum of Augustus, 12, 60, 90, 190, 196, 385, 433

Mausoleum of Constantina (S. Costanza), 433, 457, 461, 462

Mausoleum of Hadrian, 196, 285, 385, 433

Mausoleum of Helena, 431, 433, 442–43, 455, 461, 462

Mausoleum of Maxentius, 433

Palatine hill, 2, 23, 113; village of Romulus, 2, 5, 23; House of Augustus, 83, 102, 114, 141, 145; Imperial Palace, 124, 172, 181, 237; Aula Regia, statues of Dionysus and Hercules, 181–83, **151–52;** Coenatio Iovis, Nollekens Relief, 183, **153**

Palazzo della Cancelleria, reliefs from, 10, 147, 172, 177, 191–92, 194, 200, 202, 203, 455, **158–59**

Palazzo Sacchetti, relief from, 332, 334, 351, **299**

Palazzo Valentini, group portrait from, 281, **250**

Pantheon, Agrippa, 4, 11, 75, 109; Hadrian, 6, 237, 283, 338, 433

Piazza della Consolazione, reliefs from, 51–52, 414, **34–35**

Porta Flaminia, 447

Porta Maggiore, 130, 196, 197

Porta Triumphalis, 27, 192, 197

Porticus Divorum, 192

Porticus Metelli (Porticus Octaviae), 5, 6, 7, 29, 84, 181; reliefs from, 84

Roman Forum, 7, 23, 24, 99, 113, 136, 181, 193, 248, 249, 250, 409, 413, 432

Rostra, 36, 136, 248, 249, 250, 253, 413, 414, 450, 461

Sallustian Gardens, 31

Septizodium, 318, 338

Shrine of Janus Geminus, 90

Solarium Augusti, 295

Temple of Antoninus Pius and Faustina, 277, 283

Temple of Apollo Palatinus, 5, 59, 60, 82–84, 88, 102, 114, 145, **62**

Temple of Apollo Sosianus, 84–86, 114, **63–65**

Temple of Bellona, 154

Temple of Castor and Pollux, 86, 248

Temple of Concord, 82, 86, 249

Temple of Divine Augustus, 126

Temple of Divine Claudius (Claudianum), 131, 171, 181

Temple of Divine Hadrian (Hadrianeum), 161, 256, 261, 283–85, 295, 311, 312, **251–52**

Temple of Divine Vespasian, 249

Temple of Divus Julius, 82, 86–87, 248

Temple of Fides, 145

Temple of Fortuna Redux, 192

Temple of Isis, 433

Temple of Jupiter Optimus Maximus Capitolinus, 24, 25, 27, 134, 153–54, 187, 223, 224, 228, 294, 303, 424

Temple of Jupiter Stator, 197

Temple of Magna Mater (Cybele), 144, 145, 413

Temple of Quirinus, 183

Temple of Saturn, 249

Temple of Sol Invictus Elagabalus (later Jupiter Ultor), 357, 360, 412

Temple of Venus and Roma, 237, 432

Templum Pacis, 6, 7, 171, 181, 187, 193, 202, 238

Theater of Marcellus, 60, 84

Theater of Pompey, 7, 11, 42, 90, 161, 284

Tomb of Cestius, Gaius, 7, 116

Tomb of Eurysaces, Marcus Vergilius, 6, 10, 105–9, 116, 149, 196, **90–95**

Tomb of the Fonteii, 40, **19–20**

Tomb of the Haterii, 196–99, 202, 458, **164–68**

Tomb of Hirtius, Aulus, 147, 191

Ustrinum of Augustus, 12, 99, 114

Ustrinum of Antoninus Pius, 285

Ustrinum of Sabina, 254, 262

Via Appia, funerary relief, 40–42, **22**

Via Statilia, funerary relief, 40, **21**

Rome (*continued*)

 Vigna Codini, columbarium, 3

 Villa Doria Pamphili, group portrait, 381, 395, **351–53**

 Villa Farnesina, 116

 Villa of Maxentius, 418, 432–33

 Walls, Aurelian, 360–61, 375; Servian, 25, 361

Romulus, 2, 7, 23, 24, 67, 88, 96, 98, 100, 102, 115, 116, 158, 161, 241, 246, 285, 304, 347, 422, 434, 463

Sabina, Vibia, 13, 237–38, 241–42, 253, 254, 262, 263, 277, 278, 285, 287, 311, 385, **206, 222**

Sabine women, rape of, 24, 42, 89, 115, 304

Sabinus, Flavius, 171

Sabratha, theater, 344–45, 352, 353, **312**

Sacrovir, 124

St. Rémy, Monument of the Julii, 4, 16, 112–13, 116, 154, **99**

Salonica, Arch of Galerius, 9, 401, 412, 413, 416, 419–25, 426, 427, 431, 433, 434, 435, 446, 462, **387–90;** Mausoleum of Galerius, 419; Palace of Galerius, 399, 413, 418, 419, 420, 432; Small Arch of Galerius, 425, 426, **391**

Salonina, 375, 395; portraits of, 381, **350**

Salus, 157

Samnites, 25

Samus and Severus, 157, 158

Scaurus, Marcus, 11

Scipio, 26, 42

Scipio Aemilianus, 36

Scopas, 83, 114

Scopas the Younger, 49

Scribonia, 59, 75

Scriptores Historiae Augustae, 237, 238, 240, 249, 251, 277, 318, 319, 321

Season Sarcophagus, 458–59, **420**

Secundus, Quintus Petillius, 194

Selene, 311

Seleukos Nikator of Syria, 6, 233

Seneca, 129, 135, 136

Septimius Severus, Lucius, 273, 317–19, 325, 326, 332, 334, 336, 338, 340, 342, 343, 344, 347, 350, 351, 352, 353, 357, 360, 394; portraits of, 8, 319–21, 332, 336, 351, **282–83;** as Serapis, 320, 351; painted tondo of Severan family, 321, 325, 353, **284**

Serapis, 320, 353, 422. *See also* Septimius Severus, Lucius

Servius Tullius, 24

Severus, Alexander (Marcus Aurelius Severus Alexander), 319, 326, 358, 362, 393, 394; portraits of, 363, 366, 394, 395, **321–23**

Severus, Flavius Valerius, 400, 406, 432; portraits of, 407

Severus and Celer, 4, 15, 135, 181, 263

She-Wolf, 23–24, 158, 422, 434, 463, **1**

Silanus, Lucius Iunius, 144

Silvanus, 243, 252, 446

Sol, 65, 99, 158, 223, 359, 375, 393, 400, 417, 433, 434, 446, 447, 452, 453, 454, 463

Sorrento Base, 83, **68**

Sosius, Gaius, 84, 86, 114

Split (Spalato): Palace of Diocletian, 399, 417, 419; Mausoleum of Diocletian, 404, 418, 419, 426, **386**

Statius, 271

Stephanos, 4, 29–30, **6**

Stern, Raffaele, 185

Storax, Lusius, 148–49, 162, **125**

Strong, Donald, 455

Studius, 4, 60

Suetonius, 44, 45, 62, 67, 69, 72, 82, 99, 109, 124, 127, 129, 130, 131, 134, 135, 136, 138, 162, 167, 168, 169, 172, 177

Sulla, 26, 48

Sulpicius, Gaius, 80

Suovetaurilia, 50–51, 116, 141, 248, 250, 289, 296, 416, 417, 427

Susa, Arch of Augustus, 4, 110–111, 112, 115, 116, 161, 421, **96–97**

Tacitus, 13, 148, 156, 161, 256

Tacitus, Marcus Claudius, 359; portraits of, 376, 393

Tarpeia, punishment of, 89, 115

Tarquinius Priscus, 24

Tarquinius Superbus (Lucius Tarquinius), 24

Tatius, Titus, 24, 42

Tauriskos of Tralles, 338

Tellus, 65, 70, 96, 311, 422

Tertulla, Arrecina, 171, 177

Tetrarchs, 16; portraits of, 395, 403–5, 426, **366–69**

Tetrarchy, 399, 400, 408, 409, 413, 417, 424, 425, 427, 431–32

Themistokles, 34

Theodora, 417

Theodorus, 109

Theodosius, 463

Theseus, 86, 114, 261

Tiber, 2, 5, 23, 25, 100, 169, 246, 447

Tiberius (Tiberius Julius Caesar Augustus), 60, 67, 69, 70, 71, 76, 77, 78, 86, 90, 92, 98, 102, 123–24, 126, 129, 130, 141, 142, 145, 152, 153–54, 158, 161, 329, 351, 413; portraits of, 124–26, 127, 133, 149, 151, 154, 162, 208, **100–101, 109**

Tiberius Claudius Nero (father of Tiberius), 123

Tiberius Gemellus, 126

Timarchides, 5, 181

Timesitheus, 358, 366, 367, 388

Timgad, 230

Timotheus, 83, 114

Titurius Sabinus, Lucius, 42

Titus (Titus Flavius Vespasianus), 6, 141, 171, 172, 183, 202, 208, 233, 235, 424; portraits of, 131, 172–76, 181, 187, 190, 200, 202, 203, **141–43**

Tivoli: Hadrian's Villa, 16, 161, 237, 244–47, 253, 261, 262, 263, **211–15;** Temple of Hercules, 36; statue from, 36, 40, 115, 131, 162, **12**

Torlonia Relief, 255, 256

Traianus, Marcus Ulpius (father of Trajan), 207, 209, 212, **175**

Trajan (Marcus Ulpius Traianus), 2, 4, 6, 9, 86, 105, 134, 163, 199, 200, 207–8, 224, 230, 232, 233, 237, 241, 248, 249, 250, 254, 261, 262, 263, 295, 313, 318, 329, 331, 334, 338, 351, 360, 363, 436, 450; portraits of, 8, 9, 190, 208–12, 214, 223, 229, 232, 238, 241, 261, 288, 300, 369, 372, 389, 401, 406, 426, 427, 434, 435, 436, 438, 440, 445, 446, 447, 450, 461, 462, 463, **171–74;** as divus, 219–20, 248, 261, 262

Tranquillina, 367, 395; portraits of, 381

Trebonianus Gallus, Gaius Vibius, 359; portraits of, 371–72, 393, 395, **336**

Trier, Palace of Constantius Chlorus, 399

Tripoli, Arch of Marcus Aurelius and Lucius Verus, 308–9, **278**

Triumphal painting, 47–48, 54, 215

Tullus Hostilius, 24

Tyche, 224, 262, 425, 426

Tyrannicides, 246

Ulpia, 237

Ulpius Orestes, Marcus, 5

Uttedius Marcellus, 309

Valadier, Giuseppe, 185
Valeria, 417, 418, 431
Valerian (Publius Licinius Valerianus), 359, 372, 392; portraits of,
 372–73, 374, 394, **337**
Varus, 123
Vecilia Hila, 79
Velleius Paterculus, 82
Velletri, sarcophagus, 259, **229–30**
Venus, 7, 13, 30, 51, 54, 63, 65, 70, 88, 93, 96, 98, 100, 102, 114, 116,
 144, 146, 153, 154, 158, 161, 338, 342, 344, 385; women in guise of,
 103, 146, 178, 197, 280–83, 385, 394, 395, **248–49**
Vespasian (Titus Flavius Vespasianus), 131, 141, 167, 169, 171, 183,
 185, 188, 189, 191, 200, 202, 233, 235; portraits of, 8, 131, 136, 172,
 176, 187, 202, 203, 208, 273, **138–40**
Vesta, 88, 158
Vestal Virgins, 60, 88, 90, 191, 192
Vibius, Lucius, relief of, 79–80, **58**
Vibius Rufus, Gaius, 110
Vicomagistri Reliefs, 147–48, 149, 161, 162, **122**
Victory, 26, 51–52, 54, 70, 82, 87, 102, 125, 153, 156, 158, 187, 191,
 192, 209, 213, 214, 219, 221, 223, 224, 227, 252, 291, 292, 294,
 295, 298, 300–r301, 302, 303, 309, 311, 312, 331, 334, 337, 342, 352,

368, 385, 409, 411, 412, 414, 416, 417, 420, 421, 422, 423, 424, 426,
 427, 436, 446, 447, 450, 452, 453, 458, 459, 462
Vindex, Gaius Julius, 167
Vipsania Agrippina, 124
Virgil, 60, 83, 92, 93, 102
Virtus, 98, 153, 154, 158, 183, 188, 191, 192, 202, 221, 289, 303, 311,
 343, 385, 390, 392, 412, 422, 423, 424, 426, 427, 447
Vitalis, Marcus Aurelius, altar of, 382, 394, **354**
Vitellius (Aulus Vitellius), 141, 167, 169, 172, 200; portraits of, 167,
 169, 172, 202, **137**
Vitruvius, 4, 60, 109, 110
Vulcan, 51, 158

Ward-Perkins, John Bryan, 15
Wickhoff, Franz, 11, 190
Winckelmann, Johannes J., 11

Xenophon, 27

Zenobia, 359, 360, 375
Zenodoros, 4, 11
Zeuxis, 29, 109